MW01153554

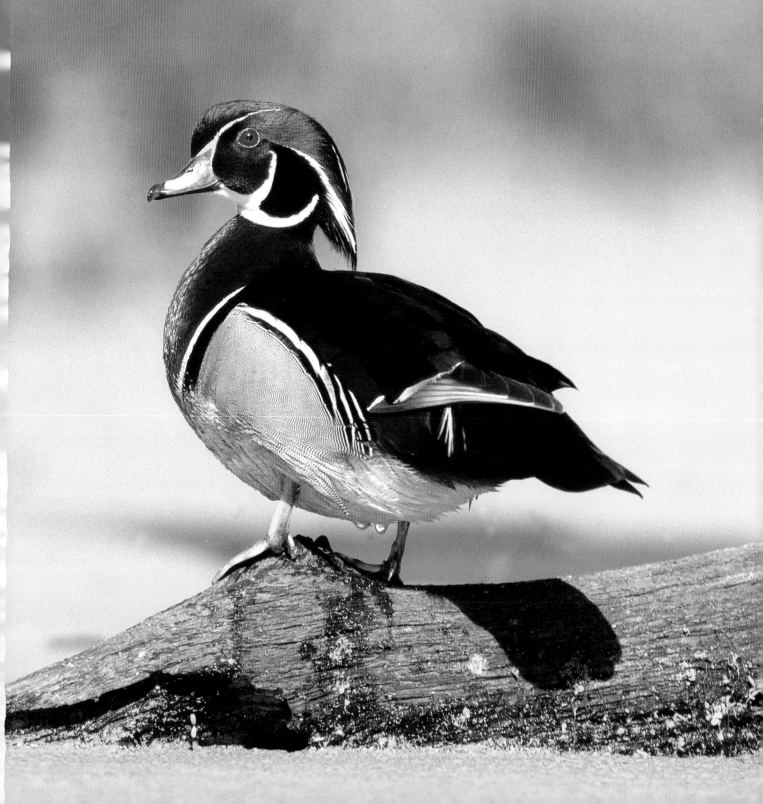

Fish and Wildlife Management

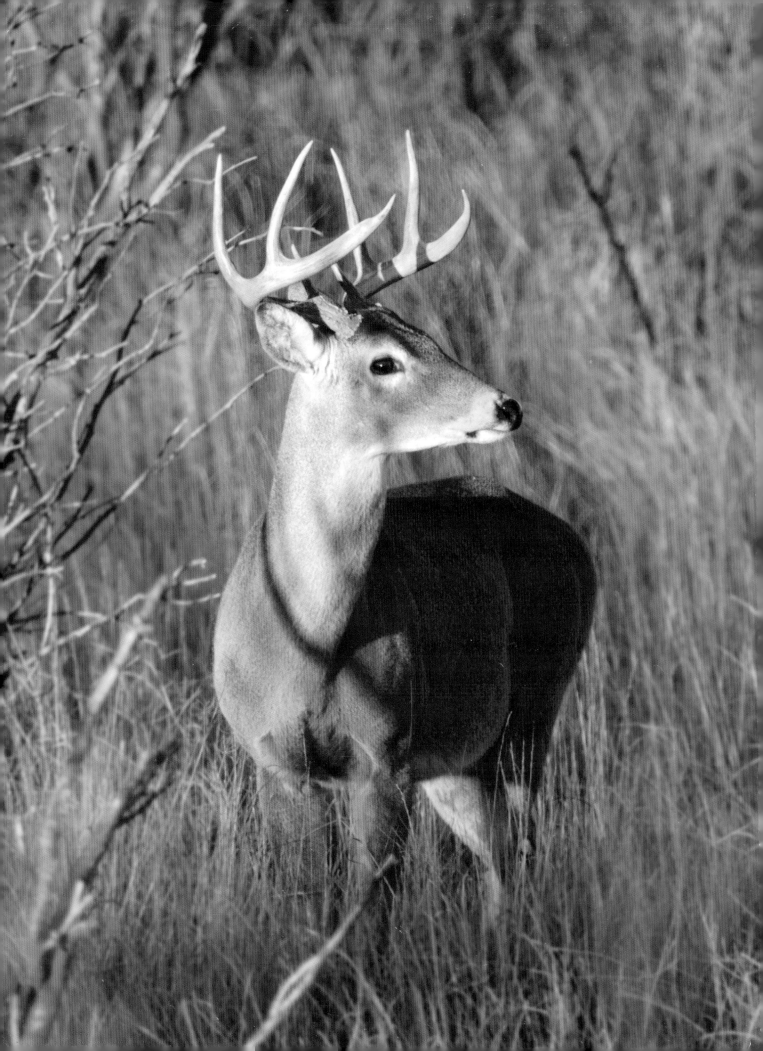

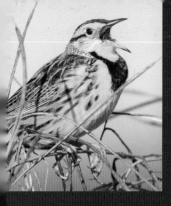

FISH AND WILDLIFE MANAGEMENT

A Handbook for Mississippi Landowners

Edited by Adam T. Rohnke and James L. Cummins

University Press of Mississippi, Jackson, in association
with Wildlife Mississippi, the Dalrymple Family Foundation,
and Mississippi State University

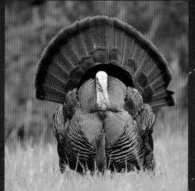
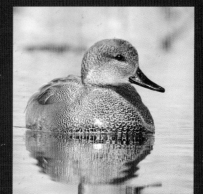

www.upress.state.ms.us

The University Press of Mississippi is a member
of the Association of American University Presses.

Designed by Todd Lape

First printing 2014
∞
Library of Congress Cataloging-in-Publication Data available

British Library Cataloging-in-Publication Data available

This publication is dedicated to all the natural resource professionals, conservationists, and private landowners who came before us. Their knowledge, leadership, mentoring, and most importantly their forethought have led to the foundation we stand upon today and into the future.

—The Editorial Team and Authors

Guy A. Baldassarre spent only a short time of his 35-year career in the South, at Texas Tech University and Auburn University in Alabama. However, his influence in wildlife, waterfowl, and waterbird ecology and management was widespread throughout North America and internationally. He was a superb author, scholar, teacher, mentor, husband, and father. I'm grateful he was my undergraduate advisor and eventual friend.

—Adam T. Rohnke

The two people who made this book possible are my mother- and father-in-law, Adine (Deanie) W. and Arch Dalrymple of Amory, Mississippi. She was a caring and beautiful lady, and he was amusing and knowledgeable storyteller, as well as a wonderful advisor, mentor, and friend. Mr. Dalrymple and I often hunted ducks and quail and fly-fished together.

Mr. Dalrymple felt that Mississippians needed a book to assist private landowners with various methods of fish and wildlife management, written at a level that most landowners could understand. Throughout their lives the Dalrymples were generous and engaged philanthropists, most recently under the auspices of the Dalrymple Family Foundation, which is the primary donor for this book.

I am especially grateful for them raising their daughter and my wife, Martha. She is the love of my life and is the one that gives me the strength and time I need to do the work I do.

—James L. Cummins

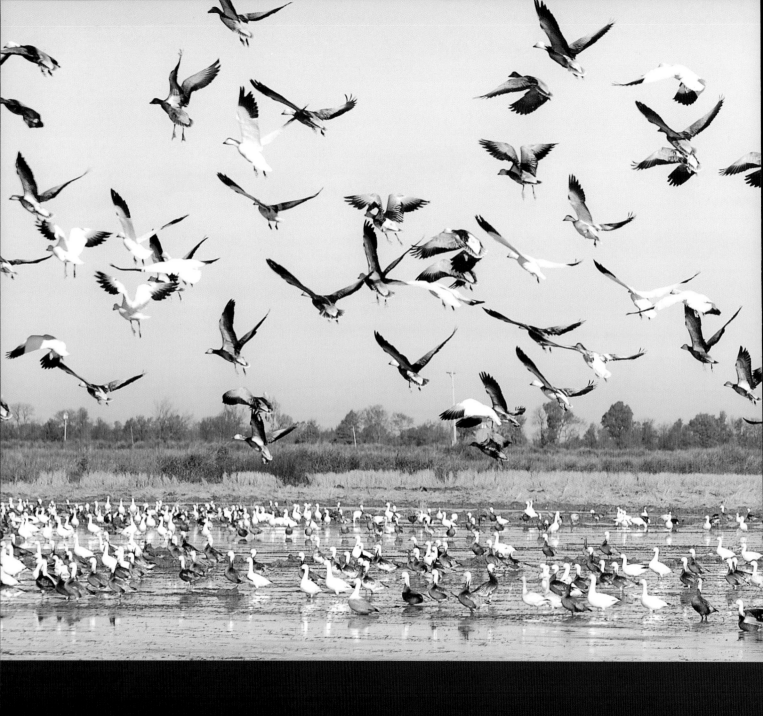

Contents

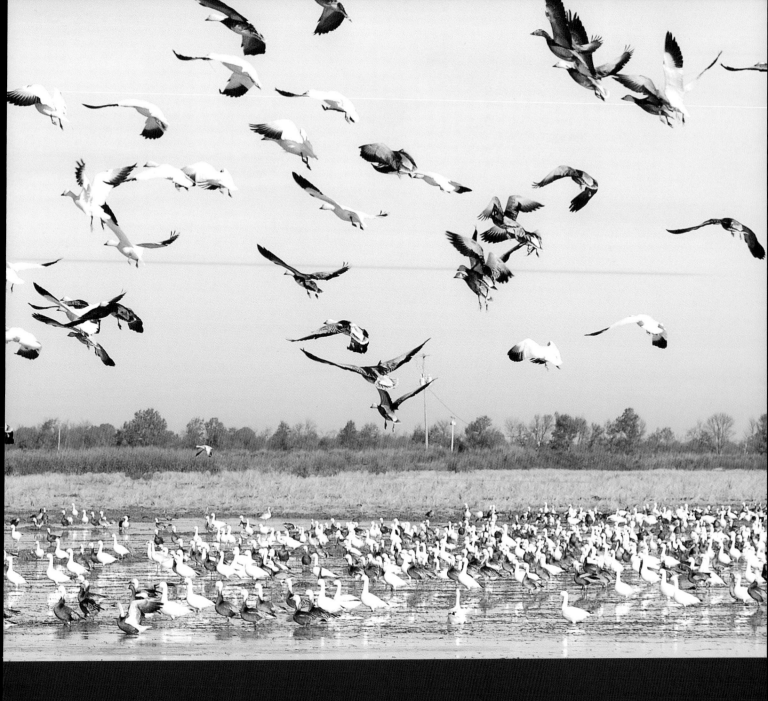

This publication would not be possible without the financial support of the Dalrymple Family Foundation; Wildlife Mississippi; and the Natural Resource Enterprise Program, a unit within the Mississippi State University's Department of Wildlife, Fisheries, and Aquaculture. The Dalrymple Family Foundation, the primary funders of this book, was founded by Adine and Arch Dalrymple. Throughout their lives the Dalrymples were generous and engaged philanthropic donors. Wildlife Mississippi is a charitable, nonprofit conservation organization dedicated to the protection, restoration, and enhancement of Mississippi's natural resources. The Natural Resource Enterprise Program is a partnership between Mississippi State University's Extension Service, Forest and Wildlife Research Center, and Agricultural Forestry Experiment Station and the U.S. Fish and Wildlife Service. The proceeds from this endeavor will be used for additional printings and a second edition, when needed.

This publication is the culmination of nearly a decade of hard work by the two managing editors, a professional editor, and many technical editors, authors, and contributors, all of whom have been individually acknowledged on the title pages of their respective chapters. The book is a true collaboration of the natural resource professionals in Mississippi representing Mississippi State University; Mississippi State University Extension Service; Mississippi Department of Wildlife, Fisheries, and Parks; U.S. Department of Agriculture Natural Resources Conservation Service; U.S. Department of Agriculture Wildlife Services; U.S. Fish and Wildlife Service; and Wildlife Mississippi. We cannot stress enough our gratitude to these individuals and their employers for their expertise, perseverance, and patience throughout this long but important process. Most of these individuals were not compensated for their contributions. They made time in their already full schedules as biologists, foresters, managers, and economists.

This routinely came from personal time, and for that we thank our families for their patience and support and hope they share in the pride of this accomplishment. All of us were driven by the purpose of this book: to provide a foundational reference for the private landowners of Mississippi interested in natural resource conservation and management on their lands.

We are also grateful for the endless supply of high-quality images that were provided to us by colleagues, graduate students, professional photographers, and others. Again, the majority of the contributors provided images free of charge, for which we are grateful.

We would like to acknowledge our consulting professional editor, Sharon Littlepage, who is responsible for making this book not only grammatically correct but also more interesting to read. We also thank Mary Jo Wallace for editing previous versions of select chapters. Finally, we thank Craig Gill, the staff of the University Press of Mississippi, and our copyeditor Lisa DiDonato Brousseau for their assistance and direction throughout the publishing process.

—**Adam T. Rohnke**
Managing Editor

—**James L. Cummins**
Project Director

Acknowledgments

The Mississippi Fish and Wildlife Foundation, commonly called Wildlife Mississippi, is a private, charitable, nonprofit conservation organization. It was founded in 1997 by members representing every county in Mississippi. These founders wanted a low-overhead, cost-efficient organization so they and others could do more for conservation. It is the mission of Wildlife Mississippi to conserve Mississippi's lands, waters, and natural heritage in order to secure the state's quality of life by making it a better place to live, work, and raise a family. Wildlife Mississippi is exempt from federal income tax under section 501(c)(3) of the Internal Revenue Code, and donors may claim a deduction for their contributions.

Wildlife Mississippi has a common-sense and effective conservation philosophy that is based on five basic values:

◆ Conservation should make economic sense, and the results of conservation actions help Mississippi's economy, retain jobs, and preserve property values.
◆ Conservation should include both public and private lands.
◆ Private property rights encourage good stewardship, and private property owners have a responsibility to maintain such good stewardship on their property.
◆ All Mississippians have a shared responsibility to conserve the state's natural areas for present and future generations.
◆ Hunting, fishing, and other forms of outdoor recreation are a part Mississippi's natural heritage and should be used as a means to provide sustainable sources of food and recreation as well as for fish and wildlife management based on sound science.

Wildlife Mississippi believes in a strategic approach to conservation that is based on five strategic goals:

◆ To educate the public about the conservation of Mississippi's lands and waters and the fish, wildlife, and plants they support;
◆ To provide quality recreational hunting, fishing, and wildlife viewing opportunities in Mississippi;
◆ To work toward the improvement of the following types of habitat in Mississippi: bottomland hardwoods, upland hardwoods and pine, longleaf pine, native prairie, rivers and streams, ponds and lakes, freshwater wetlands, coastal wetlands, and marine habitat;
◆ To consider economics in decision-making; and
◆ To develop incentive-based conservation programs with the major conservation agencies that work in Mississippi to identify problems and target strategies so that these agencies have effective and cost-efficient programs to improve Mississippi's lands, waters, and natural heritage.

FOCUS AREAS

Wildlife Mississippi believes in a focused approach to conservation that is based on four primary focus areas: conservation education, fish and wildlife habitat, outdoor recreation and parks, and conservation policy.

Wildlife Mississippi educates citizens about the conservation of natural resources. Much of this activity is directed toward landowners interested in implementing better land and water conservation practices. Wildlife Mississippi assists landowners in fully improving the environmental and economic value of their natural resources in a responsible way.

Wildlife Mississippi recognizes the need to protect, restore, and enhance the state's beaches, lakes, natural areas, and fish and wildlife habitats for future generations. Because 75 percent

Wildlife Mississippi

of Mississippi's lands are privately owned, conservation cannot be limited to public holdings. Therefore, the organization promotes the protection, restoration, and enhancement of both private and public lands and waters.

Wildlife Mississippi recognizes that outdoor recreation is a part of our way of life in Mississippi—from the hunter and angler to the young child who plays in the community park to the backyard bird watcher. The organization encourages the development of new trails, boat ramps, wildlife management areas, refuges, parks, and national forests. Safe, family-oriented outdoor recreational opportunities also promote tourism, as visitors are drawn to the beauty of Mississippi's beaches, rolling hills, and natural areas.

Wildlife Mississippi is working with conservation agencies, the Mississippi Legislature, and the U.S. Congress to identify problems and target strategies regarding the protection, restoration, and enhancement of the state's land and water resources. The organization provides policy recommendations that address the most pressing issues. Innovative programs and new ideas that will make conservation more effective, efficient, and responsive to its constituencies are highlighted. Wildlife Mississippi helps shape public policy that promotes on-the-ground action to conserve Mississippi's valuable natural resources.

AN ECONOMIC FORCE

Wildlife Mississippi recognizes that the conservation of lands and waters helps the state's economy, retains jobs, and preserves home values. At least one in twenty Mississippi jobs relies on having a healthy environment. Through the organization's efforts in protecting, restoring, and enhancing public and private lands and waters, Wildlife Mississippi is having a positive economic impact on the state. Hunting, fishing, and wildlife viewing contribute more than $2.7 billion to the state, while creating more than 66,000 jobs for Mississippians.

In the nonprofit world, Wildlife Mississippi has a reputation for being fiscally conservative.

The organization has a small professional staff that spends funds effectively and efficiently to deliver the best possible conservation throughout Mississippi. Overall, Wildlife Mississippi's management, administrative, and general expenses are only 14 percent of the organization's annual budget.

HELP US CONTINUE TO PROTECT, RESTORE, AND ENHANCE MISSISSIPPI

Wildlife Mississippi's efforts to preserve habitats by preventing land-use changes on environmentally significant lands and waters have resulted in more than 100,000 acres being protected. In addition, the organization's restoration efforts have led to approximately 75,000 acres of altered lands and waters being returned to a natural state. Finally, Wildlife Mississippi's efforts to enhance the state's land and waters by ensuring that they provide the highest quality habitat have resulted in the enhancement of approximately 175,000 acres. This is a total of more than 350,000 acres of land and waters conserved.

All Mississippians have a shared responsibility to conserve the state's natural areas for present and future generations. It is through the donations of individuals, corporations, and foundations, as well as partnerships with state and federal agencies, that Wildlife Mississippi is able to continue to conserve the lands and waters of Mississippi. No gift amount is too small, and a gift to Wildlife Mississippi may provide you with significant tax benefits. You can help Wildlife Mississippi continue to protect, restore, and enhance the lands and waters of the state by giving through bequests, charitable gift annuities, charitable lead trusts, charitable remainder trusts, donor advised funds, financial contributions, gifts of stock, gifts of life insurance or retirement assets, gifts of real estate and timber, or planned giving.

Fish and Wildlife Management

CHAPTER 1

Mississippi's Natural Bounty

Adam T. Rohnke, Wildlife Extension Associate, Department of Wildlife, Fisheries, and Aquaculture, Mississippi State University

With contributions by
Martha D. Dalrymple, Dalrymple Family Foundation
James L. Cummins, Executive Director, Wildlife Mississippi

Ranging from the shores of the Gulf of Mexico to the flat lands of the Delta and the foothills of the Appalachian Mountains, Mississippi has a vast array of abundant natural resources. Many aspects of the state's economy, both historically and to-day, are dependent upon these natural resources. The most obvious example is the agricultural and forestry industry, which employs 29 percent of the state's workforce (either directly or indirectly) and generates $7.02 billion annually. Similarly, outdoor recreational opportunities, including hunting, fishing, wildlife viewing, and other related activities, generate $2.69 billion in Mississippi. Most of these enterprises occur on private lands and provide rural communities with crucial economic opportunities and tax revenues. Moreover, most other major economic sectors (including housing, energy, and transportation) rely on the state's natural assets, especially clean and abundant water, fiber, and other vital resources such as minerals, oil, and natural gas.

Besides powering the economy, the natural resources of the state have shaped Mississippi's culture through food, art, music, and craft trades. Native and non-native fish and wildlife have long been staple items in family recipes such as gumbo, crayfish and shrimp boils, various venison dishes, and endless baskets of fried fish and other delights. Artists such as Walter Inglis Anderson, Bob Tompkins, Debra Swartzendruber, and Jerrie Glasper whose depictions of the natural flora and fauna of Mississippi, along with hundreds of musicians who commonly perform and write songs influenced by their experiences with Mississippi's natural resources, have captured the state's unique cultural imprint.

A foggy autumn morning in the forest. Photo courtesy of Raymond B. Iglay, Mississippi State University

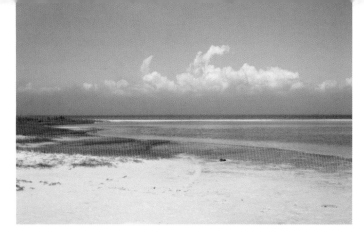
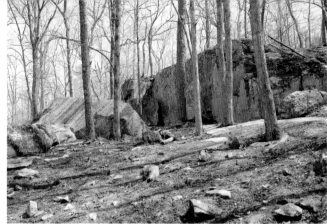
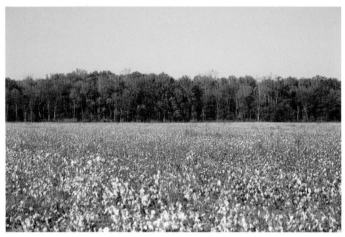
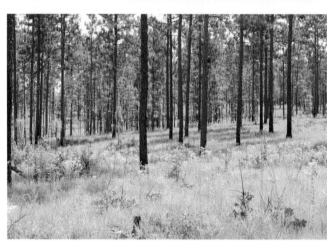

Mississippi's diverse landscape includes the Mississippi Sound, rocky outcrops in the north, the flat lands of the Delta, and the piney woods. Photos courtesy of Clay Wilton, Mississippi State University (Mississippi Sound); James L. Cummins, Wildlife Mississippi (Tishomingo and cotton field); Randy Browning, U.S. Fish and Wildlife Service and Wildlife Mississippi (long-leaf pine forest)

Table 1.1. Key geographic features of Mississippi	
Geographic feature	
Land area	47,689 square miles [a]
Agriculture	17,422 square miles (11,150,000 acres) [b]
Forestland	29,688 square miles (19 million acres total; 12.54 million acres privately owned) [c]
Islands	Cat, Deer, East Ship, Horn, Petit Bois, Round, West Ship Islands
Highest point	807 feet (Woodall Mountain in Tishomingo County) [d]
Average elevation	300 feet [d]
Lowest point	sea level (Gulf of Mexico) [d]
Surface area of water	1453 square miles (3% of land area) [d]
Rivers and streams	82,154 miles [a]
Major river systems	Mississippi, Big Black, Pearl, Pascagoula, Tombigbee, and Yazoo Rivers
Major bodies of fresh water	Arkabulta, Grenada, Okatibbee, and Sardis Lakes and Ross Barnett Reservoir
Major bodies of salt water	Mississippi Sound, Bay St. Louis, Biloxi and Pascagoula Bays
Water bodies less than 100 acres	160,000 (accounting for > 190,000 acres) [e]
Wetlands (freshwater and tidal wetlands)	2,780,947 acres
U.S. Fish and Wildlife Service refuges	14 (approximately 250,000 acres) [f]
National forests	6 (1.2 million acres) [f]
National parks	8 [f]
State wildlife management areas	50 (655,000 acres) [f]

[a] Mississippi Department of Environmental Quality
[b] Mississippi Agricultural Statistics Service
[c] Mississippi Forestry Commission
[d] U.S. Geological Service
[e] Mississippi State University Extension Service
[f] Respective agencies' websites (accessed January 13, 2013)

Table 1.2. Select species counts in Mississippi	
Species	**Number of species**
Birds [a] State bird: northern mockingbird State waterfowl: wood duck	409
Mammals [a] State land mammal: white-tailed deer State marine mammal: bottlenosed dolphin	61
Fish (freshwater) [a] State fish: large-mouth bass	204
Amphibians [a]	61
Reptiles [a] State reptile: American alligator	84
Mussels [a]	86
Crustaceans [a]	66
Ants [b]	183
Butterflies [b] State butterfly: spicebush swallowtail	140
Plants and mosses [a] State tree and flower: southern magnolia State wildflower: *Coreopsis*	3500–4000
Total endangered species and subspecies [a]	80

[a] Mississippi Museum of Natural Science
[b] Mississippi Entomological Museum

But for the majority of Mississippians, the most valuable interactions with natural resources come in the form of family traditions and recreational activities. Fishing with a grandparent on the bank of the family farm pond, planning the annual retreat to hunting camp for opening weekend of deer season, or learning to identify your first bird in the backyard—all are experiences that are closely held and cherished.

So, no matter what drives your passion about Mississippi's natural resources, it is important for all Mississippians—urbanites, suburbanites, and rural residents alike—to recognize that, collectively, we are all responsible for managing and conserving the state's environment for the use and enjoyment of future generations.

THE HISTORY OF NATURAL RESOURCE USE IN MISSISSIPPI

The following is a brief overview of the history of natural resource conservation and fish and wildlife management in Mississippi. For an extensive historical timeline of key Mississippi natural resource–related events, please refer to Appendix 1.

1800–1899
- From 1819 to 1824, John James Audubon traveled extensively in Mississippi and Louisiana.
- Federal forest reserves were established for the future protection of timber and water resources.

1900–1920
- U.S. Congress enacted legislation to aid states in the enforcement of game laws.
- Passage of the Lacey Act, which made interstate transportation of wildlife killed in violation of state law a federal crime.
- Migratory Bird Treaty Act was passed by the United States and Canada.
- Mississippi's first deer season and bag limits were set by the legislature.

◆ President Theodore Roosevelt hunted black bears near Onward, Mississippi.
◆ Intense logging was widespread in Mississippi.
◆ Merigold Hunting Club, the first of the state's hunting clubs, was formed in Bolivar County.

1921–1940
◆ Intense logging continued throughout Mississippi.
◆ Several federal and state agencies were created to protect, regulate, and enforce natural resource laws in Mississippi, including the U.S. Fish and Wildlife Service, Soil Conservation Service, Mississippi Forestry Commission, and Mississippi Game and Fish Commission.
◆ Federal Aid in Wildlife Restoration Act provided aid to states with wildlife restoration projects.
◆ The 1927 flood occurs in the Delta. In response to public outcry over this historic disaster, major flood control and navigation improvements were planned for the Mississippi River, which will forever alter the riverine ecosystem.
◆ Aldo Leopold, the father of game management, conducted a survey of wildlife conditions in Mississippi.
◆ White-tailed deer, eastern wild turkeys, and Mexican quail were purchased and released to restock several regions of the state.
◆ Several large New Deal programs were created during the Depression, including the Civilian Conservation Corps and the Tennessee Valley Authority. These were responsible for many large-scale environmental projects in Mississippi.
◆ Procurement of lands by several federal and state government agencies provided many of the large public access areas available today in Mississippi, such as the Homochitto National Forest and Yazoo National Wildlife Refuge.

1941–1960
◆ The Dingell-Johnson Federal Aid to Fisheries Restoration Act was passed by Congress.

◆ Multiple statewide white-tailed deer and eastern wild turkey surveys were conducted to monitor the success of the restocking programs. By the late 1950s the populations of both species were estimated to be more than 10,000 individuals.
◆ Mourning dove, squirrel, wild turkey, and waterfowl research projects were initiated in several regions of the state.

1961–1980
◆ The annual white-tailed deer harvest steadily increased as a statewide season was opened and selective antlerless deer hunts were implemented. Similarly, as the eastern wild turkey population grew, so did the annual harvest.
◆ Several landmark pieces of federal legislation—the Clean Water Act, National Environmental Policy Act, and the Endangered Species Act—were passed to protect and conserve the nation's water, air, soils, wetlands, and most vulnerable species.
◆ American alligators were stocked in the Mississippi Delta.

1981–2000
◆ The state's white-tailed deer population approached 1.7 million individuals.
◆ Wildlife Mississippi was formed.
◆ Under the leadership of Senator Thad Cochran, conservation programs associated with the Farm Bill, such as the Wetlands Reserve Program and the Wildlife Habitat Incentives Program, were enacted to encourage private landowners to restore wetlands, native grasslands, and wildlife habitat on agricultural and working lands.

2001–Present
◆ Farm Bill programs continue to be implemented on millions of acres, with variations and modifications to funding and approved practices based on results of monitoring of the enrolled lands.
◆ In 2005, Hurricane Katrina decimated the Gulf region, making landfall at Bay St. Louis, Mississippi, and affecting the entire state. In addition to the loss of human life and billions of dollars in damage, the

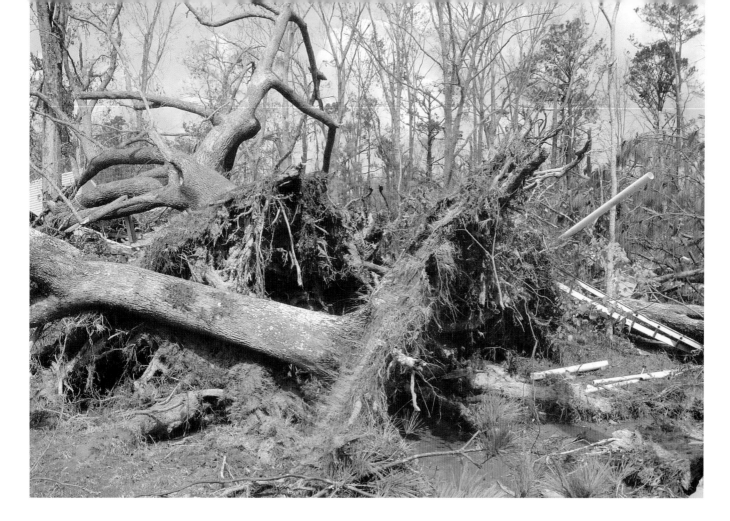

Mississippi Sound, coastal estuaries, and forest ecosystems were drastically affected.
• The Theodore Roosevelt and Holt Collier National Wildlife Refuges were established at the requests of Senator Thad Cochran and Congressman Bennie Thompson.
• The Deep Water Horizon oil spill (also called the BP oil spill), which occurred in the summer of 2010, has had vast economic and ecological impacts across the Gulf of Mexico, including coastal Mississippi. As a result of fines and settlements between the federal government and the responsible parties, billions of dollars have been secured for long-term ecological impact studies and regionwide restoration activities.

Early to Mid-1800s

Well before Mississippi became a state, Native Americans (Choctaw, Chickasaw, and the Natchez) and early European settlers were well aware of the incredible diversity and abundance of natural resources in this region of the New World. It was a majestic, wild place with ever-bountiful estuaries and bays along the coast

of the Gulf of Mexico, old growth hardwood and pine forests covering the majority of the territory, open grasslands and savannas in the northeast, many hundreds of miles of rivers and streams, and the once-forested Mississippi Delta. This blend of valuable resources eventually attracted and sustained the rapid growth of the human population and a burgeoning economy, leading to eventual statehood in 1817. In

Timber losses from Hurricane Katrina were extensive across Mississippi. Photo courtesy of iStock

An original stand of loblolly pines prior to the 1900s. Photo courtesy of Mississippi Department of History and Archives

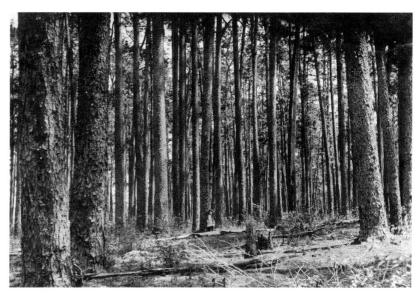

Clearcuts were a common sight in rural Mississippi in the early 1900s. Photo courtesy of Mississippi Department of Wildlife, Fisheries, and Parks

the same year, the U.S. Navy was authorized to establish forest reserves in order to protect large tracts of hardwoods for their future ship-building purposes. These and other examples illustrate the tremendous wealth of natural resources in Mississippi.

Several land treaties with the Choctaw and Chickasaw during the 1820s and 1830s, along with land acts that reduced the price of land, encouraged pioneers to move into Mississippi. Subsistence and cash-crop farming (typically cotton, corn, and tobacco) were pillars of the early local economies in small Mississippi River settlements and towns prior to the Civil War. Also during this time, subsistence and market hunting of small and big game was becoming common. Virgin timber along the Mississippi, particularly around today's Natchez, was harvested both for wood products and clearing land for agriculture. To protect these new settlements and their young economies, river engineering began with a small system of levees in the southern Delta region.

Late 1800s to Early 1900s

In the decades following the Civil War, the Mississippi landscape would forever change. Forest resource demands from the northern states and the expansion of the railroad system throughout the South gave way to massive clearcutting of the virgin timber that had covered almost 95 percent of the state in 1800. In addition, a steep upsurge in market hunting for all game species dramatically increased during the late 1800s. Harvesting of nongame species, including herons and egrets for their feather plumes to be used in women's hats and other fashions, quickly became its own viable industry with national and international markets. These activities, along with unsustainable agricultural practices (erosion and extensive wildfires are examples), would continue almost unabated until the early 1900s, when several federal and state laws were passed to protect soils, water, forests, birds, and game animals.

One of the first results of these reforms was the creation of the Mississippi Forestry Commission (1926) and the Mississippi Fish and Game Commission (1932). The latter was funded through the establishment of hunting seasons and the hunting license program (which continues to be the main funding source for today's Mississippi Department of Wildlife, Fisheries, and Parks). Both commissions were charged with protecting, managing,

Frances A. Cook, pioneer conservationist and founder and director of the Museum of Natural Science from 1932 to 1958. Photo courtesy of Mississippi Department of Wildlife, Fisheries, and Parks

LEOPOLD VISITS MISSISSIPPI

Aldo Leopold, the father of wildlife management, conducted a nationwide survey of wildlife conditions. Upon completing the survey of Mississippi in 1929, he said, "Wild turkey are steadily decreasing. They have been cleaned out of the upper ranges, and there's barely a seed stock left in the largest swamps." Furthermore, he stated, "There is no state game department and only the beginnings of a conservation movement. There is no refuge system and little law enforcement. . . . There is one offset to all these defects: a widespread and intense popular interest in game and hunting. In this respect, Mississippi excels any other state so far surveyed. The capitalization of this interest . . . is the only hope for maintaining a game supply in the face of the process of industrialization now underway throughout the South."

and enforcing the new state laws designed to protect Mississippi's natural resources. Utilizing these new powers and the foundational work of key national conservation pioneers such as Aldo Leopold and local leaders including Fannie Cook, Lucy Somerville Howorth, and Hunter Kimball, Mississippi began to turn the corner from exploitation to restoration and conservation of its resources. Unfortunately, as with the rest of the country, it would be too late for iconic species including the Carolina parakeet, the passenger pigeon, and several other animal and plant species that went extinct during this period of exploitation.

The 1930s to 2000

Capitalizing on the newly created labor force from the federal Works Progress Administration and Civilian Conservation Corps, major statewide animal population surveys were conducted and restocking programs implemented for furbearers (such as beavers), small (such as eastern wild turkey, wood duck) and large game (including white-tailed deer), and several fish species. Similarly, a number of wildlife management areas, state parks, and federal lands were established in Mississippi during this time.

After World War II, additional professional staff, law enforcement officers, and funding

Works Progress Administration field technicians collecting and preparing scientific specimens for museums. Photo courtesy of Mississippi Department of Wildlife, Fisheries, and Parks

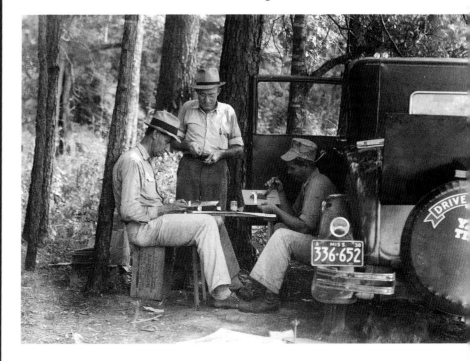

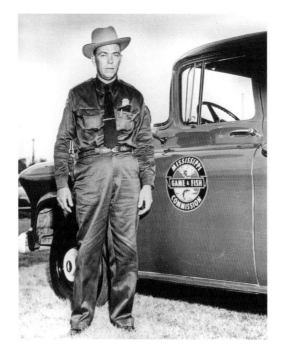

A Mississippi Game and Fish Commission officer stands next to his vehicle. Photo courtesy of Mississippi Department of Wildlife, Fisheries, and Parks

became available to continue the progress made during the first half of the century. As a result of regulated hunting seasons, rebounding habitat, and restoration activities, hunting seasons began to be liberalized and modified based on wildlife management research. Similar actions involving forestry and agriculture increased efficiency and production, but also improved soil and water protection. Much of this research was

developed through cooperative agreements with various state universities, including Mississippi State University and Alcorn State University.

In addition, state (Mississippi Game and Fish Commission, Mississippi Forestry Commission) and federal agencies (U.S. Department of Agriculture Natural Resources Conservation Service, U.S. Fish and Wildlife Service), universities (Mississippi State University Extension Service and Alcorn State University Extension Service), and nongovernmental organizations (Wildlife Mississippi, Mississippi Wildlife Federation, and others) began to recognize the importance of working with private landowners, who collectively own 90 percent of the land. By engaging landowners through educational opportunities, technical assistance, and financial resources, conservation activities on private lands throughout the state became more organized and effective.

Today and the Future

These agencies and organizations are continuing this important effort on public and private lands. From working on native species restoration and non-native species removal to designing farm ponds and restoring wetlands and much more, the partnership between natural

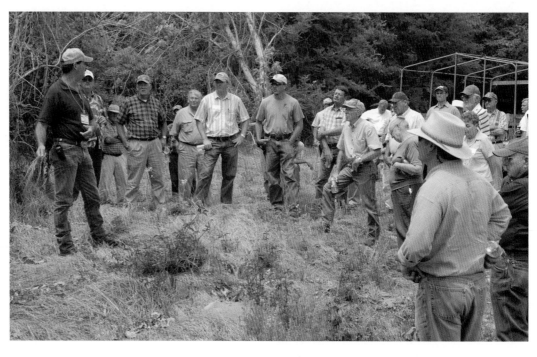

Landowners look on as a natural resource professional discusses how to identify and control cogongrass, a non-native and invasive grass in Mississippi. Photo courtesy of Adam T. Rohnke, Mississippi State University

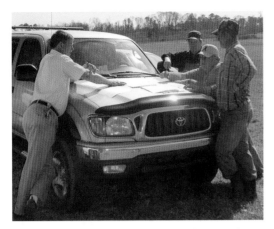

Soil engineers point out features of a new farm pond design to the contractor and property manager. Photo courtesy of Adam T. Rohnke, Mississippi State University

resource professionals and private landowners has never been stronger. Such collaboration will be especially important with the continued growth of the human population in Mississippi and even worldwide. As the demand for energy, fiber, and food continues to grow, natural resource professionals and landowners will need to employ innovative management techniques that will help maintain the state's fish and wildlife populations, sustain the forests and grasslands, and protect the water and soils.

THE PURPOSE OF THIS PUBLICATION

The tradition of Mississippi's natural resource professionals working closely with private landowners is strong. Wildlife Mississippi and the Mississippi State University Extension Service, along with authors and editors from federal and state agencies and nongovernmental organizations, have assembled this publication for our most important partners: private landowners.

This book includes seventeen chapters of in-depth discussion on topics related to natural resource management in Mississippi. Beginning with a foundational chapter on the steps of conservation planning and the basics of developing a natural resource enterprise, the authors discuss the delicate balance between profits and land stewardship. A basic introduction to Mississippi soils, the management and conservation of soil, and its importance to our economy

and natural environment is discussed. This is followed by a series of chapters about the main ecosystems (that is, cropland, grassland, woodland, wetland, and streams and rivers) and the associated fish and wildlife populations that inhabit the landscape in Mississippi. Several chapters are devoted to the natural history and specific management techniques of popular small and large game species. Finally, several chapters cover special management topics such as supplemental planting for wildlife, farm pond management, backyard habitat, nuisance animal control, and invasive plant species management and control.

All of these chapters were written by leading professionals in Mississippi, who have spent countless hours working in their respective disciplines to assist landowners. The chapters include up-to-date and applicable management techniques that can be employed by private landowners throughout the state. This book was also written for those who do not live in rural communities but have an interest in the wildlife and natural resources of Mississippi. For example, the backyard habitat chapter was specifically written for residents of urban and suburban communities interested in creating a wildlife-friendly yard.

Whether you own one-fourth of an acre or 2000 acres, we thank you for your interest in managing the natural resources on your private land and hope this handbook helps you meet your land management expectations.

For More Information

Dickson, J. G. 2001. *Wildlife of Southern Forests: Habitat and Management*. Blaine, Wash.: Hancock House Publishers.

Fickle, J. E. 2001. *Mississippi Forests and Forestry*. Jackson: Mississippi Forestry Foundation and University Press of Mississippi.

Ross, S. T., 2001. *Inland Fishes of Mississippi*. Jackson: Mississippi Department of Wildlife, Fisheries and Parks and University Press of Mississippi.

Turcotte, W. H., and D. L. Watts. 1999. *Birds of Mississippi*. Jackson: University Press of Mississippi.

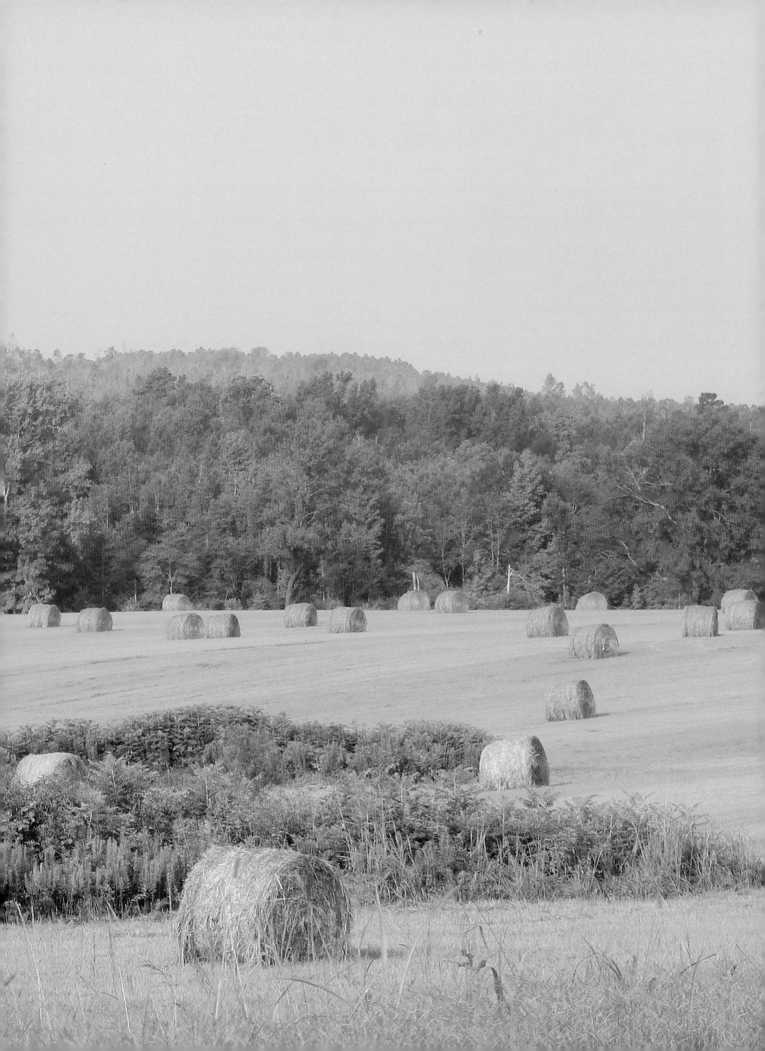

CHAPTER 2

Conservation Planning and Natural Resource Economics in Mississippi

Stephen C. Grado, George L. Switzer Professor of Forestry, Department of Forestry, Mississippi State University

Marcus K. Measells, Research Associate III, Department of Forestry, Mississippi State University

Adam T. Rohnke, Wildlife Extension Associate, Department of Wildlife, Fisheries, and Aquaculture, Mississippi State University

With contributions by

James L. Cummins, Executive Director, Wildlife Mississippi

Richard G. Hamrick, Small Game Program Leader, Mississippi Department of Wildlife, Fisheries, and Parks

L. Wes Burger Jr., Dale H. Arner Professor of Wildlife Ecology and Management, Department of Wildlife, Fisheries, and Aquaculture, Mississippi State University

Technical editor

W. Daryl Jones, Associate Extension Professor of Economic Enterprises, Department of Wildlife, Fisheries, and Aquaculture, Mississippi State University

The South is an important food- and fiber-producing region in the United States. In recent years, corn and soybean production has increased dramatically across the region as a result of greater demands for ethanol production and food supplies. This part of the country also produces more forest products than any other region in the world. Future projections all point to an increasing share of the forest market to shift to the South, particularly the south-central United States. As a result of this future commitment to forestry, agriculture, and associated industries (such as forest products, fish and wildlife, and recreation), private landowners must understand the economic, social, and environmental benefits of these industries.

The extensive agricultural and forest land base across Mississippi is rich with fertile soils that support a variety of row crops, pastures for livestock, highly productive and diverse forests, and abundant game and nongame fish and wildlife populations. This abundance of natural resources provides tremendous economic opportunities for landowners, including fish- and wildlife-related economic enterprises such as fee hunting, nature tourism, pine straw production, agroforestry, and other alternative land-use enterprises.

The economic benefits of local natural resources and associated enterprises are not limited to the individual landowner, as the economic impact from these initiatives often spreads throughout rural communities via the service (such as restaurants, hotels, entertainment) and retail (gas stations, grocery stores, hunting supply stores) industries. All of these activities add to the local tax base.

Harvested hay bales in a field. Photo courtesy of Steve Gulledge

14

The hunting season provides small rural communities and local businesses with an influx of customers. Photo courtesy of James L. Cummins, Wildlife Mississippi

Improved marketing and production practices from private lands will provide additional and often immediate household income, create new employment in all sectors of the economy, and improve the quality of life in rural communities. These impacts can breathe life back into many communities that have lost much of their farm- and timber-based employment over the past several decades. Furthermore, these opportunities can provide a renewed sense of tradition and pride that may have faded in communities where jobs have been lost.

The value of incorporating conservation practices into an enterprise can be as important to the landowner as the economic benefits. Sustainable practices improve the environment by maintaining or improving water quality, reducing soil erosion, and enhancing wildlife habitat. Reforestation of stream and river corridors for water quality protection and the creation of fish and wildlife habitat are supported by the conservation programs of recent U.S. Farm Bills. The habitat that these areas provide for game species can also generate additional economic

Hunting guides are often needed for fee hunting enterprises, providing good-paying jobs for local residents. Photo courtesy of iStock

benefits to the landowner through fee hunting enterprises. The combination of governmental programs and market-driven incentives will help landowners restore and conserve fish and wildlife habitats needed for ecosystem restoration and protection, such as bottomland hardwoods, wetlands, native prairie, and longleaf pine. Converting only a portion of idle or marginal cropland or plantation pine available in the South to multiple-use systems could lead to increased economic and social benefits for landowners and ecological benefits for wildlife.

The purpose of this chapter is to highlight the key elements of conservation planning to assist landowners in developing a comprehensive management plan. In addition, natural resource enterprise opportunities and management are discussed for landowners interested in generating income from their properties.

DEVELOPING A MANAGEMENT PLAN

Most forest landowners and farmers feel obligated to manage their land and water resources responsibly. However, only about 20 percent of landowners in Mississippi report having a written management plan. If landowners want to diversify their land-based operations to increase their income or enhance their personal satisfaction from owning land, it is imperative that they develop a management plan. Yet, in many cases, landowners lack the time and/or expertise to develop a written management plan, which can serve as a roadmap for financial success and responsible stewardship.

Personal Evaluation

Mississippians acquire land for many different reasons, often through inheritance. People may also purchase land for recreational purposes (such as hunting, fishing, and camping), as a long-term financial investment, or for enterprise development opportunities. No matter how land is acquired, landowners must identify the main purpose of the land and devise a plan to accomplish their management goals.

At this point, conservation planning becomes more about personal and family priorities than an inventory of the tangible resources, such as number of acres, farm equipment, livestock, and buildings associated with a specific property. When establishing the goals of the property, it is crucial to develop a true understanding of personal and family needs and desires in order to limit family conflicts regarding management. Common conflict points include:

- whether to continue current management or change management course (such as converting a cattle farm to a tree farm);
- respecting the wishes of ancestors;
- responsibility of costs (taxes, management expenses, legal fees) and disbursement of income (such as cattle sales, timber sales, and mineral rights); and
- use of the property by family members, distant relatives, and friends.

It is important to keep in mind during these family conversations that the decision-making process should include the desires of current and future generations.

A common logistical issue that arises when managing properties gained through inheritance

THE ECONOMICS OF NATURAL RESOURCES IN MISSISSIPPI

- Forest land comprises more than 60 percent of the land area in Mississippi.
- Agriculture and forestry is a $6.3 billion industry in the state.
- There are approximately 42,000 farms covering 11 million acres, and 125,000 public and private forest landowners holding 19.6 million acres.
- Agriculture and forestry employ approximately 29 percent of the state's workforce, either directly or indirectly.
- Hunting, fishing, and wildlife watching generated total economic impacts of $1.14 billion, $773 million, and $829 million, respectively, in 2010.

A couple meets with their lawyer to discuss legal and financial issues regarding their land. Photo courtesy of iStock

GETTING ASSISTANCE

Several agencies, organizations, and private consultants are available to Mississippi landowners for technical assistance and guidance regarding land management. All are staffed with natural resource professionals with a variety of expertise.

State and Federal Agencies

Mississippi State University College of Forest Resources
www.cfr.msstate.edu
www.msucares.com
(662) 325-2952

Natural Resource Enterprises Program of Mississippi State University Extension Service
www.naturalresources.msstate.edu
(662) 325-3174

Mississippi Department of Wildlife, Fisheries, and Parks
www.mdwfp.com
(601) 432-2199 (wildlife help desk)

U.S. Department of Agriculture, Natural Resources Conservation Service
www.nrcs.usda.gov
(601) 965-5205 ext. 130

Mississippi Forestry Commission
www.mfc.ms.gov
(601) 359-1386

U.S. Fish and Wildlife Service Mississippi Ecological Services
www.fws.gov/mississippiES
(601) 965-4900

Organizations

Wildlife Mississippi
www.wildlifemiss.org
(662) 686-3375

The Nature Conservancy of Mississippi
www.nature.org/ourinitiatives/regions/northamerica/unitedstates/Mississippi
(601) 713-3355

Mississippi Chapter of the National Wild Turkey Federation
www.nwtf.org
(800) 843-6983

Ducks Unlimited Mississippi
www.ducks.org/mississippi
(601) 956-1936

Delta Wildlife
www.deltawildlife.org
(662) 686-3370

Mississippi Land Trust
www.misslandtrust.org
(662) 686-3375

is that all or most of the family members are absentee landowners, that is, individuals who do not live on the property full-time. Absentee landowners may live in the same town or county as the property or in the same state, region, or country or even out of country. The geographic location of family members can affect management of the day-to-day operation of the property.

These are just some of the most common issues that families face when owning and managing land in common. Each family will have additional concerns that are unique to their particular situation, and it is important to recognize and consider them accordingly. Once these needs and desires are in order, the landowner(s) can move forward on developing the physical management plan for the property.

Physical Resource Planning and Management

Many components of the natural environment must be considered in combination with personal, economic, and logistical issues. The key tenets of a comprehensive natural resource management plan should include:

- a working knowledge of the local environment and associated wildlife;
- realistic management goals and objectives based on natural resource knowledge and personal capabilities;
- a general inventory of current land-use practices, natural resources (types of habitat, species present), and financial and physical resources (land management implements, buildings, and other infrastructure);
- a detailed timeline of goals and objectives; and
- maintenance of needs and evaluation of accomplishments.

Understanding Fish and Wildlife.
The management of fish and wildlife populations is complex because of the diversity of species, scale (both area and time) during which the management is taking place, seasonality, and integration with intensive land uses,

including production agriculture or forestry. Although the protocols can be complex, all landowners can manage or encourage fish and wildlife use on their properties when appropriate management principles are followed. These principles are discussed throughout the book with regard to specific management systems and select species. Landowners are encouraged to seek out the many natural resource management educational opportunities available from various federal, state, and local agencies along with many nongovernmental organizations.

Determining Goals and Objectives.
When identifying land management goals and objectives for fish and wildlife, it is important that goals are broad and allow for flexibility. Goals, objectives, and the timeline for completion should be realistic and measurable. Finally, other land-use objectives for the property, such as agriculture or forestry, should be included.

In the early stages of plan development, it is wise to have broader goals, such as "providing wildlife habitat, protecting and enhancing soil and water quality, and maintaining profitable agricultural production on our family farm." A goal such as "producing trophy white-tailed deer" may be unobtainable because of property size, geographic location, and other factors. A landowner would not know if producing trophy white-tailed deer is possible until a natural resource inventory, deer population evaluation, and consultation with a professional wildlife biologist have taken place. Setting broad goals allows for adjustments during the initial planning stages. In fact, it is common and recommended that management goals be reevaluated and modified annually as new information, techniques, and both planned events, such as timber harvest, and unplanned events, like a hurricane or tornado, occur.

A management plan should contain aspirational goals but be moderated by realistic and achievable steps. When setting goals in a wildlife management plan, the landowner needs to strike a realistic balance between personal goals and the capacity of the natural resources on the property. Landowners must take into account the amount of time needed, equipment

available, number of acres owned or controlled, and amount of money they wish to spend to achieve their management goals and objectives.

Understanding the strengths and weaknesses of the natural resources on one's property is essential when identifying obtainable goals. Because of soil differences, for example, landowners in the Red Clay Hills of Tishomingo County should not expect to harvest deer with the same antler quality as that of the Big Black River in Madison County. Similarly, a landowner with property along the Big Black River should not expect to catch smallmouth bass, which do not exist in that river system but can be found in the Tennessee River and Bear Creek watersheds. Developing an understanding of the capacity of one's land is often the second largest management hurdle (after family conflicts) for landowners.

Without measurable goals and objectives, landowners hinder their ability to determine the success or failure of management practices they have performed. Metrics can show weaknesses in existing operations and give the owner some leeway to devise new strategies for other initiatives to plug into the plan.

For example, a measurable goal for the first year may be to establish a financial and physical management plan for the family farm. The first year objectives might include:

+ conducting a family meeting on management of the farm;
+ meeting with the family attorney and accountant to discuss land accounting and other legal issues;
+ attending a forestry management workshop;
+ obtaining a soil survey and aerial map of the property; and
+ conducting a physical inventory of all infrastructure, land usage, and landscape features.

Simple and straightforward goals with specific objectives to achieve them keep the planning process orderly, which, in turn, provides a sense of accomplishment for all family members involved. This is particularly important

for absentee landowners who may not be able to directly observe on-site improvements on a regular basis.

Most landowners have several primary objectives, including agricultural, livestock, and timber production, in addition to providing wildlife habitat. When developing a fish and wildlife management plan, it is important to prioritize land-use objectives to determine where fish and wildlife management is desirable and feasible. For landowners interested in integrated management systems, there may be many objectives to choose from that accomplish different goals. Often, several conservation goals can be achieved together so that simultaneous conservation benefits are realized.

For example, an objective in the first year may be to establish a grass filter strip along a field drainage ditch to address soil erosion, water quality concerns, and wildlife habitat. Establishing the filter strip with Bermuda grass may address soil and water quality concerns, but provide relatively poor wildlife habitat. Establishing the same filter strip in native warm-season grasses enhances soil and water quality and provides greater wildlife habitat benefits. Thus, the first choice accomplishes only soil and water quality goals, whereas the second accomplishes all three goals simultaneously. Thus, receiving the right technical assistance in the initial planning stages will help avoid implementing objectives that do not maximize overall conservation goals. Involving one or more natural resource professionals (wildlife biologists, foresters, engineers) with expertise in different aspects of the conservation plan will help meet the integrated objectives set forth by the landowner.

Land Inventory.
Successful habitat improvement begins with a thorough evaluation of the property for its fish and wildlife potential. Once a landowner has established goals and objectives, it is important to then take an inventory of the property. This process should be conducted on two levels: an aerial view (satellite image or topographic map) and a more detailed inventory on the ground.

Begin the inventory by obtaining a drawing, map, or aerial photo of the land. Identifying

the current landscape features, including land-use types (such as pine plantation, hardwood, agricultural field, pasture, abandoned field, and pond), soil types, water sources (ponds, streams, and springs), and infrastructure (dams, roads, and rights-of-way) is important for land management. Other key items to include on the map are cardinal directions, approximate size of land-use areas, and a distance scale.

Maps are valuable for evaluating how different landscape features are distributed. For example, a landowner could identify isolated stands of timber throughout the property. As discussed in later chapters, linking these isolated patches through field borders and wildlife corridors can increase wildlife use of these stands. A map can quickly reveal potential locations to implement such links between these isolated stands.

Maps can also be used as a tool for evaluating progress over time. The visual nature of maps clearly illustrates additions of wildlife corridors, tree plantings, wetland restoration, and other conservation projects and is an excellent way to demonstrate progress toward one's management goals. Many landowners maintain before and after maps to illustrate the changes over time, and the maps themselves often become a source of pride.

After developing a detailed map of the property, a landowner should ground-truth the information on the map. Simply touring the property and recording specific details that were not included in the map (such as road quality,

small ephemeral bodies of water, areas with erosion issues, and animal signs like nesting sites, dens, and other activity) provide specific details not collected in the overview map. It is important to conduct these surveys several times a year to capture seasonal variation such as wildlife activity, water levels, and food sources (such as acorn crop, persimmons).

Contacting natural resource professionals to assist at this point in planning is crucial for success. A professional biologist or forester can help a landowner identify and assess various resources on the property. For example, a wildlife biologist can provide technical direction on how to accurately estimate wild game populations (for example, camera surveys for white-tailed deer or pond assessment for bream and largemouth bass), identify species of animals and plants, or recognize key elements of habitat for a given species. Likewise, a registered forester can provide a detailed timber cruise of a given property, which would provide important information on the composition of the timber stands including species, age class,

A BIRD'S EYE VIEW

Aerial photographs are available at no charge to the landowner from the Farm Service Agency in each county. Enlarged copies may be purchased for a small fee. Topographical maps are available from the U.S. Geological Survey (www.usgs.gov). Soil maps can be accessed on the Natural Resources Conservation Service Soil Survey website (websoilsurvey.nrcs.usda.gov). Several commercial websites also offer excellent mapping services for landowners and recreationalists and can be easily found through an internet search.

BEYOND ONE'S BORDER

Maps are a good way to illustrate that some wildlife and other resource management issues may not be adequately addressed on a single property. In fact, larger-scale resource management concerns like wetland conservation are more effectively addressed by landscape-level management.

Short of acquiring additional property, a landowner may find that the best option is to form a local conservation cooperative, which links smaller properties to create larger tracts of managed land that remain under individual private ownership. Forming a conservation cooperative requires sharing common goals and effectively working together to achieve those goals. Advantages of such cooperatives are leveraging the benefits of large-scale conservation efforts and potential sharing of labor, equipment, and other resources among properties.

density, and volume of wood products. This information will be crucial in making management decisions such as the rate and timing of the timber harvest.

Financial Considerations

Developing a budget is often the linchpin of conservation planning, and understanding the underlying economics of the operation(s) is central to achieving conservation success. Therefore, landowners need to develop a starting balance sheet for assets and liabilities, a balance sheet projection, profit and loss projections, and cash flow projections. Undertaking various financial analyses will also help the landowner to make appropriate land-use decisions.

The time and financial resources available to implement conservation practices will guide the selection of different management alternatives. Although some conservation programs may be available to offset management costs, there may not be programs that address every aspect of the conservation plan.

In addition to conventional or owner funding sources, landowners may be eligible for federal, state, and local grants and cost-share assistance programs. These grants will not cover all the costs, but they will help offset portions of the management costs. Cost-share assistance programs can provide funding to implement specific conservation practices on a given piece of land. Various other programs can provide financial and technical assistance to help meet environmental challenges on a property.

Popular federal programs through the U.S. Department of Agriculture Natural Resources Conservation Service include the Conservation Reserve Program, Environmental Quality Incentives Program, Grassland Reserve Program, Wetlands Reserve Program, and Wildlife Habitat Incentives Program. State programs such as the Mississippi Landowner Incentive Program and Fire on the Forty—both administered by the Mississippi Department of Wildlife, Fisheries, and Parks—are also available. Landowners are encouraged to contact these agencies to see which programs are best suited for their property and management objectives.

Implementation and Evaluation

A bit of patience goes a long way toward introducing new conservation practices. Sometimes there are failures, or objectives may need to be adjusted. Land management practices sometimes need more time to develop on the ground. Even if all conservation practices are implemented at once, it may take several years to fully realize the benefits; hence, the importance of establishing a realistic timeline.

After components of the plan are implemented, they must be regularly evaluated. Landowners should keep a record of the progress including when, where, and how the management activities were carried out and results from these activities. This record will assist in future plans by capturing site-specific information. For instance, a common recommendation for managing native warm-season grasses in Mississippi is implementing prescribed fire every 3 to 5 years to reset natural succession and control woody plants. Yet, an on-site evaluation may reveal the resurgence of woody plants and other undesirables in the second year after a prescribed burn, indicating a shorter burn cycle is needed to maintain the integrity of the native grassland. Good recordkeeping in this situation provides the basis for making these site-specific management decisions.

In addition to written records, photographs of management activities and results should be included in recordkeeping. Images are extremely beneficial when communicating with natural resource professionals because they provide a high level of detail that often cannot be described in words. This is especially true when working long distance with a natural resource professional.

DEVELOPING A NATURAL RESOURCE ENTERPRISE

Many landowners in Mississippi understand the importance of developing a natural resource, such as timber, into an income source to assist in financing the management and maintenance of their properties. New landowners often come

to this conclusion after going through the conservation planning process previously outlined. The ability to identify additional income sources that are compatible with current management systems (such as natural resource–based recreation or specialty products from the land) is a smart business practice. Such practices are not only beneficial to the landowner but to all Mississippians, as they result in the conservation of natural resources, increased access to outdoor recreation, and economic benefits to rural communities.

In this section, we discuss the planning process in developing a variety of natural resource–based enterprises in Mississippi. Topics include determining the potential for natural resource enterprises, identifying an enterprise that is compatible with the landowner's needs and abilities, assessing the market, developing a business plan, and implementing and evaluating the enterprise.

Many of the steps described previously for conservation planning serve as fundamental elements in planning a natural resource enterprise. Understanding that these enterprises rely on the balance of sound natural resource management and business practices is crucial to success.

Natural Resource Enterprise Potential in Mississippi

Mississippi is fortunate to have diverse, abundant natural resources on private lands, allowing for great enterprise opportunities for landowners. Natural resource enterprises are defined as any natural resource–based commodity or experience, and they can be divided into three broad categories: agriculture, forestry, and outdoor recreation.

Agriculture.
Traditional enterprises include row crop, poultry, livestock, or aquaculture. Nontraditional agricultural enterprises include hay rides, u-pick farms, corn mazes, and farm tours. These latter enterprises are generally referred to as agritourism or agritainment and are primarily built around providing experiences along with a multitude of products.

Table 2.1. Examples of natural resource enterprise opportunities available in Mississippi	
Type of activity	**Activities**
Consumptive	fee hunting
	fee fishing
	pick-your-own vegetables
	pumpkin patch
	Christmas trees
	holiday greenery
	pecan/nut gathering
	hay
Nonconsumptive	sporting clay course
	shooting range
	campground
	vacation cabin
	bed-and-breakfast
	bird watching
	horseback riding
	recreation trails
	hayrides
	boating
	horse boarding
	corn mazes
	petting zoos

Autumn events such as farm tours and pumpkin patches are growing in popularity throughout Mississippi. Photo courtesy of iStock

Forestry.
Traditional enterprises include pine and hardwood timber products such as pulp, chip and saw, and sawtimber. Among nontraditional forest products are pine straw mulch, specialty woods, and even shitake mushrooms.

Pine straw bailer used in hand raking operations. Pine straw harvesting has become popular among southern Mississippi landowners as a supplemental income source. Photo courtesy Stephen G. Dicke, Mississippi State University

Outdoor Recreation.
These may be either consumptive or nonconsumptive enterprises. Consumptive enterprises include fee hunting (annual and seasonal leases or day hunts for small and big game) and fee fishing (trophy largemouth bass). Nonconsumptive opportunities include camping,

recreational vehicle sites, cabins, hiking, biking, wildlife watching, horseback riding, and various water activities.

Compatibility of Natural Resource Enterprises with Landowners and Their Land

Having such a wide range of enterprise options available can seem overwhelming to landowners. Three keys to making the best decision are: (1) ensuring the potential enterprise will be compatible with their lifestyle; (2) finding compatibility with their land and current management system; and (3) identifying and accounting for costs such as reduced farm or timber revenues and increased production costs compared to the added financial, ecological, and social benefits derived from any new enterprises. For example, establishing habitat for northern bobwhite quail can reduce the area available for intensive agricultural and timber production. It can also limit or alter the timing of various silvicultural protocols (such as reduced density of tree plantings) and agricultural techniques (such as applications of chemicals or mowing), yet this can provide both hunting and bird-watching enterprise opportunities, which often garner higher lease and admission rates among outdoor recreation activities.

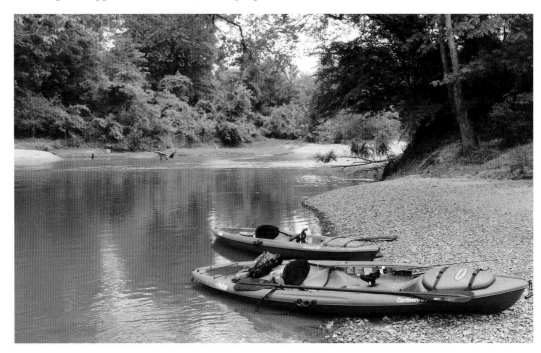

Providing paddling opportunities for recreationalists is only one example of a non-traditional source of seasonal income for landowners with water access. Photo courtesy of Steven Gruchy, Wildlife Mississippi

Personal Evaluation.
Similar to the conservation plan discussed previously, the landowner(s) and the family must assess several important issues about themselves before starting a natural resource enterprise:

◆ Do family members or partners have the time to commit to the enterprise?
◆ If considering a service-oriented enterprise such as fee hunting, along with allowing others access to their land and natural resources, does the family understand the considerable time investment needed when dealing with customers?
◆ As a family or group of landowners, do they have the practical and technical experience (such as outdoor skills, mechanical proficiency, and land management experience) needed to operate the potential enterprise?
◆ Are they willing and/or able to take the financial and legal risks associated with investing in the management and operation of the enterprise?

Involvement Level.
Natural resource enterprises require various levels of daily involvement depending upon the products or services offered. Some types of enterprises (such as annual fishing and hunting leases, timber, and alternative forest products) lend themselves to less intensive management commitments, whereas experience-oriented activities (agritourism) or labor-intensive operations (livestock and produce) will require daily commitments. A different level of commitment is required for seasonal activities including corn mazes, pumpkin patches, single-species hunting operations (quail, mourning dove); in this case, only a portion of the year will involve moderate to intense involvement from the landowner or manager.

Deciding the level of involvement in the operation is an important first step. Many properties in Mississippi are owned by absentee landowners, which can limit their direct involvement in daily operations. For example, an absentee landowner who owns 350 acres of primarily forested land 150 miles away from his home will be

less apt to start a daily fee hunting enterprise. In this situation, the landowner might prefer to offer an annual hunting lease that would involve only a couple of meetings a year with the lessee as compared to a landowner who lived on the property or within reasonable distance to manage the operation daily. As this example illustrates, the geographic location of the landowner may dictate the type of enterprise most feasible.

No matter the decision, landowners must evaluate their own situation and select an enterprise that fits with their schedule and matches their preferred level of involvement. Once this is determined, they can move on to evaluating the compatibility of the potential enterprises with the natural resources on their land.

Resource Inventory.
Building on the foundation of the physical resource inventories conducted in the conservation plan, landowner(s) can begin to evaluate which enterprises may be suitable for the property. During the evaluation, key items to keep in mind are the compatibility with current or planned land management objectives and property size.

Compatibility with Current Operations

In most cases, landowners are interested in natural resource enterprises as a way to derive more income from their properties, especially underutilized acreage. For example, agricultural landowners interested in using harvested fields for outdoor recreational purposes (such as waterfowl hunting) can maximize their annual income by using the same acreage year-round. To implement this strategy, a landowner must plan in advance, evaluate potential trade-offs with primary income-producing operations, and consider sustainability of natural resources on the property.

Creating an annual calendar of management activities on the property will be helpful in planning additional enterprises. When there is already an established primary income-producing operation, the calendar will allow the landowner to identify open times of the year when an additional compatible enterprise could be

implemented. The previous example illustrates this opportunity in an agricultural setting, which is commonly used throughout the Delta region of Mississippi. The post-harvest flooding of these lands during late autumn and winter coincides with the migration of waterfowl and other aquatic birds to the southern United States. These flooded areas attract large numbers of waterfowl, providing opportunities for hunting and viewing of these birds for a fee. Prior to the planting season in the spring, areas are dewatered around the time birds begin to migrate northward. In this case, the landowner can accomplish both economic and natural resource management goals by filling the down time in the annual calendar by operating a seasonal natural resource enterprise that complements the farming operation and provides crucial habitat for migrating waterfowl.

Each situation will need to be evaluated on an individual basis because of the unique environmental elements of each property and the individual's economic circumstances. This is an opportune time for a landowner to contact a natural resource professional to assist in evaluating potential enterprises to ensure all aspects (both positive and negative) of the proposed integrated systems are understood prior to making management decisions.

Compatibility with Property Size

According to several Mississippi State University studies, most natural resource enterprises involving outdoor recreational leasing in the state take place on properties larger than 1000 acres. Large properties typically have many opportunities for fish- and wildlife-based enterprises (such as deer and duck hunting), providing sufficient financial returns to make an enterprise feasible. Although property size is a limiting factor in both wildlife management and natural resource enterprise development with regard to particular species (such as northern bobwhite quail) or the amount of timber, for example, that can be produced, it should not deter owners of smaller properties from pursuing an enterprise. These situations will require

creativity and flexibility to make the enterprise fit their situation.

The most obvious and financially viable solution for owners of smaller properties is to consider recreational entrepreneurial cooperatives. These partnerships are formed by landowners who may not have sufficient landholdings and/or resources to engage in fish- and wildlife-based enterprise operations on their own. However, when their resources are combined, they can offer a more attractive recreational opportunity that will have higher revenue potential. For instance, a landowner with 300 acres may be interested in opening the land for an annual hunting lease. However, the lease would garner more revenue (up to 35 percent more) if the landowner had lodging and other amenities (such as a storage area and skinning shed). Perhaps an adjacent small landowner has a house and outbuilding primarily used for family activities during the summer months that is available during autumn and winter. If these two landowners were able to team up and offer a combined package of hunting access

Enterprise Research in Mississippi

A recent Mississippi State University study revealed dramatic differences between the size of private properties used for fee hunting and those not used for such enterprises. For example, in Gulf Coast counties the average size of a property used for fee hunting was 1590 acres, compared to 204 acres for those not used for fee hunting. In the Delta counties, these sizes were 1439 and 723 acres, respectively. In addition, the proportion of forest land was substantially greater on properties used for fee hunting. For example, in 1997–1998 in the Gulf Coast counties, the average property was 78 percent forested, but only those properties with at least 90 percent forest were used for fee hunting. These findings indicate that landowners of many underutilized properties could be taking advantage of fee hunting opportunities to garner additional income.

Landowners initiating recreational entrepreneurial cooperatives are excellent examples of small business development in rural areas of Mississippi. Photo courtesy of iStock

and lodging amenities, they could generate additional annual income.

Opportunities like this one are extremely common across Mississippi. Unfortunately, they are rarely pursued for reasons such as reservations about partnerships and fear of liability issues. Mostly, however, it is lack of awareness of these potential collaborative ventures.

Recreational entrepreneurial cooperatives could generate substantial economic impacts for Mississippi by using currently unproductive or underutilized land for new initiatives. These cooperatives could also provide jobs for the underemployed or displaced labor force that exists in regions like the Mississippi Delta to assist in land management or recreational activity-related operations. Additional income (both private and public sector) and employment opportunities from satellite industries and services, such as lodging, sporting goods stores, hunting outfitters, tour guides, and natural resource consultants, would be created by these new enterprises.

Evaluating the Market

Several key questions need to be answered when evaluating the market for a fish- and/or wildlife-based enterprise.

- Is there an interest or a need for the proposed enterprise?

Table 2.2. Statewide economic impacts of wildlife-associated recreation in Mississippi (2008 estimates; inflated to 2011 dollars)

Activity	Economic impact
Hunting	$1.3 billion
Angling (freshwater)	$720 million
Wildlife watching	$1.3 billion
Total	$3.3 billion
Select outfitter businesses	
Wildlife associated (fee hunting, fishing, watching) [a]	$25 million
Fee angling [a]	$1.2 million
Agritourism	$3.5 million
Wildlife watching [a]	$1 million
Horse trail riding	$3.7 million
Select wildlife species	
White-tailed deer	$955 million
Waterfowl	$152 million
Eastern wild turkey	$18 million

[a] The economic impact of these select outfitter businesses are included in the three respective wildlife-associated activities.

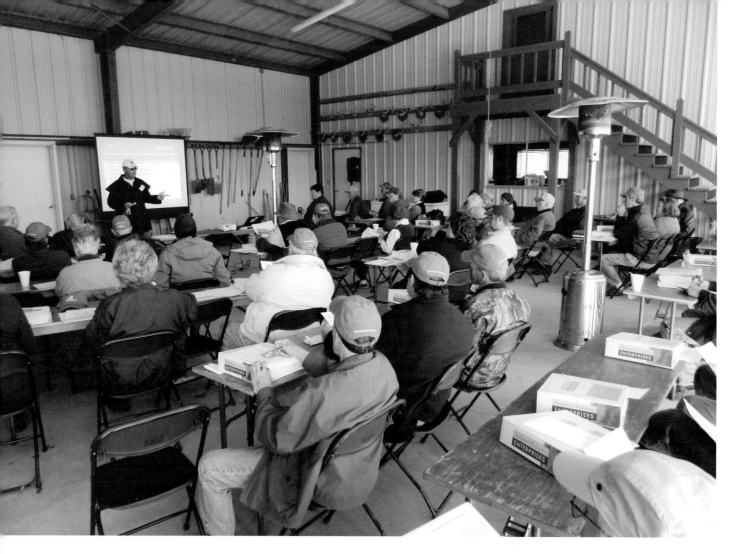

Landowners attend a workshop offered by Mississippi State University Extension Service on how to establish outdoor businesses in the state. Photo courtesy Stephen G. Dicke, Mississippi State University

• Is the interest or need sustainable to support a business venture? If so, at what level? Is it short term, long term, or seasonal?
• Who will be the potential customer base, and what are they willing to pay for this product, service, or experience?

Getting answers to these critical questions involves in-depth research of the selected enterprises. One of the best ways for landowners to find this information is to visit similar enterprises in the area and other regions of the country to see how they operate and the types of products or services they offer. Who are their clientele, and how far away do customers come from? (A simple walk through the parking lot of a venue can provide not only location information but also insight into customer characteristics.) Successful entrepreneurs quickly learn that visiting other businesses for ideas is not only crucial during the initial research phase, but also in remaining competitive once an enterprise is established.

Attending seminars, workshops, and short courses offered by trade associations, local universities (such as Mississippi State University Extension Service), and state and federal agencies will provide the latest research-based information on the market for these enterprises and offer insight into where future demand and niche markets will be. Other common topics include market trends (that is, profits, costs, and current fee structures), advertising strategies, clientele demographics, new technologies, legal and financial considerations, and insurance. Most importantly, these events typically attract key regional enterprise owners and technical experts as speakers, so attendees get excellent opportunities to interact with these business leaders.

Subscribing to trade journals and joining trade associations, such as the Mississippi Forestry Association, and business organizations like a local chamber of commerce are other ways of accessing current information about enterprise potential. This also provides

opportunities for owners of small properties or absentee landowners to find prospective partners to form recreational enterprise cooperatives or identify possible contractors, such as outfitters, guides, and land managers, who can provide additional services.

Trade association membership will often be dictated by the type of enterprise of interest. For example, a landowner interested in starting forestry and fee hunting enterprises will have several different products and will need to identify different sources of information regarding each product. For the forest management interests, the landowner would be advised to join the county forestry association to learn about the wood product market, timber management, and tax information. For information about alternative forest products, such as pine straw, the landowner may consider joining a landscaping wholesale association to keep current on the market and traits the wholesalers are looking for in pine straw. Landowners interested in fee hunting might purchase a hunt with another operator or participate in an annual hunting lease to gain firsthand experience of the services offered, amenities, management techniques, and other pertinent information. In addition, joining an outfitters association and local chapters of conservation organizations (National Wild Turkey Federation, Ducks Unlimited) would provide access to additional information about trade and associated hunting clientele.

DEVELOPING A BUSINESS CONCEPT AND PLAN

After a potential natural resource enterprise has been identified and the land management plan is nearly complete, it is time to develop the business plan. The business plan should include all business activities associated with the particular enterprise. This necessary step will help weigh the costs of doing business against potential market demand. It will also help determine the enterprise's feasibility, time required to get the business up and running, and length of time it will take to become a profitable and

integral part of the total operation. A good business plan outlines the mission and goals of the proposed enterprise(s) and acts as a guide to keep the enterprise(s) focused. It also shows potential investors or lending institutions the economic feasibility of the enterprise(s).

Key Elements of the Business Plan

A logical outline for preparing the business plan should include an introduction, description of the physical resources available, marketing plan, operating plan, organizational plan, and financial plan.

Introduction.
The introductory section should describe the proposed enterprise(s) along with the purpose or demand for starting it. Typically, it includes detailed historical information about the type of enterprise, the products and services typically offered, and the anticipated growth of this type of enterprise statewide and nationally. In addition, a clear and concise mission statement demonstrates that the landowner has a defined goal in mind and serves as the guiding principle of the enterprise into the future.

The introduction also contains measurable objectives. This allows the landowner to evaluate the progress and success of the enterprise(s) in meeting defined goals and carrying out the mission statement. Typically, a timeline for achieving the stated objectives and an anticipated date to conduct an evaluation (annual report) of these objectives are included in this section.

Physical Resources Available.
Information from the land management plan resources inventory should be used for this section of the business plan. Identification of physical resources demonstrates the landowner's level of commitment to the new enterprise, which is important to operations and potential funding sources.

Marketing Plan.
This section contains information on how the landowner evaluated the potential market and

COMMON BUSINESS STRUCTURES

Sole Proprietorship
- Owned by one person
- Business does not exist apart from the owner
- Pays self-employment tax
- Business earnings taxed only once
- Income and expenses from business included on personal tax return (single income taxation)
- Income reported on schedule C of 1040 tax form
- Unlimited liability
- Owner personally responsible for business liabilities
- Raising funds from investors is more difficult for a sole proprietorship

Limited Liability Company
- Shields personal assets by limiting liability
- Files an annual report with the secretary of state's office
- Requires an operating agreement for more than one member
- Company pays no income tax
- Income passed through to company's members
- Member pays self-employment taxes
- No limitation to the number of members
- More easily financed than sole proprietorships or partnerships

C Corporation
- Can be publicly or privately held
- Corporation is an entity separate from owners, which shields the shareholders' personal assets by limiting personal liability
- Corporation pays income taxes at the corporate level
- Income distributed to owners as dividends, which are taxed at the corporate level and as personal taxable income (double taxation)
- Numerous legal formalities in the formation process
- More complex rules and regulations
- Financing generally much easier to obtain

S Corporation
- Shields shareholders' personal assets by limiting liability
- Corporation files annually with secretary of state's office
- Corporation is generally exempt from federal income tax
- Reports the flow-through of income and losses on shareholders' personal tax returns; assessed at individual income tax rates
- Distributes dividends in proportion to shares held
- Limited to 100 shareholders
- Lots of legal formalities in the formation process
- More complex rules and regulations
- Outside financing usually much easier to obtain

General Partnership
- Owned and operated by two or more persons
- Operates in accordance with a partnership agreement (not required, but recommended)
- Must file an annual information return with the IRS to report income, deductions, gains, and losses from the operation
- Business does not pay income tax; individual partners do
- Individual partners pay self-employment tax
- Profits and losses pass through to the partners
- Business profits must be reported on personal income tax returns even if they were not distributed
- No protection from liability for any partner
- Full liability for any partner's actions fall on all partners

the proposed marketing outline. Marketing plans include the tools that will be used to promote the business (print and broadcast media, a website, special events, social media); the audience(s) to be targeted (age and family demographics, expendable income); a strategy for measuring marketing success (surveys, website tracking, focus groups); and an annual marketing budget.

Operating Plan.
The physical location and mailing address for the enterprise along with telephone numbers, email, website, and other social media contacts need to be included in this section. Descriptions of the daily tasks of management and employees and the hours of operation should be clearly defined in this part. If a seasonal enterprise, the dates of operation should be included (differentiate between employee hours of operation and actual business hours of the enterprise).

Organizational Plan.
An explanation of how the business will be structured and managed is crucial for lending, tax, and liability reasons. Most importantly, the landowner needs to decide whether a sole proprietorship, limited liability company, C corporation, S corporation, or a general partnership is best for the potential business and protecting personal assets. As with land management decisions, it is crucial that landowners consult with a business attorney and certified public accountant to decide on a business structure that would be most effective for their individual situation.

The organizational plan indicates the chain of command for operating the enterprise. List the title, duties, and responsibilities for each employee (including the owner(s) and management staff), making sure to include any special training, permits, licenses, experience, or education the proposed employees have. It is also common to include employee benefits such as leave, compensation, retirement, and medical insurance.

Financial Plan.
The key to achieving financial success is to understand the underlying economics of the enterprise, including tax implications and uses of available financial sources, as well as the sources and uses of funds, profit-and-loss projections, cash flow projections, and a balance sheet. Obtaining this information enables the landowner to conduct various financial analyses to make appropriate land-use decisions. These data will be crucial in the decision-making process if and when the landowner approaches a lending source.

The financial plan must have a realistic budget, which includes all costs associated with an enterprise. The budget also helps to determine a feasible pricing schedule and marketing plan. The statement of sources and uses of funds lists available funds and where they were obtained; it shows a lender how much you need for startup financing and how much in collateral you will contribute. The profit-and-loss statement is the estimated income and all related expenses involved in doing business. It shows total income less total expenses and the bottom line for the year. The cash flow statement shows cash receipts and cash outflows each month and determines if enough cash will be on hand to cover monthly expenses. Most businesses fail in the first 3 years of operation because they do not have enough cash on hand to cover expenses; therefore, adequate planning is imperative to ensure that enterprises remain viable over time. The balance sheet lists assets, liabilities, and owner equity. It indicates what the enterprise owns and as well as its debt structure.

Knowing the cost side of the budget (both variable and fixed) will help the landowner to determine the fee schedule for products or services. In other words, it is not a question of how much can be charged, but how much *must* be charged to be profitable and competitive with similar enterprises. Fees or prices may be determined based on one of several methods: break even plus 10 or 20 percent; prices charged by similar enterprises; what the market can bear; or other objectives, such as simply paying the taxes on the land or funding retirement. Again, this is where the personal and social aspects of enterprise management enter the decision-making process, illustrating why it is important for landowners to articulate their goals and a

mission statement clearly prior to moving forward with the business.

Financing

Financing the new enterprise is often the second largest perceived impediment (behind liability concerns) for most landowners. However, landowners who have diligently developed a business plan should be confident in securing funding for their enterprise. There are many options available, including owner financing, private or family investors, and commercial and governmental lending. Other forms of lending focus on specific elements of the business. For instance, some federal and state cost-share assistance programs target specific land management activities, such as erosion control structures and wildlife habitat improvements. Other programs may focus on employee training, new technology development, or infrastructure.

Private Funding.

Many small or seasonal enterprises are funded by the owner through personal means or financial resources from other parts of the overall operation. In multi-owner or family-owned situations, interested investors or family members may provide financing as their share of the enterprise, with the expectation of a fair financial return or use of the enterprise once the operation is up and running.

Commercial, Federal, and State Lending Institutions.

Even with a sound management plan and a well-developed business plan, the landowner should still call or visit the website of potential financing institutions to find out what information a loan officer will need. A landowner must also be prepared to answer questions and give all information as required by the lender.

Most landowners, farmers, and business owners have established relationships with a local commercial bank, which may seem to be the most convenient option for financing. Unfortunately, in many cases, a commercial bank is interested only in short-term loans, so the landowner may need to look elsewhere for financing. The Farm Credit System, through its locally owned and operated cooperative lending operations, offers long-term loans at competitive and attractive interest rates. Loans through the Farm Credit System can be used to purchase real estate, improve real estate, facilitate debt refinancing, and enable loan consolidation. Interest rates can be variable or fixed with monthly, quarterly, semi-annual, or annual payments. Also, the Farm Credit institutions have programs for young and beginning farmers, as well as those with small properties, with several attractive features for those who qualify.

The Farm Service Agency is another potential funding source. It makes and services both direct landownership and operating loans, and the agency has a guaranteed loan program along with a participation loan program. Loans guaranteed by the Farm Service Agency provide conventional lenders with a guarantee up to 95 percent of the principal loan amount. In the participation loan program, the agency lends up to 50 percent of the amount financed, and the conventional lender provides the other half.

The Mississippi Development Authority makes interest-free loans to eligible startup operations and can fund up to 20 percent or $200,000 (whichever is less) of the cost to construct or update facilities for up to 15 years. A conventional lender guarantees this loan, and the Mississippi Development Authority is assured of repayment.

Personnel

An inventory of labor availability and required skills will include both management and general labor needs. This includes estimating the number of employees (administrative, technical, and skilled and/or unskilled labor) needed to operate effectively and efficiently and the associated competitive rate of pay needed to secure top-quality personnel. A common mistake is overlooking the value of the landowners' and family members' time and labor. This time and effort must be included in the business plan to accurately reflect the true cost of labor. Finally, it is strongly encouraged that all business

Providing visible signage throughout your property to warn visitors of possible dangers is a smart business practice for making a property reasonably safe. Photo courtesy of Adam T. Rohnke, Mississippi State University

owners fully understand state and local labor laws for their area before hiring personnel.

Legal and Liability Considerations

As with any business, there are many legal and liability concerns for owners. There is no way to eliminate all liability in any business, including natural resource enterprises. However, there are many ways to reduce legal liability as it relates to natural resource enterprises in Mississippi.

The first step is for landowners to understand the current Mississippi Code related to landowner liability for recreational use of the land. Section 89-2-23 of the Mississippi Code provides some protection for landowners allowing recreational use of their land. The code differs depending on whether or not a fee is charged for use. (To view the full text of the code reflecting the landowner's duty of care for recreational use of their land, see http://www.mscode.com/free/statutes/89/002/index.htm.)

A landowner's legal obligations differ depending on whether an individual is a trespasser, a licensee, or an invitee. A landowner owes no duty to trespassers because they are not supposed to be there in the first place. The landowner only has the obligation to not willfully or wantonly injure the trespasser. Call the authorities if someone is trespassing on your property.

A licensee is someone who has permission from the landowner to be on the property (perhaps to hunt or fish), even though the landowner does not really derive any particular benefit from their presence. Landowners have no greater obligation to these guests than they do toward the trespasser, other than to warn a licensee of any known dangers on the property.

A business invitee is someone who is on the property and is benefiting the landowner. For instance, if a landowner charges guests to come on the property for hunts, fishing, trail riding, hiking, bird watching, agritainment activities, or any other outdoor recreational business, then the landowner has a duty to either make the premises reasonably safe (not perfectly safe) or to warn them of any known dangers. For instance, if a bridge across a creek is visibly unstable, a sign explaining the danger, such as "Cross at Your Own Risk," should be displayed. This is similar to grocery stores displaying "Caution: Wet Floor" signs when there has been a spill in an area. Understanding these duties as a landowner is crucial in implementing smart operating practices and using the liability protections that are available through business structuring and insurance.

Liability-Reducing Business Practices.
Many of the liability concerns of landowners can be reduced by smart operating practices including reducing hazards, educating customers, and using waivers and leases. Routine inspection and maintenance of tree stands, bridges,

trails, steps, railings, and other equipment not only reduces the overall risk of an incident but also demonstrates the landowner's attempt to make the premises reasonably safe. Maintaining records of these inspections is also recommended. In addition, there are situations where notification of danger to the customer is justified. For example, signs on wood surfaces that read "Slippery When Wet" or "Caution: Sink Hole Ahead" are excellent ways of making the property reasonably safe.

Most properties have inherent hazards such as uneven ground, insect bites and stings, poison ivy, and slipping points. In these situations, a general liability waiver listing these possible hazards while participating in activities will support that the landowner provided additional information to the customer about potential risks. However, supplying waivers immediately prior to the activity is not recommended, because in most cases the customer does not have time to read and fully comprehend the contents of the waiver. If possible, the liability waiver should be issued prior to the activity taking place. For example, sending liability waivers to the hunter a month prior to the hunting trip or to the school to be sent home with the field trip permission letters allow the customers time to fully consider what they are consenting to when signing your waiver.

Long-term lease documents provide a written agreement between the lessor and lessee for the given activity. These agreements are commonly used as guiding documents for hunting clubs regarding property borders, lease rates, club rules, liability requirements, incorporation, and arbitration in the event of a conflict (examples of leases and hunting club bylaws can be found in Appendix 2). As with well-written liability waivers, thorough leases provide support that both the landowner and hunting club were diligent in reducing hazards and risk prior to engaging in the activity.

Business Structure and Liability Protection.
Deciding which type of business structure is best for the enterprise is not only important for financial reasons but also for liability protection. Each type of business structure has

different levels of separation of the enterprise assets from the landowner's personal assets. This is an important feature for natural resource enterprise owners who have a personal residence, other business interests, and the land itself tied to the new enterprise. If litigation against the enterprise were to take place, the assets owned by that enterprise (such as insurance, equipment, vehicles) would be vulnerable, but the land and personal assets owned under other legal entities separate from the enterprise (such

ADDITIONAL BUSINESS CONSIDERATIONS

◆ The Mississippi Development Authority (www.mississippi.org) has information on the state's reporting requirements for small businesses.

◆ The Mississippi secretary of state's office (www.sos.ms.gov) has information regarding registering a trademark, incorporating a business, and registering as a limited liability company.

◆ Landowners may need to obtain a local business permit or privilege license from city and county officials.

◆ Contact the Internal Revenue Service (www.irs.gov) to obtain a federal employer identification number (request Form SS-4), which is required for all partnerships, corporations, and sole proprietorships with one or more employees.

◆ Obtain copies of IRS Publication 334 (Tax Guide for Small Business) and IRS Publication 533 (Self-Employment Tax).

◆ Complete a Mississippi Business Registration Application (Form 70-001-00-1) from the Mississippi Department of Revenue (www.dor.ms.gov).

◆ Depending on work force needed, landowners will need to purchase workers' compensation insurance if they will have five or more employees. For more information, contact the Mississippi Workers' Compensation Commission (www.mwcc.state.ms.us).

◆ Open a DBA (Doing Business As) bank account for the enterprise.

as a limited liability company) would be protected because they are not part of the business. To reduce potential liability exposure and for tax purposes, landowners are advised to seek legal counsel in considering business structures for operating an enterprise.

Liability Insurance.
Many forms of liability insurance are available for natural resource enterprises, and landowners will need to spend considerable time researching the different options available. Communicating with current insurance providers is often the easiest first step, as some enterprises can be covered under additional riders with existing farm and business policies. In other cases, such as agritourism and hunting leases, specific insurance for the enterprise may be needed. Trade associations, like the Mississippi Forestry Association, offer supplemental insurance programs to members for these types of enterprises. Again, this illustrates the importance of owners becoming involved in their respective trade associations. In a hunting lease arrangement, the landowner should require the hunting club to be incorporated and carry its own liability insurance with the landowner listed as an additional insured person on the policy. By doing so, the landowner has additional insurance protection against potential liability claims in case someone is injured or killed in hunting-related accidents on the property.

For More Information

Conservation Finance Center website: www.conservationfinancecenter.org
Mississippi Development Authority website: www.mississippi.org
Mississippi Small Business Development Center website: www.mssbdc.org
Natural Resource Enterprises Program website: www.naturalresources.msstate.edu
Wildlife Mississippi website: www.wildlifemiss.org

CHAPTER 3

Mississippi Soils

John D. Kushla, Associate
Extension and Research
Professor of Forestry,
Department of Forestry,
Mississippi State University

Andrew J. Londo, Extension
and Research Professor
of Forestry (formerly),
Department of Forestry,
Mississippi State University

Technical editor
Adam T. Rohnke, Wildlife
 Extension Associate,
 Department of Wildlife,
 Fisheries, and Aquaculture,
 Mississippi State University

People often take for granted the importance of soil in their lives. Soils provide the foundation for homes, cities, and roads. They are the media for bountiful crops and forests. Soils store and filter the groundwater that supports life on land. Indeed, soils provide for the diversity of plants and wildlife upon which Mississippians depend for commerce and recreation.

Landowners wanting to optimize their resource potential for agricultural crops, livestock, forestry, or wildlife should have a basic understanding of the soils that make up their properties. All of these resources begin with the quality of the soil. The white-tailed deer is a prime example of the impact that soil quality can have on a resource. A mature buck is nearly 40 pounds heavier, on average, in the Mississippi River Delta than its counterpart in the Lower Coastal Plain of southern Mississippi. In addition, using proper soil management techniques in various production systems is crucial for enriching the soils and protecting the community's watersheds from soil erosion.

SOIL FORMATION

Soils form through the interactions of physical, chemical, and biological activity on the geological materials exposed on the Earth's surface. Essentially, soil forms from parent material that is weathered by climate and organisms, as influenced by topography, over time. Soil took hundreds to thousands of years to develop in the landscape. Consequently, the soil itself is not a renewable resource, even though the crops and forests grown on the soil are

A recently tilled field.
Photo courtesy of iStock

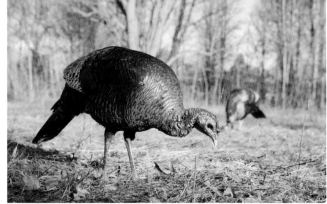

Mississippians rely on soils every day for the production of food, fiber, infrastructure of cities and towns, and the fish and wildlife pursued and watched by thousands. Photos courtesy of iStock (cotton, construction, eastern turkey); John D. Kushla, Mississippi State University (hardwood forest)

renewable. Several factors affect soil formation, including the parent material, climate, organisms, topography, and time.

Parent Material

Geologic formations that are exposed to the surface of the Earth provide the parent material for the production of soil. In Mississippi, the geology of most of the state is dominated by the Mississippi Embayment, not the Mississippi River. This large inland sea formed as the North American continent was taking shape. The Mississippi Embayment covered most of what is now Mississippi and Louisiana, a region known as the coastal plain. Thus, the geology of Mississippi is dominated by marine and alluvial sediments that were deposited anywhere from hundreds of millions of years ago to recent geologic time. The oldest deposits (some more than 250 million years ago) are in the northeastern corner of the state as part of the Appalachian foothills, whereas the youngest soils are constantly being formed by annual flooding in river bottomlands across the state.

The Mississippi River floodplain formed during the ice ages up to 1 million years ago, when great ice sheets covered much of northern

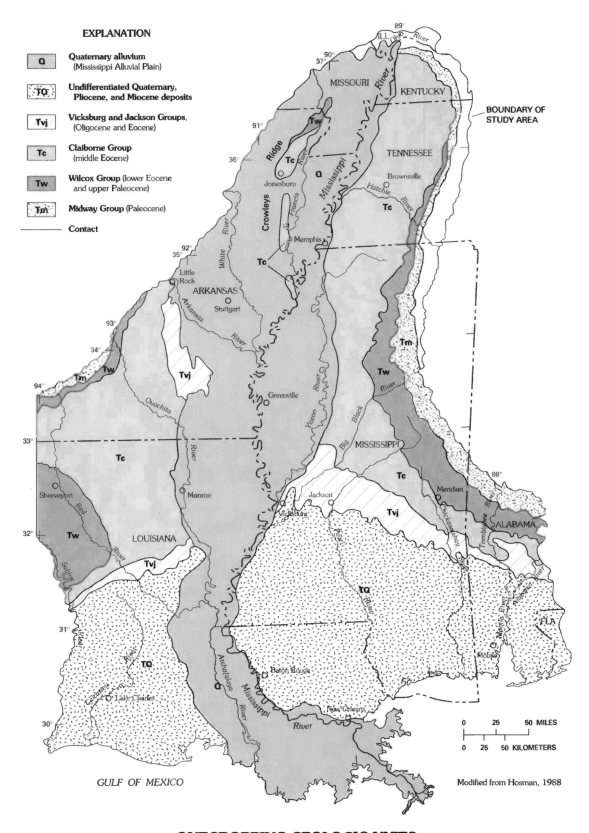

EXPLANATION

Q	Quaternary alluvium (Mississippi Alluvial Plain)
TQ	Undifferentiated Quaternary, Pliocene, and Miocene deposits
Tvj	Vicksburg and Jackson Groups, (Oligocene and Eocene)
Tc	Claiborne Group (middle Eocene)
Tw	Wilcox Group (lower Eocene and upper Paleocene)
Tm	Midway Group (Paleocene)
————	Contact

BOUNDARY OF STUDY AREA

OUTCROPPING GEOLOGIC UNITS

Modified from Hosman, 1988

A map showing the extent of the Mississippi Embayment. Adapted from Arthur, J. K., and R. E. Taylor. 1998. *Ground-Water Flow Analysis of the Mississippi Embayment Aquifer System, South-Central United States*. U.S. Geological Survey Professional Paper 1416-I

North America. The Mississippi River drained immense glacial lakes that formed as the ice sheets melted. Aeolian, or windblown, deposits of this glacial outwash formed the loess hills that border the Delta region to the east. Sedimentary deposits are relatively easier to weather than rock. The most recent alluvial sediments in the Delta are very fertile and are the basis for the success of Mississippi's agricultural industry.

Climate

Mississippi has a warm, humid climate. Weather patterns are dominated by the continent to the north and the Gulf of Mexico to the south. During the summer, average daytime temperatures are typically in the 80s. Annual average winter temperatures are in the 40s in the north and 50s along the coast. Average annual precipitation increases as we move southward across the state, with 50 inches falling annually in northern Mississippi and 67 inches at the coast. The frequency of thunderstorms also increases as we move southward, ranging from about 55 days per year in the north to 75 days annually at the coast.

Tropical storms are common in coastal counties. The Mississippi coast experiences a hurricane once every 12 years, on average. Although wind damage is limited to the coastal region, heavy rainfall and flooding can occur throughout the state during these storms. Mississippi is also in the path of tornadoes that move across the country with advancing cold fronts in the spring and autumn.

This warm, humid climate accelerates the weathering of parent materials. Weathering involves chemical reactions that transform parent material into soil, and this process occurs much faster as the temperature rises. Water is the universal solvent and provides the means for weathering. Rainwater is slightly acidic because of dissolved carbonic acid, which hastens the weathering of minerals from these sediments.

Consequently, the soils of the coastal plain are older and more weathered. The soils of the river bottomlands, including the Mississippi River floodplain, are much more variable in terms of fertility, degree of weathering, and development. This can have implications not only for agriculture, but forestry and wildlife management as well.

Organisms

The vegetation in Mississippi varies tremendously from north to south and east to west, forming several major ecoregions across the state. These include the Mississippi Delta, which is dominated by agriculture and bottomland hardwood forests including the following species: baldcypress, black gum, cottonwood, black willow, green ash, pecan, sugarberry, Nuttall oak, willow oak, swamp chestnut oak, red maple, swamp hickory, water tupelo, and black walnut.

The northern section of the state is within the Upper Coastal Plain. Vegetation is dominated by oak, pine, and mixed oak and hickory forests. Common species here include shortleaf and loblolly pines, hickory, and upland oaks (such as cherrybark, southern red, white, post, scarlet, black, and blackjack oaks).

The Lower Coastal Plain and Coastal Flatwoods regions are dominated by forests of longleaf pine, slash pine, and live oak. Longleaf pine is well-adapted to the frequent, low-intensity fires that once burned across this landscape. Although tolerant of fire as a mature tree, slash pine is less tolerant as a seedling or sapling, and so this species grows in wetter sites. Live oak is very hardy and tolerates the high winds of tropical storms and salt spray along the coast.

Pine and oak vegetation tends to produce organic acids upon decomposition of their resins and tannins, respectively. This decomposition acidifies soils, which further accelerates mineral weathering of geologic sediments.

Prehistoric man had an influence on the landscape through the use of fire. This tool was widely used by Native American cultures to clear land for farming and to keep hunting grounds open. Consequently, pre-Columbian civilizations created a mosaic of towns, agricultural fields, and extensive woodlands and savannas in Mississippi. Thus, the native vegetation successfully adapted to very frequent burning.

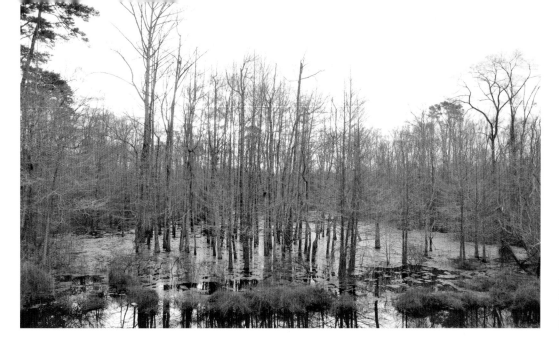

A bottomland slough in central Mississippi. Photo courtesy of Adam T. Rohnke, Mississippi State University

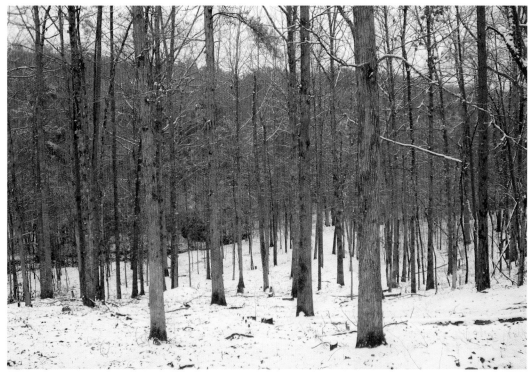

A mixed oak-hickory stand after a rare snowfall. Photo courtesy of Daniel Stephens, Bugwood.org

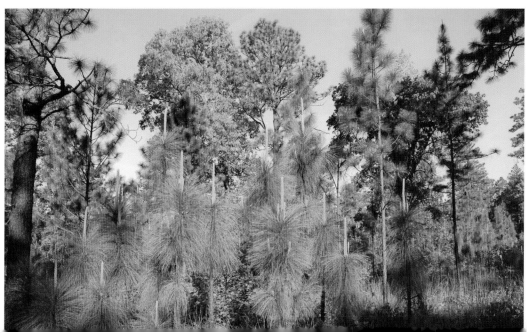

Young longleaf pines regenerating on the coastal plain. Photo courtesy of Erich G. Vallery, U.S. Forest Service, Bugwood.org

Topography

The effects of topography on soil formation occur at a local scale. First, the local topography of the land affects the drainage of water through the soil. Higher positions in the landscape, such as ridges, are drier, whereas lower positions, such as ravines, are wetter. These differences in drainage influence the types of chemical reactions involved in the weathering of parent material into soil.

Second, available moisture in the soil has a tremendous impact on the kinds of vegetation growing across the landscape. This, in turn, affects the animals living in these areas. Altogether, these differences in the plant and animal communities from one area to the next also influence the weathering of parent materials into soil.

Time

The soils across most of Mississippi tend to be very old, weathered, and lower in nutrients than those of the Mississippi River floodplain and other river bottomlands, which have the youngest, most fertile, and most highly variable soils in the state.

Prehistoric vegetation was very different than that found today. As the last ice age was ending 10,000 to 12,000 years ago, beech, hornbeam, oaks, white pine, and hemlock dominated Mississippi forests. Just as the vegetation was adapted to cooler climates, weathering processes were slower as well. Yet, as vegetation developed on bare soils, organic matter was gradually incorporated into the soil forming processes. As the climate warmed, Mississippi developed the forest composition that exists today, with southern pines, oaks, red maple, and sweetgum. The organic acids from decaying pine needles and oak leaves furthered weathering processes.

SOIL LAYERS

Over time, the interactions of climate, organisms, and topography transform parent material into soil. Intensive weathering of the topsoil

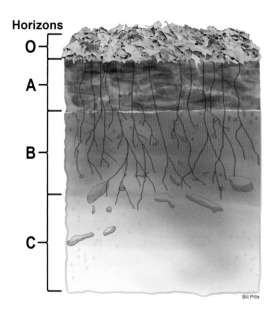

Horizons

Soil profile. Illustration by Bill Pitts

occurs near the soil surface. This weathering tends to dissolve and transport minerals in the soil downward. As the minerals move downward, the chemical and physical interactions in the soil change, with materials being deposited or created. This results in the formation of layers, or horizons, in the soil. These layers are characteristic of the existing hydrology, chemistry, and vegetation properties found in the soil. The state of these horizons—O, A, E, B, and C—on a landowner's property will affect which land uses are applicable and, consequently, land-management decisions.

The O horizon is on the soil surface and consists of leaves, branches, and other organic materials in varying stages of decomposition. In forests, this horizon is also called the litter layer. Although the litter layer is not a part of mineral soil, it is in the litter layer that organic material is recycled, with nutrients being returned to the soil through decomposition. The litter layer also helps prevent wind and water erosion.

The A horizon is commonly called topsoil. It is a combination of mineral soil and organic matter that has been incorporated from the litter layer. The topsoil is a zone of leaching, as water moving through the soil washes minerals off soil particles.

Occasionally, there is a layer called the E horizon, which is a zone of intense leaching.

Organic matter comprising the O horizon or litter layer. Photo courtesy of Adam T. Rohnke, Mississippi State University

Consequently, this layer is comprised predominantly of washed sand grains. The E horizon is prevalent in sandy soils and is most commonly found in the Lower Coastal Plain of Mississippi.

The B horizon is next and is the beginning of the subsoil. This is a zone of accumulation, usually of clay minerals or compounds of iron, aluminum, and organic complexes. Generally, it is less fertile than the A horizon.

The C horizon is the last soil horizon and is considered to be the residual parent material from which the soil formed. This layer is affected relatively little by soil organisms, as compared to O, A, E, and B horizons.

Soil Properties

Several soil physical and chemical properties are important for wildlife management, including organic matter, texture, drainage, and soil pH. These properties of the soil interact to determine its fertility, which in turn affects how much vegetation and thus wildlife can be supported, a concept known as carrying capacity. Essentially, a given unit of land can produce a set amount of biomass, measured as yield. Yield provides a certain amount of income to a farmer or forester. For example, the Mississippi Department of Wildlife, Fisheries, and Parks has been collecting and analyzing deer harvest data by county and resource area. Soils in the Delta and Loess Hills are more fertile than elsewhere in Mississippi. These regions have a greater carrying capacity, which means they can support larger, heavier-bodied deer populations on a per-acre basis. Below are more detailed descriptions of these key soil properties that are important to soil fertility.

Organic Matter.
A vital component of soil fertility, organic matter helps to retain plant nutrients and moisture. It also helps to develop soil structure, which is how individual soil particles bind together. Good soil structure has more and larger pore spaces, which are necessary for adequate aeration to plant roots. Organic matter decomposes into acidic materials, which further enhances chemical decomposition and weathering and influences soil acidity.

Plants and animals are the primary sources for organic matter. Because the natural vegetation across most of Mississippi is forest, organic matter often accumulates in layers atop the mineral soil. Soil organisms, including worms, insects, and other arthropods, eat and break down this litter layer into finer material. Decomposition continues by soil microbes and fungi that further transform the organic matter into humus. Eventually, some of the humus is mixed with the mineral soil to form the A horizon.

Texture.

Soil is composed of particles, between which are spaces called pores, which allow for the movement of water and air. Ideally, about half the volume of soil should be pore space. If the soil is too dense, plants cannot absorb sufficient water and air from the soil, thereby restricting growth or even leading to plant death. Consequently, plant roots will not penetrate severely compacted soil.

Soil texture is the distribution of the different particle sizes. Sand has the largest particles, followed by silt, and then clay. Texture can be assessed by feel and by how well moist soil sticks together. Sandy soils have individual grains, which feel gritty. If the soil holds a cast when squeezed in the hand, it is more loamy. If the soil can be rolled into thin ribbons between the fingers, it is clayey. Traditionally, because clayey soils stuck to the farmer's plow, they were referred to as "heavy." Sandy soils were called "light" because the sand grains did not stick to the plow.

Drainage.

The position of the soil in the landscape determines the depth to the seasonal water table. Wet soils (that is, very poorly, poorly, and somewhat poorly drained) have a high water table for some time during the growing season. Root growth may be limited by excessive moisture and limited aeration for respiration. In contrast, drier soils (moderately well, well, and excessively drained) have a deeper water table. As drainage improves on drier sites, moisture may become a limiting factor during the growing season.

Soil pH.

pH is a measure of acidity or alkalinity, that is, the concentration of hydrogen ions in a solution. A soil pH of 7 is neutral. Values less than 7 are acidic, whereas those greater than 7 are alkaline. Most tree species will grow well over a broad range of pH values. The soil pH influences nutrient uptake and plant growth. Many soil nutrients change form as a result of reactions in the soil, which are largely controlled by soil pH. Trees may or may not be able to utilize these changed nutrients. Some of these nutrients forms can be absorbed by plant roots,

Sandy soils are gritty, loamy soils will hold a cast, and clay soils form a ribbon when squeezed between your fingers. Photo courtesy of John D. Kushla, Mississippi State University

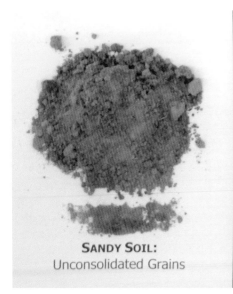

SANDY SOIL:
Unconsolidated Grains

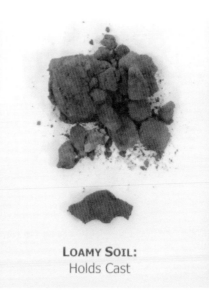

LOAMY SOIL:
Holds Cast

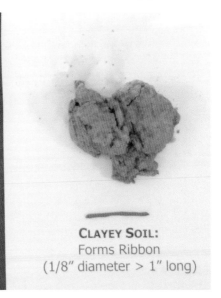

CLAYEY SOIL:
Forms Ribbon
(1/8" diameter > 1" long)

Observant landowners can identify nutrient deficiencies in their trees by discoloration of the foliage. Photo courtesy of John D. Kushla, Mississippi State University

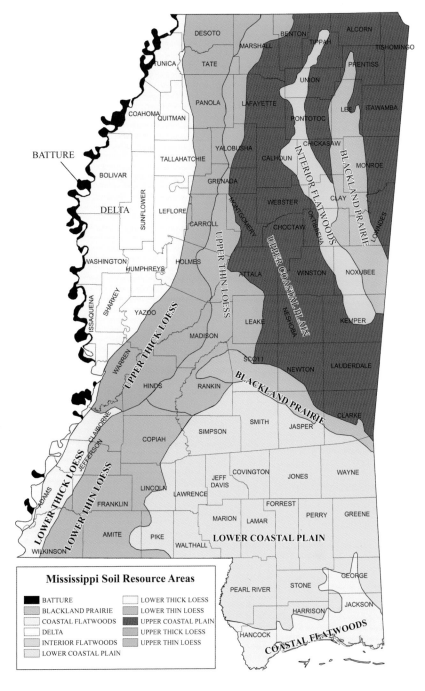

Mississippi Soil Resource Areas

- BATTURE
- BLACKLAND PRAIRIE
- COASTAL FLATWOODS
- DELTA
- INTERIOR FLATWOODS
- LOWER COASTAL PLAIN
- LOWER THICK LOESS
- LOWER THIN LOESS
- UPPER COASTAL PLAIN
- UPPER THICK LOESS
- UPPER THIN LOESS

but others cannot. Soils with a pH of 6.0 to 6.5 generally have the best growing conditions with regard to soil chemistry. At these pH levels, most nutrients are readily available. The vast majority of commercially important tree species can live in a broad range of soil pH values, as long as the proper balance of required nutrients is maintained.

Soil pH values at the extremes (less than 4.5 or higher than 8.5) can make some nutrients toxic and others unavailable to plants. At lower pH levels (less than 4.5), aluminum, iron, and manganese are readily available for plant uptake, whereas at high pH levels (higher than 8.5), calcium and potassium are overabundant. In these situations, many plants will take up too much of these nutrients and not absorb enough of the others. This is what causes the toxic conditions.

ECOREGIONS OF MISSISSIPPI

In Mississippi, several ecoregions are defined by their predominant soils and vegetation. These are the Delta, Loess Hills, Upper Coastal Plain, Blackland Prairie, Lower Coastal Plain, and Flatwoods.

Delta.
The Delta region of western Mississippi is part of the Mississippi River floodplain. Soils here are moist to wet, with medium to heavy texture. Most of this area is in agricultural production, with some in bottomland hardwoods and a little in pasture. Soybeans, cotton, wheat, and rice are the principal crops.

Soil resource areas in Mississippi. Courtesy of the Mississippi Department of Wildlife, Fisheries, and Parks

Loess Hills.

Adjacent to the Delta to the east are the Loess Hills, formed from windblown glacial outwash further north. These silty upland soils are deep, well-drained, and fertile. Forest production predominates, although agricultural production of cotton, corn, soybeans, and wheat is important as well.

Upper Coastal Plain and Interior Flatwoods.

The Upper Coastal Plain and Interior Flatwoods are ecoregions in the northeast corner of the state. Because the soils here are older and more highly weathered, they are less fertile than those to the west. These soils display advanced soil development with well-defined topsoil and subsoil horizons. Mixed pine–oak forest predominates, with loblolly and shortleaf pines and a variety of bottomland and upland oaks. Major crops include soybeans, corn, peanuts, and vegetables, with a small amount of pasture.

Blackland Prairie.

Interspersed within the coastal plain soils are the Blackland Prairie land resource areas. These bands bisect the northern and central portions of the state. Having developed from more calcareous sediments, soils in this area are fine textured with shrink-swell clays. Although forestry is significant, there is a greater amount of pasture and cropland in this resource area.

Lower Coastal Plain and Flatwoods.

In the southeastern corner of the state are the Lower Coastal Plain and Coastal Flatwoods ecoregions. The predominant soils are sandy and wet, with forests covering nearly 90 percent of the area. Due to the proximity to the coast, natural forest vegetation, including longleaf pine and live oak forests, are adapted to tropical storms.

SOIL MANAGEMENT

Proper soil management requires a long-term commitment by landowners to sustain key soil factors, including the physical condition of the soil, balance of chemical characteristics, and organic component of the soil. Management techniques vary widely depending upon the land use, soil region, and specific location and topography of a given property. Many of these techniques are covered in the chapters dealing with the management of different ecosystems and therefore are not discussed here. Prior to making any management decisions, landowners are strongly encouraged to obtain a detailed soil map, followed by site-level soil tests to gain a better understanding of the current status of these key soil factors.

Soil Testing

First, obtain a Soil Survey map of your area from the Natural Resources Conservation Service office in your county or online (http://websoilsurvey.nrcs.usda.gov/app/HomePage.htm). These manuals provide all kinds of useful information including drainage, fertility, best tree species to plant or manage, and construction guides.

Landowners can learn the properties of their soil by collecting a small sample and having it analyzed at the soil laboratory at Mississippi State University. This service is available through the Mississippi State University Extension Service for a modest fee. Landowners can obtain forms and soil sample boxes at their local county Extension offices.

- Use a clean garden spade or hand trowel to collect samples. Dig from the upper 4 to 6 inches and place material in a clean plastic bucket, because dirt or rust could contaminate the sample.
- Take several samples across the selected area to provide a representative sample. Mix these together in the bucket. Larger properties may have different soils, in which case samples should be gathered from the various representative areas. These may include ridgetops, slopes, or bottoms.
- If the soil is wet, allow it to dry prior to sending it to the soil laboratory. This will hasten the testing process, which requires a dry sample.

Items needed for collecting soil for testing include a shovel, clean container, a soil laboratory sample box, and form. Photo courtesy of Adam T. Rohnke, Mississippi State University

Table 3.1. Efficiency of fertilizer at various levels of soil acidity				
Soil acidity	Nitrogen	Phosphate	Potash	Fertilizer wasted [a]
Extremely acid pH 4.5	30%	23%	33%	71%
Very strong acid pH 5.0	53%	34%	52%	54%
Strong acid pH 5.5	77%	48%	77%	33%
Medium acid pH 6.0	89%	52%	100%	20%
Neutral pH 7.0	100%	100%	100%	0%

[a] Approximation based on the average loss of efficiency among the three major nutrients.
Adapted from *Efficient Fertilizer Use Manual*, 4th ed. IMC Global. Available online with updates at http://www.imc-agrico.com/fertilizer/education/efumanual

◆ Mix the samples from each selected area together and place a cupful in a sample box.
◆ Provide the needed information on the form and the box to ensure proper analyses are performed.
◆ Enclose a check with payment to Mississippi State University. Drop off sample boxes at the nearest Mississippi State University Extension Service office.

Routine soil testing includes measuring soil pH, lime requirements, and the amounts of available nutrients. If the landowner specifies a crop (a food plot, for example), fertilizer recommendations will be included in the results as

well. Landowners can find a multitude of helpful publications on how to interpret soil test results for wildlife food plots, agriculture, horticulture, and timber at the website of Mississippi State University Extension Service (www.msucares.com). In addition, experts at any county Extension office can assist landowners with questions regarding soil testing.

Applying Lime

Without a proper soil pH, some nutrients will be less available (for example, 20 to 70 percent of fertilizer could be wasted in acidic soils), resulting in lower yields of the intended vegetation. If the soil test determines the selected site needs lime, it is best to incorporate the lime several months before the planned activity. For example, a landowner should lime the site according to the directions of soil test results in late winter prior to planting a summer food plot for wildlife. This provides time for the lime to neutralize soil acidity. Applying lime to the surface without incorporating it into the soil may limit the liming effects to the upper 1 or 2 inches of soil. In addition, you should choose a lime that will readily dissolve with precipitation. Consult with the local county Extension office for more information on the appropriate liming materials to use.

Fertilization

As with liming, choosing the proper fertilizer material is important. Complete fertilizers include nitrogen (N), phosphorus (P), and potassium (K). This is designated on the package by three numbers representing the percentages of N, P (as phosphate), and K (as potash) by weight. Thus, a 50-pound bag of 13-13-13 fertilizer has 13 percent or 6.5 pounds elemental nitrogen, 13 percent or 6.5 pounds of phosphate (phosphoric acid), and 13 percent or 6.5 pounds of potash (potassium oxide). Incomplete fertilizers do not include all three plant nutrients.

In addition, inorganic fertilizers are composed of salts. Therefore, it is very important that when using these materials, they are watered into the soil through irrigation or rainfall

Example of an inorganic, complete fertilizer, with a plant nutrient analysis of 13-13-13. Photo courtesy of Adam T. Rohnke, Mississippi State University

to avoid burning plant roots. Slow-release fertilizers require decomposition of organic materials or coatings to release plant nutrients. In general, slow-release fertilizers are noted as such on the package. Landowners are encouraged to carefully read each product label for content and proper application information.

SUMMARY

The diverse and rich soils of Mississippi provide the foundation of natural resource commodities. By gaining a better understanding of their soils, landowners and managers have an excellent opportunity to produce high-quality agriculture, horticulture, and timber. In addition, these fertile lands provide endless opportunities for outdoor recreation including fishing, hunting, wildlife watching, and much more. With these excellent opportunities comes an inherent responsibility of individual landowners to use proper management techniques to protect Mississippi's soils for generations to come.

For More Information

Chapman, S. S., G. E. Griffith, J. M. Omernik, J. A. Comstock, M. C. Beiser, and D. Johnson. 2004. *Ecoregions of Mississippi*. Reston, Va.: U.S. Geological Survey.

Crouse, K., and W. McCarty. 2006. *Soil Testing for the Farmer*. Information Sheet 346. Mississippi State University Extension Service.

Eyre, F. H., ed. 1980. *Forest Cover Types of the United States and Canada*. Washington, D.C.: Society of American Foresters.

Fickle, J. E. 2001. *Mississippi Forests and Forestry*. Jackson: Mississippi Forestry Foundation and University Press of Mississippi.

Fisher, R. F., and D. Binkley. 2000. *Ecology and Management of Forest Soils*. New York: John Wiley and Sons.

Editors' note

Andrew J. Londo is currently the Assistant Director of Agriculture and National Resources Extension, The Ohio State University.

CHAPTER 4

Managing Agricultural Landscapes for Wildlife

Richard G. Hamrick, Small Game Program Leader, Mississippi Department of Wildlife, Fisheries, and Parks

Technical editor

L. Wes Burger Jr., Dale H. Arner Professor of Wildlife Ecology and Management, Department of Wildlife, Fisheries, and Aquaculture, Mississippi State University

Agricultural ecosystems are essential to the state of Mississippi and the nation because they produce the food and fiber that feed and clothe the world. Agriculture is Mississippi's top industry, employing approximately 17 percent of the state's workforce and generating 15 percent of taxable income. Agricultural enterprises provide the economic activity that fuels household, local, state, and national economies. According to the Mississippi Department of Agriculture and Commerce, agriculture is a $7.5 billion industry in the state, with approximately 11 million acres on 42,000 farms, which average 263 acres each.

The condition of croplands, pastures, and forests in these agricultural landscapes directly and indirectly influences the function and integrity of agricultural ecosystems and the wildlife populations they support. Grasslands, shrublands, wetlands, and forests distributed in a matrix of croplands and pastures perform important ecological services, including water filtration, sediment trapping, agrichemical retention, erosion control, soil building, water quality enhancement, temperature regulation in streams, carbon retention, and provision of wildlife habitat.

Agriculture produces valuable commodities, but it also influences the sustainability of natural ecosystems. As natural communities are converted to agriculture and small farms are combined into huge industrial agriculture complexes, formerly extensive ecosystems are lost and degraded. For example, the Lower Mississippi Alluvial Valley (Delta) and the Blackland Prairie are among the most productive agricultural regions of Mississippi. However, this productivity has come at an ecological cost through the conversion of natural hardwood forests of the Delta and tallgrass prairies of the Blackland

Eastern wild turkeys feeding in a harvested corn field. Photo courtesy of Steve Gulledge

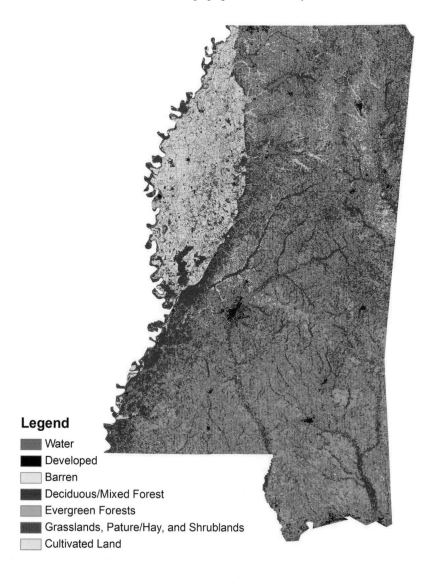

Legend
- Water
- Developed
- Barren
- Deciduous/Mixed Forest
- Evergreen Forests
- Grasslands, Pature/Hay, and Shrublands
- Cultivated Land

Primary land uses in Mississippi in 2006. Adapted from National Land Cover Database

Prairie to agricultural land uses. In fact, some plant and animal species that inhabited these ecosystems have declined or been eliminated. Nonetheless, agricultural landscapes still provide habitat for many wildlife species, and farmlands can buffer ecologically sensitive natural areas from more permanent land-use conversion (such as urban or residential development). Thus, agricultural landscapes produce more than food and fiber, and farmlands can be enhanced to provide greater wildlife conservation benefits.

Creating and maintaining natural plant communities within agricultural landscapes can reverse the decline of endangered, threatened, and at-risk species and help sustain common species. However, we cannot assume that wildlife habitats and populations will be a byproduct of agricultural land use. Conserving native species and communities in farmlands requires that portions of the landscape be strategically allocated toward conservation purposes, so it is imperative that we identify ways to sculpt ecologically sustainable agricultural landscapes.

The goal of this chapter is to help the reader visualize how conservation practices can be integrated into agricultural landscapes in ways that accommodate agricultural production and contribute to the restoration and conservation of wildlife populations. Here we summarize the effects of agricultural land use on wildlife populations, highlight factors that influence land-use decisions, define the basic principles of conservation planning, identify opportunities for integrating wildlife conservation into production systems, and describe specific conservation practices and how they might be integrated into agricultural systems.

ECOSYSTEMS

An ecosystem consists of plants, animals, and other organisms and the nonliving environment (soil, water, air) that interact with each other. Ecosystems are composed of many complex relationships we humans often take for granted. One of the most essential is the process in which soil organisms build soil organic matter and cycle nutrients from dead plants and animals that are required for plant growth. Plants provide food for animals either directly (animals that eat plants) or indirectly (animals that eat other animals that have eaten plants). These complex relationships are essential to maintain functioning ecosystems and life itself.

WILDLIFE HABITAT

Habitat is defined as the place where an organism lives. Wildlife habitat includes all the things an animal needs to survive throughout the year (food, cover, water, and space to raise young). Some species may have very specific seasonal habitat requirements for certain aspects of their life cycle, such as migration, breeding, or raising young.

AGRICULTURAL EFFECTS ON WILDLIFE POPULATIONS

Humans have modified natural habitats and ecosystems through agricultural activities for thousands of years. Archeological evidence indicates that widespread agriculture by Native Americans had transformed natural communities for centuries prior to European settlement. Primitive agriculture surely affected local wildlife populations as forests were cleared and cultivated; however, the initial impacts of agriculture on regional and continental biodiversity were likely minimal, as disturbed areas were relatively small and eventually regenerated when abandoned. Large-scale loss of biodiversity (that is, the variety of living things in a given area) in North America began in the centuries following European settlement, as timber, wildlife, and fish resources were overexploited and large-scale clearing of land for agriculture occurred to support expanding human populations.

A second wave of biodiversity loss occurred in the latter half of the twentieth century as technological advances, economic conditions, and expanding global markets intensified agricultural production. Farm acreage remained relatively stable, but the numbers of farms and farmers declined and average farm size increased. This intensification has contributed to the loss of the patchwork of hedgerows, fencerows, native pastures, wetlands, and other remnant natural habitats that formerly supported native plants and animals. Modern agricultural landscapes are the product of the cumulative impacts of past and present human land use, including logging, agriculture, ranching, and urbanization.

Agricultural land use in these human-altered systems determines the distribution, variety, and quality of natural goods and services as well as the impacts on wildlife populations. Clearly, the way we use agricultural lands will affect the sustainability of viable wildlife populations. However, given current market conditions and the narrow profit margin under which

Changes in the number of farms, farm acreage, and average farm size in the United States from 1900 to 2007. Adapted from U.S. Department of Agriculture, National Agricultural Statistics Service

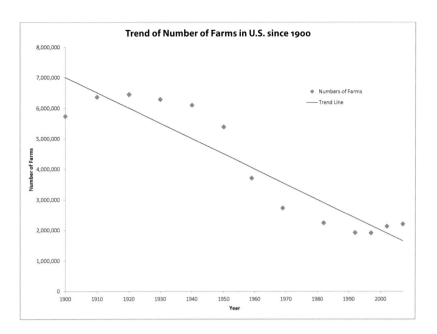

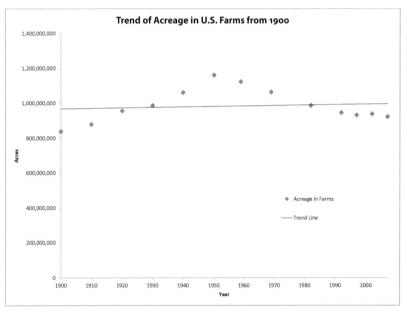

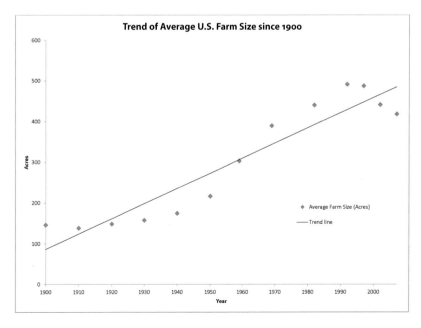

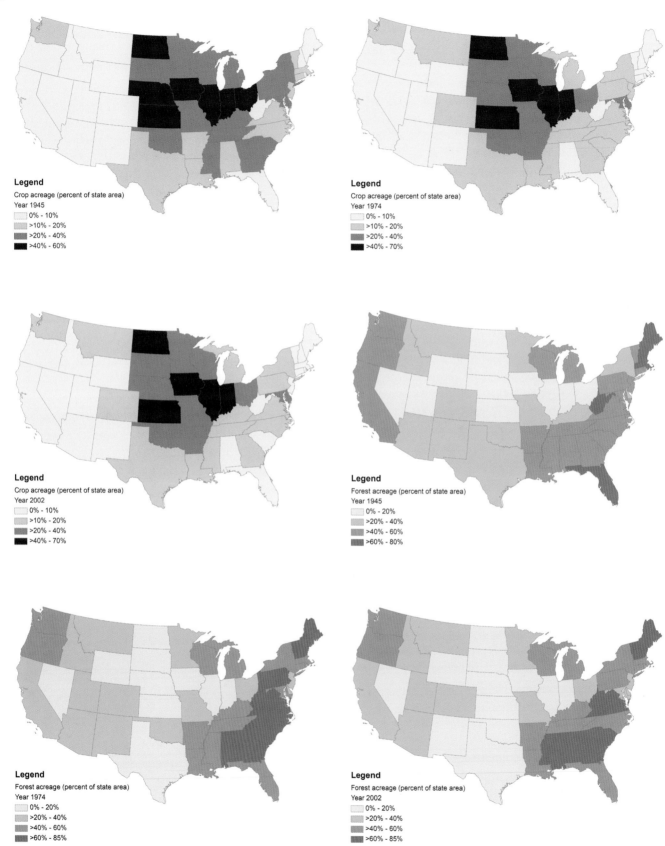

Crop, pasture, forest, and urban land use in the United States
during 1945, 1974, and 2002. Adapted from U.S. Department
of Agriculture, National Agricultural Statistics Service

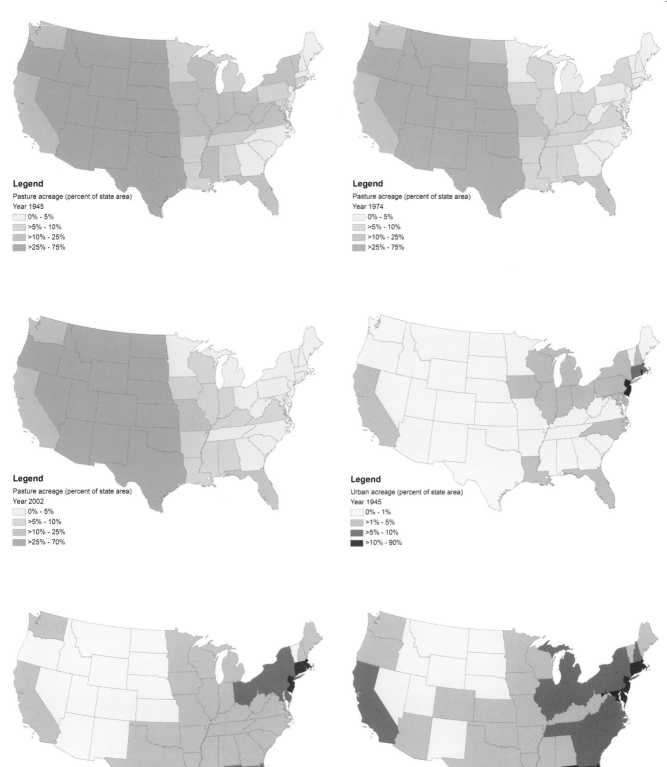

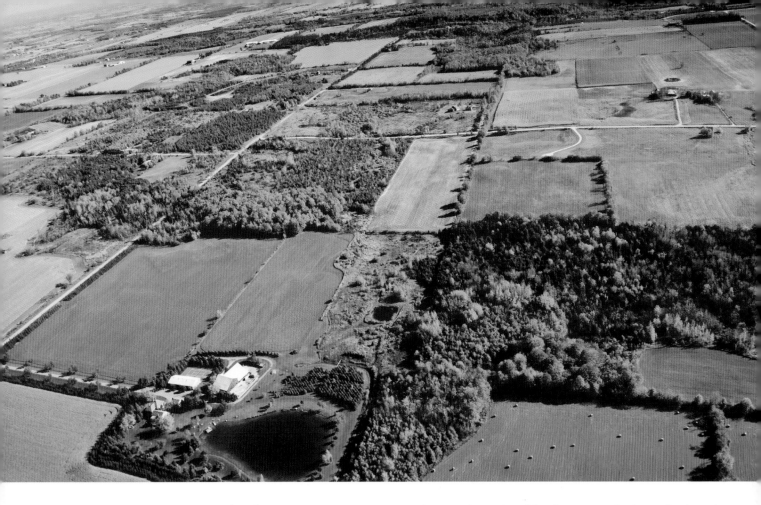

Existing patches of natural vegetation within farmlands should be protected and enhanced to provide soil, water, air, and wildlife conservation benefits. Photo courtesy of iStock

agricultural enterprises operate, it is not realistic to expect a reversion to less-intensive agricultural practices. Rather, effective conservation of farmland wildlife requires innovative solutions based on current agricultural practices that benefit the greatest number of wildlife species.

Restoring Natural Functions and Processes

Agricultural systems can be managed to provide the key ecological functions of local ecosystems.

Agricultural landscapes in which croplands and pastures are distributed among existing natural grasslands, wetlands, forests, and riparian areas (streams, creeks, rivers) can produce many natural benefits such as pollination, nutrient management, water filtration, groundwater recharge, biological pest control, and maintenance of diverse plant and animal populations. For example, native grasslands support abundant populations of flowering plants and pollinators such as bees and butterflies, which are essential

Properly placed buffer strips around agricultural fields can reduce nutrient and soil loss during rain and flooding events. Photo courtesy of Raymond Joyner, Natural Resources Conservation Service

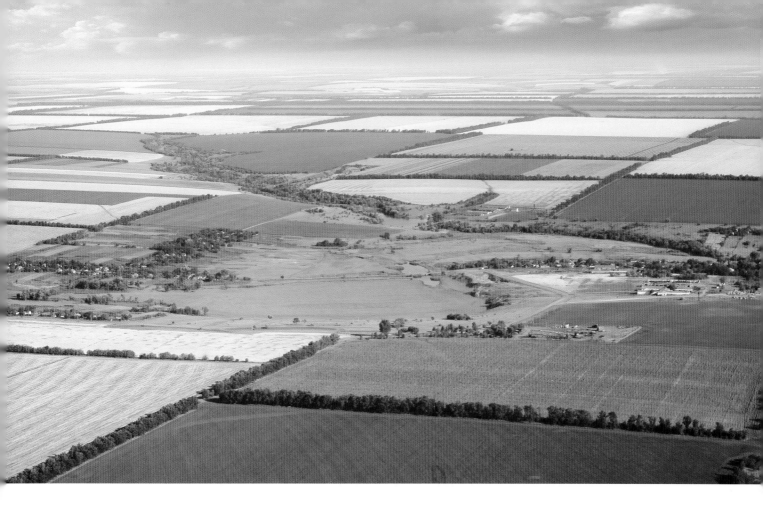

for crop production. Natural wetlands, through their water-holding capacity, can decrease the severity of flooding and recharge groundwater supplies. Riparian forests provide important habitat for wildlife and protect stream systems. These remaining patches of natural vegetation should be protected and, where necessary, enhanced through planned management.

Farmland conservation benefits can be increased by converting less-productive agricultural land, such as areas prone to flooding or low crop yields, to wildlife habitat. Restoring marginally productive agricultural lands to native plant communities and essential natural processes that maintain those communities can reestablish biological functions in farm landscapes. Conservation farming practices such as no-till, minimum tillage, residue management, and conservation buffers on actively farmed acreage can reduce negative impacts such as nutrient, soil, agrichemical, and sediment loss to surface and groundwater, thereby enhancing environmental quality.

Reversing Habitat Fragmentation

As natural communities are converted to agricultural uses, the wildlife species dependent on these communities often decline because populations become isolated from one another and are forced to occupy increasingly smaller patches of suitable habitat. This process is called fragmentation. In general, smaller habitat patches tend to support fewer plant and animal species than do large patches. Small patches are less likely to provide all the food and cover resources required to meet the seasonal habitat requirements (breeding, winter range) of wildlife throughout the year. As natural habitats become increasingly fragmented, remaining habitat patches are separated by greater distances, and the movement and exchange of individuals among patches is decreased. Fragmentation can negatively affect survival, reproduction, and genetic integrity of wildlife populations.

Direct conversion of native habitats to cropland, buildings, or roads is not the only cause of fragmentation. The invasion or establishment of non-native plants also contributes to the loss of natural communities and wildlife species. For example, grasslands are common in the Blackland Prairie, but the native tallgrass prairies have been replaced largely by pastures and hay lands dominated by non-native forage grasses such as fescue and Bermudagrass, which

Habitat fragmentation can negatively affect wildlife populations. Photo courtesy of iStock

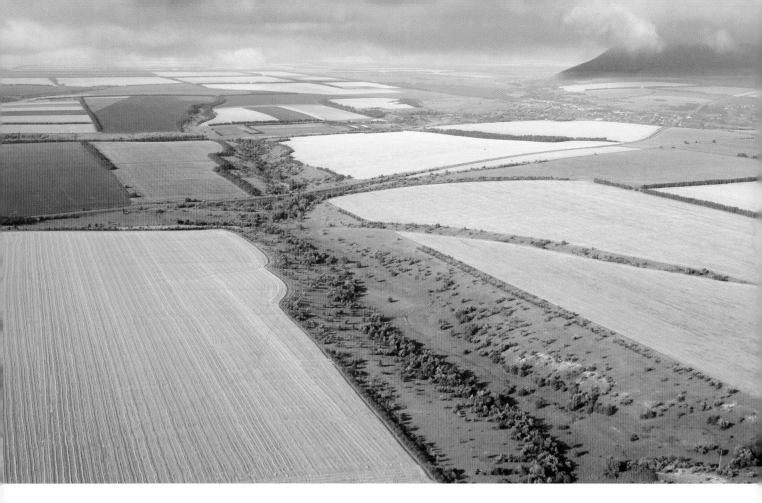

do not support the diversity of plant and animal species that native prairie grasslands once provided. Many of the small native prairie patches that remain have been invaded by non-native plants. Non-native plant species, introduced into the landscape for ornamental or forage production purposes, often outcompete native plant species and create a habitat structure to which native wildlife are not adapted. Thus, for some wildlife populations, changes in the types of plants that grow in an area can be as negative as direct conversion to cropland.

In working agricultural landscapes, the negative effects of fragmentation can be diminished by increasing habitat availability and introducing thoughtful use of natural or constructed wildlife corridors. Wildlife corridors are strips (such as a strip of native grasses or trees planted along a crop field edge) or patches (such as a former crop field converted to native grasses or trees) of vegetation that join isolated habitat patches together. Corridors can provide obvious habitat benefits, such as nesting or feeding areas, but, just as importantly, they also provide protected travel routes for wildlife to move between otherwise isolated habitat patches. This

increases both the quantity of and connectivity among habitat patches in a given area.

FACTORS THAT INFLUENCE LAND-USE DECISIONS

Wildlife resources are important to the American people and the national economy because of the many positive values associated with natural habitats and wildlife populations. The agricultural community is well positioned to play a key role in protecting and enhancing the nation's wildlife resources because of the extensive quantity of land and water resources controlled by our nation's food and fiber industry. For agricultural producers, however, allocating land to uses that protect or enhance environmental resources usually involves economic trade-offs.

Societal Benefits and Producer Costs

Shifting land from agricultural production to wildlife habitat results in direct costs associated with establishing and maintaining wildlife habitat and lost-opportunity costs for

A Conservation Reserve Program buffer established along an agricultural field edge provides wildlife habitat and conserves soil and water quality. Photo courtesy of L. Wes Burger, Mississippi State University

commodities the land would have produced. Although producers may enjoy the benefits of wildlife through enhanced hunting, fishing, or wildlife viewing, the economic benefits of wildlife production may be difficult to accrue. These economic trade-offs may help explain why agricultural producers do not often choose to manage land and water resources for wildlife that benefit society at large. To encourage more farmers to participate, conservation practices designed to enhance and protect wildlife resources on agricultural lands must achieve multiple environmental benefits, be easily integrated into production systems, and be economically neutral or beneficial to the producer.

Agricultural Policy and Conservation

Agricultural policy affects the way individuals and societies use agricultural lands and the ecological services produced by agricultural landscapes. However, creating agricultural landscapes that produce multiple environmental benefits requires that individuals and society value these services and link their production to policy and market mechanisms. Conservation programs under Federal Farm Bills encourage the use of conservation practices through a combination of education, technical assistance, and economic incentives.

These economic incentives may include cost-sharing of practice implementation costs, incentive payments, and easement payments. Although education and technical assistance are essential conservation tools, economic assistance that rewards environmental stewardship is key to securing the participation of farmers and ranchers. Agricultural producers will alter land management practices and shift land from commodity production into wildlife habitat if economic costs are addressed with sufficient compensation. This is illustrated in producers' voluntary enrollment

of more than 1.6 million acres in the Wetland Reserve Program and 34.8 million acres in the Conservation Reserve Program.

FARM CONSERVATION PLANNING

Farmers most often implement specific conservation practices in response to site-specific resource concerns. For example, a series of terraces, an overfall pipe, or a diversion might be installed to address an erosion problem in a given field. Similarly, a filter strip or riparian buffer may be installed to protect a stream corridor, enhance water quality, and provide a corridor connecting isolated habitat patches.

As buffer strips on agricultural lands, wet-soil-loving trees can reduce soil erosion by water and wind. They also serve as wildlife corridors in the open landscape. Photo courtesy of Heath M. Hagy, Illinois Natural History Survey

These site-specific approaches may or may not accomplish overall farm conservation goals. Therefore, the producer aiming to achieve a sustainable farming operation must treat it as a complete system in which integrated conservation and production goals and objectives are developed for the entire farm.

Developing a comprehensive farm conservation plan is beneficial for clearly outlining conservation goals and the objectives required to accomplish those goals. Conservation plans may even be integrated into the farm business plan, because such practices may enhance farm sustainability (including profitability) and quality of life. A conservation plan should include clear goals, objectives (with timelines for completion), maps, and budgets.

Natural resource professionals are available to assist landowners with development of conservation plans, and landowners are encouraged to utilize this technical expertise. (Refer to chapter 2 for more information on developing a comprehensive conservation plan.)

INTEGRATING WILDLIFE CONSERVATION INTO PRODUCTION SYSTEMS

By considering the whole farm as a complete system that produces both agricultural commodities and conservation benefits, landowners can develop and later implement a farm-level management plan that clearly defines both production and conservation goals and objectives. Conservation programs may be available to help implement those practices by offsetting direct costs, lost-opportunity costs, or both. Landowners are urged to take advantage of available technical assistance, frequently offered at no cost, from government agencies and non-governmental organizations.

SOURCES OF WILDLIFE, FISHERIES, AND FOREST MANAGEMENT TECHNICAL ASSISTANCE

In some cases, the services of another agency or private consultants may be required. These entities can provide referrals for such services when necessary.

Mississippi Department of Wildlife, Fisheries, and Parks
www.mdwfp.com
(601) 432-2400

Mississippi Forestry Commission
www.mfc.ms.gov
(601) 359-1386

Mississippi State University Extension Service
www.msucares.com
(662) 325-3174 (wildlife and fisheries)
and (662) 325-3905 (forestry)

U.S. Department of Agriculture, Natural Resources Conservation Service
www.nrcs.usda.gov
(601) 965-5205 ext. 130

Wildlife Mississippi
www.wildlifemiss.org
(662) 686-3375

Delta Wildlife
www.deltawildlife.org
(662) 686-3370

U.S. Fish and Wildlfe Service Mississippi Ecological Services
www.fws.gov/mississippiES
(601) 956-4900

SEEK TECHNICAL ASSISTANCE

It is best to involve as many technical assistance providers as necessary, including wildlife biologists, foresters, agronomists, and extension specialists, to meet a particular conservation objective. By working with the appropriate specialists, producers can achieve a balance between production and conservation goals. Technical assistance providers may be employed by state or federal government agencies or non-governmental organizations or be private consultants in specialty areas such as forestry, wildlife biology, grazing, and crops.

Table 4.1. Some common federal and state conservation programs used for wildlife habitat improvement in Mississippi

Program	Eligibility	Enrollment	Contract length	Annual rental payments	Cost-share payments	Incentive payments	Easements	Administrative agency	Website
Conservation Reserve Program, Continuous sign-up	Cropland that meets certain cropping history and other requirements or certain marginal pastureland suitable for use as a conservation buffer to enhance water quality	Producers can offer land for enrollment at any time, and offers are not competitively ranked	10 to 15 years	yes	yes	yes	no	Farm Service Agency	www.fsa.usda.gov
Conservation Reserve Program, General Sign-up	Cropland that meets certain cropping history and other requirements	Producers can offer land for enrollment only during designated sign-up periods, and offers are competitively ranked	10 to 15 years	yes	yes	yes	sometimes	Farm Service Agency	www.fsa.usda.gov
Forest Resources Development Program	Nonindustrial private land for timber and wildlife habitat development	Applicants may apply at any time	10 years	no	yes	no	no	Mississippi Forestry Commission	www.mfc.ms.gov
Wildlife Habitat Incentive Program	Agricultural land, nonindustrial private forest land, and tribal land	Applicants may apply at any time	10 to 15 years	no	yes	no	no	Natural Resources Conservation Service	www.nrcs.usda.gov
Wetlands Reserve Program	Private and tribal lands	Applicants may apply at any time	variable	no	yes	no	yes	Natural Resources Conservation Service	www.nrcs.usda.gov
Mississippi Partners for Fish and Wildlife Program	Private lands	Applicants work with a natural resources professional to develop a proposal, and proposals are competitively ranked	variable	no	yes	no	no	United States Fish and Wildlife Service	www.fws.gov/ mississippiES/ partners3.html

Note: These programs may change or be added or eliminated due to funding availability. Consult a natural resources management professional for assistance in selecting programs and applying conservation practices.

Conservation Programs

Agricultural producers may have several conservation programs to choose from, including some that compensate them for costs associated with practicing conservation. Most are administered by federal or other governmental agencies, although some are managed by private entities. Examples of the most popular conservation programs authorized by Federal Farm Bills include the Conservation Reserve Program and Wetlands Reserve Program.

PAYMENTS FOR THE IMPLEMENTATION OF CONSERVATION MEASURES

Conservation programs may offer one or more types of payments to landowners.

◆ A cost-share is a one-time payment for some portion of costs incurred by the landowner to implement a conservation practice.
◆ An incentive payment is offered (in addition to other supplementary payments) to encourage landowners to adopt conservation practices they might not otherwise participate in. An example of an incentive is a bonus payment of $100 per acre made to a landowner just for signing up for a conservation practice.
◆ A rental payment is typically an annual incentive payment made for land dedicated to conservation practices for the duration of the contract. Rental payments are usually made to compensate for lost opportunity to generate revenue on that land.
◆ A conservation easement is usually a one-time payment made to a landowner for placing land in an easement. Use of the easement is conveyed to an entity (such as the federal government) while the landowner retains ownership of the land. Easements are generally long-term agreements (for example, 10 years, 30 years, or permanent) to restore and protect certain land uses. An easement may also offer certain tax advantages to the landowner.

Agricultural landowners can voluntarily enroll acreage for conservation purposes, but they must meet certain eligibility requirements to qualify. Many conservation programs provide cost-share assistance to implement conservation practices for multiple environmental benefits, including enhancing and maintaining wildlife habitat and soil, water, and air quality that strengthen farms and society. The Conservation Reserve Program provides annual rental payments for land removed from agricultural production and placed in a conservation practice. Some programs, such as the Wetlands Reserve Program, may purchase easements for long-term protection of rare or sensitive systems such as wetlands or threatened and endangered species.

Several conservation programs may be used simultaneously on the same farm to accomplish specific conservation goals. For example, one program may focus on establishing native grass buffers around crop field edges to provide wildlife habitat and protect soil and water quality. Another may be aimed at managing existing forest land for improving wildlife habitat, and a third program may restore and protect a wetland. In this manner, several conservation programs are used to address whole-farm conservation goals.

It is not our intent to detail every conservation program available. Conservation programs change frequently. Most are modified regularly, and some may be eliminated altogether. Agricultural producers must evaluate the costs of production, farm conservation goals, and ability of the land to sustainably and reliably produce a profit to determine whether some portion of their land would be better used for conservation. An economic analysis of production may reveal that converting some portion of farmland to conservation actually increases profitability (although this could prove true with or without the assistance of a conservation program). So, in order to maximize both economic returns and conservation benefits, it is important to use planning and technical assistance to choose conservation programs and practices that achieve farm plan goals and objectives.

Conservation Practices

Areas of a farm that are less productive for agricultural production are the most obvious areas to devote to conservation. These may include excessively wet areas or areas prone to flooding, field edges that produce lower crop yields, areas difficult to access, or narrow or irregularly shaped portions of fields that are less efficient to plant, cultivate, and harvest. With the aid of conservation programs, conservation practices may be implemented in ways that are cost-neutral to advantageous for the producer.

The types of vegetation used to establish cover influences wildlife habitat value. Native plants adapted to local soil and climate conditions should be used to provide the greatest wildlife habitat benefits. However, conservation practices are not limited to establishing new cover. They may also include management activities such as

EXAMPLES OF CONSERVATION PRACTICES ON WORKING FARMS IN MISSISSIPPI

A Coahoma County landowner who manages a 6400-acre farm managed for row crops, recreational hunting, and diverse wildlife habitat has gained positive conservation benefits since implementing conservation practices. The property is comprised of 30 percent hardwood reforestation, 14 percent wetlands, 6 percent conservation buffers, and 2 percent forest. The remaining 48 percent of the property is used for cotton, soybean, and corn production.

As part of a comprehensive farm management plan, specific conservation practices included planting hardwood trees, establishing riparian forest buffers and native warm-season grass filter strips, and incorporating wetland restoration. Wildlife such as songbirds, rabbits, and deer responded quickly to the cover provided by these measures. Although not a specific management objective, northern bobwhite quail populations increased noticeably, a welcome byproduct of broadly applied conservation practices for this landowner.

The main goal of an owner of a 5400-acre farm in Clay County is to operate a profitable livestock and row crop operation while being environmentally responsible. The landowner is meeting this goal by integrating conservation buffers and other restorative practices into the farming operation. Twenty-five percent of the property is maintained for conservation purposes, including riparian and native warm-season grass buffers, wildlife corridors, native warm-season grass pasture, and native prairie grasslands.

As a result of these practices, soil erosion in pastures and croplands has been reduced, stream bank stability is increasing, and water quality has improved throughout the property. A primary objective for this landowner was northern bobwhite quail management, and wild quail populations have recovered to huntable levels after several years of patience and management. Other game and nongame wildlife have also responded positively to the conservation practices. As a result of the conservation successes on this farm, the landowner has started a hunting and outdoor recreation business to coincide with the cattle and row crop operations.

In both of these examples, conservation planning was accomplished by the landowner working with wildlife biologists and Natural Resources Conservation Service field office personnel. Conservation practices were implemented under the Wildlife Habitat Incentive Program, Conservation Reserve Program, and Mississippi Partners for Fish and Wildlife Program. Some costs were also offset by assistance from private conservation organizations such as Delta Wildlife and Wildlife Mississippi. By utilizing available conservation assistance, these landowners were able to effectively and efficiently accomplish their conservation goals.

Table 4.2. A list of common commercially available native plants for wildlife conservation practices in Mississippi	
Type of plant	**Species**
Grasses	little bluestem
	big bluestem
	Indiangrass
	switchgrass
Shrubs	flowering dogwood
	American plum
	sumac
Wildflowers	partridge pea
	coneflowers
	black-eyed Susan
	ironweed
	showy tickseed
	goldenrods
Trees	pines (loblolly, longleaf, and shortleaf)
	oaks, upland sites (southern red, northern red, white, and post)
	oaks, bottomland sites (Nutall, water, willow, Shumard, swamp chestnut, and overcup)
	black walnut
	pecans

Note: Consult a natural resources professional for more information on matching plant materials to specific site conditions.

prescribed burning, disking, and control of invasive species, which maintain habitat structure and composition for certain wildlife species.

Next, we discuss the more common conservation practices that agricultural producers use for wildlife habitat management. All can be implemented through conservation programs, although eligibility requirements, funding availability, and other factors dictate whether a landowner might receive cost-share assistance to implement them. After a cover, such as native grasses or trees, is established, refer to the appropriate chapters in this book for more specific management information. A wildlife biologist can provide assistance in selecting conservation practices and the types of management activities required to maintain habitat quality and achieve wildlife habitat management objectives.

Conservation Buffers.
Conservation buffers are typically strips of land, often in the range of 20 to 180 feet wide, maintained in permanent vegetation. Buffers are established to provide wildlife habitat, intercept pollutants, and reduce erosion. Conservation buffers may be established using trees, shrubs, grasses and wildflowers (herbaceous vegetation), or a combination of woody and herbaceous vegetation along field edges, drainages, or through interiors of large fields. Buffers can be useful for creating habitat (such as nesting, feeding, and other protective cover) and protected travel corridors that link separate habitat patches together. In general, larger buffer widths (50 feet or wider) are better for wildlife. In particular, wider buffers can reduce the hunting efficiency of some predatory animals.

Conservation buffers are applicable to both crop and grazing lands and can be implemented through several programs. Buffers are extremely versatile and flexible conservation practices for agricultural production systems. They remove only a small amount of land from production, but they can have substantial soil, water, air, and wildlife conservation benefits. Furthermore, establishing buffers through a

A buffer strip composed of native warm-season grass and wildflowers adjacent to an agricultural field serves as wildlife habitat. Photo courtesy of Kristine Evans, Mississippi State University

A wildlife corridor established in a cattle pasture. Note that the area is fenced to prevent livestock from grazing or trampling cover. Photo courtesy of L. Wes Burger, Mississippi State University

Filter strips stabilize soil and reduce chemical, nutrient, and soil runoff into nearby streams. This filter strip was established along a drainage ditch with native warm-season grasses to provide wildlife habitat as well. Photo courtesy of L. Wes Burger, Mississippi State University

A former crop field converted to native warm-season grasses and wildflowers. These habitats are important for many wildlife species throughout the year. Photo courtesy of Richard G. Hamrick, Mississippi Department of Wildlife, Fisheries, and Parks

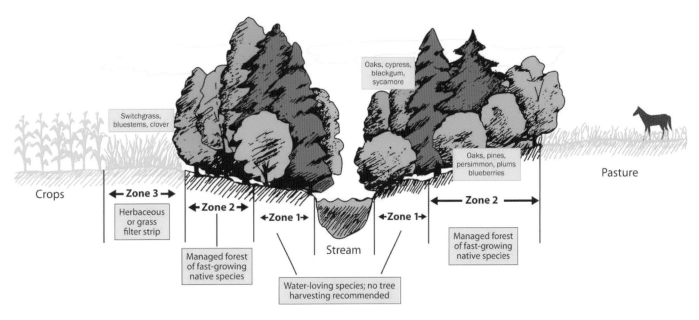

A riparian buffer may be established using transition zones to protect a stream and provide multiple wildlife habitat benefits. Herbaceous (nonwoody plants) and shrub vegetation zones provide habitat for wildlife and filter sediment, chemical, and nutrient runoff from fields. Tree zones for forest wildlife also stabilize stream banks, provide additional filtration, and moderate water temperature, which is important for aquatic species. Adapted from U.S. Department of Agriculture, Natural Resources Conservation Service by Kathy Jacobs

Former agricultural fields may be converted to forest cover with trees suitable for the site. Photo courtesy of Jason May, Wildlife Mississippi

conservation program may actually increase economic return, especially if a program provides an annual rental payment for land removed from production.

Several studies, including some conducted by Mississippi State University, have found that establishing buffers can be economically neutral to advantageous for crop producers depending on crop type and long-term average harvest yield, commodity prices, and production costs. Thus, establishing conservation buffers may be no more or less costly than continued cropping or grazing of less-productive acreage. Furthermore, many studies have found that conservation buffers do not substantially increase the abundance of agricultural insect pests. In fact, buffers often provide habitat for beneficial insects such as pollinators, which are essential for

the production of certain crops and fruits, and predatory insects that prey upon crop pests.

Converting Old Fields.
Some farmers may have whole or portions of fields they want to remove from production or existing old fields that have been idle for some time. Several options are available for converting old fields to conservation uses. Many landowners choose to plant trees in old fields to produce a future timber crop and provide wildlife habitat. Depending on wildlife management objectives, planting trees suitable for the site may be a good management option. However, some wildlife species may require native grass or grass and shrub habitat, while others need some combination of forest and grassland habitat. Thus, wildlife management objectives

and identification of cover types needed to accomplish those objectives will determine the appropriate conservation cover.

Old pasture or hay fields are often more difficult to manage for wildlife habitat than crop fields. Most fields used for livestock forage production have been managed to produce non-native forage grasses such as Bermudagrass, bahiagrass, or tall fescue. These non-native grasses can be difficult and expensive to control, but it is possible to convert former grazing or hay lands to native vegetation. The most efficient and effective way to control most non-native vegetation is with appropriate herbicides. Consult a wildlife biologist or other natural resource professional for assistance in developing a plan for controlling non-native grasses or other invasive or less-desirable vegetation.

Once the appropriate native grassland or forest vegetation cover type is established, it must be managed to maintain long-term wildlife habitat quality. For example, stands of native grasses, wildflowers, and shrubs require periodic management with prescribed burning or manipulation to prevent stands from reverting to forest cover. Tree plantings may be managed after establishment to produce revenue and improve wildlife habitat structure. (Refer to chapters 5 and 6 for more specific information on managing native grassland and forest wildlife habitat.)

Planting Native Grass Forage.
Because the state's native wildlife species are not adapted to the habitat structure produced by non-native forage grasses, such as Bermudagrass,

Native warm-season grass pastures produce quality summer forage for cattle and provide greater potential wildlife habitat benefits than non-native forage grasses. Photo courtesy of Richard G. Hamrick, Mississippi Department of Wildlife, Fisheries, and Parks

A young pine plantation adjacent to an agricultural field. Tree growth in this stand has slowed, and there is little sunlight reaching the ground. The selective removal of some trees (thinning) and other forest management practices can increase wildlife habitat diversity. Photo courtesy of Richard G. Hamrick, Mississippi Department of Wildlife, Fisheries, and Parks

bahiagrass, and tall fescue, pasture and hay lands comprised of non-native grass species provide fewer wildlife habitat benefits than native grasslands. Alternatives to non-native grasses for livestock forage are native warm-season grasses, which are drought tolerant, require less supplemental fertilization than non-native forage grasses, and produce an abundance of summer forage. Native warm-season grasses commonly used for grazing or hay are big bluestem, Indiangrass, switchgrass, and eastern gamagrass.

However, native grasses must be managed differently than non-native forage species such as bahiagrass and Bermudagrass. In particular, native grasses will not withstand close grazing and should not be grazed (or clipped) lower than 6 inches before moving cattle to another

pasture. They must also be allowed several weeks of regrowth prior to autumn dormancy. Separate winter-grazing paddocks should be maintained, as it is difficult to overseed winter forage and maintain a quality stand of native grasses on the same pasture.

Native warm-season grass forage is best used with a rotational grazing system in which pastures are divided by fencing into three or more grazing paddocks. Cattle are stocked in a single paddock that is grazed intensively for a period of time and then moved to a new paddock. In this manner, each paddock has a rest-and-recovery period before being grazed again. Because native grass forage must be maintained at a taller height during both the growing season and winter, they provide more cover for

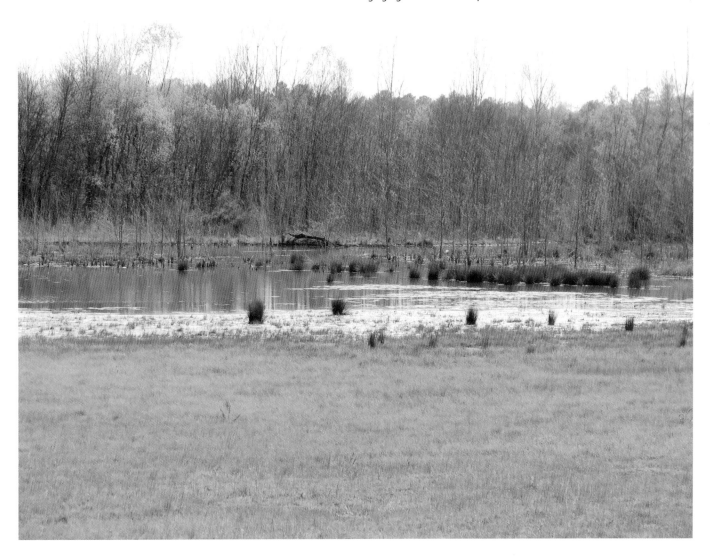

wildlife. The more clump-like growth habitat of native grasses (compared to sod-forming growth habitat of non-native forage grasses) coupled with ground disturbance from livestock also maintains bare ground areas required by some ground-dwelling wildlife, such as quail and some songbirds.

Native warm-season grasses can be beneficial for producers who want to integrate livestock production and wildlife habitat. Devoting just part of forage production to native grasses may be desirable to reduce input costs (such as less supplemental fertilization or irrigation) while increasing farm wildlife habitat benefits. It is often easier to establish native grasses on sites that have not previously grown non-native forage grasses, such as a row crop field that is being converted to pasture or hay. Thus, native grass forage may be most practical for establishing new pastures or hay fields.

As with any new farm venture, it is recommended that producers interested in using native warm-season grasses for livestock forage start by testing on a few acres to determine if native grasses are suitable for the operation. Keep in mind that it will take at least a year to fully establish a new forage stand, plus it may take some time for livestock to adjust to new forage. Cost-share programs may be available to offset establishment and fencing costs. Consult an Extension grazing specialist and other appropriate technical assistance providers for more information on grazing systems, native warm-season grass establishment, and wildlife management.

Areas prone to seasonal flooding can limit agricultural uses but attract many wetland inhabitants. Rather than continue farming these areas, producers may find it more cost-effective to convert them to permanent wetland wildlife habitat. Photo courtesy of Richard G. Hamrick, Mississippi Department of Wildlife, Fisheries, and Parks

Forest Management.

Almost all farms have existing woodlands that are utilized for wood products, recreation, or conservation values. Most farm woodlands can be enhanced to provide both economic return (such as timber) and wildlife habitat. Practices such as selective thinning to increase growing space for desirable trees and remove lower quality or poorly suited trees and/or prescribed burning, where appropriate and feasible, can be applied to increase wildlife habitat value for many species.

The types of forest management practices used will depend on the type of forest (pine, upland mixed forest, bottomland hardwood) and desired wildlife and/or timber objectives. (Refer to chapter 6 for more specific information on forest management techniques.) Conservation programs may be available to assist landowners with some of the costs associated with forest management, such as prescribed burning or invasive species control. When developing a farm conservation plan, landowners are advised to consult with both a registered forester and wildlife biologist to integrate forest and wildlife management objectives into the plan. Through advanced planning, proper forest management practices can be implemented to achieve wildlife and other conservation goals and objectives.

Wetland Restoration and Management.

Some farms, particularly in the Delta region, may have soils and other features that are suitable for wetland restoration. Wetlands are among the most degraded natural systems in the United States, and wetland restoration benefits wildlife such as shorebirds, waterfowl, fishes, and frogs. Wetlands also act as buffers to reduce the severity of flooding, cycle nutrients, and provide other beneficial environmental functions.

Wetland habitats vary. Some retain water most of the year, whereas others may be flooded during the winter and then drained or allowed to dry out during the drier seasons. Management practices may include seasonal water level adjustment, disking or prescribed burning (when dry) to manage vegetation, and planting food crops for wintering waterfowl and other wildlife.

Proper management of wetlands will depend upon the type of wetland habitat developed and wildlife management objectives. (Refer to chapter 7 for more specific information.) A wildlife biologist or other natural resource professional can provide technical assistance with wetland restoration and management. Wetland construction projects may require specialized experts such as engineers to develop plans for proper water retention and movement. Programs may be available to offset costs of wetland restoration and compensate the landowner for acreage restored to wetland habitat.

SUMMARY

Agriculture has changed dramatically during the past century. Although the numbers of farms and farmers have decreased, technological advances have led to increased intensity and scale of agricultural production on the remaining farm acreages, leading to declines of some farmland wildlife species. However, modern farm landscapes do provide important wildlife habitat, and conservation programs and practices can be applied to effectively manage wildlife habitat on agricultural lands. Natural resource professionals are available to provide wildlife management planning assistance, often at no cost. With proper planning and implementation of conservation practices, farmlands can provide many wildlife benefits while maintaining agricultural productivity and profitability.

For More Information

Cattaneo, A., D. Hellerstein, C. Nickerson, and C. My-
ers. 2006. *Balancing the Multiple Objectives of Conser-
vation Programs.* Economic Research Report No. ERR-
19. Economic Research Service, U.S. Department of
Agriculture. www.ers.usda.gov

Cummins, J. L. 2010. *Conservation Easements: A Hand-
book for Mississippi Landowners, Second Edition.* Missis-
sippi Land Trust.

Gray, R. 2009. *Field Guide to the 2008 Farm Bill for Fish
and Wildlife Conservation.* U.S. NABCI Committee
and the Intermountain West Joint Venture. www
.nabci-us.org/fbguidehome.htm

Gray, R. 2010. *Conservation Provisions of the 2008 Farm
Bill: A Handbook for Private Landowners in the Lower
Mississippi River Valley.* Wildlife Mississippi.

Lambert, D., P. Sullivan, R. Claassen, and L. Foreman.
2006. *Conservation-Compatible Practices and Programs:
Who Participates?* Economic Research Report No.
ERR-14. Economic Research Service, U.S. Depart-
ment of Agriculture. www.ers.usda.gov

Natural Resources Conservation Service Agricultural
Wildlife Conservation Center website: www.whmi
.nrcs.usda.gov/technical/projects.html

CHAPTER 5

Managing Native Grasslands

Jeanne C. Jones, Professor of Wildlife Ecology, Department of Wildlife, Fisheries, and Aquaculture, Mississippi State University

With contributions by
JoVonn G. Hill, Research Associate II, Department of Biochemistry, Molecular Biology, Entomology, and Plant Pathology, Mississippi State University

Technical editor
Richard G. Hamrick, Small Game Biologist, Mississippi Department of Wildlife, Fisheries, and Parks

Tallgrass prairies and woodland savannas once covered much of central North America and parts of the Southeast. When European settlers arrived on this continent, these vast grasslands stretched as far north as Manitoba, Canada, south to the coastal areas of Texas and Louisiana, and east into Oklahoma, Mississippi, and Alabama. These communities developed over thousands of years, shaped by soil type, climate, and fires ignited by dry lightning and Native Americans. Differences in soil types, rainfall and moisture availability, and fire incidence created diverse habitat types across the country. Mixed and shortgrass prairies and desert grasslands were prevalent in western mountain and arid regions. To the east, tallgrass prairies extended from southern Canada to Texas. From eastern Texas through Alabama, mosaics of prairies were intermixed with woodland savannas comprised of herbaceous understory plants and oak woodlands. These forested grasslands were influenced by abundant annual rainfall, fertile soils, and fire. In the sandy soils to the south of the oak woodland savannas, frequent fires produced longleaf pine savannas.

Mississippi's prairies or grasslands are part of the Blackland Prairie region, which spans across eastern Texas, Arkansas, Mississippi, and Alabama. The largest of the Blackland Prairies and the most southeastern of the tallgrass prairie type is the Black Belt of Mississippi and Alabama. This crescent-shaped region is characterized by dark fertile soils and extends more than 300 miles from southeastern Tennessee through east-central Mississippi to southeastern Alabama. To the south of the Black Belt lies the Jackson Prairie Belt, which stretches from Yazoo County across central Mississippi to Alabama's western border. Surveys from the 1800s indicate that about 356,000

Native prairie. Photo courtesy of Jeanne C. Jones, Mississippi State University

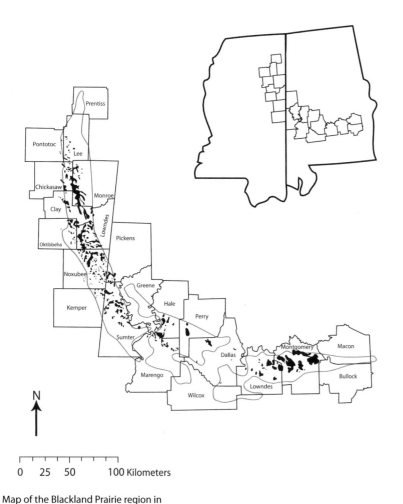

Map of the Blackland Prairie region in Mississippi. Figure courtesy of J. A. Barone

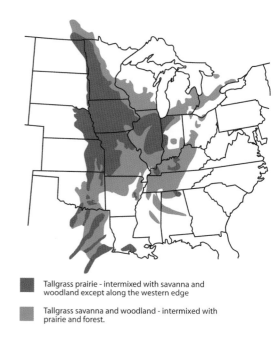

Tallgrass prairie - intermixed with savanna and woodland except along the western edge

Tallgrass savanna and woodland - intermixed with prairie and forest.

Map of the historical tallgrass prairie region in the United States. Figure courtesy of Jeanne C. Jones, Mississippi State University

Map of the Jackson Prairie region in Mississippi. Figure courtesy of J. A. Barone

acres of prairie were present in the Black Belt. Almost half of this prairie acreage was located in present-day Chickasaw, Clay, Kemper, Lee, Lowndes, Monroe, Noxubee, Oktibbeha, and Pontotoc Counties. Early records suggest that these prairies probably ranged from about 17 to 5000 acres in size. About 48,300 acres of prairies were in the Jackson Prairie Belt and western Mississippi. The greatest concentrations of these prairies were in Madison and Rankin Counties, with isolated prairies in Attala, Carroll, Clark, Coahoma, Hinds, Holmes, Jasper, Kemper, Leflore, Newton, Scott, Smith, Warren, Wayne, and Yazoo Counties.

Early explorers reported that in some areas expansive grasslands interspersed with beautiful patches of woodlands appeared as if they had been planted and manicured. The presence of unique vegetation was due, in part, to fertile alkaline soils that were underlain by specific parent formations. For example, the Jackson Prairie Belt is located on gently rolling uplands of Jackson Group and Cockfield soil formations, which are underlain by Yazoo Clay parent material. Approximately 17,290 acres of prairies in the western portion of the state were located on fertile alluvial soils that were

deposited by streams or rivers. Blackland Prairies developed on soils that originated from the Demopolis chalk of the Selma Group, a highly alkaline substrate arising from marine-deposited complexes, such as calcium carbonate (limestone). Today, evidence that this region was once covered by ocean water is revealed in chalk outcroppings that often contain fossils of marine life, such as mollusk shells and sharks' teeth (see chapter 3 for more information). The high mineral content and exposed chalk layers generally produce alkaline soil conditions on many prairie sites, although soil conditions may vary locally depending on topography and vegetation type. The combination of fertile alkaline soils, abundant rainfall, and frequent incidence of fire influenced the plant communities of Mississippi's native grasslands.

Three major plant communities existed in the Blackland Prairie region: open prairie or grasslands, chalk outcrops, and forests. Today,

prairies and chalk outcrops generally support many plants found only in Black Belt and Jackson Prairies and prairies of the Midwest. Most herbaceous plants of open prairies require regular intervals of fire to persist and thrive. With less frequent fire and higher soil moisture, prairie vegetation is typically replaced by shrubs and trees. Increased soil moisture is also influenced by landscape features such as rivers, streams, and land contour. Historical records of prairies in today's Noxubee County, where the Noxubee River and associated streams transect the Black Belt, indicate that alluvial floodplain forests of bottomland hardwoods cut across prairies, woodland savannas, and upland forests. Six forest communities have been identified in Mississippi's Black Belt: (1) dry, post oak ridges; (2) moist, oak-hickory forests; (3) bottomland hardwood forests; (4) water tupelo swamps; (5) mixed-hardwood gallery forests; and (6) prairie cedar woodlands.

A chalky outcrop located in the Blackland Prairie of Mississippi. Photo courtesy of Jeanne C. Jones, Mississippi State University

Harrell Hill Prairie in the Bienville National Forest of east-central Mississippi is a rare undisturbed native prairie of the Jackson Prairie Belt. Photo courtesy of Heather Sullivan, Mississippi Museum of Natural Science

Today very few tallgrass prairies remain over their historic range. Most of Mississippi's prairies were converted to agriculture by the late 1800s, leaving small remnants of prairies, woodland savannas, and chalk outcrops, with many of the outcrops highly eroded. Cotton-based agriculture dominated the Black Belt from 1850 until early 1900, leaving behind a mixture of pastures, old fields, and forest fragments along streams. Today, less than 1 percent of the original prairies exist in Mississippi, and most prairie remnants range in size from less than 1 to 130 acres. Most prairies that remain today are on public lands, such as U.S. Forest Service or refuge lands. A few prairie remnants may be found along unmaintained roadsides, in old cemeteries maintained by occasional prescribed fire or mowing, and on private lands in fallow fields, meadows, or unimproved pastures.

HISTORICAL CULTURES AND BIOLOGICAL COMMUNITIES

Archaeological evidence suggests that a diversity of habitats occurred within Mississippi's Blackland Prairie region. The interspersion of openings dominated by herbaceous grasses and other plants, savannas with scattered trees and shrubs, and hardwood and pine–hardwood forests created attractive wildlife habitat for many native animals. Open prairies supported reptiles, amphibians, grassland birds, and small mammals. Woodland savannas and adjacent forests sustained trees, shrubs, and vines that provided food and cover for white-tailed deer and other edge- and forest-dwelling species of wildlife. Evidence from archaeological sites indicates that the Blackland Prairie region was once inhabited by large mammals, such as bison, wolves, panthers, and black bears.

Abundant wildlife attracted indigenous people to prairies and woodland savannas. By exploring early village sites and encampments, archaeologists have found that Native Americans of the region were hunters, gatherers, and farmers. From their camps and home sites, scientists have detected animal and plant remains and artifacts left by these early people. Prior to European settlement, Native people of the Blackland Prairies hunted white-tailed deer, rabbits, beavers, and bison. Early inhabitants

also harvested large and small predators such as black bears, foxes, otters, and bobcats. Clues left in villages and encampments along streams revealed that fish, turtles, and freshwater mussels were consumed and remnants were utilized for daily items. They also used native plants for foods, building materials, tools and basketry, medicines, and spiritual rituals. Over time, Native people shaped their surroundings by clearing land for growing crops, harvesting trees for wood products, and burning grasslands and upland forests. Such activities created different stages of plant communities within the Black and Jackson Prairie Belts.

PRAIRIE PLANT COMMUNITIES

Prairies or grasslands are so named because of the dominance of warm-season perennial grasses. Prior to European settlement, native grasses were maintained by fires set by Native Americans and dry lightning strikes during drought periods. Although native grasses tolerate drought and low soil fertility, some species may reach more than 6 feet in height on fertile soils during growing seasons with abundant rainfall. The most common grasses of Mississippi' prairies were big bluestem, little bluestem, switchgrass, Indiangrass, eastern gamagrass, and broomsedge. Other grasses included sideoats grama grass, Florida paspalum, panicgrasses, giant cane or switchcane, prairie dropseed, and purpletop tridens.

Identification of Grassland Plants

Native warm-season grasses and other prairie plants can be identified with practice and user-friendly field guides. Most prairie grasses are perennial, whereas prairie wildflowers may be perennial, annual, or biennial, depending on the species.

Perennial plants sprout initially from seed, root, or rhizome structures during the first growing season and from established root systems in following growing seasons. Most prairie perennials are warm-season plants that exhibit vegetative growth, flowering, and seed production during late spring, summer, or early autumn. Perennial bunch grasses require several growing seasons to develop large root systems. After the first two growing seasons, perennial bunch grasses usually exhibit root bases and clustered aboveground leaves that remain visible even after killing frosts of winter months.

Annual plants germinate from seeds each year and do not establish root systems that overwinter. The entire life cycle is completed in one growing season. In contrast, biennial plants complete the life cycle over 2 years of growth, with many producing flowers and viable seed during their second year.

Knowledge of a plant's life habit and structural features can help landowners identify desirable plants already present on their properties and possibly avoid expenditures required to establish such plants.

Grasses

Knowledge of the unique characteristics of grasses can assist landowners in identifying both native and non-native species.

- Grass stems are round, and stem sections between solid nodes (joints along the stem) are generally hollow in cross-section.
- Linear leaves grow from stems in two major directions.
- Grasses have ligules, a vegetative structure at the base of the leaf where the leaf arises from the stem.
- Grasses lack showy petals on the flowers, with seed being highly visible on the seed head or inflorescence.

Each grass species has unique characteristics. In general, grasses can be identified during flowering or seed production based on the appearance of the inflorescence or seed head. Prior to maturation, however, the appearance of the ligule and characteristics of leaves and root systems can be used to identify grass genera. Identification is very important in monitoring the success of grassland restoration and early detection of non-native grasses on restoration sites.

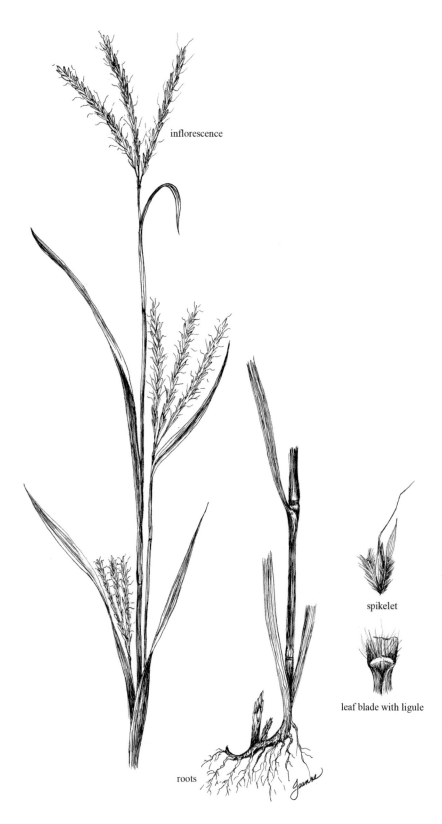

inflorescence

spikelet

leaf blade with ligule

roots

Big bluestem. Figure courtesy of Jeanne C. Jones, Mississippi State University

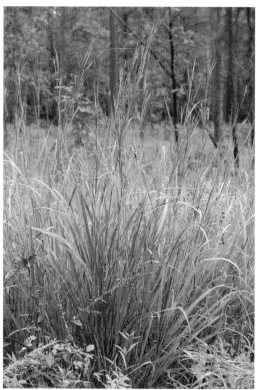

Big bluestem. Photo courtesy of Jeanne C. Jones, Mississippi State University

Native Warm-Season Grasses.

Bluestems, also known as sage grasses and beard grasses, are perennial bunch grasses that flower in late summer and autumn, when the seeds are most obvious. In general, seeds and leaves of bluestems have a furry or hairy appearance and the seeds are lightweight and spread by wind currents. The primary bluestem species of Mississippi are big, little, bushy, and slender bluestems and common broomsedge. Bluestems produce valuable nesting and escape cover for ground-nesting birds, rodents, and rabbits. Good wildlife cover is produced when bunch grasses are interspersed with bare ground. During the growing season, bunch grasses interspersed with bare ground allow easy movement of young mammals and grassland birds, such as quail chicks. When mature plants become senescent during autumn and winter months, leaves persist and fall over, producing a condition referred to as lodging. This type of cover is especially valuable for thermal and escape cover for grassland birds and mammals during winter and early spring. Seeds, stems, and leaves are eaten by some birds,

Little bluestem. Photo courtesy of Jeanne C. Jones, Mississippi State University

rodents, and many insects. Species such as big and little bluestem produce high-quality forage for livestock and American bison and are considered prairie indicator species.

Big bluestem often reaches over 6 feet in height. Bases of plants are spread by rhizomes and are tightly clustered and tufted, giving rise to broad, linear leaves that are covered by sparse to dense short hairs. Seed heads are borne at the tips of flowering stalks in two- to three-pronged arrangements of racemes that resemble a turkey's foot. Each raceme is 2 to 4 inches in length and purplish to reddish in color. Each seed has a twisted awn or hair-like structure at its tip that gives each seed head a hairy appearance. Big bluestem can be discerned from other grasses by examining the leaf base at the stem attachment point and the seed head. In big bluestem, the seed head is arranged in three-pronged racemes that appear similar to a turkey's foot. Leaves of the grass narrow slightly near the collar and widen gradually toward the leaf blade midsection. The collar and ligule of the inner leaf sheath are typically hairy and bronze in color.

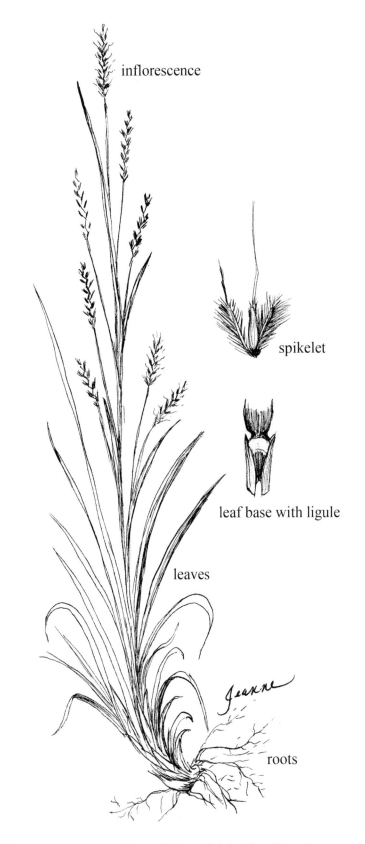

inflorescence

spikelet

leaf base with ligule

leaves

roots

Little bluestem. Figure courtesy of Jeanne C. Jones, Mississippi State University

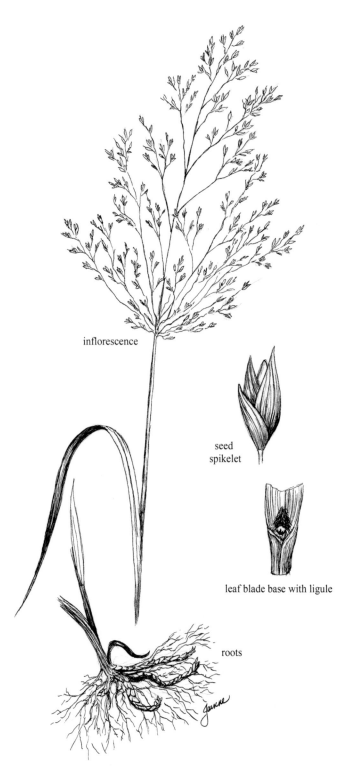

inflorescence

seed
spikelet

leaf blade base with ligule

roots

Switchgrass. Figure courtesy
of Jeanne C. Jones, Mississippi
State University

Switchgrass. Photo courtesy of Ted Bodner, U.S. Department of Agriculture PLANTS database

Big bluestem grows on a wide variety of soil types and is extremely drought-tolerant because of its deep root systems, which may reach soil depths of more than 10 feet. Its high yield and palatability to livestock make big bluestem one of the best native forage grasses in the Midwestern prairie states. In the Southeast, it is less abundant across grassland ranges, and it can be overgrazed by cattle because of its scarcity and high palatability. Cattle, which prefer this grass, may graze the plant too closely, preventing adequate seed production; therefore, plantings of big bluestem should be protected from livestock grazing during the establishment phase. After establishment, grazing should be monitored and conducted rotationally to ensure that seed production is not damaged.

Little bluestem generally grows from 2 to 4 feet in height. Stems are flattened at the base and arise in a clustered arrangement from the rootstock. Leaves and stems are reddish to purple during early growth, deepening to reddish brown with maturation. Seeds are borne in spikes along the flowering stalk. Whitish hairs that cover and surround the seeds give a fluffy appearance to the seed heads.

Little bluestem can grow on a variety of soil types and produces quality cover for wildlife.

Indiangrass. Photo courtesy of Nancy Staunton, U.S. Department of Agriculture PLANTS database

inflorescence

spikelet

leaf base with ligule

leaf base, collar

Plantings of little bluestem are very compatible with prairie legume and forb establishment. This grass has great potential for landscaping and erosion control plantings on low-fertility, drought-susceptible soils. It is a primary species targeted for establishment in native grassland restoration in Mississippi.

Switchgrass is a large perennial panicgrass that ranges from 3 to 6 feet in height. Taller, vigorous plants are common in moist fertile soils, whereas shorter and less-robust plants tend to grow on dry, less fertile soils. Because plants spread by numerous scaly rhizomes or underground roots, switchgrass often forms large, dense colonies over time. Plants are generally hairless except for on the ligule, which has dense clusters of short, whitish hairs. Switchgrass begins active growth during the warm spring months and produces abundant growth and flowers during early summer. By late summer, elliptical husk-covered seeds are borne on open seed heads (called panicles), which range from 0.5 to 1.5 feet in length. Seed are often retained on the seed head through autumn. Panicles persist on the flower stalk through winter and the following growing season, providing a useful identification trait through much of the year.

Indiangrass. Figure courtesy of Jeanne C. Jones, Mississippi State University

leaf

inflorescence

spikelet

seed

leaf base
with ligule

leaf base
with roots

Eastern gamagrass. Figure
courtesy of Jeanne C. Jones,
Mississippi State University

Eastern gamagrass. Photo courtesy of Jeanne C. Jones,
Mississippi State University

Indiangrass.

This perennial grass grows from deep under-
ground root systems and typically ranges from
4 to 7 feet in height. Leaf blades range from
10 to 24 inches and are flattened and narrow
at their base. A diagnostic feature of this grass
prior to flowering is the ligule, which resembles
rabbit ears because of the notched center and
its horn-like projections on each side. Plants
generally begin flowering in late summer, and
golden seed heads become apparent on plants
during autumn. Seeds are tan to golden, with
bristle-like awns. Awns on the seed make seed
heads appear fluffy.

Indiangrass grows in many soil types and
textures and is moderately salt- and drought-
tolerant. Although most common in prairies,
Indiangrass may also be found in bottomlands
and open woodlands.

Eastern Gamagrass.

Also called joint grass, this stout bunch grass
may reach 6 to 8 feet in height. Flattened,
smooth leaves arise from thickly jointed

Switchgrass is one of the most attractive na-
tive grasses, especially during autumn, when its
leaves exhibit curved, amber-colored growth.
Because of its value as a wildlife food and cover
plant, switchgrass is used for field border plant-
ings, erosion control filter strips, and wildlife
habitat enhancement. Of the native prairie
grasses, it is the most shade-tolerant and grows
readily under open forest cover.

Black-eyed Susans, purple coneflowers, and various species of asters are important plants for pollinators throughout the later summer months in Mississippi. Photos courtesy of iStock

Eastern red cedar and Chickasaw plum are important tree species in native grasslands across the South. Photos courtesy of Paul Wray, Iowa State University, Bugwood.org

rhizomes that grow from a centralized base called a stool. Over time, the stool may exceed 4 feet in diameter, and the center portion will lack stems and leaves. Gamagrass exhibits most growth in spring and early summer but remains green until late autumn. Seeds are produced from midsummer through early autumn. The seed heads occur as two to three spikes at the end of stems or in leaf axils (the point where the leaf meets the stem). Seed heads are 4 to 6 inches long and exhibit a jointed appearance because of the overlap of seed structures along the spike. Individual seeds are green and resemble corn kernels in shape.

Gamagrass grows best on moist but well-drained fertile soils, and it does not tolerate standing water for extended periods. Many of the seeds produced by gamagrass are not viable, and this plant may reproduce and spread primarily through rhizomes. Because of this method of reproduction and its palatability to cattle, gamagrass is easily eliminated by continuous grazing. Gamagrass is excellent forage for livestock and American bison and is often planted for native pasture or hay crops.

Forbs and Legumes

At least a third of plants growing in prairies are forbs and legumes. These plants typically have broader leaves than those of grasses. With their showy, attractive flowers, most are classified as wildflowers. Many broadleaf plants of the prairie are in the sunflower, pea, mint, and milkweed families. Plants of the sunflower family may comprise a major portion of prairie wildflower communities and include compass plant, blazing star, coneflowers, native sunflowers, black-eyed Susan, goldenrod, bonesets, daisy fleabane, and asters. Many forb and legume species produce important food for native animals including pollen, nectar, seed, and forage. Some species, such as sunflowers, produce seeds that are consumed by birds and rodents. Milkweeds are important host plants for larvae of moths and butterflies.

Native legumes of the pea family are among the most important plants in grassland ecosystems. They are adapted to fire and enhance soil fertility through nitrogen fixation via bacterial associations in their root systems. Most legumes produce palatable and nutritious foliage, flowers, and seed for many animals, including quail, turkey, rabbits, deer, rodents, and insects. Insects attracted to legumes attract insectivorous animals such as turkeys, quail, and nongame birds. Legumes that have high value to wildlife include native lespedezas, beggar lice, partridge pea, and native clovers.

Woody Plants

The incidence of fire influences how much woody understory and midstory occur in prairies and

forest savannas. Historically, woodland savannas of the Blackland Prairie region exhibited open stands of Osage orange, Carolina buckthorn, sugarberry and hackberry, ashes, eastern red cedar, persimmon, hickories, and blackjack, post, and Durand oaks. Blackland Prairie patches were typically surrounded by hardwood forests dominated by hickory and oaks, whereas upland forests adjacent to Jackson Prairie patches were comprised of hardwoods and pine. Common shrubs and woody vines of prairies include wild plum, buckthorn, hawthorn, sumac, rattan vine, native honeysuckle, wild grape, blackberry, dewberry, and green briar. Areas where streams and rivers transect grasslands are conducive to bottomland hardwood forests of oak, pecan, and hickory as well as forested wetlands of bald cypress and tupelo gum. Many of these plants produce nuts or fruit that are of high food value for many species of wildlife.

PRAIRIE ANIMAL COMMUNITIES

The habitat diversity in prairie landscapes attracts a wide range of animals that depend on a mixture of forest, forest edge, and meadow habitats. Animal inhabitants also shaped these communities by feeding on plants, dispersing seed and plant parts, and pollinating flowers. This reciprocal relationship creates a biologically rich ecosystem that supports thousands of species in Mississippi.

Insects and Other Invertebrates

The abundance of flowering plants in prairies attracts a variety of insects. Of the groups studied thus far, Mississippi's prairies support more than 950 species of grasshoppers, ants, and moths. Some insect species are rare and found in isolated populations of Alabama and Mississippi's prairies, with the nearest other locations of known occurrences being in the prairies of Oklahoma, Texas, and Kansas. At least one species of beetle and moth are found in only one place in the world: the remnants of Black Belt Prairie in Mississippi and Alabama. Other

Gulf fritillary butterflies and crayfish are common invertebrates of native grasslands. Photos courtesy of iStock (butterfly); Burrow-Chazz Hesselein, Alabama Cooperative Extension System, Bugwood.org (crayfish)

invertebrates that inhabit Mississippi's prairies include many different types of butterflies, spiders, snails, and crayfish.

Many insects are showy, colorful, and obvious to us. However, others may go undetected, living underground or inside parts of plants. All insects play important roles in plant pollination, recycling of nutrients, and as food sources for insect-eating animals such as bats, birds, and toads.

Spring peepers can be heard in low-lying grasslands and wetlands, whereas the five-lined skink can be commonly found along upland fence rows. Photos courtesy of iStock (spring peeper); Rebekah D. Wallace, University of Georgia, Bugwood.org (five-lined skink)

Eastern meadowlarks and American kestrels are both commonly found in grasslands throughout the Southeast. Photos courtesy of iStock

Amphibians and Reptiles

During high rainfall periods, prairie wetlands often resonate with the calls of breeding frogs and toads. In woodland savannas, temporary wetlands may be inhabited by salamanders. Prairies and woodland savannas are also important habitats for reptiles. Open canopy conditions typically create ample sunlight, which stimulates abundant food sources, basking areas, and ideal nesting sites for egg incubation. Mississippi's prairies are inhabited by box turtles, at least seven species of lizards, and venomous and

nonvenomous snakes including pigmy rattlesnakes, black racers, and coachwhips.

Birds

Grasslands and woodland savannas provide habitat for game and nongame bird species. Because native grasslands are now rare across the southeastern United States, many grassland birds such as quail and native sparrows have experienced population declines. The birds of Mississippi's prairies include resident and migratory species. Resident and Neotropical

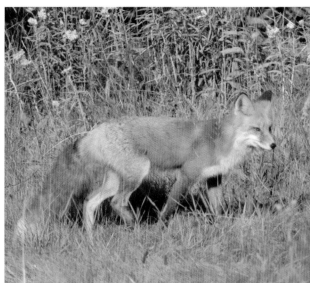

migrant birds may nest and rear young in prairies, whereas some migratory species may overwinter or stop over during migration. In the course of a year, more than seventy-five resident and migratory bird species depend on Mississippi's prairies and prairie woodlands.

Mammals

The most abundant large mammal of Mississippi's prairies is white-tailed deer. Other mammal inhabitants include cottontail rabbits and swamp rabbits, rodents (voles, rats, and mice), bats, moles, shrews, weasels, and midsized mammals such as red and gray foxes, coyotes, bobcats, skunks, raccoons, and opossums. Streams support river otters, mink, and American beavers, among others.

GRASSLAND RESTORATION

Many landowners participate in grassland restoration because of their interest in conserving native wildlife and plants and/or recreational uses, such as hunting and wildlife watching. Others may want to convert pastures dominated by agronomic grass cover to native warmseason grasses for grazing and native grass hay production.

Restoration of grasslands can be done on a large scale, in which entire fields are restored, or on smaller strips of land. Regardless of the specific goals or size of the restoration area, successful restoration and management of native grasslands can yield many benefits if planned and implemented properly.

Key Steps in Restoration Planning

The first step is to identify the primary goals for the land. Decisions concerning the purpose of the proposed restoration area will determine other management decisions. Common restoration goals include native grasslands for wildlife use, native plant conservation and wildflower areas for insects, backyard and urban wildlife habitat enhancement, grass buffers to protect erodible lands and adjacent watersheds, warm-season livestock forage production (including hay operations), and biofuel production (switchgrass).

Landowners can obtain assistance with developing a grassland restoration and management plan from agencies such as the Mississippi Department of Wildlife, Fisheries and Parks; U.S. Department of Agriculture's Natural Resources Conservation Service; Cooperative Extension Services of Mississippi State University and Alcorn State University; and nonprofit organizations including Wildlife Mississippi, Delta Wildlife, Quail Unlimited, Quail Forever, and the National Wildlife Federation.

Grasslands and field edges attract both prey and predator species, such as eastern cottontail rabbits and red foxes. Photos courtesy of iStock

Whether used for soil erosion control, forage production or wildlife habitat, native grasslands can be cost-effective, sustainable areas that benefit owners of small and large properties. Photos courtesy of John Gruchy, Mississippi Department of Wildlife, Fisheries, and Parks (buffer strips); Adam T. Rohnke, Mississippi State University (pasture and wildlife habitat)

When restoration goals have been established, a management plan should be developed. Key elements include:

- methods of restoration (including site preparation),
- competitive vegetation control,
- seed selection,
- vegetation management (such as prescribed burning), and
- associated scheduling of these activities for reaching targeted goals.

Evaluation of the proposed restoration site will provide crucial information such as condition and contour of the land (that is, soil characteristics), existing plant community, and infrastructural requirements including fencing (if the intended use is grazing) and fire lanes. Establishing these three parameters will influence the site preparation, species composition, and seeding rates of seed mixtures, as well as post-planting management activities.

Selecting the mixture of prairie plants to establish is a crucial step in setting the stage for the future management activities on the restoration area. For example, if the goal of restoring native grasses is to provide hay or forage crops for livestock or vegetation cover for erosion control, the land manager would generally select native perennial grasses seeded at high rates to provide dense grass stands and good ground coverage. If creating good wildlife habitat or restoration of prairie plant diversity is the goal, a mixture of prairie grasses, forbs, and legumes at reduced seeding rates is more appropriate.

Finally, ongoing habitat management is needed to maintain optimal habitat conditions for prairie plants and grassland wildlife. Management goals established in the planning stages will dictate future actions needed to maintain high-quality prairie habitats. Routine evaluations of the plant community will direct management activities such as prescribed

Purpose	Prairie species	Seeding rate (pure live seed/acre)	Objectives and considerations
Wildlife habitat, tall grass	big bluestem	1 pound	Nesting cover for quail, turkey, and grassland songbirds. Winter cover for quail, rabbits, and many small mammals. Escape cover for rabbits, especially near woodland edges and thickets. Legumes and forbs provide forage, seed, nectar, and pollen for insects and other animals.
	Indiangrass	½ pound	
	little bluestem	2 pounds	
	switchgrass	½ pound	
	native forbs	½ to 1 pound	
	native legumes	½ to 1 pound	
Wildlife habitat, short grass	little bluestem	3 pounds	Nesting and brood cover for quail, turkey, and other ground-nesting birds. Spring display grounds for woodcock. Brood cover for young turkey and quail. Escape and foraging cover for rabbits and rodents. Seed, forage, pollen, and nectar attract insects, seed-eating birds, deer, rabbits, and small rodents.
	sideoats grama grass [a]	1 pound	
	Indiangrass	½ pound	
	native forbs	½ to 1 pound	
	native legumes	½ to 1 pound	
Forage	big bluestem	3½ pounds	Graze on rotation only; avoid clipping during April, May, or June because of ground-nesting wildlife. Cut hay after nesting season for quail and turkey (July, August, and September).
	Indiangrass	3½ pounds	
	little bluestem	3 pounds	
Forage or filter strip	switchgrass	8 to 10 pounds	Buy cold-stratified seed or wet-chill seed before planting. Cover for rabbits, rodents, and some birds.
Forage	Eastern gamagrass	10 to 12 pounds	Buy cold-stratified seed and plant with a corn planter.

Table 5.1. Grassland seed mixtures for wildlife habitat and forage production

[a] Highly adapted to dry sites.
Seeding rates adapted from Harper, C. A., G. E. Bates, M. J. Gudlin, and M. P. Hansbrough. 2004. *A Landowner's Guide to Native Warm-Season Grasses in the Mid-South.* Publication 1746, University of Tennessee Extension Service.

burning, disking, herbicide application, and monitoring and control of non-native plants.

Establishing Native Grasslands

Approaches used to establish native grassland plants will depend on the existing plant community and habitat conditions on the property. Several habitat types may exist, depending on the type, intensity, and duration of past land uses and physical characteristics of the land (such as soil types and moisture gradients).

Rehabilitating Fallow Fields.
In cases where roadsides, fields, or pastures have gone fallow, landowners may find that many desirable native plants are already present. In these cases, prescribed fire and selective

control of undesirable plants may be used to encourage existing native plant communities. Desirable plants should generally be protected from herbicide application if possible. In some cases, undesirable vegetation may be selectively controlled with herbicides through timing of application, limited spot treatments to specific areas, or type of active ingredient to minimize injury to desirable vegetation. Soil tillage and mowing of desired annual plants such as partridge pea should be conducted following seed maturation in late autumn or winter.

In areas where undesirable non-native plants exist and desired native plants are mostly absent, control of unwanted plants and seedbed preparation will be necessary to establish native plant communities. Control of unwanted plants—especially invasive, non-native plants—should be conducted by applying appropriate herbicides and then monitoring after treatment.

Seedbed preparation may vary depending on existing vegetation cover. In many cases, prescribed burning can prepare a site for seeding of native plants directly onto or into the soil. For expensive propagules or seeds, landowners may prefer to shallow disk the soil following burning to create more bare soil surface. Care should be taken to avoid deep coverage of seed if disking is employed. Of all possible scenarios, sites with existing remnants of native plants will generally be the easiest in which to restore and maintain prairie plant communities.

Restoration of Agricultural Lands.

In the majority of cases, past land use has led to a dominance of non-native grasses, non-native forbs, and resilient native plants that are common to fallow fields. If these conditions exist, restoration will involve control of undesirable vegetation, seedbed preparation, and planting of desired native plants. Former croplands will require control of undesirable vegetation (such as competing broadleaf plants and grasses) through application of pre-emergent herbicide prior to seeding native warm-season grasses in the spring.

Control of Vegetative Competition

The high soil fertility and good climate conditions in Mississippi have allowed many areas where native grassland once existed to be converted to stands of non-native grasses for livestock forage or soil stabilization. Introduced because of their hardiness and tendency to establish dense ground cover, these non-native grasses limit wildlife habitat quality and impede successful restoration of native plants. In addition, human-created disturbance, such as soil tillage and compaction, may increase the spread of non-native plants that reduce native plant diversity and degrade wildlife habitat. Elimination of existing non-native grasses and invasive plants is important for successful restoration.

Non-Native Cool-Season Grasses.

Cool-season perennial grasses were originally established for erosion control, livestock forage and hay production, or wildlife food plots. Most species have become naturalized and have spread beyond the area of original introduction. In Mississippi, the most common and troublesome of the introduced cool-season grasses is tall fescue. This species has limited value for wildlife and causes toxicity problems for wildlife and livestock. In addition to low wildlife forage value, many non-native cool-season grasses develop dense ground coverage and thatch or litter at the ground's surface, a condition that is undesirable for ground-nesting wildlife like quail and turkey.

Cool-season grasses reduce the planting success of native species through reduction of seed germination because of the thick thatch layer and direct competition for growing space, moisture, and nutrients. Some species, including tall fescue, are allelopathic; that is, they produce toxic chemicals that restrict the growth of other plants. Therefore, effective control of these grasses should be accomplished before planting native plants.

Herbicide treatments should be applied during autumn or early spring, when cool-season grasses are actively growing (see chapter 17). Before sod is sprayed in spring, cool-season grasses should be burned, mowed, grazed, or hayed, and allowed to regrow 6 to 10 inches in height. Application to actively growing plants increases the rate of herbicide transport throughout the plant.

Non-Native Warm-Season Grasses.

With the killing of cool-season grasses, warm spring months will probably reveal an increased germination and emergence of warm-season species such as Johnsongrass, Bermudagrass, bahiagrass, vasey grass, and dallis grass. Originally introduced for hay production, livestock grazing, and soil stabilization, many of these non-native species have spread and become naturalized. Their perennial growth habit and tendency to form dense rhizomes, stolons, and aboveground growth impedes the establishment of native plants and reduces habitat quality for wildlife. Some species, such as Johnsongrass, are allelopathic.

For control of Johnsongrass, bahiagrass, and broadleaf forbs, including giant goldenrod, cocklebur, and giant ragweed, a combination of foliar (application of herbicide to actively growing portion of plant) and pre-emergent (herbicide is activated in the soil) products may be needed to reduce competition prior to planting and for several weeks afterward. Disking through patches of Johnsongrass should be avoided, because it divides the root system into many nodes that sprout into new plants, thus encouraging the spread and increased density of aboveground growth. Instead, Johnsongrass should be controlled using herbicide before disking or tillage is conducted.

Bermudagrass is one of the most difficult warm-season grasses to control. Although use of imazapyr-based herbicides can eventually eliminate Bermudagrass, control does not usually occur with a single spraying. Multiple applications over at least two growing seasons is usually required. Thus, control measures should be initiated at least 2 years prior to planting native grasses.

When controlling Bermudagrass or other non-native grasses in sites where native forbs

(Left) Tall fescue. Photo courtesy of James H. Miller and Ted Bodner, Southern Weed Science Society, Bugwood.org

(Right) Johnsongrass. Photo courtesy of Chris Evans, River to River Cooperative Weed Management Area, Bugwood.org

Bermudagrass. Photo courtesy of David J. Moorhead, University of Georgia, Bugwood.org

Typical progression of a native warm-season grass after planting in the Southeast. This field was planted in May 2005. By August 2006, it was well established and ready for management, including prescribed burning and disking on a multiple-year rotation. Photos courtesy of Craig A. Harper, University of Tennessee

Table 5.2. Primary reasons for grassland restoration failures	
Reasons for failure	**Recommendations**
Seed are planted too deeply in soil: Seed of bluestems, Indiangrass, switchgrass, and sideoats grama grass, some wildflowers, and legumes should not be planted deeper than ¼ inch.	Drill plant or cover seed no deeper than ¼ inch. Seed of many prairie plants can be spread onto the soil surface and then packed with a cultipacker to press them into the soil surface.
Inadequate control of competing vegetation: Existing sod and non-native grasses must be killed prior to planting. Non-native plants as well as high densities of some native plants, including trees and shrubs, can hamper success. After planting, reoccurrence of non-native grasses can limit prairie plant establishment.	Follow prescriptions to eliminate competing vegetation prior to planting (may take up to 2 years). If non-native invasive plants are present, this is critical. Monitoring site for reoccurrence of non-native grasses and other undesirable plants following planting and timely control of competing vegetation is essential.
Inappropriate use of herbicide: Applying too much pre-emergent herbicide or applying herbicides at the incorrect time can result in injury or death to seedlings.	Calibrate sprayer or other method of herbicide delivery to apply correct rate. Use appropriate rate of herbicide and active ingredient at the proper time (consult a professional if uncertain).
Planting seed or propagules too late in the growing season: Later planting dates limit the amount of time for young plants to become established before the dry and hot soil conditions of late summer arrive. Thus, young plants enter these stressful periods of low moisture availability with limited root development and less potential for survival.	Plant according to planting date recommendations. For most warm-season species, planting from mid-April through early June is recommended. Seed of native lespedezas and partridge pea can be planted as early as March.
Incorrect seeding rate: Pure live seed (PLS) not estimated properly; seeder or drill not calibrated properly prior to planting.	Calculate PLS from information on the product label; make sure drill or seeder is calibrated properly before planting.
Underestimating time for establishment: First year's growth of perennial grasses, forbs, and legumes may appear sparse. These plants put energy into developing strong root systems during the first year. Expect a sparse stand of the perennials with more coverage and flowering by annual plants like partridge pea. Perennials need the rootstocks from which they will develop vigorous aboveground growth, flowering, and seed production by year 2 or 3 and in successive years to come.	Learn what your grassland should look like the first and second growing season following planting. Have patience and learn to read your grasslands by inspection and study. Monitor your fields by walking and looking; always be on the lookout for invasive non-native plants, reoccurring non-native grasses, and an overabundance of native plants that may outcompete your desired seeded plants. Control these competing plants selectively in a timely manner to give your prairie plants the competitive advantage.

Adapted from Harper, C. A., G. E. Bates, M. J. Gudlin, and M. P. Hansbrough. 2004. *A Landowner's Guide to Native Warm Season Grasses in the Mid-South.* Publication1746, University of Tennessee Extension Service.

and legumes have been planted, land managers should use appropriate herbicides and carefully follow their label specifications. Because these herbicides will also kill native grasses, selective or spot spraying is recommended to avoid damage to desired native grasses, forbs, and legumes.

In addition to non-native invasive grasses, landowners may encounter other invasive plants such as cogongrass on their properties. Learning how to recognize these plants is a fundamental step toward implementing control measures quickly (see chapter 17 for identification and control recommendations).

Timeline of Grassland Establishment

Establishing most native perennial plants generally requires 2 years or more for root growth, vigorous vegetative growth, flowering, and seed production. Therefore, a basic understanding of the growth phases of perennial plants is important.

Following planting, perennials develop extensive roots that will feed aboveground plants in future years. Most of the plant's energy during the first growing season is directed into root development. This condition combined with sometimes high seed dormancy rates in warm-season grasses may yield sparse stands during the first growing season.

During the second year, plants will resprout from the roots that were established during the first growing season. At this time plants exhibit more vigorous growth and begin to develop aboveground leaves and stems. In subsequent years, plants will typically produce flowers and seed heads and exhibit more dense aboveground growth.

Setbacks and Failure

Restoration efforts can be unsuccessful if specific steps are not taken before and during the establishment period. Reasons for failure can vary and be related to local site conditions, particularly rainfall, but the most common reasons include planting seed too deeply (greater than ¼ inch), inadequate control of competing vegetation, and planting too late in the growing season. Using too much pre-emergent herbicide can also result in a planting failure. Therefore, it is important to properly calibrate the equipment used for herbicide application. Furthermore, soils that are drier and lower in organic matter typically require lower rates of pre-emergent herbicides.

Soil Amendments

Although many native plants are adapted to a wide variety of nutrient and soil pH levels, soil testing is recommended to determine soil quality conditions on the restoration site. Collection of soil samples is recommended from winter to early spring. Soil sample analyses provide specific nutrient application rates for desired plants. Thus, soil testing is a very cost-effective component of determining soil amendment needs and rates that are specific to the restoration site (see chapter 3 for more information). Although soil amendments may be added to enhance plant growth for hay or forage production, fertilizers are typically not necessary when grasslands are

established for wildlife habitat. This is especially true for legumes. Landowners can enhance nitrogen fixation in legumes by applying inoculum, a powdered additive that has the bacterial mixture needed for nitrogen fixation. Supplemental nitrogen is generally not recommended during the year of establishment for native warm-season grasses because added nitrogen enhances growth of competing vegetation.

Because most prairie and Delta soils are alkaline, lime applications are generally not needed. Soil pH levels generally range from 6.5 to 8.0 in the Black Belt region, and most prairie plants are best adapted to this pH range. However, collection and analysis of soil samples are recommended to assess soil amendment needs of specific locations.

Seedbed Preparation

In areas infested with non-native plants, the seedbed should be prepared after herbicide application and before planting. The type of seedbed preparation will depend on planting mixtures and method of planting. If seed is to be drilled, a firm seedbed free of heavy debris or dense brush is required. Grass drills can plant into dead grass, but if heavy thatch is present, the area should be burned prior to planting if possible. This cleans up debris and allows better pre-emergent herbicide contact with the soil. If existing vegetation is sparse, no preparation may be needed other than an herbicide application prior to or right after planting. If seeds are to be sown over the soil surface (broadcast seeding), the seedbed should be prepared by conventional tillage methods. If addition of fertilizers or lime is necessary, application should be conducted prior to seedbed preparation to incorporate amendments into the soil layers.

Seed and Propagules

If native plants are rare or absent at the site, experts recommend planting seed or vegetative propagules (rootstocks, corms, or rootings). Although propagules promote more rapid establishment, seeding is the most economical approach, especially on restoration sites larger than ¼ acre. Because propagules are more expensive

Common name	Scientific name	Cultivars [a]
Big bluestem	*Andropogon gerardii*	**Kaw**, **Earl**, Pawnee, Rountree
Little bluestem	*Schizachyrium scoparium*	**Aldous**, Cimmaron, Camper, Blaze
Broomsedge	*Andropogon virginicus*	Seed availability may be limited; readily colonizes most sites in Mississippi naturally
Indiangrass	*Sorghastrum nutans*	**Lometa**, **Osage**, Americus, Cheyenne, **Rumsey**
Switchgrass	*Panicum virgatum*	**Blackwell**, **Alamo**, Pathfinder
Eastern gamagrass	*Tripsacum dactyloides*	**Highlander**, Iuka, **Pete**
Sideoats grama grass	*Bouteloua curtipendula*	Haskell, Trailway, Butte

Table 5.3. Recommended native warm-season grasses for Mississippi

[a] Cultivars shown in bold have proven performance at sites in Mississippi. Other varieties or cultivars may be available. In general, when purchasing seed, request eastern varieties or cultivars if available.

than seed, landowners may establish wildflowers by planting a small source population initially and managing them over time to enhance spreading over the restoration area.

If restoration involves use of seed or propagules, these items should be ordered several months in advance of the desired planting dates. Also, it is advisable to contact commercial

Calculating Seeding Rate

The amount of seed that should be planted per acre is calculated using the percentage of pure seed and total germination, as shown in this example of a seed package label.

Pure Live Seed (PLS)
Seed: Indiangrass

Pure Seed:	Germination:
67.62%	64.00%
Other crops:	Firm/Dormant:
0.05%	22.00%
Weed seed:	Total Germination:
0.42%	86.00%
Inert:	Noxious Weeds:
26.23%	0.00%
Origin:	Test Date:
Texas	23 December 2012

The label indicates that the pure seed rate is 67.62% and the total germination rate is 86.00%. With these percentages, you can estimate the amount of bulk seed to plant to achieve the desired pure live seed (PLS) planting rate, as follows:

67.62% (pure seed) × 86.00% (total germination) ÷ 100% = 58.15% PLS

To achieve 6 pounds PLS per acre, the seeding rate is calculated as follows:

6 pounds PLS/acre ÷ 58.15 (PLS) × 100 = 10.3 pounds/acre

Therefore, approximately 10 pounds of bulk material from the seed bag should be seeded per acre to apply 6 pounds of pure live seed that will germinate.

Adapted from Harper, C. A., G. E. Bates, M. J. Gudlin, and M. P. Hansbrough. 2004. *A Landowner's Guide to Native Warm-Season Grasses in the Mid-South*. Publication 1746. University of Tennessee Extension Service.

sources well before planting season to determine the availability of seed when drafting your planting plan. When feasible, obtain seed collected from varieties that grow naturally or perform well in the Gulf coastal plain of the Southeast.

Obtaining Seed from Commercial Sources.
Native plant seeds and propagules may often be available from cooperating governmental agencies and organizations. In addition, contacts for seed companies can be found from Internet sources. However, always use reputable vendors because quality seed is important to successful restoration. When purchasing seed, consider the following criteria:

• Seed purity is related to the actual amount of seed that produce the desired plants and is usually included on package labeling or in seed catalogues. Seed purity of native warm-season grasses is typically 50 to 70 percent and higher for legumes and forbs. The remaining 30 to 50 percent includes materials that will not germinate, such as stems, leaves, and other plant debris (inert material).
• The actual amount of seed that will germinate is called pure live seed (PLS), which can be calculated from information provided on the seed packaging. Seed germination rates may be as low as 50 to 60 percent of the total weight purchased, and amounts of seed mixtures used should be adjusted accordingly to achieve the desired density of seeded plants.
• Seed mixtures should come with a guarantee against the presence of invasive plant species or noxious weeds.

Treatment and Storage of Seeds and Propagules.
Prior to planting, seed should be stored in a cool dry place free of rodent and insect pests. In Mississippi, condensation may occur on concrete floors, and moisture can wick into seed bags placed on concrete and dirt floors. To avoid moisture damage, seed bags should be placed on slats that allow ventilation. A vapor barrier of plastic is also recommended between the floor and slats.

Despite proper storage of viable seed, many plant species (such as switchgrass, eastern gamagrass, and partridge pea) exhibit high seed dormancy rates or delayed germination. Therefore, using scarified seed is recommended to maximize germination during the first growing season. As a cost-saving measure, naturally scarified seed can be generated by seeding legumes into existing grass and applying a prescribed fire.

Like seeds, propagules should be stored in a cool dry place away from direct sunlight, unless otherwise specified by product labeling. Because living plant propagules are more sensitive to extreme light, moisture, and temperature conditions, they should be planted as soon as possible.

Collection of Local Seeds and Propagules.
Collection of seed or propagules from local donor sites may be possible for planting on smaller areas, such as strips along roadsides and driveways or small patches in landscaped areas or fallow fields. However, note that collection of native plants is illegal on public lands, roadside rights-of-way, and private lands without consent of the landowner or managing agency.

Planting Dates and Methods

Planting native plants, especially prairie species, during the proper periods is essential for successful establishment. Warm-season grasses should be seeded from March through early June. Although later plantings can result in successful establishment, germination and growth of the plants may be reduced if higher soil temperatures, low soil moisture, and poor root development are factors.

For greater efficiency during top-sown or drill planting, most forbs and legumes can be planted in seed mixtures with warm-season grasses. Regardless of the planting method, seed should not be covered or planted deeper than ¼ inch, with the exception of eastern gamagrass seeds, which should be planted 1 inch deep.

Drilling.
Drilling is usually the preferred method for planting warm-season grasses. Using a drill creates a solid continuous stand and is preferred if

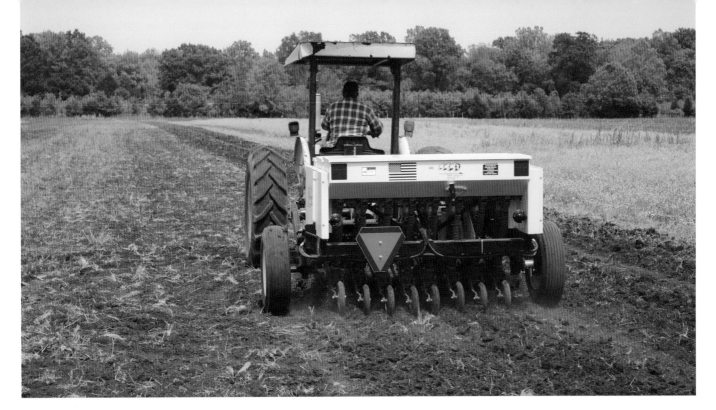

A farmer using a native warm-season grass drill to plant a buffer strip around his production fields. Photo courtesy of Wildlife Mississippi

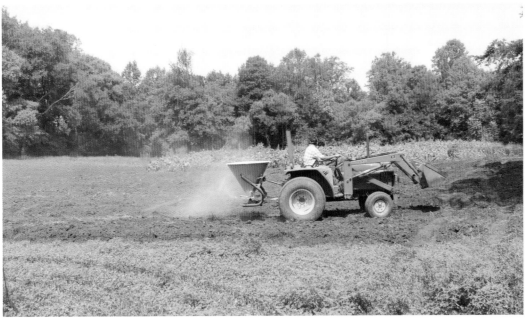

A broadcast seeder. Photo courtesy of John Gruchy, Mississippi Department of Wildlife, Fisheries, and Parks

grasses are being established for hay or forage production. Switchgrass can be planted with conventional drills, but specialized drills are required for seeding the fluffy, lightweight seed of bluestems and Indiangrass. These drills are equipped with a specialized seed box containing an agitator and picker wheels that extract the seeds, preventing them from lodging in the seed chute. All drills must be cleaned and calibrated (follow drill manufacturer's instructions for proper calibration) prior to use to ensure that seed is applied at the appropriate rate. Drills may be available for use through county

cooperatives and agencies such as the Soil and Water Conservation District. Seed of eastern gamagrass is usually planted with a corn planter in rows spaced 18 to 24 inches apart. This spacing creates a more erect growth form and is used when gamagrass is planted for hay production.

Broadcast Seeding.
Grasslands established for wildlife can be planted by broadcast application of seed using a hand-held (cyclone) or tractor-mounted seeder. Switchgrass, partridge pea, native lespedezas, and sunflowers can all be

Table 5.4. Habitat management for featured wildlife in Mississippi grasslands					
Wildlife	Percent land in grasslands	Size and arrangement of grassland	Percent land in cool-season legumes and annual grains	Percent land in mast-producing hardwoods	Percent land in thicket cover (vines, shrubs, young trees)
Northern bobwhite quail	40–80%	blocks of 2 acres or greater or strips greater than 50 feet in width	2% in firebreaks or food plots (allow to stand fallow through summer)	5–25%	10–40% (best provided in scattered patches including open forests)
Mourning dove	30–80%	blocks of 1 to 5 acres or strips of 50 feet or more in width	> 5% in firebreaks, especially annual wheat and oats	< 20%	20–50%
Wild turkey	10–30%	blocks of 2 acres or greater	2–5% in firebreaks or fields	40–75%	10–30%
Cottontail rabbit	10–80%	blocks of 1 to 5 acres or in strips of 50 feet or more in width	2% in firebreaks or food plots, especially annual clovers and vetch	10–40%	20–50%
White-tailed deer	5–30%	blocks of 2 acres or more	2–5% in firebreaks or fields, annual clovers	40–70%	20–40%
Grassland–shrub birds	30–70%	blocks of 5 acres or more or strips of 50 feet or more in width	in firebreaks only	0–25%	30–70%
Grassland birds	70–100%	blocks or fields of 100 acres or more	in firebreaks only	0	< 20%
Grassland–woodland birds	30–70%	blocks of 2 acres interspersed with blocks of woodland savanna	in firebreaks only	30–60%	20–30%
Butterflies and other insect pollinators	20–80%	blocks of 1 acre or more or strips of 30–100 feet in width preferred	2% in firebreaks, annual clovers and vetch	0	< 20%

broadcast-seeded with these conventional seeders. When planting seeds of bluestems, Indiangrass, or selected forbs (blazing star, for example), a broadcast seeder with picker wheels is preferred to spread the fluffy seed efficiently. If this type of seeder is not available, some type of carrier agent such as pelletized lime, fertilizer, cracked corn, or cottonseed hulls can be added to improve dispersal. Prior to broadcast seeding, the seedbed should be burned or disked to ensure that seed will make soil contact. Using a cultipacker or rolling the seedbed after disking may be needed to prevent seed from being buried too deeply, especially in furrows. After seeding, using a cultipacker will increase seed-to-soil contact and will improve germination rates. Disking over planted areas is not recommended because the seed could get covered too deeply.

MANAGING NATIVE GRASSLANDS FOR WILDLIFE

Prairies or native grasslands are ecosystems that depend on disturbance to maintain a dominance of native grasses, legumes, and wildflowers. Without some type of management that mimics the natural disturbances that shaped grasslands, vegetation coverage will undergo changes that produce less desirable habitat for grassland wildlife. Native warm-season grasses may become too dense for grassland wildlife, and over time woody plants will eventually outcompete herbaceous plants. Disturbance that creates open structure at ground level can enhance habitat conditions for grassland wildlife and produce the bare soil surfaces needed for seed germination of native legumes and forbs.

Habitat Management Methods

Landowners have many land management tools available to them when managing native grasslands, including prescribed fire, disking, mowing, herbicide applications, and rotational grazing. Implementation of these different methods depends on safety restrictions, access to equipment, and management objectives. Because of this complexity, landowners are encouraged to understand their options and seek professional guidance before implementing a given practice.

A slow-burning prescribed fire not only recycles nutrients back to the soil but also resets the successional stage of the grassland. Photo courtesy of Wildlife Mississippi

Mosaic burns provide several stages of grassland growth, which encourages use by many species of wildlife throughout the year. Photos courtesy of Craig A. Harper, University of Tennessee

Prescribed Fire.

The best habitat management method for prairie and other grassland restoration is prescribed fire. This practice reduces dead plant material at ground level, increases the availability of some soil nutrients, increases seed germination through seed coat scarification, stimulates sprouting and herbaceous growth, and reduces coverage of dense woody plants.

Prescribed fire can be used at different times of the year to accomplish different goals. Historically, Native Americans burned grasslands during late summer and autumn to reduce the ground layer densities of most prairie grasses and stimulate next year's coverage of legumes and wildflowers. Autumn burning allows time for seed maturation in annual plants and produces bare ground that enhances seed contact with soil. Burning at this time can also reduce woody plant cover if it is conducted before leaf fall and plant dormancy occurs. Dormant-season fires (those set in winter) reduce cover for a short duration, stimulate seed germination in native legumes, and do not disrupt reproducing wildlife. Growing-season fires set in spring and summer can enhance coverage of most prairie grasses and limit coverage of woody plants. The effects of growing-season fires on various native grasses may be influenced by climate conditions. For example, summer burning during drought years may reduce coverage of little bluestem and increase coverage of switchgrass and big bluestem.

Ground-nesting wildlife may be negatively affected by growing-season fires during spring. Therefore, burning should be conducted in mosaic or alternate strip patterns to maintain areas that have not been burned; this practice helps to promote diversity of habitat structure and avoid damage to nests and young of ground-nesting wildlife. Dormant-season or autumn burning can also negatively affect wildlife by removing thickets and other vegetation needed for escape and nesting cover. Therefore, alternate strip or mosaic burns are most desirable to retain different stages of plant succession and plant cover types across the grassland regardless of the season of burning. Mosaic burns were used as early as the 1940s by wildlife biologists,

who recommended protecting plum and blackberry thickets from burning to retain cover for quail and rabbits. Mosaic burns are also a good management technique for deer, turkey, and many nongame wildlife species.

Prescribed burning is typically needed in prairies and other grasslands every 3 to 5 years, although frequency of burning should depend on the condition of the plant community. In newly planted fields of warm-season grasses, burning may not be necessary during the first 2 years following planting. Burning should be conducted when grasses and the previous year's plant growth cover more than 70 percent of the ground surface, wildflowers and native legumes begin to decline in coverage, or woody plant coverage is beginning to exclude grasses, legumes, and forbs. Woody plants such as sumac, sweetgum, ash, and eastern baccharis will typically resprout from root systems following fire. Fire in combination with selective herbicide treatment may be necessary to reduce coverage of these woody plants.

Because burning will be conducted over time, landowners should consider establishing permanent fire lanes to restrict the movement of fire. Perimeter fire lanes can be created by disking strips of 10 to 30 feet in width. Fire lanes located within the interior of restoration sites are often used to protect thicket cover and soft and hard mast-producing trees and shrubs or to create blocks or patches that will be burned during different years. Sites targeted for fire lane creation should be inspected prior to disking to detect invasive plants that may be spread by soil disturbances (see chapter 17). To reduce soil erosion, fire lanes on a slope should be constructed so that they run horizontally with the slope contour or perpendicular to the slope direction. In addition, planting wildlife-friendly plant mixtures will provide food plants and cover while reducing erosion.

Prescribed burning requires planning and careful implementation. All prescribed burning should be conducted according to state guidelines developed by the Mississippi Forestry Commission. Planning, experience, and compliance with state regulations are necessary to accomplish prescribed burns that result in

Table 5.5. Plant mixtures and seeding rates for fire lanes	
Plant mixture	**Seeding rate (per acre)**
Warm-season annual mixture	1–2 pounds partridge pea
	5 pounds browntop millet
	10 pounds Kobe lespedeza
Warm-season annual mixture [a]	20 pounds soybeans
	15 pounds iron clay peas
	10 pounds browntop millet
	5 pounds grain sorghum
Cool-season annual mixture	25 pounds wheat or oats
	15 pounds crimson clover
	3 pounds arrowleaf clover
Cool-season perennial/annual mixture	15 pounds wheat
	10 pounds oats
	8 pounds ladino white or white Dutch clover

[a] In areas of high deer and rabbit abundance, planted beans and peas may be consumed and eliminated prior to seed production.

the least liability for managers and landowners. Therefore, landowners may choose to work with certified private contractors or state or federal agencies such as the Mississippi Forestry Commission; the Mississippi Department of Wildlife, Fisheries, and Parks; or the Natural Resources Conservation Service.

Disking.

Fire and smoke management issues may preclude burning in some areas, so disking can be used instead. Disking can set back succession, create open space at ground level, facilitate incorporation and decomposition of dead plant material, create bare soil for germination of plant seeds, and enhance coverage of annual wildlife food plants. Portions of disked areas can be seeded with legumes and forbs to increase wildlife food plants in fields dominated by warm-season grasses.

Disking during various seasons affects vegetation composition differently depending on soil conditions, climate conditions, and seed bank and plant community composition. For example, disking from late autumn through early spring will generally stimulate germination of annual plants, such as partridge pea and common ragweed, if seeds are present in the

seed bank. On areas that have good coverage of annual wildlife food plants, disking should not be conducted until seeds have matured. Spring disking can promote weeds such as Johnsongrass and sicklepod where they occur. Late summer disking may limit coverage of

A planted fire lane can serve multiple purposes, including erosion control, use as a food plot, and maintenance of the fire lane. Photo courtesy of L. Wes Burger, Mississippi State University

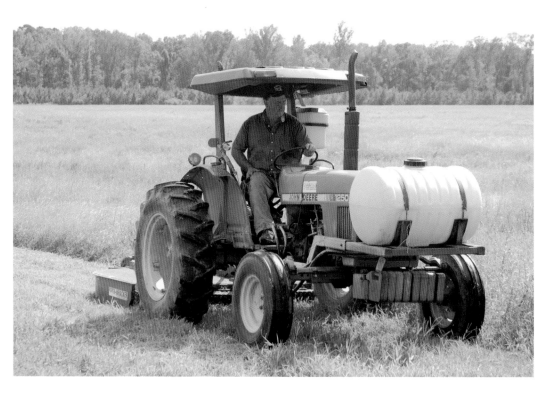

Mowing an agricultural field border. Photo courtesy of Adam T. Rohnke, Mississippi State University

perennial plants if root balls are exposed during drought periods. Because the effects are locally specific, landowners may want to experiment with disking in different seasons to determine the vegetation response. In addition, care should be taken to avoid deep disking and covering desirable seed or root systems.

As with prescribed burning, disking can be conducted in blocks or strips over several years to increase vegetation diversity by creating different successional stages. For example, a landowner can divide a field into three strips and disk each strip during a different year. By using this approach, the landowner can create interspersed strips of vegetation that are at three different successional stages. This diversity of plant communities adjacent to one another creates a greater availability of different food and cover plants in the managed area. Disked strips should be at least 50 feet in width and run with the contour of the field, in order to limit soil erosion. Because undisked strips will generally offer better escape cover, the strips that will not be disked during a particular year should be about twice as wide as disked strips. To encourage the growth of annual plants for quail and

turkey, native grassland should be disked along forest openings or near cover between October and March.

Conditions under which disking is not recommended include the presence of desired perennial wildflowers; erodible slopes or soils adjacent to a wetland, streams, or other sensitive habitats; disturbed soils with high soil acidities or toxic chemical concentrations in the subsoil or lower soil horizons; presence of chalk outcrops; or presence of invasive plants that are spread by disking (such as Johnsongrass and cogongrass).

Mowing.
Mowing of vegetation can be done in late autumn to reduce vegetation cover prior to disking or burning. However, regular mowing or clipping is *not* recommended for management of native grasslands because mowing alone increases vegetation litter layers, inhibits germination of desirable seed, and impedes movement of young game birds and other wildlife. Mowing during spring and summer destroys nests of ground-nesting animals and limits seed production in many native annual food plants.

Herbicide Applications.

Herbicides can be used to control undesirable vegetation during the establishment and management phases. Pre-emergent and foliar-contact herbicides may be used to reduce non-native plants prior to planting. After establishment, herbicide application can be important in reducing the density of perennial grasses and woody plants and eliminating non-native plants. Selective use of herbicides for targeted plants is recommended. For example, strip spraying of a grass-selective herbicide in late April can reduce grass density, create open space at ground level, and stimulate the seed bank while avoiding damage to desired forbs, legumes, and wildflowers. Spot spraying, stem application, or broadcast application can be also used, depending on the plant species targeted for control and the size of the treatment patch. Several herbicide treatments may be required for non-native grasses (see chapter 17). Because some herbicides may have residual toxic effects, selective application and lower rates are typically recommended (according to product labeling) to control problem plants and retain established native plants.

Grazing.

Rotational grazing can be used to mimic the effects of native herbivores that once inhabited prairies and other grasslands. However, newly restored grasslands should be protected from grazing by domestic livestock. Extensive research has been conducted in the Midwestern United States and research is currently ongoing in Mississippi to determine grazing regimes that can benefit native grasslands (see Harper et al. publication listed at the end of this chapter).

CONSERVATION INITIATIVES

The restoration and management of native grasslands has become a priority on many public and private lands in recent decades. On private lands, state and federal incentives and programs are available for grassland restoration, including conservation easements, tax exemptions, and cost assistance programs such as the Wildlife Habitat Incentives Program, Grassland Reserve Program, and Conservation Reserve Program. These conservation programs are intended to improve wildlife habitat; create buffers for the reduction of erosion; protect water quality by trapping sediment, chemicals, and other pollutants; and protect sensitive areas from pesticide or fertilizer runoff.

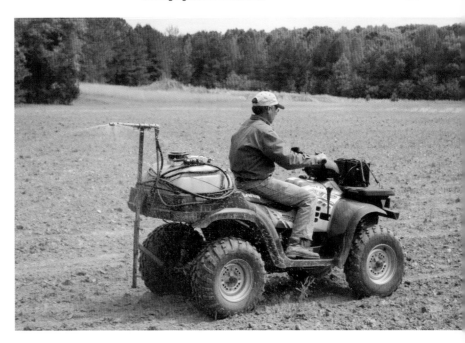

A farmer applying herbicide with an all-terrain vehicle and boom sprayer. Photo courtesy of Wildlife Mississippi

For More Information

Barone, J. A. 2005. Historical presence and distribution of prairies in the Black Belt of Mississippi and Alabama. *Castanea* 70(3):170–183.

Dickson, J. G. 2001. *Wildlife of Southern Forests: Habitat and Management.* Blaine, Wash.: Hancock House Publishers.

Grelen, H. E., and V. L. Duvall. 1966. *Common Plants of Longleaf-Bluestem Range.* Research Paper SO-23. U.S. Forest Service.

Harper, C. A., G. E. Bates, M. J. Gudlin, and M. P. Hansbrough. 2004. *A Landowner's Guide to Native Warm-Season Grasses in the Mid-South.* Publication 1746. University of Tennessee Extension Service.

Jones, J. 2007. *Restoring and Managing Native Prairies: A Handbook for Mississippi Landowners.* Mississippi State University, Wildlife Mississippi, Mississippi Land Trust, and U.S. Fish and Wildlife Service.

Peacock, E., and T. Schauwecker. 2003. *Blackland Prairies of the Gulf Coastal Plain: Nature, Culture, and Sustainability.* Tuscaloosa: University of Alabama Press.

CHAPTER 6

Woodland Management

John D. Hodges, Professor of Forestry (retired), Department of Forestry, Mississippi State University

Technical editor
Andrew J. Londo, Extension and Research Professor of Forestry (formerly), Department of Forestry, Mississippi State University

Timber is a $1 billion industry in Mississippi that supports 123,000 jobs (8.5 percent of all jobs in the state). There are 19 million acres of forest land in Mississippi, representing 68 percent of the land area. Within this forest land, 46 percent of the acreage is in hardwood, 39 percent is in pine, and 15 percent is in mixed oak and pine. Mississippi is home to 300,000 nonindustrial private forest landowners and more than 3200 certified tree farms (the top ranking in the United States). Most woodlands in the state are composed of forest stands that vary in size from a few to 100 acres or more. A stand is sufficiently uniform in age (except uneven-aged stands), composition, and site to be recognized as a separate unit.

When discussing wildlife management on forest or woodland areas, natural resource professionals often speak of the influence of forest management practices. Although important on a large scale, the real influence of forest management practices is accomplished by modifications made at the stand level. Collectively, these modifications are called silvicultural practices and include regeneration, thinning, improvement cuts, burning, and fertilization. Forest management, on the other hand, is a much broader concept, encompassing planning and scheduling for all the stands, while also taking economic and biological factors into consideration.

Silvicultural practices are tools used to modify stands to meet the objectives of the owner and are just as applicable for wildlife habitat improvement as for timber management. The basic requirements for wildlife are food, cover, water, and space. In a forested environment, silvicultural practices are used to enhance or modify one or more of these requirements and therefore improve the habitat for selected species.

Longleaf pine stand. Photo courtesy of Randy Browning, U.S. Fish and Wildlife Service and Wildlife Mississippi

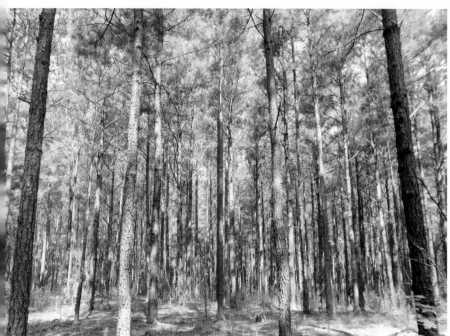

Both hardwoods and pine (natural or pine plantations) can provide wildlife habitat when managed correctly. Photos courtesy of David J. Moorehead, University of Georgia, Bugwood.org (hardwood forest); David Stephens, Bugwood.org (pine forest)

Pileated woodpeckers are primary cavity nesters. The cavities they create are often used by other forest wildlife, including many birds and squirrels. Photo courtesy of Bill Stripling

Habitat diversity is the key to managing a forest for a variety of wildlife species. Although silvicultural practices can and should be used to create or maintain diversity at the stand level, the emphasis for most owners should be on diversity at the forest level by manipulating individual stand conditions to create a mosaic of habitats across the landscape. Creating or maintaining variation in structure (height differences, for example) of the vegetation is one of the most important aspects of habitat management for a variety of wildlife species. The number of wildlife species tends to increase with structural diversity within a stand. This within-stand structure, even in plantations, can be achieved by practices such as leaving snags (standing dead trees) and legacy trees, properly using streamside management zones, and establishing wildlife habitat zones. Landscape diversity is therefore assured by using natural features of the property to create or maintain stands that differ in age, size, and species composition.

One important point often overlooked, however, is that a given silviculture practice does not always affect habitat, even for a particular

THE EFFECTS OF LIVING ON THE EDGE

Openings in the forest interior or forest edge along an active agricultural field are not always beneficial for animal species. Ground-nesting birds, including northern bobwhite quail, often fall prey to predators such as raccoons, opossum, foxes, and outdoor domestic cats in these types of habitats. These predators naturally hunt along transition areas and, with an excess of edge areas and openings, they have excellent opportunities to find nests.

have been highly fragmented, allowing the brown-headed cowbird, which prefers open spaces, to expand its range and destructive nesting habits to the east. This situation has had a damaging effect on many bird species of the forest interior, including vireos, warblers, thrushes, tanagers, and flycatchers.

An adult song sparrow feeding its own fledgling along with a brown-headed cowbird fledgling. Photo courtesy of iStock

Another negative effect of forest edge on songbirds is brood parasitism by brown-headed cowbirds. During brood parasitism, the female cowbird lays her egg in another bird species' nest and leaves. This forces the recipient parents to raise an additional offspring that often outcompetes their own young for food and space in the nest. The forests of the eastern United States

A raccoon inspecting a field's edge for food. Photo courtesy of iStock

wildlife species, in the same way. Effects of the practice differ depending on such variables as site, timing of application, location in relation to other stand treatments, arrangement or layout of the stand, and intensity of the operation (such as completeness of the clearcut or severity of a thinning). For example, small clearcuts or heavy thinning in the interior of a large forest may be very desirable for wildlife species needing open or early-successional habitat types (areas of dense shrubs, grass, and small trees), but may have little or no effect on species requiring late-successional forest types (mature trees with closed canopy with little undergrowth). On the other hand, these same types of harvests applied at the edge of the forest may not benefit—and could even be harmful—to some of the same wildlife species benefiting from the harvests in the forest interior. For example, this could harm some bird species because of nest predation in areas near the edge of the forest.

Perhaps the most important point to be made is that the woodland management practices for both forest products and wildlife habitat are very compatible and are, in fact, inseparable. Furthermore, managing for wildlife habitat usually can be done at little or no reduction in returns for timber management. Silvicultural practices used for timber management are also effective for wildlife habitat management in that landowners can manipulate variables like landscape diversity, stand structure, plant succession and diversity, and stand borders that create stand diversity. When managing for both, however, the choice, timing, and intensity of a silvicultural practice must be based on an understanding of the requirements of the targeted wildlife species as well as an appreciable knowledge of the effects on stand ecology and development.

To manage a forested area for wildlife or for a combination of timber and wildlife, the landowner must first:

- decide which wildlife species are preferred;
- identify the habitat requirements of those species, such as cover, food, water, and space (that is, how much physical area does

an individual of the select species require for all facets of it life);
- determine if these requirements are already present or can be established on the property by silvicultural manipulations; and
- evaluate whether these habitat requirements are compatible with goals for timber production.

The best way to accomplish the desired objectives is to prepare a forestry and wildlife habitat management plan. It is a good idea to enlist the services of natural resource professionals, such as foresters and wildlife biologists, when devising such a plan. Private forestry and wildlife consultants and agencies such as the Mississippi Forestry Commission and the Mississippi Department of Wildlife, Fisheries, and Parks can provide assistance.

COMMON SILVICULTURAL PRACTICES

Silvicultural practices normally used for pine stands are different from those used for hardwood stands, with the major difference being the regeneration methods used. Most pine stands are regenerated using artificial methods (such as planting seedlings), whereas hardwoods are regenerated by natural means (such as seed or sprouts from trees on the site). The silvicultural practices discussed below may be appropriate for both pine and hardwood stands, but the way they are used and the effects on the resulting stands may be quite different.

Forest Type Conversion

Of all forest practices, the one that has the most influence on biodiversity and therefore on wildlife habitat is conversion of natural pine stands, mixed pine–hardwood, and hardwood stands to pine plantations or agricultural crops. Mississippi now has more acreage in pine plantations than in natural pine stands, and most of the conversion currently taking place is from natural pine or mixed pine–hardwood to pine plantations. Extensive conversion of bottomland hardwood stands to farmland occurred in

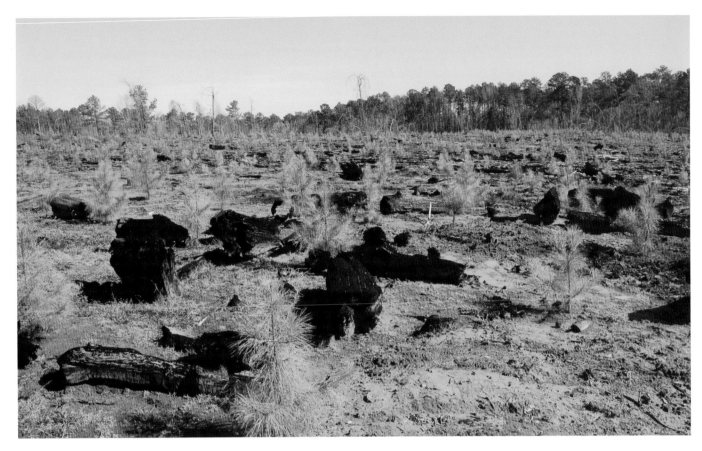

the past, primarily in the Delta, but the trend is now reversed. As a result of federal programs such as the Conservation Reserve Program and Wildlife Reserve Program, acreage in bottomland hardwoods is now increasing.

On a landscape basis, conversion of a limited amount of upland area to pine plantations may be beneficial to wildlife habitat, especially in the early stages of stand development. However, if widespread and done on large areas, conversion to pine plantation will reduce both within-stand and landscape diversity. This is especially true if accomplished by intensive site preparation, as discussed below. Landowners interested in incorporating wildlife habitat into their forest management plan should consider not only the management methods used on their property but also those of the properties in the surrounding area.

Clearcutting, Site Preparation, and Planting

Clearcutting, site preparation, and planting of pine seedlings is the most common form of stand regeneration on upland sites. It is a form of artificial regeneration that depends on seed or sprouts from an existing stand rather than nursery-grown seedlings. In terms of potential effects on wildlife habitat, what makes this technique so different from other regeneration methods is the use of site preparation methods to modify the site and control vegetation that may compete with the planted seedlings.

A variety of methods can be used alone or in combination for site preparation, including (in order of increasing intensity) burning, herbicides, chopping, disking, shearing and piling, and bedding. If the objective is to encourage a variety of wildlife species, less-intensive methods of site preparation would be preferable. Less-intensive methods may damage much of the existing shrubs and ground cover, but they are often just held in check by top kill, that is, destruction of only the stem or top of the plant, which allows the belowground portion to live and thus form a new stem. This delayed growth allows early-successional plants to become established and flourish at least for a time. The

Young pine seedlings in a recently clearcut and burned area. Photo courtesy of Erich G. Vallery, U.S. Forest Service, Bugwood.org

more-intensive methods not only destroy more of the ground flora and understory species and their ability to regenerate, but also reduce structural diversity and hasten development of the pine stand and crown closure, which further reduces the growth of subordinate vegetation. However, even the most intensive forms of site preparation may be beneficial, at least in the early stages of stand development, to some wildlife species such as white-tailed deer, quail, rabbits, and turkey, all of which, require open conditions and early-successional plant species.

Clearcutting with Natural Regeneration

Stand regeneration methods involve removal of the mature trees and replacement by young seedlings. They vary in intensity from removal of one tree at a time (single tree selection) to complete removal of the older stand (clearcutting).

Hardwoods.
Southern hardwoods, both upland and bottomland, are commonly regenerated by

clearcutting. While usually successful, allowing for natural regeneration limits a landowner's ability to control species composition and obtain the desired species in the future stand. For wildlife habitat and timber production, it is usually desirable to obtain hard-mast species such as oaks. Successful oak regeneration usually depends on the presence of advance regeneration (seedlings) at the time of harvest, and the larger the seedlings, the greater the probability of success. If advance regeneration is not present, the harvest should be delayed until it can be achieved.

If a sufficient number of oak seed trees are present, light is most often the limiting factor when attempting to establish advance oak regeneration beneath a stand. With a good acorn crop, thousands of seedlings per acre may be produced, but with insufficient light they will survive only 1 or 2 years. In very dense stands light to the forest floor can be restricted by the main tree canopy, but in most stands light is restricted by thick midstory and understory canopies. Establishing advance oak

Regeneration of green ash and other early successional plants in a section of land recently clearcut. Photo courtesy of Brian Lockhart, U.S. Forest Service, Bugwood.org

regeneration can often be achieved by controlling the lower canopies, either by harvesting or injection with herbicide. However, this operation should be timed with a good acorn crop and can be done before or soon after the acorns have germinated.

Supplemental planting of hardwood seedlings can be successful, but the seedlings must be planted where light is sufficient for establishment and then released from competition through the removal of competing vegetation when growth slows.

Pines.
Clearcutting with natural regeneration is not often used for pine regeneration, although it can be very effective and was used extensively in the past. Clearcutting is used in several ways. The strip-clearcut method involves clearcutting small patches or strips of trees, using controlled fire to reduce the logging residue in advance preparation of a seedbed, and allowing seeding from adjacent uncut stands. The seed in place technique employs prescribed fire to prepare a seedbed. Pine seed is allowed to disperse from the trees to be cut, and the trees are then removed. Finally, the seedling in place is a procedure in which the seedbed is first prepared by burning and seeds are dispersed from the trees

and later germinate to produce small seedlings. Ultimately, the parent trees are removed.

The major advantage of this type of regeneration over those using intensive site preparation is that the native herbaceous and woody vegetation is quickly re-established to produce food and cover for many wildlife species. Also, stands produced in this way are much more likely to be a mixture of pine and hardwoods. For timber production, the potential disadvantages are that the stand will not produce the maximum product value and it take longer to reach the age for final harvest.

Shelterwood and Seed Tree Regeneration

In the shelterwood method, overstory trees are removed in a series of cuts designed to achieve a new, even-aged stand under the shelter of remaining trees. The number and size of trees removed is based on the amount of light that must reach the forest floor to foster the growth of desirable species, while leaving enough trees to mitigate harmful environmental conditions on the forest floor. The seed tree method also aims to establish an even-aged canopy class, but leaves only enough trees to provide a seed source for this regeneration and not enough to affect conditions on the ground. These two

regeneration methods generally use natural regeneration. The two methods are similar except that far fewer trees are left in the seed tree method, and it is always done in two harvest cuts, whereas the shelterwood method may be done in two or more cuts. The major advantage of these two methods as compared to clearcutting is that the establishment of regeneration can be ensured before the final harvest that removes the seed trees.

Hardwoods.
The shelterwood method is often the most dependable way to regenerate hardwood stands, especially if sufficient advance regeneration is not present to justify a clearcut. Normally, the first step in the shelterwood method is a seed tree cut, which is similar to a heavy thinning, to open up the stand for seedling establishment. If there is a midstory and understory of shade-tolerant species that are undesirable, it will probably be necessary to cut or inject those trees before or soon after the new seedlings germinate. Furthermore, the seed cut and

midstory control should be timed with a good acorn or seedling crop. If the acorns or seedlings are not present at the time these operations are conducted, the probability of success is greatly diminished. Once the new seedlings are well established, 2 to 5 years after the seed cut, the residual stand can be removed in one or more harvest cuts.

For heavy-seeded species such as oaks, the seed tree method of regeneration is not appropriate in that seed distribution may not be sufficient to cover the area. For hardwoods with windblown seed, such as red maple and cottonwood, the method may have some use, but the stand can generally be regenerated just as well by clearcutting and there is no danger of losing the valuable seed trees to wind or lightning.

A variation of the shelterwood method, called irregular shelterwood or two-aged management, is being used more frequently across the South, especially for hardwoods. After regeneration is established, a few of the more vigorous shelterwood trees, possibly ten to twenty per acre, are selected for retention and

Extensive growth of ash and oak species prior to a shelterwood cut of mature trees. Photo courtesy of Brian Lockhart, U.S. Forest Service, Bugwood.org

the remainder is harvested. These retained trees can be harvested at the first entry into the new stand or allowed to grow for the full rotation.

A similar technique can also be used with clearcutting when adequate advanced regeneration is present. In this case, vigorous trees of a desirable species, usually in the smaller age/size class, are retained and all other trees are harvested. This technique can be very beneficial for many wildlife species because structure is maintained in the stand throughout the rotation. In addition, if mast-producing trees are left, seed production will occur much sooner. The technique is also financially attractive in that the trees that are left may be relatively small and have very little value, but at the next entrance into the stand they may be of much higher value for sawtimber.

The shelterwood method, particularly when used for hardwoods, can have some wildlife habitat advantages over clearcutting, especially for deer. The shelterwood method may involve two or more harvests, and each time trees are removed understory plant succession is retarded, an environment for early-successional plants is created, and the availability of browse plants is extended.

Pines.
Southern pines can be regenerated by both the shelterwood and seed tree methods. The shelterwood method is preferred for longleaf pine, whereas the seed tree method is used most often for the other pine species. The shelterwood method differs from the seed tree method in that more seed trees (often twenty or more per acre) are left after the first harvest, and the seed trees may be removed in more than one harvest after the seedlings are established.

The three steps of the seed tree method are harvest, site preparation, and seed tree removal. During the harvest, all but three to ten trees per acre are removed, depending on tree size, history of seed production, and expected competition for the newly germinated seedlings. Next, prescribed burning (the most common tool used) or mechanical and chemical site preparation can be used to control competition, reduce logging slash, and prepare a seedbed. Finally,

Pine shelterwood harvest. Photo courtesy Scott Roberts, Mississippi State University, Bugwood.org

Shelterwood harvest after a prescribed burn. Photo courtesy of David J. Moorehead, University of Georgia, Bugwood.org

A longleaf pine stand soon after the final shelterwood cut. Photo courtesy of William D. Boyer, U.S. Forest Service, Bugwood.org

Longleaf pine in an example of uneven-aged stand management in three stages: grass stage (foreground); mature (middle ground); immature (background). Photo courtesy of William D. Boyer, U.S. Forest Service, Bugwood.org

the remaining seed trees are removed 1 to 3 years after the new seedlings are established.

Benefits of Shelterwood and Seed Tree Methods. With shelterwood and seed tree methods and natural regeneration, less emphasis is placed on intensive site preparation (as occurs with clearcutting and planting), so there is a greater probability of maintaining native ground cover. With pines it is also likely that the new stand will contain a higher proportion of hardwood species. These differences may make natural regeneration methods better for some wildlife species. Also, regeneration costs may be far less with natural methods, but the production of commercially valuable material will likely be reduced.

Uneven-Aged Silviculture

Uneven-aged stands contain mixtures of at least three age classes that are in competition with each other throughout the stand. These stands are created or maintained by removing single mature trees or groups of trees usually covering ½ acre or less in size. Thinning may also be necessary in the remainder of the stand to maintain the proper size class distribution.

The uneven-aged method of silviculture is best suited for use in forest types that contain at least one shade-tolerant species that is highly desirable for management (for example, sugar maple in northern hardwood forests). However, this method has been used for both southern pine and southern hardwood forests. Landowners should be aware, too, that management efforts tend to be far greater for uneven-aged silviculture. Adequate regeneration of the desirable species is the largest challenge, because pines and most desirable hardwoods are relatively shade intolerant.

For pines, successful use of the uneven-aged method often requires intensive control (usually with herbicides) of competing hardwoods with more shade tolerance. Fire can be used at certain times in uneven-aged stands but not as frequently as in even-aged stands because of the

presence of younger age classes that can be destroyed by the fire. It will take several cutting cycles to convert an even-aged stand to an uneven-aged stand but, once converted, it has the advantage of giving a relatively even flow of forest products over time. There is some evidence that the products generated may be of higher quality and, consequently, more valuable than products from even-aged stands.

Most bottomland hardwoods that are desirable for timber or wildlife are fairly intolerant of shade. Therefore, using the uneven-aged method is difficult in these stands because it creates conditions that are more favorable to shade-tolerant competitors. Regeneration must be obtained in a similar manner as for even-aged stands and, once established, the new crop of trees must be released from competition as needed to assure survival and a competitive growth rate.

Wildlife Benefits

Because of the multi-layered canopy, uneven-aged stands have often been recommended as providing the very best wildlife habitat. Although this may be true for species like squirrels and some native and migrant songbirds, game species such as deer and turkey do not benefit as much. Therefore, the benefits of any silvicultural practice will vary by species.

FOREST MANAGEMENT TOOLS

Throughout the life of a stand, forest management practices such as thinning, improvement cuts, prescribed fire, and fertilization may be performed. These are often referred to as intermediate stand practices and are designed to improve growth and composition of the stand.

Thinning and Improvement Cuts

Thinning is harvesting to reduce the density of the growing stock and promote the growth of the remaining trees. Improvement cuts are designed to upgrade the residual stand by removing trees of less desirable species and those

Selective thinning in a loblolly pine stand. Photo courtesy Scott Roberts, Mississippi State University, Bugwood.org

Row thinning in a loblolly pine stand. Photo courtesy of Adam T. Rohnke, Mississippi State University

with poor form or vigor. Harvests in hardwood stands before the final harvest are almost always a combination of thinning and improvement cuts, and the two processes are often combined in pine stands. Thinning improves wildlife habitat by maintaining or increasing plant diversity in the understory and ground flora. Opening the canopy permits more light to reach the forest floor and allows pioneer species (the first species

Prescribed fire can be used in most forested landscapes in Mississippi to promote plants consumed by a variety of wildlife. Photo courtesy of John Gruchy, Mississippi Department of Wildlife, Fisheries, and Parks

Lush vegetation quickly responds in the spring after a prescribed burn in late winter. Photo courtesy of Chris McDonald, Mississippi Department of Wildlife, Fisheries, and Parks

to establish in a new space) to be maintained or to re-invade, while promoting the growth of those species and late-successional species.

Techniques.

Numerous techniques have been developed for thinning in forest stands. The two most common are row (or strip) thinning and selective thinning. Row thinning is often used as a first thinning method in pine plantations with good row integrity, whereas strip thinning is used in natural stands and plantations where rows are not easily determined. Selective thinning is the removal of certain individual trees to favor the growth of the remaining trees. A common practice for row thinning in pine plantations is to remove every third or fifth row and selectively thin within the remaining rows to remove the less desirable stems and those likely to be lost to natural competition. Row and strip thinning should be used only as a first thinning technique in plantations and are generally not used in hardwood stands.

Prescribed Fire

Fire, either wildfire or intentional burning, has always been a part of the ecology of southern upland forests. Native Americans used fire as a wildlife management tool, and European settlers used it to improve grazing for domestic livestock. Prescribed fires enhance wildlife habitat primarily by controlling plant succession. Many plant and animal species in the South have evolved to adapt to frequent burning. In fact, they cannot persist when the environment is altered by natural plant succession. Prescribed fires control woody vegetation, release nutrients, produce sprout growth that is more palatable and digestible by wildlife, and increase seed germination of many desirable plant species including legumes, forbs, and grasses. In addition, the vegetation produced as a result of the fires attracts an abundance of insects that are an important food source for quail, turkeys, and other birds.

A distinction should be made between fires used for site preparation following harvest and prescribed fires used underneath a stand

of trees. Site preparation fires are intense fires that produce extreme heat and may consume 80 percent or more of the available organic fuel. Site preparation burns may be done at any time of the year, but are typically used in the summer or autumn before planting in the winter. In contrast, prescribed fires are less intense fires in terms of temperature and typically consume less than 50 percent of the available fuel. They are usually employed in the winter, when fuel and soil moisture levels are moderate to high. Prescribed burning is most effective for the establishment and maintenance of wildlife plants when combined with a thinning program that provides more light to the forest floor.

Timing of Prescribed Burns.
Prescribed burning can be a valuable tool for forest and wildlife management, but it must be used at the right time of the year and under the proper weather conditions to obtain the desired results and avoid damaging the resource. Burning schedules can be tailored to create or maintain a favorable habitat for the desired wildlife species. For example, a winter burning schedule of once every 3 years will maintain a habitat conducive for quail and turkeys, whereas a schedule of 3 to 5 years can be used for deer. Summer or growing season burns may be beneficial in some cases, for example, where it is desirable to kill much of the woody vegetation rather than simply damaging the top and allowing it to sprout.

Regardless of the wildlife species to be favored, a burning schedule should be developed for the entire property, specifying areas to be burned each year and the timing of the burn. Assistance in preparing such a plan can be obtained from state forestry and state wildlife agencies or by consulting with foresters and wildlife biologists (see chapter 12 for contact information).

Prescribed Fire in Hardwoods.
In the past, fire was considered to be detrimental to production of quality hardwoods, and great efforts were made to keep it out of hardwood stands. Today, it is well documented that prescribed fire can be used effectively in mixed pine and hardwood stands and in upland hardwoods for forestry and wildlife management purposes. With upland hardwoods, fire has proven to be a useful tool for maintaining or increasing the oak component of the stand. Fire will damage the top of oak seedlings and saplings, but oaks tend to have a very vigorous root system and will sprout more vigorously than many of their woody competitors.

Except under extremely dry conditions, bottomland (floodplain) hardwood sites and upland wet sites supporting hardwoods will not sustain a fire because of the high soil and fuel moisture levels and the nature of the hardwood litter and ground cover. Most foresters and wildlife biologists now believe there is no need for establishing fire breaks and that it is best environmentally and ecologically to simply let the fire burn into the wet hardwood areas until the fuels will no longer support a fire.

Fertilization

Trees on most forest soils in the South will respond to the addition of nutrients, primarily nitrogen, but some soils are lacking in other nutrients, especially phosphorous. Fertilization is now a common practice in pine plantations, especially for short rotations on commercial lands. However, it should be used only after soil testing to determine if there is a deficiency and to obtain a recommendation for nutrients to be added (see chapter 3 for more information).

If fertilization is used, the timing of application is important. If added when trees are too young and do not have a large root system, the nutrients may be captured mostly by competing vegetation. Most recommendations for fertilization call for application at about age 3 to 4 and/or in connection with thinning, usually the first thinning in the stand.

Soils lacking nutrients produce poor-quality deer browse, and the deer that feed on it will have low body weights, smaller antlers, and be in generally poor condition. Fertilization of these soils before crown closure and at the time of thinning will produce ground flora and understory plants of superior browse quality for deer as well as food and cover for other wildlife

Clearcuts of approximately the same area but with different edge lengths and thus different degrees of wildlife diversity. Illustration by Bill Pitts

species. In general, most wildlife species will benefit from fertilization of forest stands on nutrient-deficient soils.

INTEGRATION OF WILDLIFE AND FOREST MANAGEMENT

Thus far we have provided information on common silvicultural methods used in the South that can be modified and tailored to address specific wildlife management needs, usually at little or no cost to timber production. These modifications are implemented at both the stand and forest (landscape) level and are based on stand and forest conditions that are known to influence habitat for most wildlife species, such as stand size, stand age arrangement, edge effects, plant succession, stand structure, and plant diversity. Most bottomland hardwood stands are managed using natural regeneration methods and long rotations to produce quality sawtimber, so fewer modifications for wildlife habitat may be needed than in pine stands. The following sections present other common examples of how these modifications can be implemented in pine plantations and natural stands of pure pine.

Size, Shape, and Arrangement of Regeneration Areas

The size and shape of clearcuts or regeneration areas determine their use by wildlife. For example, larger wooded areas with less edge may be preferred by some wildlife species, such as certain migrating songbirds. In contrast, the center portion of very large regeneration areas may be relatively unused, even by very mobile animals such as deer, which may frequent only the outer portions near wooded areas. In addition to providing greater use of the food resources, smaller clearcuts offer more edge, which provides a unique transition zone between the two habitat types and therefore increased plant diversity, than large clearcuts.

In general, irregularly shaped or long and narrow regeneration areas offer better habitat than square or circular areas. If regeneration areas are established in the shape of square blocks or circles, it is probably best to limit their size to about 40 acres. Elongated regeneration areas can be much larger in size, perhaps 100 acres or more, and still provide good usage of the food resource, as their longer edges offer a greater variety of plants. Also, long and narrow areas may provide more territories and home ranges for animals and enable them to benefit from the food resource and proximity to cover.

Although there is disagreement among wildlife biologists about placement or arrangement of regeneration areas, for most game species in the South it is probably best to stagger or disperse the regeneration areas to avoid having large areas of the same or similar age class. One practical technique is to make sure that adjacent regeneration areas differ in age by at least 5 years. This strategy ensures proximity of

areas of different successional stages and provides greater diversity across a property. However, it may result in a somewhat fragmented landscape that is less desirable for some wildlife species or for timber production.

Planting at Lower Densities

Recommendations for plantation spacing have varied greatly over the years, and there is still wide variation in the spacing used. A spacing of 6 feet between rows and 6 feet between trees in a row was very common at one time, although wider spacing is preferred today. For timber production, the choice of spacing is best determined by the products to be grown and the markets for products such as pulpwood. Present market conditions may dictate wider spacing, because pulpwood supplies exceed demand. Generally, wider spacing (lower densities) is best for wildlife because of greater light penetration through the canopy, permitting better growth of desirable plants for food and cover.

Buffer Zones, Streamside Management Zones, and Wildlife Corridors

Separation of regeneration areas—even though they may differ somewhat in age—by buffer strips of uncut timber (100 feet or more in width) greatly enhances diversity of habitat and provides travel corridors between fragmented habitats. Some timber harvesting can be done in these corridors at the time of the regeneration cut to remove mature timber or high-value trees likely to be lost before the next harvest in the younger stands. However, efforts should be made to minimize equipment travel in the corridors and damage to the ground flora and understory vegetation, because they are important as a food source and for protection of smaller animals.

Streamside management zones are strips of vegetation left adjacent to streams or other bodies of water primarily for use as filter strips to protect water quality. However, they may also enhance wildlife habitat. As with buffer strips, they provide travel corridors and enhance plant diversity, but, because of the water source, they

Table 6.1. Spacing and the resulting seedlings per acre	
Spacing (feet) [a]	**Number of seedlings per acre**
6 × 8	907
6 × 9	806
6 × 10	726
6 × 11	660
6 × 12	605
7 × 7	888
7 × 8	777
7 × 9	691
7 × 10 [b]	622
7 × 11	565
7 × 12	518
8 × 8 [b]	680
8 × 9 [b]	605
8 × 10	544
8 × 11	495
8 × 12	453
9 × 9	537
9 × 10	484
9 × 11	436
9 × 12	403
10 × 10	435
10 × 11	396
10 × 12	363
12 × 11	330
12 × 12	302
12 × 15	242
15 × 7	414
15 × 8	363
15 × 9	322
15 × 10	290
15 × 15	193

[a] The first value is the spacing between rows, and the second is the spacing between trees in each row.
[b] Common planting densities
Adapted from Wallace, M. J., and A. J. Londo, eds. 2008. Chapter 4: Artificial regeneration. *Managing the Family Forest in Mississippi.* Publication 2470. Mississippi State University Extension Service.

Two small streamside management zones protect streams and provide travel corridors for wildlife between two wooded areas. Illustration by Bill Pitts

may also provide the unique habitat needed by many smaller animals with limited home ranges. The state's best management practices specify the minimum size of streamside management zones (based on stream size and topography) and the type of harvest activities permitted in these zones. Some harvesting is permitted, but for the protection of both water quality and wildlife habitat, equipment use and crossing of the streamside management zones should be limited.

In larger regeneration areas where refuges (places with dense cover often used for rest by wildlife) or travel corridors are not provided by streamside management zones, it is a good practice to leave strips of relatively undisturbed vegetation across the area. These strips are sometimes referred to as habitat management zones and should be approximately 50 to 100 feet wide. Some harvesting can be done in the strips but, again, it is important to create as little disturbance as possible. One very good use of habitat management zones is to extend or connect streamside management zones so that there is a continuous corridor across the regeneration area.

Seeding of Disturbed Areas

Timber harvesting almost always results in soil disturbance and exposure of mineral soil along roads, along logging or skid trails, and on

loading decks. Compliance with the state's best management practices requires that these areas be treated, including establishment of ground cover, to minimize erosion and maintain water quality. Seeding and establishment recommendations vary widely, but some involve the seeding of non-native material and/or material that has no value for wildlife. However, the establishment of native ground cover, including native warm-season grasses, will be most beneficial to wildlife (see chapter 13 for planting recommendations).

Woody Debris and Logging Residue

For purposes of nutrient cycling and site improvement, it is generally best to leave woody debris and logging residue scattered uniformly over the site rather than concentrated at the logging deck or other places on the harvested area. Leaving the material, especially some of the larger material, on the area is beneficial to many animals, especially reptiles, amphibians, and small mammals that use it for dens, nests, foraging, and cover. However, leaving some piles of tree tops and larger material will provide cover for species such as rabbits, quail, and other birds and these piles will not decay as rapidly as the scattered material. The piles can remain anywhere in the harvested area but are best left near edges, bodies of water, or food sources.

PREPARATION AND SUPERVISION OF HARVEST OPERATIONS

Most logging contractors can effectively conduct the silvicultural operations for timber production, but they are generally unaware of modifications needed for improving wildlife habitat. The landowner or manager should therefore take the necessary steps to ensure that the operation accomplishes the desired objectives for both. These steps in preparation and supervision of the operation should begin long before the harvest contract is awarded and continue after the harvest until all objectives are accomplished.

Landowners unfamiliar with preparation and supervision of timber sales would be well advised to secure the consulting services of a forester and wildlife biologist (see chapter 2 for more information). In cooperation with the landowner, these professionals can handle all details of the sale from initial inventory and marking to layout of the sale area, preparation of the sales contract, advertisement of the sale,

supervision of harvest operations, and close-out of the tract after harvest. Consultants can receive payment for their services in different ways, but the most common is to charge a percentage of the revenue from the sale. As an alternative to using a consultant, the landowner may obtain advice for conducting the sale from the Mississippi State University Extension Service and Mississippi Forestry Commission.

Preharvest Preparation

A forestry and wildlife habitat management plan will specify the areas to receive treatment each year and the type of treatment to be applied (see the sample forest management plan in Appendix 3). Once the area is determined, the following steps should be taken before the harvest or other operation begins.

Inventory and Assessment of Treatment Area.
The need for an inventory and the type of inventory will be determined by the type of sale used. For regeneration harvests, a timber cruise

A forester evaluates a recently thinned loblolly pine stand. Photo courtesy of Adam T. Rohnke, Mississippi State University

Trees marked with highly visible fluorescent flagging indicating a stream management zone. Photo courtesy of Adam T. Rohnke, Mississippi State University

(an inventory) is normally done to determine the volume of timber to be sold by species, product class, and size class. For partial harvest (thinning), this information is obtained in conjunction with marking the trees to be removed. An alternative to sales based on inventory is one where the contractor pays based on the timber actually cut and delivered to a processing facility.

Other assessments that should be done before harvest begins include: (1) location and marking of streamside management zones, (2) layout and marking of skid trails and stream crossings if necessary, (3) marking of special areas to be protected, (4) location of logging decks, (5) marking of habitat management zones or wildlife corridors, and (6) location of any special wildlife habitat improvements such as openings and small slash piles. This information should be indicated on a detailed map of the area with a copy given to the logging contractor.

Marking and Delineation of Trees to Be Removed.

The need for marking trees and how it is done is determined by the type of harvest to be made. For regeneration harvests using artificial regeneration, the trees to be removed are generally not marked, because virtually all trees will be cut. The exception is when some trees are to be removed from areas such as streamside management zones and habitat management zones. Also, trees to be left for wildlife purposes within the harvest zones should be marked with a distinctive colored paint. When natural regeneration methods such as shelterwood or seed tree are used, the usual practice is to mark the trees to be retained rather than those to be removed.

For partial harvests (such as thinning), the most common practice is to mark the trees to be removed. A paint spot is placed on the tree at eye level and another at stump level. This

permits a check to ensure that only marked trees are removed. If row thinning is used, the trees to be removed are not marked; if trees are removed in the "leave rows," the logger makes the selection. In the logger-select method of thinning in older stands, the trees for removal are not marked, and the logger makes the selection after thorough training by a professional forester or someone with experience in how the stand should be thinned.

Preparation of a Timber Sale Agreement and Map.
The timber sale agreement and accompanying map are extremely important documents from a legal, financial, and environmental standpoint, but they are also the landowner's primary tool for ensuring that the result will meet the specific goals for timber production and wildlife habitat. A forest landowner should realize that there is no standard sale agreement. The agreement should be tailored to fit a particular harvest unit and the specific outcome desired by the owner (see the sample timber sale agreement in Appendix 3).

The map accompanying the sale agreement should be drawn at a scale that permits easy recognition of all features discussed in the agreement. Attachment of aerial photographs to the agreement is also a good idea. These photographs often permit easier recognition of property boundaries and features such as streams and trails.

In addition to the sale agreement, it is common practice to require the logging contractor to sign a performance bond and establish an account from which funds can be withdrawn by the landowner in case terms of the agreement are not met.

Sale Advertisement.
If a forestry consultant is employed, he or she will know the loggers, timber buyers, and mills that may be interested in purchasing the timber and will handle this aspect of the sale. If the landowner manages the sale, a list of companies and individuals that may be interested in the timber can be obtained from the Mississippi Forestry Commission. The sales contract and/

or bid forms can be sent to the full list of possible bidders, or a sales announcement can be sent with a form expressing interest in the sale to be returned by the potential bidder.

Tour of Treatment Site with Contractor.
Once the logging contractor has been chosen and the sales agreement has been signed, the landowner and consultant (if one is involved) should meet with the logging contractor on the tract to be harvested. This is a very critical time to ensure that the landowner and contractor

Marking at eye level and at the base of the tree allows a forester or landowner to ensure that only marked trees were harvested. Photo courtesy of Adam T. Rohnke, Mississippi State University

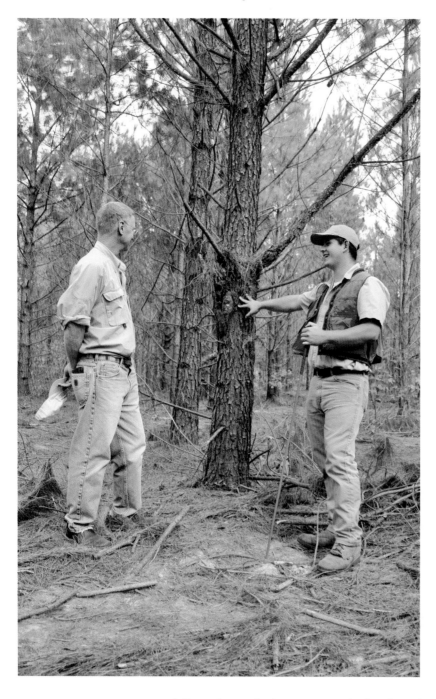

A landowner visits with his forester post-operation to review the work of the logging contractor. Photo courtesy of Adam T. Rohnke, Mississippi State University

fully understand what is expected of each and what is to be accomplished. The landowner should tour the entire tract with the logging contractor using the map prepared with the sales agreement, making sure that all information on the map and in the sales agreement is fully understood. Most failures in compliance on the part of logging contractors occur because of a lack of complete understanding of what is expected by the landowner.

Supervision of Operation

The landowner (or his/her representative) should visit the harvest site on a regular basis—daily if possible. These visits offer an opportunity to establish a good working relationship with the logging contractors and to convey the importance you attach to satisfactory completion of all aspects of the harvest agreement. If mistakes or noncompliance issues are noted, repairs or corrections can be made immediately. Simply stated, good supervision is the key to accomplishing the landowner's desired objectives.

Postoperation Activities

Near the end of the harvest and before the contractor leaves the site, the landowner should visit the site and do a complete inspection with the contractor. If repairs, wildlife habitat work, or other tasks are necessary to meet the terms of the agreement, these changes should be noted on the spot and plans made to complete the project before the contractor leaves.

After all work is complete on the site, the landowner should make a final inspection to see that all terms of the agreement have been met. It is also the time to make any desirable wildlife habitat changes, such as adding openings, before site preparation or planting begins.

SUMMARY

Silvicultural practices are used to improve product quality and production in forest stands, but the same methods may be essential for improving or maintaining wildlife habitat. If landowners wish to manage a forest area for a combination of timber and wildlife, they must (1) identify the objectives as to the wildlife species they wish to encourage, (2) understand the habitat requirements of those species including cover, food, and water in local and landscape areas, (3) determine if these requirements are present or can be established on the property by silvicultural manipulations, (4) determine if these habitat requirements are compatible with

requirements or goals for timber production, and, once these criteria are known, (5) develop a forestry and/or wildlife management plan that specifies the location, type, and timing of each operation to best meet the desired objectives for wildlife habitat and timber production.

For More Information

Brockway, D. G., K. W. Outcalt, and W. D. Boyer. 2006. Regeneration ecology and methods. Pp. 95–120 in S. Jose, E. J. Jokela, and D. L. Miller, eds. *The Longleaf Pine Ecosystem: Ecology, Silviculture, and Restoration*. New York: Springer.

Browning, R. W., J. L. Cummins, T. R. Jacobson, and H. G. Hughes. 2009. *Restoring and Managing Longleaf Pine: A Handbook for Mississippi Landowners, 2nd Edition*. U.S. Fish and Wildlife Service, Wildlife Mississippi, and Mississippi State Extension Service.

Ezell, A. W., D. J. Moorehead, and A. J. Londo. 2001. *Planting Southern Pines: A Guide to Species Selection and Planting Techniques*. Publication 1776. Mississippi State University Extension Service. http://msucares .com/pubs/publications/p1776.pdf

Monaghan, T. A., and A. J. Londo. 2000. *Forest Management Alternatives for Private Landowners*. Publication 1337. Mississippi State University Extension Service. http://msucares.com/pubs/publications/p1337.pdf

Traugott, T. A. 2000. *Prescribed Burning in Southern Forests: Fire Ecology, Techniques and Uses for Wildlife Management*. Publication 2283. Mississippi State University Extension Service. http://msucares.com/pubs/ publications/p2283.pdf

Wallace, M. J., and A. J. Londo, eds. 2008. *Managing the Family Forest in Mississippi*. Publication 2470. Mississippi State University Extension Service. http://msu cares.com/pubs/publications/p2470.pdf

Editors' note

Andrew J. Londo is currently the Assistant Director of Agriculture and Natural Resources Extension, The Ohio State University.

CHAPTER 7

Wetland Ecology and Management

Rob Ballinger, Wildlife Biologist, Wildlife Mississippi

Samuel C. Pierce, Research Associate of Aquatic Sciences, Department of Wildlife, Fisheries, and Aquaculture, Mississippi State University

Technical editor

Robert Kröger, Assistant Professor of Aquatic Sciences, Department of Wildlife, Fisheries, and Aquaculture, Mississippi State University

H istorically, wetlands have gotten a bad rap. Early documents described wetland areas as having "bad air," which was thought to cause malaria, yellow fever, and other maladies. Here in the southeastern United States, the prevalence of venomous snakes and alligators reinforced the idea that wetlands were bad places.

As a result of such negative and sometimes incorrect assumptions, as well as the advent of modern machinery that was used to construct extensive drainage ditches, wetland loss within the United States has been substantial, with estimates ranging from 40 to 60 percent. Many of the remaining wetlands are affected by human disturbances, such as roads, flood control, and pollution. A majority of this wetland loss has occurred in fertile alluvial floodplains, such as the Lower Mississippi Alluvial Valley, which includes the Delta regions of Arkansas, Louisiana, and Mississippi.

On a more positive note, the dramatic losses of wetlands and their many benefits, including wildlife habitat, reduction of flood severity, and water quality improvements, have led to the enactment of federal and state protections like the Clean Water Act. Such regulations are helping to decrease further wetland removal or significantly reduce negative impacts to these valuable systems nationwide. In addition, key wetland restoration programs such as the Wetland Reserve Program and other initiatives have created millions of acres of wetland habitat across the United States, including in the Delta region of Mississippi.

Cypress slough. Photo courtesy of James L. Cummins, Wildlife Mississippi

Mississippi Alluvial Valley 1950s

▨	- Forest cover
■	- WRP lands-2001
▦	- Rivers
▩	- Major cities

Land cover in the Mississippi Alluvial Valley around the 1950s. Reprinted from Schummer et al., *A Guide to Moist-Soil Wetland Plants of the Mississippi Alluvial Valley*

The Importance of Wetlands

Wetlands in Mississippi serve important structural, compositional, and functional roles. From a structural perspective, wetlands act as barriers to flood waters, provide flood control, and enhance the diversity of aquatic habitats. Mississippi's coastal marshes are a prime example. They not only provide natural buffers to hurricanes with their ability to absorb tidal surges, but also offer refuge and spawning grounds for some of the most economically important fisheries of shrimp, redfish, speckled seatrout, and oysters.

With regard to species composition, wetlands are reservoirs for diverse species of aquatic

Mississippi Alluvial Valley 2001

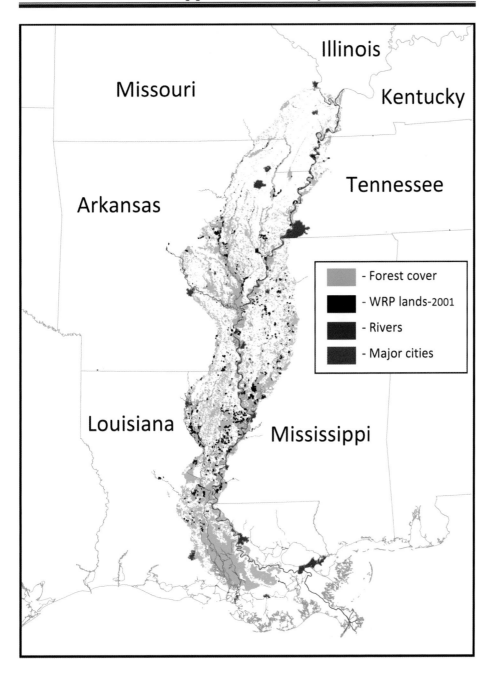

Land cover in the Mississippi Alluvial Valley in 2001. Reprinted from Schummer et al., *A Guide to Moist-Soil Wetland Plants of the Mississippi Alluvial Valley*

plants, wildlife dependent on aquatic systems (such as beavers and waterfowl), and aquatic organisms such as insects, crustaceans, fish, reptiles, and amphibians. Seasonally flooded bottomland hardwood forests, for instance, provide nesting, feeding, and resting sites for resident and migrating waterfowl and other waterbirds.

Wetlands provide vital landscape functions such as improvements to water quality through nutrient processing and sediment deposition, and they are hydrological connectors between aquatic systems. To meet demands for a growing human population, agriculture relies on chemical inorganic and organic fertilizers to boost production yields. This increase in fertilizer use

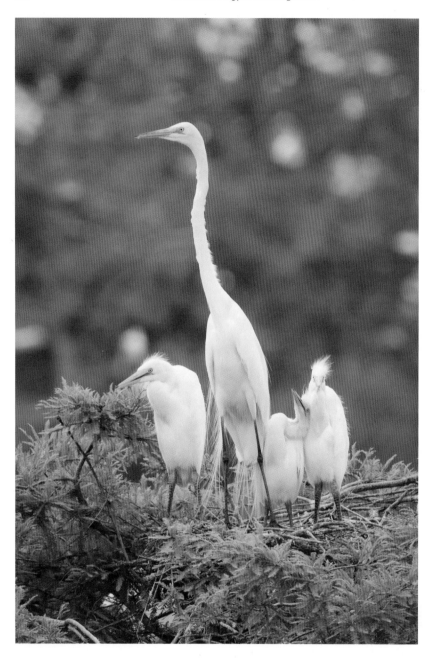

Wooded wetland areas provide excellent sites for herons, egrets (shown here), and other waterbirds, as well as rookeries (nesting areas for multiple species). Photo courtesy of Bill Stripling

results in higher rates of nitrogen and phosphorus delivery to downstream waters. Agricultural wetlands, such as managed agricultural drainage ditches, can serve this functional role by filtering, transforming, and absorbing pollutants like excess nutrients, pesticides, and heavy metals, leading to improved water quality for downstream aquatic systems. As more is understood about wetlands and their crucial roles in the environment, the more emphasis is placed on reestablishment of wetlands in landscapes where they once occurred.

PROTECTION STATUS OF WETLANDS IN MISSISSIPPI

Because of their ability to decrease nutrients and sediment in waterways, wetlands are protected under Section 404 of the Clean Water Act. Although this protection allows for some invasive practices in wetlands, including silviculture and water management, any placement of fill materials or moving of earth in an area greater than one-tenth acre requires a permit issued by the Regulatory Division of the U.S. Army Corps of Engineers. This includes building any roads (regardless of the agricultural, silvicultural, or recreational purpose), levees, dams, mounds, or soil bars.

Because it may not always be clear what a wetland is and what constitutes fill material, it is highly recommended that landowners contact their respective regulatory agency before proceeding. Under the Clean Water Act, there are two federal and two state agencies in Mississippi with regulatory authority that can provide technical guidance and permits:

U.S. Army Corps of Engineers
Vicksburg District (western Mississippi): www.mvk.usace.army.mil
Mobile District (eastern Mississippi): www.sam.usace.army.mil
Memphis District (extreme northern Mississippi): www.mvm.usace.army.mil
Nashville District (extreme northeastern Mississippi): www.lrn.usace.army.mil

U.S. Environmental Protection Agency
www.epa.gov/aboutepa/region4.html

Mississippi Department of Environmental Quality
www.deq.state.ms.us

Mississippi Department of Marine Resources (for Hancock, Harrison, and Jackson Counties)
www.dmr.ms.gov

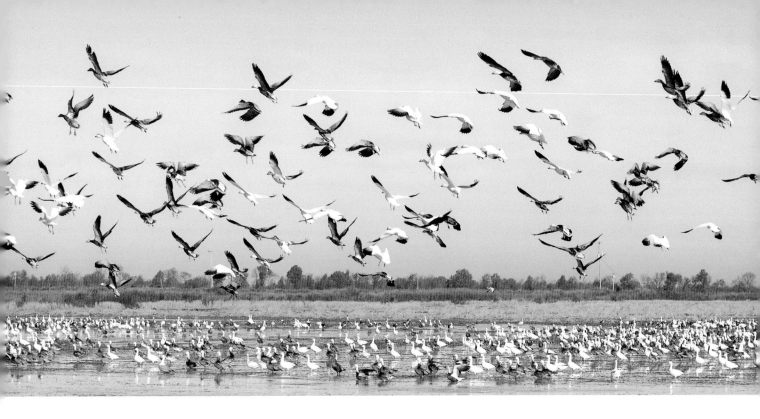

WETLAND ECOLOGY

The ecology of a wetland depends upon the physical conditions of the site itself, which in turn determines what sorts of plants and animals will live in the ecosystem. Wetlands are aquatic systems that typically exhibit three distinctive characteristics:

- ◆ land inundated or saturated with water for at least some part of the growing season;
- ◆ development of hydric soils that regularly experience anoxic conditions (lack of oxygen) as a result of inundation; and
- ◆ the presence of specific aquatic vegetation.

Key Elements of a Wetland

The water regime (hydrology) of the site is the most important physical parameter of a wetland, and soils play a secondary role. Because wetlands receive water from the surrounding watershed, the landscape surrounding the watershed is also an important factor in wetland ecology. A river bottom, for example, is likely to have a very different community of wildlife and vegetation than an isolated wetland with identical hydrology because the distance of a wetland to more permanent water bodies affects colonization by plants as well as its use as

wildlife habitat. The ecological classification of wetlands takes into account both the characteristics of the site and the surrounding terrain.

Hydrology.
The existence and movement of water ensures wetland survival and affects the type of wetland that occurs and which wetland plants will grow there. Hydrology also determines the ultimate function of that wetland and which animal life will be able to survive.

Wetland hydrology consists of several factors, the most important of which are duration and frequency of inundation (or saturation). Some types of wetlands, including many groundwater-fed wetlands, may only dry out during periods of extended drought that lower the surrounding water table. The presence of water for extended durations has profound effects on soil chemistry and can limit the types of plants found in such a wetland. In contrast, wetlands fed by surface overflow from streams and rivers may experience inundation for only a few days or weeks at a time. In these wetlands, the frequency and seasonality of inundation determine the type of wetland that develops. In forested wetlands, for example, multiple short-term floods during spring can result in thinning of the canopy and the death of seedlings, whereas extended winter flooding is a common management practice.

A flooded moist-soil unit provides important feeding areas for migratory waterfowl and other wetland wildlife during the winter in Mississippi. Photo courtesy of James L. Cummins, Wildlife Mississippi

A classic example of a soil profile with blue-gray coloration, indicating a wetland soil. Photo courtesy of Heath M. Hagy, Illinois Natural History Survey

Soils.

Wetland soils are different from upland soils in several physical, chemical, and biological characteristics. Wetland soils are typically inundated with water, meaning that the added water volume in soils occupies most of the space that would typically be filled by air in upland soils. The result is that oxygen availability for microbes in the soil is reduced because the water occupying the air spaces neither holds nor conveys oxygen as well. Because of this displacement of air, oxygen is rapidly consumed in wetland soils. Anaerobic bacteria (those that do not use oxygen during decomposition of organic matter) have evolved to use other compounds in the soil such as nitrate, manganese, and iron in decomposition. As the compounds are processed, they create key visual characteristics of wetland soils such as fading of leaf litter, blue-gray coloration, and the formation of iron particles in the soil profile. These visual soil characteristics are commonly used to determine if a site is a legal wetland in Mississippi.

Plant Life.

Most wetland plants contain a tissue called aerenchyma, spongy material that creates large air spaces for oxygen transfer from the atmosphere to the roots, allowing these plants to live in saturated or waterlogged soils. Different types of wetland plants are typically characterized by their distinctive growth form, and there are four classes of wetland plants: emergent, submerged, floating-leaved, and floating plants.

Emergent plants are rooted in the wetland soil and have portions of leaf, stem, and flowers that grow above the water surface. These plants tend to be larger than individuals in the other groups and consist of both woody and herbaceous species. Examples include bald cypress, rushes, and cattail.

Cattails. Photo courtesy of Heath M. Hagy, Illinois Natural History Survey

(Top) Water lily. Photo courtesy of University Press of Mississippi

(Bottom left) Water lotus. Photo courtesy of University Press of Mississippi

(Bottom right) Flowering water hyacinth is a common invasive non-native species in Mississippi wetlands. Photo courtesy of iStock

Bottomland hardwood forest during a dry year. Photo courtesy of William W. Hamrick, Mississippi State University

Submerged plants spend their entire life cycle (with few exceptions, such as flowering periods) beneath the surface of the water and are rooted in the wetland soil. An example in Mississippi is waternymph.

Floating-leaved plants have leaves and flowers that float on the water surface and are rooted to the wetland soil. Examples include water lily and water lotus.

Floating plants also float and have leaves and flowers on or above the water surface, but the roots hang free beneath the surface. Examples include water fern, water lettuce, and water hyacinth.

Types of Wetlands in Mississippi

Wetlands are classified based on the types of hydrology and vegetation that dominate the system. In Mississippi, wetlands include bottomland hardwood forests, swamps, bayous, marshes, ditches, abandoned catfish ponds, moist-soil units, and seasonally managed agricultural fields.

Seasonally Flooded Bottomland Hardwoods.
These forested wetlands are comprised of trees, shrubs, broadleaf plants, and grasses that withstand flooding at a variety of depths, durations, and times of year. This is the predominant wetland type in the Lower Mississippi Alluvial Valley.

Moist-Soil Wetlands.
These wetlands occur where an opening exists in bottomland hardwoods. Forest openings are caused naturally by high winds, catastrophic floods, beavers, and fires. Man-made moist-soil areas are commonly inhabited by seed-producing annuals such as smartweeds, wild millets, panicums, and sprangletop.

A well-managed moist-soil unit during the summer. Photo courtesy of Matt McClanahan, Mississippi State University

Emergent marshes provide excellent breeding and rearing habitat for waterfowl. Photo courtesy of Matt McClanahan, Mississippi State University

Emergent Marshes.

These wetlands are generally covered in 6 inches to 3 feet of water and contain vegetation that grows above the water surface and is rooted in soil. Emergent plants include cattail, bulrush, spikerush, and sedges. These marshes are valuable as nesting and brood-rearing habitat for resident wading birds. They also provide feeding, resting, and roosting habitat for migratory shorebirds and waterfowl.

Shrub and Scrub Swamps.

These wetlands usually contain 6 to 24 inches of water during the growing season. Willows, buttonbush, other woody species, and perennial leafy vegetation are examples of the plant life in these systems. In Mississippi, shrub and scrub swamps are often transitional between emergent wetlands and forested wetlands. Decaying leaves provide habitat for invertebrates that, in turn, provide food for waterbirds, fish, amphibians, and other wetland wildlife. Studies have found more than 25 pounds of invertebrates per acre in flooded willows. Wood ducks and mallards often feed on buttonbush seeds. However, the primary value of shrub and scrub in these swamps is not food, it is thermal roosting cover for waterfowl. On cold nights, the low, thick vegetation helps retain heat.

Small Depressional Wetlands.

Historically, flooding in the Delta regions of Mississippi resulted in shallow ridge-swale topography and isolated low-lying areas. Once flooded, ridge-swale topography forms isolated pockets of small depressional wetlands. The water level in these wetlands, often a few inches deep, is too shallow to support large fish communities, although they may support mosquitofish and other smaller fish species. However,

Shrub and scrub swamps provide ideal cover during the winter months for waterfowl and other wetland birds. Photo courtesy of Michael L. Schummer, Long Point Waterfowl

Small depressional forested wetlands are crucial breeding areas for amphibians in Mississippi. Photo courtesy of Tom M. Mann, Mississippi Museum of Natural Science

A small bald cypress slough in the Mississippi Delta. Photo courtesy of Alicia Wiseman, Mississippi State University

depressional wetlands are critical habitats for amphibians, reptiles, and feeding waterbirds. The lack of large predatory fish in this system provides excellent spawning and grow-out areas for developing amphibians.

Lacustrine Wetlands.
These are typically deeper systems, often with large areas of open water reaching depths of more than 3 feet and sometimes fringed with shallow, marsh-like, emergent wetland vegetation (rushes, cattails, or cypress trees). Lacustrine wetlands typically occur in old river bends, sloughs, brakes, bayous, or oxbow lakes. These wetlands are valuable as fisheries and as resting and roosting cover for waterbirds. Large lacustrine wetlands provide valuable habitat in dry years by providing hydrological characteristics that typically would be absent.

Wetland Complexes.
These include a combination of the previously mentioned wetland types. For example, a restored agricultural wetland can be hydrologically connected to a backwater wetland, and these systems then drain into a bottomland hardwood forest. Most managed tracts are not large enough to provide every wetland type. Therefore, landowners and managers should consider which wetland types are in the immediate area when deciding how to manage their man-made or natural wetlands. By providing a variety of wetland types in close proximity to each other, the diversity of species will increase and each life stage will have a better chance of survival.

Wetland Fish and Wildlife

Wetlands are important for many of Mississippi's native and migratory animals. Some are familiar, such as ducks and beavers, whereas others, such as the amphiuma, a legless amphibian often confused with an eel, are rarely seen. Wetlands are also home to many threatened

Amphiumas are common inhabitants of Mississippi's wetlands. Photo courtesy of James R. Lee, Mississippi Nature Conservancy

species, such as the black bear, and other wetland-dependent species.

Keystone Species.

Two important animals associated with wetland ecosystems are the American alligator and North American beaver, which serve as keystone species in wetlands. Keystone species are plants or animals that alter their environment to such a great extent that removing them causes an ecosystem to collapse (equivalent to removing the keystone from an arch, thus causing a doorway to collapse). However, it is well known that beaver activity in a stream can have major economic impacts on agriculture and forestry in surrounding lowlands. In addition, as the alligator population expands, increasing human conflicts with these animals are being reported. As such, managing keystone species requires landowners and biologists to view them in many contexts at the landscape level.

Alligators change wetland hydrology by creating and maintaining small pools within seasonally flooded wetlands. These wallow-pools generally have a more diverse suite of vegetation than surrounding areas. In addition, because alligators are often the top predator, they affect the abundance of other animal species (such as beaver, nutria, and turtles), sometimes with surprising benefits to animals that are considered valuable to humans (such as game fish).

The alligator, like the beaver, has historically experienced large population fluctuations because of overharvesting and subsequent conservation measures. Alligator populations were so depleted in the mid-twentieth century that they actually acquired the status of endangered species several years before the Endangered Species Act became law. Currently, alligators live in most parts of the state, with large and expanding populations in the Mississippi Delta and the Pearl and Pascagoula River basins.

Beavers are often referred to as "ecosystem engineers" because they alter their environment to suit their needs. In many cases these alterations, which include pooling of water and selective removal of certain tree species, are considered undesirable by landowners. However, in some situations, affected areas have

American alligator floating just above the water line in a wetland. Photo courtesy of James L. Cummins, Wildlife Mississippi

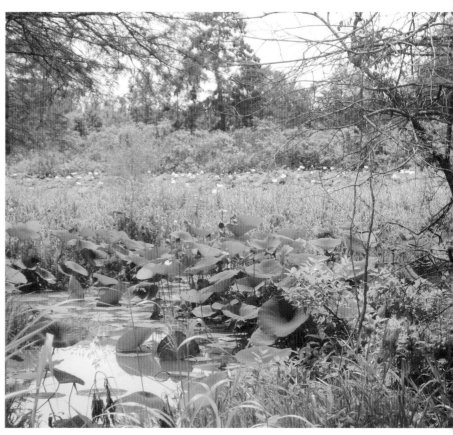

An alligator wallow-pool in a semi-forested wetland. Photo courtesy of Heath M. Hagy, Illinois Natural History Survey

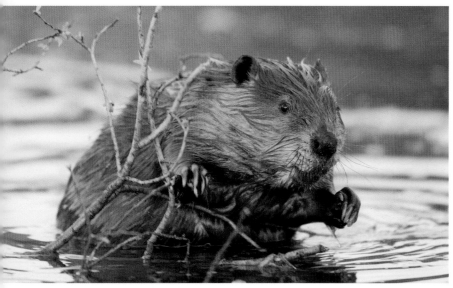

North American beaver. Photo courtesy of iStock

A large beaver pond that has killed several acres of trees. Photo courtesy of Kris C. Godwin,
U.S. Department of Agriculture Wildlife Services

beaver ponds provide foods important to many dabbling ducks, particularly in years when mast crops like acorns are unavailable. The natural wetland complex created by beavers provides diverse habitats that are readily exploited by waterfowl and other species of animals.

Fish.

Shallow vegetated areas of lakes and seasonally flooded backwaters of rivers are an important part of healthy fisheries in the southeastern United States. However, wetlands that are not regularly connected with deeper water bodies make for unsuitable fish habitat year-round because of frequent low oxygen levels and occasional dry outs. Both situations can result in fish being trapped in drying pools and succumbing to either dehydration or predation by birds and mammals. In contrast, seasonally or permanently connected backwaters of rivers can harbor a diverse array of fish rivaling that of the main channel. Because these backwaters have lower water velocity and generally fewer predatory fish, they often serve as a vital habitat for juvenile fish. Closer to the coast, estuarine wetlands can support a wide diversity of fish species, many of which use these systems primarily as nurseries.

Birds.

Hundreds of bird species depend on wetlands or periodically use wetlands (via migration) throughout the year. A well-known, wetland-dependent bird of Mississippi bottomlands is the prothonotary warbler, a small songbird with a golden yellow body and blue-gray wings. This warbler nests in cavities or nest boxes and lives in the bottomland hardwoods of rivers, sloughs, and other wetlands. The eastern wild turkey roosts, nests, and forages in Mississippi's bottomland hardwoods. Sparrows, blackbirds, and other songbirds use wetlands as stop-over habitat during their northern and southern migrations; such habitats provide excellent roosting sites and food resources. Similarly, waterfowl, shorebirds, and other waterbirds overwinter in these habitats because of their dependency on open water and food resources before migration.

increased the diversity of surrounding wetland vegetation and improved water quality. Physical habitat features created by beavers, such as dead standing timber with a well-developed shrub layer, provide excellent habitats for wood ducks and other waterfowl to roost in at night. Seed-producing annual plants associated with

Predatory birds are also attracted to the abundant prey present in wetland systems. Bald eagles and peregrine falcons are attracted by waterfowl and other waterbirds. Northern harriers and Mississippi kites target reptiles and amphibians, and red-tailed and red-shouldered hawks feed on small mammals.

BLACK BEARS IN MISSISSIPPI

The black bear population is steadily growing across Mississippi, particularly in the Delta region. Between 1970 and 2004, there were no documented cases of black bears giving birth in Mississippi. The total population was estimated to average around thirty animals annually in the state. However, in 2005 a female was confirmed to have given birth to five cubs in Wilkinson County. Since then, the population has expanded to 140 individuals across the state, with an average of five to ten cubs born each year.

Female black bear and cub taking refuge in a tree. Photo courtesy of Brad Young, Mississippi Department of Wildlife, Fisheries, and Parks

People do not typically associate the black bear with wetlands, but in Mississippi the back bear's ideal habitat is bottomland hardwoods. Adult females often choose den sites in a hollow oak or cypress tree or brush piles surrounded by thickets. Wetland habitats provide diverse food sources for black bears, including insects, berries, acorns, and other plant materials. The dependence of the black bear on these sensitive areas illustrates the importance of proper management and conservation of wetlands across Mississippi.

A singing male prothonotary warbler and a red-winged blackbird, both common wetland birds. Photos courtesy of Bill Stripling

Feral hog damage in a wetland can degrade water quality and create erosion problems for landowners. Photo courtesy of William W. Hamrick, Mississippi State University

Nutria are commonly misidentified as small beavers. The key difference is its long round tail as compared to the flat tail of the beaver. Photo courtesy of iStock

Mammals.

In addition to the American beaver, many mammal species can be found in wetland areas throughout the year. Large mammals such as black bears and white-tailed deer frequent bottomland hardwood forests and riverine areas. Black bears commonly use large hollow standing hardwood trees and areas of downed timber for their den sites.

Smaller mammals including raccoon, opossums, armadillos, and squirrels are all commonly found in the many types of wetlands throughout Mississippi. Raccoons are very capable predators of fish, crustaceans, and amphibians along river banks and small pools and depressions. Aquatic mammals such as muskrats and river otters can be found in more permanent wetlands associated with larger rivers and streams.

Problematic Animal Species.

Other species that can have a major impact on wetlands in Mississippi are not native to the region. Feral hogs can be found in virtually any environment with a dependable source of water. Generally, they prefer thickets in bottomland forests, canebrakes, or old fields. The feral hog was likely first introduced to the region during precolonial exploration. In Mississippi, these animals are often viewed as a pest rather than a game animal because of their negative impacts on agriculture, forest understory plants, and streams.

In 1939, nutria, a large aquatic rodent native to South America, was introduced to the southeastern United States via Louisiana as part of the expanding fur trade. Sometime prior to the 1960s they expanded their range into Mississippi. Nutria damage wetlands in two ways: eating and burrowing. While they have a similar diet to that of muskrats, nutria harvest far more vegetation than they actually eat. Nutria grazing can clear large patches of wetland vegetation in a single season, and continued grubbing can make reestablishment of vegetation difficult. Over the course of a few growing seasons, such behavior can drastically change the herbaceous vegetation in managed wetlands, potentially leading to erosion and wetland degradation. Aerial surveys in 2004 revealed a staggering estimate of 60,000 acres of nutria-damaged coastal wetlands.

Unlike alligator wallows, nutria tend to burrow horizontally into banks. In wetlands managed with low-elevation levee systems, nutria burrowing can cause levee breaches, possibly leading to flooding of adjacent areas and disruption of water management for waterfowl

habitat. Nutria are largely confined to the Mississippi Delta and Gulf counties, but increased hurricane activity and recent flooding of the Mississippi River could expand their range inland. Landowners should remain vigilant to their presence, as these nuisance animals are difficult to eradicate once a viable population is established. Trapping is commonly used to control nutria populations, but, unlike wild hogs, nutria do have predators in their introduced ranges. In a recent study, approximately one in three alligators trapped in southern Louisiana had nutria in their bellies.

WETLAND MANAGEMENT IN MISSISSIPPI

The key for proper wetland management is to understand that wetlands are ecologically different

PROFESSIONAL EXPERTISE IN WETLAND MANAGEMENT

Mississippi has many state and federal agencies that are available to assist landowners seeking technical guidance in the management of all types of wetlands.

Federal Agencies

Environmental Protection Agency, Region 4
www2.epa.gov/aboutepa/about-epa
-region-4-southeast

U.S. Fish and Wildlife Service
(Ecological Services)
www.fws.gov/mississippiES

U.S. Department of Agriculture Natural
Resources Conservation Service
www.ms.nrcs.usda.gov

U.S. Army Corps of Engineers
Vicksburg District (western Mississippi):
www.mvk.usace.army.mil
Mobile District (eastern Mississippi):
www.sam.usace.army.mil
Memphis District (extreme northern
Mississippi): www.mvm.usace.army.mil
Nashville District (extreme northeastern
Mississippi): www.lrn.usace.army.mil

State Agencies

Mississippi Department of
Environmental Quality
www.deq.state.ms.us

Mississippi Department of
Marine Resources
www.dmr.ms.gov

Mississippi Department of
Wildlife, Fisheries, and Parks
www.mdwfp.com

Mississippi State University
Extension Service
www.msucares.com

Nongovernmental Organizations

Wildlife Mississippi
www.wildlifemiss.org

Delta Wildlife
deltawildlife.org

Ducks Unlimited
www.ducks.org/Mississippi

Nature Conservancy of Mississippi
www.nature.org/ourinitiatives/regions/
northamerica/unitedstates/mississippi

Audubon Mississippi
ms.audubon.org

Mississippi Land Trust
www.misslandtrust.org

Mississippi River Trust
www.mississippirivertrust.org

from open-water systems, therefore requiring different management regimes. Some elements of an open-water system can exist in a wetland environment, and they do occur in many situations throughout the year, such as flooding of sloughs during the winter and early spring. Wetlands, however, are inherently more ecologically and hydrologically dynamic. Therefore, landowners interested in wetland management need to consult with natural resource professionals that specialize in wetland management when seeking assistance.

The dynamic nature of wetlands and the diversity of wetland types in Mississippi require a great deal of planning by landowners and natural resource professionals. Developing a comprehensive wetland management plan will help to ensure that all aspects of the plan have been met.

Getting Started

There are two crucial steps in developing a management plan for a proposed wetland management project. First, the landowner must determine if the selected area or property is currently a wetland. For confirmation, contact the local Natural Resources Conservation Service office and local representative of the U.S. Army Corp of Engineers, who are responsible for issuing permits for wetland activities. All federal and state laws should be followed when managing moist-soil areas. Second, if the selected area or property is not a wetland, the landowner must determine if it has the necessary physical attributes to create seasonal wetlands.

Several questions about the site that should be addressed:

♦ Is the rainfall generally adequate, or is a reliable water supply for flooding available?
♦ Do the soils have low permeability to inhibit subsurface water loss and ensure proper water control?
♦ Will a water-control structure be needed for raising and lowering the water levels?

These questions can be answered by consulting with a professional wetland biologist and/or engineer early in the planning process.

Evaluation results will greatly affect which practices, if any, can be enacted because of legal or physical restrictions associated with the proposed project area.

The next step is to determine the intended management purpose of the natural or man-made wetland. If the purpose is to provide wetland habitat for wildlife, the landowner should consider whether the wetland is intended to provide autumn and winter habitat for migrating waterfowl and other waterbirds, or whether it is aimed at more general wildlife purposes, such as creating habitat for amphibians, reptiles, and other wetland-specific animals. In contrast, the primary purpose may be to protect water quality from erosion and stormwater runoff in agricultural or urban areas. Once these steps are completed, the landowner can begin to make specific management decisions for the selected area aimed at achieving the desired outcome.

Managing Wetlands for Wildlife

Managing natural and man-made wetlands for wildlife requires that many factors be considered, including the specific types of wetlands that are legally allowed to be manipulated, water level management, the timing of water level management, vegetation responses to manipulation, and the responses of specific wildlife to these actions. In this section we discuss widely successful practices used throughout Mississippi by land managers and landowners alike. It is important to note that site-specific characteristics including soil type, topography, historical land use, weather, and other factors will determine the success of management activities on a given property.

Several wetland types in Mississippi lend themselves to active management. These include green tree reservoirs, beaver ponds, and man-made moist-soil units.

Green Tree Reservoir.
A green tree reservoir is a typical bottomland hardwood forest that is manipulated to be seasonally flooded and drained via systems of levees and water-control structures. These systems are usually complemented by one or more

canopy openings that are planted as food plots or managed for native herbaceous vegetation.

Green tree reservoirs should be flooded only when vegetation is dormant, usually between December 1 and March 15. Landowners should avoid flooding and draining at the same time each year. In addition, water depth and duration of flooding should be changed annually. Reservoirs need to be left dry one in every 4 years to reduce flooding damage and to encourage a wide diversity of plants.

Early-autumn flooding can be more harmful than flooding in late spring. Improper flooding will cause tree stress. Over time, this will kill oaks—which are desirable for acorn production for wildlife and timber production for income—and favor flood-tolerant trees such as tupelo and cypress. Landowners should monitor trees in the green tree reservoir for signs of stress and improper flooding techniques. Key flooding stress indicators include swollen and cracked tree trunks at water level, acorn crop failure, dead branches, and yellowish leaves during the growing season.

When planting a new green tree reservoir or providing supplemental trees in an existing reservoir, it is important to select tree species that provide food and winter cover and can tolerate the negative effects of flooding, to ensure longevity of the stand. The hard mast produced (predominantly by Nuttall, water, and willow oaks) provides food for common species of ducks, as well as cover during inclement winter weather. Wood ducks, in particular, use cavities in mature trees for nesting, although these cavities may be more common in trees other than oaks, suggesting that a more diverse stand of trees may attract more ducks. (For more information specific to waterfowl, see chapter 11.)

Beaver Ponds.
Beavers are prevalent throughout North America, and the ponds they construct can benefit waterfowl during breeding, migrating, and wintering periods. Mismanaged beaver populations, however, can severely degrade water course habitats and become a costly problem. The key to successfully managing beavers for

A recently planted hardwood stand that will become a green tree reservoir in 20 to 30 years. Photo courtesy of Heath M. Hagy, Illinois Natural History Survey

A beaver pond with multiple pools. Photo courtesy of Heath M. Hagy, Illinois Natural History Survey

waterfowl benefits is understanding the value of beaver ponds in meeting the seasonal needs of waterfowl.

Beaver ponds provide a mosaic of environmental conditions, depending on pond size and age, successional status, soil, and hydrologic characteristics. This system is rich in aquatic invertebrates, plant seeds, tubers, and winter buds and rhizomes for all wildlife, especially wintering waterfowl.

Despite the benefits of stable water levels and abundant herbaceous plant growth in the breeding season of waterfowl, the productivity of this system is reduced when beaver ponds are maintained over several years. The decline is primarily caused by stable water levels and limited flow, which results in oxygen-depleted conditions and high levels of organic material. The lack of oxygen causes nutrients to leach into subsurface water, pass into the atmosphere, or bind to the soil and organic matter, thereby making them unavailable to plants and animals.

Artificially increasing flow rates may help increase the decay of organic buildup, but the best approach is to periodically drain or reduce the water levels in beaver ponds to promote the decay and to reverse wetland succession.

The interval between drawdowns is difficult to prescribe because the need for such action depends on the length of the warm season, water temperature, pond size, organic load, and water flow rates.

Drawing down a beaver pond is often easier said than done because of the natural tendency of beavers to quickly plug any breach in their dam. Explosives or backhoes can be used to remove dams, but this often becomes an ongoing process because dams are quickly reconstructed. Landowners should consult with a professional engineer when removing beaver dams for a multitude of safety concerns, including the use of explosives, operating heavy equipment in sensitive areas, and potential flooding danger to properties downstream.

A smarter and more controlled option for landowners is installing a beaver-resistant water control structure in the dam. When installed properly, these devices allow for safe and precise control over water levels in a given pond. Only a fraction of the wetlands in a beaver pond complex should be dewatered during a given year to ensure adequate habitat for waterfowl and beavers in the remaining ponds.

Management strategies for migrating and wintering waterfowl should be based on the characteristics of beaver ponds. Three types may be noted: (1) few emergent plant species and shallow water areas, but with the potential for manipulating the water level; (2) abundant emergent plant species and shallow water, with the potential for manipulating the water level; and (3) no possibilities for drainage.

Ponds of the first type, which are common in Mississippi, are best managed by lowering the water level to allow germination of seed-producing annual plants that are beneficial to waterfowl. This technique, known as moist-soil management, relies on the timing and duration of drawdown to promote the germination and growth of seeds already in the soil. In rare instances, when desirable aquatic vegetation is absent and the seed bank is inadequate, commercially available seed can be used. Although moist-soil plants typically do not attain high seed production, they do support high densities of aquatic invertebrates and provide seeds

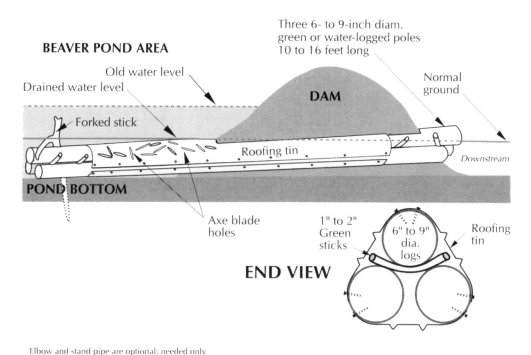

A three-log drain is a simple system made of common farm materials to control the water level in beaver ponds. Reprinted from Arner, D. H., J. Baker, and D. E. Wesley. 1966. *The Management of Beaver and Beaver Ponds in the Southeastern United States.* Water Resources Research Institute, Mississippi State University.

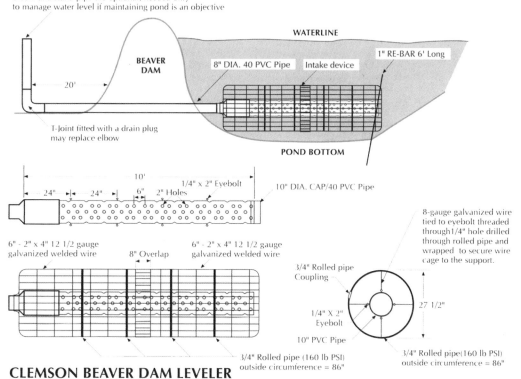

A Clemson beaver pond leveler is used for controlling water levels. Adapted from *Waterfowl Habitat Management Handbook for the Lower Mississippi River Valley.* Publication 1864, Mississippi State University Extension Service

of a better nutritional balance than many commercially available plants.

Beaver ponds with an abundance of desirable emergent plants are best left undisturbed. If undesirable plants are present, however, managers can alter the vegetative composition by water level manipulations, mechanical disturbance, burning, or herbicide application. Water level control is most easily achieved with beaver-proof control structures. The aim of both mechanical disturbance and burning is to retard vegetation growth and open dense stands

A flooded moist-soil unit during the winter. Photo courtesy of Heath M. Hagy, Illinois Natural History Survey

of vegetation. To effectively change plant composition, burning or mechanical treatments must damage the roots of plants. Both of these practices require dry soil conditions and are conducted in late winter or early spring after the water is drawn down. In limited cases, herbicides can be used to control plants where such use is permitted. Managers should make certain that the herbicide of choice is approved for aquatic use and applied at proper rates by a licensed applicator (refer to *Waterfowl Habitat Management Handbook for the Lower Mississippi River Valley*. Publication 1864, Mississippi State University Extension Service).

Impounded areas without drainage most commonly occur in cypress-tupelo wetlands where there is insufficient elevation change to use hidden drains. If the canopy of trees provides too much shade to allow aquatic plants to become established, it may be beneficial to clear small openings to help vegetation become established.

Man-made Moist-Soil Units

Moist-soil management is the drawdown of water to promote the growth of native plants on exposed mudflats and the subsequent reflooding of the same areas. Native plants favored by moist-soil management provide valuable food and cover for wetland wildlife. Seasonally flooded moist-soil areas also provide an abundance of aquatic invertebrates that are eaten by wildlife. This practice provides food and habitat for waterfowl, wading and shorebirds, reptiles, amphibians, and other wetland wildlife.

One of the benefits of moist-soil impoundments dominated by native plants is the survivability of the native seeds under long-term flooding regimes (several months or even years). This important trait of native seeds allows for long-term food stores for wetland wildlife and provides a viable seed bank for many years. Another key management benefit is that adverse weather has a lesser effect on production, because the diverse natural flora includes species

that produce well under a variety of environmental conditions. For example, water-tolerant or wetland-adapted plants such as smartweeds, barnyardgrasses, and spikerushes are productive during wet years. Beggarticks thrive on drier sites, and crabgrasses and panicgrasses do well under more intermediate moisture conditions. Because of this diversity, crop failures are less likely to occur in moist-soil management units than in flooded agricultural fields.

The total energy in moist-soil foods often is as high, if not higher than, energy from corn, milo, or soybeans. Unfortunately, little information is available on the true available energy in naturally occurring foods for waterfowl, songbirds, and mammals. However, many naturally occurring foods are known to contain essential nutrients that are not present in domestic grains. In addition, these diverse systems provide habitat for invertebrates, reptiles, and amphibians, which serve as important prey species for waterfowl, raptors, herons, and other wildlife.

MANAGEMENT OF MOIST-SOIL UNITS

Man-made impoundments provide more management flexibility to the landowner than natural wetlands because there are not as many legal restrictions regarding manipulation as there are with their natural counterparts. However, this flexibility requires the same, if not more, understanding of the natural processes of these systems.

The inherent complexity of moist-soil units—whether managing several on a single property or a combination of natural and man-made seasonal wetlands—can be overwhelming at first. Developing a master plan (including management objectives for each unit) helps the landowner gain confidence in the project and provides a blueprint for meeting goals set for the property. Regularly inspecting units and maintaining good records of management activities, weather, vegetation, and wildlife response throughout the calendar year and over several years will provide invaluable site-specific information for future management. The following sections describe these management techniques and common vegetation and wildlife responses to the technique that should be documented in annual records.

Water Level Management

Managing the water level in an individual moist-soil unit should be viewed as a continuum, creating conditions that are not necessarily desirable to maintain for extended periods. Wetland plants and wildlife are well-adapted to the dynamic nature of water fluctuations in natural wetlands. Because the topography within the impoundment basins is usually uneven, water depths are variable and provide depths suitable for more than one group of species when the impoundments are flooded. Furthermore, properties with several managed moist-soil areas with different drawdown rates and dates can provide maximum plant diversity and wildlife benefits year-round.

Drawdown.
Drawdown refers to total dewatering, whether rapid or incremental, to promote the growth of plants adapted to germinate in saturated soils and to provide the appropriate environment for associated wildlife. The drawdown process

A moist-soil unit drawn down in early summer promotes plant growth. Photo courtesy of Heath M. Hagy, Illinois Natural History Survey

Table 7.1. Germination timing, best timing for drawdown and most suitable soil moisture content to achieve the best seed production, and wildlife value of common moist-soil plants in Mississippi

Plant	Germination			Drawdown [a]			Moisture			Wildlife value	
	Early	Mid	Late	Early	Mid	Late	Dry	Moist	Wet	Food	Habitat
Sprangletop			•			•		•		•	•
Crabgrass		•			•	•	•			•	•
Panicgrasses	•	•	•		•	•	•			•	•
Barnyardgrass	•		•		•	•		•		•	•
Spikerush	•	•	•	•	•	•	•			•	
Beakrush		•				•		•	•	•	•
Common rush		•		•				•		•	•
Red-rooted sedge		•				•			•	•	•
Common burhead		•						•	•	•	
Pennsylvania smartweed	•		•	•				•		•	•
Curltop ladysthumb	•		•					•		•	
Dock	•		•	•			•			•	
Marsh purslane	•				•	•		•	•	•	
Beggarticks		•	•		•	•	•	•		•	
Swamp milkweed		•				•		•			•
Morningglory		•	•		•		•	•		•	
Buttonbush						•			•	•	•
Black willow	•			•				•		•	
Green ash	•							•		•	
Common ragweed		•	•		•		•			•	
Cocklebur		•	•		•			•		•	
Sneezeweed		•	•		•	•	•	•			
Sesbania		•	•		•	•					

[a] Early, March 15 to May 1; Mid, May 1 to July 15; Late, after July 15.

U.S. Department of Agriculture Natural Resources Conservation Service, Mississippi Division. 2000. *Moist-Soil Management for Wildlife*. Publication MS-ECS-646-01.

in moist-soil units provides constantly changing water conditions that promote the germination and growth of a wide variety of plants. The process also creates timely habitat conditions that can be exploited by a variety of wildlife; for example, autumn drawdowns concentrate prey in both space and time for the arrival of migrating waterbirds.

There are two general considerations for drawdowns: the rate at which the area is dewatered and the time of year the drawdown occurs. Both these factors produce different results for the plant and wildlife communities.

For example, in slow drawdowns, impoundments are gradually drained during a period of 2 weeks or more. This approach allows use by a diversity of wildlife species over an extended period of time. In addition, slow drawdowns, when applied at the correct time of year, allow for germination of a greater diversity of preferred plant species.

Fast drawdowns occur within a few days and simultaneously produce similar water conditions over the entire impoundment. Fast drawdowns late in the season may produce less desirable vegetation than those early in the season.

Table 7.2. Response of common moist-soil plants to drawdown timing

Plant	Early [a]	Midseason [b]	Late [c]
Swamp timothy	+	+++	+
Rice cutgrass	+++	+	
Sprangletop		+	+++
Crabgrass		+++	+++
Panicgrass		+++	++
Wild millet (*Echinochloa crus-galli*)	+++	+	+
Wild millet (*E. walteri*)	+	+++	++
Wild millet (*E. muricata*)	+	+++	+
Red-rooted sedge		+++	
Chufa	+++	+	
Spikerush	+++	+	+
Pennsylvania smartweed	+++		
Curltop ladysthumb	+++		
Dock		+++	+
Sesbania	+	++	
Cocklebur	++	+++	++
Beggarticks	+	+++	+++
Aster	+++	++	+
Toothcup	+	++	+
Morningglory	++	++	

[a] Completed within first 45 days of the growing season
[b] Completed after first 45 days of growing season and before July 10
[c] Completed after July 10
+, fair response; ++, moderate response; +++, excellent response
Modified from Fredrickson, L. H., and T. S. Taylor. 1982. *Management of Seasonally Flooded Impoundments for Wildlife*. Resource Publication 148, U.S. Fish and Wildlife Service.

Yet, a fast drawdown rate may be necessary for other logistical purposes, such as levee repair, drain replacement, or other management needs. Regardless of whether a drawdown is slow or fast, total seed production usually is higher on impoundments after early drawdowns, but late drawdowns result in higher plant densities and greater species diversity.

Moist-soil areas do not have to be completely drained. A partial drawdown (one-fourth or one-half of the drain boards) of the area will provide moist-soil benefits while still producing late spring and summer habitat for wildlife. The remaining water will evaporate over time and sustain conditions favorable for the continued germination of preferred moist-soil plants. Any remnant pools will provide water for early bird migrants, mammals, reptiles, and amphibians in the late summer and early autumn.

Flooding.
Similar to incremental drawdowns, reflooding of moist-soil units or natural areas by pulsing water encourages the growth of important plant species along with making habitat and food available to wetland wildlife. Timing of flooding will depend on water availability (unless pumping from a well) and the management objectives set

by the landowner. Generally speaking, this takes place from mid-August through mid-December.

Vegetation Management

Identification of seedlings is essential if desirable species are to be encouraged and undesirable plants controlled. Landowners are encouraged to review the identification sources provided at the end of this chapter.

Generally speaking, plants regularly encountered on moist-soil areas are categorized by their suitability as food and habitat resources. Plants that address energy or nutritional needs for wildlife are considered desirable, whereas plants that interfere with such production are classified as undesirable. The latter often become dominant after repeated annual drainage of impoundments.

Even though plants have been placed in these categories, it is important to emphasize that some plants classed as undesirable for seed production might provide excellent cover. For example, plants such as cattails, trees, shrubs, and vines can create management problems on some sites but can be attractive to waterfowl in January and provide excellent cover for nesting songbirds in the spring.

If not managed properly, vegetation can become too thick for wildlife in a short time. Photo courtesy of Heath M. Hagy, Illinois Natural History Survey

Encouraging Desirable Vegetation.

Two important factors that determine plant responses to moist-soil manipulations are the timing of annual drawdowns and the stage of growth (number of years since the area was disturbed by disking or plowing, or the number of years since the impoundment was flooded continuously). For example, early drawdowns tend to stimulate germination of smartweeds on early-successional sites. However, smartweeds are less likely to respond to early drawdowns by the third year after the soil has been broken up by disking or continuous flooding was conducted. Midseason drawdowns result in millets, and late-season drawdowns tend to generate sprangletop, beggarticks, panicgrass, and crabgrass.

After germination and early growth, plants should attain a height of 4 to 6 inches before impoundments are reflooded. Barnyardgrass, sedges, and smartweeds respond well to shallow flooding (1 to 2 inches), but panicgrasses, crabgrasses, and beggarticks are less tolerant. Water depths should be 1 to 2 inches over as much of the area as possible so that the newly established plants will not be completely submerged for extended periods. Water levels can be increased gradually to a maximum of 6 to 8 inches as the desired plants grow, but should generally equal only about one-third of the total height of newly established moist-soil plants.

Complete submergence for longer than 2 or 3 days can retard the growth of millets, other grasses, and smartweeds. Water levels must be lowered if the majority of the desirable plants that are submerged do not reach the surface within the 2- to 3-day limit. If the plants develop a light-green cast, the water is probably too deep and should be lowered immediately. With experience, a manager can estimate the water tolerance of plants in an area and manipulate the water level accordingly.

Disturbance.

Once areas have been under moist-soil management for 4 years or more, there is a gradual increase in perennial species, including some excellent seed producers. Perennials such as rice

Disking is the preferred method for maintaining proper vegetation density in a moist-soil unit. Photo courtesy of Heath M. Hagy, Illinois Natural History Survey

Mowing is another option to maintain preferred plant species for waterfowl and wetland wildlife. Photo courtesy of Heath M. Hagy, Illinois Natural History Survey

cutgrass and marsh smartweed not only produce seeds but, like most other fine- or multi-leafed plants, also provide excellent habitats for invertebrates. Desirable seed-producing plants tend to decrease each year as an area is managed for moist-soil plants and the soil is undisturbed. Therefore, moist-soil areas should be broken up by disking or undergo prescribed burning every 2 or 3 years. This will also help to control the growth of undesirable woody plants.

Controlling Undesirable Herbaceous Vegetation. Some of the same techniques used to encourage desirable vegetation can also control

Table 7.3. Schedule of typical water level management in Mississippi

Timing	Rate	Activity	Purpose/result
March 15 to May 1	lowering levels every 4 to 10 days	early-season drawdown	high levels of seed production
	release of all water at once	fast drawdown	uniform stand of vegetation
May 1 to July 15	lowering levels every 4 to 10 days	midseason drawdown	favors desirable grasses
After July 15	lowering levels every 4 to 10 days	late-season drawdown	favors native grasses
August 15 to September 15	raising levels every 4 to 10 days	flooding (25%)	feeding areas for early migrators
October 15 to December 15	raising levels every 4 to 10 days	incremental flooding of remaining area	provides extended source of food and habitat

undesirable vegetation. Timing of reflooding is particularly important if undesirable herbaceous plants such as cockleburs or asters germinate before desirable species. Reflooding to shallow depths should then begin as soon as desirable species are established and begin to grow. Initially, water levels should be kept low (1 inch or less) so that growth of the desired vegetation is not inhibited by flooding.

Moist-soil manipulation (disking, for example) and carefully timed flooding over a series of years tend to result in abundant annuals, which are preferable when high seed production is the management goal. Perennials become increasingly common wherever moist-soil management has been practiced for several years without soil disturbance. Some perennials are excellent seed producers, and those that develop early in the season provide robust cover for migrating songbirds. On sites that are difficult to drain, however, the establishment of perennials with large underwater rhizomes may be not suitable because they often form dense stands and shade out food-producing species.

Mowing, mechanical chopping, shredding, and crushing followed by burning or flooding have been used to eliminate various types of low-value vegetation. Grazing can also provide moderate success in some situations.

Herbicides have a residual effect on some desirable moist-soil plants. The extent of the detrimental effects depends on the chemical, application rate, and time elapsed since the chemical was last used. Managers should not expect maximum production on such sites until the herbicides have decomposed or flushed from the soil. It is important to read the product label to first determine whether the chemical to be applied is intended for use in terrestrial, wetland, or aquatic systems; if wetland use is appropriate, carefully follow the instructions regarding the quantity of product, rate of application, and type of application (such as spray or wick).

Controlling Undesirable Woody Growth.
Early drawdowns restrict the germination of woody species adapted to wet sites. However, irrigation may then be required to stimulate germination of seed-producing plants during dry seasons.

Impoundments in areas where moist-soil management has been initiated within the past 5 to 7 years should be disked once every 3 years to control woody growth and to stimulate seed production of annuals. Once an area has been managed for moist-soil plants longer than 5 to 7 years, there appears to be less need for soil disturbance.

Plant Litter.
If the accumulation of plant litter in an area becomes excessive, germination and growth of desirable plants may be reduced because of shading. Litter can be burned and the soil exposed, a practice used extensively in the

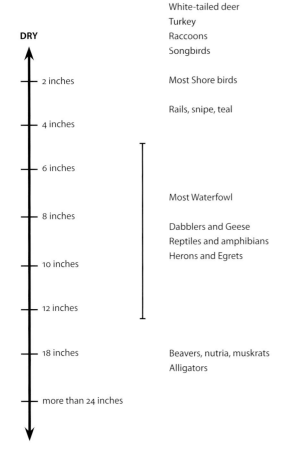

DRY

— 2 inches

— 4 inches

— 6 inches

— 8 inches

— 10 inches

— 12 inches

— 18 inches

— more than 24 inches

White-tailed deer
Turkey
Raccoons
Songbirds

Most Shore birds

Rails, snipe, teal

Most Waterfowl

Dabblers and Geese
Reptiles and amphibians
Herons and Egrets

Beavers, nutria, muskrats
Alligators

Water-level continuum for various species of wildlife.

southern coastal regions to set back succession. When possible, a burn should be conducted in early spring after the vegetation dries and before new germination occurs.

Manipulating Water Levels for Wildlife

Management practices often revolve around a set calendar date, although exact timing varies with latitude, local climatic conditions, and hunting seasons. Because environmental variations are an inherent part of habitat management, managers should adopt a flexible framework based on climate and the life histories of plants and animals, rather than on a set calendar date. Making use of plants or wildlife as indicators for specific habitat manipulations will greatly improve outcomes. For example, the arrival of a shorebird species in spring might be used as a cue that a series of habitat manipulations should be started.

Autumn Flooding and Winter Impoundment.
The flooding of moist-soil areas in autumn can be timed based on the arrival of waterfowl. Impoundments can begin to be flooded incrementally over 4 to 10 days to a depth of 4 to 10 inches across a single unit. If several units are available, staggering the flooding timing and

White ibis and juvenile white-faced ibis commonly use exposed mudflats of natural wetlands and drawn down moist-soil units. Photo courtesy James Faega, Mississippi State University

levels is recommended to provide habitat diversity and access to food throughout the winter.

Spring Drawdown.

After an early-spring drawdown, most areas within an impoundment are nearly devoid of old vegetation. This situation is ideal for shorebirds because they respond well to shallow water zones that are interspersed with mudflats. The most attractive water depths are between 1 and 2 inches. However, on some sites within each impoundment (especially on sites that are flooded to shallow depths), new growth of spikerushes, old clumps of soft rushes and bulrushes, as well as the stems and blades of grasses and sedges provide concealment for rails and late-wintering passerines. Like waterfowl, shorebirds have preferred feeding depths. Because most of the emergent vegetation has often been eaten by waterfowl or flattened by wind and wave action by early spring, shorebirds often find an ideal habitat when they arrive.

Gradually fluctuating water levels maximize the potential for use by shorebirds. For example, a slow drawdown concentrates shorebirds in the zone of shallow water near mudflats. Changing water levels daily or continuously can provide the largest effective area of this zone. As habitat conditions deteriorate in the initial units, properties with several moist-soil units can be manipulated by managing water levels to maintain shorebird concentrations for longer periods.

Grasses, rushes, sedges, arrowheads, and water plantains provide emergent cover. These flooded sites with diverse vegetative cover are ideal for insects. Swallows, chimney swifts, and eastern kingbirds feed over these areas and rest on the emergent vegetation. Exposed mudflats make seeds, invertebrates, and lower vertebrates (small fish, reptiles, and amphibians) available to a variety of wildlife, including foraging songbirds, blackbirds, crows, raptors, egrets, herons, and raccoons.

SUMMARY

Wetlands are incredibly diverse ecosystems that are vitally important to many wildlife and fish

species in Mississippi. Furthermore, these systems play an important role in protecting water resources important for drinking water, food, and recreation that sustain Mississippi's citizenry and modern economy. Because the majority of the land in Mississippi is privately owned, it is imperative that landowners not only understand but also embrace this tremendous responsibility when managing wetlands on their properties.

For More Information

Arrington, D. A., L. A. Toth, and J. W. Koebel Jr. 1999. Effects of rooting by feral hogs (*Sus scrofa* L.) on the structure of a floodplain vegetation assemblage. *Wetlands* 3:535–544.

Barnes, W. T., and E. Dibble. 1988. The effects of beaver in riverbank forest succession. *Canadian Journal of Zoology* 86:484–496.

Bastian, R. K., and J. Benforado. 1988. Water quality functions of wetlands: natural and managed systems. Pp. 87–97 in D. D. Hook, W. H. J. McKee, H. K. Smith, et al., eds. *The Ecology and Management of Wetlands.* Vol. 1. *Ecology of Wetlands.* Portland, Ore.: Timber Press.

Borst, M., A. L. Riscassi, L. Estime, and E. L. Fassman. 2002. Free-water depth as a management tool for constructed wetlands. *Journal of Aquatic Plant Management* 40:43–45.

Cooper, C. M., and M. T. Moore. 2003. Wetlands and agriculture. Pp. 221–235 in M. M. Holland, E. R. Blood, and L. R. Schaffer, eds. *Achieving Sustainable Freshwater Systems: A Web of Connections.* Washington, D.C.: Island Press.

Cowardin, L. M., V. Carter, F. C. Golet, and E. T. LaRoe. 1979. *Classification of Wetlands and Deepwater Habitats of the United States.* Publication FWS/OBS-79/31. Washington, D.C.: U.S. Fish and Wildlife Service.

Dahl, T. E., and C. E. Johnson. 1991. *Status and Trends of Wetlands in the Conterminous United States: Mid-1970s to Mid-1980s.* Washington D.C.: U.S. Fish and Wildlife Service.

Dodds, W. K., and M. R. Whiles. 2010. *Freshwater Ecology: Concepts and Environmental Applications of Limnology.* Amsterdam: Elsevier.

Fisher, J., and M. C. Acreman. 2004. Wetland nutrient removal: a review of the evidence. *Hydrology and Earth System Sciences* 8:673–685.

Gray, M. J., H. M. Hagy, J. A. Nyman, and J. D. Stafford. 2013. Management of wetlands for wildlife. Pp. 121–180 in C. A. Davis, J. T. Anderson, and W. Conway, eds. *Wetland Techniques.* Oak Park, Ill.: Bentham Science, Ltd.

Hook, D. D. 1993. Wetlands: history, current status and future. *Environmental Toxicology and Chemistry* 12:2157–2166.

Jordan, F., H. L. Jelks, and W. M. Kitchens. 1997. Habitat structure and plant community composition in a northern Everglades wetland landscape. *Wetlands* 17:275–283.

Kröger, R. 2008. Agricultural wetlands. Pp. 391–406 in R. E. Russo, ed. *Wetlands: Ecology, Conservation, and Restoration.* New York: Nova.

Kröger, R., M. M. Holland, M. T. Moore, and C. M. Cooper. 2007. Hydrological variability and agricultural drainage ditch inorganic nitrogen reduction capacity. *Journal of Environmental Quality* 36:1646–1652.

Kröger, R., M. M. Holland, M. T. Moore, and C. M. Cooper. 2008. Agricultural drainage ditches mitigate phosphorus loads as a function of hydrological variability. *Journal of Environmental Quality* 37:107–113.

Madramootoo, C. A., G. T. Dodds, and A. Papadopoulos. 1993. Agronomic and environmental benefits of water-table management. *Journal of Irrigation Drainage Engineering* 119:1052–1065.

Mitsch, W. J., and J. G. Gosselink. 2000. *Wetlands*, 3rd ed. New York: John Wiley and Sons.

Moore, M., T. R. Kröger, M. A. Locke, R. F. Cullum, R. W. Steinriede Jr., S. Testa, J. R. E. Lizotte, C., T. Bryant, and C. M. Cooper. 2010. Nutrient mitigation capacity in Mississippi Delta, USA drainage ditches. *Environmental Pollution* 158:175–184.

Nelms, K. D., B. Ballinger, and A. Boyles, eds. 2007. *Wetland Management for Waterfowl Handbook.* U.S. Department of Agriculture Natural Resources Conservation Service, www.mdwfp.com/media/8838/wetlandmgtforwaterfowl.pdf.

Poach, M. E., and S. P. Faulkner. 2007. Effect of river sediment on phosphorus chemistry of similarly aged natural and created wetlands in the Atchafalaya Delta, Louisiana, USA. *Journal of Environmental Quality* 36:1217–1223.

Schummer, M. L., H. M. Hagy, K. S. Fleming, J. C. Cheshier, and J. T. Calicutt. 2011. *A Guide to Moist-Soil Wetland Plants of the Mississippi Alluvial Valley.* Jackson: University Press of Mississippi.

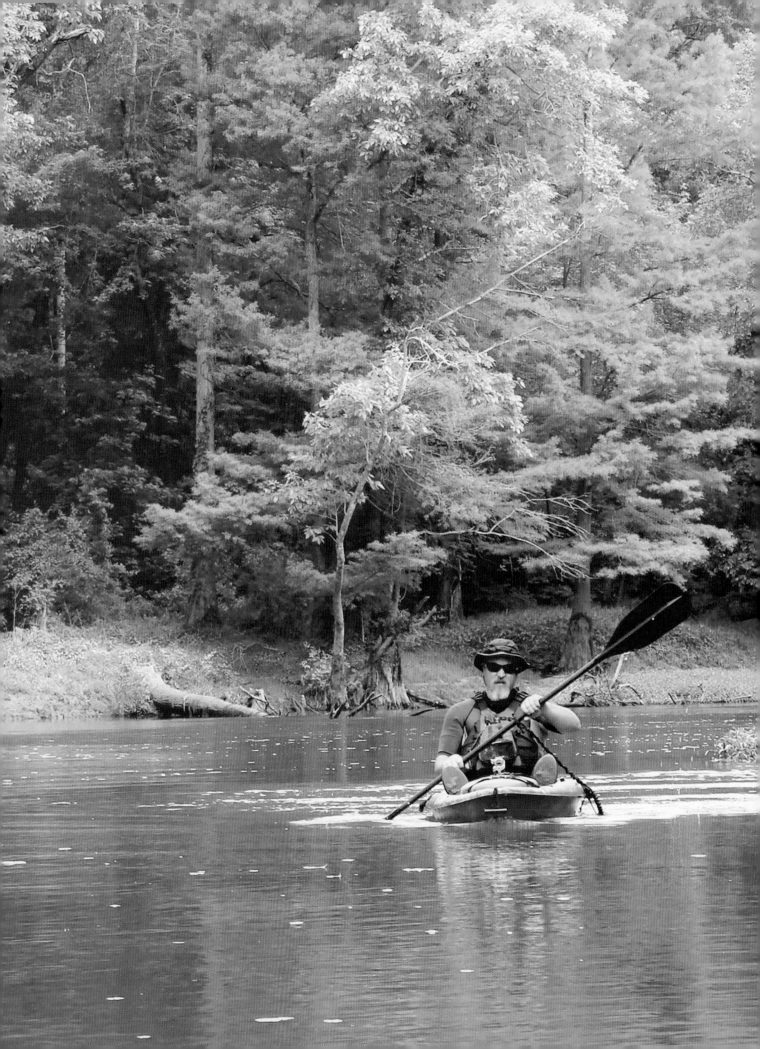

Andrew E. Whitehurst,
Conservation Biologist
(formerly), Mississippi Museum
of Natural Science, Mississippi
Department of Wildlife,
Fisheries, and Parks

Technical editor
Adam T. Rohnke, Wildlife
 Extension Associate,
 Department of Wildlife,
 Fisheries, and Aquaculture,
 Mississippi State University

CHAPTER 8

Managing Streams and Rivers

Mississippians have long felt a strong connection to streams and rivers, which run through our history, our literature, and our personal experiences. Streams and rivers support a rich variety of fish, other aquatic animals, and plants, while their floodplains and hardwood bottomlands provide essential high-quality wildlife habitat for deer, turkeys, rabbits, squirrels, most of the state's migratory and native songbirds, and countless other varieties of wildlife.

Many of Mississippi's streamside landowners take great pride in owning land along the numerous waterways of the Magnolia State. With that ownership comes additional responsibilities and considerations for protecting the public waterways all Mississippian's rely on in their daily lives. Most landowners don't view this as burdensome, but more as a badge of honor.

Streamside landowners have tremendous opportunity to be good stewards of the water, land, and wildlife within the stream and along its banks. Such landowners often want their land to generate income for them, but the water is a shared resource. The nature of flowing water as a common resource brings with it certain ethical obligations of stewardship and the need to adhere to applicable laws regarding water pollution. Land management decisions along the stream will have effects downstream and, in some cases, upstream as well. Landowners can profitably manage their streamside property, while also maintaining habitat for wildlife and protecting the physical and biological integrity of the stream.

Our contemporary appreciation of streams is for their natural beauty and for the fish and wildlife resources they sustain. We in Mississippi recognize that healthy streams have an intrinsic value beyond the growing commercial

A shaded stream in
Mississippi. Photo
courtesy of Steven
Gruchy, Wildlife
Mississippi

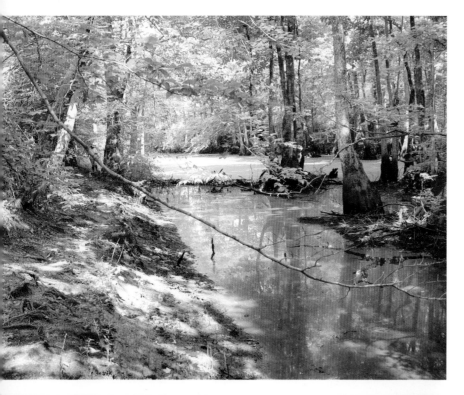

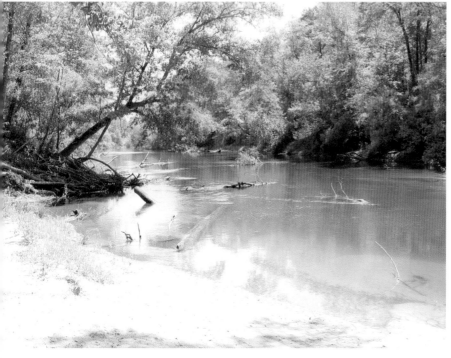

Diverse habitats including bottomland hardwood sloughs, floodplains, and slow-moving streams are associated with Mississippi waterways. Photos courtesy of Mississippi Department of Wildlife, Fisheries, and Parks

recommended forestry best management practices when harvesting timber or clearing land.

Our hope is that by learning more about the value of healthy streams and the dependence of stream fish and aquatic life on water quality and bank stability, landowners will choose to protect streams by incorporating conservation techniques into their present and future land management activities.

MISSISSIPPI'S PUBLIC WATERWAYS LAW

Landowners along Mississippi streams are in a special category because, in many cases, they are tax-paying private owners of the land along and under stream beds. The water itself is a public resource under the Public Waterway Law (Mississippi Code section 51-1-4). Mississippi streams that have a mean annual flow of 100 cubic feet per second are considered public waterways. Citizens have an implicit, historical right to use these bodies of water, and this has been accepted as common law since statehood. Nineteenth-century navigation laws secured streams for use as highways for commerce, whereas modern public waterway law ensures recreational rights such as free transport on the water and freedom to fish and engage in water sports such as canoeing, swimming, or inner-tubing. On streams too small to be considered public waterways, there is no public right of use attached to the water and permission is needed from private landowners to use these streams. (For information on public waterways in Mississippi, visit the Mississippi Department of Environmental Quality at www.deq.state.ms.us.)

STREAM CHANNEL PROCESSES AND BANK STABILITY

enterprises and human activity they support today. Many statewide organizations have invested heavily in the promotion of nonregulatory, voluntary conservation measures on private land that protect stream water quality and bank stability, such as the adherence to

Streams are broadly classified according to their bed materials and temperature. Whether a stream is classified as bedrock or alluvial depends on the geology of the basin through which the stream flows. Coldwater streams can support trout and salmon year-round. Warmwater streams, such as ours in Mississippi,

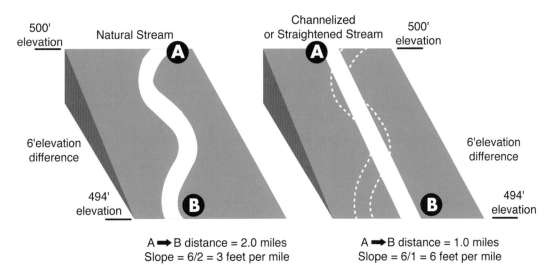

500'
elevation

Natural Stream

A

6'elevation
difference

494'
elevation

B

A ➡ B distance = 2.0 miles
Slope = 6/2 = 3 feet per mile

Channelized
or Straightened Stream

A

500'
elevation

6'elevation
difference

494'
elevation

B

A ➡ B distance = 1.0 miles
Slope = 6/1 = 6 feet per mile

Channelization of streams causes a dramatic change in slope of the overall stream section that has been altered, often resulting in stream-bed scour and other erosional issues. Adapted from *Mississippi Streamside Landowner's Handbook*, Mississippi Department of Wildlife, Fisheries, and Parks

support species such as bass, catfish, and sunfish. Classic coldwater mountain trout streams that have large boulders and flow over rocky beds usually fit the bedrock type. Alluvial streams like ours in Mississippi flow through deposits of sand, silt, and clay and move this material (called alluvium) downstream in a constant process of shaping and reshaping their beds, banks, and floodplains. The water deposits some of this material in the beds, and when the streams overflow their banks, the alluvium gets deposited in the floodplains. The Mississippi River is a big alluvial stream that, over history, has built natural levees along its banks and delta at its mouth. Over thousands of years it has moved its channel laterally (east to west) hundreds of miles. The Pearl and the Pascagoula Rivers are warm-water alluvial streams.

All streams, whether alluvial or bedrock, have four basic characteristics that define them: slope, discharge, sediment load, and particle size. Slope describes the vertical drop of a stream from its headwaters to its mouth or to the sea. Slope is the proportion of fall to run. For example a 1-foot drop over 100 feet of length gives a 1/100 or 1 percent slope. Discharge is the volume of water carried by the stream, measured as cubic feet per second. Sediment load and particle size describe the amount and size of the silt, sand, gravel, rocks, and other substances picked up and moved by flowing water. Slope, discharge, sediment load, and particle size influence one another. A channel will remain

stable if changes in sediment load and particle size are balanced by changes in water discharge and slope.

When slope, discharge, or sediment characteristics are changed, a channel will respond in one of two ways: degradation (picking up sediment or bed scour across the system) or aggradation (deposition of sediment across the system). A degrading channel cuts into its bed when increased flow picks up bed materials and moves them. An aggrading channel has its bed built up as flow decreases and drops sediment. For instance, the discharge of a stream can be decreased by diverting some of its water, perhaps for irrigation or industrial use. With less discharge, water moves more slowly, and the stream may deposit more of its load of sediment and suspended materials on its bed. Channelizing a stream by straightening (cutting across bends) and deepening a section of it will have the opposite effect.

In a channelized stream section, slope is altered. Compared to the natural, unchannelized condition, water will fall from a higher elevation to the lower elevation over a shorter distance. If a mile of bends is bypassed by channelizing and straightening, a stream that used to drop 6 feet in 2 miles now drops that same 6 feet in 1 mile. The water will be moving faster and can carry more material. This stream will begin cutting a deeper channel where the water runs faster. Sediment will then begin to move or slough from above the

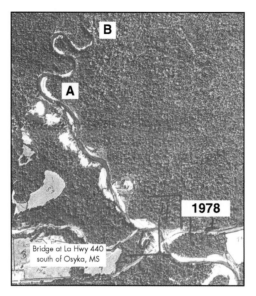 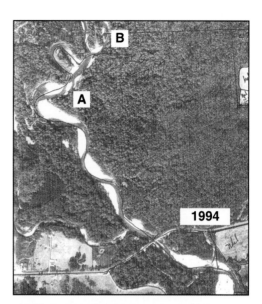

Headcutting on the Tangipahoa River between 1978 and 1994. Note the widening of sandbars and loss of forest canopy as the headcut migrates upstream, leaving new sandbars where forests once grew. Photo courtesy of Mississippi Department of Wildlife, Fisheries, and Parks

A stream bank that has become unstable because of headcutting and other negative impacts. Photo courtesy of Robert Kröger, Mississippi State University

deepened or straightened section. This system-wide sloughing is a form of accelerated erosion that is referred to as "headcutting" because of the tendency for the sloughing to work its way upstream or toward the headwaters of a stream. A local term for headcutting is "blowout."

Other activities besides channelization can cause headcutting, including natural occur-

rences such as increased runoff after fires in the watershed. For example, scooping sand or gravel from a stream bed and trenching across it to bury a pipe can initiate headcuts. When a hole or trench is dug in the bed of the river, it can create a knickpoint, a disturbed area that alters the flow of water along a stream bed, often increasing the erosive energy and turbulence of the

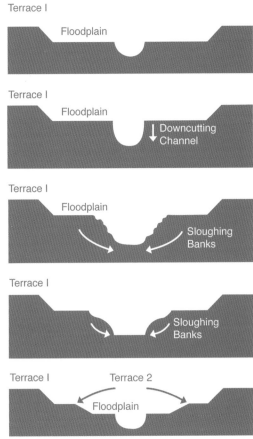

Terrace I
Floodplain

Terrace I
Floodplain
↓ Downcutting Channel

Terrace I
Floodplain
Sloughing Banks

Terrace I
Sloughing Banks

Terrace I Terrace 2
Floodplain

The five stages of the channel evolution model. Adapted from *Mississippi Streamside Landowner's Handbook*, Mississippi Department of Wildlife, Fisheries, and Parks

water. As a result, the disturbed area becomes larger as the stream bed erodes in the upstream direction, removing these bed materials and carrying them downstream. As the knickpoint migrates, it can cause the banks along the channel to become unstable and slough down so that the next flood will wash them away. If a streamside is forested, the banks above a headcut will become unstable as the sand washes out and the trees will topple into the stream. Headcutting is the same process as the creation of gullies on land. Gullies stop migrating upslope in a field when the rainfall stops. However, headcuts have a constant source of erosive energy as long as the stream flows.

This general pattern of headcutting and channel response was described in the channel evolution model. The model breaks the process down into five stages: (1) stable, (2) incision,

(3) widening, (4) stabilizing, and (5) stable. Over time, the stream cuts down in its bed in response to some change or disruption of its equilibrium.

HISTORICAL STREAM DISTURBANCE IN MISSISSIPPI

In the southeastern United States, in general, and in Mississippi, in particular, human activity has touched almost every stream. The land-use changes that have taken place in the past 250 years can be attributed to land clearing for agricultural activities, settlement patterns, timber harvest, road and railroad building, and the spread of towns and cities.

Settlement and development of land by Europeans first followed rivers and Native American trade routes. With the arrival of railroads in Mississippi in the 1830s, settlement followed along their routes. Forests were cut at a much faster pace than in pre-railroad times. In the 70 years from the end of the Civil War to the Great Depression, a majority of the old-growth pine and hardwood forests were cut and taken to mill and market by rail. Mississippi's pine and other southern-grown lumber helped build Chicago and countless other nineteenth-century American cities. It was also used to help rebuild Europe after both world wars.

Ox-drawn log carriages were used during the removal of virgin timber in southern Mississippi. Photo courtesy of Mississippi Forestry Commission

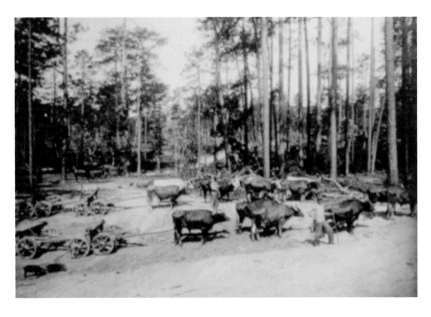

Modern stormwater systems are engineered to reduce flooding hazards by quickly removing water from urbanized areas, resulting in increased volume and velocity of water in urban and suburban streams throughout Mississippi. Photos courtesy of iStock

As farms were abandoned, forests reclaimed the poor or marginal land, and many of the streams became clear. However, some streams still retain a massive amount of sediment from this earlier time, and it is shifted around as the streams seek equilibrium in an altered physical state. In portions of Mississippi that receive drainage from hilly land that was farmed in the nineteenth century, the streams are still affected by these increased loads of sediment. The Loess Hills and the North-Central Hills of Mississippi are the two physiographic regions where streams most notably show the effects of land uses of a century ago. Even the best remaining natural streams have a long history of alteration. However, some streams hardly show these effects, and these are the ones that people find most attractive and will work hard to conserve.

MODERN STREAM DISTURBANCE

Farming and silviculture have cycles of temporary land-use changes. Crops or trees are planted on prepared sites, where they grow and are harvested. Farming has an annual cycle from planting to harvest, whereas the cycle of

The landscape of much of the South changed after these old forests were cleared. When the landscape transformed from forest to small farms, the rivers and streams draining these areas showed the effects of land-use changes. Over the years, streams that ran clear became muddy as sediment and topsoil from fields and hillsides were washed into them.

A channelized stream lined with rip-rap performs as an efficient drainage ditch in a suburban area. Photo courtesy of Robert Kröger, Mississippi State University

forestry activities is longer, from 15 to 40 years or more. The land recovers, or at least stabilizes, within these cycles, and there is some soil loss in rainwater runoff. However, the soil still allows water to percolate down and seep into the earth (groundwater infiltration). The soil of a pasture, field, or forest remains permeable and eventually recovers from disturbance.

Development poses a much more difficult problem for infiltration and draining water off the land. Hardened surfaces such as roads, streets, and parking lots do not allow water to percolate into the soil. On undeveloped land, precipitation ordinarily takes days to percolate down into the shallow groundwater and then seep into a stream, where it contributes to the stream's base flow. With development, less water seeps into the soil and more rainfall is transmitted as runoff, which is quickly delivered to the stream. Development is permanent, and there is no cycle over which the land can regain its ability to absorb water through percolation or seepage.

In essence, development disrupts the equilibrium of a natural stream or river. Stream discharge is increased as runoff finds its way to the main channel more quickly. The stream rises much faster than when it drained fields and forests. Flash floods now occur, when they did not prior to development, and the stream channel will adjust to handle the greater, faster, and higher stormwater flows. Over time, the stream must carry a greater volume of water and sediment and will adjust its slope by cutting into its bed if its bed materials are soft enough. When water reaches hard clay formations or sandstone and can no longer cut downward, it will top the banks and spread out into the floodplain (if the stream channel is not too deeply incised). The stream may also undercut its banks and cause them to fail.

In urbanizing basins where small streams must carry increased stormwater runoff, streams change their character physically and biologically. Fish and aquatic life that cannot tolerate the radical changes in the altered stream environment simply disappear. A stream that supported a dozen or more species of fish prior to urbanization will sustain only two or three species afterward. This marks the death

An all too common site in Mississippi: an agricultural field tilled right up to the edge of a ditch, exposing this field to major soil loss throughout the winter months. Photo courtesy of Robert Kröger, Mississippi State University

of a natural stream and its transformation to an urban ditch. There are streams bearing the evidence of this course of events at the sprawling edges of Mississippi cities and increasingly on the developing fringes of smaller towns that incorporate adjacent rural communities.

Even rural streams face various threats to their health from road construction projects, pipeline crossings, and excessive sediment and polluted runoff from farming and forestry activities. All of this is collectively called nonpoint source pollution. Therefore, soil conservation measures and water quality improvement practices (known as best management practices) have been formulated to reduce the impacts of nonpoint source pollution on streams.

Any stream affected by channel or bank disturbance, coupled with nonpoint source runoff, eventually can show the effects of accelerated

erosion (headcutting). Best management practices reduce adverse impacts to a stream's water quality, and their use will help fight the effects of accelerated erosion.

STREAM ECOLOGY

The stream environment is defined by flowing water. A river's source of nutrients comes from the things that wash into it or that are covered by flood waters, and these nutrient sources are processed by invertebrates. In one respect, rivers and streams are like long, wet, moving compost piles with populations of invertebrate decomposers, shredders, filter feeders, and predators. These small organisms are, in turn, eaten by fish. Leaves and woody debris from streamside forests are a very important source of organic or carbon-based nutrients that drive an allochthonous system. This Greek word means "other earth" and signifies that the nutrients driving the food chain in a river are washed in from the floodplain of the stream. River ecosystems are dependent on the annual cycles of flooding and the annual introductions of organic material, especially leaves, and the organisms that process them.

Many species adapted to life in flowing water depend on seasonal cues for reproduction.

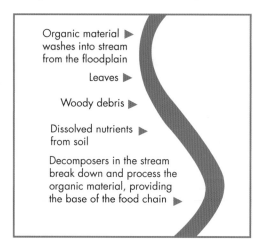

The allochthonous food chain of a stream or river. The river receives nutrients from organic material that washes in from the floodplain. Adapted from *Mississippi Streamside Landowner's Handbook*, Mississippi Department of Wildlife, Fisheries, and Parks

Streams are at low flow in the summer and early autumn and at peak flows during late winter and spring. Many species of fish follow flood waters out of the banks and onto the floodplain, where they feed. In addition, some spawn as river waters move out onto the floodplain, where their young can take advantage of abundant food. The dominant fish species in warm-water streams in Mississippi are bass, sunfishes (bream), catfish, suckers, minnows, and darters.

River-dependent fish species must migrate up and down rivers during their life cycles. American eels live as adults in rivers and migrate to the sea to spawn, while the breeding Gulf sturgeon lays eggs in river-bottom gravel beds and then returns to the waters of brackish bays and estuaries of the Mississippi Sound. In streams that drain to the Gulf of Mexico, migratory fish species include eels, sturgeon, herring, striped bass, paddlefish, and some species of shad. Dams prevent the movements of these migratory species.

Many species of birds and mammals inhabit the lands surrounding streams and rivers, which are often referred to as stream or river management zones. These fertile lands provide excellent food resources, including trees and shrubs that produce hard and soft mast (such as acorns and berries), which also serve as excellent cover and nesting habitat. Semi-aquatic mammals such as beaver and muskrats thrive in these environments that are rich in aquatic vegetation. In turn, predatory mammals (raccoon, skunk, and mink) and birds (osprey, bald eagle, Mississippi kite, least tern, and belted kingfisher) depend on the fish, invertebrates, crustaceans, and other terrestrial and semi-aquatic wildlife as prey items.

SUSTAINABLE FORESTRY: BEST MANAGEMENT PRACTICES AND STREAM MANAGEMENT ZONES

The forest products industry has recognized the need to develop and adopt sound soil conservation measures to ensure that neither the soil nor its nutrients are wasted through erosion or stormwater runoff. With the passage of the federal Clean Water Act in 1972, stream water quality became a concern of timber harvesters and forestry operations. Best management practices are sound soil conservation measures that industrial and private forest landowners can use to ensure good water quality during and after harvest, thus achieving the goals of the Clean Water Act.

Best management practices for forestry in Mississippi remain voluntary for all private landowners. They are promoted through landowner education efforts by the Mississippi State University Extension Service, Mississippi Forestry Commission, Mississippi Forestry Association, and agencies concerned with forest management and conservation such as the Department of Wildlife, Fisheries, and Parks, which sponsors the Scenic Streams Stewardship

CLEAN WATER ACT

The federal Clean Water Act established the basis of water quality standards today. These standards included setting national goals for the elimination of point source (single source of polluted discharge) and nonpoint source water pollution (that from many sources over a landscape, such as roads, lawns, and agricultural fields).

The act is administered in each state by an agency approved by the U.S. Environmental Protection Agency. In Mississippi, the regulatory agency is the Mississippi Department of Environmental Quality, which enforces the act primarily through a permitting process and water protection education. The National Pollution Discharge Elimination System is a permitting process that regulates point source pollution in U.S. waterways. In the case of nonpoint source pollution, the Mississippi Department of Environmental Quality provides education about best management practices to municipalities, private industry, and private landowners. These practices are related to stormwater management, construction, agriculture, forestry, land disposal, surface mining, and hydrological modification.

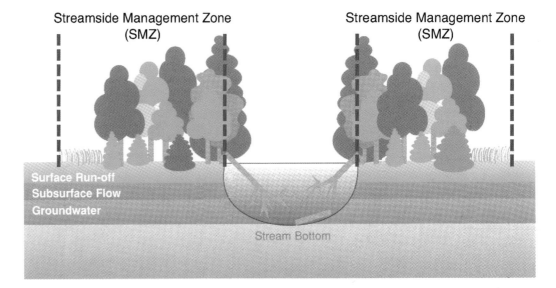

Streamside Management Zone
(SMZ)

Streamside Management Zone
(SMZ)

Surface Run-off
Subsurface Flow
Groundwater

Stream Bottom

The streamside management zone is the most important best management practice for stream bank stability. Reprinted from *A Stakeholder's Guide to the Conasauga River of Georgia and Tennessee*, Southeast Aquatic Research Institute

Program and is committed to the use of best management practices to protect stream quality.

One important best management practice for Mississippi is the use of appropriate erosion control measures at loading decks and during site preparation, replanting, and revegetation operations. Another best management practice is the planning and proper installment of skid trails and logging roads, including creating water bars, and completing road repair after timber harvest. The use of topographic maps or aerial photography can aid in planning and locating roads and trails so that they reduce or eliminate drainage problems and runoff. Logging contractors are also required to keep stream crossings to a minimum and employ culverts and other methods to protect bank stability.

Streamside management zones are buffer zones or bands of vegetation and trees adjacent to streams and rivers left intact during and after timber harvest to prevent erosion and maintain water quality and wildlife habitat. In 2008, the Mississippi Forestry Commission revised Mississippi's best management practices booklet. Among the changes was redrafting the prescribed widths for streamside management zones. The recommended widths of buffer zones along perennial streams (year-round flow) range from 30 to 60 feet, depending upon the percent slope. These recommendations provide minimum effective widths for soil and water protection.

Table 8.1. Minimum recommended widths for stream management zones in Mississippi	
Slope [a]	**Stream management zone width**
0–5%	30 feet
6–20%	40 feet
21–40%	50 feet
Over 40%	60 feet

[a] Slope is the ratio of rise to run. A 5% slope has a 5 foot change in elevation (rise) over 100 feet of distance (run), or 5/100.

Source: *Mississippi's BMPs: Best Management Practices for Forestry in Mississippi*, Mississippi Forestry Commission

A landowner may want wider buffer zones and may require them in the timber deed or contract when timber is sold. The only way that a landowner can be absolutely sure that best management practices are used on a harvest job is to have this request stated explicitly in the timber deed or contract. Landowners should protect their soil and land by the inclusion of best management practices in any timber sale and protect themselves with a good sale contract. We strongly advise landowners to obtain the services of a registered consulting forester to manage harvest selection and act as the landowner's agent in the sale.

Best management practices and particularly streamside management zones are the best preventive methods for the protection of

water quality during timber harvest. Stream-side landowners who sell timber should use best management practices to protect the value of their land, particularly the soil, so that it stays in place to grow more trees in the future. Productive, well-managed forests provide stream protection and a host of other benefits such as good water quality, recreation, aesthetics, and stable habitat for fish, aquatic invertebrates, and wildlife along the stream. Moreover, proper forest management for stream health and wildlife are not only compatible but profitable. Other forest management practices that encourage healthy wildlife populations include timber thinning, prescribed burning, managing forest openings, establishing forest corridors, retaining mast trees and fruit-bearing shrubs, creating and maintaining snags, leaving a majority of timber slash in place, and creating brush piles.

AGRICULTURAL BEST MANAGEMENT PRACTICES

Along most streams in Mississippi, the dominant land uses are forestry and agriculture. Agricultural best management practices are recommendations to farmers on how to reduce soil loss and polluted runoff during row crop planting and cultivation and in cattle and dairy operations. The soil loss per acre can be dramatic for row crop farming operations: from 18 to 20 tons per acre per year. The loss of an inch per acre over 1 to 2 years can occur without good soil conservation practices. Soil losses reduce yields, and production losses can easily cost from $30 to $60 an acre annually.

Current row crop farming practices include best management practices that control erosion and soil loss with no-till or low-till crops. The use of buffer strips, conservation tillage,

Impacted streams with steep slopes often require advanced engineering techniques such as terraced caged-rock along their most erodible sections. Photo courtesy of Robert Kröger, Mississippi State University

A tree-covered stream bank provides protection from the streams erosive powers during high-water events. Photo courtesy of Adam T. Rohnke, Mississippi State University

terraces, and the practice of leaving crop residue in place all help keep soil exposure to a minimum and are good ways to prevent erosion. Farmers face the prospect of investing in different equipment to take advantage of new reduced-tillage technology, and some tax incentives are available for the purchase of this equipment. In farm fields already suffering from erosion, engineered solutions such as drop-pipes, grade stabilization structures, and slotted-board risers can repair problems that will only worsen over time without attention.

Cattle or dairy operations should fence cattle out of streams where adequate water sources are available. Cattle can be very hard on the softer soils and sand of stream banks. The introduction of manure directly into streams is an added problem that should be avoided for the health of the herd and the health of downstream users. Single-strand electric fences are particularly useful along stream margins because they do not snag debris during high-water events and, if they do break, they are much easier to repair then traditional three- or four-strand barbed fencing.

CLEARING ALONG STREAMS FOR CAMPS AND BOAT RAMPS

Land adjacent to streams is scenic and consistently commands high prices in real estate markets. Naturally, when people buy high-priced land along streams, they want to enjoy the natural beauty. This often includes plans for clearing the banks to get a better view. Construction projects may include stairs down the bank, small docks or bulkheads, or a concrete, graveled, or rip-rap boat ramp. The disturbance to stream bank vegetation and soil during construction projects can be as drastic and harmful as total removal or as minor and benign as cutting away only enough vegetation to create a dirt footpath. The worst thing to do along a stream is to clear all the trees and shrubs and plant a lawn. More often than not, this begins a battle with erosion. Likewise, grading banks down and building boat ramps will usually start a fight with the river that the landowner will lose.

Over time, landowners who disturb the banks least will have fewer battles with the

stream. Building camps well back from the immediate bank will ensure that bank stability is not decreased by earth-moving machines and other construction activities. The stems of woody vegetation and the trunks of trees act to slow flowing water and decrease its erosive power. The living roots of shrubs and trees hold soil in place along stream banks. Clearing for a view of the stream must be balanced

with the amount and kind of vegetation that is removed.

The native trees and shrubs that cling to banks are adapted to that place. They thrive because the moisture, soil, nutrients, and hours of sunlight per day are right. Selective removal of some branches or light pruning can be a way to balance the desire for a view with the necessity of having adequate vegetation

STREAM AND WATER REGULATORY AND MANAGEMENT AGENCIES AND ORGANIZATIONS IN MISSISSIPPI

Regulatory Agencies

U.S. Army Corps of Engineers
Federal agency with regulatory authority over navigable waterways and wetlands
Vicksburg District (western Mississippi):
www.mvk.usace.army.mil
Mobile District (eastern Mississippi):
www.sam.usace.army.mil
Memphis District (extreme northern Mississippi): www.mvm.usace.army.mil
Nashville District (extreme northeastern Mississippi): www.lrn.usace.army.mil

Mississippi Department of Environmental Quality
State agency with regulatory authority and permitting responsibilities for waterways and wetlands
www.deq.state.ms.us

Mississippi Department of Marine Resources
State agency with regulatory authority and permitting responsibilities for waterways, wetlands, and coastal waters in Hancock, Harrison, Jackson Counties
www.dmr.state.ms.us

Technical Agencies and Nongovernmental Organizations

U.S. Department of Agriculture Natural Resources Conservation Service
Key federal agency for providing technical guidance and financial assistance in water and soil conservation
www.ms.nrcs.usda.gov

U.S. Fish and Wildlife Service Ecological Services
Federal agency providing technical guidance and financial assistance for landscape scale conservation.
www.fws.gov/mississippiES

Wildlife Mississippi
Conservation organization working with landowners to conserve stream and river habitats throughout Mississippi.
www.wildlifemiss.org

Mississippi Soil and Water Conservation Commission
State agency charged with technically and financially supporting the water and soil resources of the state
www.mswcc.state.ms.us

Mississippi Department of Wildlife, Fisheries, and Parks
Houses the Scenic Streams Stewardship program
www.mdwfp.com

Mississippi Chapter of the Nature Conservancy
Organization with a dedicated stream restoration team
www.nature.org

Water Quality Lab at Mississippi State University
Conducts stream and wetland research and analysis throughout Mississippi
fwrc.msstate.edu/water/index.asp

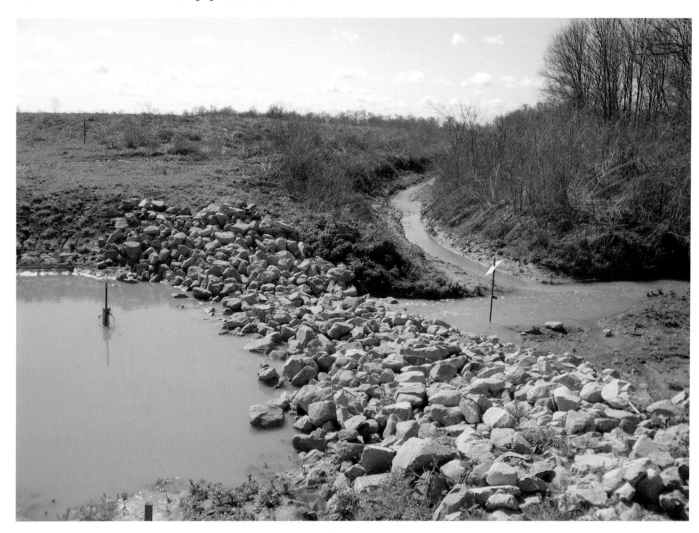

A rip-rap weir installed in this agricultural setting slows the water in this main drainage ditch, reducing the danger of erosion along the banks and at the intersection with an auxiliary drainage ditch. Photo courtesy of Robert Kröger, Mississippi State University

along banks to stabilize them during seasonal high-water events.

LEGAL AND REGULATION CONSIDERATIONS WITH LAND MANAGEMENT ACTIVITIES

There are legal and regulatory issues, too, that may be triggered by construction projects that disturb banks and put fill or sediment into streams. This is especially true in the coastal management zone (Hancock, Harrison, and Jackson Counties) and along navigable rivers. Before committing to a construction project that disturbs banks, it is best to get advice from the proper regulatory agency or from a professional who understands streams. Wetland permits involving stream banks are handled by the

U.S. Army Corps of Engineers and by the Mississippi Department of Environmental Quality. Projects within the coastal management zone are administered by the Mississippi Department of Marine Resources.

Each county in Mississippi has a U.S. Department of Agriculture office, which will provide soil conservation expertise from professionals at the Natural Resources Conservation Service. Professionals from federal and state soil conservation agencies are available to consult with streamside landowners free of charge.

STREAM RESTORATION

The earlier discussions of accelerated erosion (headcutting) in stream channels provide a background about the physical processes affecting

streams. As headcuts migrate up river channels and even small tributaries, they cause the banks to slough and channels to change. The lasting effects of headcuts are overly widened, degraded, and possibly incised (down-cut) channels in the knick zone and transportation and deposition of sediment in the downstream direction. Streams can recover from these disturbances, but they typically take decades and even centuries to do so.

Soil movement off agricultural land can be dramatic, as the discussion of soil loss illustrated. Streams that drain agricultural areas receive whatever washes off the surrounding lands. If soil conservation practices are poor or absent, streams deteriorate both physically and biologically. The biological effect most often shows up as a decline in the diversity of species living in the stream. Which species show the most dramatic declines depends upon the particular stream. Some lose diversity of freshwater mussels, whereas in others there is a decline in the number of fish species.

Stream restoration is the intervention by soil specialists, engineers, and biologists to stop or slow the decline in the physical form and biological functions of the waterway. Stream restoration in agricultural settings is usually aimed at halting field erosion or stopping gully or rill erosion from affecting the local drainage network of farm ditches and canals that flow into existing streams or rivers.

Stream restoration becomes a priority when headcuts on streams are collapsing stream banks and taking property because of the effects of accelerated erosion. This form of restoration can take the form of bank stabilization by armoring the banks and/or deflecting water away from problem areas and building grade-control structures. In cases of severe erosion, it is common to combine some of these techniques. Usually, this work is accomplished with some application of stone or rock. Increasingly, softer structures and materials are being used in stream bank restoration. Logs, biodegradable material, or live plantings of willow or other tree cuttings can hold banks together while native vegetation becomes established. Stream restoration calls for soil scientists and

civil engineers to work with the natural energy of the stream through manipulations that will allow the channel and banks to recover their integrity. With the return of physical integrity comes an increase in the biological health of a stream or waterway.

An assessment of the overall condition of the entire watershed is necessary as a first step in deciding whether stream restoration techniques should be used at all and, subsequently, which ones to use. Because a stream is a balanced system of discharge, slope, and sediment load, any man-made alteration in the name of restoration will have a consequence on one or more of these three factors. The key to restoration is in predicting desired outcomes for these manipulations and in carefully considering the choices in the planning stages of a project.

The Natural Resources Conservation Service's biologists and technicians throughout Mississippi can be consulted about stream restoration needs. The Waterways Experiment Station of the U.S. Army Corps of Engineers has several staff members with expertise and experience in stream restoration as well. Periodically, this group teaches a stream restoration course at the Waterways Experiment Station in Vicksburg, Mississippi.

Stream Restoration with Bank Plantings Using Native Plants

Living roots hold stream banks together. If a bank has been cleared and needs replanting or if planting is part of a restoration project, contractors need a source of plant materials. It is impractical to provide a list of all the possible types of plants that may be dominant along rivers and creeks in Mississippi. The best advice is to plant more of the vegetation types that are already well-adapted to growth conditions along the bank.

What grows well on a specific zone of a bank or streamside area should be noted and identified, so that a commercial source can be located. If naturally occurring seedlings or daughter plants of native species can be transplanted within the site, then the restoration can use perfectly adapted plant material. One caution

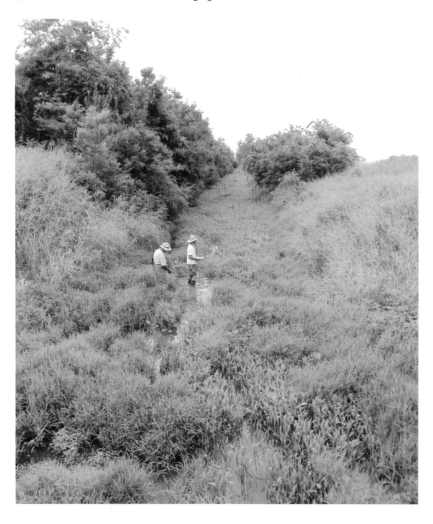

An urban drainage ditch with well-vegetated banks and a balanced stand of aquatic plants, both of which slow the water flow and allow the plants to process some of the nutrients in the water prior to it emptying into a larger waterway. Photo courtesy of Robert Kröger, Mississippi State University

is to try to avoid invasive or non-native plants in your restoration planting.

Free help is available from your county's Mississippi State University Extension specialist or from the Natural Resources Conservation Service office in your county with its team of biologists, soil specialists, and technicians. A district forester from the Mississippi Forestry Commission also can help with plant selection and planting.

MISSISSIPPI STREAM CONSERVATION PROGRAMS

Landowners interested in furthering their streamside management practices into the future and beyond the footprint of their own properties have opportunities through formal programs such as the Scenic Streams

Stewardship Program and conservation easements. These programs protect land and streams through nonregulatory practices and tax incentives that not only benefit the landowners but also the communities they live in.

Scenic Streams Stewardship Program

The goal of Mississippi's Scenic Streams Stewardship Program is to encourage voluntary private conservation efforts by streamside landowners in a nonregulatory framework. Landowners are invited to make voluntary management agreements that maintain scenic values without interfering with their property rights.

When a stream or river is nominated to the program, landowners are invited to establish voluntary stewardship agreements. Basic participation is through a written, nonbinding agreement with the Department of Wildlife, Fisheries, and Parks that best management practices for forestry will be made a requirement in the timber contract if the landowner sells timber along the stream.

The Scenic Streams Stewardship Program applies to streams that have not been channelized within the past 5 years and are considered by law to be public waters. Designation as a public waterway depends on the volume of water that flows in the particular section of the stream. According to the Public Waterway Law (Mississippi Code section 51-1-4), a stream is a public waterway if the mean annual flow volume is at least 100 cubic feet per second.

This program helps landowners to manage timber harvest operations so that streams are protected without mandatory regulations. The program considers one stream at a time, with support originating at the community level. For more information on ways to protect and preserve rivers and streams or to nominate a stream to the Scenic Streams Stewardship Program, contact the Mississippi Museum of Natural Science in Jackson.

Conservation Easements

Landowners who wish to do more to protect land along streams can create conservation easements

along their stream sections. Since 1986, the conservation easement has offered federal income tax deductions if easements are made in perpetuity for conservation purposes and held by a qualified third-party trustee such as a nonprofit land trust. Easements are binding contracts that affect heirs and buyers of property and are recorded in a courthouse. They are said to "run with the land."

Conservation easements are restrictions on some aspect of development that the landowner imposes on the property. The resulting reduction in the property value can be offset as a federal income tax deduction. These deductions are called "qualified conservation contributions" in section 170(h) of the IRS tax code. Such easements also reduce the value of the landowner's total estate for estate tax purposes. A Mississippi income tax credit helps with some of the landowner's expenses incurred in creating easements along designated scenic streams (see Mississippi Code section 27-7-22.21). Up to $10,000 of credit toward 50 percent of eligible transaction costs can be taken against state income tax over 10 years. Transaction expenses that qualify for the credit are costs of appraisal of land and timber, costs of baseline surveys of plants and animals present on the property, legal fees, recording fees, land survey and boundary marking costs, title searches, and maintenance and monitoring fees. The services of a certified public accountant or tax attorney can help landowners with the decision to create conservation easements.

For More Information

Mississippi Chapter of the Nature Conservancy website: www.nature.org
Mississippi Department of Environmental Quality website: www.deq.state.ms.us
Mississippi Department of Marine Resources website: www.dmr.state.ms.us
Mississippi Department of Wildlife, Fisheries, and Parks Scenic Streams Stewardship Program website: www.mdwfp.com
U.S. Fish and Wildlife Service Mississippi Ecological Services website: www.fws.gov/mississippiES
Whitehurst, A. 2003. *Mississippi Streamside Landowner's Handbook*. Jackson: Mississippi Museum of Natural Science.
Wildlife Mississippi website: www.wildlifemiss.org

Editors' note

Andrew E. Whitehurst is currently the Water Policy Director at the Gulf Restoration Network.

CHAPTER 9

White-Tailed Deer

Chad M. Dacus, Director, Wildlife Bureau, Mississippi Department of Wildlife, Fisheries, and Parks
William T. McKinley, Deer Enclosure Program Coordinator, Mississippi Department of Wildlife, Fisheries, and Parks
Chris McDonald, Assistant Director, Wildlife Bureau, Mississippi Department of Wildlife, Fisheries, and Parks
Lann M. Wilf, White-Tailed Deer Program Biologist, Mississippi Department of Wildlife, Fisheries, and Parks

Technical editor
Bronson K. Strickland, Associate Professor of Wildlife Ecology and Management, Department of Wildlife, Fisheries, and Aquaculture, Mississippi State University

W hite-tailed deer are an important recreational and economic resource in Mississippi. Deer is the most hunted game species in the state, generating an annual economic impact of more than $1 billion, according to the Natural Resource Enterprise Program at Mississippi State University. Today, white-tailed deer are found in every county of Mississippi, with an estimated population of 1.75 million.

During colonization by the French around 1700, white-tailed deer populations were likely found throughout Mississippi. However, the lack of undergrowth in virgin pine and hardwood forests probably supported smaller deer populations than we have today.

The first deer hunting season in Mississippi was established in 1905 and allowed only bucks to be harvested until 1915. Even with the established seasons, market hunting, the unregulated harvest of game for commercial sale, practically eliminated deer from the Mississippi landscape. By 1929, Aldo Leopold, the founder of wildlife management and conservation, estimated that only a few small herds remained in inaccessible areas of the Mississippi River floodplain and in the Pearl and Pascagoula River swamps. The Mississippi Game and Fish Commission was created in 1932 and conducted the state's first game survey in 1933. This survey estimated only a few hundred deer scattered over thirty-four of the eighty-two counties.

While this overharvesting of deer was occurring, from 1900 to 1925 most of the virgin pine and hardwood stands were harvested. This resulted in abundant undergrowth, creating ideal deer habitat throughout the state. By 1940, the Mississippi Game and Fish Commission maintained forty refuges

Mature white-tailed buck in autumn. Photo courtesy of Steve Gulledge

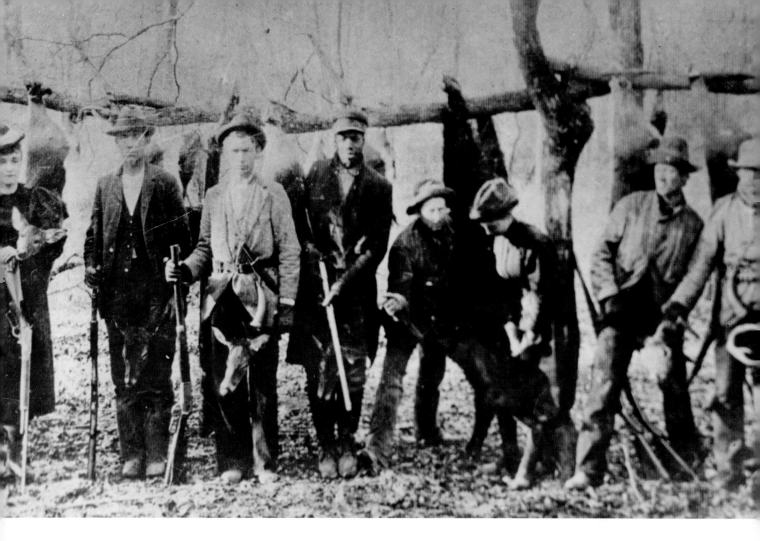

A typical 1897 hunting camp scene in Mississippi demonstrating the unregulated harvest of white-tailed deer and black bears. Photo courtesy of Mississippi Department of Archives and History

encompassing 241,138 acres. Approximately 400 deer were purchased and released into these refuges between 1933 and 1940. Most were purchased from Mexico and North Carolina. Private entities also purchased deer from Alabama, Louisiana, Wisconsin, and Kentucky. By 1953, almost two-thirds of the deer used for restocking came from the Leaf River Refuge in southeastern Mississippi. Between 1931 and 1965, at least 3142 deer were released into almost every county of the state, with most counties receiving fewer than seventy-five deer. In 1969, the deer population was estimated to be 260,000, with deer present in every county in the state, and deer seasons were open in parts of all counties. Today, deer seasons are open throughout the state, with an estimated annual harvest exceeding 300,000.

ECOLOGY AND BEHAVIOR

Male white-tailed deer are known as bucks, and females are known as does. The young are known as fawns until 1 year of age and are yearlings between the ages of 1 and 2 years. Few wild white-tailed deer live beyond 10 years.

While all are the same species, white-tailed deer in Mississippi vary significantly in weight, antler size, birth rates, and timing of breeding. These differences appear to be influenced by soil fertility, with the greatest weight, largest antlers, and earliest breeding occurring on the most fertile soils. Weights of mature bucks vary from an average of 161 pounds in the poorer soils of the Lower Coastal Plain to an average of 202 pounds in the rich soils of the Mississippi Delta. The average length of antler main beams of mature bucks ranges from 18 inches in the Coastal Flatwoods to 21 inches in the Mississippi River Batture lands. Average breeding seasons range from late November in Mississippi to early February in southeastern Mississippi.

Pelage (Coat)

White-tailed deer have two different hair coats during a year: a summer coat and a winter

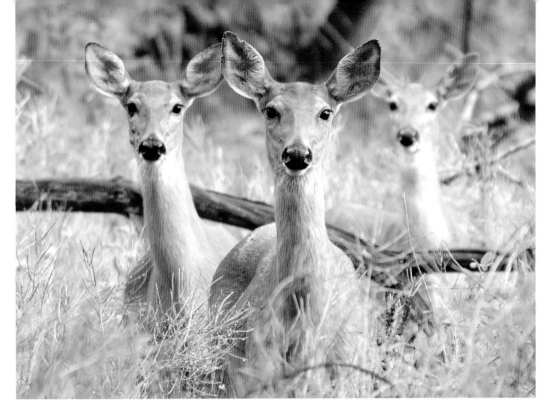

The reddish-brown summer coat of white-tailed deer provides excellent camouflage in dense vegetation. Photo courtesy of iStock

The grayish-brown winter coat of the white-tailed deer. Photo courtesy of iStock

coat. The reddish-brown summer coat, consisting of short, thin hairs, is molted from August through October. The grayish-brown winter coat is composed of long, thick, hollow hairs and provides insulation during colder months. It is molted April through May. Both coats feature white hair around the fringe, under the tail, on the belly, under the chin, inside the ears, and around the muzzle and eyes. A white throat patch is also found on the ventral surface of the neck.

When fawns are born, their coat is reddish brown with white spots, which provides camouflage to protect the young from predators. Fawns molt into their adult colorations at 3 to 4 months of age.

Antlers

When a buck fawn is born, the pedicles (the origin of the antlers on the skull) are already formed. By 3 to 4 months of age, the pedicles are visible as bumps, or buttons, on the deer's head, and so the young males are commonly referred to as button bucks. From these pedicles, bucks grow their first set of antlers at 1 year of age. As bucks get older, antler size generally increases up to maturity at 5 to 7 years of age. Average antler mass increases four-fold from yearling to 2.5 years of age and nine-fold from yearling to 5.5 years of age. Antler points,

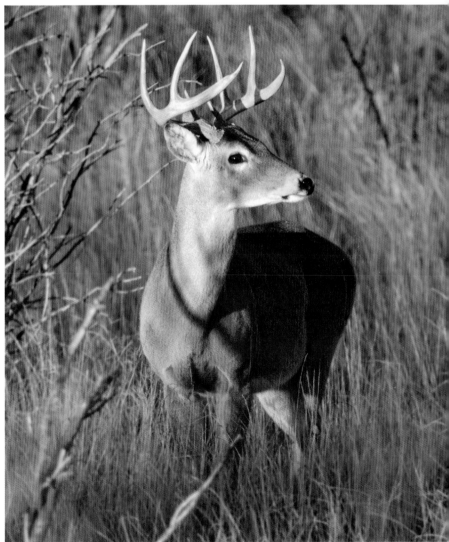

Total Antler Points

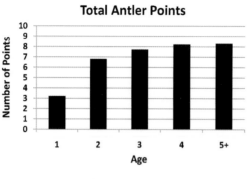

Inside Spread

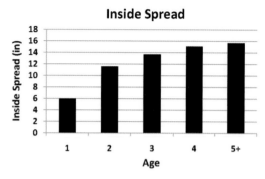

Main Beam Length

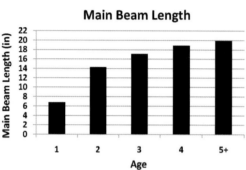

Basal Circumference

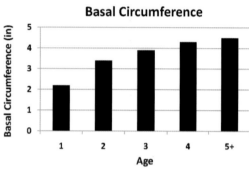

Antler growth patterns of white-tailed deer in Mississippi. All antler size characteristics increase with age and typically are at their maximum size when a buck reaches maturity at 5 to 7 years of age. Notice that main beam length is one of the best indicators of a buck's age, whereas total antler points is the poorest indicator, because the number of antler points does not increase much after 2 years of age. Figure courtesy of Bronson K. Strickland, Mississippi State University

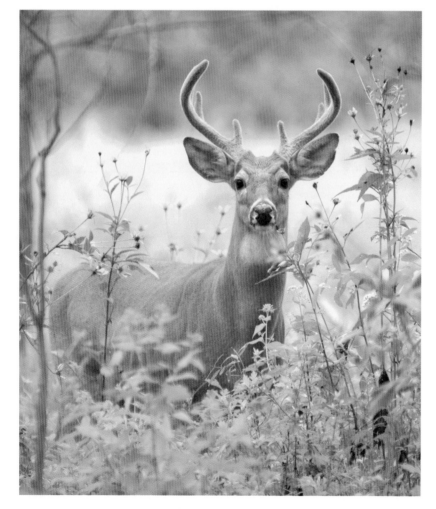

main beam length, and antler spread generally increase with age. Antlers are classified as typical (symmetrical points rising from the top of the main beams) or atypical (points that do not grow from the top of the main beam). The frequency of atypical points increases in older males. Body weight and antler development of yearling males is directly related to date of birth. The later in the year they are born, the smaller the body weight and antlers.

Bucks go through an annual process called antlerogenesis in which antlers grow, harden, and are shed. Antlers are the fastest growing normal tissue in the animal kingdom. Antlerogenesis is controlled by both hormones and photoperiod (the amount of light in a day). Antlers normally begin to grow during late February to mid-March, with growth completed by early autumn. While growing, antlers are covered in a fuzzy skin called velvet. At this time, the antlers are living tissue full of blood vessels and are very sensitive. While in velvet, the antlers can be damaged or broken, which may cause some of the atypical antler growth often seen by hunters.

A typical yearling white-tailed deer buck in the summer. Photo courtesy of iStock

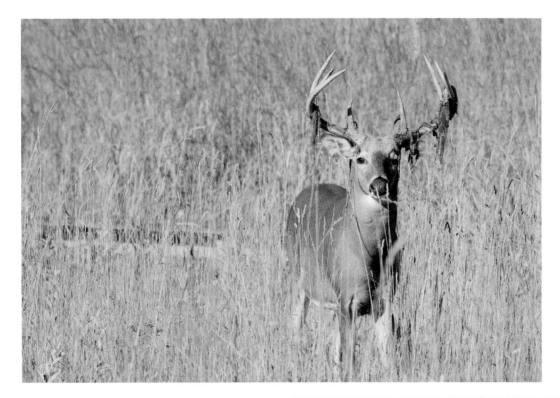

In early autumn, white-tailed deer bucks begin to rub their antler against trees and shrubs to remove the velvet. Photo courtesy of iStock

As summer ends and autumn begins, antler growth stops. The blood vessels close and the testosterone level in the blood increases, causing the antlers to harden or mineralize. Once mineralization is complete, the velvet skin begins to itch, prompting the buck to rub the antlers to remove the velvet. The shedding of velvet usually happens quickly, sometimes in just hours. When the velvet is shed, the antler is now dead tissue, affixed to the skull via the pedicle. Dried antlers are composed of approximately 45 percent protein, 22 percent calcium, 11 percent phosphorus, and 1 percent fat. The remainder is comprised of trace amounts of other minerals and carbon. The buck, which has been infertile since shortly after shedding his previous antlers, is now once again capable of breeding. Antlers will remain intact until spring unless injury occurs.

During the spring, bucks begin to shed their antlers. At this time, the buck's testicles begin to recess, and the testosterone level in the blood decreases, causing the antlers to separate from the pedicle. Most bucks in Mississippi shed their antlers in March, although some shed them as early as January or as late as May. New antlers begin to grow almost immediately after

the previous antlers are shed, and a brief increase in testosterone is needed to initiate antler growth. A diet of 16 percent protein is generally considered optimum for antler development.

Feeding Habits

Deer habitat in Mississippi can be divided into three general regions: Delta, Hills, and Lower Coastal Plain. The Delta includes the Delta

A shed antler is often a neat find for hikers and turkey hunters in early spring. Photo courtesy of iStock

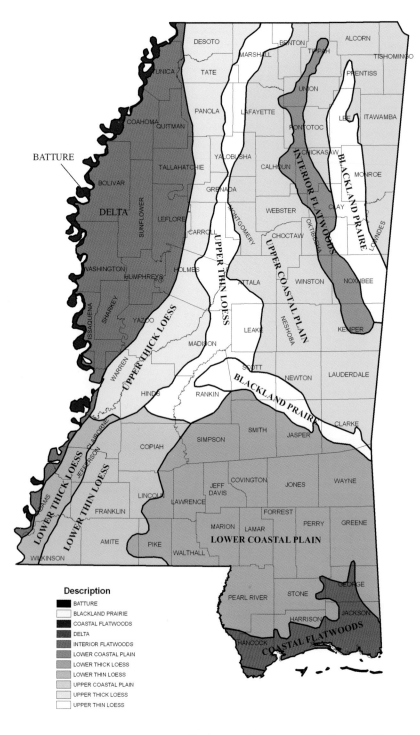

Mississippi soil regions.
Figure courtesy of Mississippi
Department of Wildlife,
Fisheries, and Parks

of the state the same plants may not be present or may not be selected by deer.

Both soft and hard masts (that is, the seeds of shrubs and trees, with soft mast being foods like berries and hard mast food like acorns) are important components of a deer's diet during autumn and winter. Mast production is highly variable and may be absent in some years. In lean mast years, vegetation must carry the deer herd through the winter. If there is a shortage of browse because of an overpopulated deer herd, the deer will suffer. Losing deer to starvation is unlikely but possible. Shortage of browse negatively affects a deer herd by decreasing reproduction, body condition, and antler development. (A diet of 16 percent protein is generally considered optimum for antler development.) These negative impacts can be seen for several years even after corrective measures are taken.

The time of year and deer herd density determines which plants a deer herd consumes. Wildlife biologists base their management recommendations on plant abundance, degree of utilization (low, intermediate, high), and time of year that certain plants are used by deer.

Delta.
The most important mast producers in the Delta are pecans and oaks, especially Nuttall, water, willow, and overcup oak. Soft mast, such as persimmons and honey locust beans, matures in early autumn and is available before hard mast, such as acorns and pecans. Persimmons only last for a short time, but honey locust beans usually last well into winter.

Southern dewberry is the primary winter food source for deer throughout most of the Delta. However, some dewberry will be consumed throughout the year. Japanese honeysuckle is a good indicator species of deer density, showing a browse line under moderate deer density. Because of the limited range of this plant throughout the Delta, however, its absence should not be a cause for concern. Throughout summer, deer will browse a variety of plants based on plant maturity, nutritional content, and moisture content. The plants consumed most by deer in the summer are trumpet creeper and greenbrier. Heavy use of these

and Batture soil regions. The Lower Coastal Plain encompasses the Lower Coastal Plain and Coastal Flatwoods soil regions. The Hills are comprised of the remaining soil regions across the state. Food preferences and feeding habits vary within each habitat region. That is, deer in one part of the state prefer certain plants adapted to that particular area, whereas in other parts

Honey locust seed pod. Photo courtesy of Adam T. Rohnke, Mississippi State University

Southern dewberry growing along a field edge. Photo courtesy of Adam T. Rohnke, Mississippi State University

One of several species of greenbrier that grow in Mississippi. Photo courtesy of Adam T. Rohnke, Mississippi State University

plants by midsummer indicates an overpopulated deer herd. Heavy browsing over several years will cause trumpet creeper to grow like a shrub and greenbrier to grow as a single erect stalk instead of growing as a trailing vine. With the high fertility of Delta soil, however, plants are able to recover quickly when a deer herd is brought into balance with the habitat.

The Hills.

As in the Delta, deer commonly consume persimmon and honey locust during early autumn, although crabapples are also a favorite in the Hills. American beautyberry, blackberry, wild blueberry, wild grapes, and wild plums are soft mast species available in the Hills. Primary mast producers are red and white oaks. Dominant red oak species include cherrybark, laurel, Nuttall, southern red, Shumard, water, and willow, and dominant white oaks are post, white, and swamp chestnut.

Numerous plants are consumed by deer in the Hills during the warm season. However, because deer populations tend to be greater here than in any other region, in many areas, primary warm-season plants are completely consumed by mid to late summer. Japanese honeysuckle is a good example. A critically important plant to deer in the Hills, Japanese honeysuckle is a perennial that is available to deer year-round. But many locations show browse lines on this plant by late summer, thus reducing its availability in the cool season. In other areas, Japanese

Blackberry bush in a forest opening. Photo courtesy of Adam T. Rohnke, Mississippi State University

This heavily browsed cedar tree provides clear evidence of a high deer population in the Hills of Mississippi. Photo courtesy of Mississippi Department of Wildlife, Fisheries, and Parks

honeysuckle and other important plants such as ragweed and sumpweed have been eliminated completely. Soil fertility in the Hills varies, but plants can recover, albeit slowly, when the deer herd is balanced with the habitat. For example, eastern baccharis is a winter species with low nutrient content; when this shrub is consumed during winter, it is an indication that deer density is likely too high. Two trees that are used as indicator species because of the low nutrient value of their foliage are sweetgum and eastern red cedar. Deer browse damage on these three species indicates the herd is overpopulated.

Lower Coastal Plain.
The Lower Coastal Plain has the lowest soil fertility of any region in the state, meaning that plants here have less nutrition than the same species in the Delta or the Hills. Hard mast is more important during autumn and winter in the Lower Coastal Plain compared to any other region of the state. Poor mast years negatively affect reproduction and even survival in this region. Hard mast species include chinquapin, beech, pecan, and oaks such as southern red, post, blackjack, white, bluejack, live, and laurel. Soft mast is an important supplement to browse, particularly during the summer stress period. The ripened fruits of plants such as blueberry, blackberry, grape, American beautyberry, persimmon, Chickasaw plum, crabapples, and sumac provide a valuable food source from spring through early autumn. Some of the most abundant winter browse species in the Lower Coastal Plain are yaupon and gallberry. Although readily browsed, these plants have low nutritional value and therefore are undesirable from a deer management standpoint. However, their plentiful presence is a critical component of the winter diet. More highly preferred species are found in southeastern Mississippi, but their abundance is limited in the absence of effective habitat management.

With proper and aggressive habitat management, an abundance of browse species become available to deer. Many of these plants

A young winged sumac tree on the edge of an old logging deck in a pine plantation. Photo courtesy of Adam T. Rohnke, Mississippi State University

Yellow jasmine is a vine with a showy yellow flower seen throughout the Mississippi landscape in the spring. Photo courtesy of Rebekah D. Wallace, Bugwood.org

are found in the Hills and Delta, but a few, such as titi, are primarily confined to the Lower Coastal Plain. Yellow jasmine tends to replace Japanese honeysuckle as an important winter browse. By late summer, the plant maturation process causes leaves to become less palatable, which coincides with the summer stress period. During this time, the deer will begin to switch primarily to consuming plants that continue to produce new growth such as honeysuckle, yellow jasmine, and greenbrier.

Social Behavior

Bucks are either solitary or found in the presence of females from late autumn through midwinter. Then from late winter through summer, they form bachelor groups. Does, however, travel in a matriarchal family unit year-round. The female-led family is typically comprised of an adult doe, her fawns from that year, and her previous female offspring. Between 6 months and 1.5 years of age, young bucks disperse from

A matriarchal family group consisting of adult does and fawns. Photo courtesy of iStock

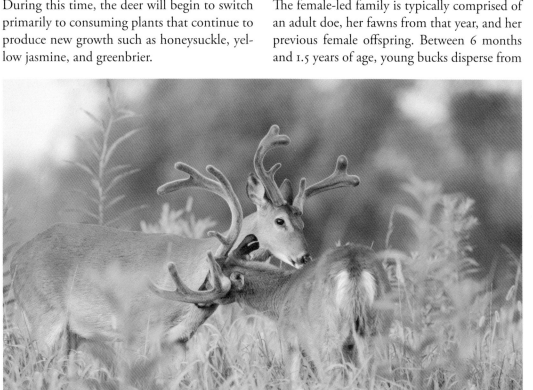

White-tailed bucks can often be seen together during the summer months. Photo courtesy of Steve Gulledge

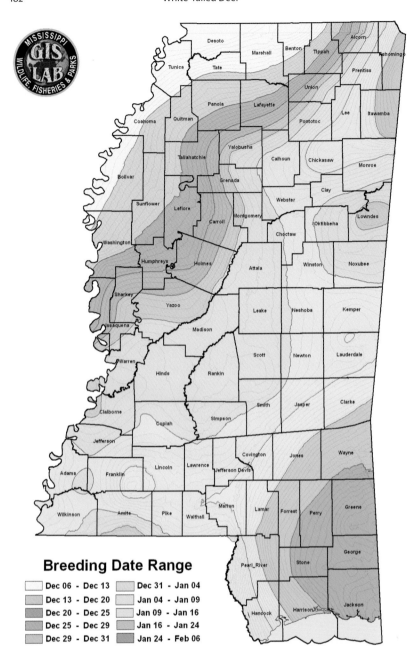

Breeding Date Range

☐ Dec 06 – Dec 13	☐ Dec 31 – Jan 04
☐ Dec 13 – Dec 20	☐ Jan 04 – Jan 09
☐ Dec 20 – Dec 25	☐ Jan 09 – Jan 16
☐ Dec 25 – Dec 29	☐ Jan 16 – Jan 24
☐ Dec 29 – Dec 31	☐ Jan 24 – Feb 06

Average breeding dates of white-tailed deer across Mississippi. Figure courtesy of Mississippi Department of Wildlife, Fisheries, and Parks

this unit, traveling up to 12 miles in Mississippi. Buck home ranges vary in size from 600 to 2000 acres (depending on habitat type and time of year) and vary among individual deer. Doe home ranges are typically half the size.

Reproduction

Breeding, also called the rut, occurs across Mississippi during autumn and winter. The rut occurs as early as mid-November in northern Mississippi and as late as early March in southern Mississippi. Statewide, the average

breeding date for deer is January 2. Breeding is usually confined to a 2-month period on any given property.

Does produce fawns once per year. They typically breed first when they are 1.5 years of age. The first breeding usually produces one fawn, and subsequent breeding usually results in twins. In extremely healthy herds, does may breed before reaching 1 year of age, and triplets are sometimes produced by older does. Adult does can go through three to seven estrous cycles if not bred, but most does are bred during their first estrous cycle in Mississippi. Breeding may occur with more than one buck, and twin fawns may have different sires. Gestation averages 200 days.

Timing of the rut is controlled by several factors, including day length, genetics, and herd health related to habitat conditions. Day length is the external cue that triggers the physiological process of estrous to begin, but when it actually occurs is influenced by the doe's genetics and health. Poor body condition can override genetic timing by preventing a doe from reaching a critical body weight needed to begin estrous. This can delay estrous for a month, or even a year in younger does. Hunters usually observe more chasing activity just prior to the average breeding date. Local environmental and herd conditions can alter the average breeding date. For example, nutritionally stressed deer may exhibit later breeding because it takes them longer to build up the necessary energy reserves for the reproductive cycle to begin. Also, if the buck-to-doe ratio is skewed severely toward does, many will not breed until their second or third estrous cycle. These late breeders extend the breeding season and cause the average breeding date to be later.

Summer is a busy and stressful time for does. Fawns are born across the state from May through September, with most births taking place in July. For the first 3 to 4 weeks, does will leave the fawns bedded, counting on the spotted coloration of their offspring to provide camouflage. Usually, the mothers return about every 4 hours to nurse. The fawns are relatively scent-free during their first few days and are able to run by the fifth day. At about 4 weeks, the youngsters begin to follow

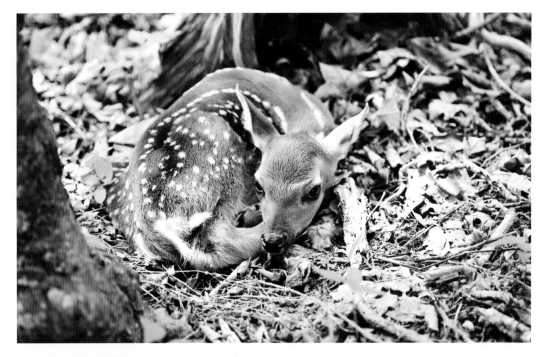

Fawns rely on being scent-free along with their spotted coloration to protect them from predators. Photo courtesy of iStock

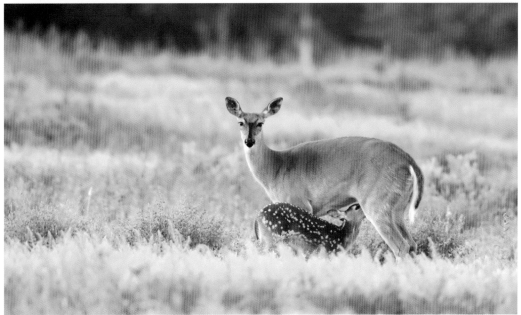

An alert doe keeps watch as her fawn nurses. Photo courtesy of iStock

their mother, and they can survive without her at approximately 2 months.

POPULATION MANAGEMENT

Deer populations grow at different rates and display different population characteristics based on the quality of the habitat and the number of deer living in that area. Wildlife managers can influence deer population characteristics, such as reproductive rate, body size, and antler size, by manipulating the habitat, the deer population size, or both. Here we describe the most common management strategies for deer in Mississippi and some techniques for estimating the number of deer in an area.

Harvest Strategies

White-tailed deer populations are typically managed under one of three harvest strategies:

A hunter weighs his deer prior to processing the animal. Photo courtesy of Landon Wimberly, Brosnan Forest, Norfolk Southern

traditional or numbers management, quality management, or trophy management.

Traditional Management.
Under traditional management, the goal is to maximize deer population numbers within the habitat's carrying capacity, which allows the maximum annual harvest of bucks. Few, if any, antlerless deer are harvested annually. Any buck that meets the state's legal harvest requirements is eligible, with most harvested between 1.5 to 2.5 years of age. Compared to trophy management, neither antler size nor habitat management is as much of a concern under traditional management. In fact, fewer hunters and managers in Mississippi today are choosing this approach.

BUCK HARVEST: ANTLER CRITERIA EXPLAINED

Historically, any antlered buck was eligible for harvest, which resulted in removal of most 1.5-year-old bucks. In 1995, the Mississippi Legislature passed the Four Point Law, requiring a legal buck to have four total points. The Four Point Law protected the most obvious yearling bucks, spikes, and three points, but allowed removal of larger 1-year-olds. Researchers at Mississippi State University investigated the long-term impacts of this strategy and determined that over time the average antler size had decreased.

In 2009, the Mississippi Department of Wildlife, Fisheries, and Parks recommended that buck harvest be based on inside spread and main beam length, because these antler characteristics are much better indicators of age than the number of points. This led to the current regulations, with three zones based on soil regions (Delta, Hills, Lower Coastal Plain) with unique antler criteria. These regulations are based on data collected in the Deer Management Assistance Program.

Because regulations are subject to revision, current regulations are not permanent. However, they should remain in place for 3 to 5 years to evaluate their effectiveness. For more information, visit the website of the Mississippi Department of Wildlife, Fisheries, and Parks at www.mdwfp.com.

TO CULL OR NOT TO CULL

Culling is a relatively new buck management practice for Mississippi deer managers. Often, it is a misused practice that can do more harm than good. Unless a deer herd is balanced with the habitat and bucks are allowed to reach maturity, then culling is simply a reason to shoot more young bucks.

One misconception is that culling improves herd genetics. This simply is not so, at least in the short term. In many cases, what hunters perceive as bad genetics is simply poor nutrition. Bucks that do not get high-quality food early in life cannot grow antlers expressing their genetic potential. Most deer managers should remove more antlerless deer to balance the herd with the habitat.

Culling can help in ideal situations. In a healthy herd and habitat, removing bucks with undesirable antlers is beneficial. As previously stated, genetic improvement is not the motive. Instead, ensuring the availability of abundant, high-quality food is the objective. Taking bucks with undesirable antlers frees up food resources for younger bucks to show their potential. In other words, cull bucks are removed to prevent them from eating and reducing the food supply for other deer.

Quality Management.
Many, if not most, managers in Mississippi choose quality deer management as their harvest strategy. Under this strategy, deer populations are managed for quality, not quantity. Healthy deer herds and older bucks are the target of quality deer management. Objectives include holding deer populations below carrying capacity of the habitat, protecting young bucks (1.5 to 2.5 years of age), balancing the sex ratio, and increasing fawn recruitment. Adequate harvest of does must be met annually to be successful. Antler criteria such as minimum spread and/or minimum main beam length are commonly used to protect young bucks from harvest. Most bucks harvested under quality deer management should be 3.5+ years of age.

Quality deer management requires the collection and analyses of biological data from all harvested deer to make management decisions. Data include jawbone measurements for aging deer, live or dressed weight, antler measurements, and occurrence of lactation. Additional data can be collected to estimate population

AGING WHITE-TAILED DEER

White-tailed deer are aged using the tooth wear and replacement technique. This photograph shows the jawbones from a fawn, yearling, adult (2.5+ years old), and an old adult (5.5+ years old). On both fawns and yearlings, the third tooth, known as the third premolar (P3), is three-cusped. However, a fawn has only four of six teeth erupted, which include three premolars and one molar (notice the lack of M2 and M3). On a yearling, all six teeth will be fully or partially erupted (M2 fully erupted and M3 partially erupted). Between the age of 1.5 and 2.5 years, the premolars are replaced. The third premolar is replaced by a two-cusped tooth (compare P3 on the fawn and yearling with the P3 on the adult). To age the animal beyond 2.5 years, you can examine tooth wear by looking at the amount of dentine versus enamel visible. Notice the difference in wear on the crests of the adult teeth and the old adult teeth.

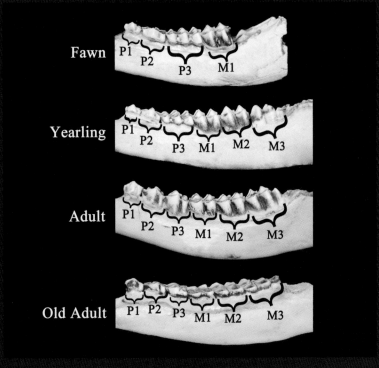

Examples of white-tailed deer jawbones. Photo courtesy of Bronson K. Strickland and Melissa Grimes, Mississippi State University

characteristics such as density, sex ratio, and fawn recruitment. Camera surveys, hunter observation, and spotlight surveys are the three most common techniques used to estimate population characteristics in Mississippi.

This harvest strategy emphasizes managing deer habitat properly to produce quality deer herds. Habitat management includes timber management, natural vegetation management,

and supplemental plantings. Without proper attention to the habitat, quality management goals cannot be reached.

Trophy Management.
This harvest strategy is basically quality deer management taken to a higher level. Trophy management still requires both data collection and proper habitat management to meet

MAGNOLIA RECORDS PROGRAM

Since 2000, more than 7500 harvested deer have been scored, of which more than 4600 met the minimum requirements (125 inches of antler for typical and 155 inches for atypical). An analysis of those bucks meeting the minimum requirements indicates that counties in the western and east-central regions of the state have the highest average antler scores. For many hunters, the true measure of a bona fide trophy is a buck with an inside spread surpassing 20 inches. To date, more than 740 deer with inside spreads greater than or equal to 20 inches have been recorded. The deer with the widest inside spread on record, 27 inches, was harvested by Richey Buchanan in Lowndes County in 2007.

To view all entries and to learn more about the Magnolia Program, visit the website of the Mississippi Department of Wildlife, Fisheries, and Parks at www.mdwfp.com and search for Magnolia Records.

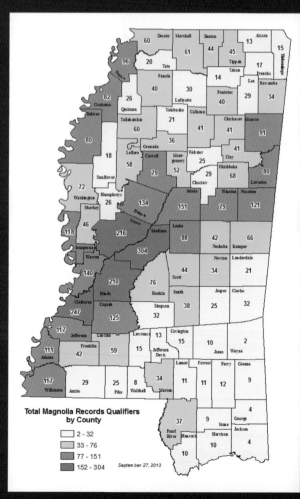

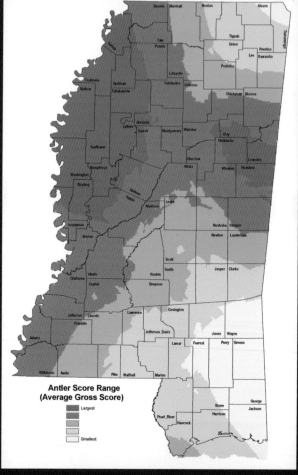

Total Magnolia Record qualifiers by county. Figure courtesy of Mississippi Department of Wildlife, Fisheries, and Parks

Average antler gross score range across Mississippi. Figure courtesy of Mississippi Department of Wildlife, Fisheries, and Parks

management goals. However, deer harvest management is much more complicated. Under most true trophy management programs, a trophy buck is one having a minimum Boone and Crockett score of 150 inches. Normally, one trophy buck is harvested per 1000 to 1500

FEEDING WHITE-TAILED DEER IN MISSISSIPPI

To properly manage white-tailed deer in Mississippi, biologists with the Mississippi Department of Wildlife, Fisheries, and Parks recommend a complete deer management program, which includes:

- habitat management practices to improve overall conditions;
- herd management to balance sex ratio, age structure, and population numbers within the available habitat;
- supplemental plantings that provide year-round forage;
- education of hunters and land managers; and
- not allowing feeding to replace a complete deer management program.

Currently, Mississippi has regulations regarding the feeding of white-tailed deer. These regulations require feed to be a complete ration (that is, food providing protein, carbohydrates, and fiber) during the high-stress periods, which include late summer and late winter. The regulations restrict the use of corn to spring and autumn. In an attempt to limit disease transmission, the feed may be placed only in an aboveground covered feeder or distributed from a timed spin-cast feeder. No feed may be piled on the ground. The feeders must be more than 100 yards from property boundaries, and hunting is not allowed within sight or within 100 yards of the feeders.

All of these regulations are subject to change annually. For up-to-date feeding regulations, visit the deer page on the website of the Mississippi Department of Wildlife, Fisheries, and Parks at www.mdwfp.com.

HEMORRHAGIC DISEASE

Hemorrhagic disease, sometimes referred to as epizootic hemorrhagic disease or bluetongue, is considered the most important viral disease of white-tailed deer in the United States. Biting midges of the genus *Culicoides* transmit hemorrhagic disease, which normally occurs from late summer through autumn. Infected deer may exhibit a variety of symptoms, including fever, swelling around the head or neck, difficulty breathing, and death. Annual mortality rates are usually less than 25 percent, but rates greater than 50 percent have been documented. On a brighter note, hemorrhagic disease has not destroyed any free-ranging deer population.

Hunters most frequently encounter the evidence of hemorrhagic disease while observing harvested deer. During the high fever, an interruption in hoof growth occurs, which causes a distinctive ring around the hooves.

Mississippi Department of Wildlife Fisheries and Parks biologists have monitored the presence of hemorrhagic disease in Mississippi for several years. Hemorrhagic disease is always present in Mississippi deer herds, with peaks occurring every 3 to 5 years. You can report sick deer to the Mississippi Department of Wildlife, Fisheries, and Parks at (601) 432-2199.

Corn piles attract multiple untargeted species, including raccoons, opossums, and eastern wild turkeys. Photo courtesy of William T. McKinley, Mississippi Department of Wildlife, Fisheries, and Parks

acres annually. Many hunters and managers in Mississippi say they practice trophy management, but they really do not.

Two types of bucks are harvested under trophy management: trophy bucks and management/cull bucks. Trophy bucks are not harvested until they reach at least 5 to 6 years of age, when they have reached their peak antler production. Management/cull bucks are those that carry undesirable antler traits, will not meet trophy requirements, or are too mature. Harvest of management/cull bucks is not encouraged to improve genetics of the deer herd (as research has clearly demonstrated this is not effective); instead, removal of these lower quality bucks provides more forage for those that remain. The ability to judge buck age and antler score in the field is required under trophy management. Age and antler score are the two dominant factors in deciding if or when a buck is harvested.

Many trophy managers turn to supplemental feeding to maximize antler production. Supplemental feeding is defined as the placement of artificial food, such as protein pellets, to increase the nutritional intake. Currently, it is legal in Mississippi to feed deer, but it is illegal to use feed to bait deer for hunting. If nutrition is a limiting factor, feeding can be used to improve antler production, body weight, and reproduction.

Although feeding has benefits, many disadvantages are associated with this practice. Because of the unnatural concentration of animals associated with feeding, the probability of disease transmission among deer and other wildlife species, such as turkeys and raccoons, increases. High concentrations of deer can also negatively affect habitat. Overuse of high-quality plants can occur, leaving only lower quality plants. Over time this can alter the vegetative community. Feeding deer can also result in overpopulation. As nutrition is increased, reproduction and survival can increase. If surplus animals are not harvested, deer can become overpopulated, which will again lead to habitat degradation. Managers should carefully consider both the positives and negatives before implementing a feeding program.

Population Estimation

Hunters often want to know exactly how many deer the property they hunt holds at a given time. For most free-ranging populations in Mississippi, it is impossible to know the exact number. Therefore, biologists and managers use population estimates rather than exact numbers to make management decisions. The three most commonly used techniques to estimate deer population characteristics in Mississippi

TRAIL-CAMERA TECHNOLOGY

Researchers from Mississippi State University's Deer Ecology and Management Laboratory have created a revolutionary product called BuckScore, software that enables hunters, biologists, and wildlife managers to score bucks without ever laying a hand on them. The researchers developed sets of unique statistical equations that provide an estimate of antler size based on measurements taken from trail-camera photographs. Tests have shown

that BuckScore technology can estimate the gross score to within 6 percent of the actual value. This technology will help hunters and managers make informed harvest decisions that coincide with the management strategies on their property. For more information about BuckScore and how to purchase this software, go to www.BuckScore.com.

A well-placed trail camera provides ample opportunities to view the quality of deer present on a property. Photo courtesy of William T. McKinley, Mississippi Department of Wildlife, Fisheries, and Parks

are camera surveys, hunter observations, and spotlight counts.

Camera Survey.

The popularity of infrared cameras among hunters and managers has grown tremendously over the past few years. Infrared cameras can be used on most properties to gain needed information about the deer herd, including estimated population density, age structure, sex ratio, and fawn recruitment. Camera surveys are conducted during September and October and again in January and February. Based on Mississippi's current feeding regulations, managers must obtain a permit prior to conducting a camera survey using feed placed on the ground. The application can be found at the website of the Department of Wildlife, Fisheries, and Parks (www.mdwfp .com). There is no charge for the permit.

Camera stations are baited with corn for 1 to 2 weeks prior to camera activation to allow deer to become accustomed to using the bait sites. The survey is then conducted for a 1- to 2-week period. To obtain the best deer population density estimates, a minimum camera density of one camera per 100 acres should be used. Estimates of age structure, sex ratio, and fawn recruitment can be obtained using one camera per 200 to 500 acres. Fawn recruitment should not be estimated during autumn, because fawns do not use bait stations as much; instead, a winter

camera survey should be conducted. Once the camera survey results are acquired, the manager can make decisions for future management. For instance, if sex ratios are skewed toward females, then increased harvest of females may be necessary. Or if fawn crops are unusually low, then the source of poor fawn production must be found. It could be poor nutrition, resulting in does producing fewer fawns, or, if habitat is sufficient, predation could be the culprit, especially in the form of coyotes. This could be inferred simply by the number of incidental coyote photos in the camera survey.

Infrared cameras can also be used to help make decisions regarding buck harvest based on antler quality of the current buck population. This information can be used to determine which bucks should be harvested and which should be protected. The greatest advantage of camera surveys is the physical evidence of the quality of deer residing on a property, whereas the major disadvantage is cost. However, with recent improvements in digital infrared cameras, cost can be dramatically reduced.

Hunter Observation.

Hunter observation is possibly the easiest, cheapest, and least time-consuming method used to estimate deer population characteristics. Research has shown that observation data can provide a reliable index of relative

abundance, population density, sex ratio, and fawn recruitment. These data also provide important information on age structure and management success. If selective harvest criteria are used to manipulate the harvest of bucks, observation data can be as important as harvest data because information is gained on the age structure and antler characteristics of those bucks not harvested.

However, hunter observation data are useless if not collected accurately and consistently. Time spent collecting and analyzing those data will be wasted, and correct management decisions cannot be made. Although observation data can be collected throughout the entire year or during more specific time periods, such as the hunting season, only the data collected during the same time period for each year can be compared. For example, data generated during the summer of one year cannot be compared to data collected during the autumn and winter of another year. Regardless of the time chosen, data should be collected accurately and consistently over time to provide a reliable index on population characteristics.

To properly collect observation data, count every deer seen during each outing regardless of whether the same individual deer is seen during more than one observation period. (In other words, individual deer may be counted more than once.) Because an index, not an absolute count, of population characteristics is calculated, a total number of deer is not required. If a deer cannot be positively identified as a buck, doe, or fawn, record it as "unknown." Take your time and be careful when assigning deer to buck, doe, or fawn categories because misassignment can severely bias the estimate.

Spotlight Counts.
Spotlight counts have been used for many years to estimate deer population characteristics. Spotlight counts provide an index of population abundance, density, sex ratio, and fawn recruitment. This technique involves driving transects (a measured distance on a road) at night through different habitat types, because they may vary in deer density. All deer observed along transects are counted, and estimates are derived from the number, sex, and age of deer

tallied. Spotlight counts are usually conducted before leaf fall (September and October) and/or after leaf fall (January and February) over a three-night period during each season. Accuracy is influenced by season, habitat type, vegetative structure, deer movement, and observer experience. Spotlight counts are highly variable; therefore, at least three nights are needed to get a representative count of deer.

Field Judging Deer

Selective harvest strategies are often used to aid in meeting deer management goals in Mississippi. Harvest criteria may include minimum age, minimum antler measurements, and gender. Hunters must accurately judge these parameters in the field to generate reliable and effective data collection.

An adequate antlerless deer harvest is a necessary component of a sound deer management program. One potential problem associated with antlerless deer harvest is the harvest of buck fawns, or button bucks. If the management objective is to increase the number of larger older bucks, button bucks must be protected from harvest. This means, in many cases, all fawns should be protected to ensure button bucks are not harvested. Spotted fawns are easily distinguishable from adult does during early autumn. However, by midautumn, spots are lost when the summer coat is shed and turns brownish to grayish. Once the coat is replaced, hunters must use other physical and behavioral characteristics to distinguish fawns from adult does.

Body size of a fawn is smaller compared to that of an adult doe. However, as fawns continue to grow throughout the hunting season, they are more often mistaken for adult does. The average weight of a fawn in Mississippi during the hunting season is 65 pounds, whereas the average weight of a mature doe exceeds 100 pounds. Hunters can use the forehead and snout to judge whether the deer in question is a fawn or adult doe. A fawn's forehead and snout are shorter than those of an adult doe. Buck fawns also have pedicles that are developing and are covered with hair. However, the pedicle may break the skin and be visible toward the end of the hunting season.

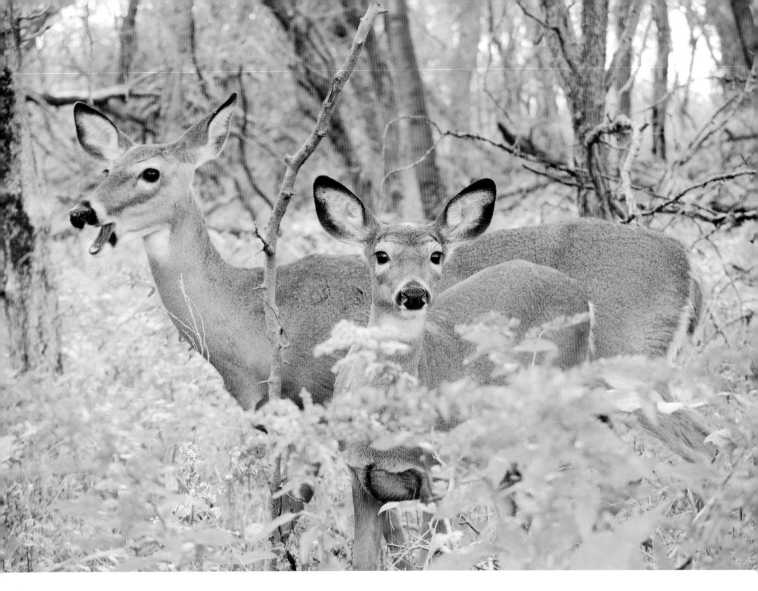

Behavior can also be used to distinguish between adult does and fawns. Fawns are more playful and naive than adult does. A buck fawn is often the first antlerless deer observed when hunting because he is less wary and more curious. If a lone deer appears to be a doe, it is usually a button buck or spike. Does and fawns usually travel together. When attempting to harvest an adult doe, wait until at least two deer are present. This allows for comparison of physical and behavioral characteristics between the animals.

Physical characteristics can also be used to estimate the age of bucks in the field. A 1.5-year-old often resembles a doe with antlers. These bucks do not have developed muscle characteristics as do older bucks. A 1.5-year-old buck has thin hindquarters, a slender neck, and long thin legs. The average weight of a 1.5-year-old buck in Mississippi is 114 pounds.

The physical characteristics of a 2.5-year-old buck are similar to those of a 1.5-year-old buck except that minor neck swelling is present during the rut and the hindquarters are thicker. The average weight of a 2.5-year-old buck in Mississippi is 149 pounds and the average inside spread is 12.0 inches. At this age, antler size is about 60 percent of antler size at maturity.

At 3.5 years of age, a buck's neck begins to swell during the rut. However, there is a difference between the neck and shoulders. The chest

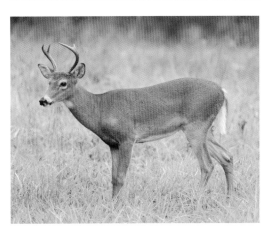

An example of a yearling white-tailed buck in Mississippi. Photo courtesy of Steve Gulledge

A hunter can be more confident of the age class being selected when several deer are present. Photo courtesy of iStock

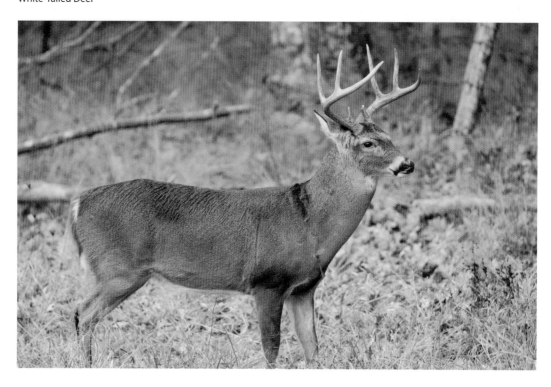

An example of a middle-aged white-tailed buck in Mississippi. Photo courtesy of Steve Gulledge

appears deeper than the hindquarter area, and the legs still appear long for the body. The average weight of a 3.5-year-old buck in Mississippi is 169 pounds, and the average inside spread is 14.1 inches. Antler size is approximately 75 percent of antler size at maturity.

At 4.5 years of age, a buck has most of his adult body size and weight. The neck is fully

developed and blends into the shoulders. The waist is as deep as the chest. The average weight of a 4.5+-year-old buck in Mississippi is 182 pounds, and the average inside spread is 15.5 inches. Antler size is approximately 90 percent of antler size at maturity.

At 5.5, 6.5, and 7.5 years of age, a buck has a sagging belly. The neck and shoulders blend

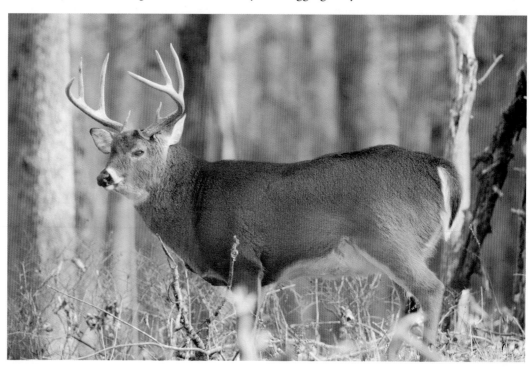

An example of a mature white-tailed buck in Mississippi. Photo courtesy of Steve Gulledge

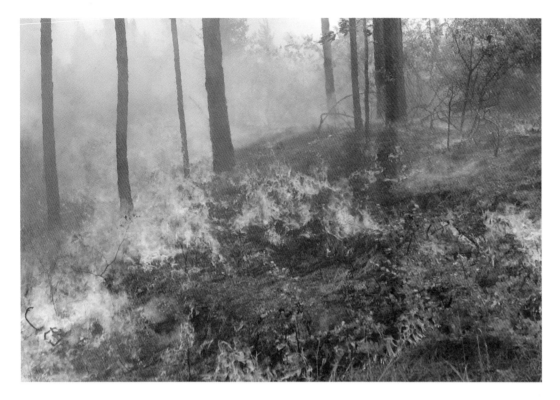

A prescribed burn in late winter or early spring will reduce hardwood and other undesirable understory competition, in turn providing more open space for desired food plants for white-tailed deer. Photo courtesy of Scott L. Edwards, Mississippi Department of Wildlife, Fisheries, and Parks

to form one large mass. Because of the large shoulder mass, the legs appear shorter compared to those of a younger buck. Bucks of this age class also have squinty eyes. Antler size peaks at this age.

At 8.5+ years of age, physical characteristics of bucks begin to deteriorate. Neck muscularity decreases, a potbelly is present, and a swayed back is apparent. Skin loosens around the neck and head because of loss of muscle tone. At 8.5 years of age, antler size usually begins to decline.

Accurately estimating the size and age of deer takes years of practice in the field. If bucks are harvested based on selective harvest criteria, antler criteria should be used instead of age at first. Antler criteria, such as minimum inside spread or main beam length, can be used to protect younger bucks. During the first few years of a management program that employs antler criteria, hunters will pass younger bucks. This will allow hunters to study physical and behavioral characteristics. After hunters are experienced at field judging deer, age can be used as a harvest criterion. However, caution must be used because many mistakes can be made by harvesting deer based on estimated age alone.

Management Timeline

Management takes time. In most cases, it takes 3 to 5 years after management is initiated to see improvements in a deer herd, usually because habitat recovery from a previously overpopulated herd is necessary. Once herd density is optimal, deer need several years of better habitat to start expressing their genetic potential. Also, it takes several years to correct adult sex ratio and buck age structure problems.

The first step in deer management is setting a management goal. Most deer managers today choose quality deer management or trophy management as their goal. Regardless of the goal, a good habitat management plan has to be part of the overall plan.

Habitat management can be divided into two periods: dormant season and growing season. Two habitat management techniques used during the dormant season to improve deer habitat are prescribed burning and disking. Prescribed burning can be used in pine stands, abandoned fields, and forest openings. Disking of fields, roadsides, and utility rights-of-way during late February or early March will improve deer habitat. Mast-producing trees can be planted during the dormant season to

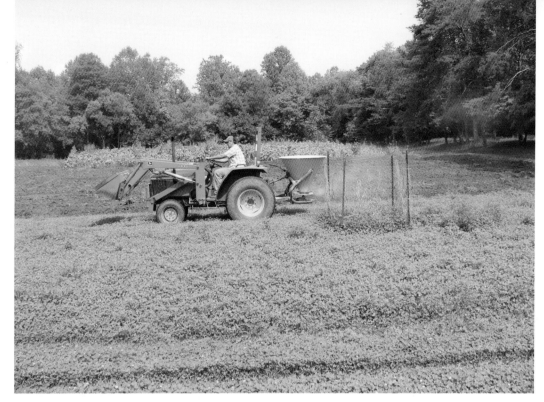

Food plots can provide needed nutrition for white-tailed deer during the high-stress periods, including late winter and late summer. Photo courtesy of Chris McDonald, Mississippi Department of Wildlife, Fisheries, and Parks

increase mast production in the future. Timber harvesting, such as thinning or small clearcuts, will open the forest canopy.

The growing season usually begins during early to mid-March and lasts through September. During the growing season, several management techniques can be implemented to increase the amount and quality of deer food available, including timber removal and planting warm- and cool-season food plots. Depending on the deer density, most summer plots should be 1 to 5 acres in size. Soil samples should be taken before planting to determine the appropriate soil amendments needed for each plot (refer to chapter 13 on supplemental wildlife food plantings).

The summer months can be spent observing deer using the habitat improvements to the property. Summer can also be a time to gather information from a biologist regarding deer harvest management and putting a harvest plan together. The Mississippi State University Extension office; the Department of Wildlife, Fisheries, and Aquaculture at Mississippi State University; or the Mississippi Department of Wildlife, Fisheries, and Parks are agencies staffed with biologists who can assist land managers in management decisions. This plan should include the number of antlerless deer and the type(s) of bucks that should be harvested. If the goal is to harvest bucks of a

certain age or older, antler criteria (such as inside spread or main beam length) can be used to protect younger bucks. Time should be spent during the summer educating hunters on the management plan and discussing deer harvest strategies.

By the time the growing season comes to an end, autumn supplemental plantings

GETTING ASSISTANCE

Several agencies are available to Mississippi landowners and hunters for technical assistance and guidance related to deer management. All are staffed with professional wildlife biologists with a variety of expertise.

Mississippi Department of Wildlife, Fisheries, and Parks
www.mdwfp.com
(601) 432-2199 (wildlife help desk)

Mississippi State University Department of Wildlife, Fisheries, and Aquaculture
www.msucares.com
(662) 325-3174

U.S. Department of Agriculture, Natural Resources Conservation Service
www.nrcs.usda.gov
(601) 965-5205, ext. 130

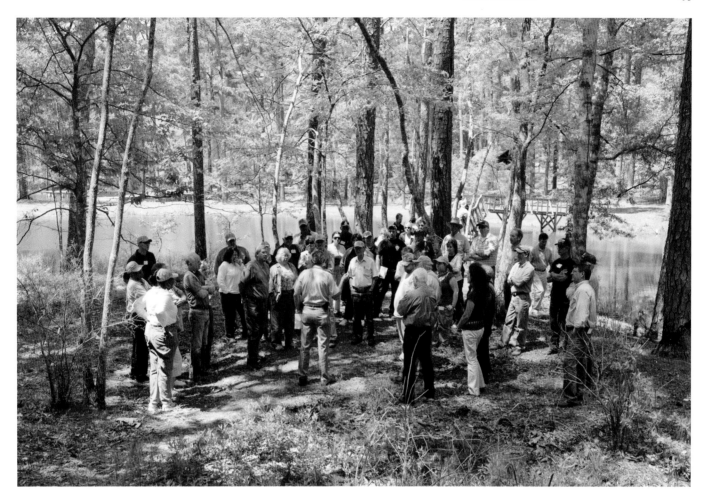

and obtaining population estimates should be planned. Information on antler quality of bucks, fawn recruitment, and sex ratio can be gathered prior to the hunting season. Population estimates can be obtained using camera surveys or spotlight counts during the autumn or from hunter observation data collected during the hunting season.

By the time deer season opens, habitat improvements should be completed for the year. Now is the time to implement the deer harvest strategy set during the summer. As soon as the hunting season is over, it will be time to get back to work.

Remember that management success cannot be accomplished overnight. Improvements in biological parameters such as body weight, lactation rate, antler measurements, and age structure may not be observed until 3 years after management is initiated. Be patient. The hard work will pay off.

For More Information

Demarais, S., D. Stewart, and R. N. Griffin. 1999. *A Hunter's Guide to Aging and Judging Live White-Tailed Deer in the Southeast*. Publications Mississippi State University-ES 2206 and FWRC WF113. Mississippi State University Extension Service.

Hamrick, B., and B. K. Strickland. 2011. *Supplemental Wildlife Food Planting Manual for the Southeast*. Publication 2111. Mississippi State University Extension Service.

Hamrick, B., B. Strickland, S. Demarais, W. McKinley, and B. Griffin. 2013. *Conducting Camera Surveys to Estimate Population Characteristics of White-Tailed Deer*. Publication 2788. Mississippi State University Extension Service.

Mississippi State University Deer Ecology and Management Laboratory website: www.msudeerlab.com

Mississippi Wildlife, Fisheries, and Parks website: www.mdwfp.com

Strickland, B. K., and S. Demarais. 2007. *Using Antler Restrictions to Manage for Older-Aged Bucks*. Publication 2427. Mississippi State University Extension Service.

Mississippi landowners and hunters attending a habitat management workshop offered by Mississippi State University. Photo courtesy of Adam T. Rohnke, Mississippi State University

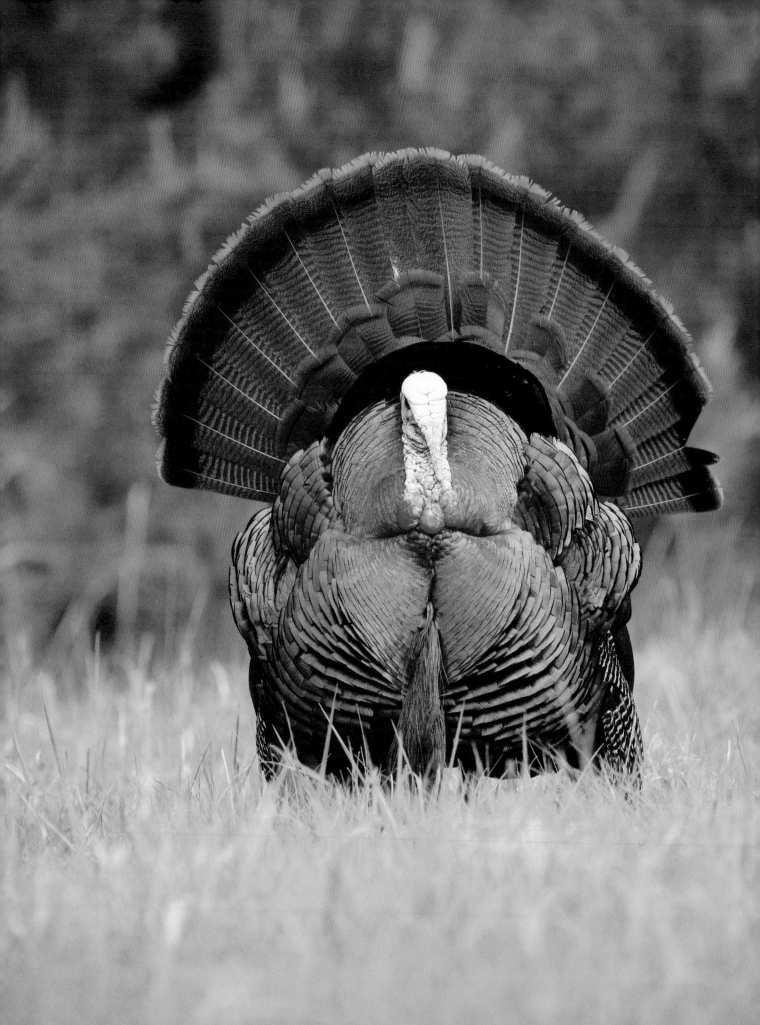

Eastern Wild Turkey

Adam B. Butler, Wild Turkey
Program Biologist, Mississippi
Department of Wildlife,
Fisheries, and Parks

Technical editor
K. Dave Godwin, Wild Turkey
 Program Coordinator,
 Mississippi Department of
 Wildlife, Fisheries, and Parks

Prior to European settlement, the forests of Mississippi were home to an estimated 1 million wild turkeys. Between 1880 and 1930, however, most of the state's woodlands had been cleared to make way for agriculture, towns, roads, and industry, and the loss of habitat did not bode well for the birds. Furthermore, no laws restricting the harvest of wild turkeys existed, and a growing human population exhibited ever-increasing pressure on the resource by killing turkeys for subsistence and market. The combination of habitat destruction and unrestricted hunting decimated Mississippi's turkey populations, and by the early 1940s only an estimated 4700 birds remained within the state.

Turkey restoration efforts began as early as 1918. Many of these attempts focused on releasing game-farm turkeys into the wild, but most were unsuccessful. Turkeys raised in captivity lacked the instincts required to survive, and losses were substantial. Early attempts to relocate wild turkeys were also unable to establish viable populations because of ineffective capture techniques. However, the development of cannon nets in the 1950s finally allowed for successful restoration. The cannon net enabled the capture of large numbers of turkeys, significantly speeding up the restoration process. From the 1960s through early 1990s, dedicated wildlife professionals spent countless hours capturing and moving wild turkeys all across the state. To date, more than 3500 wild turkeys have been caught and relocated within Mississippi. These efforts sowed the seeds for the abundant populations that we enjoy today.

A fanned out male eastern
wild turkey. Photo courtesy
of Steve Gulledge

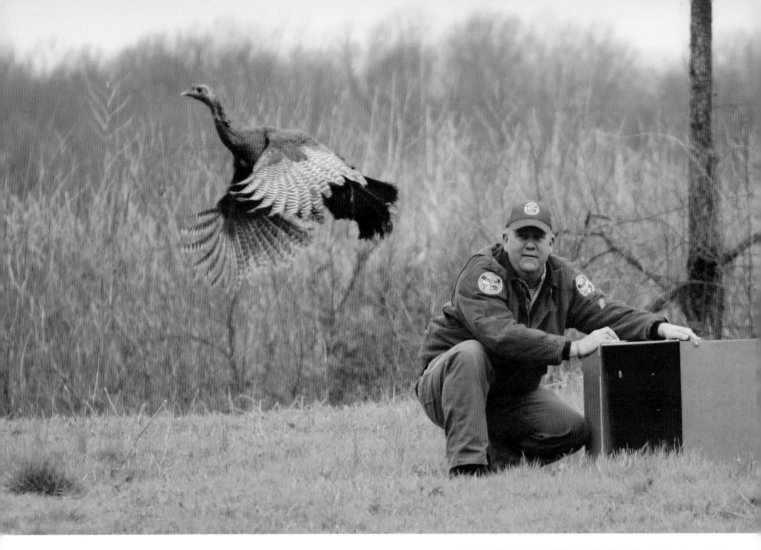

Unlike early reintroductions, current trapping and release efforts of wild birds are more successful. Photo courtesy of Mississippi Department of Wildlife, Fisheries, and Parks

With the advent of the cannon net, wildlife professionals were able to capture large numbers of turkeys from the wild for transport and release into unoccupied ranges. Photo courtesy of Mississippi Department of Wildlife, Fisheries, and Parks

LIFE HISTORY AND ECOLOGY

The key to proper management of wild turkeys is understanding their basic biology and the birds' primary needs throughout the year. Wild turkeys are complex animals whose requirements vary seasonally. By understanding these needs and how they can be met, landowners can develop more effective management techniques that will yield the highest quality of turkey habitat.

Breeding Season

In Mississippi, the breeding season of the wild turkey spans approximately 4 months, beginning in late February. Initiation of the breeding season is triggered by increasing lengths of daylight in early spring, and signs of its onset are first noticeable in adult gobblers. During this time, males begin to establish dominance hierarchies by strutting, posturing, and occasional fighting. Typically, only dominant males are allowed to breed, and these individuals attract flocks of receptive hens from long distances with their gobbling. Approximately 3 to 4 weeks after the onset of gobbling in males, the large flocks that were formed and maintained throughout the winter begin to break up, and significant range shifts may occur. Although some breeding activity may take place within wintering areas, it is common for turkeys to move several miles from wintering to breeding ranges. This shift typically happens by late March, and the move places hens near areas of suitable nesting cover.

After breeding, hens begin to search for nest sites. Their social behavior also changes. Most

Differences between the sexes are easily distinguishable by physical characteristics. Male wild turkeys (gobblers) appear black or iridescent, with heads that may be dark red, white, or pale blue depending on their level of excitement. Adult gobblers are easily distinguishable from juvenile males (jakes) by their well-developed beards that extend more than 6 inches past the feathers of the body. Hens are often only half the size of mature gobblers. Hens also appear much duller in color, with body feathers giving a drab or brown impression. Photos courtesy of Steve Gulledge

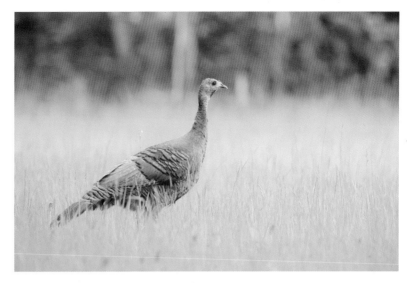

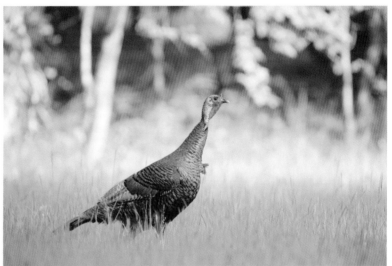

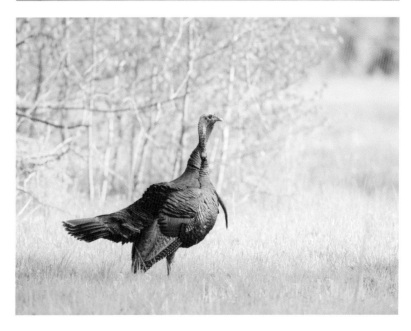

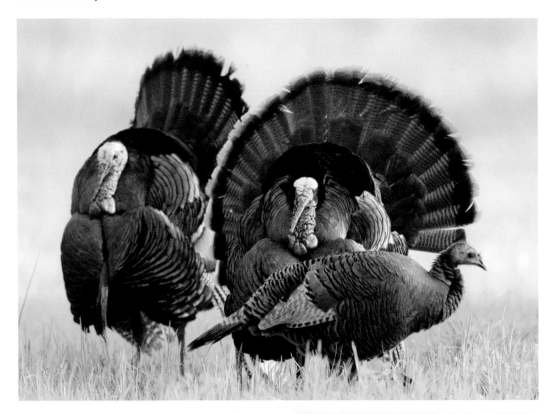

During the breeding season, gobblers attract hens by gobbling and strutting. Photo courtesy of Steve Gulledge

Wild turkeys nest on the ground, exposing them to extreme predation pressures, which makes the provision of quality nesting habitat very important. Photo courtesy of Harlan Starr

In Mississippi, the majority of turkey eggs hatch between mid-May and mid-June. Photo courtesy of Kyle Marable

nesting hens lose their flocking instincts and intentionally avoid other females. Any interaction that nesting hens have with other turkeys typically takes place long distances from their nest. Nests are constructed on the ground in areas that contain dense plant cover, which helps conceal the incubating hen. Hens often place nests at the base of downed logs, trees, or other woody debris. Most nests are located within 300 feet of an edge, such as roads, streams, or transitional areas between two distinct habitat types.

In Mississippi, most wild turkey nests are initiated by early to mid-April and consist of a shallow depression lined with plant litter. After

selecting a suitable location, hens lay a single egg each day until a clutch of ten to twelve eggs has been laid. Most eggs are deposited during the late morning or early afternoon. Between laying visits, hens camouflage the nest by covering it with leaves or other debris. Hens may incubate the nest sporadically during the final days of egg-laying, but continuous incubation usually begins immediately or the day after the final egg has been laid. Incubation lasts approximately 28 days in wild turkeys, and hens typically leave the nest to feed once daily.

Post-breeding Season

When ready to hatch, the young turkeys, known as poults, take approximately 24 hours to break free of the egg shell. Typically, all eggs within a clutch will hatch relatively simultaneously, and this synchronization is coordinated by chipping calls that poults make to one another while still within the egg. Turkey poults are able to walk and feed themselves immediately after hatching. Therefore, coordination of the hatch is critical to ensure that the entire group, now known as a brood, will all be able to leave the nest and begin foraging together.

Upon leaving the nest, the hen usually leads her poults directly to feeding areas. The diet of newly hatched poults is composed almost completely of insects. Poults grow rapidly and nearly double their body size every few days. Consequently, poults have voracious appetites and must consume large quantities of insects

Wild turkey poults forage primarily on insects during the first few weeks of their life, so adequate bugging grounds are imperative. Photo courtesy of National Wild Turkey Federation

Young wild turkeys are prone to very low survival rates. Even in good years, only one-quarter to one-half of all poults will survive to their third week of life. Photo courtesy of Brian Jackson

Outside of the breeding season, adult male turkeys tend to stay in bachelor flocks away from hens and their young. Photo courtesy of Steve Gulledge

because the protein from this single food source is essential to fueling body development. Research has shown that during the first 2 weeks of life, nearly 90 percent of the brood's day is spent feeding, and they may consume up to an astounding 3600 items (mostly insects) during that period. The home range of a hen and her new brood typically encompasses only a few acres if adequate bugging grounds are available.

Young turkeys are unable to fly until they are approximately 2 weeks old. This leaves the group very vulnerable to predation. Mortality is extremely high for young poults during these first few weeks, and survival is lowest if hens have to lead their young long distances to find suitable habitat. As a result, the quantity and availability of brood habitat is arguably the most critical habitat component for healthy turkey populations.

Gaining the ability to fly is a huge milestone in a young turkey's life and, once attained, the likelihood of surviving to adulthood increases dramatically. Flight allows for quicker escape and the ability to roost in trees, thus decreasing their susceptibility to predators. By the fourth week, the diet of the juvenile turkey begins to become similar to that of adults, shifting from predominately insects to mostly vegetative matter. Between the first and second month of the poult's life, broods from different hens begin to combine. It is not uncommon during mid to late summer for three or four adult hens to travel together with a mixture of one another's broods. These groups are called a crèche, and the adult hens aggressively exclude others from joining the group. These mixed associations of several hens and their poults often remain together until the onset of winter.

Unlike many other birds, male turkeys do not play a role in rearing the young. Instead, they spend most of the post-breeding season apart from hens. By midsummer, many of the male bachelor flocks that were together prior to

the onset of the breeding season have reformed. During summer, gobblers tend to have smaller core areas than at any other time of year, subtly shifting to new areas as different soft mast and seeds become available. Typically, gobbler summer ranges center around open fields and mature timber stands.

Overwintering

In early autumn, the changing seasons mark a transitional time for turkey populations. Most of the food sources they have depended on throughout the spring and summer begin to decline. At the same time, more hard and soft mast becomes available within older forests. In many areas, this disparity can cause dramatic home range shifts. Beginning in September, turkeys gradually reduce their use of open habitats, and shift their ranges into areas that contain high proportions of mature hardwood forests. Home range shifts of up to several miles are common, although the distance that turkeys will move often depends on the proximity of mature hardwoods and the success of the acorn crop.

As turkeys shift into winter areas, large flocks may form. These flocks are often segregated by sex and, in the case of gobblers, by age.

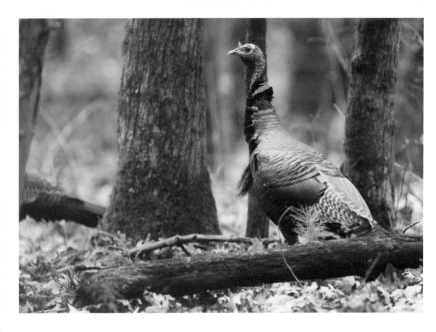

Telemetry research conducted in Mississippi has shown that gobbler and hen flocks tend to use different habitat types during winter: hens seldom venture far from the bottomland forests along major creek drainages, whereas gobblers are more willing to make use of uplands or the pine–hardwood transition areas along secondary creeks. This division in core use areas between the sexes is believed to be a mechanism to reduce competition for the limited resources of winter.

During early autumn, wild turkeys shift their home ranges to areas of mature hardwoods, where they can find hard mast and other food resources that will sustain them throughout the winter. Photo courtesy of Steve Gulledge

MISSISSIPPI: A LEADER IN WILD TURKEY RESEARCH

Mississippi turkey hunters have much to brag about. Their home state consistently produces some of the nation's densest turkey numbers, and Magnolia State longbeards are often regarded as some of the most call-shy in the country. However, there is something else they should be proud of: Mississippi has been at the forefront of turkey research for more than 30 years.

In the early 1980s the Mississippi Department of Wildlife, Fisheries, and Parks and Mississippi State University partnered in an ambitious study to understand the needs of wild turkeys. The result was a 15-year research effort known as the Cooperative Wild Turkey Research Project. The project was unprecedented in its scope, investigating nearly all aspects of turkey biology, population dynamics, and habitat use on industrial pine forests in Kemper County and the Tallahala Wildlife Management Area. Many of the project's findings are cited today as the most authoritative work ever conducted on wild turkeys in the southeastern United States.

Although the Cooperative Wild Turkey Research Project concluded its groundbreaking study in the late 1990s, the partners are still working to solve current wild turkey issues. Examples of recent turkey projects include studies of jake survival, impacts of prescribed fire, statewide difference in gobbling activity, and the feasibility of restocking in the Delta.

Predators

Many species prey upon wild turkeys at various life stages. Bobcats, coyotes, fox, and great horned owls are all known to prey upon adult wild turkeys. Of this group, however, bobcats are the only predator of any significance. Crows, snakes, and midsized mammals such as raccoons, opossums, and skunks are most frequently cited as the primary nest predators. Turkey poults can also be susceptible to predation from nearly all the aforementioned species as well as house cats, dogs, and numerous birds of prey.

In wild turkey populations, the annual impacts of predation can be substantial. On average, almost half of all hens are killed by predators during the year. Most losses come during the spring and summer when nesting and brood-rearing responsibilities cause female turkeys to be especially vulnerable. Even in good years, nearly half of all nesting attempts will end in failure, and the bulk of losses occur due to depredation events. Predation on turkeys is most extreme on the young; between one-half to three-quarters of poults typically die within the first 2 weeks of life. Adult gobblers are the least susceptible to predation. Telemetry studies in Mississippi have shown that fewer than 10 percent of adult gobblers die annually from nonhunting-related mortality.

Although predators play a tremendous role in the fluctuations of local populations, it is important to remember that turkeys have developed behaviors and traits that allow them to flourish—in spite of predation pressures—under proper conditions. Dealing with predation directly through trapping and predator control has rarely been confirmed by science as an effective or economical means of increasing turkey populations. Conversely, numerous studies have demonstrated that focused efforts to improve habitat conditions are the best defense against predation. For instance, one study in Mississippi found that in areas of quality nesting habitat, nest success averaged 65 percent, whereas in nearby areas of poor habitat, a mere 25 percent of nesting attempts were successful. These and other findings illustrate the importance of

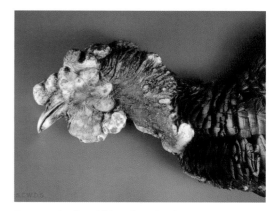

An example of a gobbler infected with avian pox. Photo courtesy of Southeastern Cooperative Wildlife Disease Study

high-quality habitat in mitigating the effects of predators on turkey populations.

Disease

Wild turkeys can be susceptible to various diseases. Typically, disease is not considered a limiting factor, but local outbreaks can sometimes occur and may cause short-term declines in population. The most commonly encountered turkey disease is avian pox, a virus that can infect nearly all bird species. Lesions or nodules on the heads, feet, and other areas of exposed skin may be outward symptoms. Avian pox is nearly always present in turkey populations at low levels, and infected individuals may recover. However, most fall victim to predators as a result of their weakened condition. Histomoniasis, or blackhead disease, is another well-known turkey killer. Blackhead disease is actually a parasite, and although infections are always fatal, outbreaks are rare. There are many other diseases and parasites of wild turkeys, although their impacts are minor and should be of no concern to land managers.

HABITAT REQUIREMENTS

Management for any wildlife species demands an understanding of the habitat characteristics required and why those features are important. Habitat requirements for turkeys vary seasonally and, as a result, the birds often need up to

four or five square miles to meet their annual needs. These large home ranges make it difficult to maintain populations of turkeys exclusively on small tracts of land. However, owners of small properties should not be discouraged from managing for turkeys, as movements within seasons can be very localized, particularly if diverse habitats are mixed together in close proximity. In the Southeast, nesting, brood-rearing, and wintering habitats are three critical components that should be addressed when turkeys are a management objective. If all are integrated into a property's management plans, the majority of the year-round needs of the birds may be met on relatively small acreages.

Nesting Habitat

Nesting hens do not necessarily search out a specific habitat type in which to nest. Instead, they try to select areas that provide a specific vegetative structure comprised of a moderately dense layer of plant growth from the ground level to approximately 3 feet in height. This type of structure is found within the early stages of plant succession that develops 2 to 4 years following soil disturbances. Briar thickets, grassy patches, or shrub/scrub areas all offer cover that is well-suited for nesting.

Hens will select nests in nearly any area that provides adequate cover. Utility rights-of-way, old fields, thick woods edges, and young pine plantations all offer the vegetation that hens seek. However, a potential problem with these areas is that they also serve as travel corridors for some nest predators, so nests may experience inflated levels of predation. It is therefore important to ensure that nesting cover is scattered throughout a property, rather than focused only in a few concentrated areas. This will decrease the odds of nest predators locating

Good nesting cover is composed of moderately dense plant growth for the first few feet above ground level. With proper management, quality nesting cover can be found in a variety of different habitat types, such as pine stands (top), old fields (middle), or bottomland hardwoods (bottom). Photos courtesy of Mississippi Department of Wildlife, Fisheries, and Parks

prime nesting sites and, ultimately, ensure higher reproductive success.

Brood Habitat

Improving the quality and quantity of brood habitat is probably the most beneficial step a land manager can take to increase local turkey populations. Because of low survival rates that poults experience during the first few weeks of life, it is necessary to give them every advantage possible, and this means providing specific types of cover. Ideal brood habitat is open at ground level so that young poults can move about and forage easily. However, concealment is critical. Therefore, the vegetation should be high enough to hide the poults (about 12 inches), but low enough that the hen can see her surroundings as she scans for danger. An abundance of insects is another essential for good brooding zones. Because insects are attracted by lush vegetation, good brood habitat nearly always includes tender, young herbaceous growth.

In general, open areas provide better quality brood habitat than forested areas, so increasing the availability of openings can be an excellent way of improving turkey habitat across a property. Old fields, pastures, food plots, and roadsides are all areas that may serve as good bugging grounds for hungry poults. Adequate brood habitat can also be found in pine or hardwood forests if these areas are managed properly.

Wintering Habitat

Wild turkeys depend heavily upon hard and soft mast to meet energy demands throughout the autumn and winter. Consequently, retention of older hardwood stands across the landscape can be a critical factor in sustaining turkey populations throughout the year. High-quality wintering habitat contains a diversity

Quality brood habitat contains a lush, diverse understory (top) and can be found in openings or food plots (middle) or in recently burned timber stands (bottom). Photos courtesy of Mississippi Department of Wildlife, Fisheries, and Parks

of mast-producing trees, which ensures food availability in the event of a mast failure by any one species. Hackberry, black cherry, American beautyberry, wild grape, dogwood, persimmon, and black tupelo all provide fruit sought by turkeys during the autumn and early winter. Important hard mast producers include the various oak species, pecans, American beech, and eastern hophornbeam. In the Lower Coastal Plain, the seeds of longleaf pine can also be a relished winter food item, although seed production is very sporadic.

MANAGEMENT RECOMMENDATIONS

Wild turkeys thrive in areas where different habitat types such as pine forests, hardwoods, and fields or other openings converge to create a diverse landscape that can meet all the birds' year-round needs. Specific management actions directed at improving conditions for turkeys will vary depending upon the major habitat type that is being affected. Nevertheless, habitat management for wild turkeys often comes down to balancing the right amount of thick,

early-successional cover, which is absolutely essential to the success of nesting and brood rearing, with the more open habitats preferred by adult turkeys throughout most of the year.

Pine Forests

Much of Mississippi's landscape is dominated by piney woods. Naturally occurring pine forests, such as mixed pine–hardwood stands in northern and central Mississippi and mature longleaf forests in the south, can provide excellent turkey habitat. However, these types of forests are often replaced by artificially planted pine forests. Although pine plantations offer unique management challenges, certain practices can be used to help improve their attractiveness to turkeys and other wildlife.

Thinning of Pine Plantations.
The life of a typical planted pine stand in Mississippi begins as a clearcut following the removal of the timber from the previous stand. Cutover areas can provide good habitat for both young and adult turkeys, but only for a short period. Most clearcuts offer abundant food items that

Wintering habitat for wild turkeys is composed of older hardwood stands with a diversity of mast-producing species. Photos courtesy of iStock

American beautyberry. Photo courtesy of Chris Evans, River to River Cooperative Weed Management Area, Bugwood.org

Common ragweed. Photo courtesy of John D. Byrd, Mississippi State University, Bugwood.org

Greenbrier. Photo courtesy of Adam T. Rohnke, Mississippi State University

Thinning and other management practices, such as prescribed burning, are critical tools for managing turkeys in forested habitats. Photo courtesy of National Wild Turkey Federation

turkeys relish, such as blackberries, dewberries, grass seeds, and other soft mast. The abundance found within cutovers is short-lived, because within a few years vegetative growth becomes so thick that it obstructs movement, and value as habitat is lost until the stand can be thinned. Depending on the species and quality of site, most planted pines in Mississippi receive their first commercial thinning between 12 and 18 years of age. When viewed as wildlife habitat, this thinning marks a major fork in the road for the stand.

Thinning reduces the density of stems within the stand and opens the canopy. The intensity of thinning can be gauged by the basal area of the timber that remains. Basal area is a forestry term that describes the cross-sectional area of all the trees within the stand on a per-acre basis. Ideally, reduction of stands to a basal area of 70 square feet per acre is a good trade-off between timber production and habitat for wildlife species such as turkey. This density is slightly more than half that of the typical density prior to

thinning and is beneficial because the trees that remain increase their growth rates as a result of greater spacing and less competition.

Thinning to a basal area of 70 square feet per acre can also have important results for wild turkeys by allowing more sunlight to reach the forest floor. This stimulates the growth of many of the understory plants that turkeys depend on for food and cover. Plants such as blackberry, American beautyberry, ragweed, greenbrier, seed-producing grasses, and various legumes usually appear from the seed bank following timber removal. In addition, many of these leafy plants will attract a host of insects, making even more turkey food available. Some of these species also provide the type of structure that is needed for good brood habitat. Within a couple of years after thinning, the density of vegetation will increase and offer an abundance of nesting cover.

Thinned pine stands can provide excellent turkey habitat for a few years. However, as with cutovers, the quality of these stands begins to decline as the vegetation becomes overly thick. On many sites in Mississippi, fast-growing species such as sweet gum, wax myrtle, red maple, and yaupon can dominate the under- and mid-stories of many thinned pine plantations within a few years. These species have little value as food for turkeys but, more importantly, their overabundance will shade out many of the understory plants that are beneficial. As these undesirable species become well established, brood and nesting habitat will quickly disappear. Eventually, adult birds will limit their use of those areas because the thick vegetation restricts their ability to scan for predators.

Prescribed Fire.
To maintain a high-value understory, prescribed fire must be used within pine forests and should be considered an essential tool for forest landowners who wish to manage for wild turkeys. Prescribed burning promotes the proper vegetation and structure for nesting and brood-rearing cover and increases food availability throughout the year. This is achieved by reducing the woody-stemmed plants in the forest's midstory, consuming leaf litter on the ground, and jump-starting germination

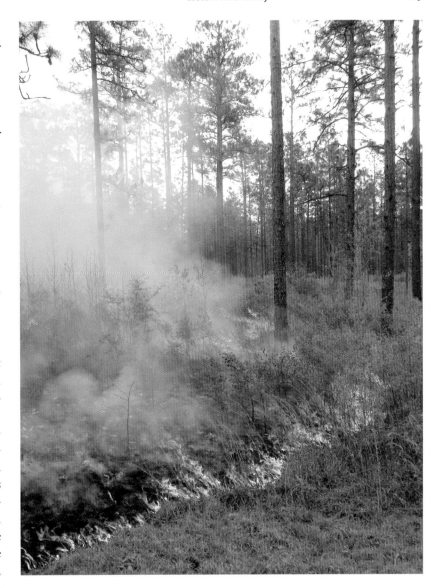

of high-quality plants that have been dormant in the soil. Ideally, a property should be broken into 50- to 75-acre patches, with different blocks being burned in different years. This will allow varying stages of vegetation to be located close together, creating a patchwork of habitat types, and will limit travel time for turkeys between different habitat components. Ideal burn rotations vary throughout Mississippi. In the mixed pine–hardwood forests of the north, burn cycles of 3 to 4 years may be adequate to maintain turkey habitat. However, in southern Mississippi, 18- to 24-month rotations may need to be used.

Most prescribed fire applications occur during late winter. However, this timing may not

Prescribed fire is essential for maintaining quality turkey habitat in pine forests. Controlled burns can reduce undesirable vegetation while also improving brood-rearing and nesting habitat. Photo courtesy of Mississippi Department of Wildlife, Fisheries, and Parks

always be effective in reducing the encroachment of undesirable species in the forest understory. Incorporating growing season fires or burns conducted after bud-break in spring may reduce invasive woody-stemmed species in the understory and promote grasses, forbs, and legumes. Turkey hunters are often opposed to burning during spring because of the potential for disturbing nesting hens. While this concern may be well intended, it is ultimately unjustifiable because the long-term gains in habitat quality far outweigh the loss of a relatively small percentage of nests.

Herbicide Applications.

In certain situations, fire alone may not be enough to eliminate the encroachment of unwanted understory species. In these cases, applications of selective herbicides may be needed to eradicate undesirable hardwood stems and return the site to conditions that can be maintained with fire. Within forested stands, herbicides can be applied in several different ways. Stem injection is a selective method that targets individual saplings. Stems are hacked mechanically and squirted with highly effective herbicides that will kill the tree. This method is very selective, but also labor-intensive. Broadcast applications can be made with skidders or tractors or aerially from helicopters. These types of applications are quicker, but issues may arise if certain tree species are to be maintained.

Management Considerations for Pine-Dominated Landscapes.

Land managers interested in wild turkeys should be aware that suitability for turkeys can decline in landscapes dominated by artificial pine stands if specific allowances are not made. In these systems, the spatial arrangement of the landscape elements can determine the use of various habitat components by wild turkeys. To the greatest extent possible, landscape diversity should be promoted and maintained. Hardwood stands and managed openings should be retained and well distributed. Leaving wide (greater than 150 feet) streamside management zones can be a good way of preserving hardwood areas and providing travel corridors for

In landscapes that are dominated by pine forests, practices such as leaving wide streamside management zones are critical to ensure a diversity of habitat components are available. Photo courtesy of John Auel, Mississippi State University

wildlife. If at all possible, clearcuts larger than 100 acres should be avoided, as should the practice of clearcutting stands that are adjacent to pine regeneration areas in the earliest stages of growth. Dispersing clearcut operations across the landscape will prevent large contiguous areas from becoming unusable to the birds. Finally, longer timber rotations are favorable; if turkeys are an objective, timber planning should target rotations of at least 35 years.

Hardwood Forests

Mature, mast-producing hardwoods such as oaks, hickories, pecans, and beech are a critical component of good turkey country. In fact, the relative value of turkey habitat can often be judged based on the availability of hardwoods within the landscape. Not only do they provide the food stores that help sustain turkeys throughout the winter, but with proper management they can meet many of the birds' year-round needs.

Management for wild turkeys should emphasize the preservation of hardwood stands. Clearcutting and conversion of these stands to pine plantations should be avoided, although these areas can be improved through sound forestry practices. Selective thinning of hardwoods may dramatically improve habitat conditions within the stands. Implementing treatments

The creation of permanent openings is one of the best ways to foster wild turkey populations. Photo courtesy of Mississippi Department of Wildlife, Fisheries, and Parks

that create an uneven forest structure and open the canopy allows for the development of a rich understory and fosters the regeneration of oak, pecan, and other heavy-seeded species. Ideally, the intensity of thinning should vary throughout the hardwood stand, so that some areas are heavily thinned and others are thinned lightly or not at all. This practice leaves patches of ground cover randomly scattered within the stand, creating ideal nesting conditions in a maze-like fashion, which predators have difficulty searching. With additional space opened following harvest, residual trees have room to expand their branches, thereby boosting acorn production.

Managed Openings

Openings maintained in grassy and weedy cover such as pastures, old fields, utility rights-of-way, or roadsides can be heavily used by wild turkeys, particularly during the spring. In fact, of all the improvements that may be made to increase the use of a property by turkeys, few things can yield better results than the creation of permanent openings. Openings of 3 to 20 acres are ideal for turkeys; this range is large enough to provide areas with adequate resources, but small enough so that the birds are always within a safe distance of cover. When maintained in low grassy cover, these areas can serve as display areas during the mating season, offer high-quality nesting and brood-rearing cover, and provide an abundance of food throughout the year.

As with any habitat type, openings must be actively managed or their value as turkey habitat may begin to decline. An excellent technique to enhance conditions for turkeys in open areas is strip disking. As the name implies, strip disking involves lightly disking alternating linear strips along the contour of the land throughout the field. This technique will hinder encroachment of woody-stemmed species within these fields, and the periodic soil disturbance will continually promote a rich community of early-successional plant species that provide valuable food and cover for wildlife. Strip disking can be done anytime between October and March, although the exact timing

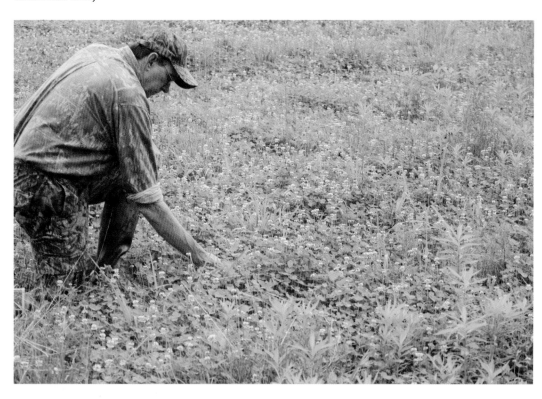

Openings planted in clovers are an excellent option for landowners interested in turkeys, and they provide great bugging grounds for hens and poults. Photo courtesy of Steve Gulledge

at which the soil disturbance is conducted can have an influence on the composition of the plant community that responds. Autumn and early winter disking tend to promote forbs and legumes, whereas disking in late winter or early spring is more likely to generate annual grasses.

Food Plots

Over the past several decades, supplemental plantings (commonly known as food plots) have become increasingly popular with hunters. While food plots play a role in an overall turkey management plan, their value should always be kept in the proper context, along with realistic expectations for positive outcomes. In the Southeast, a lack of food resources rarely limits wild turkeys; therefore, planting specific foods for turkeys may not yield an increase in the population. Some of the other habitat recommendations that have been outlined should be viewed as most critical for turkeys and should receive more emphasis when turkeys are a management objective. However, food plots can complement other management practices, especially high-quality food plots that will increase the use of focal management areas by turkeys.

Many commonly used cool-season food plot mixes for white-tailed deer will also be consumed by wild turkeys. Particularly attractive are mixes that include clovers. Turkeys readily forage on clover leaves throughout the winter and spring, and the abundant insects found in clover patches during spring and early summer make these areas beneficial to hens fueling up for egg-laying or in search of high-quality brood habitat. Clover stands can be slow to develop in autumn, so mixing with cereal grains such as wheat and oats can provide forage before clover growth becomes adequate. Clovers are generally divided into perennials or annuals, and several varieties of each are adaptable to different soil conditions. White clover may be of special interest to landowners because of its hardiness and longevity.

Other food plot options for turkeys include sorghum, browntop millet, or chufa. These warm-season plantings provide a high-energy food source for wild turkeys. Fields of sorghum and millet can also offer excellent bugging areas, especially if left fallow during the second summer following planting. Chufa produces a nut-like tuber that turkeys scratch up and eat. Chufa is planted in late spring to early summer,

but the tubers do not mature until autumn and may remain available until late winter. Chufa does best on sandy to loamy soils and should not be planted on heavy clays. Because wild hogs will also heavily use chufa plots, this plant should be avoided in areas with high hog densities.

SUMMARY

Wild turkeys were abundant in Mississippi prior to European colonization, but populations were decimated by habitat destruction and overhunting by the early twentieth century. However, the efforts of dedicated wildlife professionals fostered the comeback of these birds from the brink of extinction. Today, the return of wily old gobblers to the springtime woods is hailed as one of wildlife conservation's greatest success stories, but management of the species is at a turning point. Population restoration has been completed across the state, and now wild turkeys are primarily limited by habitat availability. Ensuring the continued abundance of this majestic bird into the twenty-first century will depend upon the commitment of private landowners to good land stewardship that will provide a high-quality environment in which wild turkeys can thrive.

For More Information

Barnett, S. W., and V. S. Barnett. 2008. *The Wild Turkey in Alabama*. Montgomery: Alabama Department of Conservation and Natural Resources.

Dickson, J. G., ed. 1992. *The Wild Turkey: Biology and Management*. Mechanicsburg, Pa.: Stackpole Books.

Hurst, G. 1998. *The Wild Turkey in Mississippi*. Jackson: Mississippi Department of Wildlife, Fisheries, and Parks.

Mississippi Department of Wildlife, Fisheries, and Parks' Wild Turkey Program website: www.mdwfp.com/turkey

National Wild Turkey Federation website: www.nwtf.org

CHAPTER 11

Waterfowl

T. Adam Tullos, Wildlife
Extension Associate,
Department of Wildlife,
Fisheries, and Aquaculture,
Mississippi State University

With contributions by
Bronson K. Strickland,
 Associate Professor of
 Wildlife Ecology and
 Management, Department
 of Wildlife, Fisheries, and
 Aquaculture, Mississippi
 State University

Technical editor
J. Brian Davis, Assistant
 Professor of Wildlife
 Ecology and Management,
 Department of Wildlife,
 Fisheries, and Aquaculture,
 Mississippi State University

Landowners, hunters, and other outdoor enthusiasts have long enjoyed observing and hunting waterfowl in Mississippi. Major rivers and tributaries and coastal marshes of the Magnolia State help sustain more than 1 million acres of habitat for waterfowl and other wetland wildlife during migration and winter. Mississippi's wetlands, bottomland hardwood forests, and agricultural lands provide important habitats for more than twenty-five species of North American waterfowl.

Ducks are classified as either divers or dabblers. Divers propel themselves underwater with large feet attached to short legs situated far back on the body, whereas dabblers have smaller feet and their legs are further forward. Although some dabblers dive to feed or escape predators, they usually skim food from the surface or feed in shallow water by tipping forward to submerge their heads and necks. The diving ducks in Mississippi include bufflehead, canvasback, hooded merganser, lesser scaup, redhead duck, ring-necked duck, and ruddy duck. The dabblers typically found in the state are American black duck, American wigeon, black-bellied whistling ducks, blue-winged teal, gadwall, green-winged teal, mallard, mottled duck, northern pintail, northern shoveler, and wood duck. The state's geese include Canada goose, snow and Ross's geese, and white-fronted goose. Most of these waterfowl migrate through the state during migration, but black-bellied whistling ducks, hooded mergansers, mottled ducks, wood ducks, and Canada geese are resident waterfowl that nest in Mississippi.

Most waterfowl visit Mississippi from November to March, although some wood ducks and blue-winged teal migrate into and beyond Mississippi as early as September. The greatest densities of waterfowl typically occur in

A pair of flying mallards.
Photo courtesy of Daniel A.
Skalos

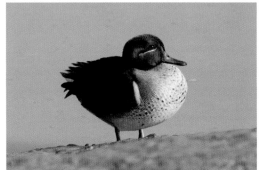

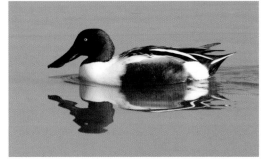

Mississippi is home to twenty-six species of waterfowl, ranging in size from green-winged teal to snow geese. Snow geese, northern pintail, green-winged teal, and northern shoveler are pictured. Photos courtesy of Bronson K. Strickland, Mississippi State University (snow geese); Daniel A. Skalos (northern pintail, green-winged teal, northern shoveler)

late December and January, but the largest diversity of species may occur in February and March. Sustained cold weather and snow cover in northern states help to increase numbers of mallards and other ducks in Mississippi, especially if abundant water exists in the Delta. Despite any inclement weather, more than two dozen species of waterfowl may be found in Mississippi during autumn and late winter, which attests to the diversity of habitats in the state that are important to these birds.

MIGRATORY FLYWAYS

There are four primary waterfowl migration routes, called flyways, in North America: the Atlantic, Mississippi, Central, and Pacific. Mississippi is one of fourteen states and three Canadian provinces that comprise the Mississippi Flyway. The Mississippi Flyway was formally recognized in 1952, and all flyways are within science-based, governmentally designated boundaries derived from historical migration corridors of waterfowl through North America.

Flyways provide the biological and geographical framework for biologists to evaluate migratory bird populations and estimate continental habitat conditions. These experts establish the first and last days of the waterfowl hunting season, daily bag limits, and species-specific bag limits (such as four mallards allowed per day) each year within the flyways.

HISTORICAL LANDSCAPE

The prairie pothole region is a large geographic area that extends from northern Iowa northwesterly into southern Canada, and it serves as the most important breeding grounds for North America's ducks. Historically, this region consisted of more than 200,000 square miles of integrated wetlands, lakes, and native prairie. Similarly, the Mississippi Alluvial Valley, part of which encompasses the Mississippi Delta, includes 25 million acres extending from the Missouri Bootheel to southern Louisiana. Historically, this large area was comprised mostly

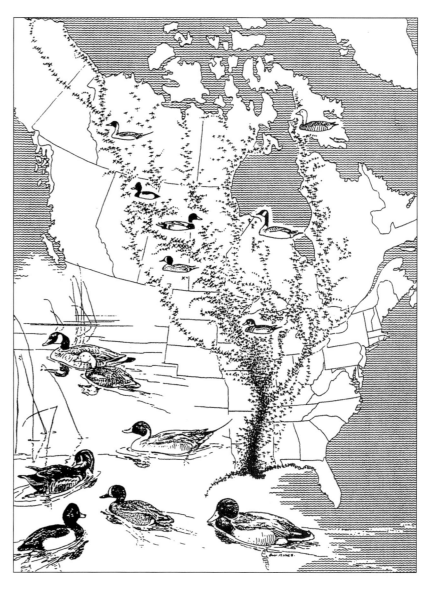

of bottomland hardwood forest. Both landscapes are critical to waterfowl, one serving as the primary breeding area and the other helping to sustain wintering waterfowl. Both the northern grasslands and southern bottomland hardwoods also contain fertile soils, which have paved the way for the region's predominately agricultural environment today. As a result, more than 50 percent of North America's wetlands were converted to agricultural production over the past century, including about 80 percent of bottomland hardwoods.

With this great loss of wetlands in North America, some agricultural lands provide core habitats for waterfowl today. Waste seed from crops such as rice, corn, and milo provide

The Mississippi Flyway is comprised of fourteen states and three Canadian provinces. Figure courtesy of The North America Flyway Directory, U.S. Fish and Wildlife Service

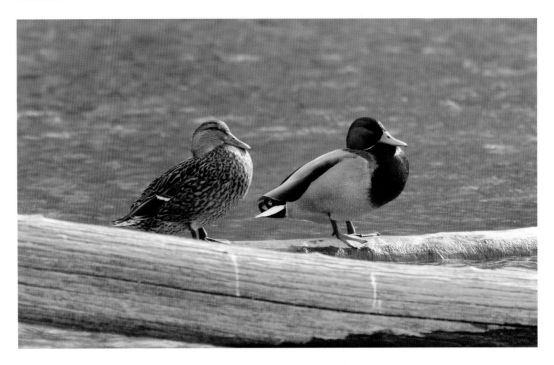

These mallards illustrate the difference in coloration between males and females at the peak of the breeding plumage period. Photo courtesy of Daniel A. Skalos

important sources of energy for waterfowl during the biannual migrations. Given the dramatic changes in historical waterfowl habitats, conservationists formulated grand initiatives, such as the North American Waterfowl Management Plan adopted in 1986, considered one of the world's most comprehensive conservation plans ever produced. The plan helps protect, restore, and enhance remaining natural habitat, such as grassland and bottomland hardwood forests and other resources in all of the migratory flyways. Conservation programs in Mississippi include the Wetlands Reserve and Conservation Reserve Programs. These programs have been highly successful in protecting and restoring wetlands and other native habitats on private lands and have secured critical waterfowl habitats through perpetual or other long-term conservation easements.

LIFE HISTORY AND ECOLOGY

Waterfowl are members of the family Anatidae, which includes swans, geese, and ducks. These birds are primarily characterized by large or specialized bills, webbed feet, rounded bodies, and, in some cases, long necks. Some species are highly migratory, like northern pintail and blue-winged teal, whereas others are more sedentary, like the giant Canada goose.

Body Form and Plumage

Ducks, geese, and swans all molt (lose and replace their feathers) each year. Ducks are generally brightly colored and are sexually dimorphic, meaning the plumage differs in pattern and color between males and females. Geese and swans, however, lack distinctive plumage differentiation between the sexes. Basically, geese and swans wear only one plumage per year, whereas ducks have two. Part of the reason for these differences is that geese and swans mate for life, but ducks select new mates each year.

Male ducks are typically the most colorful and attain their breeding plumage during autumn and winter, long before breeding season arrives. Feathers of female ducks are typically drab brown year-round. Female mallards and others will molt into an even darker brown plumage in late winter for better camouflage when nesting. Males molt their breeding plumage and undergo a complete wing molt soon after the breeding season, wearing the brown or basic plumage for several weeks. Females molt their body and wing feathers, temporarily

Observers and hunters consider drake pintails to be one of the most attractive duck species because of their elegant appearance, sharp colorations, and multicolored speculums. Photo courtesy of Daniel A. Skalos

becoming flightless, like males, after rearing their broods in late summer.

Waterfowl Food Habits

North American ducks consist of diving, dabbling, and perching ducks. Divers possess a streamlined body form, with their heavily webbed feet located farther back on the body, which enhances their swimming ability above and below the water surface. Dabblers and perching ducks have more of an upright and centered body position, allowing them to be generalists by foraging both in water and on land.

Divers.
Diving ducks are so named because they dive underwater, often to depths of 3 to 5 feet or more, to feed on submerged plants, which are rooted to the bottom or grow beneath the water surface, such as widgeon grass. Other foods important to divers include clams, mollusks, and other invertebrates. When attaining flight, divers can be easily distinguished from other ducks because they must briefly run atop the water surface before becoming airborne.

Some species of diving ducks prefer deeper, more permanent bodies of water such as bays, rivers, and estuaries, and Mississippi's coastal marshes are especially attractive to these diving ducks. In the Delta, catfish ponds, major rivers, and oxbow lakes, or brakes, often contain lesser scaup, ring-necked ducks, ruddy ducks, and other diving ducks during winter and spring migration.

(Top) Diving ducks, or divers, feed 3–5 feet below the water's surface. (Bottom) Divers first run across the top of the water to gain speed for flight. Figure courtesy of Mississippi State University Agricultural Communications

The lesser scaup is commonly found on large deep bodies of water throughout Mississippi in autumn and late winter. Photo courtesy of Daniel A. Skalos

Dabblers feed from the water surface or by tipping up to reach various food items in the soil below. (Bottom) Unlike divers, dabblers can rise up immediately to attain flight. Figure courtesy of Mississippi State University Agricultural Communications

Northern shovelers (or spoonbills) have a wide bill that enhances their ability to filter water for small plant material and invertebrates. Photo courtesy of Daniel A. Skalos

Dabbling and Perching Ducks.
The dabbling and perching ducks are often referred to as dabbling, pond, or puddle ducks because they prefer shallow water. These ducks often feed by tipping up as they forage in shallow water for seeds, tiny insects, and wetland plant parts. Unlike diving ducks, dabblers gain flight quickly by springing up vertically from the water to gain flight.

Dabbling ducks may occur in large concentrations in early autumn and winter, especially during migration, in newly flooded habitat with abundant food and when using sanctuaries isolated from human disturbance. However,

as winter progresses and more ducks become paired, flock size tends to decrease as pairs naturally segregate from larger concentrations.

Food Selection

Ducks vary in body size, neck length, and bill design. These slight variations enable different species to forage together within the same habitat because they often search for slightly different foods. A suitable array of plants and associated aquatic insects have adapted to different elevations within wetland habitats. Therefore, different species of ducks often occupy different zones, or water depths. For example, smaller ducks like teal prefer mudflats and water only a few inches deep, whereas mallards may feed in 3 inches of water but loaf or rest in 3 feet of water in bottomland brakes. Others such as gadwall, wigeon, and northern shoveler feed on plant seeds, tubers, leaves, and associated aquatic invertebrates in these same habitats. Although there is some dietary overlap among the dabblers, enough diversity exists among species that competition for food is reduced or nonexistent in most habitats.

Courtship

Many dabbling ducks begin to pair during autumn migration and winter. As winter gives way to spring, the male duck generally follows the female on spring migration and ultimately to her nesting ground of choice. Male and female ducks form pairs with different individuals each year and thus perform elaborate courtship rituals when attracting new mates. The courtship rituals may involve elaborate extended physical displays from both sexes or be as simple as a male guarding a specific feeding area for his mate. Unlike ducks, geese and swans typically mate for life; thus, their courtship is not as ritualized as that of ducks.

Mallards, the ancestor of many domestic duck species, participate in elaborate courtship displays. Male (or drake) mallards perform courtship rituals during autumn, winter, and spring. These usually begin with several males shaking their heads and tail feathers in the

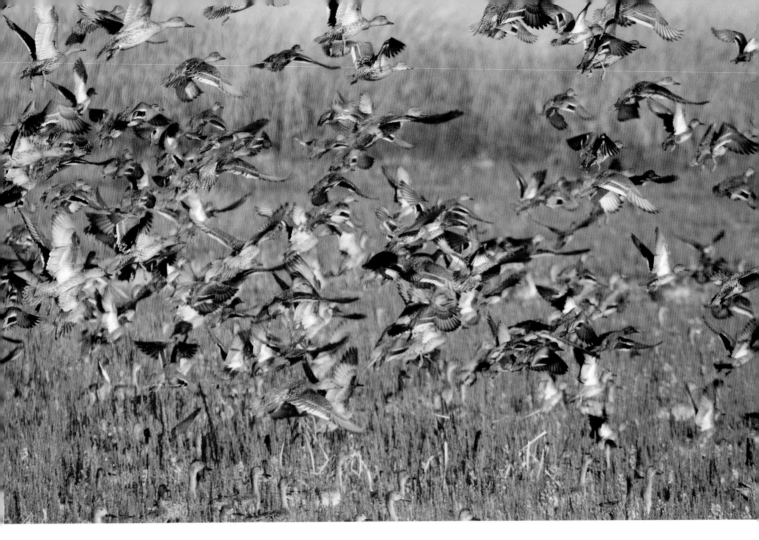

presence of a female. While swimming around an intended female, males lift their breasts out of the water and stretch their necks. An interested female may follow suit by extending her neck just above the water and swimming toward the preferred male. This encourages the continued courtship displays from the male, allowing her to evaluate each one's performance as a potential mate. Once paired, both sexes expose their speculums as if preening (cleaning feathers with the bill) prior to copulation. These activities may continue for weeks and sometimes includes aggressive behavior between individual males and females.

Nesting

Although Mississippi supports many species of waterfowl during migration and winter, wood ducks, hooded mergansers, and local Canada geese nest in the state. More recently, the black-bellied whistling duck has nested in Mississippi, and some mottled ducks have been observed nesting in the three coastal counties.

Most ducks migrating through or overwintering in Mississippi nest in the prairie pothole region of the north-central United States and Canada. A smaller proportion of ducks nest in Alaska, the Boreal Forest of Canada, and the Great Lakes region. Snow and greater white-fronted geese nest further north in arctic river delta regions of Canada and Alaska.

The abundance of birds observed in the Mississippi Flyway during winter is influenced by several factors, one being the nesting success of birds during the previous breeding season. The quality of breeding habitats in the prairie pothole region is largely driven by winter snow cover and spring rainfall. Other important breeding areas of North American ducks include the Great Lakes region and Central Valley of California. California is unique in that it is critical to both breeding and wintering mallards, which are largely confined to the Pacific Flyway. Peak timing of nesting varies, not only because of so many different species of nesting waterfowl, but because of the diversity of geographic regions. Mallards that winter in Mississippi are often

Dabbling ducks such as northern pintail, American wigeon, and green-winged teal use the same shallow wetland areas when feeding. Photo courtesy of Daniel A. Skalos

A female mallard guards her young. Photo courtesy of Ducks Unlimited, Inc.

Canada geese can be aggressive toward any threat, including natural predators, pets, and humans. Photo courtesy of iStock

CANADA GEESE IN MISSISSIPPI

Canada geese were first brought to Mississippi during the 1980s by the Mississippi Department of Wildlife, Fisheries, and Parks to provide hunting opportunities for sportsmen. Most of these birds were transplanted from Michigan. Resident Canada goose populations continue to grow here because these long-lived birds are extremely adaptable in their use of various habitats, resulting in high survival rates of their young. For instance, geese do well in the manicured spaces created by humans in residential and recreational areas including reservoirs, public parks, and golf courses. Because of these traits, Canada geese have become troublesome for landowners and resource managers in some parts of the state.

nesting by mid-April in the prairies, whereas greater white-fronted geese may not nest until May and June in the high arctic.

Of the nesting waterfowl in Mississippi, wood ducks and hooded mergansers are secondary cavity-nesters, meaning they rely on tree cavities carved out previously by other birds (such as pileated woodpeckers) or weather events such as ice and tornadoes that naturally form cavities. Black-bellied whistling ducks will also use cavities, especially man-made wood duck nest boxes, or nest on the ground. The mottled duck appears similar to a hen mallard and nests in grassy or shrubby areas, especially over water, in the wetlands of coastal Mississippi. Resident Canada geese are becoming ever more common in the state, often nesting among areas with ample green grass and ponds or lakes, such as golf courses.

Most ducks nest on the ground, and nesting material varies greatly and may include grasses, brush, cattail, or bulrush. In their breeding areas in the western United States and Canada, redhead and canvasback ducks nest over water and use cattail, bulrushes, or other emergent marsh vegetation to form nest bowls. Dabbling ducks may nest near the water's edge or as far away as 1 mile from water.

Upon arrival at the breeding grounds, female ducks locate a site favorable for establishing a nest. The aggregate of eggs that waterfowl lay is called a clutch. Clutch sizes of waterfowl vary among species, but most dabbling and diving ducks lay eight to ten eggs. Typically only female ducks incubate eggs and care for the young. The female and ducklings (her brood) all depart the nest 1 day after the eggs hatch to begin foraging for food.

In contrast to ducks, geese and swans lay four to eight eggs, and clutches of five or six eggs are most common. Also unlike ducks, male geese guard their female partner and also help tend to the brood. Waterfowl are unique from most other birds in that the young feed themselves. Young waterfowl need protein to build muscle and feathers, so they eat insects or green plants, often feeding on them as soon as they depart the nest. The typical family group of geese will remain together for at least 1 year.

MISSISSIPPI WATERFOWL HABITATS

Western Mississippi is comprised of an alluvial plain, also known as the Delta. Historical abundance of waterfowl in Mississippi resulted largely from habitats associated with the Mississippi and other rivers, sloughs, and oxbows. The Delta was once predominately forested, but these woodlands were cleared and eventually converted to diverse agricultural lands. Today, shallowly flooded habitats like rice fields provide critical food and loafing areas for waterfowl and other birds. Also, agricultural land managers have begun to provide important seasonally flooded wetlands that complement forested, brake, oxbow, and other important wetland habitats for wintering waterfowl.

The Delta is the largest and most important region for waterfowl in Mississippi, but other parts of the state host smaller numbers of ducks that are associated with reservoirs, small lakes and ponds, smaller wetlands, and natural waterways.

Riverine Corridors

Rivers are historically important navigation corridors for waterfowl that undertake lengthy migrations and provide important habitats. Before the construction of major levee systems along the Mississippi and other rivers, water rose slowly and broadly, often forming large shallow pools across the Delta. This provided diverse habitats for many birds, as most wetland-dependent species prefer water that is no more than 10 inches deep. However, since the advent of river channelization, flood waters today often rise quickly and to depths that prohibit adequate feeding (more than 18 inches) by most dabbling ducks. Moreover, when water reaches agricultural fields inside the levees or in areas not protected by levees, it quickly recedes if it is not trapped by water control structures, ultimately depriving the soil of rich nutrients once deposited by the river.

Despite these significant changes to the Mississippi River and Delta, smaller tributaries such as the Coldwater, Tallahatchie, Yocona, Yalobusha, Sunflower, Yazoo, and Big Black

One of the many curves of the Mississippi River contains some of the remaining bottomland forest of the Delta. Photo courtesy of Matt M. Weegam

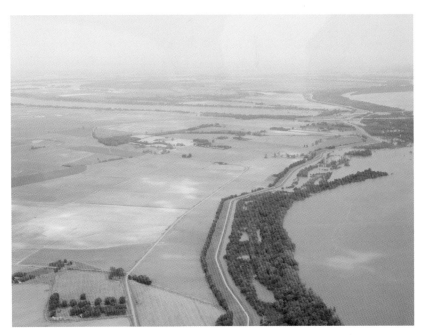

The Mississippi River approaching the top of the mainline levee during historic flooding in 2011. Photo courtesy of William W. Hamrick, Mississippi State University

meander through some of the most fertile farmland in the United States. When Mississippi backwaters flood, they are quite seductive to ducks, especially when these streams remain shallowly flooded. Purposefully flooded agricultural fields of rice or other grain are especially important to waterfowl conservation.

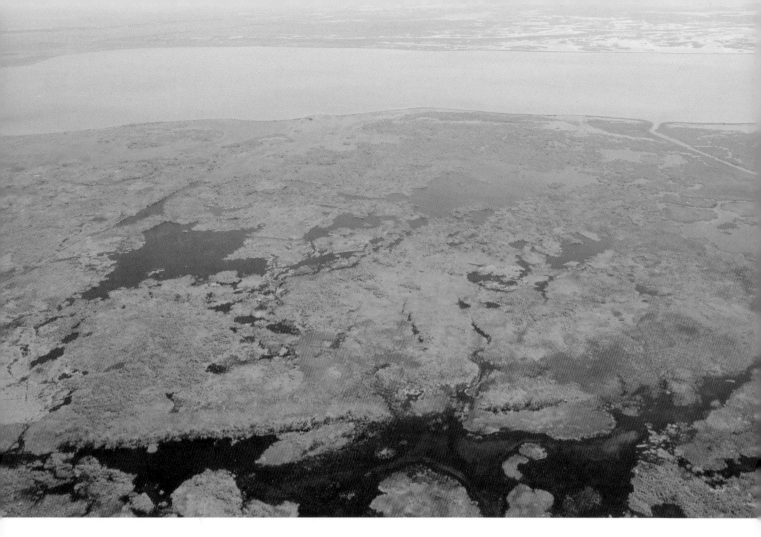

Coastal wetlands are critical habitats for overwintering waterfowl and provide many ecological functions, including hurricane storm-surge protection. Photo courtesy of Ducks Unlimited, Inc., Lafayette, Louisiana, Field Office

Furthermore, when landowners enroll lands into Farm Bill conservation programs that promote wetland management, they help supplement agricultural wetland habitats. Together, shallowly flooded agricultural fields, seasonal wetlands, and Wetland Reserve Program lands all contribute to a diversity of critical habitats needed by birds to survive winter and prepare for breeding in spring.

In eastern Mississippi, rivers such as the Tennessee-Tombigbee, Pearl, Pascagoula, and other smaller systems are not surrounded by large tracts of quality wetland or agricultural habitats, like those in parts of the Delta or elsewhere. However, wood ducks, mallards, gadwall, and other species use these habitats, especially if floods occur or extremely cold temperatures persist and freeze smaller wetlands. Nonetheless, where landowners in eastern Mississippi can develop shallow, seasonal wetlands that contain desirable moist-soil plants, even on areas as small as 20 acres, ducks may be attracted to these sites, and quality hunting can be enjoyed 1 to 2 days per week.

Coastal Wetlands

In addition to interior waterfowl habitats of the Mississippi Delta, coastal wetlands of southeastern Mississippi provide important habitats for a diversity of birds. Situated between the Pine Hills and the Gulf of Mexico are rich estuarine systems, such as the Mississippi Sound and St. Louis, Biloxi, and Pascagoula Bays. Areas like Point Aux Chenes and Middle Bays provide important habitat to wintering diving ducks such as lesser scaup and redheads in most years. Collectively, southern coastal marshes of the Mississippi Flyway provide habitat for more than 400,000 geese, 4 million ducks, and hundreds of thousands of shorebirds.

Coastal wetlands are often categorized to as one of four different marsh types: salt, brackish, intermediate, or freshwater marsh. Plant communities in these wetlands are influenced by salinity levels, which influence food availability and waterfowl use.

Salt marshes are typically dominated by smooth cordgrass or needle rush. These habitats

An aerial view of the modern-day Mississippi Delta shows the extensive agriculture that takes place in this region. Photo courtesy of Google Earth

are good sources of crustaceans, but they may have limited seeds or vegetation used as forage by waterfowl. Tidal influences also affect water depth and duration.

Brackish marshes are mostly dominated by bulrush, marsh hay, and submerged aquatic vegetation like widgeon grass. These areas are usually nutrient-rich with waterfowl foods because they provide aquatic invertebrates and submerged vegetation favored by many waterfowl.

Intermediate marshes are influenced by tides and have much less salinity than salt marshes. Intermediate marshes tend to be dominated by common reed, narrow-leaf arrowhead, and submerged pondweeds, much of which provide energy-rich food for waterfowl.

Freshwater marshes are usually associated with a major creek or river. This marsh type lies between rivers and bays in southern Mississippi. These wetlands are often called bayous and sloughs and primarily differ from upland freshwater marshes only by latitude. Vegetation such as wild rice, cattail, and other aquatic plants often grow in freshwater marshes.

Agricultural Landscapes

More than any other human activity, the profound change from pristine wetlands and associated grasslands to agriculture production has greatly influenced habitat use and some populations of waterfowl. Throughout the breeding ranges of ducks, most agricultural conversions have been detrimental because large-scale reduction of prairie grassland (the critical nesting habitat for ducks) has greatly reduced safe nesting sites. Also, the accompanying widespread drainage of wetlands and use of pesticides have resulted in fewer wetland habitats that supply seeds, aquatic insects, and cover for breeding ducks and their broods. Fortunately, many species of waterfowl have adapted and learned to coexist and nest in agricultural landscapes.

For migrating and wintering waterfowl, waste grain and associated invertebrates are available to birds in shallowly flooded habitats, such as rice or corn fields. Because of the loss of the historical wetlands, flooded agricultural fields are now an essential habitat for waterfowl.

Table 11.1. Schedule for producing and managing small grains for waterfowl in Mississippi

Activity	Timing	Management recommendations
Spring drainage	About 2 weeks before planting date for crop grown	Hold water on cropland until near planting time to control weeds and to encourage use of food by waterfowl and other wildlife.
Ground preparation	14 days or more after drawdown	Disk as needed to prepare a seedbed, or use burn-down herbicides and plant using no or reduced tillage.
Planting	After seedbed preparation or best planting dates in your area; consult with an extension agent	Recommended seeding rates: rice, 90 pounds/acre; Japanese and browntop millet, 12–25 pounds/acre; corn, 18,000 kernels/acre
Fertilization	Consult extension agent for dates to apply	For best results, soil test and follow recommendations. Rice: up to 180 pounds/acre of nitrogen and up to 40 pounds/acre of phosphorus and potassium. If you apply a blend, use 20-10-10 at a rate of 800 pounds/acre. For rice, divide the nitrogen into two applications, one preflood and another midseason. Millets: up to 60 pounds/acre of nitrogen and up to 40 pounds/acre of phosphorus and potassium. If you apply a blend, use 300 pounds/acre of 20-10-10 or 450 pounds/acre of 13-13-13. Corn: up to 200 pounds/acre of nitrogen and up to 60 pounds/acre or phosphorus and potassium. Apply one-third of the nitrogen and all of the phosphorus and potassium at planting. Apply the remaining nitrogen at six-leaf stage. If you apply a blend, use 400 pounds/acre of 13-13-13 and 350 pounds/acre of 34-0-0 at six-leaf stage. Or apply 800 pounds/acre of 20-10-10 all at once.
Weed control	Early part of the growing season	Selectively treat areas with herbicides, bush-hogging, or disking when cocklebur, coffeeweed, or other undesirable broadleaved plants cover more than 25% of the ground. Review herbicide recommendations for more thorough coverage of this topic. Be sure to read and follow all the label instructions when applying herbicides.
Flooding	May to June	For rice production, flood rice when plants are 5–6 inches tall, and keep 2–4 inches of water throughout the growing season.
	August 15 to September 30	Shallowly flood (2–6 inches) 10% of the total managed area to provide habitat for early migrants such as blue-winged teal.
	November 15 to January 1	Increase water levels gradually to flood entire management area.

Adapted from Strickland, B. K., et al. 2009. *Waterfowl Habitat Management Handbook for the Lower Mississippi River Valley.* Publication 1864. Mississippi State University Extension Service.

Waste grain from corn, rice, barley, chickpea, and other crops is available in fields following harvest. In the northern United States and Canada, waterfowl commonly feed in dry fields for grain prior to migration to southern wintering areas. The grain provides birds with important sources of energy for migration. Waste grain lying in fields that survives winter is also consumed by waterfowl as they fly north during spring migration. Although this energy-rich food provides strength for birds to make long-distance flights, waste grain lacks other essential vitamins and minerals. Therefore, waterfowl must supplement their diets with aquatic invertebrates and seeds of wild grasses and weeds during winter and as they migrate in spring and prepare to nest.

River channelization, damming, and other modifications have eliminated or reduced the quality of wetlands nationwide. Today, the interior of the United States contains numerous man-made reservoirs, ponds, and wetland areas that are often surrounded by agricultural lands. These new wetland habitats are beneficial to waterfowl if they contain natural wetland foods, but also if they are in proximity to grain fields. Species like mallards, green- and blue-winged teal, northern shoveler, northern pintail, and some diving ducks use flooded agricultural fields during winter. The primary downside to the conversion to agricultural lands it is that they have allowed snow goose populations to grow by many millions during this and the previous century. Whereas snow geese once wintered in the coastal marshes and foraged on shoots and rhizomes of marsh plants, super-abundant corn and other grain throughout the United States have caused uncontrolled population growth of white geese. Most troubling is that an environmental collapse could occur on the species' breeding grounds of the high arctic of North America if populations are not controlled by liberalized hunting or other means.

Managing Agricultural Fields for Waterfowl.
Although agricultural crops attract waterfowl for hunting, it is imperative to remember that grains are lacking in other essential nutrients that can be provided by native vegetation in natural wetland habitats or managed wetlands (such as moist-soil units). The energy content of grains differs among varieties. With the exception of soybeans, agricultural foods provide great energy, but that energy declines rapidly when seeds are exposed or flooded for more than 2 months (for more information on supplemental plantings, see chapter 13).

Several methods can be used to manage post-harvested agricultural fields. For example, rice stubble can be partially burned or rolled to create openings in the stubble, permitting access by landing birds. Corn fields may be partially harvested, with other portions of the field left standing. Alternating rows of standing and harvested corn provides structural diversity of the field, helps conceal hunters, and may provide additional access to corn later if water rises and floods new ears.

If agricultural habitats are provided for waterfowl, it is critical to understand that only normal agricultural practices are permitted when hunting. For example, a manager cannot leave portions of rice, corn, or other agricultural crops unharvested and then roll, bush-hog, or otherwise manipulate the remaining standing crop. This practice is regarded as baiting and is a federal offense if hunted over or in proximity to these areas. When managing harvested fields, managers should flood them in a staggered fashion; in other words, do not flood every acre at the same time prior to waterfowl season. Partially flooding fields throughout the hunting season helps preserve the waste grain in the fields and ensures new habitat for ducks.

Bottomland Hardwoods

Seasonally flooded bottomland hardwood forests provide important habitats for as many as eight species of waterfowl, but particularly mallards and wood ducks, during winter. Also, wood ducks and hooded mergansers nest in natural tree cavities throughout their range. Bottomland hardwood forests are unique systems in the southern United States and provide resources like few other habitats on the wintering grounds in North America. When flooded, bottomland hardwood trees such as

WOOD DUCK

Mississippi's state duck is the wood duck, and it is arguably one of the most beautiful of all waterfowl worldwide. Found in forty-two states and five Canadian provinces, the wood duck frequents bottomland hardwood forests, scrub/shrub wetlands, sloughs, and streams in Mississippi.

Female and male wood duck. Photo courtesy of iStock

By the early twentieth century, the wood duck was nearly extirpated from North America. Unregulated hunting was the primary factor, but deforestation and drainage of wetlands compounded the population decline. The Migratory Bird Treaty Act of 1918 was critical in curbing the decline of wood ducks. Man-made nest boxes helped re-establish local populations of wood ducks, and by the mid-1990s an estimated 100,000 nest boxes nationwide helped to produce more than 300,000 ducklings annually.

A wood duck fledgling preparing to leave the nest box. Photo courtesy of iStock

Paired male and female wood ducks select nest sites in January and February, with the first eggs laid in February or March. Similar to other duck species, the female tends to the hatching and raising of the ducklings. Female wood ducks typically lay a clutch of ten to twelve eggs and can lay two clutches a year. The eggs hatch after roughly 30 days, and within 24 hours the female and ducklings leave the nest.

Ducklings are capable of feeding themselves a typical diet of aquatic insects, seeds, and plant material. Wood duck broods seek shallow brushy wetlands for food and cover, which protects them from predators and weather.

Wood Duck Nest Box Design and Management

◆ Constructing nest boxes of 1-inch-thick cedar or cypress boards is recommended for durability and maintaining proper temperature and protection for the eggs.

◆ A box that is 12 inches wide × 20 inches high × 12 inches deep is ideal for producing ducklings.

◆ Place 3–4 inches of wood shavings (not sawdust or wood chips) in the bottom to create a soft area for eggs to lie in the box. Hens pull down feathers from their bodies to further insulate the eggs.

◆ Attaching a screen mesh or roughing inside the box directly below the entrance hole eases the ducklings' exit from the box.

◆ Nest boxes can be placed directly over water, adjacent to suitable wetland habitat, and alongside sloughs or wetlands.

◆ The tree or post the nest box is attached to should be fitted with a predator guard made of a metal band or cone that is at least 2 feet wide.

◆ Boxes should be cleaned and wood shavings replaced at least twice a year, once in July or August following the nesting period and again in December or January.

red oaks and pecans produce abundant nuts. Other benefits include seeds from moist-soil grasses that grow in forest gaps, invertebrates, and even the wing-shaped dry fruit (samara) of maple, ash, and elm trees. Foods in bottomland hardwood forests are important because they supplement waste grain and weed seeds found elsewhere. Flooded bottomlands also provide a sense of security for ducks so they can hide among flooded trees. Mallards,

A seasonally flooded bottomland hardwood forest in the Mississippi Delta. Photo courtesy of Stephen J. Dinsmore, Iowa State University

SOURCES OF MOIST-SOIL MANAGEMENT TECHNICAL GUIDANCE

State and Federal Agencies

Mississippi Department of Wildlife, Fisheries, and Parks
www.mdwfp.com
(601) 432-2400

Mississippi State University Extension Service
www.msucares.com
(662) 325-3174 (wildlife and fisheries)

U.S. Department of Agriculture Natural Resources Conservation Service
www.nrcs.usda.gov
(601) 965-5205

Mississippi Department of Environmental Quality
www.deq.state.ms.us
(601) 961-5171

Nongovernmental Organizations

Wildlife Mississippi
www.wildlifemiss.org
(662) 686-3375

Delta Wildlife
www.deltawildlife.org
(662) 686-3370

Ducks Unlimited
www.ducks.org/mississippi
(662) 253-5048

gadwall, wood ducks, and other species actually perform courtship rituals in flooded forests, and the habitats also provide space for established pairs of ducks to remain segregated from larger groups of birds. Even floating logs are important because mallards and wood ducks commonly rest and preen their feathers while sitting atop logs. Sometimes, ducks like to get out of the water.

Managing Bottomland Hardwoods for Waterfowl. When creating new hardwood impoundments or managing existing ones, landowners should have a registered forester conduct a timber cruise to inventory the composition and density of trees in the selected stand. For existing forested wetlands, gathering information periodically to document changes in forest stand composition is recommended. It is also important to secure all required permits before impounding forest tracts. For example, a Corps of Engineers 404 permit may be required if earthen materials are moved (such as levee construction) in bottomlands because they will likely contain hydric soils.

Two primary habitats of bottomland hardwood forests may be attractive to waterfowl: live forest that is mostly composed of red oak trees and areas of dead timber or beaver ponds. Bottomland hardwood forests with

Beaver activity, such as dam building, can provide excellent waterfowl habitat, but often these flooded areas conflict with local human activity. Photo courtesy of Heath M. Hagy, Illinois Natural History Survey

large, acorn-producing red oak trees (including cherrybark, water, willow, Nuttall, and Shumard oaks) provide waterfowl with energy-rich acorns. Generally, the greatest abundance of acorns is produced from individual trees that are 14 to 30 inches in diameter at breast height or larger. Ensuring that light gaps are sufficient to enter the forest floor also helps generate growth of moist-soil weeds and grasses and allows access by mallards. Forests that contain beaver activity can also be productive for waterfowl. If mudflats are present in summer, these areas can be overseeded with Japanese millet. Other moist-soil plants may also grow if mudflats exist to facilitate plant germination.

One of the most fundamental aspects of managing bottomland hardwood forest for waterfowl is water management. Historically, bottomlands were flooded intermittently in winter, when heavy rains would inundate lowlands for a brief period before drying up. This pattern may have been repeated throughout winter. Today in managed green-tree reservoirs, landowners tend to flood in early autumn (September or October) when free waste agricultural water is available. Also, water is often maintained all winter at depths desired by hunters to enable easy access by boats. These two fundamental changes over time have encouraged growth of more water-tolerant overcup oaks, but their

acorns are too large for ducks to consume. Thus, to avoid displacement of valuable red oaks by overcup oak, landowners are encouraged to flood hardwoods in early to mid-November and to fluctuate these dates by 1 to 2 weeks annually, if possible. Draining these wetlands is also important because managers want to avoid flooding trees during budding. Therefore, sites should be drained no later than March 1 each year. If water management schemes are not somewhat dynamic and follow what occurred naturally, a gradual decline in red oaks and regeneration of overcup and other undesirable plants is likely to occur. This would likely lead to an eventual decrease in use of bottomlands for food by ducks.

The best scenario for managing bottomland hardwoods is to mimic the historic intermittent flooding during winter. Another option would be to flood one forest, or a portion of it, at one point (for example, on November 15) and flood another forest, or the other portion, later, perhaps 2 to 4 weeks after the initial winter flooding. Whichever timeline you choose, such regimes are beneficial because they mimic natural flooding and ensure dynamic habitats for waterfowl throughout winter.

Another important aspect to consider is water depth. Ducks prefer to forage in depths of less than 18 inches, but even shallower depths of about 10 inches are advantageous. In late winter following the duck hunting season, water levels that recede to just several inches allow ducks easier access to aquatic insects, which are critical foods for birds as they prepare for spring migration and breeding.

Moist-Soil Wetlands

Moist-soil is another term for a seasonally flooded wetland. These wetlands typically contain grasses (such as wild millets and panicgrasses), forbs, tuber-producing plants, and shrubs that have many benefits for waterfowl. Moist-soil wetlands are called seasonal because, to be productive later in autumn and winter when waterfowl arrive, these wetlands should be dry in late spring and summer. Pioneering or early-succession plants like wild grasses and

Table 11.2. Schedule for managing moist-soil areas for waterfowl in Mississippi		
Activity	**Timing**	**Management recommendations**
Early-season drawdown	Over the first 45 days after the last killing frost	Slow drainage (decrease water levels in 6-inch increments every 2–4 weeks until area is drained), which permits wildlife to use food resources and young wood ducks to fledge.
Midseason drawdown	From 46 to 90 days after the last killing frost	Slow drainage as described above.
Late-season drawdown	More than 91 days after the last killing frost	Slow drainage as described above.
Vegetation monitoring	About 14 days after drawdown	Monitor the occurrence of cocklebur, coffeeweed, and woody plants every 14 days, and implement control when these species cover more than 50% of the ground.
Weed control	After monitoring and as needed	After cocklebur, coffeeweed, and other broadleaved plants have emerged, control with an appropriate selective broadleaf herbicide. [a]
Fertilization (not required)	When desirable grassy/weedy plants are 2–6 inches high	Apply urea at 75–100 pounds/acre. For maximum seed production, conduct a soil test and follow recommendations.
Flooding	August 15 to September 30	Shallowly flood (2–6 inches) 10% of the total managed area to provide habitat for early migrants such as blue-winged teal.
	September 30 to November 15	Increase water levels slowly until entire area is flooded by November 15.
	December to January 15	Some managers save several moist-soil areas for flooding in December and January, when more waterfowl are present.

[a] For specific herbicide recommendation, see the table on p. 19 of the publication listed above.
Adapted from Strickland, B. K., et al. 2009. *Waterfowl Habitat Management Handbook for the Lower Mississippi River Valley*. Publication 1864. Mississippi State University Extension Service.

weeds need mudflats on which to germinate in spring or summer. Moist-soil plants grow well in open areas like abandoned rice fields and in openings of bottomland hardwood forests. These plants tolerate soil moisture and occasional flooding, as long as they are not covered with water for more than 1 to 3 days during the growing season. These wetland plants are well-adapted to grow in wet soils, which make them ideal in a variety of lowlands.

Moist-soil communities typically include annual plants such as smartweed, wild millets, panicums, sprangletop, and pigweeds, among others. Collectively, these plant communities may produce more than 2000 pounds per acre of seeds, tubers, invertebrates, and other food. These seasonal wetlands require managers to be diligent in maintaining the annual plant communities. After 2 to 4 years of annual flooding and drainage of these wetlands, a perennial plant community may gradually overtake the early-succession, high-seed-producing annual plants that provide necessary foods for waterfowl. To maintain early-succession plant communities, wetland managers should be ready to use a variety of techniques that might include

A well-established moist-soil unit in early autumn prior to flooding for the waterfowl hunting season. Photo courtesy of Richard Kaminski, Mississippi State University

disking, strip planting, mowing, herbicide application, timing of spring and/or summer drawdown, or combinations of these. Although reducing plant succession is generally required at some point, the frequency with which it has to occur will vary by region and even in specific fields on a single property. Soil type, slope of the land, and many other factors differ among wetlands, and the method and frequency of disturbance will also vary. Chapter 7 of this handbook and other sources listed at the end of that chapter provide specific management prescriptions and should be consulted before initiating wetland plant succession management.

APPLICATION OF WETLAND MANAGEMENT TECHNIQUES

Although the application of specific techniques to manage seasonal wetlands is based on sound science, managers must be attentive and flexible as conditions change. Prior to implementing significant management practices, landowners are encouraged to consult with a qualified wildlife biologist to help identify current conditions and assist with planning future goals and objectives.

Location

One of the most important management decisions is to select a good location in which to develop new wetlands or conduct habitat manipulations on existing habitats. The realtor's mantra—location, location, location—is just as applicable to land managers as it is to homebuyers. Managers must remember that waterfowl need diverse habitats, including bottomland hardwood forest, agricultural lands, seasonal wetlands, and permanent water. An individual landowner can sometimes provide all of these on a single property, but this would require thousands of acres. Where thousands of acres of habitat do occur on one tract of land, managers can attempt to allocate these different habitats throughout the property to attract waterfowl. For example, landscapes that contain approximately 50 percent cropland, 20 percent seasonal or moist-soil wetland, 10 percent permanent water, and 10 percent buck-brush (or scrub and shrub) have been shown to attract the most mallards in winter in Mississippi.

In reality, most landowners do not have thousands of acres and must provide habitats in much smaller confines. In those instances, a landowner should note what neighboring landowners provide for waterfowl habitat. If, for example, most habitats include flooded rice and soybean fields, a manager might consider providing something different but important to ducks, such as moist-soil or seasonal wetland. If neighboring lands are primarily large tracts of flooded forest, then providing seasonal wetland or agricultural crops (such as dirty corn) will provide something different but attractive to ducks on the property.

In most instances, the type of land managed will dictate which habitats are most likely to result. However, there are several important nearby landscape features to consider when selecting properties for waterfowl management: river or stream corridors, agricultural fields, bottomland hardwood forest, seasonal or moist-soil wetlands, scrub/shrub wetlands, and available resting and loafing areas or potential sanctuary. The size and distribution of these waterfowl habitats are what biologists term

habitat mosaics, or complexes. Generally, the larger and closer a property is to this mosaic of habitats in the landscape, the more ducks (like mallards) will be attracted.

Financial Considerations

A second common challenge for landowners is the cost associated with managing waterfowl habitats. Costs of wetland development can vary depending on the desires of the land manager and current conditions of the property. Where no wetlands currently exist, the cost to develop them may be more than $1000 per acre. This is especially true when developing a turn-key wetland restoration project, or one that involves sculpting a wetland from flat ground. However, the good news for Mississippi landowners is that a diverse network of federal, state, and local agencies and nongovernmental organizations provide technical guidance and financial assistance in many circumstances. Perhaps the best example of private land initiatives to restore wetlands in Mississippi is the Wetlands Reserve Program, administered by the Natural Resources Conservation Service. Once wetland impoundments have been established, managers can forecast annual maintenance costs of fuel, water, mechanical disturbance, chemical application, and other techniques

for maintaining productive wetlands. Costs can also be greater for areas that have been neglected and where significant restoration of levees, water control structures, and similar water management activities are required. On the other hand, if infrastructure (such as pipes and levees) already exists, wetland costs could be greatly reduced.

Water Management.
The ability to control the timing of flooding, drainage, and water depths are three of the most important factors in managing wetlands. Properties with existing irrigation or levees, such as current or abandoned rice fields and catfish ponds, may be ideal because the infrastructure for water management already exists and will help reduce overall restoration costs. If these systems do not exist and a water delivery system must be devised, the costs to do so will vary depending on approach. For example, drilling a deep-water electric well may cost tens of thousands of dollars, whereas use of a Crisafulli pump that can be attached to a tractor can be more economical. Among the most coveted water-delivery systems is one in which wetland impoundments can be flooded by gravity. That is, water enters a wetland unit positioned at slightly greater elevation, and water is allowed to flow downhill into subsequent units. Thus, this system is much like those used in rice fields. The advantage is that significant electric or diesel power costs would be averted. However, this system takes deliberate planning and development by wetland engineers or very skilled agricultural producers who have experience with gravity flooding in agricultural fields.

Vegetation Establishment or Control.
Establishing agricultural crops attractive to waterfowl (such as corn, rice, or milo) usually requires use of farm equipment and personal expertise. Landowners without such expertise should consider interacting with agricultural producers in nearby farming communities. An important consideration for managing seasonal or moist-soil wetlands is to monitor plant response in spring and summer. For example, if wetland units become established with seasonal

EXAMPLES OF HABITAT MANAGEMENT COSTS FOR WATERFOWL IN MISSISSIPPI

The following is a list of the average per-acre cost of enhancements (in 2011 dollars):

Pumping	$36
Dirt work and pipe	$975
Vegetation management	$100
Planting trees	$185
Establishing native grasses	$207

Source: U.S. Department of Agriculture Natural Resources Conservation Service

A WATERFOWL HABITAT DEMONSTRATION

From 2004 to 2007, a waterfowl habitat demonstration was conducted on a privately managed wetland in Tallahatchie County, Mississippi. The demonstration area was established to measure the cost per acre of various levels of moist-soil management and its impact on habitat quality and waterfowl harvest.

Costs per acre for management activities increased from $50 per acre in the first year to $150 per acre in the third year, as the level of management increased. Over the three-year period, the types of management practices conducted on the property included autumn and spring disking, late drawdowns, strip planting of food plots, autumn mowing (in native plant areas), early-season irrigation of moist-soil plants, herbicide application, and liming and fertilization.

There was a noticeable increase in both waterfowl use of the area and hunted harvest over the study period.

◆ Hunters increased daily harvest by 0.4 birds/man/day in the first year, 0.6 birds/man/day in the second year, and 1.1 birds/man/day in the third year.
◆ Over time, these specific management activities had positive impacts on waterfowl-friendly vegetation such as wild millet, fall panicum, and sprangletops.
◆ Increasing management costs up to $150 per acre increased habitat quality for targeted vegetation types and, regardless of waterfowl autumn flight forecasts, yielded a higher waterfowl harvest for hunters, further demonstrating the connection between management expenses, habitat quality, and hunter harvest success.

grasses and other favorable wetland weeds, little management is necessary because these are desired conditions. However, when wetlands become overrun with cocklebur, coffeeweed, or other undesirable plants after drawdown, significant intervention with use of chemical, bush-hogging, flooding and draining, or other techniques may be required in summer to rid undesirable species and promote desired vegetation. Absentee landowners should consult with a knowledgeable local farmer or other land steward who can evaluate and modify wetland plant communities in spring or summer, that is, prior to autumn, when it becomes too late to make beneficial changes. If reforestation or other long-term management schemes are desired, consultation with a qualified forester is recommended.

SUMMARY

Although much of the historic habitat in Mississippi has been altered through human development and agriculture, Mississippians—especially private landowners—have a great opportunity to conserve and manage quality habitat for these birds to persist into the future using the management strategies described in this chapter. No single strategy will be the so-called silver bullet in waterfowl conservation. Instead, a collection of strategies is necessary to provide the needed habitat, including the protection of natural habitat such as river corridors and coastal marshes, the creation of man-made wetlands, and the use of waterfowl-friendly agricultural practices.

In addition to these habitat strategies, the public, conservation professionals, and political leaders will need to work together on implementing the North American Waterfowl Management Plan through innovative approaches like conservation incentive programs and other policy initiatives. By doing so, future generations will be able to continue enjoying waterfowl through observation and hunting.

For More Information

Mississippi Department of Wildlife Fisheries and Parks website: www.mdwfp.com

Mississippi State University College of Forest Resources website: cfr.msstate.edu

Nelms, K. D., B. Ballinger, and A. Boyles, eds. 2007. *Wetland Management for Waterfowl Handbook*. Natural Resources Conservation Service. www.mdwfp.com/media/8838/wetlandmgtforwaterfowl.pdf

Reinecke, K. J., R. M. Kaminski, D. J. Moorhead, J. D. Hodges, and J. R. Nassar. 1989. Mississippi Alluvial Valley. Pp. 203–247 in L. M. Smith, R. L. Pederson, and R. M. Kaminski, eds. *Habitat Management for Migrating and Wintering Waterfowl in North America*. Lubbock: Texas Tech University Press.

Strickland, B. K., R. M. Kaminski, K. Nelms, A. Tullos, A. W. Ezell, B. Hill, K. Casscles Godwin, J. C. Chester, and J. D. Madsen. 2009. *Waterfowl Habitat Management Handbook for the Lower Mississippi River Valley*. Publication 1864. Mississippi State University Extension Service. http://msucares.com/pubs/publications/p1864.pdf.

Turcotte, W. H., and D. L. Watts. 1999. *Birds of Mississippi*. Jackson: University Press of Mississippi.

Wildlife Mississippi website: www.wildlifemiss.org

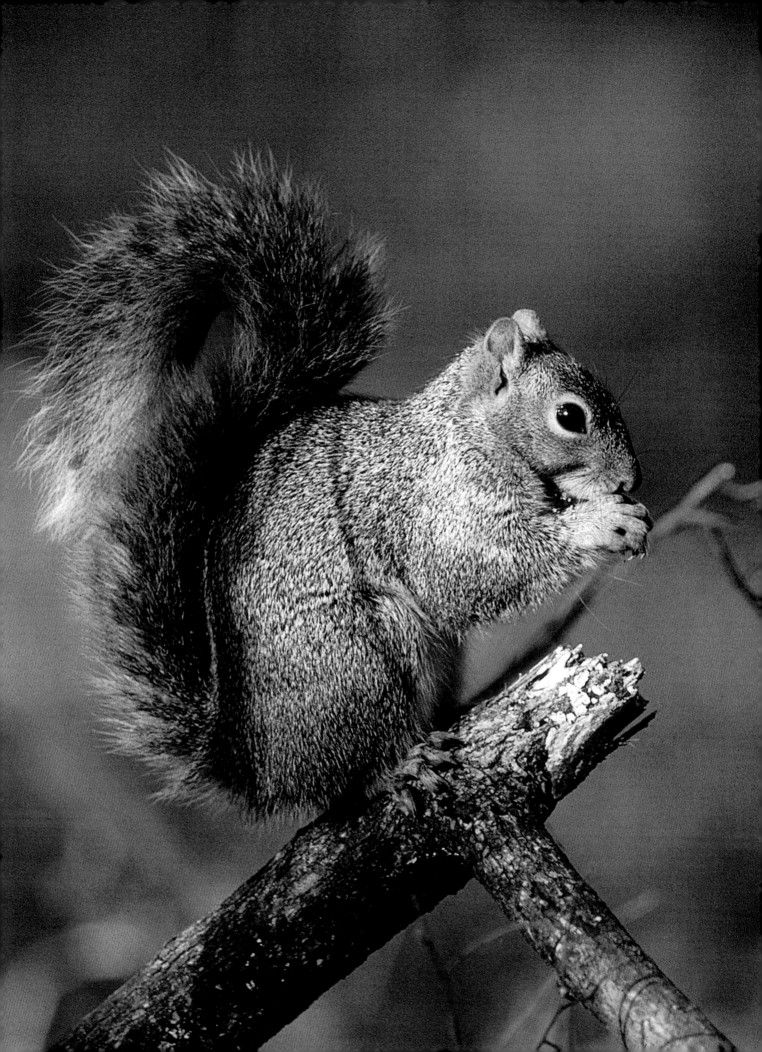

CHAPTER 12

Small Game

Richard G. Hamrick, Small Game Program Leader, Mississippi Department of Wildlife, Fisheries, and Parks

L. Wes Burger Jr., Dale H. Arner Professor of Wildlife Ecology and Management, Department of Wildlife, Fisheries, and Aquaculture, Mississippi State University

Technical editor

K. Dave Godwin, Wild Turkey and Small Game Program Coordinator, Mississippi Department of Wildlife, Fisheries, and Parks

Small game species, including northern bobwhite quail, rabbits, and squirrels, are present throughout Mississippi and have been pursued by Magnolia State hunters for many generations. Not too long ago, small game species represented the primary quarry for Mississippi hunters, as these populations remained abundant during a period when white-tailed deer and wild turkeys were uncommon. Small game hunting continues to be very popular and presents an excellent opportunity to introduce youth and others to hunting wild game.

Many private landowners are interested in managing habitat for these small game species, and successful management is sometimes possible on tracts smaller than those needed for effective deer or turkey management. This chapter provides some basic information on the ecology and management of common small game species in Mississippi.

NORTHERN BOBWHITE QUAIL

The tradition of quail hunting is an important part of the state's outdoor heritage. As recently as the 1980s, wild quail populations were abundant enough to provide good hunting opportunities in many areas of the state. However, quail populations have declined in Mississippi and most other regions where they were once abundant. Today, quality wild quail hunting is only locally available in Mississippi. Although wildlife researchers have been documenting quail population declines since the early twentieth century, the rate has increased dramatically since the mid-1900s.

Fox squirrel. Photo courtesy of Michael Kelly, Wild Exposures

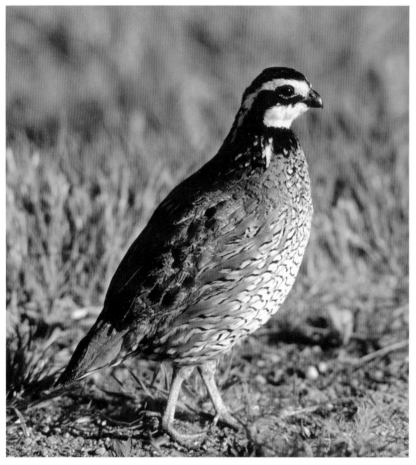

Northern bobwhite quail.
Photo courtesy of iStock

Dwindling quail populations have been blamed on numerous factors, including coyotes and other predators, fire ants, wild turkeys, pesticides, and the introduction of Mexican quail. Although many factors influence quail populations, declines have been primarily caused by deterioration of habitat quality caused by large-scale changes in the way land is used in Mississippi and throughout the South. Quail are dependent upon early-successional habitats, and many other wildlife species associated with these habitats are also experiencing population declines.

Abundant bobwhite populations of past decades were usually an accidental by-product of diverse land-use practices that created a patchwork of different habitats. Until the mid-1900s, fields of row crops, native grasses, and annual weeds were well distributed among forested lands. Prescribed fire was frequently used to manage vegetation in fields and forests, improve livestock grazing quality, and for other reasons such as the perceived control of ticks and other pests. The patchy cover these rural land management practices created was perfect habitat for northern bobwhite quail. However, modern

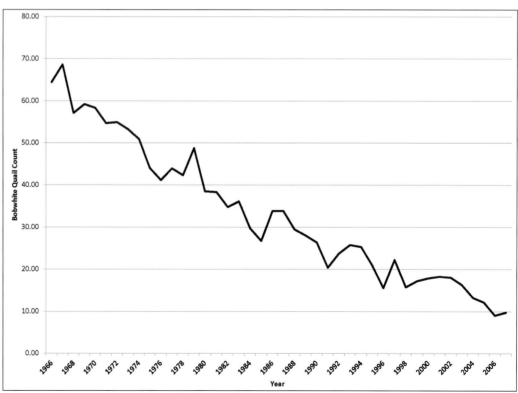

Breeding season northern bobwhite quail population trends in Mississippi, 1966–2007. Adapted from North American Breeding Bird Survey

land-use practices have sought to maximize the production of food, fiber, and forest products and have generally simplified the landscape.

Modern farming practices have resulted in increased field size, more intensive and efficient cropping practices, and fewer fallow areas. Agricultural chemicals minimize weed and insect populations that once provided quail food and cover resources in less-intensive cropping systems. Non-native grasses such as fescue and Bermudagrass, which form dense mats of vegetation at ground level and reduce accessibility of these areas for quail, have been widely adopted for livestock forage or soil stabilization. Quail

NATURAL SUCCESSION

The composition of plant communities changes through time, and this process is called succession. After a natural disturbance such as a fire, tornado, or hurricane or a man-made disturbance such as timber harvest or tillage, openings are made within a mature plant community. These openings allow sunlight to reach the ground, which fosters the growth of the early-successional plant community. The rate at which plant communities change is affected by factors such as soil fertility, moisture, and temperature.

Annual grasses and broadleaf forbs, plants that live and set an abundance of seed in one growing season, often flourish immediately after a disturbance. Perennial grasses, forbs, and low brush, which grow for many seasons from established rootstock, become dominant within 1 or 2 years following a disturbance. After 4 to 5 years of no further disturbance, early-successional plant communities are lost as young trees become the dominant cover type and shade out ground cover plants.

Early-successional habitat can be maintained in old fields or grasslands and as ground cover in relatively open forests. Management practices such as timber harvest, prescribed fire, and tillage (e.g., disking or harrowing) mimic natural vegetation and soil disturbances and therefore help to maintain early-successional plant communities.

habitat quality has also been diminished by the conversion of small agricultural fields to forest, expansion of densely planted pine plantations, and reduction of prescribed burning as a land management tool because of potential smoke management and liability concerns. The combination of these practices has resulted in a lack of suitable grassy cover for nesting, weedy areas for brood rearing, and scattered woody patches for escape cover.

Many changes in forestry and agricultural practices reflect technological advances that have permitted the United States to remain competitive in the world market. However, these economic successes and changes in land management have led to declines in the quality of habitats for quail and other wildlife.

Quail Habitat Requirements

Habitat is defined as the environment in which an animal finds all the things it needs to survive, such as water, food, shelter, and space. Quail must have adequate food and cover resources to meet their living requirements throughout the year. Some cover types are used more frequently during autumn and winter, whereas

Quail often build their nests at the base of mature bunch grasses, such as the broomsedge pictured here. Photo courtesy of Richard G. Hamrick, Mississippi Department of Wildlife, Fisheries, and Parks

others may be used mostly during the spring and summer breeding season.

Nesting Habitat.
Quail nesting cover is characterized by native bunch grasses such as broomsedge and little bluestem. Good nesting cover is provided if the grasses are allowed to grow undisturbed for 2 to 3 years. Quail often build their nests at the base of these grasses, which provide a concealed area in which to lay and incubate their eggs.

Brood-Rearing Habitat.
Brood-rearing habitat is characterized by an abundance of annual plants such as ragweed, partridge pea, and other broadleaf plants that grow to cover bare ground underneath. Good brood-rearing habitat is typically provided within 1 to 2 years of the soil being disturbed by disking (preferably from October to February) or prescribed burning that stimulates growth of annual plants. Quail chicks are about the size of bumblebees when they hatch and flightless until about 2 weeks of age. Although an adult female or male will attend to the brood, the chicks are not dependent on adults to feed them. Bare ground with cover

Quail brood-rearing habitat is characterized by an abundance of annual broadleaf plants and grasses that provide cover overhead with bare ground underneath. Photo courtesy of Richard G. Hamrick, Mississippi Department of Wildlife, Fisheries, and Parks

LIFE HISTORY OF THE NORTHERN BOBWHITE QUAIL

The "bob-white" calls of male quail in spring and summer signal that the breeding season is in progress. Pairs begin forming as early as March, and mating takes place from May to September. In one breeding season, individual quail may pair and attempt to nest with as many as three mates. Bobwhites readily re-nest when nests are destroyed, and it is common for some females to produce more than one brood per season. The average clutch size is twelve eggs, and each nesting attempt (that is, the period including egg-laying, incubation, and fledglings leaving the nest) requires from 35 to 48 days. Broods may hatch anywhere from early May to early October, but the peak occurs around mid-July.

In late summer and early autumn, birds begin to form coveys, or social groups, of twenty to thirty birds. These coveys may decline to groups of ten to fifteen birds as each covey settles into its winter range. About 75 to 80 percent of autumn populations are juvenile birds raised a few months earlier. As much as 75 percent of the autumn population may die from predators, hunter harvest, and other factors by the following spring. Despite such high death rates, quail populations (with their high reproductive potential) are able to persist and grow rapidly when adequate habitat is available.

Quail eat a variety of plant and animal foods. Hard seeds of annual grasses and broadleaf plants are heavily consumed, and many of these seeds persist through the winter without deteriorating. Acorns, fruits, pine seed, and other mast crops and grain crops such as corn, wheat, and beans are eaten frequently when available. Insects, worms, and other invertebrates are also seasonally important, especially for nesting females and chicks. Succulent green vegetation can also be a part of their diet.

Thicket cover is a critical quail habitat component used for escaping predators and for protected resting areas. Photo courtesy of Richard G. Hamrick, Mississippi Department of Wildlife, Fisheries, and Parks

overhead is essential for chicks to move about freely and catch insects while being concealed from predators. The open structure of brood habitat also allows chicks to remain relatively dry, as they can suffer hypothermia if they remain wet, even during warm weather.

Escape Cover.
Thicket cover such as blackberry, wild plum, or other brushy thickets is the final critical quail habitat component. Scattered thickets are used to escape predators and for protected resting areas. From a quail habitat perspective, thicket cover should be well dispersed in patches or strips throughout an area rather than being overly dominant in any given area, because too much thicket cover may limit growing space for essential nesting and brood-rearing cover.

Other Habitat Requirements.
Roosting cover may be considered an essential habitat component (quail roost on the ground, not in trees). Roost sites are typically grassy areas or thickets in close proximity to relatively open areas in which quail can fly unobstructed

if disturbed during the night; the flightless chicks often scatter by running across the ground. Quail habitat must also provide food resources such as seeds and insects. However, when the essential cover types discussed previously are properly managed, suitable roosting areas and adequate food resources should be produced as well.

Habitat Arrangement and Scale.
Because the habitat types used by quail can be structurally different, the arrangement of habitat patches is also important. Nesting and brood-rearing cover must be in close proximity for newly hatched chicks to move from thicker nesting cover to more open brood-rearing cover. Escape cover must be available throughout an area to reduce vulnerability to predators. When all required cover types are provided, more of the overall area is usable habitat than if those cover types are located far from one another.

To maintain wild quail populations that can sustain any amount of hunting, suitable habitat must be available on the scale of several thousand acres. Not all landowners have adequate

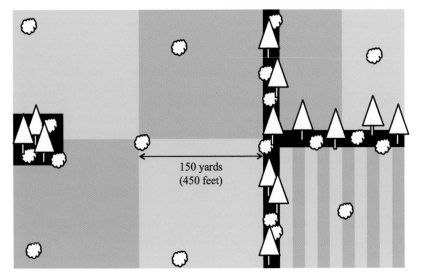

Sites undisturbed 2 to 3 years, perennial native grass cover abundant

Sites recently disturbed (1 to 2 years), annual broadleaf plants/grasses abundant

Shrubby thicket patch (plum, blackberry, etc.)

Hedgerow, woodland, or other mixed woody and shrubby cover

An example of a habitat management schematic for northern bobwhite quail. Illustration by Bill Pitts

Fields or natural grasslands that are comprised of native grasses and broadleaf plants can be managed for quail habitat. Photo courtesy of Richard G. Hamrick, Mississippi Department of Wildlife, Fisheries, and Parks

A flexible way to provide quail habitat on farmland is to establish habitat buffers at least 30 feet wide along the edges of agricultural fields. Photo courtesy of Kristine Evans, Mississippi State University

landholdings to manage on this scale, but there are ways to increase the scale of quality quail habitat. Several local landowners with an interest in increasing quail populations can work cooperatively to enhance habitat and effectively increase the scale of available habitat. (Refer to chapter 2 for more information on this topic.) Although wildlife biologists and other natural resource professionals are available to provide technical assistance, landowners can be some of the most effective advocates of quail management in local communities.

Quail Habitat Management

Although the northern bobwhite quail situation may seem bleak, the good news is that local populations can be held stable and even increased with proper habitat management. Studies have demonstrated that habitat management has produced local population increases of 100 to 600 percent over 2 to 5 years, despite the fact that state, regional, and national populations continue to decline. Landowner perceptions and hunter accounts often reinforce these findings.

Quail are ground-dwelling birds that depend upon ground cover vegetation and structure. Thus, quail habitat can be managed in grasslands, fields, and forests if proper ground cover can be maintained. Quail habitat maintenance requires active management, because early-successional habitat will be lost without frequent disturbance. Because every tract of land is unique, there is not a fixed formula for

Upland hardwood and mixed pine–hardwood forests can be managed for quail habitat if suitable ground cover is maintained. This upland hardwood stand is managed by periodic prescribed burning. Photo courtesy of L. Wes Burger, Mississippi State University

Prescribed fire is the most efficient way to maintain early-successional plant communities and manage quail habitat where it can be used safely. Photo courtesy of Richard G. Hamrick, Mississippi Department of Wildlife, Fisheries, and Parks

Pine forests or plantations can be managed so that suitable ground cover is produced for quail habitat. Thinning and prescribed burning are essential for maintaining woodland quail habitat quality. Photo courtesy of Richard G. Hamrick, Mississippi Department of Wildlife, Fisheries, and Parks

A field being managed on a rotation with prescribed fire. The field has been divided into four sections, and alternating sections are burned each year (greener areas are recently burned). Photo courtesy of Richard G. Hamrick, Mississippi Department of Wildlife, Fisheries, and Parks

bobwhite habitat management. The following management practices can be used to improve habitat quality and increase populations in nearly every situation and should provide a useful guide for most management cases. Wildlife biologists can provide more site-specific technical assistance to landowners interested in enhancing bobwhite habitat on their properties.

Prescribed Fire.
Where it can be used, prescribed fire is the most efficient way to maintain early-successional plant communities and manage quail habitat. On each tract managed for quail, a third to a half of the acreage should undergo a prescribed burn each year, but landowners are advised to limit the size of individual burn units to less than 50 acres

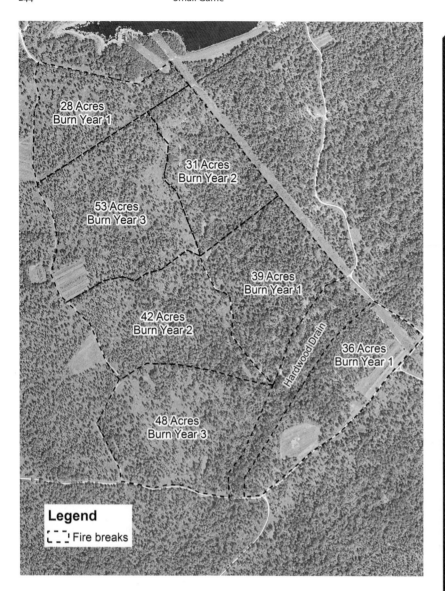

28 Acres
Burn Year 1

31 Acres
Burn Year 2

53 Acres
Burn Year 3

39 Acres
Burn Year 1

42 Acres
Burn Year 2

36 Acres
Burn Year 1

Hardwood Drain

48 Acres
Burn Year 3

Legend
⌐ ¬ Fire breaks

A 3-year prescribed burn map for a property in Mississippi. Figure courtesy of Richard G. Hamrick, Mississippi Department of Wildlife, Fisheries, and Parks

whenever possible. This technique is referred to as managing on a rotation, in which, for example, each third previously treated is burned again after 3 years of undisturbed growth. By managing in this way, some portion of habitat is in a different stage of growth each year. Prescribed fire maintains desirable food and cover plants, reduces buildup of dead plant residue, and moderates unwanted woody growth.

Disking.
Disking (or harrowing) during autumn and winter is also a useful quail management tool and is sometimes recommended as a substitute disturbance tool where prescribed burning is not feasible. Disking may also be used in conjunction with prescribed burning. Periodic

PRESCRIBED FIRE

Prescribed fires are different from wild fires. Prescribed fire is the intentional use of fire during certain weather conditions, using appropriate techniques, and with adequate supervision and preparation to accomplish specific objectives. Wild fires are caused by natural events (such as lighting), accidents, or arson.

Prescribed fire can be a very cost-effective land management tool with many benefits to the landowner and the ecosystem. The Mississippi Prescribed Burning Act establishes prescribed burning as a property right of landowners, but it further outlines procedures that must be followed to minimize potential liability. Specifically, prescribed burning must:

♦ be conducted under the supervision of a certified prescribed burn manager;
♦ follow a written, notarized burn plan prepared in advance of the burn;
♦ be conducted with a burn permit issued by the Mississippi Forestry Commission; and
♦ be considered in the public interest (such as improving wildlife habitat or reducing hazard fuel).

Anyone can become a certified prescribed burn manager by receiving appropriate training, where students learn about fire weather, fire behavior, burning techniques, and burn plan preparation. Contact the Mississippi Forestry Commission for more information on certified prescribed burn manager training. Landowners may also consider hiring a contractor who conducts prescribed burning for a fee.

Although fire is a natural process, many of our natural plant communities and wildlife species are adapted to and even dependent on prescribed fire. It is a technique that should not be feared but respected and used correctly. Landowners are urged to become certified and experienced in the safe and legal use of prescribed fire before attempting it on their property. Otherwise, they should hire a certified contractor.

disking may be beneficial on sites that undergo prescribed burning, particularly if perennial grasses such as broomsedge become dominant and plants like ragweed, partridge pea, and other annuals are sparse. Disking is more efficiently used in fields or forest openings, and it may even be suitable for relatively open woodlands if the site is free of stumps and other potential hazards. (Be extra cautious disking in woodlands to avoid injury or equipment damage.)

Disking to maintain early-successional habitat does not require complete incorporation of surface litter (plant material). Rather, disk until about half the surface litter is buried. Disking maintains desirable food and cover plants, reduces buildup of dead plant residue, and moderates unwanted woody growth. Disking during autumn or winter often produces good brood-rearing cover the following summer.

Like prescribed fire, disking should be used in a rotational fashion, where a third or half of suitable acreage is disked each year. In larger field settings, a technique often used is strip-disking, which involves disking strips 30 feet wide or wider, skipping twice the disked strip width, and disking another section throughout the field. The process is repeated on previously undisturbed areas in successive years, and the rotation starts over every 3 years.

Mowing.
Mowing (also referred to as clipping or bush-hogging) should be used only for very specific management objectives, such as maintaining trails, cutting back thickets to encourage new growth near the ground, or to facilitate disking or herbicide treatments. Large-scale mowing results in an accumulation of dead plant residue (which can impede quail chick movements), favors perennial plant dominance, and only temporarily limits unwanted woody growth. To avoid destroying quail nests, limit mowing to the months of October through March. For areas like trails, which require frequent summer mowing, begin cutting in spring and then as needed to prevent birds from nesting in those areas.

Thicket Cover.
As a general rule, maintain about 10 to 20 percent of areas managed for quail as scattered,

Rotational strip-disking during October to February can be used to maintain early-successional plant communities in fields or other open areas. Photo courtesy of L. Wes Burger, Mississippi State University

The annual broadleaved plants (mostly partridge pea) in this strip, which was disked the previous autumn, will provide excellent brood-rearing cover. The standing broomsedge in the adjacent strips that were not disked will provide close nesting and roosting cover. Photo courtesy of L. Wes Burger, Mississippi State University

Large-scale mowing results in no available cover for quail and other wildlife. Mowing does little to promote growth of annual plants important for brood-rearing habitat and natural food production. Photo courtesy of L. Wes Burger, Mississippi State University

In addition to favoring perennial-dominated plant communities, mowing results in a dense thatch of cut plant litter on top of the ground. It is difficult for quail (especially chicks) and other small wildlife to move through this thatch once new plant growth emerges. Photo courtesy of L. Wes Burger, Mississippi State University

shrubby thickets spaced about 100 to 200 yards apart. Many properties have existing shrubby or other cover types such as hedgerows, fencerows, and wooded edges that can be managed to provide suitable thicket cover. Well-established thickets may be rejuvenated by periodic cutting or burning to keep the brushy growth low to the ground. (Wild plum, sumac, blackberry, and other perennial shrubs will usually sprout back from the roots after cutting or burning.)

Where thicket cover is lacking, such as the interiors of large fields, native shrubs like wild plum and sumac may be planted. Thickets can also be established naturally by letting selected areas grow undisturbed for 3 to 5 years, and shrubby cover will often develop. Do not disk or burn these areas while cover establishes. Brush piles (tops of hardwood or cedar trees piled several feet high and about 20 feet in diameter) may also be constructed to provide short-term thicket cover while natural or planted thickets develop.

Non-Native Vegetation.

The presence of grass cover on a particular site does not necessarily translate to quail habitat. Some properties may have an abundance of non-native vegetation such as Bermudagrass, bahiagrass, or tall fescue. These grasses have been widely introduced for erosion control and livestock forage, but they provide poor quail habitat. These species form a dense sod at ground level, impeding quail movement and often excluding desirable native plants that serve as quality food and cover resources. Because native grasses grow in bunches, there is space for bare ground and desirable seed-producing plants (such as native legumes and annual grasses) to grow around them.

Other non-native vegetation, such as privet and sericea lespedeza, may also degrade quail habitat quality. Non-native vegetation usually cannot be controlled or suitably managed by treatments such as disking or prescribed burning alone. A series of herbicide treatments properly combined with fire or mechanical treatment is often the most effective method of control. (Refer to chapter 17 for more information.) Consult a natural resources management professional for assistance in identifying and controlling non-native vegetation.

Supplemental Plantings.

A common mistake many landowners make when attempting to encourage quail is an overemphasis on food plantings. With comprehensive habitat management, an adequate supply

ANNUAL MANAGEMENT CALENDAR FOR NORTHERN BOBWHITE QUAIL

Because quail are adapted to early-successional habitats, annual disturbance is needed to maintain habitat quality. Consequently, quail management is active management.

January
◆ Get ready for the year of work ahead. This is a good time to review management plans and inspect equipment so that necessary repairs can be made.
◆ Consider not harvesting wild quail after January, but continue to enjoy bird dog work.

February to April
◆ Perform a prescribed burn of 30–50 percent of grass fields and upland forests each year. Each year, individual burned units should be well distributed among unburned units.
◆ Begin mowing or clipping areas that require mowing throughout the summer to prevent birds from nesting there.
◆ Identify and begin preparing sites that will be planted as food plots.
◆ Spray undesirable cool-season grasses (such as fescue) with appropriate herbicides.

May and June
◆ Disk, fertilize, and plant food plot strips with plants such as grain sorghum or milo, Egyptian wheat, browntop millet, corn, and cowpeas. Long, narrow food plots are preferable to small, square or circular plots. Plots should be placed near escape cover.
◆ Listen for the "bob-white" call of male quail. The number of calling males may be used as a rough measure of population abundance and trends. For larger properties, a formal call-count survey may be useful. Contact a wildlife biologist for more information on establishing quail call-count surveys.

July to September
◆ Watch for broods of quail chicks.
◆ Spray undesirable warm-season grasses (such as Bermudagrass) or woody brush with appropriate herbicides.

October
◆ Prepare new fire breaks (disking, dozer work) for the next burn season while the weather is dry.
◆ Strip-disk to halt plant succession and regenerate annual weed communities. For sites that are not too wet, strip-disking can also be done in February and early March to leave more standing cover over winter, spread workloads, and create a diversity of plant communities.
◆ Listen for coveys calling in the half-hour before sunrise on cool, clear mornings. This may be used as a measure of autumn population abundance (contact a wildlife biologist for more information).
◆ Spray undesirable cool-season grasses with appropriate herbicides.

November and December
◆ Finish spraying undesirable cool-season grasses with herbicides in November.
◆ Enjoy quail hunting or bird dog work. As a general rule, harvest no more than 25 percent of the estimated autumn population of wild quail. Also, keep in mind that harvest during the early part of the season has fewer potential negative effects on the population.

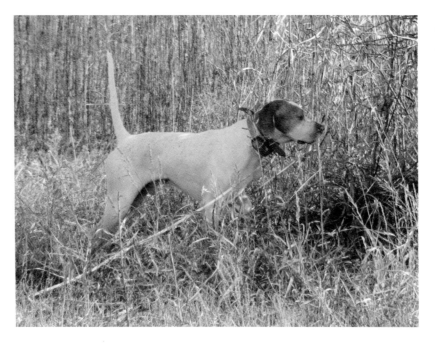

Although not recommended as a wild quail population restoration tool, using pen-raised quail to train hunting dogs is a valid practice. Photo courtesy of Richard G. Hamrick, Mississippi Department of Wildlife, Fisheries, and Parks

of natural food is usually available. Therefore, the primary focus should be on providing the necessary cover for reproduction and escaping predators. However, modest amounts of supplemental food plantings (usually hard-seeded crops that will persist into winter, such as grain sorghum or Egyptian wheat) can be valuable for periods when natural foods are less plentiful, such as late winter and early spring. Limit plantings to small patches or strips that are well dispersed throughout the area managed for quail (one planting per 20 acres) and always in close proximity to secure cover. (For more information on food plots, refer to chapter 13.)

Harvest Management

While quail have a high reproductive potential in quality habitat, it is important to control harvest on managed lands. As a general rule, harvest no more than 25 percent of the estimated autumn population of wild quail. Covey call-counts are a relatively easy way to estimate autumn populations. Contact a wildlife biologist for more information on this topic.

Pen-Reared Quail

Research indicates that releasing pen-raised quail is not a viable solution to restoring wild quail populations. Wild birds are usually absent because there is a habitat deficiency, and if habitat cannot support wild birds, there is little reason to believe it would support pen-raised birds. Furthermore, the effects that releasing large numbers of pen-reared birds might have on remaining wild quail populations (for example, how crossing wild and captive strains might affect the survival abilities of subsequent generations) is not fully understood. A small percentage of pen-raised birds do survive and reproduce with wild birds, and genetic differences have been detected. There have also been concerns that releasing pen-raised birds might cause predators to focus more on quail, thereby increasing depredation on wild populations. Finally, there is always the possibility that releasing birds raised in captivity may introduce diseases and parasites into wild populations of quail, turkeys, and other birds.

Given these initial considerations, the more appropriate uses of pen-raised quail are for training dogs and as a supplementing hunting opportunity where wild quail are not abundant. Every effort to minimize disease problems should be made when releasing pen-raised quail, and only disease-free, vaccinated birds should be used. Check with the Mississippi Department of Wildlife, Fisheries, and Parks to understand all pertinent regulations (including permit or license requirements) prior to release.

RABBITS

Rabbit hunting has played an important role in the state's outdoor heritage. Many Mississippians have been introduced to hunting by following a pack of beagles through the Magnolia State's fields and woodlots. As is the case with northern bobwhite quail, changes in land-use practices during the latter half of the twentieth century have been detrimental to rabbit habitat quality across much of Mississippi. While some excellent rabbit hunting opportunities are still available, rabbit populations and hunting popularity have declined in many areas. However, this important small game resource continues

to provide thousands of hours of outdoor recreation for many hunters.

Two distinct species of rabbits are common to all regions of Mississippi: the cottontail rabbit (also called hillbilly) and the swamp rabbit (or cane cutter). The swamp rabbit resembles the cottontail and is most readily distinguished by its larger size. An average adult swamp rabbit weighs nearly 4 pounds (with weights up to 6 pounds not uncommon), whereas the average adult cottontail weighs approximately 2.5 pounds. The swamp rabbit has proportionately shorter and rounder ears, a yellowish cast on coarser fur, and a tawny color fur on the rump when fluffed compared to a grayish color on the cottontail. The tops of the cottontail's hind feet are lighter tan to whitish, whereas the tops of the swamp rabbit's hind feet are generally darker brown. The cottontail also has a rusty red patch of fur on the back of its neck.

Rabbit Habitat Requirements

Habitat use varies somewhat between the state's two rabbit species, but both generally use early-successional habitats that are rich in annual grasses and broadleaf forbs and perennial grasses, forbs, and low brush. The cottontail is very adaptable and can survive in nearly any type of mixed grassy and brushy cover, but they are usually associated with more upland agricultural fields, grasslands, and open-canopy forests. They reach their highest populations in areas that provide a patchwork of several usable habitat types. As their name implies, swamp rabbits are associated with wet areas and prefer moist lowlands and brushy cover along streams and ditch banks.

Nesting Habitat.
Female rabbits construct a grass and fur-lined nest in a shallow hole in which to give birth to their young. The nest is typically concealed in dense grass stands or other secure cover.

Escape Cover.
Similar to quail, rabbits use brushy areas such as blackberry or wild plum thickets as secure areas to escape predators or to rest. Thickets are

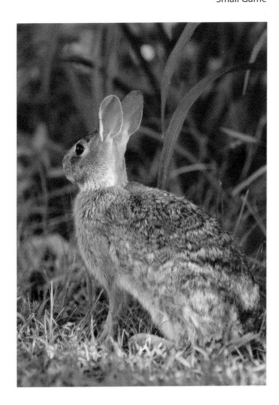

Cottontail rabbit. Photo courtesy of Steve Gulledge

REPRODUCTION CYCLES OF MISSISSIPPI RABBITS

Cottontail breeding usually begins in January and continues into September. Young are born blind and nearly hairless. The average litter size is four or five young, with the largest litters generally born in May and June. The pregnancy period is about 28 days, and rabbits may become impregnated again while nursing young. A wild female cottontail will normally produce four or five litters per year. Thus, a single female has the potential to add twenty to twenty-five young to the population in a single year. The average cottontail lifespan in the wild is 15 months.

Swamp rabbit reproduction begins in February and continues through mid-July. The average litter size is three or four young, and female swamp rabbits birth an average of two or three litters per year. The swamp rabbit pregnancy period is approximately 40 days. Because the pregnancy period of swamp rabbits is longer, their young are more developed (compared to cottontails) at birth. The average swamp rabbit lifespan in the wild is 24 months.

important cover components. Although rabbits are relatively tolerant of large amounts of low brushy cover, it should not be so dominant that it excludes growing space for other essential food and cover resources, such as grasses and herbaceous broadleaf plants. Instead, thicket cover should be dispersed among grassy areas throughout a property.

Other Habitat Requirements.
Rabbits consume a wide variety of plant foods but prefer succulent green vegetation and, unfortunately, garden crops. It is relatively easy to distinguish rabbit cuttings from deer browse in the garden. Rabbit cuttings are generally made at a 45-degree angle from vertical, whereas deer usually nip plant stems evenly, leaving a level cut. Highly palatable foods such as legumes are usually preferred when available. Research has indicated two stress periods when food can be in short supply or of poor quality. During winter, as plants become dormant and green vegetation dies off, food can be limited, and rabbits often feed on dead vegetation, twigs, buds, and the bark of trees. Extreme drought periods during the summer can also limit nutritional value of rabbit foods, which can negatively affect rabbit reproduction. Thus, the availability of quality food resources has an effect on rabbit population productivity.

Rabbit Habitat Management

Although land-use changes have led to declines in rabbit habitat quality and populations, carefully implemented management practices can dramatically increase local rabbit numbers. For example, it is important to remember that rabbits thrive in young plant communities. If left undisturbed for an extended period, a field of grasses and briars that has plenty of rabbits will shift to young trees and shrubs and eventually develop into a mature forest, which is better suited for squirrels than for rabbits. Therefore, rabbit habitat management requires frequent treatments to keep the cover at a suitable stage.

Another key is maintaining a diversity of habitat types in a patchwork across the landscape.

Patchy habitat types will generally provide more of the rabbit's food and cover requirements than an area with one large block of the same habitat (such as a large agricultural field or pine plantation).

Many of the same practices used for quail habitat management are applicable to encouraging rabbit populations. In grasslands, prescribed burning, strip-disking, and rotational mowing can be used to manipulate native vegetation and improve rabbit habitat. In upland forest areas, thinning and prescribed burning encourage the growth of briars, grasses, and herbaceous broadleaf plants, all of which benefit rabbits. In bottomland forest areas, selective thinning and creating ½- to 1-acre forest openings increase the growth of beneficial ground cover vegetation for rabbits. In agricultural lands, field borders and oddly shaped areas can be left idle to provide natural cover.

Prescribed Fire.
Where it can be used, prescribed fire is the most efficient way to maintain early-successional habitat for rabbits (Refer to Quail Habitat Management section for more information on using prescribed fire.) About a third to a fourth of acreage managed for rabbits should undergo prescribed burning each year. This technique is referred to as managing on a rotation, in which each previously treated area is burned again after several years of undisturbed growth. Thus, some portion of habitat is in a different stage of growth each year. Prescribed fire maintains desirable food and cover plants and moderates excessive woody brush growth.

Disking.
Disking may be used as a substitute disturbance tool where prescribed burning is not feasible. Disking may also be used in combination with prescribed burning to manage plant communities (such as burned sites that are dominated by grasses with few broadleaf plants). Disking maintains desirable food and cover plants for rabbits and moderates unwanted woody growth. Like prescribed fire, disking should be used in a rotational fashion.

Mowing.

Mowing (also referred to as clipping or bush-hogging) can be used on a rotation, similar to strip-disking, to encourage new vegetation growth. However, prescribed burning or disking promotes a greater number of desirable natural food plants and more effectively controls undesirable woody brush. Thus, mowing should not be used as the sole management tool for maintaining rabbit habitat. Mowing is a useful supplemental practice to facilitate disking or herbicide treatments. In moderation, it is also useful to establish travel lanes through grass fields to improve hunting access and visibility. Limit mowing to the months of October through February to avoid peak periods when rabbits are raising young.

Thicket Cover.

Maintain about 20 to 40 percent of areas managed for rabbits in scattered, shrubby thickets spaced about 100 yards apart. Existing hedgerows, fencerows, and wooded edges can be managed to provide suitable thicket cover. Well-established thickets may be rejuvenated by periodic cutting or burning to keep the brushy growth low to the ground. (Wild plum, sumac, blackberry, and other perennial shrubs will usually sprout back from the roots after cutting or burning.)

Where thicket cover is lacking, such as the interiors of large fields, native shrubs like wild plum and sumac may be planted. Thickets can also be established naturally by letting selected areas grow undisturbed for 3 to 5 years. Do not disk or burn these areas while cover becomes established. Brush piles (tops of hardwood or cedar trees piled several feet high and about 20 feet in diameter) may also be constructed to provide short-term thicket cover while natural or planted thickets develop.

Non-Native Vegetation.

Non-native vegetation such as Bermudagrass, tall fescue, and sericea lespedeza have been widely introduced in the state for erosion control and livestock forage. These non-native plants generally degrade rabbit habitat value because they exclude desirable native plants that provide quality food and cover resources. Effective control of non-native vegetation often requires one or more treatments of an appropriate herbicide (refer to chapter 17 for more information). Consult a natural resources management professional for assistance.

Supplemental Plantings.

Supplemental food plantings can be used when succulent natural foods are less abundant. In particular, cool-season small grain and legume plantings provide quality winter food resources for rabbits. Plant small patches or strips of supplemental foods in close proximity to secure cover throughout the area managed for rabbits. (Refer to chapter 13 for more information on specific food plantings for rabbits.)

Harvest Management

Although rabbits have a high reproductive potential in quality habitat, it is important to control harvest on managed lands. Research suggests that a harvest rate of less than 25 percent of the total population should have little negative impact on a healthy rabbit population. Managers can use repeated spotlight counts to develop an estimate of local rabbit populations and set harvest goals accordingly. Contact a wildlife biologist for more information on techniques to estimate rabbit populations.

TREE SQUIRRELS

The eastern gray squirrel and the fox squirrel are the two species of tree squirrels found in Mississippi. The gray squirrel is commonly referred to as the cat squirrel because of its cat-like call. The fox squirrel is often called the red squirrel in Mississippi.

The average body length of a gray squirrel (nose to base of tail) is approximately 8 to 10 inches, with an 8-inch tail. Adults generally weigh just over 1 pound on average. This species is normally grayish in color, although albino and black specimens do occur. Most black

Gray squirrel. Photo courtesy of iStock

Bachman or hill country fox squirrel. Photo courtesy of William W. Hamrick, Mississippi State University

squirrels in Mississippi are fox squirrels, although black gray squirrels are relatively common in some local areas of northern states. One way to distinguish between the species is that gray squirrels have pink paw soles, whereas fox squirrels have black paw soles. The average gray squirrel lifespan in the wild is 1.5 years; that of

fox squirrels is unclear, but may be more than 5 years.

The fox squirrel is significantly larger than the gray squirrel, with adults weighing approximately 2.5 pounds. The body length ranges from 10 to 15 inches, with a 12-inch tail. Two subspecies of fox squirrels are commonly found in Mississippi. The Bachman, or hill country, fox squirrel is common to upland areas and is characterized by a black mask and white coloration on the nose, ears, and paws. The golden-bellied, or Delta, fox squirrel, is found in the western portion of the state, primarily within the Mississippi Alluvial Valley. The Delta fox squirrel has two common color phases: one is a glossy black phase, and the other is a reddish phase generally lacking the white appendage coloration found on the hill country fox squirrel. Hill country fox squirrel populations have declined substantially in many areas because of changes in land use and management. Delta fox squirrel populations are generally more stable where forest cover is available.

Tree squirrels in Mississippi have two annual breeding periods, in winter and summer. Individual females can produce two litters annually,

Golden-bellied or Delta fox squirrel. Photo courtesy of Jackie Fleeman, Mississippi Department of Wildlife, Fisheries, and Parks

with an average litter size of three. The pregnancy period lasts 45 days, and the greatest incidence of pregnant squirrels occurs from July through mid-August and from mid-January through February. Young squirrels, which are born blind, deaf, and mostly hairless, are weaned at 10–12 weeks of age.

Squirrel Habitat Requirements

More than any other factor, the availability of food resources such as acorns, nuts, and fruits likely drives squirrel population productivity and survival. Specific food items include fruits and/or seeds of ash, elm, gum, ironwood, maple, mulberry, cherry, pine, oak, beech, pecan, hickory, dogwood, holly, walnut, persimmon, and poplar trees, as well as wild grapes. Leaves, buds, insects, eggs, and fungi are also eaten when available.

Mature forest is the primary habitat component required for squirrels. Closed-canopy hardwood and mixed pine–hardwood forests will typically support more gray squirrels than forests comprised mostly of pines. Gray squirrels have also readily adapted to living in urban areas. Habitat use of fox squirrel subspecies in Mississippi is less clearly understood. Hill country fox squirrels are often found in more open-canopy pine or mixed pine–hardwood forests and areas that have many forest patches among agricultural fields. Delta fox

squirrels primarily use mature hardwood forests or woodlots found throughout their range. Although squirrels are dependent on forest habitats, they will venture into residential areas, orchards, agricultural fields, and other unforested areas to take advantage of abundant food resources.

Fox squirrels spend proportionally more time on the ground than gray squirrels, although the latter frequently take to the ground, usually in search of food. Fox squirrels are often associated with more open forest conditions, whereas gray squirrels appear to favor forest

Fox squirrels are very active on the ground, and open habitats offer easier mobility and provide better opportunities for detecting potential predators. Photo courtesy of Richard G. Hamrick, Mississippi Department of Wildlife, Fisheries, and Parks

Mature hardwood forests with abundant cover near the ground (low brush, fallen trees) typically support abundant gray squirrel populations. Photo courtesy of Richard G. Hamrick, Mississippi Department of Wildlife, Fisheries, and Parks

areas with heavier ground cover such as shrubs, young trees, or fallen trees.

Both species use leaf nests and cavity dens. Squirrels build nests of leaves and twigs 25 feet or more from the ground. Hollow trees and tree cavities are used for dens. Leaf nests and dens are used for resting, avoiding predators, relief from extreme temperatures, and raising young.

Squirrel Habitat Management

Few landowners probably give much consideration to squirrel habitat management, perhaps because two scenarios are common. Either forest cover is lacking and cannot support many squirrels, or forest cover is present and of adequate age, so an abundance of squirrels can be found. Like many other small game species, squirrels have been largely taken for granted, with little thought given to habitat and population conservation. In fact, quail, rabbits, and the hill country fox squirrel have already experienced population declines in many areas because of changes in land use and management. However, habitat for species as common as gray squirrels can be managed to maintain and enhance existing habitat quality to ensure sustainable hunting opportunities.

Squirrel habitat management largely entails managing and conserving forests to provide natural foods and den sites. Structural habitat characteristics selected by gray and fox squirrels must also be provided for those species, and management practices can be directed to producing those habitat characteristics within forests. Because individual landowner objectives, site conditions, and past management practices vary, timber management prescriptions will likely differ considerably among properties. Consult a registered forester and wildlife biologist to develop a plan that achieves both forest and wildlife management objectives.

Forest Restoration.
Where forest cover is lacking, such as in expansive agricultural fields, forest restoration is a good way to increase future habitat availability for squirrels. In the Delta region, bottomland hardwood restoration is particularly beneficial for increasing squirrel habitat. Although the full benefits of establishing a new forest may take many years, forest restoration can provide many quality outdoor experiences for future generations.

Timber Harvest.
Many landowners must generate revenue from their land, and timber production is an important source of income for many forest landowners in Mississippi. Large-scale clearcutting of forest tracts can obviously have negative effects on squirrels because vast amounts of habitat are lost. Limit clearcuts to 20 acres or less, if possible, when squirrels are a management objective. Conserve trees within a zone at least 100 to 200 feet on both sides of streams (200 to 400 feet total) to provide squirrel and other wildlife habitat and protect water quality. These streamside management zones will maintain some forest cover for squirrels, as it may take more than 20 years to regenerate a cut-over site (particularly hardwood tree species) to provide adequate squirrel habitat.

Selective timber harvest may be a useful strategy both to generate timber revenue and maintain or even enhance squirrel habitat. Squirrels appear to be relatively tolerant of selective timber harvest, although it may have some short-term negative effects. Timber harvest plans that

After selective timber harvest, canopy openings increase sunlight on the ground, thereby enhancing regeneration of trees and other plants. Downed logs and tree tops provide cover and substrate for mushrooms and other fungi. Photo courtesy of Scott L. Edwards, Mississippi Department of Wildlife, Fisheries, and Parks

retain a diversity of seed- and fruit-producing trees, shrubs, and vines for seasonal food resources should have few adverse impacts on squirrel populations. Retention of cavity trees for dens is desirable in all forest types.

To improve hill country fox squirrel habitat, landowners can enhance upland forest stands by selective thinning and prescribed burning. As a general guideline, thin until 30 to 50 percent of the canopy is open, and retain desirable pine and hardwood trees in the remaining 50 to 70 percent of the forest canopy. Conserve hardwood forests associated with drainages in upland pine forests. Research indicates that even small hardwood drainages (sometimes referred to as hardwood stringers) within predominately upland pine forests are important to fox squirrels.

Prescribed Burning.

Prescribed burning is usually not widely associated with squirrel management. However, burning open, upland forests improves habitat structure for the hill country fox squirrel. Prescribed burning of upland forests reduces brush

Low-intensity fires may be used to maintain desirable ground cover conditions for hill country fox squirrels in upland hardwood forests. Photo courtesy of John P. Gruchy, Mississippi Department of Wildlife, Fisheries, and Parks

An artificial nest box for squirrels. Figure courtesy of Ohio Division of Wildlife, Department of Natural Resources

and maintains grassy ground cover. Hardwoods such as post oak, blackjack oak, and turkey oak are very fire tolerant. Other hardwoods such as white oak, hickory, and red oak are relatively fire tolerant and will often persist after prescribed fires. Retain a diversity of hardwood species in upland forests for mast and cavity tree production. Pine forests may be burned as frequently as every 2 to 3 years, whereas upland hardwood stands may be burned every 3 to 5 years or more. Prescribed burning may negatively affect the quality of hardwood trees for certain timber products. If hardwood timber production is an objective, prescribed burning may be limited to drier, upland sites where hardwood timber quality is lower.

Artificial Dens.
In areas lacking mature trees that produce natural cavities, artificial dens may be built to supplement tree cavities. Squirrels use leaf nests extensively, but cavities or artificial dens may be more secure and sheltered from extreme weather. For landowners who would like to try artificial dens, several free plans can be obtained from a quick Internet search or by visiting a Mississippi State University Extension Service office. Artificial dens for squirrels should be placed 20 feet or higher in trees, although these structures may be inhabited by wildlife other than squirrels. If permanently securing a den

TECHNICAL ASSISTANCE

Wildlife biologists and other natural resource management professionals are available to provide technical assistance to landowners interested in managing small game habitat and populations on their property. Those who wish to develop an integrated forest and wildlife management plan are advised to consult with both a wildlife biologist and registered forester.

Mississippi Department of Wildlife, Fisheries, and Parks
www.mdwfp.com
(601) 432-2400

Mississippi Forestry Commission
www.mfc.ms.gov
(601) 359-1386

U.S. Department of Agriculture Natural Resources Conservation Service
www.nrcs.usda.gov
(601) 965-5205 ext. 130

Mississippi State University Extension Service
www.msucares.com
(662) 325-3174 (wildlife and fisheries) and
(662) 325-3905 (forestry)

Wildlife Mississippi
www.wildlifemiss.org
(662) 686-3375

Delta Wildlife
www.deltawildlife.org
(662) 686-3370

to a tree, use aluminum nails rather than steel nails or screws, because aluminum nails are soft and less likely to damage saws or injure sawyers if the tree is cut in the future.

Harvest Management

Like most other small game species, squirrels have a relatively high reproductive potential. Squirrel population productivity is closely tied to available food resources, particularly acorn and other nut crops. The legal harvest of squirrels generally has no negative effects on populations. Intensive harvest may negatively affect hill country fox squirrels where populations have become more isolated and limited to smaller patches of suitable habitat. Squirrel populations are difficult to measure, but simple observation usually provides a relative index of population abundance because squirrels are often visible and vocal prior to hunting season (which begins in October).

SUMMARY

Although small game wildlife populations are sometimes taken for granted, these species are an important part of the state's hunting heritage. Small game hunting is often a great starting point for beginning hunters. Small game species that have experienced substantial population declines, such as northern bobwhite quail, can be increased with proper habitat management. Species that are common and abundant, such as the gray squirrel, can be managed to ensure populations are conserved for long-term hunting opportunities. With planning and dedication, small game hunting traditions can be preserved for future generations.

For More Information

Dickson, J. G., ed. 2001. *Wildlife of Southern Forests: Habitat and Management.* Blaine, Wash.: Hancock House Publishers.

Hamrick, R., W. Burger, B. K. Strickland, and D. Godwin, eds. 2012. *Ecology and Management of the Northern Bobwhite.* Publication 2179. Mississippi State University Extension Service.

Hamrick, R., D. Godwin, and B. K. Strickland. 2012. *Ecology and Management of Rabbits in Mississippi.* Publication 2467. Mississippi State University Extension Service.

Hamrick, R., B. K. Strickland, and D. Godwin. 2012. *Ecology and Management of Squirrels in Mississippi.* Publication 2466. Mississippi State University Extension Service.

Sun, C., and A. J. Londo. 2008. *Legal Environment for Forestry-Prescribed Burning in Mississippi.* Research Bulletin FO351. Mississippi State University Forest and Wildlife Research Center. www.fwrc.msstate.edu/pubs/burning.pdf

CHAPTER 13

Supplemental Wildlife Food Plantings

William W. Hamrick,
Wildlife Extension Associate,
Department of Wildlife,
Fisheries, and Aquaculture,
Mississippi State University

Technical editor
Bronson K. Strickland,
 Associate Professor of
 Wildlife Ecology and
 Management, Department
 of Wildlife, Fisheries, and
 Aquaculture, Mississippi
 State University

The purpose of establishing and planting wildlife food plots is to provide wildlife with nutritious forages during times of the year when natural forages are less palatable or unavailable, or simply to improve diet quality for a particular wildlife species. This chapter provides information about planting forage crops to supplement the diets of game species. In addition, these same plantings are consumed by many nongame wildlife species. Although there is evidence that wildlife species do benefit from supplemental food plantings, wildlife food plots are not an acceptable alternative to sound habitat management practices, but rather a way to augment the existing habitat. Sound habitat management in combination with a good food plot program, including warm- and cool-season forages, will produce the best results.

The practice of planting forages solely for the benefit of wildlife species originated from white-tailed deer and turkey reintroductions in the eastern United States, which began in the 1930s and continued through the 1960s in some areas. The combined effects of overhunting and human land-use practices that either destroyed or permanently altered millions of acres of habitat across the landscape had resulted in severe declines in deer and turkey populations throughout much of the region. Thus, in addition to the challenges of successfully capturing and relocating animals, wildlife professionals were faced with challenges of restoring quality habitats to provide cover and adequate food resources to sustain their populations. One successful management practice that stemmed from these events is supplemental food plantings or what are more commonly known today as wildlife food plots.

Food plot with box stand. Photo courtesy of James L. Cummins, Wildlife Mississippi

Wildlife species have long benefited from agricultural crops (corn, beans, grain sorghum, wheat), either through directly consuming the crop or eating waste grains following harvest. In addition, deer and turkey use of cool-season forages planted for livestock grazing has been well documented over the years. Therefore, planting openings of grain and forage crops to provide relocated deer and turkey with additional food sources just made good sense.

In the beginning, wildlife food plot practices were limited to only a handful of states, namely forest lands of the north-central and northeastern United States, where initial deer restocking efforts began. In the 1940s and 1950s, researchers began to learn more about deer nutrition, including seasonal dietary needs in relation to stress periods. As a result of these findings, wildlife biologists across the country began to recognize the value of food plots as a deer management tool. Also, wildlife food plots provided some unforeseen benefits by attracting game and increasing hunter harvest and public viewing opportunities, as well as providing visible evidence that something was being done. Within a few years, openings planted in seasonal forage crops for wildlife were commonplace on many state lands.

By the late 1970s and early 1980s, deer populations were flourishing on many intensively managed state lands and some private lands. Although turkey populations were not necessarily flourishing, they had been reestablished in many areas. Nevertheless, the results were in, and the hunting public had begun to take notice. Throughout the 1980s, the practice of planting wildlife food plots continued to grow in popularity with private landowners, especially in the Southeast. By the latter part of the decade, public interest in wildlife food plots had led to the creation of a commercial food plot industry.

Today, food plots are more popular than ever among private landowners and hunting enthusiasts. In the last 30 years, food plots have evolved to include many new crops and crop varieties to provide the wildlife manager with options for just about every game species and soil condition.

ESTABLISHING A FOOD PLOT

There are three important factors to consider when establishing food plots on a property: the location, size, and shape.

Location

The easiest and most convenient locations for food plots are any openings already present in the landscape. Usually, these openings have previously established access roads or paths, reducing the landowner's startup costs of converting them to food plots. Some examples include old log-loading decks, timber salvage spots, wide fire lanes, private roadsides, thinned rows in pine plantations, and portions of old fields and pastures. Although some amount of clearing (limb trimming, cutting vines and saplings, and debris removal) may be required initially, the cost, time, and effort involved are minimal in comparison to creating new openings in the landscape. On properties leased for hunting, these types of openings are often the only option for leaseholders to establish food plots. Landowners or lessors should not establish food plots or create any kind of soil disturbances on utility rights-of-way (power line, underground cable, or pipeline) without first consulting the overseeing authority. There may be personal and public safety concerns, legal issues, and unforeseen conflict between right-of-way management practices of the overseeing authority and the landowner (such as aerial herbicide application causing harm to a recently established food plot).

On properties where pre-established openings for food plots are not readily available and additional food plots are needed or desired, a bulldozer operator can be hired to create new openings. A skilled operator can usually clear approximately 2 acres of land in a day. Average hourly pay rates range from $70 to $80, but vary according to travel distance, local competition and demand, and site conditions. Landowners should keep in mind that clearing and establishing access roads is usually necessary when creating new openings.

Many corporate and some private landowners who lease hunting rights to sportsmen readily allow leaseholders to actively manage existing openings for wildlife. However, creating a few additional openings is not always out of the question on leased lands. Today's corporate landowners and/or their land managers tend to be more open-minded and agreeable to wildlife management practices than in the past. The best approach for obtaining permission to create new openings on a leased property is to arrange a meeting with the landowner and/or land manager to discuss the need for these additional openings and the proposed locations. Be prepared to give up a previously established opening in exchange for each new opening created. Permission to create new openings on a leased property should be obtained in writing and signed by the grantor. Also, it is always a

When possible, make use of existing openings for food plot locations. Some examples are (from left to right): old log loading deck, old pasture opening, daylighted roadside, utility right-of-way, and wide fire lane in a pine stand. Photos courtesy of Scott L. Edwards, Mississippi Department of Wildlife, Fisheries, and Parks (wide fire lane); William W. Hamrick, Mississippi State University (others)

good idea to make sure the lease agreement includes a clause that allows for the management of existing openings for food plots.

The presence of natural and/or pre-established openings on a property does not necessarily make them the best location to establish a food plot. Some criteria for evaluating a site's potential as a food plot location include soil properties, topography, nearby habitat and travel corridors, and the distance and visibility from public roads.

Soil Properties.

Sites with moderate- to well-drained soils are considered the best locations for establishing food plots. Soils of this type contain sufficient quantities of coarse fragments (sand) that create space between soil particulates and allow for better aeration, water infiltration, and root growth. As a result, these soils are more easily tilled and more resistant to compaction. However, because of their porous nature, moderate- to well-drained soils retain less water and experience more rapid leaching of nutrients and minerals. Soil properties for a site can be easily determined using soil maps, which can be obtained from the Natural Resources Conservation Service, either through a local office or online (Web Soil Survey at http://soils.usda.gov/survey/). As a general rule, perennials should be planted on the best soils and annuals planted on less-productive soils.

Topography.

As it pertains to soil erosion, topography is certainly one of the most important factors in evaluating a site's potential as a food plot location. Sites with somewhat flat or gently rolling topography are the best locations. In the event that site topography is not fairly obvious because of vegetation, topographic maps are useful in determining the lay of the land. For sites with some amount of slope, soil erosion may be offset by plowing on the contour and leaving alternating 10- to 15-foot-wide strips of native vegetation perpendicular to the slope when tilling. Also, leave 10- to 45-foot-wide undisturbed strips of native vegetation along food plot edges adjacent to steep terrain. In addition to being

a good soil management practice, these areas make for good transition zones and increase habitat diversity.

Nearby Habitat and Travel Corridors.

The vicinity of resources such as cover and water is another factor to consider when evaluating potential food plot locations. Food plots near

USING AERIAL PHOTOGRAPHS AND TOPOGRAPHIC MAPS TO SELECT FOOD PLOT LOCATIONS

Topographic maps and aerial photographs are excellent resources for selecting food plot locations based on their vicinity to high-use wildlife areas and travel corridors. Whereas aerial photographs illustrate land cover and transition zones, topographic maps provide a clearer picture of the landscape's terrain and are more useful for identifying any natural funnels that may serve as wildlife travel corridors.

An aerial photograph and topographic map comparison of food plot locations for the same property. Blue dots on the topographic map represent food plot locations from the aerial photo, and dotted lines throughout the property indicate typical high-use deer travel corridors in relation to topography. Topography map is courtesy of Esri, and aerial image is courtesy of Google Earth.

suitable resting and escape cover typically experience greater use by wildlife species. Though water is rarely a limiting factor in the southeastern United States, food plots conveniently located near a water source may increase their appeal to wildlife.

Landscape features such as transition zones and topography also factor into the evaluation of food plot locations. Transition zones are areas within the landscape where two different land cover types meet; therefore habitat differs in both species composition and structure. As a result, these areas represent some of the most diverse habitats within the landscape and are highly used by wildlife, especially deer, as both foraging areas and travel corridors. In addition, an area's topography often forms natural funnels that influence wildlife movements throughout the landscape. Therefore, food plots located close to these landscape features will attract more wildlife and experience greater use than those located off the beaten path.

Distance and Visibility from Public Roads.
Landowners should not establish food plots within sight of public roads. Not only will this minimize poaching and trespassing problems, but it reduces disturbances to wildlife. Also, limit the number of public access points into a property and secure all remaining access points with locking gates. As a general rule, establish food plots at least 100 yards inside property boundaries. If creating food plots to increase game harvest opportunities, be sure to check state game laws to ensure the plots are the required distance from public roads for legal hunting.

Size

Food plot size will vary according to management objectives, property size, budget, and equipment needed for establishing and planting. However, food plots typically range in size from several acres to much smaller. One of the greatest factors to consider is the size of the equipment used to plant and maintain food plots. Large tractors and equipment are difficult to maneuver and are often impractical

Narrow firelanes in pine monocultures can serve as good locations for wildlife food plots during the early stages of tree growth. However, as trees mature, foodplots become less productive due to lack of sunlight and tree root competition for water and nutrients. Photo courtesy of Bobby Watkins

for most food plot work unless planting large waterfowl impoundments, dove fields, or extensive open strips in the landscape. Nor is it practical to prepare and plant a 3-acre or larger food plot using an all-terrain vehicle and its specific implements.

As a general rule, food plot size is most often scaled to the animal species targeted for management. For example, food plots for deer and turkey management are typically larger and fewer in number (one 1- to 3-acre plot per 100 acres) than those intended for small game species such as quail and rabbits (one ¼- to ½-acre plot per 15 to 20 acres). Typically, habitat management plans recommend only a small percentage of the total managed property be planted in food plots.

Shape

When deciding on a food plot's shape, mark off an area with flagging tape to delineate the outline of the opening. This helps visualize how the opening will look and can be easily modified until it conforms to the desired shape. In general, narrow openings are often more appealing to wildlife because there is less distance to escape cover. Create a variety of irregularly shaped openings that range in width from 20 to 40 yards. Make use of vegetation and

topography to incorporate some hidden turns or visual barriers within the opening. There is no set limit regarding length of openings, but a good rule of thumb is for the length to equal or exceed twice that of the width.

SOIL PH AND FERTILIZATION

Providing high-quality, palatable forages for wildlife through supplemental plantings begins with soil testing. Soil test results provide information regarding soil pH (acidity and alkalinity) and fertility, including both micro- and macronutrient levels. Furthermore, soil test results include the necessary lime and fertilizer application rates to amend soil pH and nutrient deficiencies based on the optimal requirements of different forage types. Soils in food plots of annual plantings should be tested yearly, whereas those for perennial plantings can be tested every other year. Soil management not based on an annual or biannual soil analysis—that is, using a "this is what we've always done" approach—wastes time and money and, in most cases, does not help wildlife. In addition, this approach can actually cause long-term damage to soils. Because the potential for leaching is greater in coarse-textured versus fine-textured soils, coarse-textured soils often require more soil maintenance and should be tested yearly.

Most soils in the southeastern United States tend to be acidic and occasionally require agricultural lime applications to adjust soil pH levels within a desirable range. Forage crops perform best in soils with pH values between 5.8 and 6.5. Maintaining soil pH within this optimal range enables forage plants to maximize fertilizer efficiency for better growth and yield, and it increases forage palatability and nutritional values that meet the needs of wildlife. In addition, micronutrients important to plant growth and nutritional value such as zinc, manganese, and iron are either unavailable or toxic to some plants if soil pH is too acidic or alkaline. It is important to note that lime moves and reacts slowly in the soil and should be applied 3 to 6 months before planting. Also,

COLLECTING AND SUBMITTING SOIL SAMPLES FOR TESTING

The first step in food plot soil testing is to collect handful-sized topsoil samples. Dig or probe 4–6 inches below the ground surface in ten to twenty locations throughout the plot. These samples from the same plot are called subsamples. Next, transfer the subsamples to a single clean container, such as a bucket or large bowl, and mix well. Remove about a cup from this mixture and place it in a sample container for testing. Label the container with your name, address, and crop(s) to be planted in the plot(s). If sampling soils in more than one food plot, be sure to label each sample accordingly. Collect and submit soils for testing at least 3 months before planting to allow time for processing. Soil sample containers and information on soil testing are available through the Mississippi State University Extension Service (see address below) or the Natural Resources Conservation Service.

Using a soil probe to collect a sample for testing. Photo courtesy of John Gruchy, Mississippi Department of Wildlife, Fisheries, and Parks

Mississippi State University
Soil Testing Laboratory
Box 9610
Mississippi State, MS 39762-9610
(662) 325-3313
http://msucares.com/crops/soils/testing
.html

lime is not water soluble and should be disked into the soil whenever possible.

The most common method of replenishing soil macronutrients is through application of pelletized or liquid chemical fertilizers. Chemical fertilizer is sold in formulations expressed as ratios of the percentage of nitrogen (N), phosphorous (P), and potassium (K) per 100 pounds of fertilizer. For example, 100 pounds of 34-0-0 contains 34 pounds of nitrogen, 0 pounds of phosphorous, and 0 pounds of potassium. Fifty pounds of 34-0-0 contains 17 pounds of nitrogen, 0 pounds of phosphorous, and 0 pounds of potassium. Treated animal manures from a trusted source may be used in place of chemical fertilizers, but nutrient content levels are less certain than in chemical fertilizers. In general, cereal grains require a complete fertilizer with equal amounts of nitrogen, phosphorous, and potassium, such as 13-13-13. Legumes, on the other hand, fix their own nitrogen in the soil and usually require a fertilizer with very little or no nitrogen, such as 0-20-20.

It is important to note that untreated animal manure such as poultry litter or cow manure should *not* be used to fertilize wildlife food plots. These materials may contain some antibiotics and hormones that have adverse effects on wildlife and/or water quality. In addition, animals infected with a viral illness or having high internal parasite loads often shed these pathogens in their feces and pose a disease risk to wildlife. For example, poultry litter can expose turkey and northern bobwhite quail to blackhead disease and avian pox.

Calculating Food Plot Area

Before any soil amendments are made and planting occurs, it is important to quantify how much lime, fertilizer, and seed are actually needed for each food plot. Recommendations for soil amendments and planting rates are expressed in relation to area; that is, pounds or tons per acre. Food plot area can be calculated by one of several methods: (1) measure length and width of the food plot to calculate square footage and convert that value to acreage; (2) use a planimeter (a handheld measuring instrument used to calculate distance) to trace around the edges of food plots on scaled aerial photographs; or (3) map food plots with a Global Positioning System (GPS) unit and enter data

CALCULATING FERTILIZER RATES BASED ON SOIL TEST RESULTS

Fertilizer recommendations from soil test results are based on a per-acre basis. Chemical fertilizers are sold in formulations expressed as ratios (such as 34-0-0), which represent the percentages of nitrogen, phosphorus, and potassium in each bag of fertilizer. For example, a 100-pound bag of 34-0-0 fertilizer contains 34 pounds of nitrogen, 0 pounds of phosphorus, and 0 pounds of potassium.

The following example demonstrates how to calculate the amount of nitrogen for a 2-acre food plot based on a recommended application rate of 300 pounds/acre of 34-0-0 formulated fertilizer.

300 pounds/acre / 0.34 = 882 pounds/acre × 2 acres = 1764 pounds of nitrogen

Because most fertilizer is sold in bagged quantities of 50 pounds: 1764 pounds / 50 pounds/bag = 36 bags of 34-0-0.

CALCULATING FOOD PLOT AREA IN ACRES

The following example shows how to calculate area for a 300-foot long by 200-foot wide food plot:

area = length × width
300 feet × 200 feet = 60,000 square feet

Because 1 acre equals 43,560 square feet:
60,000 square feet / 43,560 square feet/ acre = 1.38 acres

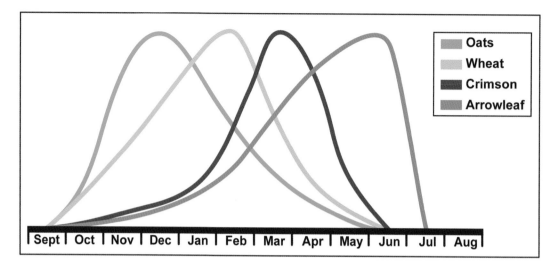

Peak production times and life cycle of a forage mix containing four different cool-season annuals. Illustration by Bill Pitts*

points into a Geographic Information Systems (GIS) computer software program.

The first method is the simplest and can be done using nothing more than one's stride length to step off food plot length and width. Because the chief unit of measurement for this method is based on the number of steps, correct counts and consistent stride length are important. Stride length can be measured later. While this method is not precise, it is quick, easy, and still reasonably accurate. If a food plot is irregular in shape, measure the various edges, calculate the average for length and/or width, and use those values to calculate acreage.

SUPPLEMENTAL FORAGE CROPS

Research indicates that no particular forage crop can meet all the needs of a wildlife species year-round. Nutritional studies of white-tailed deer have shown that when range conditions are excellent, deer with unlimited access to supplemental feed pellets continue to prefer native plant forages. Therefore, best management practices recommend a combination of sound habitat management and a good food plot program including warm- and cool-season forages. Select adapted varieties based on soil and site characteristics, nutritional value, cost, and the wildlife species managed. When experimenting with different varieties and planting combinations, plant small areas as test plots before establishing larger plots. Refer to Tables

13.1 to 13.4 for species- and site-specific planting recommendations.

Mixed-Forage Plots

Regardless of season, planting food plots of two or more forage crops is an excellent way to maximize the benefits of wildlife food plantings. Mixed-forage plots provide wildlife with diverse forage types that are available for greater year-round use. As a result, these plots often experience more frequent wildlife use and typically appeal to more than one species, as compared to a single-forage plot. Furthermore, if for some reason one crop is not successful, a second or third crop still stands to produce.

Mixed-forage plots may be planted using either a broadcast seeder or grain drill. Small-seeded mixes (such as those containing a combination of cool-season annual grasses, clovers, and chicory) are typically broadcast, whereas large-seeded mixes (such as those containing combinations of corn and soybeans) are best drilled in rows. Drilling large-seeded mixed-forage plots improves forage and seed production, as compared to broadcast planting. One popular method of diversifying mixed-forage plots of large-seeded grains is to plant several long, alternating strips (20 to 40 feet wide) of different types of forage. Another method is to plant widely spaced rows of corn or grain sorghum first, and then several weeks to a month later, plant cowpeas or forage soybeans between the rows to provide protein-rich forages.

Seed Mixes

Many seed companies sell seed mixes, but those made locally are often just as productive, if not more so, than commercial brands. Most seed stores and farmer cooperatives will gladly mix seeds to order, and these mixes are usually more accurate in proportion and less expensive. Another option for mixed-forage plantings is to calculate the recommended or desired proportions of seed for each species and separately hand sow them on top of one another. This method works best with small-scale food plot planting. Be sure to order seed mixes several weeks to a month in advance to ensure availability and ample planting time.

A cool-season mixed-forage plot of oats, wheat, arrowleaf, and ladino and crimson clovers during May. A warm-season mixed-forage plot of grain sorghum with wildlife soybeans planted in between rows. Cowpeas planted in the same row with corn. Photos courtesy of William W. Hamrick, Mississippi State University (cool-season plot and cowpeas); Scott L. Edwards, Mississippi Department of Wildlife, Fisheries, and Parks (warm-season plot)

CALCULATING SEEDING RATES FOR MIXED-FORAGE FOOD PLOTS

One of the most common problems with mixed-forage food plots is planting excessive proportions of seed. Such overplanting within mixed-forage food plots wastes money and reduces forage production because of plant competition and overcrowding.

The following example shows how to calculate the correct amount of seed to include in a seed mix of 40 percent Elbon rye, 30 percent crimson clover, and 30 percent red clover. Multiply the recommended full planting rates per acre of each forage species by the desired percentage to calculate the amount of each species to include in the seed mix.

120 pounds Elbon rye/acre × 0.4 = 48 pounds rye
30 pounds crimson clover/acre × 0.3 = 9 pounds crimson clover
12 pounds red clover/acre × 0.3 = 3.6 pounds red clover

Cowpea seeds recently treated with inoculant are spread out and drying before being planted. Photo courtesy of William W. Hamrick, Mississippi State University

A cyclone spreader used to disperse large-grain seed in a food plot. Photo courtesy of John Gruchy, Mississippi Department of Wildlife, Fisheries, and Parks

Developing your own seed mix can be both enjoyable and cost-effective. However, such an endeavor requires time spent researching and asking questions of an agronomist and/or a forage specialist regarding which types of forage work well together (competition), soil adaptations, and growth rates. Start out small when developing a new seed mixture. Plant several small experimental or test plots (such as 10 feet × 10 feet) to evaluate seed mix performance before conducting more large-scale plantings.

Legume Seed Inoculation

Before planting legumes, it is best to inoculate the seeds with a packet of plant-specific nitrogen-fixing bacteria. These specialized bacteria fix nitrogen to the nodules of legume roots and enhance nitrogen production and intake by plants. This is especially helpful when planting legumes in newly established food plots where levels of these naturally occurring bacteria may be low. In turn, inoculants increase the foliage and seed production of legumes, decrease fertilizer costs, and increase soil quality. Many legume seeds are now conveniently pre-inoculated before being packaged for sale. However, in the event that pre-inoculated seed is not available, seed inoculation is a fairly simple process and usually can be completed in 1 to 2 hours.

When using inoculants, be sure to use the plant-specific inoculum and follow seed treatment instructions. Also, if broadcast planting using a cyclone spreader, do not mix inoculated seed with fertilizer. Although this planting method saves time, the salts in fertilizer can kill the bacteria. Inoculating legume seeds requires a little extra time and care, but the process is inexpensive and can make the difference between planting success and failure.

Preparing and Planting Food Plots

Some farm equipment is needed to plant and maintain wildlife food plots. A tractor large enough to pull 5-foot implements is sufficient in most cases. Also, all-terrain vehicles and equipment specifically designed for use with them have become popular in recent years.

Useful implements include a heavy-duty mower (bush-hog), disk, drop spreader or broadcast spreader/seeder (cyclone spreader/seeder), and a small grain drill or row planter that will accommodate at least two rows. A seed drill or row planter is not essential for most plantings, but such implements are useful for establishing more productive grain plots. A hand-seeder is often useful for planting small-seeded crops (such as clovers and cool-season annual grasses) and may be used in place of a broadcast spreader implement. It is also useful for seeding places too dangerous, too small, or too wet to safely and efficiently operate machinery.

Whenever possible, postpone planting until reliable rainfall patterns occur. Seed sown on excessively dry soils often settle too deeply and experience poor germination. On more than one occasion, food plots have been planted after a light rain only to be followed by 2 to 3 consecutive weeks of drought conditions. The seeds germinate and sprout but are unable to survive the extended dry period, and the end result is a total crop failure. Finally, planting times that coincide with timely rains will reduce seed depredation by mice, rats, and birds such as crows and turkeys.

Some preparation before planting is often required for wildlife food plots. If perennial weeds such as Bermudagrass or morningglory dominate a plot, a post-emergent broad-spectrum herbicide application followed by mowing and/or burning may be necessary before the first tilling, and this is almost always necessary when using low-till and no-till planting methods. Depending on the degree of the weed problem and species being planted, a pre-emergent herbicide application may also be necessary at planting time. This is usually the case when planting warm-season food plots. If using a pre-emergent herbicide, make sure it is appropriate to use with the chosen forage crop(s). For more information regarding herbicide use, consult the label and/or a certified herbicide specialist. Always read each label carefully and follow instructions explicitly.

There are three basic ways to plant supplemental food plots: till, low-till, and no-till. Tillage involves breaking or plowing the soil for

Tank sprayer application of herbicide to kill unwanted vegetation prior to establishing a food plot. Photo courtesy of John Gruchy, Mississippi Department of Wildlife, Fisheries, and Parks

Disking a large food plot. Photo courtesy of John Gruchy, Mississippi Department of Wildlife, Fisheries, and Parks

Using a cultipacker after disk-
ing provides a level and firm
seedbed, that helps to increase
germination rates of small-
seeded plants. Photo courtesy
of John Gruchy, Mississippi
Department of Wildlife,
Fisheries, and Parks

For smaller plots with coarse
soils, dragging a section har-
row or section of chain-link
fence can effectively smooth
out the soil for increased ger-
mination rates. Photo courtesy
of John Gruchy, Mississippi
Department of Wildlife, Fisher-
ies, and Parks

the preparation of a seedbed. Low-till methods
incorporate the use of seed drills and the seed is
drilled into the soil with minimum soil distur-
bance. No-till methods are simply broadcasting
seed on top of the ground without any distur-
bance to the soil.

Tillage.
Till methods (disking or plowing) are the most
commonly used means of preparing and plant-
ing wildlife food plots. Some preplanting prep-
arations to consider with this method are early
tilling and establishing a good seedbed. Tilling
the soil a few weeks to several months before
planting allows ample time for turned-under
vegetation to decompose and build soil nutri-
ents. Keep in mind that soil disturbances stim-
ulate germination of the natural seed bank and
may increase weedy species competition. In ad-
dition, exposed soil loses moisture more rapidly
and increases the potential for soil erosion.

Establishing a firm seedbed produces the
best results for most forage crops, especially
small-seeded crops that require shallow planting

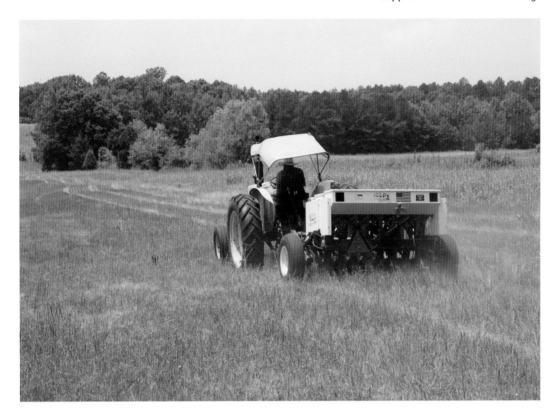

Using a low-till seed drill is an effective way of planting food plots with little disturbance to the soil. Photo courtesy of John Gruchy, Mississippi Department of Wildlife, Fisheries, and Parks

depths. Once the soil has been adequately tilled, prepare a firm seedbed by rolling the plot with a cultipacker. If a cultipacker is not available, a good rain followed by several days of sunshine is usually adequate to establish a firm seedbed. Recently tilled plots sometimes require smoothing before planting, which ensures more uniform seed distribution and planting depths. The most common method of smoothing rough-tilled soils is to drag the plot with a section harrow or a 6- to 8-foot length of chain-link fence.

When using the broadcast method to plant food plots, distribute the seed and roll the plot a second time with the cultipacker to press the seeds into the soil. Food plots planted with a row planter should also be rolled once with a cultipacker before planting.

Low-Till.
Low-till planting is the practice of using a grain drill to plant seeds without major disturbance to the soil. Grain drills cut small grooves in the ground, deposit the seed, and firm the soil back over the groove in a single pass. Also, the grain drill's more precise seed placement capability requires less seed per acre than broadcast planting and results in higher germination rates and seedling survival. Thus, low-till significantly boosts food plot productivity and reduces the cost and labor involved in planting. Also, because seed drills create so little soil disturbance, low-till is ideal for areas susceptible to soil erosion, plus it conserves soil moisture. Use of no-till planting equipment often requires an herbicide (glyphosate) application 2 to 4 weeks prior to planting.

Although seed drills can create more productive food plots, they are expensive, and the cost is a drawback for most landowners. Also, they do not perform well on rough ground and are impractical for sites with stumps and rocks. Furthermore, unless using a small-seed drill specifically designed for planting food plots, operators will find that most seed drills are too heavy and wide for convenient transport and are difficult to operate in small areas.

No-Till.
As the name implies, no-till planting involves no soil disturbances whatsoever. No-till planting, also known as top sowing, is the simple practice of broadcasting seed directly on areas

White-tailed deer. Photo courtesy of iStock

of naturally exposed soil or on top of already-present vegetation. Much like low-till planting, no-till is ideal for areas that are susceptible to erosion or inaccessible to machinery. For areas prone to severe erosion, wheat or oat straw mulch may be necessary to help retain soil moisture and hold seeds in place. Both cool- and warm-season food plots can be planted using the no-till method.

SUPPLEMENTAL FOOD PLANTING RECOMMENDATIONS FOR PARTICULAR WILDLIFE

When developing a food plot program for wildlife, it is important to consider the target species and their seasonal nutritional needs. For example, during late spring and summer, wildlife species require higher levels of protein to assist in reproduction and development. During autumn and winter, seasonal nutrition requirements shift more toward foods high in carbohydrates to meet increased energy demands. In addition to providing a direct food source for some wildlife species, food plots may also serve as bugging areas for upland game birds and provide cover for foraging. Therefore, selecting supplemental forage crops that provide wildlife with the necessary nutrients according to seasonal demands is the best way to maximize the benefits of a food plot program.

White-Tailed Deer

White-tailed deer eat a variety of foods including leaves, buds, vines, lichens, mushrooms, hard and soft mast, agricultural crops, and some grasses. During spring and early summer, naturally occurring deer browse is high in protein and complex carbohydrates. Deer body fat stores are increased during autumn and early winter with a variety of mast crops, such as persimmons and acorns, which are good sources of carbohydrates.

The two most critical seasonal periods for white-tailed deer are summer, when adult females are lactating and bucks are growing antlers and food quality is declining, and late winter, when food quality and quantity are low,

Table 13.1. Suggested cool- and warm-season planting mixes and planting dates for white-tailed deer

Season	Mixes	Planting dates
Cool-season	arrowleaf, crimson, and ladino clovers; oats; and winter wheat	September 1 to October 15
	red clover, cereal rye, and oats	September 1 to October 15
	Austrian winter peas and oats	September 1 to October 15
	ladino white clover, forage chicory, oats, or winter wheat	September 1 to October 15
Warm-season	corn and cowpeas or forage soybeans	May 1 to June 15
	grain sorghum and cowpeas or forage soybeans	May 1 to June 15

Note: Leave wide rows between corn or grain sorghum rows and 2 to 3 weeks later use a row planter or broadcast seeder to plant cowpeas or forage soybeans in the empty wide rows. Leave the corn and grain sorghum stalks standing throughout the winter.*

and mast from oaks and other trees is scarce. It is during these periods that food plots are most beneficial to deer.

The minimal protein levels in forage required for antler development varies with age, but 16 to 18 percent is likely needed to maximize antler size. Younger animals that are actively growing require much higher levels of protein than adult animals. Weaned fawns require up to 20 percent protein for optimum growth. Active management of native vegetation and an effective food plot program (cool- and warm-season annuals and perennials) can ensure the availability of forages with more than 16 percent protein. (See chapter 9 for more information.)

Cool-season plantings of wheat, oats, cereal rye, forage chicory, and clovers provide excellent winter forage for deer, and clovers will continue to do so into late spring. Typically, these species are planted in some assorted mixture of one or two cool-season grasses and several legumes. Warm-season plantings recommended for deer include large-seeded grains like corn and sorghum as well as protein-rich legumes such as peas and beans.

Eastern Wild Turkey

Turkeys are strong scratchers and consume a diet of animal and plant matter. During their first 2 weeks of life, turkey poults feed almost entirely on protein-rich insects. After 4 weeks,

their diet begins to include foods typical of the adult turkey diet: a variety of plant matter (seeds, leaves, fruits, tubers, forbs, and grasses) and insects. In addition to well-managed native habitats, cool- and warm-season food plantings that provide desirable foliage, fruit, and seed production are beneficial.

Food plots for wild turkeys should be located near prime turkey habitat. Large tracts of mature bottomland and upland hardwoods or pine-hardwood mixtures interspersed with open areas are preferred habitat. Open areas

Eastern wild turkey. Photo courtesy of iStock

Table 13.2. Suggested cool- and warm-season planting mixes and planting dates for eastern wild turkey		
Season	**Mixes**	**Planting dates**
Cool-season	arrowleaf and crimson clovers, oats, cereal rye, and winter wheat	September 1 to October 15
	birdsfoot trefoil, oats, and cereal rye or winter wheat	September 1 to October 15
	crimson clover, oats, and cereal rye or winter wheat	September 1 to October 15
	red clover, oats, and cereal rye or winter wheat	September 1 to October 15
Warm-season	sunflower and cowpeas or forage soybeans	April 15 to June 1
	alternating strips of grain sorghum and browntop millet	May 1 to June 15
	deer joint vetch and alyceclover	May 1 to June 15

Note: Leave wide rows between corn or grain sorghum rows and 2 to 3 weeks later use a row planter or broadcast seeder to plant cowpeas or forage soybeans in the empty wide rows. Leave the corn and grain sorghum stalks standing throughout the winter.*

Bobwhite quail. Photo courtesy of iStock

such as old fields and logging roads are excellent sites for food plots (see chapter 10 for more information).

Cool-season plantings for turkeys include cereal rye, wheat, triticale, and clovers such as crimson, red, arrowleaf, and ladino. Recommended warm-season plantings for turkeys include grains or large seed producers, beans, native legumes, and chufa. Many food plots intended for white-tailed deer use also serve as adequate forage areas for wild turkeys.

Northern Bobwhite Quail

Supplemental food plantings often provide some critical food resources for northern bobwhite during late winter and early spring, when food is most limited. However, too much emphasis on supplemental food planting can negatively affect habitat quality, especially because providing proper cover for the daily and seasonal needs of quail is often the most challenging factor in their population maintenance and growth. Before considering supplemental food plantings, landowners should focus on providing the necessary cover for reproduction and escaping predators (see chapter 12 for more information).

Once the appropriate habitat components are in place, plant supplemental food crops for quail in strips or small patches near secure thicket cover. As a general rule, plant no more than 5 to 10 percent of acreage in supplemental food plantings. Among those commonly recommended are partridge pea, common lespedeza, millets, and wildlife soybeans in conjunction with corn or sorghum. An ideal food-planting strategy for quail is strip planting corn or sorghum in wide rows with native warm-season grasses and broadleaf annuals in between

Table 13.3. Suggested cool- and warm-season planting mixes and planting dates for quail and rabbits

Season	Mixes	Planting dates
Cool-season	birdsfoot trefoil, oats, and winter wheat	September 1 to October 15
	ladino and red clovers, oats, and winter wheat	September 1 to October 15
	crimson clover and small burnett	September 1 to October 15
	red clover, oats, and cereal rye	September 1 to October 15
Warm-season	partridge pea and native warm-season grasses	April 1 to June 1
	sunflower and cowpeas	April 15 to June 1
	corn or grain sorghum and browntop millet	May 1 to June 15

Note: Leave wide rows between corn or grain sorghum rows and 2 to 3 weeks later use a row planter or broadcast seeder to plant cowpeas or forage soybeans in the empty wide rows. Leave the corn and grain sorghum stalks standing throughout the winter.*

ESTABLISHING A DOVE FIELD

Traditional agricultural fields are ideal places to hunt mourning doves. However, landowners and/or land managers can create their own dove fields for hunting. The following are factors to consider when choosing a site:

♦ Dove fields should be at least 5 acres, and larger fields often will attract proportionately greater numbers of doves.
♦ Corridors between agricultural fields will improve chances of attracting more doves.
♦ Locations with close proximity to water—creeks, ditches, or farm ponds with exposed shorelines—are also appealing.
♦ Fields with nearby perching and loafing areas will increase the attractiveness for doves.

A popular practice for attracting mourning doves is strip management, which entails leaving strips of grain crops and native vegetation established in 15- to 20-foot-wide alternating bands across a field. An excellent example of a strip-managed field is one with alternating strips of

millet, grain sorghum, sunflower, bare dirt, and native forbs and grasses. Leave 5-foot-wide dirt strips between each band of grain crops or native vegetation. Weed control in the bare dirt strips will be necessary periodically throughout the growing season (May through August). For best results either disk or pull a do-all through the dirt strips about once every 2 weeks.

Dirt
Grain crop (e.g., Brown-top millet, Grain sorghum) or sunflowers

A dove field with alternating strips of grains, bare dirt, and native grasses. Illustration by Bill Pitts*

To attract doves for September shoots, plant summer grain crops by May 15. Begin mowing strips within the field 2 to 3 weeks before the expected hunting dates. Mowing every 1 to 3 weeks will shatter seed and facilitate feeding. Be sure to leave some standing rows of crops for hunter concealment.

Mourning dove. Photo courtesy of iStock

Northern pintail. Photo courtesy of iStock

adapted for strong scratching on the ground for food. Therefore, recently prepared and/or harvested grain fields and timber harvest areas attract doves because of the clean ground and scattered seeds.

In addition to food sources, doves need areas in which to obtain grit and water. Grit is small bits of gravel and larger grains of sand. It is an important component of the dove diet because it helps grind food in the gizzard. A water source, such as a farm pond, within 1 mile of the food source is ideal. Doves prefer watering areas with little cover and few trees around the edges. Also, they rarely go directly to the water, but prefer to loaf first in nearby trees or on power lines.

Waterfowl

The southeastern United States is an important region in North America for migrating and wintering waterfowl. Bottomland hardwood swamps, coastal marshes, and flooded agricultural lands serve as critical habitats for ducks and geese. Portions of the Lower Mississippi Alluvial Valley alone winter about 5 million ducks and geese each year. Although public refuges and wildlife management areas provide excellent habitat, private lands—especially those in grain production or those currently being managed for waterfowl—play a large role in providing additional resources for waterfowl (see chapter 11).

Supplemental food plantings for waterfowl are mostly intended for species of dabbling ducks, including mallard, gadwall, northern pintail, northern shoveler, American wigeon, and blue-winged and American green-winged teal. Dabbling ducks have diverse diets of natural and agricultural seeds, tubers, foliage, and aquatic invertebrates and typically feed in shallow water by tipping up or dabbling on the water surface.

Shallow farm and/or beaver ponds and other impoundments of at least 5 acres can be made attractive to waterfowl with food plantings of corn, grain sorghum, and Japanese and browntop millets. Also, oak species not producing small acorns can be removed from

rows. Allow the stalks to remain standing over the winter; grasses will lodge underneath and provide excellent loafing and foraging cover.

Mourning Dove

Doves are strictly seed-eaters and feed primarily on the seeds of forbs, grasses, and small grains with occasional use of berries and hard mast. They seek food by sight and prefer to land in areas where the ground is bare and then walk to a food source. Dove feet are not

Season	Mixes	Planting dates
Table 13.4. Suggested planting mixes and planting dates for dabbling ducks		
Cool-season	none recommended	
Warm-season	Japanese millet and chufa	May 1 to June 1
	corn or grain sorghum and browntop millet	May 1 to June 15

Notes: Mechanical manipulation of these crops in the same year of planting is illegal for waterfowl hunting. Leave stalks standing throughout the dormant season and allow grain to fall naturally. For mixed plots in which large-seeded grains are the primary crop, plant widely spaced rows and 2 to 3 weeks later plant a secondary crop (browntop millet) in the spaces between the rows of corn or grain sorghum. An alternative to planting a secondary crop is to allow native warm-season grasses to grow in the spaces between corn or grain sorghum rows.*

pond edges to allow seed-producing grasses and sedges (moist-soil plants) to flourish. Water control structures are necessary to maintain shallow water levels and keep ponds and impoundments drained throughout the growing season.

MONITORING FOOD PLOT GROWTH AND USAGE

Exclusion cages provide a quick and simple means for monitoring forage growth and wildlife use of food plots. These structures allow landowners and land managers to compare forage growth inside the cage with forage consumption outside the cage. Although different wildlife species will utilize food plots, exclusion cages are most practical for monitoring deer grazing. For example, tall and lush forage growing inside the cage but forage eaten down to soil level outside the cage demonstrates an overgrazing problem. These findings are a good indicator of too many deer, too little food plot acreage, poor habitat quality, or a combination of all three factors. In addition, exclusion cages

CONSTRUCTION AND PLACEMENT OF EXCLUSION CAGES

When constructing an exclusion cage, use 4-foot-high welded wire fencing with a mesh size of 2 × 4 inches or smaller. Cut wire in 8-foot sections and connect the two ends from each section to form a cylindrical cage. Exclusion cages can be set out immediately after planting or within 1 to 2 days following plot germination. If the main objective is to examine grazing pressure and forage preference, wait 1 to 2 days following plot germination and place the cage in an area where stand success best represents that for the plot as a whole. Where food plots are subject to edge effects from surrounding trees or brush, place the exclusion cage near the plot's center to reduce shading and competition with native vegetation. Set cages in an upright position and drive

An exclusion cage. Photo courtesy of Adam T. Rohnke, Mississippi State University

stakes or steel T-posts into the ground on at least two sides of the structure. Fasten the cage to the stakes or T-posts to hold it in place to prevent foraging animals from pushing it over. When collecting data from food plot exclusion cages, measure forage height inside and outside the cage every 2 to 3 weeks. When measuring height outside the cage, take five to ten measurements throughout the plot and calculate the average.

will provide information about which forage species are most utilized by wildlife.

Game cameras are another great tool for monitoring wildlife use of food plots. Not only do cameras record different species using plots, but they also document how often plots are visited and for what length of time. Another advantage is that camera footage and images can be used for estimating species population numbers and, when used in conjunction with exclusion cages, will provide a clearer picture for management recommendations. Taken at weekly intervals over the course of several months, camera images of forage growth can provide valuable data about forage consumption and grazing pressure, but exclusion cages are a much better tool for observing these differences.

RECORDKEEPING FOR FOOD PLOTS

Probably the most overlooked aspect of food plot management is recordkeeping. Maintaining the most basic records, such as soil testing results, liming, fertilization, exact planting dates, seeding rates for each forage species, and species variety, can improve production and reduce costs. For example, a landowner might plant a forage species at a lower rate than recommended and produces the same or better yield. For obvious reasons, this is good information to have and maintain. Also, collecting and recording data from exclusion cages will reveal useful information about forage planting choices:

- Overall, did the forage perform well?
- Was performance site-dependent?
- Is it worth planting again?
- If a mixed-forage plot, was one species less productive or less preferred in comparison to other forage species? Can this forage species be excluded next year?

Investing a little time to keep accurate and detailed food plot records is a small price to pay for the potentially high rewards such information can provide. Not only will it enable landowners and managers to make more informed decisions about food plot management, but seeing and experiencing the fruits of one's labor are very satisfying.

FOOD PLOT MAINTENANCE

After preparation and planting, food plots also require some degree of maintenance, including clearing plot edges, soil sampling, aerating, and mowing or burning. Probably the most frequent maintenance tasks are monitoring and controlling weeds.

Food plots planted in cool-season annuals rarely require any sort of weed control. Many of the worst weed species have growth cycles that do not coincide with those of cool-season annual forages. There may be an occasional need to control some cool-season weed species, but it is rarely on a large-scale basis. On the other hand, food plots planted in warm-season forages require the most intensive weed management. Both pre-emergent and post-emergent herbicide applications are usually necessary to establish productive warm-season food plots. Grains like corn and sorghum require additional applications of nitrogen fertilizer.

Cool-season perennial food plots (such as ladino clovers, forage chicory, alfalfa) can be productive over the course of several years if they are properly maintained. Post-emergent herbicide applications are usually necessary to control grass and broadleaf weeds in the spring and summer. Also, mowing to stimulate new growth followed by fertilizer applications often are recommended in spring and late summer to early autumn. During late spring and summer, cool-season perennial plots should be closely monitored for insect damage and, if signs appear, treated quickly.

Herbicides

Herbicides for food plot maintenance are characterized based on application as pre-planting, pre-emergent, post-emergent, and spot-spray herbicides. Pre-planting herbicides are used to control actively growing weeds and undesirable brush or trees in and around food plots. These are sprayed on the foliage of the plants.

Pre-emergent herbicides are applied to the soil before or during planting and kill weeds as they germinate. Post-emergent herbicides are applied over the tops of vegetation after the crop is up and growing. Herbicides used for spot-spray applications may contain some of the same chemicals or have the exact formulation used for pre-planting or post-emergent treatments. Spot-spray applications should be used only to treat scattered infestations of an easily identified weed (such as Johnsongrass) in a clover plot.

In recent years, many new herbicides have been developed and approved for food plot use. As a result, increased competition in the marketplace has resulted in herbicides being more affordable and cost-effective. Do not be sold on brand names; many of the less recognized or generic brands of herbicides are just as effective when used properly. Make sure herbicides are appropriate for use with the forage crops chosen for planting. Always read each label carefully and follow instructions explicitly.

SUMMARY

Planting and managing food plots are an excellent way to provide additional food sources and enhance nutrition for wildlife. Also, managing food plots for wildlife can be a very rewarding experience for landowners, managers, and hunters. There is something to be said for seeing one's time and hard work pay off in the form of improved carrying capacity of the land, improvements in animal health and condition, and increased hunter harvest and wildlife viewing opportunities. Furthermore, these rewards can serve to promote a strong bond between the practitioner and the land.

A successful food plot program requires careful planning, dedication, and an understanding of basic agricultural and soil management practices. It also requires some basic knowledge of forage types, including nutritional values, response to grazing pressure, and soil adaptations. However, the combinations of management practices and expenses will vary depending on one's objectives.

Although food plots do provide potential benefits for wildlife species, it is important to remember that good wildlife management extends beyond planting food plots and enhancing food-producing native plants. Food is only one component of the habitat. Instead, a more comprehensive approach that prescribes a small percentage of the total managed property to be planted in food plots as well as addressing population issues and all other facets of habitat management will prove more beneficial to wildlife. Recognizing and implementing this important concept is what enables many hunters to make the transition to being wildlife managers.

For More Information

Ball, D. M., C. S. Hoveland, and G. D. Lacefield. 2002. *Southern Forages.* Norcross, Ga.: Potash and Phosphate Institute and Foundation for Agronomic Research.

Dickson, J. G. 2001. *Wildlife of Southern Forests: Habitat and Management.* Blaine, Wash.: Hancock House Publishers.

Halls, L. K. 1984. *White-Tailed Deer: Ecology and Management.* Harrisburg, Pa.: Stackpole Books.

Hamrick, B., and B. Strickland. 2011. *Supplemental Wildlife Food Planting Manual for the Southeast.* Publication 2111. Mississippi State University Extension Service.

Harper, C. A. 2008. *A Guide to Successful Wildlife Food Plots: Blending Science with Common Sense.* Publication 1769. University of Tennessee Extension Service.

Kammermeyer, K., K. V. Miller, and L. Thomas Jr. 2006. *Quality Food Plots: Your Guide to Better Deer and Deer Hunting.* Bogart, Ga.: Quality Deer Management Association.

Larson, S. J. 1967. *Agricultural Clearings as Sources of Supplemental Food and Habitat Diversity for White-Tailed Deer.* Massachusetts Cooperative Wildlife Research Unit.

McCabe, R. E. and T. R. McCabe. 1984. Of slings and arrows: an historical retrospection. Pp. 19–72 in L. K. Halls, ed. *White-Tailed Deer: Ecology and Management.* Harrisburg, Pa.: Stackpole Books.

Nelms, K. D., J. Allison, B. Strickland, and B. Hamrick. 2012. *Growing and Managing Sunflowers for Dove Fields in the Southeast.* Publication 2725. Mississippi State University Extension Service.

Webb, L. G. 1963. Utilization of domestic forage crops by deer and wild turkeys with notes on insects inhabiting the crops. *Proceedings of the Annual Conference of the Southeastern Association of Game and Fish Commissions* 17:92–100.

Wildlife Mississippi's Wildlife Habitat Seed Program, www.wildlifemiss.org/seed

*Adapted from Hamrick, B., and B. Strickland. 2011. *Supplemental Wildlife Food Planting Manual for the Southeast.* Publication 2111. Mississippi State University Extension Service.

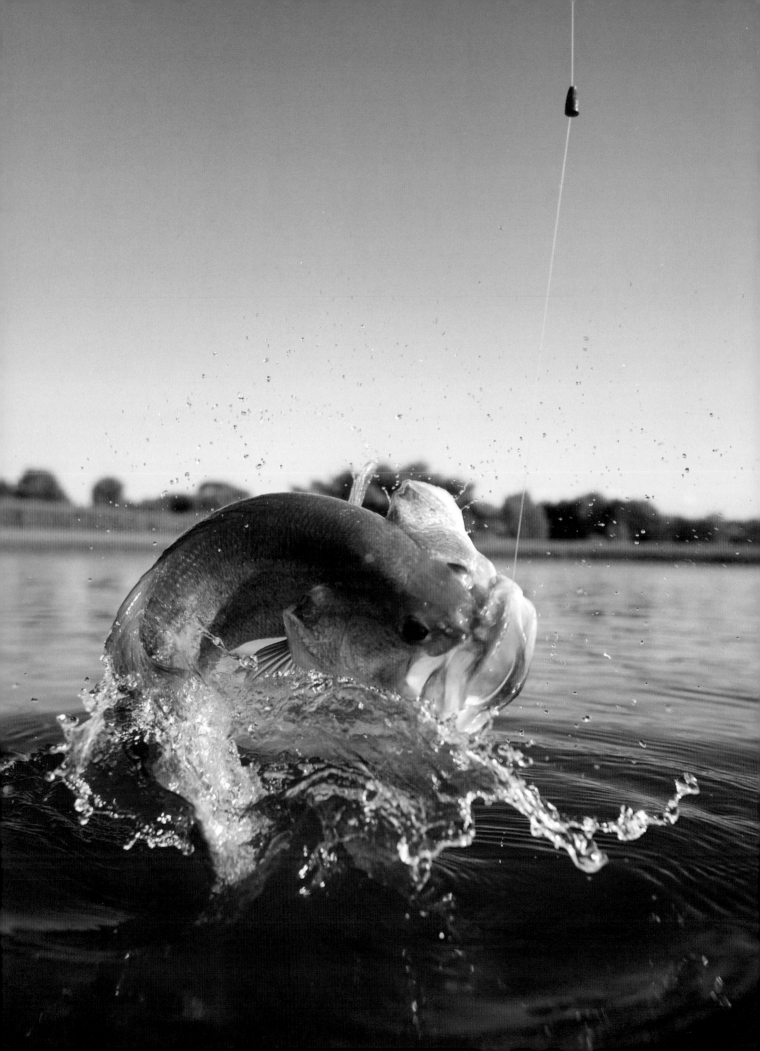

Managing Ponds for Recreational Fishing

J. Wesley Neal, Associate Extension Professor of Fisheries, Department of Wildlife, Fisheries, and Aquaculture, Mississippi State University

Technical editor
Adam T. Rohnke, Wildlife Extension Associate, Department of Wildlife, Fisheries, and Aquaculture, Mississippi State University

A pond that consistently produces good catches of fish is a result of proper planning, construction, and management. Poor planning, improper construction, or lack of proper management results in lakes and ponds that are relatively unproductive or problematic.

It is critical that the landowner's objectives for the pond are clearly defined before the first soil is moved. What will the pond be used for, and what kinds and sizes of fish are preferred? These questions must be answered early in pond development so that a proper management plan can be created. Keep in mind that all objectives cannot be met in a single pond, and compromises may be necessary. Landowners with several ponds may consider applying different management strategies to different ponds.

After the pond is completed, success or failure depends on using management practices to establish and maintain good fish populations. Proper stocking with the correct species and numbers of fish, stocking at the proper time of year, a balanced harvest, water quality management, and aquatic weed control are basics the pond owner should understand. Many unmanaged ponds could produce many more pounds of fish than they now produce if good management practices were implemented.

SETTING POND OBJECTIVES

Perhaps the most important decision that a pond owner will make is deciding what purposes the pond will serve. If it is to be used for something other than fishing, such as irrigation, fire protection, swimming, wildlife habitat,

A largemouth bass.
Photo courtesy of iStock

A proud angler holds his catch. Photo courtesy of iStock

Ponds can be managed for aesthetics and provide many types of water-based recreation, such as fishing, canoeing, and wading. Photos courtesy of iStock

livestock water supply, or home cooling, these uses may require different design considerations than for fishing alone. The preferred species and sizes of fish that the pond owner would like to catch (that is, the management objective) need to be determined in the planning stages. Stocking and management will differ based on this objective. Some pond owners prefer bream fishing and manage the pond to produce a good crop of large bream. Some prefer a good all-around fishery. Many want only a chance at catching trophy bass, whereas others are happy with quality catfish. Usually, a pond can only be managed successfully for one management objective at a time.

POND CONSTRUCTION

Designing a quality fishing pond requires many important steps. These include selecting the best possible location, determining pond size and depth, planning for the dam and water control structures, and considering fish habitat prior to impounding water in the pond.

Site Selection

The site selection process is extremely important. Before selecting a pond site, consider the shape of the land (topography), water supply, and soil type. If possible, carefully assess more than one location, and select the most practical, attractive, and economical site. Consider possible problems, such as runoff from agriculture, past land uses, or the potential to attract trespassers.

Water availability should be adequate, but not excessive, and may be provided by springs, wells, or surface runoff. Although well and spring water is usually high quality, it may be low in oxygen when it is pumped or flows out of the ground. Standing surface water (such as that pumped from creeks and sloughs) should not be used to fill ponds if it can be avoided,

A professional survey of an existing pond or potential site for a new pond is critical for water management. Photo courtesy of iStock

as this will be a source for unwanted fish, parasites, and fish diseases. For ponds where surface runoff is the main source of water, the contributing drainage area should be large enough to maintain a suitable water level during dry periods. The drainage area should not be so large, though, that expensive overflow structures are needed and water exchange occurs too frequently. As a rule, a pond in Mississippi should have 5 to 10 acres of drainage area for each acre of impounded water.

Suitable soil is one of the primary factors in selecting a pond site. The soil should contain a layer of clay or silty clay material that water will not seep through. Sandy clays are also usually satisfactory. The more clay in the soil, the better it will hold water. At least 20 percent clay is necessary to hold water. To determine soil suitability, take soil borings at close intervals and have them analyzed. About four borings per acre is sufficient if the soils are uniform, or more may be required if there is significant variability in soil composition.

Natural Resources Conservation Service personnel can assist in site selection, soil suitability, engineering survey, design, and obtaining all necessary permits. They can estimate the cost of the earthwork, make quality control

As with wildlife management and agriculture, farm pond management begins with gaining an understanding of your soil chemistry and other structural characteristics. Photo courtesy of iStock

checks during construction, and provide information on other aspects of planning, design, and construction. This service is free and may save money in future reconstruction costs needed to fix a poorly designed or sited pond.

Determining Size and Depth

The size of a pond should be based on the landowner's needs and desires. Bigger is not always better. Small ponds (1 to 3 acres) provide enjoyable fishing if good planning is a priority and proper management guidelines are followed. Larger ponds and lakes have many other uses, such as water supply, irrigation, swimming, boating, and hunting, and they are less susceptible to water level changes. For surface runoff ponds, the area of land that flows into the pond should be used to determine the pond's size.

Ponds in Mississippi should have an average depth of about 5 to 6 feet and a maximum depth of no more than 10 to 12 feet. About half of the pond should be 4 to 5 feet deep. This lets fish forage on the bottom, even in summer when low oxygen concentrations are common in deeper water, while maintaining enough depth to sustain the fish during drought. However, about 20 percent of the pond bottom should be at least 6 feet deep to provide winter refuge and summer refuge in extremely dry years. During summer, evaporation can reduce water levels at a rate of up to ½ inch per day, and ponds may lose 2 feet or more in water depth over the season. The pond banks should be moderately sloped and reach at least 3 feet deep to minimize the risk of aquatic plants becoming too abundant. Deep ponds are not necessary for productive fisheries and may experience water quality problems, such as low dissolved oxygen, which can kill fish. In summer, most Mississippi ponds have low oxygen levels at depths greater than 4 feet.

Dam and Water Control Structures

Dams should be at least 8 to 12 feet wide at the top, depending on the height of the dam. Dams less than 12 feet high require an 8-foot top width. Dams between 12 and 15 feet high require a 10-foot top width, and those higher than 15 feet require a 12-foot top width. Dams with tops wider than the required minimum are much easier to maintain. If the dam is to be used as a road, it should be at least 16 feet wide across the top.

Dams must be cored with clay to prevent seepage. The slope of the dam should be no steeper than 3:1 on the waterside. On the backside, a 4:1 slope lets vegetation on the dam be safely maintained. (A dam with a 3:1 slope, for example, will have a 1-foot rise for every 3 feet of horizontal space.) Establish suitable perennial vegetation on the dam as soon as possible to prevent erosion, muddy water, and maintenance problems. Non-native grasses such as Bermudagrass and bahiagrass are commonly planted because they establish a sod quickly and tolerate mowing to just a few inches in height. A good, deep rooted native grass (such as switchgrass or big bluestem) is an eco-friendly alternative that provides better wildlife habitat, requires less mowing, and tolerates drought better than non-native grasses. For native grasses, mow twice

TECHNICAL ASSISTANCE

Several agencies can provide technical assistance and guidance related to farm pond management to Mississippi landowners and anglers. All of these agencies have professional fisheries biologists on staff. The Natural Resources Conservation Service also has engineers available to assist landowners in surveying and pond design.

Natural Resources Conservation Service
www.nrcs.usda.gov
(601) 965-5205

Mississippi Department of Wildlife, Fisheries, and Parks
www.mdwfp.com
(601) 432-2199 (wildlife help desk)

Mississippi State University's Department of Wildlife, Fisheries, and Aquaculture
www.msucares.com
(662) 325-3174

A 4:1 slope allows landowners to safely control vegetation on a levee. Photo courtesy of Adam T. Rohnke, Mississippi State University

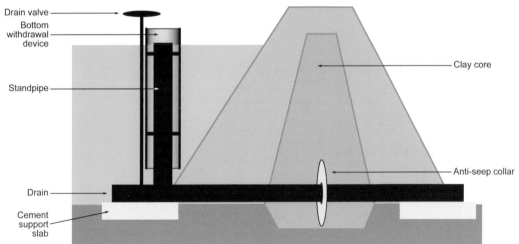

Drain valve
Bottom withdrawal device
Standpipe
Clay core
Anti-seep collar
Drain
Cement support slab

Recommended pond levee and water control structures. Illustration by Bill Pitts*

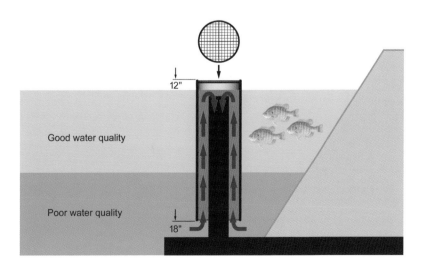

12"
Good water quality
Poor water quality
18"

A bottom draw-off device used to remove deep, low-oxygen water, which increases water quality and available habitat. Illustration by Bill Pitts*

per year to a height no shorter than 6 inches. Do not let trees or shrubs grow on the dam, as they will weaken it and increase the likelihood of leaking or failure. However, if large trees are growing on an older pond dam, they should not be removed because their decaying root systems may weaken the dam.

A combination drain and overflow pipe (or standpipe), as well as an emergency spillway, are necessary for good pond management. It is very important that the drainpipe be placed on the pond bottom so the water can be completely drained. Controlling the water level is important for weed control and fisheries management. The overflow pipe is the outlet for normal water flow through the pond. The emergency spillway is an area lower than the top of the dam on one side of the dam to safely release excessive runoff after a heavy rainfall. It is also a good idea to fit a larger pipe over the overflow pipe starting 18 inches off of the bottom and extending to 12 inches above the surface. This pipe will draw water from the deeper areas of the pond where there is no oxygen. During periods of water flow through the pond, this upward circulation will improve the water quality in the pond, increase usable habitat, and reduce the risk of a fish kill. The outside pipe must be at least one and a half times the interior width of the standpipe in order to allow for maximum flow.

Shoreline and Habitat

Banks should be moderately sloped until reaching a water depth of 3 feet near the shoreline to eliminate shallow water areas around the pond edge where aquatic plants often start. Use a 3:1 slope where possible (the depth increases 1 foot for every 3 feet away from shore) until reaching the minimum depth.

Many pond sites have trees in the basin, most of which should be cut and salvaged or piled and burned. It is acceptable to leave some trees, bushes, and brush piles in the basin. During construction, decide which trees to leave, clear unwanted trees, and develop fish attractors, such as brush piles, gravel beds, earthen

humps, and channels. Such underwater cover provides habitat for certain aquatic organisms that fish eat, as well as cover for game fish. These areas should be marked so that they can be located after they are flooded. This can be done using a buoy or a duck decoy, for a more natural look. Usually 10 to 25 percent of the pond bottom should have some tree cover (fish attractors) where possible. It is important to leave tree cover in the right areas. Leave bushes and trees in deeper water areas, along creek runs, and in the middle of the pond or lake. Leave trees in small clumps.

STOCKING

A healthy pond has a balance between predator and prey populations. In ponds of at least 1 acre in size, largemouth bass and bluegill provide this balance better than any other species. A few other species, specifically redear sunfish (shellcracker or chinquapin), channel catfish, grass carp, and fathead minnows can be added to provide a variety of fishing opportunities. These species, when stocked at recommended rates and managed properly, can provide years of good fishing. Ponds should only be stocked with fish from reliable fish hatcheries to prevent bringing in undesirable fish species, parasites, or diseases.

Channel catfish may be stocked with bass and bream or stocked alone, but other species of catfish should not be stocked in ponds. Crappie are never recommended for small lakes and ponds less than 50 acres because they tend to overpopulate, resulting in a pond full of small, skinny crappie, bream, and bass. Crappie compete with bass for food, and they should not be stocked into lakes less than 500 acres if trophy bass fishing is the desired objective.

Size of the pond has a direct influence on future fishing potential, but there are few limitations if expectations are reasonable. A pond that is stocked with bream and bass should be at least 1 acre in size, preferably larger. Although small ponds can normally provide unlimited bream fishing, there is a potential for overharvesting the bass in ponds less than 1 acre.

Stocking Rates and Sequence for Ponds an Acre or Larger

It is important to stock a pond in the proper sequence and with the recommended numbers to achieve a balanced fish population. To begin, choose the desired stocking combination from Table 14.1. Stock fingerling bream (bluegill and redear sunfish), catfish, triploid grass carp, and fathead minnows in autumn or winter. The pond should be at least half full and filling. The following spring, when the bream and fathead minnows are ready to spawn, stock fifty largemouth bass per acre. This ensures that small bream and minnows are available for the small bass.

Largemouth bass feed on the small bream, preventing an overpopulation of bream. Fathead minnows provide supplemental winter forage for largemouth bass and bream. If timing is such that the pond cannot be stocked

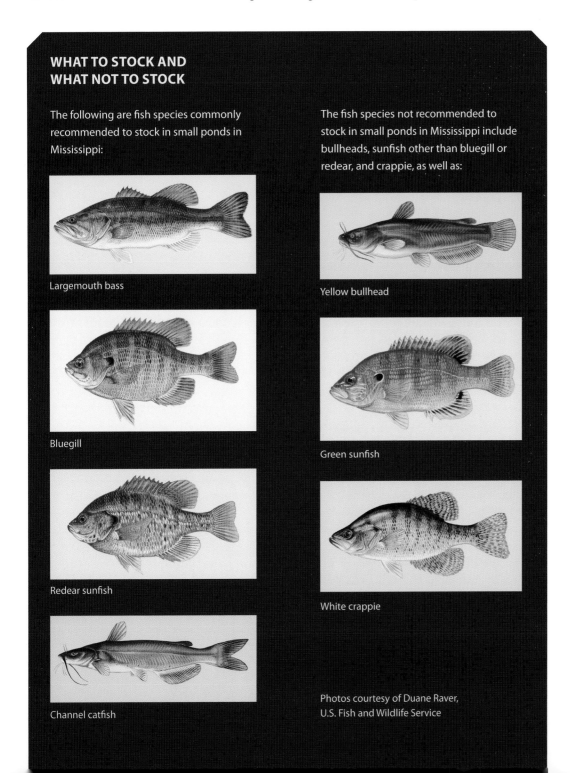

WHAT TO STOCK AND WHAT NOT TO STOCK

The following are fish species commonly recommended to stock in small ponds in Mississippi:

Largemouth bass

Bluegill

Redear sunfish

Channel catfish

The fish species not recommended to stock in small ponds in Mississippi include bullheads, sunfish other than bluegill or redear, and crappie, as well as:

Yellow bullhead

Green sunfish

White crappie

Photos courtesy of Duane Raver,
U.S. Fish and Wildlife Service

Table 14.1. Recommended stocking rates (number of fish fingerlings per acre) and species combinations for ponds larger than 1 acre. Use the regular (Reg) stocking rates unless you intend to immediately initiate and maintain a fertilization program. If you will fertilize, use the fertilized (Fert) stocking rates.

Stocking combination	Largemouth bass [a]		Bluegill [a]		Redear sunfish [a]		Channel catfish [b]		Fathead minnows [c] (pounds)		Grass carp [d,e]	
	Reg	Fert	Reg	Fert	Reg	Fert	Reg	Fert	Reg	Fert	Reg	Fert
Bass, bluegill	50	100	500	1000	-	-	-	-	10	10	5	5
Bass, bluegill, catfish	50	100	500	1000	-	-	50	100	10	10	5	5
Bass, bluegill, redear	50	100	350	700	150	300	-	-	10	10	5	5
Bass, bluegill, redear, channel catfish	50	100	350	700	150	300	50	100	10	10	5	5
Channel catfish	25	-	-	-	-	-	150	-	-	-	5	5

Note: Stock all species except bass in autumn, when the pond is at least half full and filling, and then stock bass during the following spring.

[a] No additional stocking is necessary after the initial stocking of largemouth bass, bluegill, or redear.

[b] Channel catfish will not reproduce well in ponds with bass and must be replaced when they have been removed.

[c] Fathead minnows are optional for bass ponds and will provide extra food and faster growth. However, they are quickly eliminated and must be restocked on a regular basis.

[d] Grass carp are recommended to prevent aquatic weed growth. Large grass carp (20 pounds) are not as effective at controlling weeds, so restock two or three grass carp per acre every 5 to 7 years to maintain control.

[e] Larger lakes (greater than 10 acres) that have significant open water should only stock three grass carp per acre.*

in this sequence, consult a fisheries biologist to discuss an alternative stocking strategy that might work. Because all situations are different, there is no single recommendation that can easily apply to all cases.

If a fertilization program will be immediately implemented and continuously maintained, double the stocking rates to achieve quicker results and avoid bream crowding. A properly fertilized pond can be stocked with 1000 sunfish per acre in autumn, either all bluegill or 700 bluegill and 300 redear sunfish, followed by 100 largemouth bass per acre the following spring. Up to 100 catfish per acre can be stocked in fertilized ponds. Keep triploid grass carp stocking rates at five per acre for weed prevention.

After the initial stocking of fingerling fish, do not add any fish to the pond except on the recommendation of a fisheries biologist. Adding fish to the pond year after year can lead to overcrowding and stunted fish. This has ruined the fishing in many ponds in Mississippi. With proper management, a correctly stocked pond generally results in a balanced fish population, ensuring good fishing for years to come. Catfish can be restocked after more than half of the fish from the original stocking have been removed. Remember to stock larger (8- to 10-inch) catfish to avoid feeding catfish to the bass in established ponds.

Stocking Options for Ponds Less than an Acre

The bass–bream stocking combination tends to be less successful in ponds less than 1 acre in size because bass are easy to overharvest and the bream become too abundant to grow to a harvestable size. However, there are alternative options available to owners of smaller ponds, namely catfish-only and hybrid bream combinations.

When stocked at 100 to 150 per acre, channel catfish grow well alone, with few diseases problems. When only one fish species occupies a pond, fish will grow faster with supplemental

feeding. Natural foods include decaying organic matter, plant material, crayfish, small fish, and insects. The relatively low stocking rate (100 to 150 per acre) ensures good growth to a harvestable size in a reasonably short time. Do not encourage catfish spawning because of potential crowding and disease problems. To control catfish population size, stock twenty-five largemouth bass per acre to the ponds to eliminate any catfish fingerlings less than 6 inches. Catfish can be restocked after more than half of the fish from the original stocking have been removed. Remember to stock larger (8- to 10-inch) catfish to avoid feeding catfish to bass in established ponds.

Hybrid sunfish are a good option for small ponds because they grow quickly, especially when fed, and they are easy to catch. The most commonly used hybrid sunfish results from crossing male bluegills with female green sunfish. These hybrids are 85 to 95 percent males, readily accept artificial feed, and grow faster than bluegills or redear sunfish under similar conditions. Successful hybrid sunfish ponds require that stocking rates and harvest recommendations are carefully followed. Best growth can be achieved by stocking 750 hybrids and fifty bass per acre and then feeding a commercially prepared feed of at least 28 percent protein. Commercial catfish pellets are the most economical feed. Never give the fish more food than they will eat in 5 to 10 minutes and adjust the amount as fish grow. If fish do not eat all the feed offered in that time period, reduce the feeding rate to avoid overfeeding and wasting feed and money.

Never stock hybrid sunfish into ponds containing other fish, and never stock them in combination with other bream species. Hybrid bream will not produce enough offspring to yield good bass growth rates, and they will cross-breed with other sunfish species and create undesirable offspring. Hybrid sunfish should only be stocked in small ponds following the exact recommendations noted above. Always stock hybrids in combination with a predator fish because, contrary to popular belief, they are not sterile. Because most hybrid populations are predominantly males, they have lower reproductive potential, but they do reproduce. Hybrid sunfish will overpopulate unless largemouth bass have been stocked with them.

Periodic restocking is necessary to sustain a fishery for more than a few years. Pond owners should keep records of the number of hybrids removed and plan to restock when 50 to 70 percent of the originally stocked hybrid fish have been caught and removed. At restocking time, larger hybrid sunfish fingerlings (3 to 4 inches) should be stocked, since they are less likely to be eaten by the bass than smaller fish. Restock at the same rates as the initial stocking. Check with local suppliers before starting a hybrid bream pond to make sure that larger fingerlings are available. If they are not, the pond will need to be drained or poisoned and restocked when fishing quality declines.

MANAGING PONDS

Good fishing can be enjoyed for years if a sound pond management program is followed. Building the pond properly, stocking the correct species at recommended rates, and controlling weeds are necessary first steps for proper pond management. Continued good fishing depends on harvesting the correct number, sizes, and species of fish each year.

Fishing and harvest are critical to good pond management. To ensure a balanced fish population, release all of the bass that are caught the first and second year of fishing. In most cases, bream can be removed during the second year following stocking without harming the population. By the third year, harvest 15 pounds of bass per acre per year from ponds that are not fertilized. In fertilized ponds, this number is 30 pounds per acre. Harvest primarily small bass less than 13 inches, and release intermediate size bass (14 to 18 inches). This will ensure rapid growth of bass, an adequate number of bass for reproduction, as well as control of the bream. Harvesting too few bass leads to stockpiling and slow growth of bass, which is a common problem in Mississippi ponds.

Although a less common problem, removing too many bass can lead to bream crowding.

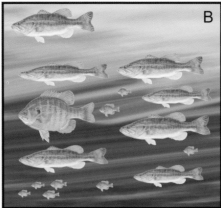

Management options for bass–bream ponds in Mississippi. (A) Balanced bass–bream pond with wide size ranges of both predator and prey. This scenario is best for good bass and bream fishing. (B) Bass-crowded pond with many small, thin bass, and few but large bream. The scenario provides fast action with small bass and extra large bream for the panfish enthusiast. (C) Bream-crowded pond with no large bream and very few but large bass. This scenario can lead to trophy bass, but requires additional management efforts to be successful. Illustration by Bill Pitts*

When bass are overharvested, the remaining bass can no longer eat enough bream, and the bream become overcrowded and grow very slowly. Once bream become overcrowded, bass reproduction is reduced or stopped completely. Keep a record of fish harvested and ask others who fish the pond to provide the number and size (length and weight) of bass and bream they remove from the pond (for an example of a farm pond harvest record sheet, see Appendix 4).

If the pond is also stocked with channel catfish, spread the catfish harvest over 3 to 4 years. Channel catfish may reproduce, but offspring usually do not survive because of bass predation. Restock with channel catfish when 60 percent of the originally stocked catfish have been removed. In a bass and bream pond, it is necessary to restock with 8- to 10-inch channel catfish to ensure the bass do not quickly consume these fish. Do not overstock catfish, because it leads to poor growth and possible disease problems as well as excessive competition with bream for food.

Management Options

A bass-crowded condition commonly occurs in Mississippi ponds where bass fishing is primarily catch and release. In such ponds, most bass caught are less than 12 inches long with poor body condition, and the bream are hand-sized and in good condition. If large bream are desired, a bass-crowded pond will produce these results. If good fishing for both bass and bream is desired, follow the harvest recommendations in the Managing Ponds section. Trophy

bass fishing will require careful protection of certain sizes of bass, usually through a protective slot size limit, as well as harvest of most of the smaller (less than 12 inches) bass to prevent them from becoming crowded (see the Managing for Trophy Bass section).

Determining Fish Balance

Seining is a quick and easy way to determine the condition of a pond, and pond owners should invest in a good seine net. A 30-foot seine that is 6-feet deep and made of ¼-inch mesh works well and can be purchased from any net maker. The seine ends should be attached to wooden or metal poles to make handling much easier.

A pond's fish balance should be checked using a seine every year from late May to July. During this period, both bass and bream have reproduced and are still small enough to be caught effectively using the seine. Fishing with the seine is easy. A swinging gate or perpendicular haul can be used in several areas of the pond to capture young fish. Just make sure that the weighted line of the seine remains on the bottom at all times, or the fish will escape under the net. Make about five hauls around the pond, and then compare the catch to the information in Table 14.2 to determine the condition of the pond.

The balance of a bass-bream pond also can be determined by close examination of fishing catch. This is made much easier if good catch and harvest records are kept throughout the year. When fishing, make sure to use a variety

A. The "Swinging Gate"

B. Perpendicular haul

Two easy seining techniques for determining bass and bream reproduction in ponds. Ponds should be assessed using a seine between late May and July. Illustration by Bill Pitts*

Table 14.2. Assessment of pond balance in a bass–bream pond when sampling with a seine			
Largemouth bass	**Bluegill/redear sunfish**	**Other species**	**Population condition**
No young bass present	many recently hatched sunfish, no more than 1 or 2 midsized sunfish	no other species	bass crowded
No young bass present	no recently hatched sunfish, many midsized sunfish	no other species	bream crowded
Young bass are present	many recently hatched sunfish, a few midsized sunfish	no other species	balanced population
Young bass are present	no recently hatched sunfish, no midsized sunfish	no other species	bass crowded, bream may be absent
Few or no young bass	few or no bluegill	carp, shiners, suckers, bullheads, shad, other sunfish species, or other undesirable species	undesirable fish population

Note: This information does not apply to ponds managed for trophy bass.*

Table 14.3. Assessment of pond balance using record of fishing catch			
Largemouth bass	**Bluegill/redear sunfish**	**Other species**	**Population condition**
Bass usually less than 12 inches and thin, a rare trophy bass possible	sunfish mostly large, may average 8 inches or more	no other species	bass crowded
Very few bass caught, and those caught are large	mostly small sunfish, typically 3–5 inches	no other species	bluegill crowded
Bass average 12–16 inches, but smaller and larger sizes also caught	sunfish typically 6 inches or larger, but all sizes caught	no other species	balanced population
Bass usually less than 12 inches and thin	no sunfish caught	no other species	bass crowded, sunfish may be absent
Few bass caught	few sunfish caught	carp, shiners, suckers, bullheads, shad, other sunfish species, or other undesirable species	undesirable fish population

Note: This information does not apply to ponds managed for trophy bass.*

BALANCED POPULATION

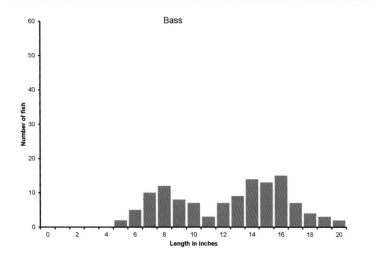

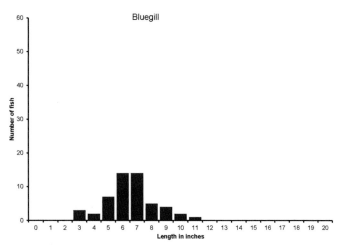

BASS-CROWDED POPULATION

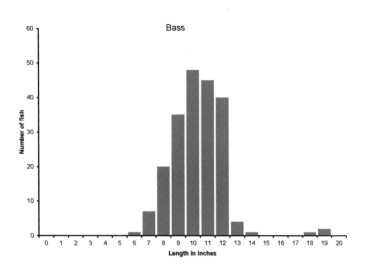

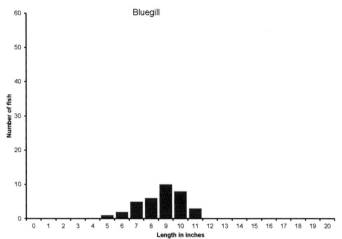

BREAM-CROWDED POPULATION

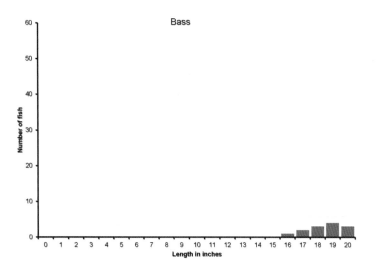

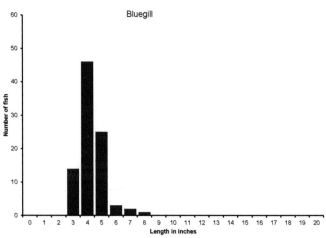

Simple bar graphs such as these can be constructed from fishing data if good catch records are maintained. These bar graphs are important management tools that can be used to diagnose population balance problems. Illustration by Bill Pitts*

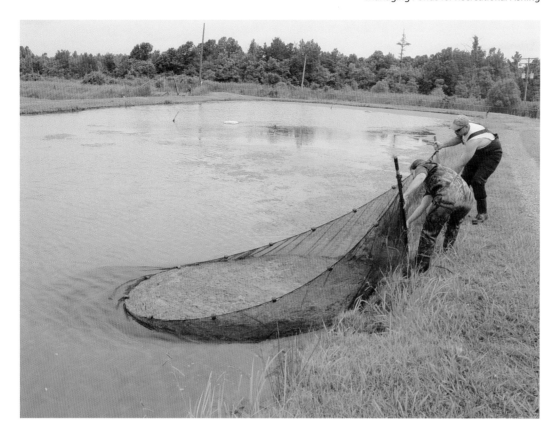

Using a minnow seine to remove filamentous algae from a small pond. Photo courtesy of J. Wes Neal, Mississippi State University

If aquatic weeds become a problem, they can be controlled through physical, mechanical, biological, and chemical methods. Each method has advantages and disadvantages, and combining methods into an integrated weed control plan is usually most effective. Consider the following when treating weed infestations:

- Identify the problem weed.
- Choose the most economical and efficient control method or combination of methods. A combination of techniques usually provides the best long-term control.
- If a chemical method of control is selected, be sure it is economical, safe, and effective. Calculate pond area or volume to be treated, and carefully follow instructions on the label.
- Pay close attention to pond use restrictions following herbicide treatment.

Physical Control

Rooted plants cannot grow where sunlight does not reach the bottom. Therefore, deepening shallow pond edges so that they drop quickly to 3 feet deep is an effective means of reducing weed coverage. Use a 3:1 (1 foot increase in depth for each 3 feet from shore) slope so that the bank remains stable and does not collapse. Another physical technique, called a drawdown (removal of part of the water), can be effective and economical in controlling many kinds of aquatic weeds (for more information, see section on Drawdowns). Pond dyes can be used to control submersed aquatic weeds by shading the plants so that they do not receive enough sunlight. Dyes should only be used in ponds that have little outflow, because flowing water will wash the dye out of the pond. Also, dye reduces pond productivity and should not be used in ponds that are fertilized.

Mechanical Control

This may be as simple as cutting a willow tree or removing a few unwanted plants (such as cattails) that have just gotten started along the water margin, or it may involve raking or seining algae that is on the bottom or free-floating.

Triploid grass carp can be stocked in recreational fishing ponds to prevent or control problems with excessive aquatic vegetation. Photo courtesy of J. Wes Neal, Mississippi State University

While cutting and removing a few plants by hand can be effective in small and limited areas, mechanical aquatic weed control on a large scale is generally difficult and impractical. Mechanical plant removal is usually not a permanent solution, as plants may grow quickly and recolonize, but it can be used to clear the majority of plants to improve effectiveness of other techniques such as biological or chemical control.

Biological Control

Biological control involves the use of an animal or other living organism to control the weeds. Biological control has many advantages over other weed control means. It takes much less human effort than most mechanical control means and does not require expensive and sometimes hazardous aquatic herbicides. In addition, use of animals provides longer-term control than other means because the animals usually have a lifespan of several years.

Triploid grass carp (white amur) from China are commonly used for aquatic weed control. How much vegetation grass carp will consume depends upon several environmental conditions, such as water temperature, water chemistry, and the kinds of plants available. Consumption rates also vary with fish size. For example, until they reach weights of about

6 pounds, grass carp may eat 100 percent of their body weight in vegetation per day. As they grow larger, consumption decreases: up to about 13 pounds, they eat 75 percent of their body weight per day, and above 13 pounds, they slow down to about 25 percent of body weight per day.

Grass carp prefer soft, low-fiber aquatic weeds such as duckweed and various underwater plants. However, grass carp cannot necessarily control some of the plant species that they prefer to eat. These plants grow very quickly, and grass carp may not be able to eat them quickly enough. Duckweed is a good example of a plant that grass carp love, but usually cannot control. One solution is to increase the density of grass carp, but this carries its own risks. High densities of grass carp can interfere with bream reproduction, stir up mud, and potentially lead to low oxygen. In cases where fifteen or more grass carp per acre are stocked, it is a good idea to remove many of these fish once the weeds are controlled.

The number of grass carp required to control weed problems varies, depending on the degree of weed infestation, kind of weed, size of pond or lake, and size of fish stocked. The general rule in farm ponds is to stock enough grass carp to control the weeds in one to two seasons but not so many that they quickly eat all the vegetation. For most farm pond situations where weeds have already become a problem, five to ten grass carp per acre usually will achieve desired weed control. In ponds with severe weed problems, higher rates of fifteen to twenty grass carp per acre may be necessary for plant control. In such cases, it is sometimes more effective to treat the pond chemically with an herbicide first, and then stock moderate numbers of grass carp to prevent the regrowth of weeds.

Chemical Control

Herbicides are generally species specific, meaning that they are effective only on certain plants, and they are expensive. Chemical control requires using aquatic herbicides (and surfactants) that have met strict Environmental Protection Agency standards for use in an

Table 14.4. Some common aquatic weeds that can be controlled with herbicides and grass carp

Type of plant	Aquatic weeds	2,4-D	Carfentrazone-ethyl	Copper complexes, copper sulfate [a]	Diquat	Endothall [b]	Fluridone	Glyphosate	Hydrothol 191	Imazamox	Imazapyr	Penoxsulam	Sodium carbonate peroxyhydrate	Triclopyr	Grass carp
Algae	plankton (single cell)			•									•		
	filamentous and water net			•	•				•						
	Chara & Nitella			•					•						•
Floating weeds (not attached to bottom)	duckweed		•		•		•				•	•			•[c]
	salvinia (common or giant)		•		•			•				•			
	watermeal		•		•		•				•	•			•[c]
	water hyacinth	•	•		•			•		•	•	•		•	
	water lettuce		•		•					•	•	•			
Emersed weeds (attached to bottom)	American lotus	•	•		•		•				•			•	
	watershield	•	•				•							•	
	white water lily	•	•				•			•	•			•	
	water pennywort		•		•					•	•				
Submersed weeds	bladderwort				•	•	•			•					•
	coontail				•	•	•							•	•
	bushy pondweeds (*Najas*)				•	•	•								•
	parrotfeather	•			•	•	•				•	•		•	•
	Eurasian watermilfoil	•	•		•	•	•					•		•	•
	pondweeds (*Potamogeton*)				•		•							•	•
	elodea			•	•	•	•								•
	hydrilla		•	•	•	•	•		•			•			•
	spikerush	•					•								•
Marginal weeds	alligatorweed	•	•		•		•	•		•	•			•	
	water primrose	•	•		•		•	•		•				•	
	smartweed	•			•		•	•		•	•			•	
	willows	•						•			•			•	
	cattail				•			•		•	•				
	bulrush							•			•				
	burweed	•													
	phragmites							•		•	•			•	

Note: Approved aquatic herbicides change regularly; for up-to-date recommendations, please check the most recent edition of Mississippi State University Extension Publication 1532, *Weed Control Guidelines for Mississippi*, and always follow label recommendations.

[a] Check pond water alkalinity before using products containing copper due to risks of copper toxicity. Use only when alkalinity is 50 ppm or higher.

[b] Be very careful when using endothall, as it can be toxic to fish when misapplied.

[c] Grass carp are best used in combination with herbicide treatment for these species.*

Chemical application to control a severe water lettuce infestation. Photo courtesy of J. Wes Neal, Mississippi State University

SAFETY WHEN USING CHEMICALS

Before applying or handling herbicides, read and follow the label. When applying herbicides, applicators and handlers must wear personal protective equipment. Items that are often required include:

- long-sleeved shirt;
- long pants;
- boots or shoes with socks;
- chemical-resistant gloves; and
- protective eye wear.

Maintain and clean personal protective equipment by following the herbicide manufacturer's recommendations. If no recommendations are available, wash clothing in laundry detergent and store away from other laundry. After handling or applying herbicide, the user should wash hands well before eating, drinking, chewing gum, using tobacco, or using the restroom.

aquatic environment. The herbicides are of low toxicity to fish and wildlife (and humans) when used according to guidelines, rates, and restrictions specified on the label for each herbicide. Some herbicides have restrictions on how long to wait before cattle may re-enter treated areas and limiting irrigation usage immediately following treatment. Table 14.4 lists many of the common aquatic weeds that occur in Mississippi and the herbicides that are usually effective in their control.

The surface area and/or volume of water in the pond must be known or estimated in order to add the correct amount of herbicide. Pond volume is determined by multiplying the surface acreage by the average depth of the pond, and is measured in acre-feet. Always follow label instructions and precautions when applying herbicides.

The season to apply herbicides is very important. Usually treatments applied in spring or early summer, when the weeds are actively growing, bring the best results. Herbicide applications in late summer and autumn are

generally less effective for many species. Many of these plants make mature seeds by midsummer that will sprout the following year. In hot weather, be careful not to deplete oxygen in the pond by killing too many weeds at one time. Low dissolved oxygen levels can result from the natural decay of treated (killed) aquatic plants. Fish kills may result if the dissolved oxygen level becomes too low in the pond. It is seldom safe to treat more than half the pond at one time in the summer, unless treating marginal aquatic weeds. A good rule to prevent oxygen depletion is to treat one-third of the pond, wait a week and treat another third of the pond, and wait another week and treat the remaining portion.

LIMING PONDS

Just like many gardens, some ponds can benefit from the occasional addition of agricultural limestone. This is true for ponds that have an alkalinity less than 20 ppm. Alkalinity is the measure of the buffering capacity of the water. In waters with low alkalinity, pH might fluctuate from less than 6 to as high as 10 or above every day, which can make fish sick or grow slowly. Ponds with low alkalinity are unproductive, even when sufficient nutrients are in the water either naturally or because the pond is fertilized.

For fish production and health, alkalinity of at least 20 ppm is recommended. Greater production in bass–bluegill ponds is attained in high alkalinity waters because this buffering capacity makes phosphorus and other essential nutrients more available to the algae. Also, fish are stressed by extremes in pH and by rapid changes in pH, and tend to grow more slowly and be more susceptible to illness when alkalinity is low. A pH value between 6.5 and 9.0 is optimum for fish ponds. After oxygen, poor water chemistry is the next most common cause of fish kills in ponds. When alkalinity is very low, stressed fish may die during weather changes and rain events, with a few fish of all species dying each day. Alkalinity testing kits are easy to use and widely available at many pool and spa stores and at county agriculture cooperatives. Also, most county extension offices or Natural Resources Conservation Service centers can test water alkalinity.

The most common method of increasing alkalinity in waters is by adding agricultural limestone (calcium carbonate). Addition of lime to these ponds elevates alkalinity and increases pH in the water. Neutralization of bottom soil with lime prevents phosphate from adhering to it, thereby increasing phosphorus concentrations in the water (the primary nutrient in ponds). As a result of these changes in water quality, phytoplankton blooms develop and pH fluctuates less. If a pond has a high rate of water flow in and out, liming may not be a solution. Such a pond will have a low water retention time and the lime will be washed out quickly.

Soil Testing

If building a new pond or determining the lime requirement of an existing pond, first have the soil tested to determine how much lime is needed. Soil sample boxes, instructions, and information sheets are available at county extension offices. Soil samples are easy to take in dry ponds, but this process may require some creativity in ponds with water. A metal can attached at the end of a long stick is one method to collect soil samples in ponds with water. Here are the steps for sampling pond soils:

- If the pond is larger than 3 acres, partition the pond into 3-acre blocks, and sample each block separately. (If the pond is less than 3 acres, collect three samples per acre.)
- Collect about a pint of soil from each of ten locations per block.
- Thoroughly mix the ten samples together in a bucket.
- Take one sample from the mixture and air-dry it.
- Repeat this procedure for each 3-acre block in the pond.
- Place each sample in a soil sample box (available at all Mississippi State University Extension offices; go to www.msucares.com to locate nearest county office) and submit to the Soil Testing Lab at Mississippi State University. Be sure to indicate in the "crop

grown" area on the submission form that this sample is for a farm pond.

The sample will be analyzed, and the lab report will indicate if the pond needs lime and how much to apply. Note, however, that this this liming recommendation will need to be adjusted based on the quality of the agricultural limestone available.

Applying Lime

Only agricultural limestone should be used for existing ponds with fish populations. This is the same form of lime that farmers use on their crop and pasture land. It is available in bulk or bag form. *Never* use quicklime, hydrated lime, slaked lime, builder's lime, or other more potent liming agents. These other forms are different chemical compounds that are very caustic and may kill fish.

It is best to lime the pond in autumn or winter, at least 2 months before the growing season. Liming a pond in the spring will increase pH, remove soluble phosphorus, and reduce free carbon dioxide. This will affect the productivity of the pond. By liming the pond in autumn or winter, it has time to equilibrate prior to the growing season.

It is easiest to apply lime when the pond is dry. To be effective, the lime should be spread evenly over the entire pond bottom. To accomplish this, a spreader truck or tractor spreader can be driven along the pond bottom, or the lime can be spread by hand. It is not necessary to disc the lime into the soil, but this will accelerate its neutralizing activity. It is more difficult to apply lime in ponds that are full of water, but this is more often when ponds are limed. The lime needs to be spread across the entire pond surface as evenly as possible. Remember, the goal is to lime the bottom soil, not the water. For small ponds (less than 1 acre), it may be possible to back the spreader truck up to pond in several locations and broadcast the lime. For larger ponds, it will be necessary to load the lime onto a boat or barge and then shovel or wash the lime uniformly into the pond.

A lime treatment will usually last from 2 to 5 years, depending on how much water flows through the pond and how acidic the bottom soils are. A method that usually works well is to apply the amount of lime the soil testing report calls for, then apply one-fourth of that much each following year to be sure the lime requirement continues to be satisfied.

CONVERTING LIMING RATES

The soil analysis report from the Soil Testing Laboratory will provide a liming recommendation in tons per acre. However, this recommendation is for pure calcium carbonate ($CaCO_3$), which is 100 percent active. Commercial liming materials vary in their ability to neutralize soil due to chemistry and particle size.

The neutralizing value (NV) depends on the chemical itself. Pure calcium carbonate has an NV of 100. Agricultural limestone may have NV values between 85 and 109 depending on its specific chemical composition.

The neutralizing efficiency (NE) of agricultural limestone depends on the fineness of the mixture. Small particles dissolve more quickly and completely and are more reactive than larger particles. Therefore, finely crushed agricultural limestone has higher NE.

The liming requirement will be noted in the soil test report, and NV and NE can be obtained from the limestone distributor. These three values are used to calculate the precise amount of lime needed, as shown below. If NV or NE are not available, use NV = 0.85 and NE = 0.75 as conservative estimates.

In this example, the $CaCO_3$ recommendation is 3 tons/acre, NV is 0.90, and NE is 0.80.

Tons needed = liming requirement / (NV × NE)
Tons needed = 3 tons/acre / (0.90 × 0.80) = 4.2 tons/acre

Multiply 4.2 by the surface acreage of the water to get total lime requirement.

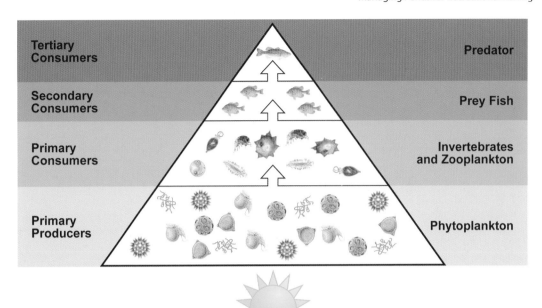

Tertiary Consumers	Predator
Secondary Consumers	Prey Fish
Primary Consumers	Invertebrates and Zooplankton
Primary Producers	Phytoplankton

A pond has a relatively simple food chain. Illustration by Bill Pitts*

FERTILIZING PONDS

The decision of whether to fertilize a fishing pond should be considered very carefully. Proper fertilization will significantly increase the total weight of fish produced in a pond, often by as much as three to four times. Fertilizer stimulates the growth of microscopic plants. These phytoplankton form the base of the food chain: they are eaten by small animals, which serve as food for bream, which in turn are eaten by bass. Phytoplankton blooms make the water turn green, which also shades the bottom and discourages the growth of troublesome aquatic weeds.

However, there are many reasons not to fertilize, including potential water quality issues, high expense, and the fact that it is a long-term commitment. In fact, most ponds should not be fertilized. If only a few people fish a larger pond, it does not necessarily need fertilization to have good fishing. However, in a heavily fished pond, proper fertilization will produce the best fishing. Fertilization will significantly increase the total weight of fish produced in a pond, therefore increasing the number of fish that need to be harvested. As a general rule, 30 pounds of small bass (less than 13 inches) per acre should be harvested each year, and 90 to 120 pounds of bream per acre should be removed each year in fertilized ponds. In ponds that are not fertilized, only half as much harvest is required.

Here are some cases in which ponds should not be fertilized:

- The pond is not fished heavily. Fertilizing a large pond is a waste of time and money

A balanced phytoplankton bloom shades the bottom of the pond and reduces the growth of aquatic weeds. Photo courtesy of Michael Sherman, Mississippi State University

Region	Lime	Fertilizer form		
		Liquid	Granular (0-46-0)	Water-soluble powder
Delta	not needed	usually not needed	usually not needed	usually not needed
Thick and Thin Loess Bluff	usually not needed	½ gallon/acre each application	4 pounds/acre each application	2 to 4 pounds/acre each application
Blacklands	usually not needed	½ gallon/acre each application	4 pounds/acre each application	2 to 4 pounds/acre each application
Upper Coastal Plain and Interior Flatwoods	2 tons/acre	¾ to 1 gallon/acre each application	8 pounds/acre each application	4 to 6 pounds/acre each application
Lower Coastal Plain	2 to 3 tons/acre	1 gallon/acre each application	12 pounds/acre each application	6 to 8 pounds/acre each application

Table 14.5. General fertilizer recommendations for the various soil regions in Mississippi

Note: Have the soil tested to ensure that your ponds need a fertilization program before you begin.*

if it is only fished (and fish are kept) occasionally. Fertilization will simply produce more fish that aren't caught, increasing the possibility of crowding and slow growth.

• The pond is muddy. Mud keeps sunlight from passing through the water and binds up phosphorus in fertilizer. This prevents good phytoplankton growth. If a pond stays muddy most of the time, do not fertilize the pond until the mud problem is corrected.

• The pond is infested with undesirable fish. If undesirable fish dominate the pond, renovate the pond, restock, and then begin fertilizing.

• The pond is infested with weeds. During warm months, pond weeds use up the fertilizer the microscopic plants should get. The pond stays clear even after repeated fertilizer applications, but the weed problem worsens.

• The pond's fish population is out of balance. If the bream population is overcrowded, it means there are not enough bass to keep the bream down. It would be counterproductive to fertilize in this case.

• Pond fish are fed commercial feed. It is not necessary to fertilize ponds if a feeding program is correctly implemented. Commercial feed adds nutrients to the water,

and the addition of fertilizer can degrade water quality.

• The system has too much water flow. In some spring-fed ponds, too much water flows through the pond to maintain phytoplankton blooms. In this case, fertilizer is constantly being diluted and will have little positive effect.

Those ponds that will benefit from fertilizer include:

• Ponds that are heavily fished. Ponds that receive heavy fishing pressure may be at risk of overharvest or poor fishing. Fertilization can increase the abundance of fish to compensate for heavy fishing.

• Ponds managed for trophy bass. Producing large bass relies on overabundant prey and low bass density. A fertilization program and removal of small bass can achieve good results.

Type, Formulation, and Rate of Fertilizer Application

Fertilizer is always marked with three numbers separated by dashes. These numbers indicate the percentage of the fertilizer product that is made of nitrogen (N), phosphorus (P), and

potassium (K), respectively. A fertilizer with an N-P-K of 13-37-0 is 13 percent nitrogen, 37 percent phosphorus, and 0 percent potassium. The key ingredient for ponds is phosphorus (middle number), so select a fertilizer with high phosphorus content.

Several types of fertilizer can be used, and all can be effective if the pond soil pH and water chemistry are in the correct ranges. Pond fertilizers are available in liquid, granular, or powdered forms. Liquid fertilizers dissolve most readily, followed by powders, and then granular types. Typical formulations for liquid fertilizers include 10-34-0 and 13-37-0. Apply these fertilizers at the rate of ½ to 1 gallon per acre, depending on pond location and soil fertility. Powdered, highly water-soluble fertilizers with formulation of 12-49-6 or 10-52-0 are available and have proven to be effective and convenient. These formulations are typically applied at the rate of 2 to 8 pounds per acre, again depending on pond location and soil fertility. Granular fertilizers are less expensive and are available in many formulations. Most older ponds (more than 5 years old) respond well to a phosphorous-only fertilizer such as triple superphosphate (0-46-0), which is the most economical formulation. Rates range from 4 to 12 pounds per acre per application. In some areas, it may be difficult to buy 0-46-0, but 0- 20-0 is usually available. If it is, use twice the amount recommended for 0-46-0.

How to Apply Fertilizer

Begin fertilization when water temperatures have stabilized at 60°F or higher. Usually this temperature occurs around March 15 in southern Mississippi and April 1 in central and northern Mississippi. Early fertilization will shade the pond bottom and help control filamentous algae, a common problem in Mississippi ponds in spring. Make the first three applications of fertilizer 2 weeks apart. This should establish a good bloom. The ideal bloom makes the water green and results in a visibility of about 18 inches. Use a yardstick with a white tin can lid on the end to measure the bloom, or you can make or buy a Secchi disk. When the lid is visible in

24 inches of water, it is time to fertilize again. When water temperature drops below 60°F in the autumn, stop fertilizing for the year.

Never broadcast granular fertilizer, and never apply undiluted liquid fertilizer. Both forms of fertilizer will rapidly sink to the bottom and be tied up in soils instead of becoming available in the water. This will not achieve a bloom and wastes money. Finely powdered water-soluble fertilizers can be broadcast into areas at least 2 feet deep, where it will dissolve before reaching the bottom. If granular fertilizers are used,

A Secchi disk is useful for measuring water clarity to determine if more fertilizer is needed. Photo courtesy of J. Wes Neal, Mississippi State University

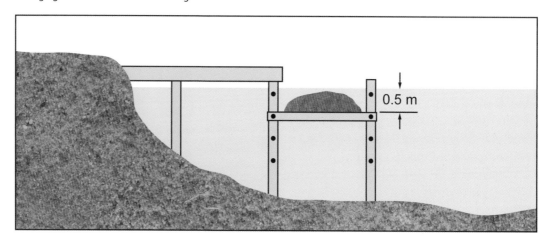

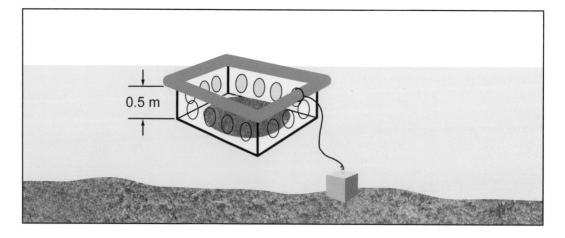

A fertilizer platform (top) or floating fertilizer box (bottom) can be used to allow granular fertilizer to dissolve in the surface water, where it can be used effectively, and prevents fertilizer from contacting bottom sediments. Illustration by Bill Pitts

apply them in a way that minimizes fertilizer-soil contact. This can be accomplished by making fertilizer platforms, one for each 5 to 6 acres of water. Build the platforms so they can be raised or lowered. Pour the right amount of fertilizer on the platforms so 4 inches of water will cover them. Waves will dissolve and distribute the fertilizer throughout the pond. Building a platform can be difficult in existing ponds. An alternative method is simply to place bags containing the needed amount of fertilizer in shallow water with the top side of the bag cut out. The bags separate soil and fertilizer, and waves will dissolve and distribute the fertilizer.

Dilute liquid fertilizer with at least five parts water to one part fertilizer before application. In small ponds, spray liquids from the bank with hand-held sprayers. Boats make application easy in larger ponds. The diluted fertilizer can be sprayed over the water surface or let it flow into the prop-wash of an outboard motor.

New ponds, or those that have never been fertilized, sometimes fail to respond to fertilizer, and it can be difficult to start up a phytoplankton bloom. If the first efforts to produce a bloom with 0-46-0 or other low-nitrogen fertilizer don't work, even after liming the winter before, use a more complete (high-nitrogen) fertilizer, such as 20-20-5, at a rate of 40 pounds per acre on the specified schedule until the pond gets a green bloom. Continue with a normal application rate of high-phosphorus pond fertilizers after that.

DEALING WITH MUDDY WATER

Muddy water limits fish production in ponds because the phytoplankton at the base of the food chain must have sunlight to grow, and clay particles adsorb phosphorus, making it unavailable. Silt and mud deposits also cover

fish eggs and fill the pond, and most pond fish feed using their sight.

Controlling the erosion in a pond's watershed is essential for permanent control of most muddy water problems. If livestock are muddying the pond, fence off the pond and install drinking troughs below the pond. Some fish species, such as bullheads and common carp, can keep a pond muddy. In this case, renovate the pond and start over.

After the source of muddy water has been identified and corrected, test the water for alkalinity. Ponds with low alkalinity also tend to have low water hardness, which can cause clay particles to remain in suspension for long periods of time. If alkalinity is less than 50 ppm, adding agricultural limestone may help clear

IMPORTANT POINTS ON FERTILIZATION

Once you start fertilizing, you must continue fertilization from year to year. Stopping fertilization will leave the pond with too many fish for the food produced, and fish will starve and crowd quickly, resulting in poor condition and growth.

Improper fertilization of only once or twice a year is worse than no fertilization. Follow the fertilization recommendations in this manual and maintain the recommended bloom density for the entire growing season.

Do not try to kill aquatic plants by applying fertilizer. Although fertilization can shade the bottom and prevent weed growth, fertilization after weeds are established usually just makes more weeds.

A bloom should develop after two or three fertilizer applications. Many fish ponds do not develop a satisfactory phytoplankton bloom when fertilized at recommended rates because of low soil pH and water alkalinity. Lime can increase fish production in ponds with acid bottom mud and soft water by altering the soil pH and alkalinity of the water. If a bloom does not develop after four applications of fertilizer, check for lime requirements, too much water outflow, too many weeds, or muddy water.

the pond. Spread 2 tons of crushed agricultural limestone per acre. The limestone will dissolve and release calcium and magnesium ions that settle the clay over several weeks. Once the pond is cleared, the small algae begin to grow and muddy water conditions are unlikely to redevelop.

If alkalinity is above 50 ppm or if adding agricultural limestone does not clear the pond, one of the following methods may help to remove the clay from the water:

- Apply 500 pounds of organic material per acre such as old hay (approximately ten square bales per acre broken up and broadcast evenly over the pond surface), cotton seed husks, compost, or other similar organic material. Be careful using organic material in the summer, because decomposition may deplete oxygen and cause fish to die.
- Apply 40 to 90 pounds of alum (aluminum sulfate) per acre-foot of water. The dosage depends on the severity of the muddy water. Moderately turbid water (can see about 12 inches into the water) should be treated with 40 pounds per acre-foot, whereas severely turbid water (can see less than 6 inches into the water) may require up to 90 pounds per acre-foot. This translates to about 200 to 450 pounds of alum per surface acre of water for a pond with 5-foot average depth. Alum removes alkalinity from ponds, lowers pH, and can lead to fish kills in ponds with low alkalinity. To counteract this effect, apply hydrated lime at the same time as alum at half of the alum rate. Hydrated lime by itself can cause fish kills, so be careful when using this method to clear ponds.
- Use gypsum (calcium sulfate dihydrate) at the rate of 260 to 600 pounds per acre-foot of water, depending on the severity of the turbidity. This translates to about 1300 to 3000 pounds of gypsum per surface acre of water for a pond with 5-foot average depth. Spread the gypsum from a boat over the pond surface, and stir with an outboard motor. The gypsum will keep the water

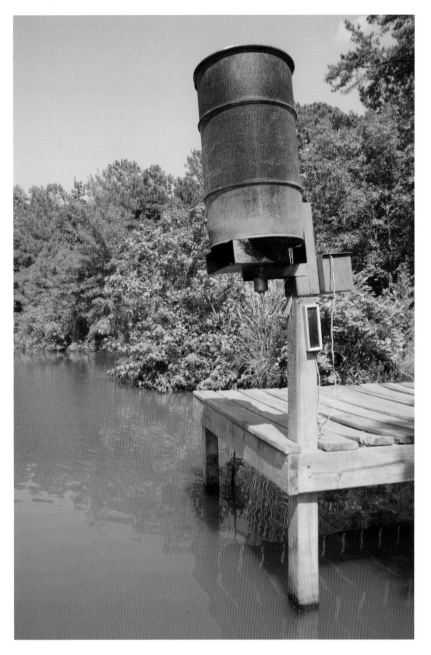

A fish feeder can be used to increase the growth of bream and catfish. Photo courtesy of Ray Iglay, Mississippi State University

enough to feed fish. However, growth of bluegills can be increased with a supplemental feeding program. Bluegills readily accept feed and can be attracted quickly to feeding areas. Small ponds stocked only with channel catfish or hybrid sunfish should always receive feed to maximize fish growth. Here are some rules of thumb

- Feed at the same time and place each day.
- Use floating feed, with a pellet size small enough to be easily eaten.
- Never feed more than the fish will eat in 5 to 10 minutes. Keep in mind that uneaten feed may pollute the water.
- If fish stop eating, stop feeding for a few days. Watch for signs of disease.
- Do not feed in very cold or very hot water.
- Taper the feeding rate as winter approaches to about one-fourth of the feed rate of the previous summer.
- Automatic feeders will give good growth results where small ponds are unattended for long periods.
- Do not try to feed fish up to large sizes without some harvest to reduce the number of fish. Otherwise, crowded large fish may become diseased and die.

Following these simple rules will provide good growth rates while minimizing the risks of deteriorating water quality.

DRAWDOWNS

One of the most useful and inexpensive pond management practices is to reduce the water level over winter. Water levels are reduced to some predetermined level, generally exposing 35 to 50 percent of the pond's bottom area. Winter drawdowns can be useful in controlling aquatic weeds and can help manipulate fish populations. They are also useful when repairing, redesigning, and liming ponds. To perform a winter drawdown, the pond must have a drain pipe that will let the water levels be lowered and kept down throughout the winter. Ponds without a drainpipe can be retrofitted for one.

clear as long as it is not washed from the pond. When used according to recommendations, gypsum will not kill fish, change the pH of the water, or harm livestock. When water clears, fertilization can be resumed.

FEEDING

It is not necessary to feed fish in a healthy bream-bass pond to produce good crops of fish. Natural food organisms will typically be abundant

Drawdown for Aquatic Weed Control

Aquatic weed problems are common in farm ponds and usually are challenging to manage. Winter drawdown can be an inexpensive and convenient control technique, as dewatering exposes weeds to air-drying and freezing temperatures. For effective weed control, drop the water level of the pond to expose aquatic weeds in the more shallow portions of the pond. Usually, water levels are reduced 3 to 4 feet, enough to expose 35 to 50 percent of the pond bottom, but this percentage may vary greatly depending upon topography and design of the pond. Maximum drawdown should be accomplished by mid to late November, and the water level should remain low through February. Spring rains will fill the pond. If necessary, deepen the shoreline to 3 feet deep while water levels are reduced, which will reduce the likelihood of weeds returning. After reflooding, if weeds persist and begin to sprout, apply an appropriate herbicide. The combination of a winter drawdown, shoreline deepening, and effective early spring herbicide application usually does a good job of eliminating or greatly reducing aquatic weed infestations.

Drawdown for Fisheries Management

Winter drawdown is also a good fish population management technique in largemouth bass and bluegill ponds. By reducing the water level and pond area, forage fish, such as bluegills, are driven out of shallow water refuges and concentrated in open water, making them more available for bass to eat. This is a good technique to use in ponds with crowded bluegill but still containing viable bass populations. The increased feeding by largemouth bass on bluegill reduces bluegill numbers and provides more food for the bass. Routine annual drawdowns can help maintain a balanced bass and bluegill fishery. However, drawdowns can make bass-crowded situations worse. In a bass-crowded pond, do not use winter drawdowns until pond balance is restored.

Drawing down a pond about 3 feet in winter exposes pond banks and helps to control aquatic weeds. This concentrates bass and bream and helps prevent bream crowding while promoting bass growth. Photo courtesy of J. Wes Neal, Mississippi State University

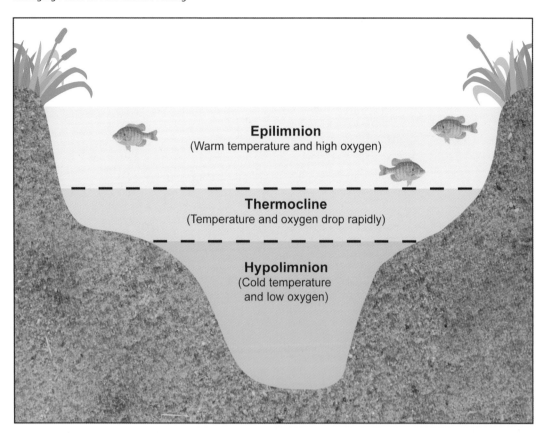

Epilimnion
(Warm temperature and high oxygen)

Thermocline
(Temperature and oxygen drop rapidly)

Hypolimnion
(Cold temperature
and low oxygen)

Stratification of water layers
in a pond during summer.
Illustration by Bill Pitts*

UNEXPECTED FISH KILLS

Occasionally, a fish kill occurs in farm ponds because of water quality problems, infectious disease, or misused agricultural chemicals (pesticides). Swarming of winged fire ants in late winter or early spring also has caused fish kills. As the swarming ants fall into a pond, small and intermediate-sized bream gorge themselves on the ants. If enough ants are eaten, the fish will die. Bass are rarely affected. In some cases, the losses from fish kills may be enough to affect the balance of the fish population.

Oxygen Depletions and Pond Turnovers

By far the most frequent cause of fish kills in farm ponds is low oxygen levels, which can be the result of two separate phenomena in ponds. The first is simple oxygen depletion, which usually occurs from July through September in the time of highest water temperature. Die-offs caused by low dissolved oxygen levels result from

natural biological processes and there are rarely any effective preventive measures except for running an expensive aerator every night. Factors that can contribute to low oxygen levels include:

- dense plankton blooms or dense stands of pond weeds;
- several days of cloudy weather that reduces plant oxygen production;
- high temperatures, which decrease the solubility of oxygen in water and increase oxygen consumption by plants and animals;
- sudden die-off of plants or algae, especially associated with herbicide use;
- unusual weather patterns such as storm fronts and heavy, cold rain;
- overstocking of fish;
- excessive fertilization;
- high feeding rates; and
- input of organic matter such as hay, straw, or cottonseed meal for turbidity or algae control and materials such as animal manure or sewage.

Another condition, often called pond turnover, can occur after heavy cold rains from late spring to early autumn when temperatures drop suddenly. During calm, hot days, the pond becomes stratified and develops temperature layers. The layer of water at the surface is exposed to the sun and warms quickly. This warm layer weighs less than the cool water below, so these layers do not mix. Surface layers contain high levels of oxygen produced by the phytoplankton, and fish tend to remain in this upper layer. The cooler bottom layers are cut off from the surface layers and their sources of oxygen, so oxygen levels drop over time due to normal biological processes. In fact, these deep waters can actually develop an oxygen demand, which is like having negative oxygen levels. When a heavy, cold rain enters the pond, it mixes the two layers of water. When this occurs, oxygen levels throughout the pond may drop too low for fish to survive.

A severe mixing event can kill nearly every fish larger than 1 or 2 inches in a single night. It is not uncommon to find large dead fish on dry land in the watershed above the pond following a turnover. These fish swam up the incoming rain waters seeking oxygen. Adult fish die first, and intermediate-sized fish follow if the low oxygen level is very low or if it continues for many days.

Usually, by the time an oxygen problem is recognized, it is too late to save fish. However, an early symptom of a low dissolved oxygen level is fish at the surface of the pond at sunrise. Fish appear to be gasping for air. If the low oxygen event is discovered early enough, it may be possible to save some fish by using emergency aeration. A powerhouse-type aerator works great, but most people do not have access to aquaculture equipment. Alternatively, a boat with an outboard motor can be backed halfway into the pond, the motor tilted at a 45° angle to the water surface, and the motor run at high speed to move a "rooster tail" of water into the air and across the pond. Any such technique that mixes water and air can help provide an oxygen refuge for fish.

Following a severe fish kill, some fingerling fish will usually survive, but there is a tendency toward overcrowded bream afterward. Contact a fisheries biologist to have them assess the status of the fish population after a severe fish kill.

pH and Mineral Problems

Poor water chemistry is the second leading cause of fish death in Mississippi ponds. Fish in acidic water with low alkalinity and hardness are more likely to get sick, especially during times of stress such as spawning season or periods of rapid temperature change. A few fish, usually of different species (although catfish are especially sensitive), die every day and many may have sores or lesions. If this is the case, have the pond water alkalinity measured to determine if agricultural limestone is needed. Liming increases the dissolved minerals in the water, which reduces stress on the fish.

Infectious Diseases and Parasites

Bream and bass generally do not have significant problems with infectious diseases in well-balanced ponds, although occasional sores on individual fish during spawning season or after an injury are not uncommon. These external sores do not pose any health hazard to humans. Occasionally, bass and bream have small white or yellowish grubs imbedded in the flesh. These grubs, although not pleasant to look at, pose no threat to humans. The affected area can be trimmed away, and the rest of the fish is safe to eat.

Infectious diseases and parasites of channel catfish are common problems in catfish ponds. Overstocking, inconsistent feeding, and poor water quality contribute to this in recreational ponds. Disease and parasite problems of catfish rarely occur when low stocking densities (100 to 150 per acre) are used. Stress from handling may cause die-offs of fish within 2 weeks of stocking new or established ponds.

ATTRACTING FISH

The primary purpose of many farm ponds in Mississippi is recreational fishing. With proper

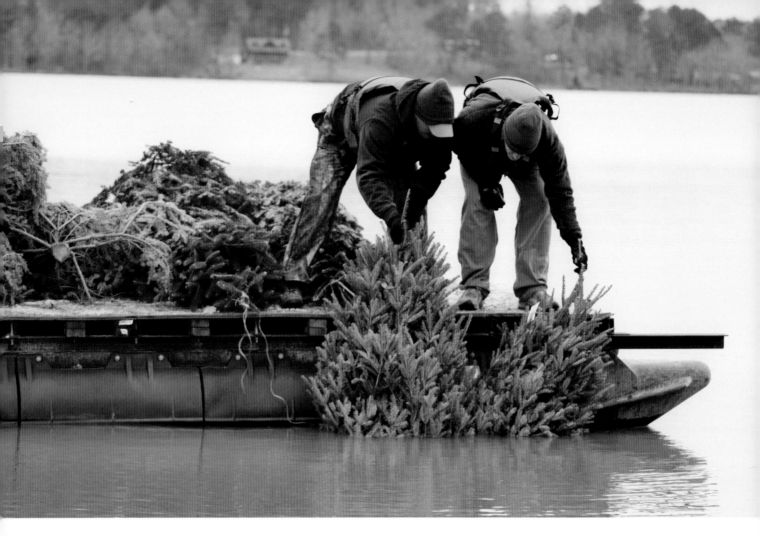

Christmas trees and other brush can be placed in large piles to attract fish by using cinder blocks to hold them in place. Photo courtesy of J. Wes Neal, Mississippi State University

management, even small ponds can provide excellent fishing. One of the best ways to enhance the fishing experience is to create fish attractors at strategic locations in a pond or lake with a well-managed fish population.

Game fish such as bass and bream are attracted to cover or shelter of all types. Shelters provide areas where prey fish can hide from predators and where predators can find prey species. They also provide spawning areas and harbor large numbers of invertebrates and insects that small fish feed on. Natural cover that provides shelter for fish includes ditches, creeks, trees (standing or tree tops), stumps, vegetation, and other irregular features of the bottom. In ponds where natural shelter for fish is missing or inadequate, artificial structures can be installed to act as fish shelters that will attract and hold fish.

Trees

For small ponds, dead bushy-crowned trees 10 to 15 feet tall make excellent fish attractors. Larger dead trees can be used in larger lakes. In ponds of less than 1 acre, one brush shelter is enough, whereas larger ponds can support one or two shelters per acre. Select attractor sites anglers can access. Good locations are in water 4 to 8 feet deep near creek channels, points, or drop-offs. Never leave trees or brush in shallow areas near the bank.

Up to 20 percent of the pond area can have some tree shelter. Place three to five trees at each location. Green trees will usually sink without weights, but some trees, such as cedar, will float. Add weights to these varieties to keep the shelters in place. Drive a stake or use a floating buoy to mark the shelter site permanently.

Many new pond sites have trees in the basin. Keep some trees, bushes, and brush piles to use in establishing fish shelters. However, most should be cut and removed from the pond site.

Gravel Beds

Gravel beds are extremely attractive to bream for spawning, and bream will use these gravel

beds frequently throughout the spring and summer. Select an area in water 3 to 4 feet deep that is convenient for fishing. Drive a stake to mark the spot, and place washed gravel (½-inch diameter) around the stake, creating a bed of gravel 4 to 6 inches deep. A load of 3 to 5 cubic yards will make a gravel bed 12 to 15 feet wide. For best results, provide a frame to hold the gravel in place. If the frame is made of treated lumber or other material that can float, make sure it is securely anchored to the bottom. Add gravel beds to flooded sites or strategically place them during drawdowns. Avoid sites that have a silt erosion problem.

RENOVATING PONDS

The ultimate fate of many farm ponds is an unbalanced fish population that is undesirable to anglers and has little recreational fishing value.

Once a fish population reaches such a condition, the best solution is usually to eliminate the resident fish and restock with a desirable combination of fish at recommended rates. The easiest way to renovate a pond is to drain and completely dry the pond. This also provides the opportunity to make modifications to the pond or to add habitat. If any pools of water remain in the basin, they will need to be drained or poisoned, as small fish can survive in these pools for a very long time and will ruin renovation attempts.

Many ponds were not constructed with a drain, and all of the water cannot be removed easily. These ponds will need to be poisoned. Rotenone is the only pesticide that is economical for killing fish populations. Rotenone is available at most farm and chemical supply stores. It is classified as a restricted use pesticide and cannot be purchased without a private pesticide applicator's certificate. Rotenone keeps

A pea gravel spawning bed has been installed in front of this fishing pier during water drawdown. This gravel bed will attract bream during the spawning season, making them easy to catch. Photo courtesy of J. Wes Neal, Mississippi State University

Table 14.6. Rotenone concentrations (using 5% active liquid rotenone) required for selected applications

Purpose	Acre-feet treated per gallon [a]	Concentration (ppm)	
		Active rotenone	5% formulation
Selective shad kill	30	0.005	0.1
Complete renovation: no carp, bullheads, bowfin, or gar	3.0	0.05	1
Complete renovation: ponds with carp and/or bullheads	1.5	0.1	2
Complete renovation: ponds with bowfin and/or gar	1.0	0.15	3

[a] To calculate acre-feet, multiply the surface acreage of the pond by its average depth.*

PRIVATE APPLICATOR CERTIFICATION

Many effective herbicides and pesticides used in invasive species management have been classified for restricted use due to several potential environmental and safety concerns. As a result, landowners interested in purchasing such products are required by law to obtain a private applicator certificate. Certification can be obtained through the Mississippi State University Extension Service's Private Applicator Certification Course, which is offered several times a year by the county extension offices.

During the interactive 2-hour program, landowners learn about general pesticide safety, minimizing spray drift, federal record keeping, and federal worker protection standards. After passing a short exam, the individual receives a certificate that is valid for 5 years in Mississippi.

Interested landowners can find the certification class schedule and other information about the Pesticide Applicator Training program at msucares.com/insects/pesticide.

fish from using oxygen, but it does not remove oxygen from the water. Fish treated with rotenone move to the shallow water or to the surface of deeper water soon after exposure to the chemical. Fish species respond differently to rotenone, so it is a good idea to know what species are in the pond before treatment of the pond. Rotenone breaks down when exposed to the environment. The breakdown is rapid and is affected by temperature, light, oxygen, and alkalinity. Most waters are safe for restocking within 5 to 6 weeks. In general, the cooler the water, the longer rotenone lasts.

Using Rotenone

Reducing the water area and volume as much as possible before treating increases effectiveness and reduces costs. Lowering the water level will pull fish out of their shallow water cover, which can be difficult to treat. Rotenone is available in a wettable powder or a liquid formulation. Liquids are easier to get into solution and are more reliable for total fish kills. The liquid formulations typically contain 5 percent rotenone, although some contain 2.5 or 7 percent. Treatment rates for a complete kill depend on the objective of the pond renovation and the species present. All formulations must be diluted with water and evenly distributed throughout the water column. Spray the chemical over the pond surface or drip it into the prop wash of

an outboard motor. The key is to have an even distribution; otherwise, fish may find safe areas and not be killed. Application in an S pattern throughout the pond will maximize coverage.

The best time to eradicate fish from a pond is late summer or early autumn. Water temperatures are at their highest at this time, and the weather is usually dry, allowing for easy draining. Killing the fish at this time also reduces the time between the kill and restocking, which minimizes the chance the pond will be contaminated by unwanted fish before restocking. This is an important consideration, because letting in unwanted species can defeat the purpose for the renovation. It is important to wait until the rotenone dissipates before restocking.

SUMMARY

Quality fishing ponds are the product of proper planning, design, construction, and management. The guidelines described in this chapter are a great starting point to help you develop, improve, or maintain a small lake or pond. However, it is advisable to seek professional help along the way. Trained professionals, including county extension agents, Natural Resources Conservation Service agents, and Mississippi Department of Wildlife, Fisheries, and Parks biologists, are available to answer more specific questions. Trying to manage a pond when you are uncertain about the correct approach can be frustrating and often expensive. Make sure you have the best information up front to save yourself time and money.

For More Information

Mississippi Weed Science Committee, eds. 2013. *Weed Control Guidelines for Mississippi*. Publication 1532. Mississippi State University Extension Service.

Neal, J. W. 2011. *Sport Fish Suppliers and Stocking Guidelines for Stocking Mississippi Ponds*. Publication 2525. Mississippi State University Extension Service.

Neal, J. W., D. K. Riecke, and G. N. Clardy, eds. 2010. *Managing Mississippi Ponds and Small Lakes: A Landowner's Guide*. Publication 1428. Mississippi State University Extension Service.

* Adapted from Neal, J. W., D. K. Riecke, and G. N. Clardy, eds. 2010. *Managing Mississippi Ponds and Small Lakes: A Landowner's Guide*. Publication 1428. Mississippi State University Extension Service.

Backyard Wildlife and Habitat

John T. DeFazio Jr., Wildlife Biologist, U.S. Department of Agriculture Natural Resources Conservation Service

Technical editor
Adam T. Rohnke, Wildlife Extension Associate, Department of Wildlife, Fisheries, and Aquaculture, Mississippi State University

Many people enjoy watching wild animals and feeding birds in their backyard. In fact, approximately 43 percent of households in the United States, or 65 million people, provide food for wild birds. More than 730,000 individuals in Mississippi enjoy watching wildlife in their backyards, with the majority reporting a special interest in watching birds. Similarly, gardening is the fastest-growing and one of the most popular recreational activities in the United States. Combining these activities with the proper knowledge and planning can result in mutually beneficial spaces where landowners can enjoy nature while providing much-needed habitat for local wildlife.

THE BASICS OF WILDLIFE HABITAT

Just like people, animals need a place to live. Habitat is the place where an animal makes its home. For animals to survive and do well, habitat must provide their four basic requirements: food, water, cover, and space. Each species has its own unique habitat requirements, which vary as animals mature and seasons change. Also, habitat components should be properly arranged to maximize their value to wildlife.

When designing a backyard wildlife habitat, property owners need to manage elements such as plants, water, food, and nesting boxes and other structures to meet the needs of the targeted wildlife species. Of course, food, water, and cover must be provided throughout all seasons of the year and located within close proximity of each other. As a general rule, the greater

Eastern bluebird carrying insect to its nest. Photo courtesy of Michael Kelly, Wild Exposures

the variety of habitat elements provided, the greater the number of wildlife that will be attracted to a backyard wildlife habitat.

Food

When furnishing food for wildlife, just follow one simple rule: supply food through natural vegetation as much as possible during all four seasons of the year. In addition, remember that different species of wildlife need different types of food. The greater variety of food available in a backyard wildlife habitat, the more successful it will be in providing for a wide range of wildlife needs. Therefore, planting trees, shrubs, vines, flowers, and herbaceous plants that produce acorns and nuts, fruits and berries, seeds and grain, nectar, browse (twigs and buds), and forage (grasses and legumes) will attract a greater diversity of wildlife. Be aware that the insects, reptiles, amphibians, birds, and mammals attracted to backyard habitats will serve as a food source for predator species such as hawks, raccoons, and snakes.

For a year-round food supply, choose plantings that produce or hold seeds, fruit, and nuts throughout each of the four seasons. Natural foods may be supplemented by artificial feeding, which is especially important in late winter and early spring when natural foods are least available. However, food must be accompanied by two other key elements, water and cover, to enable wildlife to flourish in backyard habitats.

TAKING THE GOOD WITH THE BAD

When designing and constructing a backyard habitat, homeowners should remember that wildlife are wild and they eat other wildlife.

Wildlife Are Wild

Providing supplemental food or food plants should not be used as a way to attract animals to treat as pets. First and foremost, it is dangerous to people, their pets, and, ultimately, to wildlife. Such interactions typically result in wildlife becoming aggressive toward humans, which, in turn, can lead to the animal having to be euthanized for safety concerns.

No matter the size or the cuteness factor, wild animals such as this gray squirrel can inflict serious injury to humans, especially children, when attempted to be hand fed. Photo courtesy of iStock

Wildlife Eat Other Wildlife

Predators serve an important role in providing balance between animals and the resources they consume. Predators also remove weak and injured individuals, thus improving the overall health of the population. Homeowners who understand predation is a natural process will be better prepared when predation does occur in their backyard habitat. It is also important to remember that predators come in all shapes and sizes including mammals, birds, and reptiles (primarily snakes).

Northern water snakes are common throughout Mississippi, especially on properties with water bodies. Unfortunately, they are typically mistaken for their venomous counterpart, the cottonmouth, and as a result are often killed by humans. (Cottonmouths are very heavy bodied, have a wide dark band on the side of the face, and a short stubby tail.) Photo courtesy of Adam T. Rohnke, Mississippi State University

Water

Wildlife needs water for both drinking and bathing. Of the four basic habitat components, water is often the one in shortest supply. Yet water can be easily furnished for many animals by installing a birdbath. A permanent water source, such as a small garden pond, will be required to provide habitat for aquatic animals such as frogs, salamanders, and fish. Regardless of how water is supplied, all sources should be placed so that predators, such as cats, cannot sneak up on the wildlife attracted there.

OUTDOOR CATS

There are more than 77 million pet cats in the United States, and nearly 65 percent spend most of their time outdoors. According to recent estimates, each year domesticated and feral cats kill hundreds of millions of birds, small mammals, reptiles, and amphibians. Studies also show that well-fed cats and those with bells on their collars kill as much wildlife as those without food or belled collars.

Keeping cats indoors not only reduces their negative impact on wildlife but also increases their lifespan. Outside cats live an average of 5 years, whereas indoor cats typically live from 12 to 17 years. Increased risk of injury, exposure to disease, and vehicle collisions are a few factors that reduce an outdoor cat's lifespan.

Small birds such as this chickadee are common prey to outdoor cats. Photo courtesy of iStock

Cover

Cover provides shelter from adverse weather, protection from predators, a place for nesting and raising young, and serves as a safe home base. Therefore, food and water should be located within 10 to 15 feet of cover, which comes in many forms such as trees, shrubs, flowers, grasses, ponds, or structures like brush piles, rock piles, hollow trees, or nesting boxes.

Also, different wildlife species have different cover requirements. The ideal backyard wildlife habitat area will include a rich diversity of plants, vegetation types (trees, shrubs, wildflowers, grass), water sources, and artificial structures (nesting boxes and shelves, brush piles, rock piles), all of which will allow birds and other animals to choose the appropriate cover needed for feeding, hiding, and nesting. Again, providing a higher diversity of cover will attract a more varied wildlife population.

Space

Each species of wildlife has its own space or territorial needs including space to feed, drink, bathe, roost, rest, breed, and raise young. In fact, the arrangement of space is the most important factor, as few wildlife species will be attracted to a well-manicured lawn. Therefore, mimicking natural habitats by avoiding straight lines and perfect symmetry and interspersing necessary habitat elements within the backyard landscape will maximize the value to wildlife.

The boundary where different habitats meet is known as an edge. Edges support a richer diversity of wildlife species because they have a greater variety of food, cover, and other habitat components close to each other. Another important aspect to consider is establishing corridors, which are areas of continuous vegetation that connect different habitat areas and allow wildlife to move from one area to another without being exposed to predators.

CREATING A LANDSCAPE DESIGN

Developing a backyard wildlife habitat plan has several basic steps. First, a site map is drawn and

an inventory is taken of existing habitat. Next, the landowner decides which wildlife species he or she wants to attract and learns about their habitat requirements. Once the essential habitat components are identified, it's time to make a list of the potential additions to the backyard habitat. Finally, the right plants are selected and the backyard habitat plan is implemented, perhaps over the course of several years.

Site Map

Draw a map of the property to scale. The map should accurately include the location of property lines; houses; walkways; driveways; fences; underground water pipes and utility lines;

existing trees, shrubs, and other vegetation; and any other features that may affect the backyard landscape. This map will serve as a blueprint for the backyard wildlife habitat plan.

Inventory of Existing Habitat

Make an environmental analysis of the property by conducting an inventory of existing habitat elements. By assessing what is already present, it will be easier to determine which habitat components need to be added. Within the space of the backyard, identify plants and other habitat features that provide the basic needs of food, water, and cover. Begin by identifying and making a list of all existing

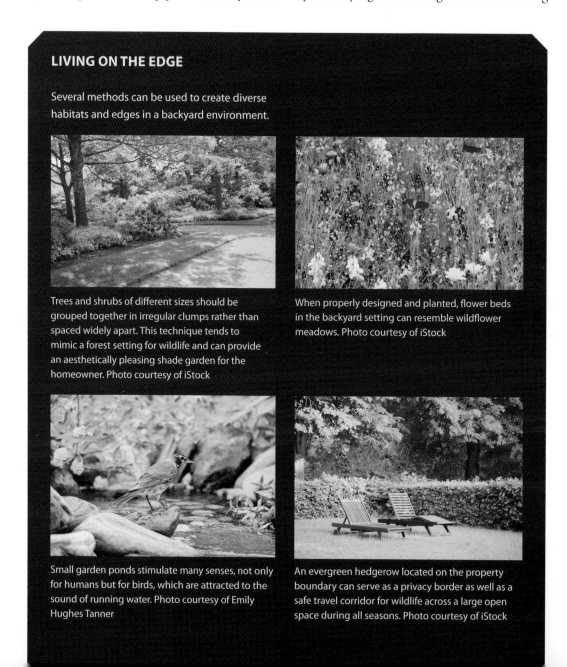

LIVING ON THE EDGE

Several methods can be used to create diverse habitats and edges in a backyard environment.

Trees and shrubs of different sizes should be grouped together in irregular clumps rather than spaced widely apart. This technique tends to mimic a forest setting for wildlife and can provide an aesthetically pleasing shade garden for the homeowner. Photo courtesy of iStock

When properly designed and planted, flower beds in the backyard setting can resemble wildflower meadows. Photo courtesy of iStock

Small garden ponds stimulate many senses, not only for humans but for birds, which are attracted to the sound of running water. Photo courtesy of Emily Hughes Tanner

An evergreen hedgerow located on the property boundary can serve as a privacy border as well as a safe travel corridor for wildlife across a large open space during all seasons. Photo courtesy of iStock

plants. Many people find it worthwhile to invest in a few plant identification guides, which should be available from a local bookstore or online.

For each plant identified, determine what value it has to wildlife in terms of food and/or cover, such as type of food it provides (seed, nut, berry); time of year the food is available; species of wildlife using the food produced; classification of plant (evergreen or deciduous); and type of cover it provides (ground, shrub thicket, midstory, or tall canopy). Next, identify all other existing features such as birdbaths, feeders, natural cavities, nesting boxes, and special habitats like tall grass, thickets, and wet areas.

Determine Wildlife Species and Habitat Requirements

Become familiar with the birds, mammals, reptiles, amphibians, and other animals that are native to the area. Consider the location of the property. Compared to rural areas, backyard habitats in a city may not attract some of the larger mammals and game birds such as white-tailed deer and wild turkey. However, regardless of location, habitat can be provided for a variety of creatures including squirrels, chipmunks, rabbits, songbirds, bats, frogs, lizards, turtles, fish, and butterflies.

Next, determine which habitat requirements related to food, water, and cover must be supplied for the targeted animals. Compare this information with the existing habitat inventory to determine which elements are lacking. For example, suppose that frogs were one of the targeted wildlife species. The existing habitat inventory shows that the backyard habitat provides food and cover for frogs such as low-growing herbaceous plants and shrubs as well as a leaf mulch pile. However, the only source of water is a birdbath. Frogs need a permanent water source to reproduce. Therefore, a small garden pond should be included in the backyard wildlife habitat plan.

Develop the Backyard Wildlife Habitat Plan

First determine which essential habitat components are needed. Several factors to consider are:

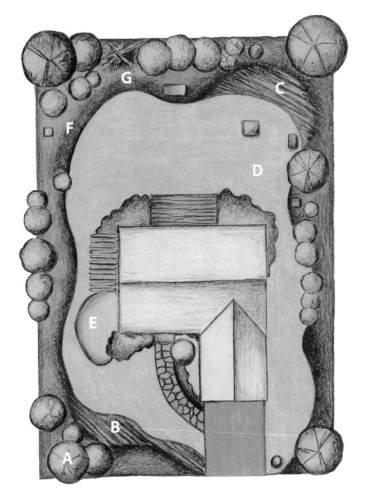

♦ types of food that are lacking;
♦ season of the year food is not present or scarce;
♦ type of cover that is available;
♦ whether a suitable range of structural diversity (ground cover, shrub layer, midstory, and tree canopy) is available;
♦ whether adequate cover within 10 to 15 feet of all food and water sources is available, especially during winter;
♦ whether a permanent water source is present; and
♦ types of artificial structures to be considered (feeders, nesting boxes and shelves, brush and rock piles) for the targeted wildlife species.

Make a list of the potential additions to the backyard habitat. At this time, list plant additions in general terms, such as summer-fruiting shrub, autumn berry tree, evergreen shrub, and

In this example of a backyard wildlife habitat plan for a typical residence, all four essential habitat elements of food, water, shelter, and space have been provided. The plan includes diverse vegetation such as large and small trees, shrubs (a), ground covers (b), vines, native grasses, and wildflowers (c). In addition, most plantings are grouped together. The plan also includes useful artificial structures such as bird feeders (d), birdbaths, small ponds (e), nesting boxes (f), and brush piles (g). Remember that wildlife diversity is best achieved by providing habitat diversity. Figure courtesy of Mississippi State University Extension Service

wildflower garden. However, artificial structures listed should be very specific, such as a hummingbird feeder, bluebird nesting box, bat house, birdbath, and garden pond. During the plant selection phase, the wildlife plantings list for Mississippi backyard habitats shown in Appendix 5 can be used to select appropriate plants for the backyard wildlife habitat area.

Now it's time to determine the exact location of each plant, structure, or feature to be added. Begin by carefully examining the site map, keeping in mind the principles of providing food, water, and cover for wildlife as well as their proper arrangement in the space. Also consider map elements such as property lines, fences, and underground utilities when considering where to dig for the new plantings. Once the location of each plant, structure, and feature has been determined, add them to the plan map using some type of unique landscape symbol.

When developing the backyard wildlife habitat plan, make sure family needs are considered as well as those of the targeted wildlife species. As new elements are added to the yard, remember that special features such as feeders, nesting boxes, birdbaths, and garden ponds should be visible from a window, patio, deck, or other viewing area but at a safe distance to reduce window strikes and disturbance to nesting areas. Feeders, nest boxes, and other special features should be at least 15 feet from natural cover and 30 feet from windows. In addition, apply films, tape, or decals on the outside of windows to make them visible to birds. Winter-fruiting plants also should be located so that wildlife can be watched from indoors during inclement weather.

ENERGY SAVINGS

Proper tree placement can provide additional benefits for homeowners. Energy bills can be reduced by planting evergreens on the northern side of the house to provide protection from cold winter winds. In addition, tall deciduous trees along the southern and western sides of the house will provide shade from the summer sun, yet allow sunlight to pass through during the cold winter months.

Make Plant Selections

Next it's time to choose which plant species to add to the backyard wildlife habitat area. Chances for success will greatly increase by choosing plants that will grow in the specific area, thrive in the type of soil present, grow well under the site's existing light conditions, and provide food and/or cover for wildlife.

Choose native plants over non-natives whenever possible. Native plants have several advantages, including:

- better adaptability to the climate of the area;
- reduced susceptibility to disease and attacks from insects;
- less need for maintenance;
- more resistance to drought and other weather extremes; and
- greater attraction to native wildlife.

Diversity should also be an integral component of the backyard wildlife habitat area. Plant diversity can be increased by providing a wide array of trees, shrubs, vines, wildflowers, grasses, and other herbaceous plants. Structural diversity includes incorporating different levels of habitat such as ground cover, shrub layer, midstory, and tree canopy. A broader assortment of plant species will also help protect against disease and insect attacks.

The U.S. Department of Agriculture plant hardiness zone map can be used to help determine if a particular plant will grow well in a specific geographic area. In addition, mature plants that are thriving in surrounding neighborhoods and communities also provide a good indication for success. Be aware that some plants can be induced to grow outside their climate zone with additional care, but also with the possibility of reduced growth.

Implementing the Backyard Habitat Plan

After the backyard wildlife habitat plan has been developed and specific plant species chosen, it's time to implement the plan. Don't try to complete everything the first year, but phase

the plan in over several years. Some critical habitat components, however, can be introduced immediately. For example, provide food by adding several bird feeders with a selection of seeds, and offer water by installing a bird-bath or two. Also, plant fast-growing shrubs and construct brush piles to help furnish cover for backyard wildlife during the first autumn and winter.

POPULAR BACKYARD WILDLIFE

There are hundreds of wildlife species that use backyards across the state. Popular among Mississippians are songbirds, which bring not only vibrant colors but endless natural music to the landscape throughout the year. Many home-owners enjoy watching squirrels in their daily activities (to the disgust of many homeowners who feed birds) including chasing each other, climbing, and feeding. Those lucky enough to have wetlands on their property or the ability to construct small ponds and wet areas will get to enjoy the aerobatics of dragonflies on the hunt and the entertaining acoustics of frogs, such as the spring peeper, and fowler toads in the evening.

Butterflies

Mississippi is home to more than 140 species of butterflies. The most common method used to attract butterflies is to plant a flower garden. However, having a basic understanding of but-terfly biology will help in planning and devel-oping a butterfly garden habitat.

A butterfly's life cycle includes four stages: egg, caterpillar, chrysalis (pupa), and adult. After mating, female butterflies lay their eggs on spe-cific plants (also known as host plants) that cat-erpillars prefer to eat. Some caterpillars feed on only one kind of plant, whereas others feed on a wide range of species. For example, monarch caterpillars feed only on milkweeds, but eastern tiger swallowtail caterpillars will consume leaves from many broadleaf trees and shrubs.

Once caterpillars emerge from the eggs, they begin to eat. The caterpillars shed their skin

A buckeye butterfly on purple coneflower. Photo courtesy of Emily Hughes Tanner

KEYS TO DEVELOPING A SUCCESSFUL BUTTERFLY GARDEN

- ◆ Plant a garden of nectar-producing flow-ers. Choose clustered flowers that have short flower tubes or flat-topped blossoms.
- ◆ Butterflies are especially attracted to flowers with red, yellow, orange, pink, or purple blossoms. Plant flowers in large masses to make it easier for butterflies to locate them.
- ◆ Plant a mixed assortment of flower-ing plants that will continuously bloom throughout the entire growing season, in spring, summer, and autumn.
- ◆ Include host plants that attract butterfly caterpillars in the landscape design.
- ◆ Locate butterfly and wildflower gardens in open, sunny areas.
- ◆ Provide water with a wet sand, earth, or mud watering station; also, place a small, gravel island in a birdbath.
- ◆ Place several flat stones in sunny areas near wildflower gardens to provide bask-ing sites.
- ◆ Avoid using garden pesticides because most are toxic to butterflies.
- ◆ Don't worry about weeds because they provide additional food and cover for butterflies.

several times before forming a chrysalis. Butterfly caterpillars produce silk, which is used to fasten leaves together for protection and attach the chrysalis to plant stems. When the butterfly reaches the adult stage, the chrysalis splits open, and the butterfly emerges. Immediately, the adult butterfly begins to search for nectar-rich flowers on which to feed. Most adult butterflies live from 14 to 21 days.

Butterflies are perching feeders and drink nectar and water from a straw-like organ called a proboscis. Butterflies prefer flowers with broad-headed blossoms and short flower tubes, which allow them to easily reach the nectar with their proboscises. Butterflies are unable to drink from open water. However, nectar provides them with adequate water. Butterflies will also gather to drink or puddle at small mud puddles and damp sandy areas.

In order to fly, butterflies need sunlight for a good portion of the day to keep their body temperatures between 85 and 100°F. As a result, they rarely feed on plants in the shade. On cold days, butterflies will bask in the sun to warm their bodies. They also need shelter from strong winds. Cover needs are usually met by host food plants as well as various trees, shrubs, grasses, and other native vegetation.

Hummingbirds

Of the 340 species of hummingbirds in the world, only the ruby-throated hummingbird is common in Mississippi. Ruby-throated hummingbirds migrate across the Gulf of Mexico twice a year, in spring and autumn. This more than 500-mile, nonstop flight takes approximately 18 to 24 hours. Ruby-throats primarily winter in Central America and Mexico. They return to the Gulf Coast in late February or early March and normally fly south for the winter before November.

Nectar from flowers is the main food source of ruby-throated hummingbirds, although their diet is supplemented by small insects such as mosquitoes, spiders, gnats, and fruit flies. Hummingbirds fulfill their water requirement through nectar and, therefore, do not need to

drink from open water. Because of its high rate of metabolism, a hummingbird may consume more than half of its weight in food and eight times its weight in fluids daily. Hummingbird nests are constructed from thistle, dandelion and milkweed down, ferns, young leaves, and mosses. Spider webs and pine resin are used to attach nests to tree limbs and branches. Nests are usually constructed under the shelter of overhead leaves and may be built over water. Common nest trees are oak, maple, beech, birch, hornbeam, poplar, sugarberry, and pine. Hummingbirds are also important pollinators of flowering plants. Ecologically, hummingbirds play an important role in the pollination of numerous species of flowering plants. In the continental United States, hummingbirds are key wildflower pollinators.

The best way to attract hummingbirds is to plant flowering annuals, perennials, shrubs, vines, and trees with bright red or orange tubular flowers. For best results, blossoms should

be 2 feet or higher above the ground. As hummingbird enthusiasts know, these birds are also attracted to sugar-water feeders. However, if not conducted properly, artificial feeding can be hazardous to hummingbirds.

Bats

Fifteen species of bats can be found in Mississippi. Those native to the Magnolia State are insectivores, feeding primarily on night-flying insects such as mosquitoes, moths, beetles, fruit flies, mayflies, caddisflies, and midges. Insectivorous bats consume 30 to 50 percent of their body weight in insects each night, or as many as 3000 to 7000 mosquitoes. Because of the large numbers of insects eaten, bats have a very important role in keeping crop pests in check. Studies have shown that even small colonies of bats in agricultural areas have significantly reduced crop damage and, likewise, the demand for chemical pesticides.

The best way to attract bats is by installing a bat house. In Mississippi, the species most likely to use a bat box include the big brown bat, southeastern myotis, eastern pipistrelle, Mexican free-tailed bat, and evening bat. Bat houses can be purchased from a number of suppliers,

KEYS TO SUCCESSFUL HUMMINGBIRD FEEDING

◆ Choose feeders that can be taken apart and cleaned thoroughly to prevent fungi, molds, and bacteria from developing.
◆ Every 4 to 5 days, clean feeders using hot water, vinegar, and a bottle brush. (Do not use soap.) Rinse thoroughly before refilling.
◆ Fill feeders daily with a mixture four parts water to one part sugar (do not use honey or add food coloring to the mixture).
◆ Do not use insect repellents to control ants, flies, bees, and wasps on feeders.
◆ To control unwanted insects, use feeders with bee guards and a water-filled ant guard; apply salad oil or petroleum jelly to the wire that holds the feeder.
◆ Contrary to popular belief, leaving feeders up in the autumn will not keep birds from migrating. In fact, it is advisable to maintain feeders through early December to provide a reliable food source for late migrants and those birds that may not have put on enough fat to endure the rigors of migration.

BAT FALLACIES

Because several misconceptions have led to an undeserved fear of bats, let's set the record straight.

◆ Bats are not blind. Actually, most bats can see very well.
◆ Bats do not fly into human hair nor do they attack people. Bats use echolocation, or sonar, to navigate and capture insects in the dark. In fact, their echolocation is so sensitive that they can detect objects the width of a thread.
◆ Bats can contract rabies. However, it is extremely uncommon, with less than half of one percent ever contracting the disease. People or pets are more likely to get rabies from a dog, fox, raccoon, or skunk than from a bat.

Bat houses can be placed on poles, trees, or on the side of structures. Photo courtesy of iStock

including Bat Conservation International, a nonprofit organization dedicated to bat conservation, restoration, and public education. When purchasing a bat house, choosing houses certified by Bat Conservation International will ensure that they are "bat-approved."

IMPROVING BACKYARD HABITAT

Most backyards are relatively small and as a result will be lacking one or more of the key habitat requirements. In most cases, homeowners can remedy this situation through the landscape design process described previously. But sometimes, the specific needs of food, water, and nesting areas can only be met through artificial sources, such as bird feeders, birdbaths, small ponds, and nesting structures. Knowing how to fulfill these needs while keeping in mind that wildlife is wild can make these improvements the most effective elements of the habitat and enjoyable for the homeowner.

Artificial Feeders

Because natural foods may not be available year-round, artificial feeders can be used to supplement natural foods and to attract wildlife for easy viewing. In general, supplemental feeding

will not improve wildlife survival. However, there is increasing evidence that supplemental feeding during crucial time periods such as cold winters and migration periods can be helpful, especially for birds.

Many kinds of commercially made feeders are available. Plans for building feeders are also available from your local Natural Resources Conservation Service or Mississippi State University Extension Service office. Feeder offerings for birds usually consist of one or more of the following: seeds and grains, fruits, nuts, suet, or peanut butter.

Different types of birds prefer different types of seeds and grains. The most common useful seeds and grains are sunflower, millet, and cracked corn. Of the three, black oil sunflower seeds will attract the greatest variety of bird species. However, some species are best attracted by providing a specific type of food. For example, thistle seed will attract American goldfinches, pine siskins, and purple finches. Robins, thrushes, bluebirds, mockingbirds, and orioles can be attracted to feeders by offering fruit such as raisins, apples, oranges, and white seedless grapes. Suet (beef fat) or peanut butter can be used to attract insect-eating birds such as woodpeckers, chickadees, and nuthatches. Suet should be used only as a winter food. When temperatures rise, suet will quickly turn rancid. During the summer and other periods of warm weather, peanut butter mixed with corn meal, cracked corn, or oatmeal will be the food of choice for insect-eating birds.

Most bird species have a preference for a particular food, feeder type, and feeding spot. Therefore, the kind of birds that a specific feeder attracts will depend on the kind of feeder used, the type of food offered, and how the food is presented. For a well-rounded feeding program, establish a ground feeder, a low platform feeder about 4 feet high, a high platform feeder about 8 feet high, several hopper or tube hanging feeders with different types of seeds, a thistle feeder, and several hanging suet and peanut butter feeders about 5 to 8 feet high. (Refer to Table 15.1 for the preferred foods and feeder types for common birds.)

Sometimes unwanted species such as brown-headed cowbirds, house sparrows, and European

Black oil sunflower seeds are preferred by most birds because of the soft shell and large amount of protein in the seed. Photo courtesy of Adam T. Rohnke, Mississippi State University

A wide variety of perching birds including northern cardinals, chickadees, and blue jays will use a hopper-type birdfeeder. Photo courtesy of Adam T. Rohnke, Mississippi State University

starlings will invade feeders. Feeding these birds should not be encouraged. However, if they become a nuisance, temporarily empty feeders and place their preferred foods on the ground away from feeders. Refill feeders once the nuisance species are using the ground feeding area.

Nesting Boxes

Many birds and mammals use tree cavities for nesting, but nesting boxes can be used to supplement the shortage of natural cavities. In addition, some birds will use nesting platforms,

ROLL UP YOUR SLEEVES AND GET STICKY!

Rolling pine cones in a peanut butter mix can be a fun activity for children and provide a high-energy food for birds.

♦ Mix one part peanut butter, one part flour, and one part vegetable shortening with three parts corn meal or cracked corn in a large bowl.
♦ Tie a string around each pine cone near the top.
♦ Roll the pine cone in the peanut butter mixture or use a spatula to cover the pine cone.
♦ Hang coated cones from bird feeders or tree branches throughout the backyard.

Platform feeders are the most basic type of feeders for attracting primarily ground-feeding birds, including mourning doves and eastern towhees. Photo courtesy of Adam T. Rohnke, Mississippi State University

Bird species	Food	Feeder type
Table 15.1. Preferred foods and feeder types for twenty-eight common bird species in Mississippi		
American goldfinch	thistle, hulled sunflower	thistle, tube
American robin	chopped fruit	low platform
Blue jay	peanut kernels, sunflower	platform
Brown thrasher	hulled black-striped sunflower	ground
Brown-headed cowbird	proso millet	ground
Carolina chickadee	oil-type sunflower, suet [a]	tube, hanging
Chipping sparrow	proso millet	ground
Common grackle	black-striped sunflower	ground
Dark-eyed junco	proso millet, cracked corn	ground
Eastern bluebird	chopped fruit	low platform
European starling	peanuts, cracked corn	ground
Evening grosbeak	oil-type sunflower	high platform
House sparrow	proso millet	ground
Mourning dove	proso millet, cracked corn	ground
Northern cardinal	sunflower	low platform
Northern oriole	chopped fruit	low platform
Northern mockingbird	chopped fruit	low platform
Nuthatches	black-striped sunflower, suet [a]	tube, hanging
Pine siskin	thistle, sunflower	thistle, tube
Purple finch	oil-type sunflower, thistle	high platform, thistle
Red-winged blackbird	proso millet	ground
Eastern towhee	white proso millet	ground
Song sparrow	proso millet	ground
Tufted titmouse	peanuts, black-striped sunflower	tube
White-crowned sparrow	sunflower, proso millet	ground
White-throated sparrow	sunflower, proso millet	ground
Woodpeckers	suet [a]	hanging
Wood thrush	chopped fruit	ground

[a] Use suet only during cold winter months; substitute peanut butter mix in summer and warmer weather

KEYS TO SUCCESSFUL BIRD FEEDING

♦ Use a wide variety of feeders and feeding spots stocked with different types of seeds, grains, fruits, and nuts.
♦ For insect-eating birds, provide suet during cold winter months and peanut butter mix during warmer months.
♦ Maintain feeders year-round.
♦ To reduce spoilage, provide enough food for only a few days.
♦ Protect food from inclement weather and moisture.
♦ Clean feeders when they become soiled.
♦ Keep feeders predator-free by using pole guards and locating them close to cover.
♦ Discourage nuisance species by keeping foods they like to eat out of feeders. If this does not work, try scattering their preferred foods in a location away from buildings and feeders.
♦ Locate feeders for easy visibility from a window, patio, or porch.

which are nesting boxes without sides or a front. Nesting boxes should be designed and correctly located for a particular species, which will also help to discourage unwanted, non-native birds such as the house sparrow and European starling.

Providing Water

Wildlife needs water to survive. Indeed, water is one of the most effective components that can be added to a backyard habitat. Also, studies have shown that the sound of moving water is particularly attractive to wildlife. There are several key points to remember when supplying water:

- Establish a variety of different types of water sources.
- Water should be available year-round.
- Water should be fresh, clean, and abundant.
- Water containers should be cleaned regularly to reduce disease transmission and prevent mosquito production.

Water can be supplied in many ways. Some of the most common methods are placing shallow containers filled with water throughout the backyard habitat, installing a birdbath with misters, adding a fountain, and constructing a small garden pond with a waterfall.

CHARACTERISTICS OF A QUALITY NESTING BOX

Buy or construct nesting boxes that have the following:

- removable tops or sides for easy maintenance;
- roofs with sufficient slope to shed water;
- roofs that extend over all sections of the box and at least 2 to 3 inches over the entrance hole;
- rough or unfinished interior;
- ventilation gaps between the roof and sides or several ¼-inch holes drilled into the sides of the box just beneath the roof overhang; and
- several ¼-inch drainage holes in the bottom of the box or a box floor with the corners cut away.

Installing a metal border around the entry hole of a nest box can deter squirrels from chewing a wider hole and attempting to enter the box. Photo courtesy of iStock

KEYS FOR A SUCCESSFUL NESTING BOX

- Buy or build nesting boxes designed specifically for the targeted wildlife species.
- The most critical component is the size of the entrance hole. Properly sized, it will prevent larger birds from destroying eggs and/or young. Do not place a perch beneath the entrance hole because it can attract problem species.
- Locate the box in the appropriate habitat at the proper height for the target species.
- Most birds are territorial and will not nest too close to each other. Space boxes according to habitat requirements of the target species.
- Clean and repair nesting boxes prior to and after the nesting season: before February 1 and after November 1.
- Remove old nests after the young leave the nest.
- Install a predator guard if snakes, raccoons, or other predators are a problem.

A predator guard can be constructed by affixing a metal cone to the pole approximately 12 to 18 inches below the bottom of the nest box. Photo courtesy of Adam T. Rohnke, Mississippi State University

A simple birdbath not only provides an essential water source for backyard wildlife but can also enhance the beauty of the garden. Photo courtesy of iStock

The traditional pedestal-mounted birdbath is favored by many homeowners for its cheaper cost and ease of installation and maintenance. Ceramic or cement birdbaths should be permanently secured into the ground to prevent them from falling onto children and pets. Birdbaths should have the following characteristics:

- diameter of 24 to 36 inches with gradually sloping edges;
- depth of 3 inches or less;
- surface that is rough-textured to prevent slippage;
- mounted at least 3 feet off the ground; and
- located about 15 feet from dense cover.

A more natural approach would be to install a permanent garden pond. This can be done by digging a hole in the ground to fit the shape of a preformed fiberglass or plastic pool available at many garden centers. Alternatively, a pond can be constructed using a polyvinyl chloride liner.

BUILDING A BACKYARD POND

1. Choose an open area that will blend in with the natural surroundings and be easily seen from a window, patio, or deck.
2. Use a rope or string to lay out the shape of the pond on the ground.
3. Begin digging. Most of the pond should be a minimum of 24 inches deep with a portion at least 36 inches deep. Construct several tiers, each about 12 inches wide, within the basin at various depths.
4. After digging, remove any rocks from the pond basin and place at least a 1-inch layer of damp sand on the bottom.
5. Use a polyvinyl chloride (PVC) liner specifically designed for pools to keep water from seeping into the soil. To determine the amount of PVC liner to purchase, multiply the maximum depth of the pond by three. Then add this number to both the length and the width of the pond.
6. Spread the PVC liner over the pond, allowing the liner to gently sag. Place several large rocks around the edge of the liner to hold it in place, then slowly fill it with

water. As the weight of the water smoothes out the liner, remove the rocks along the edge to allow the liner to conform to the shape of the pond. Slightly pull on the liner to smooth out any wrinkles. Finally, place large rocks on the liner around the edge of the pond to hold it securely in place.
7. Let the water sit for a few days to allow chlorine to evaporate. Then stock the pond with a mixture of native aquatic plants; potted plants should be placed on tiers within the pond basin. About 60 percent of the surface area should be covered with native floating aquatic plants, which help keep the water clear by reducing the amount of sunlight available for algae growth.
8. Aquatic plants should be in place for 3 to 4 weeks to allow the pond ecosystem to establish itself. Then, stock about 1 inch of fish per square foot of surface water.
9. A pump and filter may be added if desired. Pumps add oxygen to the water and can be used to create fountains and waterfalls.

SUMMARY

There are several key points to remember about constructing a backyard habitat. Provide food, water, and cover for the targeted wildlife species. Inventory the existing habitat to determine which habitat elements are already available, and develop a backyard wildlife habitat plan that focuses on providing weak or missing habitat elements. Select native plantings that will provide food and/or cover for wildlife. Supplement native habitat with artificial feeders, nesting boxes, and other structures valuable to wildlife. Finally, implement the plan over several seasons. One of the most important points to remember is that the greater the variety of habitat elements provided, the greater the diversity of wildlife that will be attracted to the backyard habitat.

For More Information

Ajilvsgi, G. 1990. *Butterfly Gardening for the South*. Dallas, Texas: Taylor Publishing.

Burt, W. H., and R. P. Grossenheider. 1976. *A Field Guide to the Mammals of America North of Mexico*. Boston: Houghton Mifflin.

Coleman, J. S., S. A. Temple, and S. R. Craven. 1997. *Cats and Wildlife: A Conservation Dilemma*. University of Wisconsin Cooperative Extension Service.

Conant, R. 1975. *A Field Guide to Reptiles and Amphibians of Eastern and Central North America*. Boston: Houghton Mifflin.

Dennis, J. V. 1985. *The Wildlife Gardener*. New York: Alfred A. Knopf.

Johnson, C. J, S. McDiarmid, and E. R. Turner. 2004. *Welcoming Wildlife to the Garden: Creating Backyard and Balcony Habitats for Wildlife*. Vancouver, B.C.: Hartley and Marks.

Kress, S. W. 1995. *The Bird Garden: A Comprehensive Guide to Attracting Birds to Your Backyard Throughout the Year*. New York: DK Publishing,

Martin, A. C., H. S. Zim, and A. L. Nelson. 2011 [1951]. *American Wildlife and Plants: A Guide to Wildlife Food Habits*. New York: Dover.

Martin, E. C., Jr. 1983. *Landscape Plants in Design*. Westport, Conn.: AVI Publishing.

McKinley, M. 1983. *How to Attract Birds*. San Francisco: Ortho Books.

Merilees, W. J. 1989. *Attracting Backyard Wildlife*. Stillwater, Minn.: Voyageur.

Mizejewski, D. 2004. *Attracting Birds, Butterflies, and Other Backyard Wildlife*. Washington, D.C.: National Wildlife Federation.

National Wildlife Federation. 1986. *Planting an Oasis for Wildlife*. Washington, D.C.: National Wildlife Federation.

Opler, P. A. 1998. *A Field Guide to Eastern Butterflies*. Boston: Houghton Mifflin.

Peterson, R. T. 1980. *A Field Guide to Birds*. Boston: Houghton Mifflin.

Robbins, C. S., B. Bruun, and H. S. Zim. 1983. *Birds of North America*. New York: Golden.

Roth, S. 2002. *Attracting Butterflies and Hummingbirds to Your Backyard*. Emmaus, Pa.: Rodale.

Terres, J. K. 1994. *Songbirds in Your Garden*. New York: Algonquin Books.

Tufts, C. 1993. *The Backyard Naturalist*. Washington, D.C.: National Wildlife Federation.

Tufts, C., and P. Loewer. 1995. The National Wildlife Federation's Guide to Gardening for Wildlife: How to Create a Beautiful Backyard Habitat for Birds, Butterflies and Other Wildlife. Emmaus, Pa.: Rodale Organic Gardening Books.

U.S. Department of the Interior, Fish and Wildlife Service, U.S. Department of Commerce, and U.S. Census Bureau. 2006. *National Survey of Fishing, Hunting, and Wildlife-Associated Recreation*. www.census.gov/prod/2008pubs/fhw06-nat.pdf

CHAPTER 16

Wildlife Damage Control and Management

Kristina C. Godwin, State Director of Mississippi, U.S. Department of Agriculture Animal and Plant Health Inspection Service Wildlife Services

With contributions by

Ricky D. Flynt, Alligator and Furbearer Program Coordinator, Mississippi Department of Wildlife, Fisheries, and Parks

William W. Hamrick, Wildlife Extension Associate, Department of Wildlife, Fisheries, and Aquaculture, Mississippi State University

Bronson K. Strickland, Associate Professor of Wildlife Ecology and Management, Department of Wildlife, Fisheries, and Aquaculture, Mississippi State University

Technical editor

Ben C. West, Western Extension Regional Director, University of Tennessee

Wildlife damage management is the art and science of working to resolve conflicts between people and wildlife. Just as wildlife management is not an exact science, neither is wildlife damage management. After all, the definition of damage is in the eye of the beholder. What one person perceives as damage may not be viewed the same way by another. For example, a deer in someone's backyard may be a wonderful experience for that individual, but when the same deer walks over to the neighbor's yard and eats all the flowers, that animal is likely to be considered a problem.

The goal of wildlife damage management is to find solutions that resolve conflicts between people and wildlife, while conserving wildlife populations and the environment consistent with management objectives. This goal is achieved by using methods that are safe, legal, effective, economical, and practical. Successful resolution of wildlife conflicts depends on the proper application and use of control methods. Timing, diversity, and persistence of control methods are keys to resolving wildlife conflicts.

Conflicts occur between people and wildlife for several reasons. Expanding human populations, changes to wildlife habitats, and increasing environmental awareness are among the most frequently cited. Most wildlife species need a certain amount of preferred habitat to live in, and habitats can maintain a certain quantity of wildlife without being harmed. The maximum number of animals a habitat can support is known as the biological carrying capacity. Environmental factors such as food, shelter, water, and space all influence biological carrying capacity.

Wild pig damage on the shoulder of the Natchez Trace Parkway. Photo courtesy of Rex Allen Jones

City centers in the southern United States are expanding because of recent population growth and shifts in economic and retirement opportunities from northern states. Photo courtesy of iStock

Another concept often used in wildlife damage management is wildlife acceptance capacity. This is the maximum wildlife population acceptable to people in a given area, and it can differ significantly from biological carrying capacity. Consider an example with skunks. A given parcel of land may have a biological carrying capacity of ten skunks per acre. But if this same parcel of land has your house, your barn, and your garage, ten skunks per acre is probably more than you would want on your property. There is a difference between what

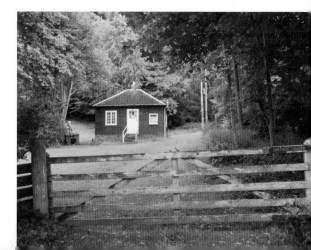

Whether living on a farm, in the city, on the waterfront, or in the woods, landowners will have interactions with wildlife. Photos courtesy of iStock

you will accept and what can be sustained upon a given piece of land.

Whether people are willing to coexist with wildlife is influenced by five factors: (1) their willingness to accept the presence of wildlife, in general; (2) whether wildlife will interfere with their ability to earn a living; (3) a threat to personal health and safety; (4) the possibility of negative habitat impacts caused by wildlife; and (5) wildlife conflicting with other wildlife. All of these factors are based on an individual's experiences, perceptions, and beliefs about wildlife. Not surprisingly, conflicts between humans and wildlife are bound to occur as each species competes for limited land, water, and other resources essential to life. Of course, the situation becomes even more complex because humans introduce cultural and behavioral

differences into the mix. Even the geographic region where we live and our awareness of environmental issues affect how we react to wildlife.

LAWS AND REGULATIONS

Several federal laws oversee activities involving wildlife damage management, including the Animal Damage Control Act; Federal Insecticide, Fungicide, and Rodenticide Act; Endangered Species Act; Migratory Bird Treaty Act; Eagle Protection Act; and Fish and Wildlife Act.

Animal Damage Control Act

The Animal Damage Control Act of 1931 authorized and directed the Secretary of Agriculture to establish a federal agency to assist with the management of wildlife damage. It allowed the new agency (currently known as U.S. Department of Agriculture Animal and Plant Health Inspection Service [APHIS] Wildlife Services Program) to cooperate with other agencies, organizations, and institutes in order to manage wildlife damage. Overall, its mission is to protect agriculture, human health and safety, threatened and endangered species, and property without negative impacts on wildlife populations.

Federal Insecticide, Fungicide, and Rodenticide Act

The use of most pesticides is covered under the Federal Insecticide, Fungicide, and Rodenticide Act. A pesticide is any substance or mixture of substances intended for preventing, destroying, repelling, or mitigating any pest. Some pesticides can be purchased over the counter at retail outlets. These are known as general-use pesticides. Restricted-use pesticides require the user to be a certified applicator because these products can cause human injury or environmental damage even when used as directed.

Some pesticides used in wildlife damage management are chemical repellents that can frighten, irritate, sicken, or even kill animals. Rather than rely on store-bought products that may be dangerous if used improperly, some

U.S. DEPARTMENT OF AGRICULTURE APHIS WILDLIFE SERVICE PROGRAM IN MISSISSIPPI

The APHIS Wildlife Services Program provides federal leadership in the field of wildlife damage management. The program's responsibilities include:

◆ protecting threatened and endangered species by managing wildlife conflict;
◆ monitoring zoonotic wildlife diseases (those that can transfer between wildlife and humans); and
◆ providing assistance to the public (technical assistance or direct control) to reduce or eliminate damage caused by wildlife.

Direct control activities are provided for a fee through a cooperative service agreement. For more information about the APHIS Wildlife Services Program in Mississippi, contact the state office at (662) 325-3014, or visit online at www .aphis.usda.gov/wildlife.

individuals may try a home remedy—such as using moth balls to repel bats in the attic—to solve a wildlife problem. As a rule, such methods are generally ineffective. In addition, because of the regulations associated with this act, they often constitute a violation of federal law.

Endangered Species Act

All wildlife damage management activities must comply with the Endangered Species Act. This act specifically states that no federally listed species can be harassed, harmed, pursued, hunted, shot, wounded, killed, trapped, captured, or collected without a federal permit from the U.S. Fish and Wildlife Service. There are a number of criteria used by U.S. Fish and Wildlife Service to determine if a species should be listed under the act, and a public involvement process must be conducted as part of listing a species as threatened or endangered. A species may be listed across its entire range or just within a part of it. For example, the Louisiana black bear is federally protected as a threatened species south of Highway 82 in Mississippi. Anyone caught violating the act is subject to a felony, which may include a fine as well as time in prison.

The Migratory Bird Treaty Act

The Migratory Bird Treaty Act protects nearly all bird species in the United States. If causing damage, species covered under this act can be harassed without a permit, but they cannot be captured, harmed, shot, wounded, killed, or collected without a permit from the U.S. Fish and Wildlife Service. Evidence of damage must be provided to the U.S. Fish and Wildlife Service. This evidence must include documentation of the bird and/or birds causing damage, economic impacts the species is/are having on the resource being damaged, and the dollar amount of actual damage done. The U.S. Department of Agriculture APHIS Wildlife Services Program works with individuals to obtain these numbers and assist with applying for a depredation permit from the U.S. Fish and Wildlife Service.

Eagle Protection Act

This law protects both bald and golden eagles, including their parts, nests, or eggs, and prohibits molesting or disturbing the birds in the United States. Even though bald eagles have been delisted from the Endangered Species Act, they are still covered under the Eagle Protection Act. Therefore, a permit from the U.S. Fish and Wildlife Service is still required when bald eagles cause problems and require harassment or removal, such as at an airport where they may be nesting or causing safety issues to aircraft taking off or landing.

Fish and Wildlife Act

This law was passed on August 8, 1956, and has been amended frequently. The Fish and Wildlife Act establishes a comprehensive national fish, shellfish, and wildlife resources policy, with emphasis on the commercial fishing industry, but also with regard to the inherent right of every U.S. resident to fish for pleasure, enjoyment, and betterment and to maintain and increase public opportunities for recreational use of fish and wildlife resources. In 1972 a new section was added, which is commonly referred to as the Airborne Hunting Act. It prohibits shooting, attempting to shoot, or harassing any bird, fish, or other animal from aircraft except for certain specified reasons, including protection of wildlife, livestock, and human life as authorized by a federal or state issued license or permit. States authorized to issue permits are required to file reports with the Secretary of the Interior.

State Laws

Most states have laws for protecting wildlife. State laws can be more restrictive than federal laws, but not *less* restrictive. Although laws governing wildlife vary by state, most fall under the state wildlife or natural resource agency, which in our state is the Mississippi Department of Wildlife, Fisheries, and Parks. There are exceptions to this, however, as some state agricultural agencies have jurisdiction over particular wildlife laws or policies.

Mississippi has numerous wildlife species that are state-protected, such as American black bear, green salamander, rainbow snake, southern hognose snake, and peregrine falcon. The complete list can be obtained from the Mississippi Museum of Natural Science in Jackson (www.mdwfp.com/museum.aspx). In short, all wildlife damage activities involving state-protected species and any game species or furbearer killed outside of normal hunting and trapping seasons must be permitted by the Mississippi Department of Wildlife, Fisheries, and Parks.

PREVENTIVE OPTIONS

The most effective approach to managing wildlife damage is reducing the potential of the damage occurring. Preventative measures include modifying resources, using proper feeding techniques, and eliminating direct human-wildlife interactions (such as raising a wild animal as a pet). To do this effectively the landowner needs to understand the basic requirements of the problem animal in order to discourage it from initiating the damage activity. When done correctly, preventative management is the most effective and economical for the owner.

Modify Resources

Wildlife can cause numerous problems to agriculture and landscaping, but good management can abate many wildlife issues and also serve as a vital tool in wildlife conflict resolution. For example, catfish farmers use sacrificial ponds stocked with shad (a preferred food of the double-crested cormorant) to reduce the impacts of this bird species on catfish production ponds. Using agricultural varieties less palatable to birds and other species is another option. Producers may also want to consider planting seeds deeper in the ground. This technique has been successful in areas where birds have quickly picked seeds out of the ground after planting. Urban and suburban dwellers are introducing into flower and vegetable gardens less-appetizing plants to thwart deer from making a meal out of their landscaping.

Table 16.1. Landscape plants rarely damaged by deer browse	
Type of plant	**Species**
Trees	honey locust
	American holly
Shrubs	boxwood
	forsythia
	butterfly bush
	yucca
Annual flowers	ageratum
	snapdragon
	begonia
	dahlia
	blanket flower
	four o'clock
	geranium
	blue salvia
	marigold
Perennials	yarrow
	ornamental chives and onions
	butterfly milkweed
	coreopsis
	purple coneflower
	mint
	bee balm
	daffodil
	ferns
	sage
	goldenrod

Note: Deer will eat almost anything during periods of stress. Adapted from Bruzuszek, R. F. 2010. *Discouraging Deer in the Garden*. Mississippi State University Extension Service Fact Sheet.

Avoid Feeding Wildlife

To help prevent problems with wildlife, people should avoid certain behaviors such as feeding animals. Providing corn to attract deer for closer observation, for example, will encourage other animals that may not be welcomed. Also, bird feeders can attract predators such as foxes, coyotes, and birds of prey, which often prey

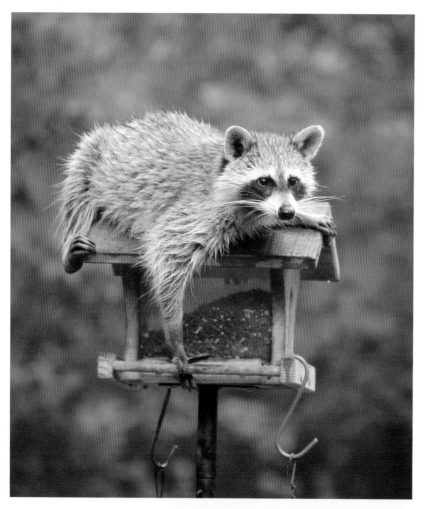

upon the birds the observer wants to attract to the feeding station. (Readers are encouraged to follow the recommended practices in chapter 15 regarding bird feeding stations.) In addition to increased predation, disease outbreaks are always a concern wherever wildlife are being fed. Canine distemper, a viral disease that can impair an animal's respiratory and digestive tract, is a fairly common disease found in canines throughout Mississippi. This potentially deadly infection can be easily transferred between animals using the same feeding areas.

Avoid Treating Animals as Pets

Many wild animals look cute and fuzzy, but they can also be dangerous. It is best to let wild animals be just that—wild animals. Many people have been attacked by protective adult geese while trying to pet or feed young goslings. This is also true of baby raccoons, skunks, and squirrels. Bears are especially prone to attack if their young appear to be threatened by approaching people. Not only is it unsafe, but trying to maintain a wild animal as a pet, whether free-roaming or contained, is illegal without proper state and/or federal permits.

Bird feeders often attract more than just birds. Mammals such as this young raccoon can be problematic as they become accustomed to human-provided food. Photo courtesy of iStock

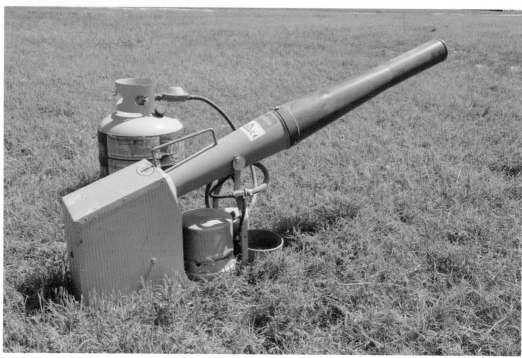

Bird cannons are common devices used in agricultural settings to discourage large flocks of birds from damaging crops. Photo courtesy of Adam T. Rohnke, Mississippi State University

COMMON TOOLS USED IN WILDLIFE DAMAGE MANAGEMENT

Many of the preventive measures are effective in specific situations and for limited periods of time. When they do not work or cannot be attempted because of logistical or economic constraints, there are several effective direct management tools that can be used to solve wildlife damage management problems. Nonlethal methods should always be explored first. In many situations, persistent harassment, when legal, can minimize or even prevent property damage by wildlife.

Harassment

Noise devices are popular harassment tools. For example, pyrotechnics are similar to firecrackers shot out of a cap pistol. Propane-fueled cannons can be set on a timer to go off at regular intervals. These tools work fairly well for numerous types of bird problems. Unfortunately, animals will eventually become accustomed to these sounds if other techniques are not used over time or if the equipment is allowed to be used in just one location without relocating it from time to time. Another noise device is playing bird distress calls on a loud speaker attached to the roof of a moving vehicle. Using all three of these noise harassment methods simultaneously is the most effective approach.

Physical disturbance is a harassment method most commonly practiced using trained dogs to chase problem animals. This technique has been used successfully with resident Canada geese, especially in urban and suburban areas, where other methods cannot be implemented.

Fencing

Fencing is a commonly used tool for some species of animals, particularly white-tailed deer. It can also be used to exclude rabbits, coyotes, and other animals from an area. Numerous types of fencing are available and can be purchased at just about any type of store that sells garden equipment or companies specializing in fencing equipment. Fences must be constructed to a height that will keep the problem animal from jumping over the top.

For burrowing or digging animals, portions of the fence need to be buried at certain depths to keep the animal from bypassing the barrier. Although effective when properly installed, fencing can be costly and require additional labor output for larger areas. Landowners should consult with their Mississippi State University Extension wildlife specialist or local Mississippi Department of Wildlife, Fisheries, and Parks officer for additional information.

Exclusion

Exclusion is a way to allow animals to move out or away from an area or structure and prevent them from gaining access again. This technique often works with bats, where one-way doors or outlets are created to let them out but not back in. Bats use their sense of smell to find openings they have repeatedly used to gain access to structures. By creating a one-way door or tube kicked back away from the structure, they are unable to gain access back into it. Exclusion methods also include using netting to protect soft fruit crops such as blueberries and cherries. Bird netting typically reduces, but rarely

A one-way bat exclusion device mounted below a building eave. Photo courtesy of Ricky Walker, U.S. Department of Agriculture APHIS Wildlife Services

Table 16.2. Common problem wildlife in Mississippi, their legal status, and the most common control methods

Wildlife	Legal status	Trap control method	When it can be trapped/controlled
Beavers	nuisance	trapping (Conibear, foothold, snares), hunting	year-round on private property
Feral hogs	nuisance	trapping (coral or large cage traps, snares), hunting	year-round on private property
Resident Canada geese	federally protected		only with depredation permit from U.S. Fish and Wildlife Service
Vultures	federally protected		only with depredation permit from U.S. Fish and Wildlife Service
Black birds	protected unless depredating on agriculture		under guidelines from Mississippi Department of Wildlife, Fisheries, and Parks or permit from U.S. Fish and Wildlife Service
Bats	nongame wildlife		state permit/license
Double-crested cormorants	federally protected		only with depredation permit from U.S. Fish and Wildlife Service
Snakes	nongame wildlife		state permit/license
Moles	nongame wildlife		state permit/license
Voles	nongame wildlife		state permit/license
Raccoons	game animal	trapping (foothold, cage, snares), hunting	see regulated hunting seasons with Mississippi Department of Wildlife, Fisheries, and Parks
Coyotes	nuisance	trapping (foothold, snares), hunting	year-round on private property
Foxes (red and gray)	nuisance	trapping (foothold, snares), hunting	year-round on private property
Skunks	nuisance	trapping (cage), hunting	year-round on private property
Alligators	federally and state protected	permit only	regulated permit draw hunts

Compiled by U.S. Department of Agriculture APHIS Wildlife Services and Mississippi Department of Wildlife, Fisheries, and Parks (Ricky Flynt). When this document was published, the legal statuses were current. State and federal regulations can change annually, so please verify with appropriate agency prior to using control method.

eliminates, damage caused by birds to these types of crops. But when used in conjunction with other methods, it represents yet another tool for the arsenal and can be very effective.

Trapping

Trapping has a long history in North America and at various periods of time has been a major economic enterprise. Because trapping was so effective by the turn of the twentieth century, many animals faced extirpation or even extinction. To reverse this trend, laws were created to regulate trapping in many states. Today, trapping continues to be one of the most common tools used in wildlife damage management.

Mississippi has a designated trapping season for animals classified as furbearers. A state trapper's license is required for this activity. If trapping on private land, a person must also obtain permission from the landowner. Trapping regulations may vary between state-owned wildlife management areas and federal lands. Traps can be used to capture state-listed nuisance species on private property year-round in Mississippi, including beavers and feral hogs.

When performed according to instructions from trained professionals, trapping is a safe

and effective method for capturing and removing nuisance animals. All users should respect a trap and its capabilities when setting it. Trapping not only requires skill and knowledge of the device's specifications, but also a familiarity with the targeted animal's biology and ecology (such as habitat, sign, tracks, and foraging requirements) to increase the success rate of capture and reduce the take of untargeted animals or pets. Moreover, an ethical trapper ensures that his or her traps are properly set and routinely checked, as required by state law. (For additional information about reducing unintended injury or suffering of the target species, see Trapping Laws at www.mdwfp.com.)

Traps are divided into two main categories: nonlethal and lethal. Common nonlethal traps include foothold traps, cage traps, and snares. Both foothold and cage traps allow animals to be released alive, especially untargeted catches like house cats. In the discussion that follows, traps are also grouped according to specific types.

Cage Traps.
These traps are commonly used in urban and suburban areas to minimize injury to captured pets (or other untargeted animals) and for the safety of the handler. Traps should match the size of the nuisance animal for best effectiveness. Cage traps can also be placed on trails or in areas where skunks and other undesirable animals enter holes in raised structure foundations. These traps can be wrapped and placed within brush or bushy material to be hidden from view.

Baiting live traps for most nuisance animals can be done simply by placing a can of sardines, cat food, or even peanut butter and jelly sandwiches inside the trap at the back of the pan. Skunks, raccoons, and opossums readily enter live traps baited with such foods. Other animals such as coyotes and bobcats are not quite so easily caught in cage traps.

Foothold Traps.
Foothold traps are designed to hold an animal's foot without damaging the limb or the animal. Some types feature padded jaws that allow the blood to circulate and reduce the chances for

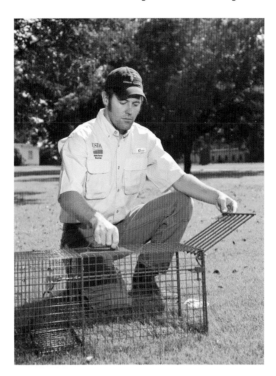

Cage traps are versatile options for many different species of animals in diverse situations. Photo courtesy of U.S. Department of Agriculture APHIS Wildlife Services

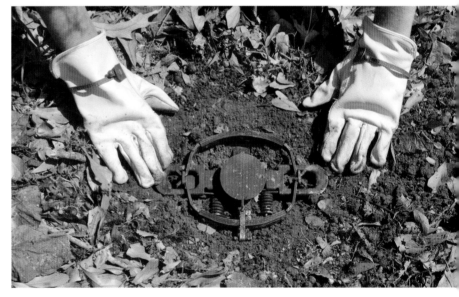

injury. The trap should be set in an area where the target animal generally walks or travels; ideally, it should be slightly buried under dirt for concealment. When the animal steps on the pan of the trap, it is caught by the foot. The animal can then be removed with a snare pole or, in the case of a research project, animals are sedated and then removed. If necessary, captured animals may be euthanized. Target animals for foothold traps are coyote, bobcat, beaver, raccoon, and foxes. Refer to state law on use of

Proper placement of a foothold trap in a wooded area. The trapper is wearing gloves during setup to avoid leaving human scent on the trap. Photo courtesy of U.S. Department of Agriculture APHIS Wildlife Services

A typical snare trap in place. Photo courtesy of U.S. Department of Agriculture APHIS Wildlife Services

Commonly used to trap beaver, the Conibear trap is most effective when positioned below the waterline at the entry point to the water source. Photo courtesy of U.S. Department of Agriculture APHIS Wildlife Services

lures and baits when trapping, as this can vary for trap type and species by state and by season. (See Trapping Laws at www.mdwfp.com.)

Snares.

A snare is another tool for live capture. It is a simple trap consisting of a cable loop set to catch the animal around a certain part of the body as it travels through an area. The cable is usually anchored to a tree or stick that the animal cannot break free from. A snare lock can be used to release untargeted animals such as deer. Baiting and removal methods are similar to those of foothold traps. Snares are commonly used to capture beavers, coyotes, and black bears.

Lethal Traps.

Some traps, such as the Conibear trap, are designed for lethal removal of animals. This trap is commonly used in beaver control work as well as for nutria (large plant-eating, semi-aquatic rodents native to South America) and muskrat damage complaints. This trap is safest and most effective when set under water to capture these animals in their routine activities, including entering and exiting their nests or entry points to main water sources. By setting traps underwater, the trapper can reduce the chances of capturing untargeted animals.

PROBLEM SPECIES IN MISSISSIPPI

Any species at one time or another can cause problems for people. For example, hawks can prey on songbirds at bird feeders, and mice, squirrels, lizards, and raccoons can get into houses. Here we discuss some of the birds, mammals, and large or venomous reptiles that cause the majority of problems encountered in Mississippi.

Beavers

Because of the state's numerous streams and river systems, Mississippi provides abundant habitat for beavers. It is difficult to imagine that this animal was almost extirpated from the state shortly after the turn of the twentieth

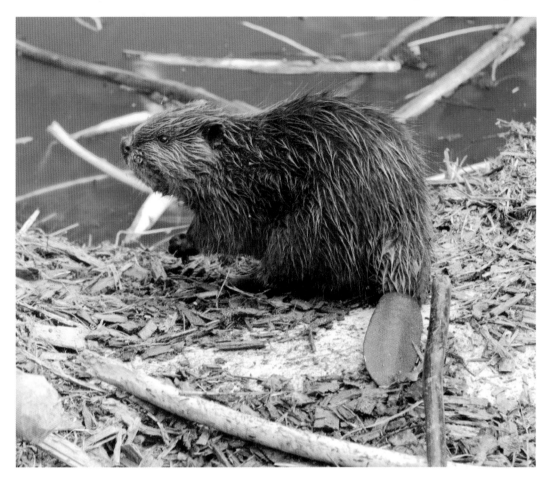

A young beaver near its lodge. Photo courtesy of iStock

Beavers are powerful animals that can easily damage or remove medium-sized trees (left center) and larger trees (pine tree, right center). Photo courtesy of U.S. Department of Agriculture APHIS Wildlife Services

This young pine stand was destroyed by standing water backing up from a nearby beaver lodge. Photo courtesy of U.S. Department of Agriculture APHIS Wildlife Services

In recent decades, Canada geese have thrived in the suburban landscape across the United States. Photo courtesy of iStock

century. Today, beavers cause a tremendous amount of destruction every year. They build dams as their primary defense mechanism against predators, but, unfortunately, these structures raise water levels and can create havoc for humans.

Beavers live in either lodges or bank dens and feed on roots, grasses, bushes, and tree bark. Their teeth grow continuously, so they must gnaw on hard material such as trees to keep their teeth from growing into their skulls. Because of their ability to dam water, beavers can threaten valuable resources by flooding. Roads, agricultural crops, timber resources, and private property damage can be in the hundreds of thousands of dollars yearly because of flood damage. Beavers can also cause pond levees to collapse by tunneling out bank dens. They cause damage to landscaping by removing or destroying trees and vegetation. Disease issues such as giardia, a parasite that causes diarrheal illness, may also be associated with beavers.

Control Methods.
Beaver removal is most commonly done by trapping or shooting. Live removal is generally not recommended for several reasons. First, live-trapped beavers can stress very easily and die. Second, beavers are territorial, so moving them into another family's territory can lead to fighting, injuring, or killing each other. Third, by moving animals, a new problem may only be created for someone else.

Beavers can be removed by private citizens during the normal trapping season or by a private landowner on his or her property out of season. To ensure the methods used are legal, work with the Mississippi Department of Wildlife, Fisheries, and Parks conservation officer in your county.

Resident Canada Geese

After resident Canada geese were introduced to the state by humans several decades ago, some

populations of Canada geese have become nonmigratory (year-round) residents. Unfortunately, these birds have reproduced to the point they are causing problems—most notably their droppings and aggressive nature during the gosling-rearing period—in suburban settings, municipal parks, golf courses, state parks, and federal recreational facilities.

Lethal Control Methods.
These birds are federally protected and can only be controlled after obtaining a depredation permit from U.S. Fish and Wildlife Service. Effective lethal control of Canada geese usually includes two steps: reducing current-year nest and egg production and removal of adult birds. Nest and egg destruction can be accomplished through physical destruction using a pin to puncture the egg, egg oiling, and a technique called egg addling, which destroys the embryo but not the outer shell of the egg. The last technique encourages the adult birds not to

abandon the nest and produce additional eggs elsewhere. The most common removal methods are the annual waterfowl hunting seasons and capture. An early hunting season has been established for resident Canada geese and is encouraged in areas where permissible.

Capture of adult geese can only be done under permit and only during specific times of the year. The most effective method is rounding up geese during the flightless period, which is generally in June when birds are molting feathers. Once captured, they can be moved or euthanized.

Nonlethal Control Methods.
Physical harassment options include using trained dogs to chase geese. This tool is effective but can be expensive. Over time, it can be less effective as geese become accustomed to the disturbance. Another technique involves the use of anthraquinone, a chemical that can be sprayed on turf; when ingested by the geese,

Dozens of adult Canada geese rounded up in a pen during the flightless period in June. Photo courtesy of U.S. Department of Agriculture APHIS Wildlife Services

Feral swine can vary in coat coloration, ranging from black, brown, and reddish brown (shown) to gray with spotting and other markings. Photo courtesy of Rex Allen Jones

Feral swine damage in an old field. Typical signs include wallowing holes (left center) and major soil disturbance. Photo courtesy of William W. Hamrick, Mississippi State University

it causes them to become sick. Anthraquinone acts as an inhibitor to eating grass or turf, especially on golf courses or expensive manicured areas. Other landscape management options include planting grass varieties less preferred by geese and varying mowing regimes. Stringing wire short distances apart across small bodies of water has also been effective in keeping geese out of an area because they need long runways to land and take off.

Feral Swine

Feral swine are fast becoming one of the most destructive wildlife species in Mississippi and other states. These animals have an incredible reproductive capacity and, other than humans, very few natural predators. They can exist in extreme environments and readily adapt to almost any food source available. Feral swine in Mississippi have damaged golf courses, private

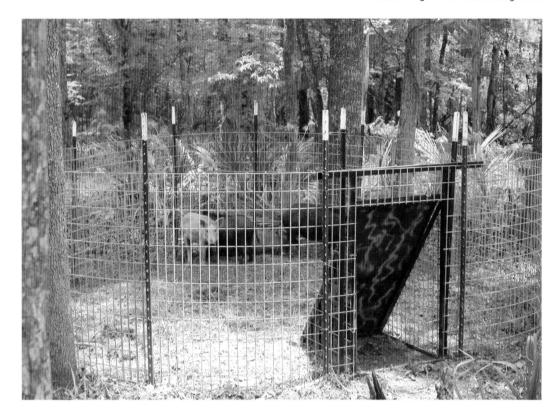

Coral traps are the most efficient method of trapping feral swine available to private landowners. Photo courtesy of Chris Jaworowski, Alabama Department of Conservation and Natural Resources

property, earthen levees, and agricultural crops such as rice, peanuts, soybeans, and corn. They also compete for food resources with native turkey, deer, and squirrels. An adult feral swine can eat up to 5 pounds of mast per day. These animals are also capable of carrying and transmitting several diseases to humans and livestock. Active feral swine disease surveillance is ongoing in Mississippi.

Feral swine are considered a nuisance species by state law and can be taken on private property during any time of the year, day or night. Feral swine are smart and tend to move about with just a small amount of disturbance. Control can be difficult after populations are established.

Control Methods.
Coral trapping, shooting, and hunting with dogs can all be effective tools to control feral swine. Snares have also been used successfully to capture them in specific situations. At this time, there are no pesticides legal for use on feral swine.

Coral traps are large circular traps that can hold several animals. The key to a successful coral trap is the door. Different door types are available for purchase or can be built to the trapper's specifications. All traps must have open tops in Mississippi, so untargeted animals (most notably the protected black bear) can escape. Animals should be euthanized immediately upon capture. Use protective gloves for handling dead animals, as this will help reduce chances of any possible disease transmission. Transporting live feral swine in Mississippi without a permit is illegal. Contact your local county conservation officer for baiting and permitting requirements.

Shooting is an effective control method for feral hogs. Adult boars have a tough protective plate covering the shoulder area. Therefore, a hunter needs to be sure the ammunition is of such caliber and weight to effectively penetrate this area if, indeed, it is the target. Hunting with dogs is a popular sport and can increase the hunter's success rate. However, caution should be taken because feral swine are potential carriers of pseudorabies, a potentially fatal disease that can be transmitted from swine to dogs.

Feral swine control in Mississippi is a major undertaking and will require the cooperation of every landowner with these animals on his or

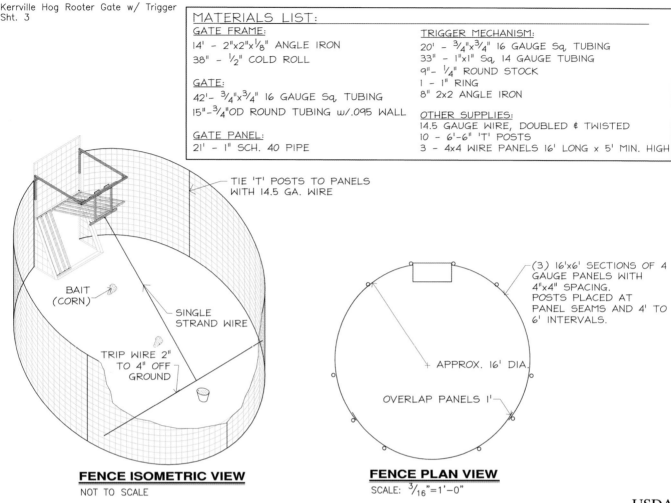

Kerrville Hog Rooter Gate w/ Trigger
Sht. 3

MATERIALS LIST:

GATE FRAME:
14' - 2"x2"x$\frac{1}{8}$" ANGLE IRON
38" - $\frac{1}{2}$" COLD ROLL

GATE:
42'- $\frac{3}{4}$"x$\frac{3}{4}$" 16 GAUGE Sq. TUBING
15"-$\frac{3}{4}$"OD ROUND TUBING w/.095 WALL

GATE PANEL:
21' - 1" SCH. 40 PIPE

TRIGGER MECHANISM:
20' - $\frac{3}{4}$"x$\frac{3}{4}$" 16 GAUGE Sq. TUBING
33" - 1"x1" Sq. 14 GAUGE TUBING
9"- $\frac{1}{4}$" ROUND STOCK
1 - 1" RING
8" 2x2 ANGLE IRON

OTHER SUPPLIES:
14.5 GAUGE WIRE, DOUBLED & TWISTED
10 - 6'-6' 'T' POSTS
3 - 4x4 WIRE PANELS 16' LONG x 5' MIN. HIGH

TIE 'T' POSTS TO PANELS
WITH 14.5 GA. WIRE

BAIT
(CORN)

SINGLE
STRAND WIRE

TRIP WIRE 2"
TO 4" OFF
GROUND

(3) 16'x6' SECTIONS OF 4
GAUGE PANELS WITH
4"x4" SPACING.
POSTS PLACED AT
PANEL SEAMS AND 4' TO
6' INTERVALS.

APPROX. 16' DIA.

OVERLAP PANELS 1'

FENCE ISOMETRIC VIEW
NOT TO SCALE

FENCE PLAN VIEW
SCALE: $\frac{3}{16}$"=1'-0"

United States Dept. of Agriculture • Wildlife Services • (573)449-3033 • 1714 Commerce Court, Suite C, Columbia, MO 65202 **USDA**
Designed by Bob Sims (TX USDA) • Drafted by Rhonda Bonnot (MDC) • Trigger Design by Dan McMurtry (MO. USDA) With cooperation from MDC Design & Development

The Kerrville Hog Rooter Gate with trigger trap is one of several cost-effective trapping options available to private landowners. Figure courtesy of U.S. Department of Agriculture APHIS Wildlife Services

her property. Illegal transportation across state lines and within the state only increases their numbers and allows the potential introduction of transmittable diseases to humans and livestock. After populations become established, it is increasingly difficult to eradicate them at the local level, and most likely impossible on a statewide level. Right now, the next best option is to educate the public about the effective and legal use of acceptable control methods.

Vultures

Mississippi has both black and turkey vultures. Over the past several years, the number of complaints involving these two species has increased. Most problems are associated with roost sites established on cell phone towers and water tanks within city limits. Vultures cause damage to these structures with their droppings and ability to pull on wires and insulation. They are also attracted to rubber roof tops. The general public tends to think of these birds as eerie, and their presence in roost sites can be very disturbing to some individuals. Vultures also prey on cattle and other agricultural animals, especially during birthing periods when females are down and unable to defend themselves or their young. Vultures are among the few bird species that have the ability to smell. This is how they are able to locate road kills and other feeding opportunities.

Control Methods.
Vultures are protected by the Migratory Bird Treaty Act, so lethal removal can be done only

Black vulture. Photo courtesy of iStock

Turkey vulture. Photo courtesy of iStock

if the landowner has a depredation permit from the U.S. Fish and Wildlife Service. Noise devices are less invasive, and they must be persistently used over an extended period of time, generally a minimum of 2 weeks. Birds should not be allowed to land in the roost site without being harassed. Research is currently being done on other techniques that could be effective in forcing these birds to relocate.

Black Bird Roosts

Every year during winter, several areas of the state experience problems with large numbers of European starlings, grackles, and red-winged blackbirds, known collectively as black bird roosts. These birds, which establish roost sites in areas with fairly thick trees, congregate by the thousands. Noise and droppings are the main complaints as these roost sites become established. Black bird roosts that have been established for several years can harbor histoplasmosis. A respiratory virus, histoplasmosis is caused by a fungus that naturally exists in

Both black and turkey vultures roost in trees and on man-made structures. Photo courtesy of U.S. Department of Agriculture APHIS Wildlife Services

European starling. Photo courtesy of iStock

Common grackle. Photo courtesy of iStock

Red-winged blackbird. Photo courtesy of iStock

Black birds can congregate by the thousands in large trees in both urban and rural areas. Photo courtesy of David Schwaegler

the soil across the Southeast, and most people living here have probably been exposed to it. There are incidents, however, where people came in contact with the spores, developed the virus, and became ill. Further questions about this disease should be directed to the Mississippi State Department of Health.

Control Methods.
Black bird roosts can be very difficult to disperse. The two most common techniques are noise and thinning the secondary and tertiary branches of trees within the roost site. Persistent noise is really the key to successful roost dispersal. It generally takes several mornings and evenings of using pyrotechnics, propane cannons, or other noise devices to successfully disperse the birds from the roost site. Very few, if any, legal lethal control methods can be used. For black birds causing problems at dairy cattle feeding sites or other feedlot situations, chemical control may be an option. These are restricted-use chemicals applied by a certified applicator and approved for use within the state.

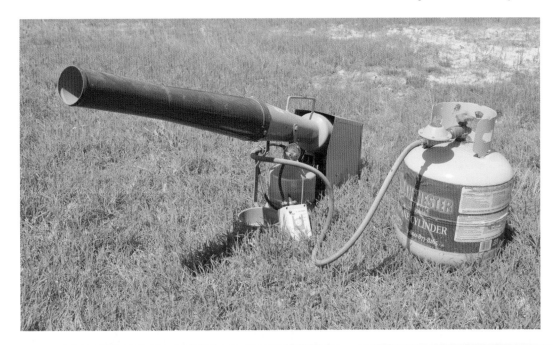

Propane-fueled bird cannons can effectively disperse problematic bird species. Photo courtesy of Adam T. Rohnke, Mississippi State University

The little brown bat (or little brown myotis) is difficult to distinguish from other bats in the Southeast. Little brown bats range from 3 to 4 inches in body length and 0.25 to 0.45 ounces in weight. Photo courtesy of Timothy Carter

As their name implies, big brown bats are typically larger, averaging 3.5 to 5.5 inches in length and 0.4 to 0.6 ounces in weight. Photo courtesy of Timothy Carter

Bats

Numerous species of bats can be found in Mississippi. All are protected by state law, and several are protected under the Endangered Species Act. There are no registered chemical repellents or pesticides that can legally be used for bat control. Most bat problems are caused by three species in Mississippi: the little brown bat, big brown bat, and the Mexican free-tailed bat. Although these three species tend to dwell in structures, other species are somewhat solitary in nature and do not congregate in colonies to the same degree as the structural dwellers. Occasionally, a solitary bat will be found mixed in with a colony of structure dwellers.

Problems with bats tend to be associated with noise within buildings or homes, and if

Mexican free-tailed bats have a tail that noticeably extends past the tail membrane (upper-left corner). These bats also show grooves or furrows on the lips and are similar in size to the big brown bat. Photo courtesy of Timothy Carter

the colony has been in the structure for any length of time, an odor of urine generally develops from the accumulation of guano (bat droppings). Bats can harbor the rabies virus, so it is extremely important not to handle these animals if possible. If bitten by a bat, the person should go immediately to a county health department facility to begin post-exposure treatment, which consists of five shots given in the arm over a 4-week period.

Control Methods.

The most acceptable approach to resolving problems with bats is to exclude them from the structure where they live. Exclusion should not be done between the months of May through August, as such activities could seal pups (baby bats) inside. Basically, exclusion consists of creating a one-way exit door that allows animals out but not back in. Bat entrances can be found by observing the structure during evening hours to see where they are coming out, or during early morning to locate their point of entry. Established sites will have guano present along with dark rub marks where the bats

have rubbed up on the structure during entry and exit. The exclusion device should remain in place for at least 1 month to allow all animals a chance to get out. The structure should be inspected for any cracks ¼ inch or larger, and these should be sealed before exclusion activities begin.

Bats will try to re-enter the structure once excluded and will test the building for several days or weeks trying to re-enter. During that time, bat boxes can be installed. Some animals may use them temporarily until a new roost site is established. Avoid using bat exclusion devices that actually capture the animals so they can be moved. Bats may harbor the rabies virus and should not be relocated, thus possibly causing problems somewhere else. Also, bats have a very strong affinity for roost sites and need to be moved as far away as possible to ensure they will not come back and re-infest the structure. Although bats are voracious insect eaters and great for mosquito control, they should not be allowed to interact with humans.

Bat guano can test positive for histoplasmosis. For that reason, workers cleaning up a site

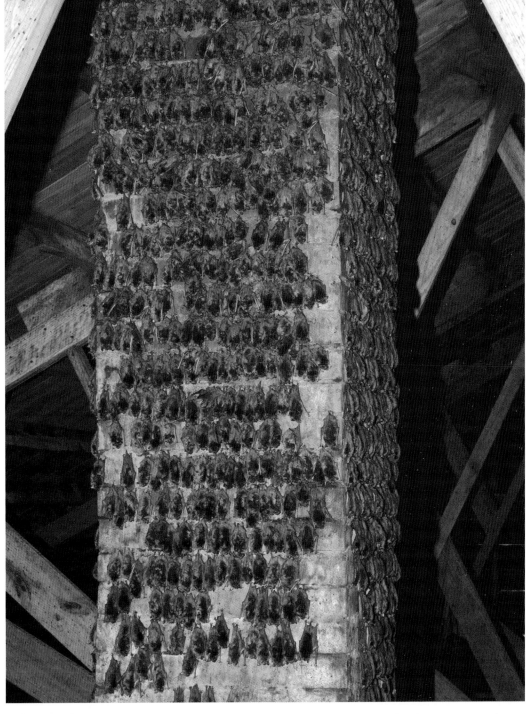

A large established colony of little brown bats in the attic of an older building. Photo courtesy of Timothy Carter

Two bats exiting a one-way exclosure device on the side of a building. Photo courtesy of U.S. Department of Agriculture APHIS Wildlife Services

Double-crested cormorants are commonly found diving for fish in both natural bodies of water and aquaculture ponds. Photo courtesy of U.S. Department of Agriculture APHIS Wildlife Services

should be required to use a respirator. Consultation with the Mississippi Department of Health is advised for large structural cleanup. Generally, companies outfitted for asbestos removal have the proper equipment to remove large amounts of bat guano.

Bat problems are not solved overnight. Once exclusion has been accomplished, the building should be monitored over several months to ensure that animals do not find other entrances that may have been missed upon initial inspection. If this occurs, exclusion will need to done on the new entrance and exit sites.

Several pesticides, including moth balls, are being marketed as effective bat repellants, but this is absolutely false. The active ingredient in moth balls is naphthalene, which must be put out in such high concentrations to ward off bats that the product would kill the human residents of a building before it does anything

to the bats. Right now, there are no legal, effective repellents available for bat removal.

Fish-Eating Birds

Several species of fish-eating birds live in Mississippi. These birds generally create problems for aquaculture facilities. Double-crested cormorants, for example, cause significant losses—sometime millions of dollars—to the catfish industry every year. An adult cormorant eats approximately 1.5 pounds of fish per day. During one day in February 2010, 55,000 double-crested cormorants were counted just within the Mississippi Delta.

Fish-eating birds not only affect the aquaculture industry, they also negatively affect recreational fishing areas. In Mississippi, private ponds and lakes with recently stocked fingerling fish have been affected by fish-eating birds,

Great egrets congregate in large numbers on the banks of aquaculture ponds. Photo courtesy of Les Torrans

Alligators can be seen in and around housing developments. Photo courtesy of Lynn McCoy, Mississippi Department of Wildlife, Fisheries, and Parks

especially double-crested cormorants. Other species of concern regarding fish depredations are American white pelicans, great blue herons, great egrets, wood storks, and night herons. All of these birds are protected by the Migratory Bird Treaty Act.

Control Methods.
Currently, there is a depredation order in place that allows aquaculture producers to lethally remove cormorants on their ponds. To do so, the APHIS Wildlife Services Program must first verify that the producer is using nonlethal techniques before the U.S. Fish and Wildlife Service will allow the facility personnel to lethally remove the birds under the depredation order. Producers must use steel shot and are required to report the number of cormorants killed every year. For all other birds, a depredation permit must be issued.

Alligators

These animals occasionally cause problems for homeowners living near the coast or inland

Garter snakes are common in backyards and gardens across Mississippi. Their primary prey include amphibians, invertebrates, and small rodents. Photo courtesy of David Cappaert, Michigan State University, Bugwood.org

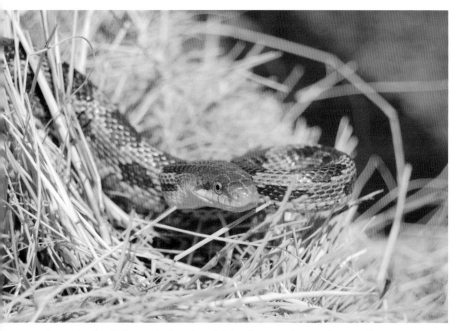

Rat snakes (or chicken snakes) are beneficial and pose no threat to humans. They prey on rodents. Photo courtesy of John Hardy, Mississippi Department of Wildlife, Fisheries, and Parks

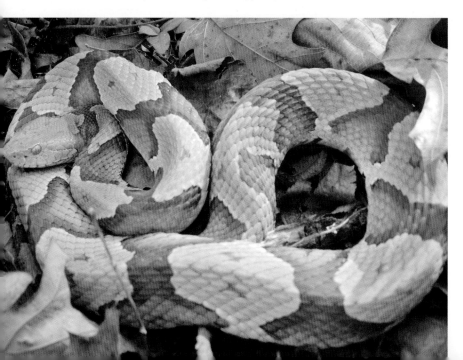

waterways. Just the presence of an alligator is frightening to some people. Alligators feed primarily on fish and small birds and occasionally on animals like beavers or nutria. Alligators cause problems when they become accustomed to people feeding them, either directly or indirectly. They quickly lose their fear of humans after zeroing in on a readily available food source. Restaurants and obliging customers on many of the state's waterways provide access to food sources by improperly disposing of garbage. Boaters can inadvertently provide food when cleaning fish and leaving carcasses and other fish parts in areas accessible to alligators. Unfortunately, alligators have been known to take small pets and attack people. These instances are rare, given the state's alligator population. In most cases, alligators have a healthy fear of people and will stay away from human activity.

Control Methods.

Alligators are protected by the Convention on International Trade of Endangered Species (better known as CITES). Alligators are considered to be similar to reptiles classified as globally rare or protected. Therefore, there is no open hunting season on alligators, but they can be taken by the regulated permitted hunting process as designated by the Mississippi Department of Wildlife, Fisheries, and Parks. Alligator hunts are conducted on a draw-permit basis in several areas throughout Mississippi. Permit-holders are required to take a one-day safety and harvesting instructional class before being allowed to hunt with their permit in the designated body of water. If you have a potential problem with an alligator, contact the state alligator biologist with the Mississippi Department of Wildlife, Fisheries, and Parks.

Snakes

Mississippi has numerous species of snakes. Snakes can help with rodent and insect control

Copperheads are one of six venomous snake species in Mississippi. If left alone, they are only a minor threat to humans. Photo courtesy of Allen Bridgman, South Carolina Department of Natural Resources, Bugwood.org

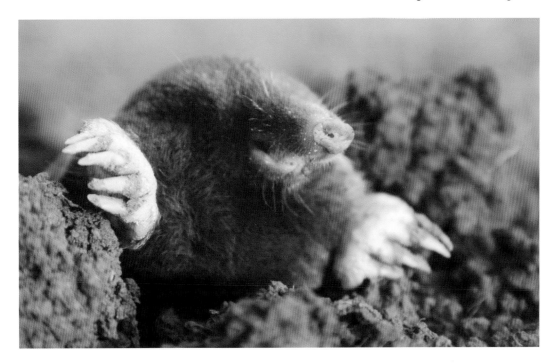

Eastern mole. Photo courtesy of iStock

Woodland vole. Photo courtesy of iStock

and are generally secretive and try to stay out of the way of humans. With each species of snake come specific habitat requirements, some of which cause problems for people. Most snakes eat insects, with the exception of the poisonous species, which eat mice, rats, fish, and occasionally rabbits and squirrels. Often it is the search for food that brings these animals in contact with people.

Control Methods.

In most situations where snakes are found in homes, schools, or other buildings occupied by people, high populations of insects or mice have been discovered. The best recommendation is to keep garbage and clutter away from buildings because they offer food and cover for snakes. Also, grass and weeds should be mowed and kept low.

Although people try home remedies such as sulfur or broken glass to get rid of snakes, none of these remedies work, as the snake does not recognize these as deterrents. When searching for prey, snakes really only have one tool: smell. Like most animals, snakes use their nose to smell, but this sense is not highly developed. Instead, their forked tongues have a highly developed sense of smell, which they use to pick up chemical signals from their prey. It is these signals, when brought from the tongue to the Jacobson's organ (pits in the roof of the mouth) that let the snake know prey is near. Many stores sell products advertised as snake repellents, but they generally do not work because the snake does not recognize the chemical active ingredients as something harmful to them.

Moles and Voles

Both moles and voles help aerate soil by tunneling. Mole activity and problems including tunneling throughout a lawn or garden area is often a result of a large grub infestation. An easy way to remember the difference between the dietary needs of voles and moles is V (voles) for vegetation and M (moles) for meat. Although moles are meat eaters, they also like insects.

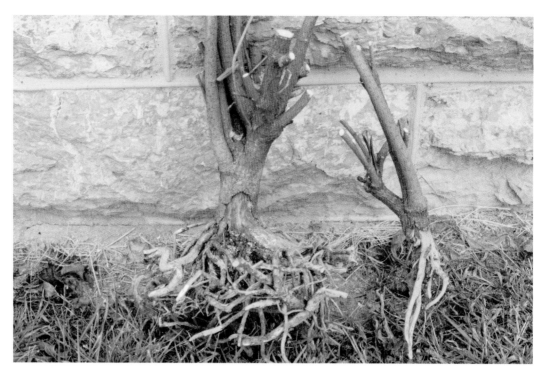

Root girdling of plants and bushes is the most common damage caused by voles. Photo courtesy of Mary Ann Hansen, Virginia Polytechnic Institute and State University, Bugwood.org

Mounds and tunneling by moles can be extensive in backyards and especially problematic on golf courses. Photo courtesy of Stephen Vantessel, Wildlife Control Consultant, LLC

Control Methods.
For starters, the best thing a landowner can do is to apply a grubacide to the lawn or flower bed and eliminate the food source that moles seek. Keep lawns well manicured and flower beds free of weeds as much as possible. These animals require cover and are favorite prey items for most of the state's predatory birds, so reducing cover will help. Pesticides on the market such as poisoned peanuts generally do not work for moles because they are meat-eaters. If a homeowner's tulip bulbs are being eaten, that is the result of a vole not a mole. Poisoned peanuts would be a much better choice for this animal. Traps can also be useful for both species and can be found in most county co-ops or lawn and garden supply stores. These are usually either a harpoon style trap set above the tunnel activity or a small box or pincer trap set in the tunnel runs. Using a combination of both trapping and a grubacide is the most effective way to deal with problems caused by moles and voles.

Armadillos

Armadillos can be a nuisance to many homeowners, especially those with well-manicured, fertilized lawns and gardens. These animals burrow and dig for their food, mainly grubs and worms. Any lawn or garden with an ample supply of either is an invitation to an armadillo.

Control Methods.
These animals conduct their activities primarily at night, so they are very hard to catch.

Armadillos are not easy to trap because they do not generally come to any kind of bait. Funneling them into box traps using long slender wood planks along the side of a house or other structure has been used somewhat successfully. The most effective method is to apply a grubacide to the affected area. This removes the animal's food source and should force it to move on to more suitable hunting areas to find food. These types of products can be purchased at local farm supply or county cooperatives. Store personnel can offer further assistance in recommending products that will be most effective for the area to be treated.

SUMMARY

Wildlife damage management focuses on resolving conflicts between people and wildlife. It may be as minor as a raccoon in a chimney or as far-reaching as millions of dollars in losses caused by an errant wildlife species out of control. The negative impact of the double-crested cormorant on aquaculture is a case in point.

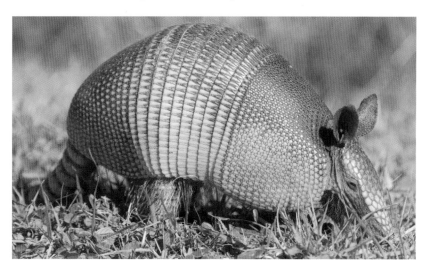

Nine-banded armadillos are commonly found throughout Mississippi and the Southeast. Photo courtesy of iStock

Wildlife are important to most people, so how do we resolve problems with animals that share the same resources? In most cases, there are no easy answers. Nonlethal methods are most commonly employed first. Often, it takes more than just one method and one treatment to resolve the conflict. Timing, persistence, and diversity must all be considered in choosing any problem-solving tool. Practicality, safety, legality, and economics are other factors that should be assessed.

For more information, consult your local Mississippi State University Extension agent or contact the U.S. Department of Agriculture APHIS Wildlife Services Program. The APHIS website is also an excellent resource for learning more about managing wildlife conflict.

For More Information

Center for Resolving Human-Wildlife Conflicts at Mississippi State University, http://humanwildlifeconflicts.msstate.edu

Conover, M. 2002. *Resolving Human–Wildlife Conflicts: The Science of Wildlife Damage Management*. Boca Raton, FL: CRC Press.

Internet Center for Wildlife Damage Management website: http://icwdm.org

AGENCIES THAT PROVIDE TECHNICAL GUIDANCE FOR WILDLIFE PROBLEMS IN MISSISSIPPI

U.S. Department of Agriculture APHIS Wildlife Services Program
Provides technical, direct control, and legal advice
www.aphis.usda.gov
(662) 325-3014

Mississippi Department of Wildlife, Fisheries, and Parks
Provides legal and technical advice
www.mdwfp.com
(601) 432-2199 (wildlife help desk)

Mississippi State University Extension Service
Provides technical advice
www.msucares.com
(662) 325-3174 (wildlife and fisheries)

Randy Browning, Partners Biologist, U.S. Fish and Wildlife Service and Wildlife Mississippi

Technical editor
Andy W. Ezell, Professor
 and Head of Forestry,
 Department of Forestry,
 Mississippi State University

CHAPTER 17

Managing Invasive Plants

Non-native plants have been introduced into the United States over the past few centuries for various reasons. It is estimated that 100 million acres in the United States are infested with some type of non-native vegetation. Although certain plants were introduced accidentally, most have been established as ornamentals or as livestock forage. Others have been used for soil stabilization, soil reclamation, and wildlife forage.

Many non-native plants have proven beneficial and are used on a regular basis. For example, the majority of supplemental forage species previously mentioned in this book were introduced. However, numerous introduced species have become naturalized, and landowners often do not realize they are non-native. In the absence of natural predators and pathogens, many have become invasive and have infested the state's forests, wildlife openings, pastures, rights-of-way, and waterways. Invasive, non-native plants threaten the integrity of natural ecosystems by outcompeting natural vegetation and subsequently degrading species diversity and the value of wildlife habitat. These non-native plants threaten the livelihood of landowners by hindering land management practices and ultimately reducing forest and agricultural productivity.

Terrestrial invasive plants include trees, shrubs, vines, forbs, grasses, sedges, and ferns. Among common invasive trees in Mississippi are mimosa, chinaberry, and Chinese tallowtree. Invasive shrubs such as autumn olive, Chinese privet, Japanese privet, bicolor lespedeza, and non-native roses are also common. Invasive vines that thrive within the state's boundaries include Japanese honeysuckle, kudzu, and wisteria. A couple of subshrubs that have become invasive are sericea lespedeza and tropical soda apple. Grasses that

Kudzu. Photo courtesy of iStock

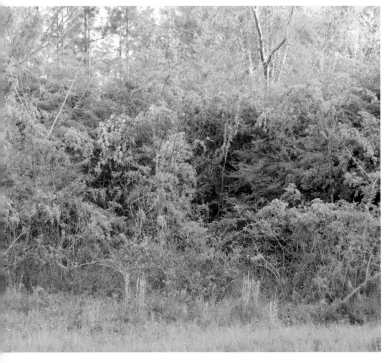

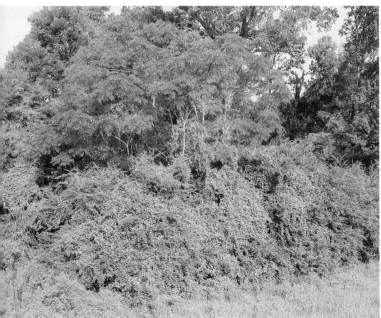

Mississippi has a large diversity of invasive species that come in many forms, including Chinese wisteria, Chinese privet, mixed invasive shrubs and vines, and cogongrass. Photos courtesy of Randy Browning, U.S. Fish and Wildlife Service and Wildlife Mississippi

have infested countless acres within Mississippi are tall fescue and cogongrass. Deep-rooted sedge and Japanese climbing fern are other nuisance plants that infest portions of the state.

Terrestrial invasive plants are spread a multitude of ways, and their dispersal often occurs along stream corridors or rights-of-way. A few invasive plants infest areas rapidly by wind-blown seed or spores, whereas others spread across the landscape by bird- and mammal-dispersed seeds. Unfortunately, natural spread is often accelerated by individuals who plant non-native species or transport equipment or soil contaminated with one or more of them.

Landowners can deter the establishment of invasive, non-native species on their property by becoming aware of potential problems associated with these species, being vigilant of any infestations, and reacting promptly and eradicating these species while infestations are small.

To control or eradicate non-native plants, it is important to understand the particular species in question. Most invasive species are perennial and have extensive root systems. Treatments such as cutting, chopping, or prescribed burning usually give only temporary control of aboveground vegetation. Mechanical root raking and disking have been known to spread cogongrass, a rhizome-producing plant. Although intensive grazing has been shown to reduce vigor of some palatable plants such as kudzu, this practice actually spreads others such as tropical soda apple.

Applying appropriate herbicides is the most effective method of controlling non-native, invasive plants. Herbicides can effectively kill the entire plant and are the preferred method of

Non-native invasive plants can be introduced and spread through natural means, such as animals, as well as human activities, such as landscaping and resource extraction. Photos courtesy of iStock (American robin, mowing, logging operation); Mark Crosby, University of Georgia, Bugwood.org (cogongrass)

control, especially when erosion is a concern. Because of the tenacity of some species, however, several herbicide treatments may be required for adequate control or eradication. Integrated control methods may be necessary for effective, cost-efficient control of large infestations. Cutting and/or prescribed burning can reduce aboveground biomass (vegetative matter) and subsequently reduce the amount of herbicide needed. However, as previously mentioned, it is important to understand the characteristics of the particular species infesting your property. For example, well-established stands of cogongrass should be burned with extreme care, particularly if it is growing under desirable trees. Cogongrass burns at extremely high temperatures (around 840°F), and such high heat can damage or kill overstory trees.

APPLYING HERBICIDES

Before applying herbicides, the landowner must understand the different types of application methods. Large infestations are often treated with broadcast applications of foliar sprays applied by helicopter, tractor, or skidder. However, broadcast applications are generally not selective and often damage or kill untargeted species. Selective herbicide treatments that minimize herbicide contact to untargeted plants include directed foliar applications, basal sprays, cut stump, injection, and soil spot treatments. The treatment chosen will depend upon the species to be controlled, the size of the target plant or infestation, and the surrounding vegetation. Before applying any herbicide, carefully read and follow all product labels. Use the most effective herbicide for the species to be controlled, and use the correct method of application during the optimum time period.

If possible, do not apply herbicide when plants are undergoing drought stress, as chemical uptake is poor under these conditions. Landowners must be patient when using herbicides, as some of them move slowly through the plant and visual evidence may not appear for several weeks. Also, do not use soil-active herbicides on invasive plants when they are under or within the root zone of susceptible trees or

SAFETY WHEN USING CHEMICALS

Before applying or handling herbicides, read and follow the label. When applying herbicides, applicators and handlers must wear personal protective equipment. Items that are often required include:

- long-sleeved shirt;
- long pants;
- boots or shoes with socks;
- chemical-resistant gloves; and
- protective eye wear.

Maintain and clean personal protective equipment by following the herbicide manufacturer's recommendations. If no recommendations are available, wash clothing in laundry detergent and store away from other laundry. After handling or applying herbicide, the user should wash hands thoroughly before eating, drinking, chewing gum, using tobacco, or using the restroom.

HOW TO CALCULATE CORRECT HERBICIDE PERCENTAGE

The herbicide rates in this chapter are expressed as a percentage of the total solution used. Determining the amount of herbicide needed is simple, but the units should be converted to fluid ounces to make measuring easier.

There are 128 fluid ounces in a gallon. Once the percentage of herbicide needed is determined, the percent expressed as a decimal should be multiplied by 128 to calculate the number of ounces to add to the spray tank.

For example, if a 2 percent glyphosate solution is needed for foliar application, multiply $0.02 \times 128 = 2.56$ fluid ounces. If you have a 4-gallon backpack sprayer, multiply $2.56 \times 4 = 10.24$. This means you'll put 10.24 fluid ounces of glyphosate in the spray tank before filling the backpack sprayer with water to the 4-gallon mark.

shrubs that are to be retained. Always consult product labels to determine the sensitivity of untargeted plants before applying herbicides.

Directed Foliar Application

Directed foliar sprays are usually applied with low-pressure spray systems, such as backpack sprayers. However, large infestations often require the use of spray systems mounted on tractors, skidders, or all-terrain vehicles. Foliar spray applications use herbicides that are mixed in water. Surfactants (substance that assists chemical adhesion to foliage) should be added to foliar herbicides to improve chemical movement into the plant. Consult product labels for appropriate types and rates of adjuvants (additives to assist in chemical effectiveness) for the herbicide selected. Herbicide solutions should be applied to the leaves and growing tips to the point of runoff. Foliar-active herbicides are generally safe to use around vegetation to be retained. However, some foliar herbicides are not selective, and care must be taken to avoid drift or accidental spray onto untargeted plants.

Basal Application

Basal sprays are herbicides that are usually mixed in commercial basal oils along with a penetrating agent. These mixtures can be sprayed, brushed, or swabbed onto the lower 18 to 20 inches of the targeted plant's stem. Basal applications are generally made to trees or shrubs with diameters of 2 inches or less, but they can be applied to susceptible species of trees with diameters of up to 6 inches if they have thin bark. However, thick woody bark of mature trees prevents the movement of most basal sprays into the stem.

Cut Stump Application

Stumps of trees or saplings can be treated with herbicide concentrates or mixtures. Stumps are treated by applying the appropriate herbicide to the outer edges of larger stumps or to the entire surface of smaller stems. Make sure the cambium area (the layer of cells just inside the bark

that transports nutrients and water throughout the plant) is thoroughly covered to prevent resprouting. Applications should be made with a sprayer or brush within 2 hours of cutting the stem. Basal oils and penetrating agents can be added to the herbicide when trees have been cut for longer periods of time, but results are typically better with application soon after felling. Most trees can be stump treated anytime of the year except during heavy sap flow periods, generally during March and April.

For small properties, the application of herbicide via an all-terrain vehicle is a common and efficient approach to managing vegetation. Photo courtesy of Adam T. Rohnke, Mississippi State University

Using the basal spray method on a young tree. Photo courtesy of Adam T. Rohnke, Mississippi State University

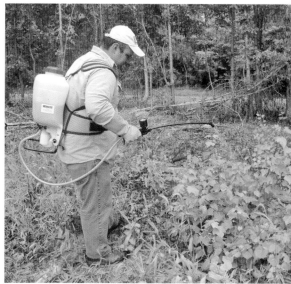

Cut stump application using a backpack sprayer. Notice the blue dye used in the herbicide solution to increase the accuracy of application. Photo courtesy of Adam T. Rohnke, Mississippi State University

Injection

Herbicides can be injected into the stem of trees with commercial injectors or by the hack-and-squirt method. The latter is conducted by simply creating shallow, downward cuts into the stem with a hatchet or machete (the hack). Care should be taken to cut just through the cambium layer and not too deeply into the stem, as herbicide uptake will be reduced. A small amount of herbicide is generally applied to the wound with a spray bottle (the squirt). Follow label rates for the amount of herbicide and number of injections or hacks for each inch of diameter of the stem. Care should be taken

Spot treatment application employed in a recently harvested pine plantation. Photo courtesy of Adam T. Rohnke, Mississippi State University

to avoid spillage out of the hack. Also, avoid using this method within 48 hours of a rainfall event, because excess soil-active herbicide can be washed off the stem and could move into the root zone of desirable trees or shrubs. Most trees can be injected anytime of the year except during heavy sap flow periods, generally during March and April. Autumn and winter applications, however, are usually more effective.

Soil Spot Treatment

In some cases, soil spot treatment may be an effective application method. Especially suitable for large infestations, this method consists of applying measured amounts of soil-active herbicides with a spot gun or backpack sprayer within 3 feet of the woody stem of the target plant. Exact amounts of herbicide are applied on predetermined grid spacing as specified on the herbicide label.

CHOOSING THE RIGHT HERBICIDE

The herbicide chosen will depend upon the species to be controlled, the size of the target plant or infestation, and the surrounding vegetation.

Using the hack-and-squirt injection method. Photo courtesy of Adam T. Rohnke, Mississippi State University

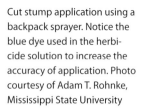
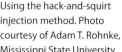
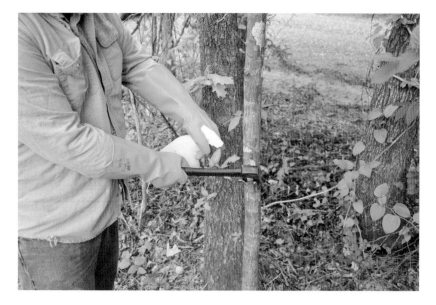

Table 17.1. Common herbicides used to control invasive plants in Mississippi		
Type of herbicide	**Trade name**	**Active ingredient(s)**
Foliar-active	Accord	glyphosate
	Garlon 3A	triclopyr [a]
	Garlon 4	triclopyr [a]
	Krenite S	fosamine
	Pathfinder II	triclopyr
	Remedy	triclopyr
Foliar- and soil-active	Arsenal AC	imazapyr
	Banvel	dicamba
	Chopper Gen 2	imazapyr
	Escort XP	metsulfuron
	Grazon P+D	2,4-D + picloram
	Journey	imazapic + glyphosate
	Milestone VM	2-pyridine carboxylic acid
	Pathway	2,4-D + picloram
	Plateau	imazapic
	Tordon 101	2,4-D + picloram
	Tordon K	picloram
	Transline	clopyralid
	Vanquish	dicamba
	Velpar L	hexazinone

[a] Garlon herbicides can have some soil activity when applied at heavy rates or mixed with oil.

Depending on the chemical composition, herbicides enter targeted plants through their leaves, stems, or roots or through a combination of these three parts.

Glyphosate, Garlon 3A, and Garlon 4 are nonselective foliar-active herbicides, and care should be taken to avoid drift or spray on untargeted plants. Garlon herbicides can have some soil activity when applied at heavy rates or mixed with oil. Garlon 4 and Vanquish can become volatile and move, therefore causing possible damage to untargeted plants if applied when ambient temperatures exceed 80°F. Transline is a foliar- and soil-active herbicide that primarily controls legumes and is safe to use around non-leguminous trees. Caution should be used when applying foliar- and soil-active herbicides such as Arsenal AC, Chopper Gen 2, Pathway, Tordon 101, Tordon K, Escort XP,

or Velpar L. If these products are applied to the soil, untargeted hardwoods may be injured or killed if their roots overlap those of the target.

SPECIFIC SPECIES MANAGEMENT AND CONTROL RECOMMENDATIONS

Here we provide species-specific natural history accounts and management information for landowners and managers. An abbreviated table of this information is included at the end of the chapter. Please note that this information (including herbicide names, application rates) was current at the time this book was written. Brand names, legal application rates, formulations, and legal use of specific chemicals can change as a result of new research findings and regulations. Please refer to the chemical

A medium-sized mimosa tree along a road in Hinds County, Mississippi. Photo courtesy of Adam T. Rohnke, Mississippi State University

PRIVATE APPLICATOR CERTIFICATION

Some of the effective herbicides and pesticides used in invasive species management have been classified for restricted use due to several potential environmental and safety concerns. As a result, landowners interested in purchasing such products are required by law to obtain a private applicator certificate. Certification can be obtained through the Mississippi State University Extension Service's Private Applicator Certification Course, which is offered several times a year by the county extension offices.

During the interactive 2-hour program, landowners learn about general pesticide safety, minimizing spray drift, federal record keeping, and federal worker protection standards. After passing a short exam, the individual receives a certificate that is valid for 5 years in Mississippi.

Interested landowners can find the certification class schedule and other information about the Pesticide Applicator Training program at msucares.com/insects/pesticide.

(Top) Mimosa leaves and flowers. Notice the bipinnately compound leaves. Photo courtesy of Adam T. Rohnke, Mississippi State University

(Bottom) Pods containing the seeds of the mimosa tree. Photo courtesy of Randy Browning, U.S. Fish and Wildlife Service and Wildlife Mississippi

information available on product labels. Although brand name herbicides are mentioned in this chapter, numerous generic herbicides are also available. Consult your local herbicide dealer for compatibility and/or availability.

Mimosa

This species, also known as silktree, was introduced as an ornamental into the United States from Asia in 1745. Mimosa is a deciduous, leguminous tree that may reach 50 feet in height. Single or multiple stems support bipinnately compound leaves (leaflets are on a lateral leaf stem leading from a central leaf stem that comes from the branch) that are 6 to 16 inches long and 3 to 5 inches wide. The leaves are finely divided and have a fern-like appearance. The pink, showy blossoms are fragrant and borne from May to August. Seeds ripen in long, flat pods from August to September and may be viable for many years.

Mimosa grows in a variety of soil types in either dry or wet sites. Although it prefers full sun, it is tolerant of partial shade. Mimosa invades open, disturbed areas such as vacant lots or roadsides. It can also be a serious problem along stream banks, where seed is easily transported by water.

Control.
Mimosa can be controlled with foliar applications of 2 percent solutions of glyphosate, Garlon 3A, or Garlon 4. It can also be controlled with a 0.2 to 0.4 percent solution of Transline or with 2 ounces of Escort XP or 7 ounces of Milestone VM per acre. Saplings can be controlled with a 20 percent solution of Garlon 4 mixed in commercial basal oils plus a penetrating agent or with 100 percent Pathfinder II when applied to juvenile bark as a basal spray. Larger stems can be injected or cut stumps treated with labeled rates of Garlon 3A, Arsenal AC, or Chopper Gen 2 (see Table 17.2). Foliar herbicides work best when they are applied from July to October. Basal, cut stump, and injection treatments can be made anytime except during high sap flow, which is generally March and April. Consult product labels for

A young chinaberry tree adjacent to a ditch. Photo courtesy of Chuck Bargeron, University of Georgia, Bugwood.org

appropriate types and rates of adjuvants to be used for the herbicide selected.

Chinaberry

Originally from Asia, chinaberry was introduced as an ornamental in the mid-1800s. It is a medium-sized tree and can reach a height of 50 feet. Alternately whorled (cyclic arrangement of leaflets on secondary leaf stem), bipinnately compound leaves (leaflets are on a lateral leaf stem leading from a central leaf stem that comes from the branch) are from 12 to 24 inches long and 9 to 16 inches wide. Showy, fragrant blue flowers yield yellow fruits that persist throughout the winter. However, these fruits are poisonous to humans and livestock.

Chinaberry is semi-tolerant to shade and grows along roadsides and forest margins. It is

Leaves of a chinaberry. Note the whorled bipinnately compound leaves. Photo courtesy of Randy Browning, U.S. Fish and Wildlife Service and Wildlife Mississippi

Chinaberry fruit. Photo courtesy of Randy Browning, U.S. Fish and Wildlife Service and Wildlife Mississippi

also common around old home sites. Colonies are formed from root sprouts, and spread is generally through bird-dispersed seeds.

Control.

Chinaberry can be controlled with foliar applications of a 1 percent solution of Arsenal AC or with 2 percent solutions of Chopper Gen 2, Garlon 3A, or Garlon 4. Saplings can be controlled with a 20 percent solution of Garlon 4 mixed in commercial basal oils plus a penetrating agent or with 100 percent Pathfinder II when applied to juvenile bark as a basal spray. Larger stems can be injected or cut stumps treated with labeled rates of Arsenal AC, Chopper Gen 2, Garlon 3A, Pathway, or Pathfinder II (see Table 17.2). For best results, foliar applications should be made from July through September. Basal, cut stump, and injection treatments can be made anytime except during high sap flow, which is generally during March and April. Consult product labels for appropriate types and rates of adjuvants for the herbicide selected.

Chinese Tallowtree

Commonly known as popcorn tree, Chinese tallowtree is native to China and Japan. In those countries, the waxy coating on the seeds is used for making machine oils, fuel oils, soaps, and candles. It was introduced into South Carolina in the 1700s as an ornamental. During the 1900s, it was distributed in the Gulf Coast by the U.S. Department of Agriculture in an attempt to establish a soap-making industry. However, this effort proved unsuccessful, and the trees escaped cultivation. Although highly invasive, tallowtree is considered an excellent honey plant by the beekeeping industry.

These are small- to medium-sized trees that can reach heights of 60 feet. The alternate (offset pattern of leaves from twig), simple heart-shaped leaves turn a deep red in the autumn, making it a popular ornamental. Seeds are produced in three-lobed capsules that mature in late summer. Capsules split and reveal three wax-coated white seeds that resemble popcorn. Mature trees may produce up to 100,000 seeds

Chinese tallowtree in a field.
Photo courtesy of Randy
Browning, U.S. Fish and Wildlife
Service and Wildlife Mississippi

annually, with seed persisting on the tree into
the winter.

Although tallowtree is shade-tolerant and
grows best in moist or wet soils, it will grow
in a range of soils in places like hardwood bot-
tomlands, old fields, coastal flatwoods, stream
banks, and rights-of-way. Tallowtree is tolerant
of periodic inundations and saltwater exposure.
Seeds are spread primarily by birds and water.

Control.
Tallowtree can be controlled with foliar appli-
cations of a 1 percent solution of Arsenal AC, 2
percent solution of Chopper Gen 2 or Garlon
4, or 20 percent solution of Krenite S. Sapling
tallowtrees (less than 2 inches in diameter) can
also be controlled with a 20 percent solution
of Garlon 4 mixed in commercial basal oils
plus a penetrating agent or with 100 percent
Pathfinder II when applied to juvenile bark as
a basal spray. Larger stems can be injected or
cut stumps can be treated with labeled rates
of Arsenal AC, Chopper Gen 2, Garlon 3A,
or Pathfinder II (see Table 17.2). Velpar L can
be used to treat intensive infestations with one

squirt of a spot gun per 1 inch of stem diam-
eter. Best control is achieved when foliar herbi-
cides are applied from July through September.
Basal, cut stump, and injection treatments can
be made anytime except during high sap flow,
which is generally March and April. Consult
product labels for appropriate types and rates
of adjuvants for the herbicide selected.

Ripened white fruit of Chinese
tallowtree surrounded by
heart-shaped leaves in early
autumn. Photo courtesy of
Randy Browning, U.S. Fish and
Wildlife Service and Wildlife
Mississippi

A field border of autumn olive shrubs. Photo courtesy of Randy Browning, U.S. Fish and Wildlife Service and Wildlife Mississippi

Ripe red berries of the autumn olive shrub. Photo courtesy of Randy Browning, U.S. Fish and Wildlife Service and Wildlife Mississippi

Autumn Olive

This species is a nitrogen-fixing shrub that was introduced from China and Japan in 1830 for wildlife habitat, strip mine reclamation, and shelterbelts (long strips of tree plantings to provide wind breaks in open environments).

Autumn olive is a brushy deciduous shrub that reaches heights of 20 feet. Alternate leaves are greenish gray above and silvery beneath. Silvery white to yellow blooms are fragrant and develop into small red berries from August to November.

Autumn olive is tolerant of drought and grows best on upland sites. It is shade-intolerant and will not invade closed-canopy forests. However, it readily invades forest openings, forest margins, rights-of-way, and fields. Autumn olive is still planted for wildlife habitat and shelterbelts and is spread primarily by bird- and mammal-dispersed seed.

Control.
Autumn olive may be controlled with foliar applications of Banvel, Vanquish, or Arsenal AC as a 1 percent solution or with a 2 percent solution of Chopper Gen 2. Seedlings and saplings can be controlled with a 20 percent solution of Garlon 4 mixed in commercial basal oils plus a penetrating agent or with 100 percent Pathfinder II when applied to juvenile bark as a basal spray. Cut stumps can be treated with a 20 percent solution of glyphosate or labeled rates of Arsenal AC or Chopper Gen 2 (see Table 17.2). Foliar herbicides work best when applied from April through September. Basal, cut stump, and injection treatments are more effective when applied from January to February or May to October. Consult product labels for appropriate types and rates of adjuvants for the herbicide selected.

Chinese Privet

Introduced from China and Europe as an ornamental shrub in the early 1800s, Chinese privet is an evergreen shrub that reaches heights of 30 feet. Leaves are opposite (arranged directly across from each other) and less than 2 inches long. Chinese privet blooms from April to June and produces a fragrant, showy cluster of white flowers. Small green berries are produced in early summer and ripen to dark purple or black in winter.

Chinese privet is shade tolerant and can develop impenetrable thickets that crowd native

A typical fence row thicket of Chinese privet grew as a result of either being planted or from seed deposited by birds while perching on fence wire. Photo courtesy of Randy Browning, U.S. Fish and Wildlife Service and Wildlife Mississippi

Chinese privet berries. Notice the opposite leaf pattern. Photo courtesy of Randy Browning, U.S. Fish and Wildlife Service and Wildlife Mississippi

hardwoods and other vegetation. This shrub grows in a variety of soils and readily invades both bottomland hardwood and upland pine sites. Heavily browsed by white-tailed deer, Chinese privet is spread primarily by bird- and mammal-dispersed seed.

Control.

Chinese privet can be controlled with a 1 percent solution of Arsenal AC, 2 percent solution of Chopper Gen 2, 3 percent solution of glyphosate, or 1 ounce of Escort XP per acre when applied to foliage. Saplings can be controlled with a 20 percent solution of Garlon 4 mixed with commercial basal oil plus a penetrating agent or 100 percent Pathfinder II when applied to juvenile bark as a basal spray. Cut stems can be painted with solutions of 10 percent Velpar L, 20 percent glyphosate, 20 percent Garlon 3A, or 50 percent Krenite S. Large stems can be injected or stumps can be treated with labeled rates of Arsenal AC or Chopper Gen 2 (see Table 17.2). Foliar herbicides work best when applied from August through September. However, if glyphosate is the selected

Young Japanese privet shrub in the interior forest. Photo courtesy of Nancy Loewenstein, Auburn University, Bugwood.org

Japanese privet berries closely resemble Chinese privet berries. Photo courtesy of Nancy Loewenstein, Auburn University, Bugwood.org

herbicide, best results are achieved with foliar application from November through February. Basal, cut stump, and injection treatments work best when applied from January to February or May to October. Consult product labels for appropriate types and rates of adjuvants for the herbicide selected.

Japanese Privet

This species was introduced from Korea in 1794 and again from Japan in 1845. Japanese privet has been widely planted as an ornamental shrub. Japanese privet is an evergreen shrub that reaches heights of 35 feet. Thick, opposite, leathery leaves are 2 to 4 inches long. Japanese privet blooms from April to June and produces clusters of white, showy, fragrant flowers. Small green berries are produced in early summer and ripen to a purple-black during the winter.

Japanese privet is a shade-tolerant shrub that grows in a variety of habitats that include forest openings, fence rows, and abandoned fields. However, this species does not grow well on wet sites. Spread is primarily through bird-dispersed seed.

Control.

Japanese privet can be controlled with a 1 percent solution of Arsenal AC, 2 percent solution of Chopper Gen 2, or 3 percent solution of Garlon 4 when applied to foliage from August through September. Glyphosate used as a 3 percent solution will also control Japanese privet when applied to the foliage, with winter applications from November through February working best. Saplings can be controlled with

Bicolor lespedeza infestation in a pine stand. Photo courtesy of Chris Evans, Chris Evans, River to River Cooperative Weed Management Area, Bugwood.org

a 20 percent solution of Garlon 4 mixed with commercial basal oil plus a penetrating agent or with 100 percent Pathfinder II when applied to juvenile bark as a basal spray. Cut stems can be painted with a solution of 10 percent Velpar L, 20 percent glyphosate, 20 percent Garlon 3A, or 50 percent Krenite S. Large stems can be injected or stumps can be treated with labeled rates of Arsenal AC and Chopper Gen 2 (see Table 17.2). Basal, cut stump, and injection treatments work best when applied from January to February or May to October. Consult product labels for appropriate types and rates of adjuvants for the herbicide selected.

Bicolor Lespedeza

This shrub is a perennial legume that was introduced from Japan as an ornamental in the late 1800s. Since then, bicolor lespedeza has been established for soil stabilization and improvement projects as well as for wildlife habitat. Bicolor lespedeza has three-leaflet leaves and reaches a height of 10 feet. Flowering occurs from June to September. Purplish white blooms produce single-seeded pods, with seed maintaining viability for 20 years or more.

Often planted as forage and vegetative cover for northern bobwhite quail, bicolor lespedeza is shade tolerant and spreads easily into adjacent forest and along stream banks. Prescribed burning tends to promote growth and spread of this non-native plant.

Flower of bicolor lespedeza. Photo courtesy of Randy Browning, U.S. Fish and Wildlife Service and Wildlife Mississippi

Tropical soda apple in a pasture. Photo courtesy of J. Jeffrey Mullahey, University of Florida, Bugwood.org

The immature and mature fruit of tropical soda apple. Photo courtesy of Florida Division of Plant Industry Archive, Bugwood.org

Control.

Bicolor lespedeza can be controlled from July to September with foliar application of a 0.2 percent solution of Transline or 2 percent solution of glyphosate, Garlon 4, or Velpar L. It can also be controlled with 0.75 to 2 ounces per acre of Escort XP plus a surfactant mixed in water, when applied in June and July. Best control is achieved when vegetation is mowed 1 to 3 months prior to spraying. Consult product labels for appropriate types and rates of adjuvants for the herbicide selected.

Tropical Soda Apple

A perennial shrub native to Brazil and Argentina, tropical soda apple was introduced into Florida during the 1980s. These shrubs can attain heights of 6 feet and create infestations thick enough to impede livestock movement. Thorns up to ¾ inch in length are produced on numerous parts of the plant. White flowers develop into large fruits that average 1 inch in diameter. Immature fruits have a mottled watermelon appearance, whereas mature fruits are yellow.

Tropical soda apple can occur on both moist and dry soils. Infestations have occurred in pasturelands, forestlands, orchards, and along ditch banks and crop fields. Each plant can produce as many as 200 fruits with each fruit producing up to 420 seeds. The fruit is readily consumed by livestock and wildlife, resulting in the primary method of spread. However, spread can also occur through the movement of contaminated sod, hay, and equipment.

Control.

Tropical soda apple can be controlled with a 0.5 percent solution of Milestone VM, 1 percent solution of Grazon P+D, 2 percent solution of Garlon 4, Remedy, or Arsenal AC, or 3 percent solution of glyphosate. Consult product labels

Multiflora rose in bloom. Photo courtesy of James H. Miller, U.S. Forest Service, Bugwood.org

for appropriate types and rates of adjuvants for the herbicide selected. Herbicide should be applied at the time of flowering (May to August) and before fruits are set. Mowing can be used to stop fruit production, and a herbicide should be applied once sufficient regrowth occurs.

Non-native Roses

Several rose species have been introduced from Asia as ornamental shrubs and as rootstock for domestic roses. They have also been planted as living fences. Non-native invasive species include multiflora rose, Macartney rose, and Cherokee rose. Except for multiflora rose, these shrubs are evergreen. Roses are erect-climbing or trailing shrubs that may grow 10 feet or more in length or height. White flowers, which bloom from April to June, produce rose hips from July through December.

Wild roses can grow on a variety of wet to dry soils. This non-native plant thrives in full sun but grows well in shade. Infestations of wild roses can occur along rights-of-way or along forest edges, and the plants often climb and cover trees. Non-native roses colonize by sprouts and from stems layering in the soil. Spread occurs primarily from bird- and mammal-dispersed seed.

Control.

Wild roses can be controlled with foliar applications of a 4 percent solution of glyphosate, 2 percent solution of Garlon 3A, Garlon 4, or Chopper Gen 2, or 1 percent solution of Arsenal AC when applied from August to October. Escort XP applied at or near the time of flowering (April to June) at a rate of 1 ounce per acre when mixed in water will also control wild roses. Milestone VM will also control this non-native shrub when applied at a rate of 7 ounces per acre from July to October. Vines that are too tall to spray may be controlled with basal applications of a 20 percent solution of Garlon 4 mixed with basal oils and a penetrating agent or with 100 percent Pathfinder II. Cut stems can be treated with labeled rates of Arsenal AC, Chopper Gen 2, or glyphosate (see Table 17.2). The best control with basal and cut stump applications is achieved January to February or May to October. Consult product labels for appropriate types and rates of adjuvants for the herbicide selected.

Japanese Honeysuckle

This species was introduced from Japan in the early 1800s as an ornamental. Japanese honeysuckle is a shade-tolerant, semi-evergreen to

Japanese honeysuckle flowers. Photo courtesy of Adam T. Rohnke, Mississippi State University

Invasion of Japanese honeysuckle into an old home site. Photo courtesy of Chuck Bargeron, University of Georgia, Bugwood.org

evergreen vine that can reach 80 feet in length. White or pink and yellow fragrant flowers are produced from April to August and yield small, glossy black berries.

Japanese honeysuckle is considered a choice deer browse and is often planted or maintained as food plots for such. The foliage and seeds are also consumed by other wildlife species such as rabbits, turkeys, quail, and songbirds. Unchecked, however, this non-native can outcompete and smother native vegetation.

Control.

Japanese honeysuckle can be controlled from July to October with a 2 percent solution of glyphosate or with a 3 to 5 percent solution of Garlon 3 or Garlon 4. When untargeted plants are a concern, cut stems can be treated from July to October with a 20 percent solution of glyphosate or Garlon 3A. Escort XP can be applied at a rate of 2 ounces per acre over the top of loblolly and slash pines from June to August.

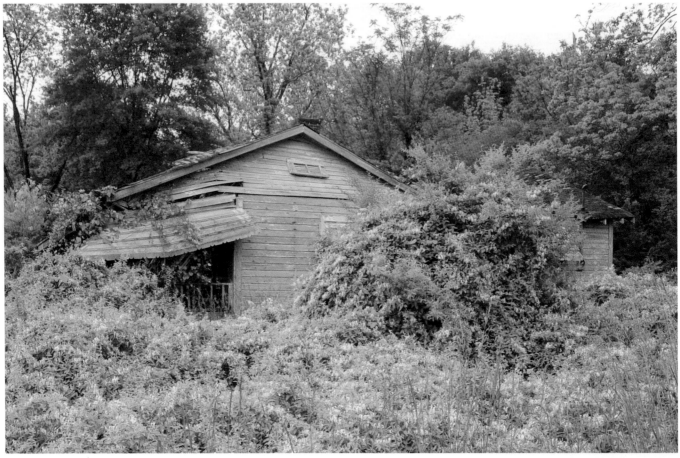

Kudzu leaves. Photo courtesy of Adam T. Rohnke, Mississippi State University

Trees and stumps covered with kudzu. Photo courtesy of Randy Browning, U.S. Fish and Wildlife Service and Wildlife Mississippi

However, Escort XP has been known to damage and even kill longleaf pine seedlings and therefore should not be used over this pine species. Consult product labels for appropriate types and rates of adjuvants for the herbicide selected.

Kudzu

Originally introduced from Japan in 1876 at the Philadelphia Centennial Exposition, kudzu was established as a forage crop for livestock and later promoted and planted by the Soil Conservation Service for erosion control. Also known as "the vine that ate the South," "mile-a-minute vine," or "foot-a-night vine," this species can grow up to 12 inches per day under ideal conditions. Kudzu is a deciduous, perennial, leguminous climbing vine with dark green three-leaflet leaves. Fragrant purple flowers are produced from June to September and yield flat seed pods. Kudzu is supported by semi-woody tuberous roots that may reach depths of 16 feet.

Kudzu grows in a wide variety of sites, but does best on well-drained sandy loams. Kudzu can be found in rights-of-way, old fields, vacant lots, and forested lands. Because of its rapid

Wisteria vines weave horizontally and vertically into all levels of the forest canopy, allowing for quick expansion in a newly invaded area, and can be seen from long distances in early spring throughout Mississippi. Photo courtesy of Chris Evans, River to River Cooperative Weed Management Area, Bugwood.org

The numerous and beautiful purple blooms of wisteria have resulted in its wide use in landscaping across the United States. Photo courtesy of iStock

growth, this plant often covers buildings and power lines and smothers trees and other native vegetation.

Control.

Kudzu is readily browsed by deer and grazed by cattle, but does not tolerate excessive grazing. Therefore, grazing can reduce its overall vigor and improve herbicide efficiency. Kudzu can be controlled with a 2 percent solution of Tordon K, 3 percent solution of Tordon 101, or 4 percent solution of Garlon 4 or glyphosate. Milestone VM will also control kudzu when applied at a rate of 7 ounces per acre. Caution

should be used when applying Tordon herbicides, because these soil-active products can kill untargeted hardwoods if applied to the ground within their root zone. When safety to surrounding vegetation is a concern, apply a 0.5 percent solution of Transline. Although Transline is effective in many areas, it has shown limited success in northern Mississippi. Escort applied at the rate of 4 ounces per acre will also control kudzu in young loblolly or slash pines. However, Escort should not be used over longleaf pines. Foliar applications should be applied from July through September (see Table 17.2). Kudzu can also be controlled with basal applications of a 20 percent solution of Garlon 4 with a basal oil and penetrating agent or with 100 percent Pathfinder II when applied from January to April. Consult product labels for appropriate types and rates of adjuvants for the herbicide selected.

Wisteria

This species was introduced into the United States from Japan in the early 1800s as an ornamental porch vine. Wisteria is a deciduous, high-climbing, woody leguminous vine that has alternate, odd pinnately compound leaves (arranged on central stem that braches off from

twig). Fragrant, showy, purple flowers dangle from the vine from March to May and produce flattened seed pods.

Wisteria grows on a variety of wet to dry sites. Because seeds are large and seldom consumed, they are rarely dispersed by wildlife. The primary mode of seed dispersal is by water along stream channels.

Control.
Wisteria can be controlled with foliar applications of a 2 percent solution of Tordon K, 3 percent solution of Tordon 101, or 4 percent solution of Garlon 4 or glyphosate. Wisteria can also be controlled with Milestone VM when applied at a rate of 7 ounces per acre. Caution should be used when applying Tordon herbicides, as these soil-active products can kill untargeted hardwoods if applied to the ground within their root zone. When safety to surrounding vegetation is necessary (both pines and hardwoods), foliar applications of Transline should be applied using 1 ounce per gallon of water. Consult product labels for appropriate types and rates of adjuvants for the herbicide selected. Best control occurs when herbicides are applied from July through September.

Sericea lespedeza

This forb is a perennial legume introduced from Japan in 1899. Sericea lespedeza has been used by government programs for erosion control and for wildlife forage. Alternate three-leaflet leaves crowd along the stem. The purple and white flowers, which bloom from July to September, produce single-seeded pods.

Sericea grows in a wide range of soils and invades forest openings, uplands, moist savannas, old fields, and rights-of-way. This non-native forb spreads primarily by bird- and mammal-dispersed seed.

Control.
Sericea lespedeza can be controlled from July to September with foliar applications of a 2 percent solution of glyphosate, Velpar L, or Garlon 4. When safety to surrounding vegetation is necessary, a 0.2 percent solution of Transline

The leaflets of sericea lespedeza. Photo courtesy of Randy Browning, U.S. Fish and Wildlife Service and Wildlife Mississippi

Sericea lespedeza can quickly colonize a disturbed area. Photo courtesy of Randy Browning, U.S. Fish and Wildlife Service and Wildlife Mississippi

Active growth occurs in the autumn and winter, and flowering takes place in the spring.

Tall fescue has been established for forage, turf, soil stabilization, and wildlife food plots. This non-native plant became a preferred forage for many livestock managers. As a result, millions of acres of tall fescue have been planted in the United States. However, some varieties can become infected with an endophytic fungus, which can cause reproductive and nutritional stress for livestock and wildlife. Tall fescue spreads by expanding root crowns and seed. This grass tends to choke out more desirable native forage species and has spread along rights-of-way, into forested stands, and into openings.

Control.

Tall fescue can be controlled with a 0.5 percent solution of glyphosate, 1 percent solution Arsenal AC, or 2 percent solution of Chopper Gen 2. Tall fescue has been effectively controlled with applications of 10 to 12 ounces of Plateau or 20 to 24 ounces of Journey per acre. Consult product labels for appropriate types and rates of adjuvants for the herbicide selected. For example, better control may be obtained by adding 1 quart of methylated seed oil and 1 quart of 28-0-0 liquid fertilizer to the Plateau solution. Best control is achieved when herbicide is applied in the spring (March through April) prior to seeding.

Cogongrass

Considered "the seventh worst weed in the world," cogongrass was introduced accidentally into Alabama in 1912, when it was used as packing material in shipments from Japan. In the early 1920s, it was planted in several southern states as a potential forage crop. Although there is some forage value when the grass is young, it quickly becomes unpalatable because of high silica concentrations in the leaves. Before the nature of this invader was understood, cogongrass was occasionally used for soil reclamation and soil stabilization.

Cogongrass is an invasive perennial grass that forms dense colonies, with foliage reaching

can be used. Escort XP has shown the best control of sericea lespedeza when applied at a rate of 0.75 to 2 ounces per acre when mixed with water; this herbicide will not harm trees except for legumes, cottonwood, black cherry, dogwood, ash, elm, and longleaf pine. Best control is achieved when vegetation is mowed 1 to 3 months prior to spraying.

Tall Fescue

This species is an erect cool-season perennial grass that was introduced from Europe in the mid-1800s. Tall fescue grows on sites with all moisture levels and reaches a height of 4 feet.

Cogongrass infestation in a pine plantation. Photo courtesy of David J. Moorehead, University of Georgia, Bugwood.org

Mature white seed heads of cogongrass in the understory of a mature pine plantation. Photo courtesy of Chris Evans, River to River Cooperative Weed Management Area, Bugwood.org

a height of 4 feet. The leaves are generally yellowish green and have an offset midrib. Cogongrass has numerous attributes that contribute to its extremely aggressive nature. This grass blooms early in the spring, and each plant can produce up to 3000 seeds. These seeds are very light and can be dispersed by the wind for a distance of 15 miles or more. Studies indicate that seed germination rates of 90 percent or more are possible. Cogongrass has an extremely dense root system and also reproduces asexually via rhizomes.

Cogongrass can grow in soils ranging from rich sandy loams to poor sands. This nuisance species grows best in full sun; however, it thrives in deep shade and persists during severe droughts and periodic inundations.

Although cogongrass has a relatively high rate of natural spread, mechanical dispersal accelerates the problem. Cogongrass can be distributed great distances when contaminated hay, turf, or nursery stock are used. To make matters worse, cogongrass cultivars with red foliage are currently being sold in the United States as an ornamental. These cultivars, known as Japanese blood grass 'Red Baron' or 'Rubra,' apparently revert back to the green form when planted in a warm environment. This non-native can also spread along various rights-of-way through the movement of contaminated soil and equipment. Landowners and contractors can also spread cogongrass across the landscape with day-to-day operations. Construction and maintenance of food plots, fire lanes, and roads

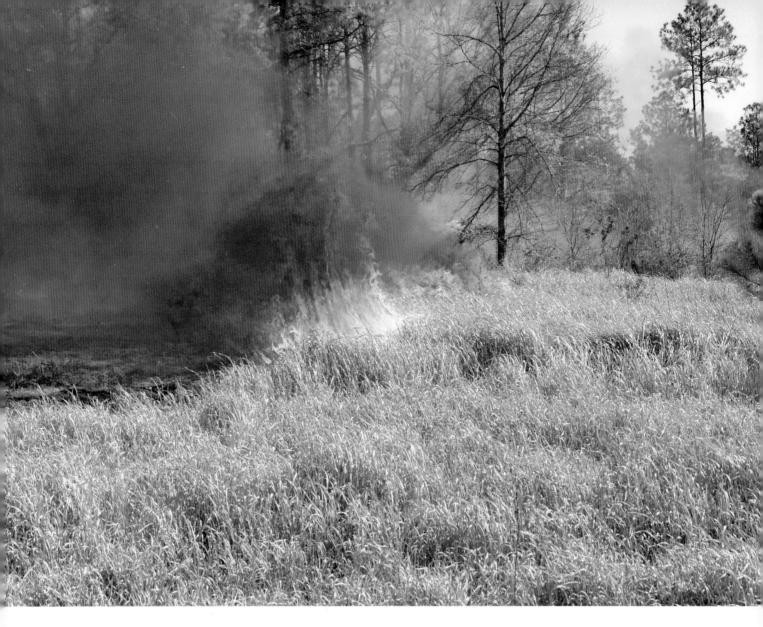

Prescribed burn of a cogon-grass-dominated field. Photo courtesy of Randy Browning, U.S. Fish and Wildlife Service and Wildlife Mississippi

can be an avenue for spread if contaminated equipment is not thoroughly cleaned before moving to another location. Timber harvest practices can also spread cogongrass when tree tops are dragged through areas where it has taken root.

Infestations of this non-native plant have serious implications for resource management. Dense stands of cogongrass can cause significant stress on forested stands by competing for available moisture and nutrients and by literally growing through tree roots. Cogongrass is also allelopathic, meaning it produces enzymes that inhibit the growth of other plants. Dense stands of this aggressive weed create physical barriers that keep native plant seeds from ever reaching mineral soil. Another serious implication is that cogongrass burns at extremely high temperatures, and vigorous stands can cause

significant loss of forest products from either prescribed burns or wildfires.

Numerous species of wildlife are adversely affected by this noxious weed. Unchecked, cogongrass will not only displace the native vegetation that wildlife depend upon, but will also create stands so dense that many ground-dwelling animals find it difficult if not impossible to travel through. Few insects feed on cogongrass, and large infestations create biological deserts that have no value as brood-rearing habitat for quail and turkeys or as foraging grounds for songbirds.

Control.
Cogongrass is best controlled in fields and pastures by integrating mowing, burning, disking, and herbicides. Because all of these measures are not practical in forested habitats, herbicide may be the only means of control.

Control has been achieved with a 2 to 4 percent solution of glyphosate, 2 percent solution of Chopper Gen 2, or 1 percent solution of Arsenal AC. However, only glyphosate should be used when cogongrass is growing under desirable hardwoods. Optimum control is achieved when herbicide is applied from August through September, prior to plant dormancy, but glyphosate may be used in March and April to reduce seed head production. Consult product labels for appropriate types and rates of adjuvants for the herbicide selected. All treated areas should be closely scrutinized and will likely require multiple applications and/or spot treatments.

Deeprooted Sedge

This sedge is native to South America and was first reported in the United States in 1990. Although a recent invader, deeprooted sedge is already infesting the southeastern coastal states. This plant is robust and has deeply set thick rhizomes. Leaves are glossy with dark purple to black leaf bases.

Deeprooted sedge reproduces both by rhizomes and seeds. Mature plants can produce up to 1 million viable seeds each year. This species can grow in wet to dry sites, and infestations occur in open disturbed habitats such as roadsides, ditches, fallow fields, pastures, and open forests. Infestations have also been reported along the edges of rice fields and salt marshes. Because this plant produces rhizomes, cultivation tends to spread rather than control this non-native plant by scattering the roots. Spread can be reduced by cleaning machinery, clothing, vehicles, and other equipment that may be contaminated with tiny seeds.

Control.
Deeprooted sedge can be controlled with a variety of herbicides. Consult product labels for appropriate types and rates of adjuvants for the herbicide selected. However, best control is currently achieved with a solution of glyphosate applied at the rate of 48 to 64 ounces per acre or with sequential applications of glyphosate applied at the rate of 24 to 32 ounces per

Deeprooted sedge. Photo courtesy of Charles T. Bryson, U.S. Department of Agriculture Agricultural Research Center, Bugwood.org

acre. For best results, apply herbicide from July to October.

Japanese Climbing Fern

This species is native to Asia and Australia and was introduced from Japan in the 1930s as an ornamental. Japanese climbing fern is a lacy-leaved perennial that can climb up to 90 feet.

A tree infested with Japanese climbing fern. Photo courtesy of Randy Browning, U.S. Fish and Wildlife Service and Wildlife Mississippi

Table 17.2. Herbicide application rates and methods for common invasive plants in Mississippi. These herbicides should be used individually at the noted rate, not as a mixture of the herbicides listed.

Species	Application method					Timing
	Foliar Spray	**Basal**	**Cut stump**	**Injection**	**Spot treat**	
Mimosa	2% glyphosate 2% Garlon 3A 2% Garlon 4 2 ounces Escort XP/ acre 7 ounces Milestone VM/acre 0.2–0.4% Transline*	20% Garlon 4 with basal oil + penetrant 100% Pathfinder II	50% Garlon 3A 6 ounces Arsenal AC in 1 gallon of water 12 ounces Chopper Gen 2 in 1 gallon of water	25% Arsenal AC 50% Garlon 3A 2:1 ratio of Chopper Gen 2 with water		Foliar spray July to October or *July to September; basal, cut stump, or injections May through February
Chinaberry	1% Arsenal AC 2% Chopper Gen 2 2% Garlon 3A 2% Garlon 4	20% Garlon 4 with basal oil + penetrant 100% Pathfinder II	50% Garlon 3A 100% Pathway 100% Pathfinder II 6 ounces Arsenal AC in 1 gallon of water 12 ounces Chopper Gen 2 in 1 gallon of water	25% Arsenal AC 50% Garlon 3A 100% Pathway 2:1 ratio of Chopper Gen 2 with water		Foliar sprays July to October; basal, cut stump, or injections May through February
Chinese tallowtree	1% Arsenal AC 2% Chopper Gen 2 2% Garlon 4 20% Krenite S	20% Garlon 4 with basal oil + penetrant 100% Pathfinder II	50% Garlon 3A 100% Pathfinder II 6 ounces Arsenal AC in 1 gallon of water 12 ounces Chopper Gen 2 in 1 gallon of water	50% Garlon 3A 25% Arsenal AC 2:1 ratio of Chopper Gen 2 with water	1 squirt Velpar L per 1 inch diameter, within 3 feet of stem	Foliar sprays July to October; basal, cut stump, or injections May through February; spot treat March to July
Autumn olive	1% Banvel 1% Vanquish 1% Arsenal AC 2% Chopper Gen 2	20% Garlon 4 with basal oil + penetrant 100% Pathfinder II	20% glyphosate 6 ounces Arsenal AC in 1 gallon of water 12 ounces Chopper Gen 2 in 1 gallon of water			Foliar sprays April to October; basal and cut stump January to February or May to October
Chinese privet	1% Arsenal AC 2% Chopper Gen 2 3% glyphosate* 1.0 ounce Escort XP/ acre	20% Garlon 4 with basal oil + penetrant 100% Pathfinder II	10% Velpar L 20% Garlon 3A 20% glyphosate 50% Krenite S 6 ounces Arsenal AC in 1 gallon of water 12 ounces Chopper Gen 2 in 1 gallon of water	25% Arsenal AC 2:1 ratio of Chopper Gen 2 with water		Foliar sprays August to December or *November to March; basal, cut stump or injections January and February or May to October
Japanese privet	1% Arsenal AC 2% Chopper Gen 2 3% Garlon 4 3% glyphosate*	20% Garlon 4 with basal oil + penetrant 100% Pathfinder II	10% Velpar L 20% Garlon 3A 20% glyphosate 50% Krenite S 6 ounces Arsenal AC in 1 gallon of water 12 ounces Chopper Gen 2 in 1 gallon of water	25% Arsenal AC 2:1 ratio of Chopper Gen 2 with water		Foliar sprays from August to October or *November to March; basal, cut stump, or injections January to February or May to October
Bicolor lespedeza	0.2% Transline 2% glyphosate 2% Garlon 4 2% Velpar L 0.75–2.0 ounces Escort XP/acre*					July to September or *June and July
Tropical soda apple	0.5% Milestone VM 1% Grazon P + D 2% Garlon 4 2% Remedy (pastures) 2% Arsenal AC 3% glyphosate					May to August (at time of flowering)

Non-native roses	1% Arsenal AC 2% Chopper Gen 2 4% glyphosate 2% Garlon 3A 2% Garlon 4 7 ounces Milestone VM/acre** 1 ounce Escort XP/acre*	20% Garlon 4 with basal oil + penetrant 100% Pathfinder II	20% glyphosate 6 ounces Arsenal AC in 1 gallon of water 12 ounces Chopper Gen 2 in 1 gallon of water			Foliar sprays August to October, *April to June, or **July to October; basal or cut stump January and February or May to October
Japanese honeysuckle	2% glyphosate 3–5% Garlon 3A 3–5% Garlon 4 2 ounces Escort XP/acre*		20% glyphosate 20% Garlon 3A			Foliar sprays and cut stump July to October or *June to August
Kudzu	0.5% Transline* 2% Tordon K 3% Tordon 101 4% Garlon 4 4% glyphosate 7 ounces Milestone VM/acre 4 ounces Escort XP/acre*	20% Garlon 4 with basal oil + penetrant 100% Pathfinder II				Foliar sprays July to October or*July to September; basal January to April
Wisteria	7 ounces Milestone VM/acre** 4% glyphosate* 2% Tordon K** 3% Tordon 101** 4% Garlon 4** 1 ounce Transline/gallon of water***					*September and October, **July to October, or ***July to September
Sericea lespedeza	0.2% Transline 2% glyphosate 2% Velpar L 2% Garlon 4 0.75–2.0 ounces Escort XP/acre*					July to September or *June and July
Tall fescue	0.5% glyphosate 1% Arsenal AC 2% Chopper Gen 2 10–12 ounces Plateau/acre 20–24 ounces Journey/acre					March and April
Cogongrass	2–4% glyphosate 1% Arsenal AC 2% Chopper Gen 2					August to October
Deeprooted sedge	24–32 ounces glyphosate/acre* 48–64 ounces glyphosate/acre					July to October, *with sequential applications when using the lower rate
Japanese climbing fern	1% Arsenal AC 2% Chopper Gen 2 4% Garlon 3A 4% Garlon 4 4% glyphosate 1–2 ounces Escort XP/acre					July to October

Note: Always consult product labels to determine sensitivity of untargeted plants to herbicides before applying

Spread occurs rapidly by windblown spores, and areas are colonized through the production of rhizomes. Japanese climbing fern grows in soils ranging from moist to well-drained loams. Dense mats of this fern will choke out native vegetation and can cover and smother shrubs and trees. Frost top kills aboveground vegetation each autumn. However, dead vegetation acts as a trellis for new spring growth. Climbing fern is a fire hazard because it creates ladder fuels that readily transport fire from ground fuels to the forest canopy.

Control.

Climbing fern can be controlled from July to October with foliar applications of a 1 percent solution of Arsenal AC, 2 percent solution of Chopper Gen 2, or 4 percent solution of Garlon 3A, Garlon 4, or glyphosate. Escort will also control climbing fern when applied at rates of 1 to 2 ounces per acre when mixed in water. Consult product labels for appropriate types and rates of adjuvants for the herbicide selected.

SUMMARY

Numerous non-native plants have been introduced into Mississippi. Many have become invasive and now infest natural ecosystems, industrial forests, agricultural lands, and rights-of-way. When allowed to go unchecked, these infestations have the potential to degrade wildlife habitat diversity and negatively affect forest and agricultural productivity.

Once landowners and land managers become aware of the problems associated with many of these noxious weeds, control and/or eradication can often be achieved with the correct application of an appropriate herbicide. Depending on the species, other management activities such as burning, cutting, or grazing may improve the level of control. Regardless of the species of concern, always read and follow product labels before applying herbicides. Mention of any specific herbicide in this chapter does not represent endorsement by the author or agencies and organizations associated with this publication.

For More Information

Amazing Story of Kudzu website: http://maxshores.com/the-amazing-story-of-kudzu

Barnes, T. G., and B. Washburn. 2001. Controlling tall fescue, common Bermuda, and bahia grass. *Wildland Weeds* 4(3):5–8.

Browning, R. W. 2002. Cogongrass: The perfect weed? *Tree Talk* 13:14.

Browning, R. W., J. L. Cummins, T. R. Jacobson, and H. G. Hughes. 2009. *Restoring and Managing Longleaf Pine: A Handbook for Mississippi Landowners, 2nd Edition.* U.S. Fish and Wildlife Service, Wildlife Mississippi, and Mississippi State Extension Service.

Bryson, C. T. 1996. Biology, spread and control of deeprooted sedge (*Cyperus entrerianus* Boeckeler) in the United States. *Proceedings of the Weed Science Society of America* 36:32.

Bryson, C. T., J. D. Byrd, and R. G. Westbrooks. 1995. *Tropical Soda Apple* (Solanum viarum *Dunal) in the United States.* Jackson: Mississippi Department of Agriculture and Commerce, Bureau of Plant Industry.

Bryson, C. T., J. D. Byrd, and R. G. Westbrooks. 2004. *Tropical soda apple* (Solanum viarum *Dunal) Identification and Control.* Jackson: Mississippi Department of Agriculture and Commerce, Bureau of Plant Industry.

Byrd, J. D., and C. T. Bryson. 1999. *Biology, Ecology, and Control of Cogongrass* [Imperata cylindrica (*L.) Beauv.*]. Fact Sheet No. 1999-01. Jackson: Mississippi Department of Agriculture and Commerce, Bureau of Plant Industry.

Carter, R., and C. T. Bryson. 1996. *Cyperus entrerianus*: a little known aggressive sedge in the southeastern United States. *Weed Technology* 10:232–235.

Center for Invasive Species and Ecosystem Health websites: www.bugwood.org, www.invasive.org, and www.forestryimages.org

Colie, N. C., and D. G. Shilling. 1993. Cogongrass [*Imperata cylindrica* (L.) Beauv.]: A good grass gone bad! Botany Circular No. 28. Florida Department of Agriculture and Consumer Services, Division of Plant Industry.

Gray, R. 2010. *Conservation Provisions of the 2008 Farm Bill: A Handbook for Private Landowners in the Lower Mississippi River Valley.* Wildlife Mississippi.

Johnson, E. R. R. L., and D. G. Shilling. 2005. Fact Sheet: Cogon Grass. *Weeds Gone Wild: Alien Plant Invaders of Natural Areas.* Jill M. Swearingen, ed. Plant Conservation Alliance's Alien Plant Working Group. http://www.nps.gov/plants/alien/fact/imcy1.htm.

Jose, S., J. Cox, D. L. Miller, D. G. Shilling, and S. Merritt. 2002. Alien Plant Invasions: The Story of Cogongrass in Southeastern Forest. *Journal of Forestry* 100:41–44.

Kudzu (*Pueraria montana* var. *lobata* (Willd.) Maesen and S. Almeida) website: http://www.nps.gov/plants/alien/fact/pum01.htm

Miller, J. H. 2003. *Nonnative Invasive Plants of Southern Forests: A Field Guide for Identification and Control.* General Technical Report SRS-62. U.S. Forest Service Southern Research Station.

Miller, J. H., and K. V. Miller. 1999. *Forest Plants of the Southeast and Their Wildlife Uses.* Champaign, Ill.: Southern Weed Science Society.

Patterson, D. T., E. E. Terrell, and R. Dickens. 1979. Cogongrass in Mississippi. *Mississippi Agriculture and Forestry Experiment Station Research Report* 46(6):1–3.

Southeast Exotic Pest Plant Council Invasive Plant Manual website: http://www.se-eppc.org/manual/index.html

The 1800s

1817 Mississippi is admitted as a state.

 The U.S. Navy is authorized to establish forest reserves to protect hardwoods for building its ships.

1818 Gideon Lincecum, a pioneering physician and naturalist, moves to the Tombigbee River area of Mississippi.

1819 Artist and naturalist John James Audubon travels to Mississippi to paint ornithological specimens.

1820 The Treaty of Doak's Stand (between the United States and the Choctaw Nation) provides for a large land cession.

 The Land Act of 1820 lowers the minimum price of land to $1.25 per acre.

1821 The naturalist John Wesley Monette moves to Natchez, Mississippi.

1822 Dr. Rush Nutt, a Mississippian, invents the practice of planting cowpeas between rows of corn to increase fertility and reduce soil erosion.

1823 Paul Wilhelm produces a report on the virgin forests of Mississippi.

1824 John James Audubon continues to travel extensively in Mississippi.

1825 Gideon Lincecum moves to Cotton Gin, Mississippi. He reports the regular burning of the forests by the Indians.

1826 Mississippi College is created.

1829 Mississippi's General Assembly authorizes the creation of the Board of Internal Improvements to alleviate inadequacies of the state's road and river transportation.

1830 The Treaty of Dancing Rabbit Creek provides for cession of the last of the Choctaw's lands.

1831 Lands formerly owned by the Choctaws are sold.

1832 In the Treaty of Pontotoc, the Chickasaws cede their lands.

1833 Mississippi requests federal aid to improve river navigation.

1835 Meek brothers begin manufacturing Kentucky fishing reels.

1837 The Panic of 1837 financial crisis breaks the land boom in Mississippi.

1838 Duck decoys are first made in Mississippi.

1839 The Jefferson College Agricultural Society is formed.

1840 The Mississippi Legislature authorizes the creation of the University of Mississippi.

1841–43 J. F. H. Claiborne publishes a series of sketches in the *Natchez Free Trader and Gazette* describing the extensive longleaf pine forests of southern Mississippi.

1844–45 Henschel fishing rod is developed.

1849 U.S. Department of Interior is established.

1851 Approximately 3 million pounds of rice are produced, primarily in Perry and Harrison counties.

1852 Benjamin Wailes gathers fish collections from Mississippi and sends them to the U.S. National Museum.

 Julio T. Buel receives the first U.S. patent on a spinner bait (artificial bait).

1853 Wailes' fish collections are sent to Louis Agassiz, founder of the Museum of Comparative Zoology at Harvard.

1854 The Mississippi Legislature orders the *Report on Agriculture and Geology of Mississippi*, which includes a list of eighty-nine bird species found in the state.

1857 President James Buchanan appoints Jacob Thompson of Pontotoc as Secretary of the Interior.

1859 Yazoo County leads the nation in cotton production with 64,075 bales of ginned cotton.

1871 Congress passes a joint resolution for the protection and preservation of food fishes of the coasts of the United States.

 Alcorn University is founded.

1872 James Heddon is credited with the first artificial lure, known as the plug today.

 Congress sets aside Yellowstone as the nation's first national park.

1873 Initial publication of *Field and Stream* magazine, which becomes the major American sportsmen's magazine and a forum for conservation advocacy.

1875 Arkansas passes the first law banning market hunting of waterfowl.

 The American Forestry Association is founded.

1876 Commercial hunters regularly sell game in markets.

1878 Mississippi State University, the state's land-grant institution, is created.

1879 Congress establishes the U.S. Geological Survey as part of the Department of the Interior.

1880 Charles T. Mohr publishes *The Timber Pines of the Southern United States*.

1881 The Division of Forestry is established in the Department of Agriculture.

Appendix I

History of Fish and Wildlife Conservation in Mississippi

1882 Oliver Hay, ichthyologist and vertebrate paleontologist, collects and describes fish in Mississippi.

1883 The American Ornithologists' Union is founded.

1884 Mississippi University for Women is founded.

 The Eastman-Gardiner Lumber Company of Laurel is one of the first mills in Mississippi to use the band saw.

1885 The Chicago fishing rod is developed.

1887 Theodore Roosevelt and George Bird Grinnell found the Boone and Crockett Club.

1888 The Audubon Society is founded by George Bird Grinnell.

1891 Congress passes the Forest Reserve Act, giving the president power to establish forest reserves or what later became known as national forests.

1892 Millsaps College opens.

 The Sierra Club is organized by John Muir, a talented engineer, naturalist, writer, botanist, and geologist.

1893 Influenced by Germany, the forestry movement in the United States begins promoting scientific and efficient forest management.

1896 Congress establishes the Division of Biological Survey in the Department of Agriculture.

1897 Congress passes the Appropriations Act, which states that forest reserves are to be managed for timber and water resources.

1898–99 Congress enacts legislation to aid states in the enforcement of game laws.

1900–1920

1900 The Lacey Act is passed, making interstate transportation of wildlife killed in violation of state law a federal crime.

1901 Albert F. Ganier studies and photographs Mississippi kites in the Vicksburg area.

 The Tupelo National Fish Hatchery opens.

1902 President Theodore Roosevelt, as guest of Harley Metcalfe and guided by a famous bear hunter named Holt Collier, goes on a bear hunt near Onward, Mississippi. To ensure that the president shoots a bear, the guide traps a 600-pound bear in advance and ties it to a tree. However, the president refuses to shoot the captive bear. The story gets out, and a new toy, a stuffed bear, is named a teddy bear to honor the president's sportsmanship.

1903–04 Charles Stockard writes and publishes records of birds of the Mississippi Gulf Coast, southwestern Mississippi, and Lowndes County.

 The Nettleton Fox Hunting and Fishing Association is established.

1905 Congress reserves to itself and the president the right to create federal wildlife reserves and empowers the Secretary of Agriculture to prevent hunting, trapping, killing, or capturing game animals "except under such regulations as may be prescribed from time to time."

 The U.S. Forest Service is created.

 Mississippi's first deer season is set by the legislature to extend from September 15 through March 1.

1906–07 The Agricultural Appropriations Act states that the Forest Service shall aid in enforcement to protect fish and game.

1908 President Theodore Roosevelt organizes a National Conservation Conference that is attended by forty-four governors.

1909 A bag limit of five deer per year is established in the state.

 Andrew Allison, Mississippi's first ornithologist of distinction, provides the first reports of winter birds of Hancock County and summer birds of Tishomingo County.

1910 The University of Southern Mississippi is founded.

1911 The Weeks Act initiates a program of fire protection in forests.

1915 The Mississippi Legislature declares only buck deer to be legal game and retains the five deer season limit.

1916 The United States' international commitment to managing waterfowl is formalized in a treaty with Canada.

 A Southern Forestry Congress is organized to promote forest protection.

 Congress authorizes the president to acquire lands for refuges.

 The National Park Service is created.

1917–18 Pioneer scientist and conservationist Fannye A. Cook begins lobbying political and civic leaders for the creation of a state-level wildlife conservation agency.

 Congress passes the Migratory Bird Treaty Act.

1920 The Association of State Foresters is organized and takes the lead in promoting the protection of southern forests.

 Charles Grubbs establishes the first duck decoy factory in Pascagoula.

1921–1940

1921 Merigold Hunting Club is incorporated in Bolivar County.

1922 Anderson-Tully Company begins its purchase of timberland in Mississippi.

1926 After working at the Smithsonian Institution in Washington, D.C., Fannye Cook returns to Mississippi to promote wildlife conservation.

 The Mississippi Forestry Commission is created.

1927 The Federal Aid to Wildlife Restoration Act passes, providing federal aid to states with wildlife restoration projects.

The Mississippi Association for the Conservation of Wildlife is organized with the help of the Parent-Teachers Association, Mississippi Forestry Association, the Federation of Women's Clubs, and hunting and fishing clubs.

The 1927 flood ravages the Delta.

Poitevin Brothers start making the Singing River brand of decoys in Pascagoula.

1928 Aldo Leopold, the father of game management, launches a nationwide survey of wildlife conditions. He reported, "Wild turkey [in Mississippi] are steadily decreasing. They have been cleaned out of the upper ranges, and there's barely a seed stock left in the largest swamps."

The deer hunting season is reduced to November 15 through February 15 and the bag limit to three deer.

1929 Aldo Leopold states, "With the possible exception of very limited parts of the Delta, deer can nowhere be said to persist in numbers justifying hunting."

1930 Intense logging period ends in Mississippi, where most of the virgin timber has been harvested.

The first tree nursery is established in the state in cooperation with the U.S. Forest Service.

1931 Deer are stocked on the grounds of the Merigold Hunting Club.

1932 The Mississippi Game and Fish Commission is organized.

1933 The Fish Rescue Program is initiated.

The Soil Erosion Service is established in the U.S. Department of the Interior.

The Civilian Conservation Corps, Tennessee Valley Authority, and Homochitto National Forest are created.

1934 Congress passes the Duck Stamp Act.

The Mississippi Game and Fish Commission purchases a truck and converts it into a moving wildlife museum.

The Coordination of Wildlife Conservation Act is passed by Congress.

1935 Congress enacts the Soil Conservation Act, establishing the Soil Conservation Service.

Fannye Cook plans the State Plant and Animal Project, a Works Progress Administration project.

1936 The Junior Game and Fish Commission is organized.

The Migratory Bird Treaty and the Migratory Bird Hunting Stamp Act are passed by Congress.

The initial land for Yazoo National Wildlife Refuge is purchased.

President Franklin D. Roosevelt convenes the North American Wildlife Conference.

Conservationist and political cartoonist J. N. Darling establishes the National Wildlife Federation.

Congress passes the Flood Control Act, authorizing the Soil Conservation Service to conduct watershed work.

The Southern Hardwoods Laboratory at Stoneville is created.

1937 The Pittman-Robertson Act is passed. It levies a tax on sporting arms and ammunition to fund wildlife improvement projects.

1938 The magazine *Mississippi Game and Fish* is launched.

The Mississippi Forestry Association, the Natchez Trace Parkway, and the Mississippi Soil and Water Conservation Commission are created.

1939 The state wildlife museum opens.

The Leaf River Refuge is established in Perry County.

The Mississippi Forestry Commission establishes a tree nursery in Mount Olive.

The Lyman National Fish Hatchery opens.

1940 The Mississippi Legislature passes the Timber Severance Tax Law.

The U.S. Fish and Wildlife Service is created.

1941–1960

1941 A survey estimates 7357 deer and 5000 wild turkey in the state.

The Pascagoula Decoy Company opens.

1942 The Mississippi Game and Fish Commission is curtailed because of World War II, with the closure lasting through 1945.

The Meridian National Fish Hatchery opens.

1943 As of April, the deer population of Mississippi is 10,498. More than one-third of the state's deer population is in Issaquena, Yazoo, Sharkey, and Warren Counties.

1946 The Mississippi Legislature empowers the Mississippi Game and Fish Commission to regulate and enforce stream pollution laws.

The Mississippi Forestry Commission establishes a tree nursery in Winona.

The U.S. Forest Service establishes the Oxford Research Center of the Southern Forest Experiment Station to conduct research in northern Mississippi and eastern Tennessee.

1947 Yazoo Basin wildlife resources survey is initiated.

Mississippi Outdoors begins publication.

1948 The Sardis Waterfowl Refuge is established.

The Farm Game Habitat Project is initiated, and the Choctaw Refuge is established.

1949 The mourning dove, squirrel, wild turkey, and waterfowl research projects are initiated by the Mississippi Game and Fish Commission.

Hugh L. White Wildlife Management Area (7500 acres) is purchased in Marion County for $49,500.

1950 The Future Farmers of America, 4-H youth activities, and farm game project are initiated.

The Adams County Refuge is established.

1951 The Dingell-Johnson Federal Aid to Fisheries Restoration Act is passed by Congress.

The Southern Hardwoods Laboratory at Stoneville publishes a guide on the management of hardwoods.

1952 The wild turkey population in Mississippi is estimated to be 10,000.

Lake Mary Crawford is constructed in Lawrence County.

The Smokey Bear Act is passed by Congress to protect use of the mascot of the U.S. Forest Service created in the early 1940s to educate the public about the dangers of forest fires.

1953 The Mississippi Game and Fish Commission distributes 708,000 *Lespedeza bicolor* seedlings for quail.

A state survey shows significant population increases of wild turkey in Bolivar and Tunica Counties.

1954 Sunflower Wildlife Management Area is established.

Congress passes the Watershed Protection and Flood Prevention Act.

The School of Forestry at Mississippi State University is created.

1955 The Mississippi Ornithological Society is organized.

The Southern Institute of Forest Genetics is established at Gulfport.

1956 The Mississippi Forestry Commission establishes a tree nursery in Waynesboro.

1957 The Nuisance Beaver Control Program begins.

The Soil Conservation Service is assigned responsibility for the National Inventory of Soil and Water Needs.

1958–59 The Sunflower Greentree Waterfowl Project is constructed.

1960 The Mississippi Legislature passes the Forestry Bank Law to provide loans to owners of small properties to develop their forests.

1961–1980

1961 The first antlerless deer season in Mississippi is held in Bolivar County at Catfish Point.

1962 Conservationist Rachel Carson publishes *Silent Spring*, which helped to launch the modern American environmental movement.

1963 Deer harvest reaches 14,820 deer.

Ross Barnett Reservoir is completed.

1964 Congress establishes the National Wilderness System.

Congress passes the Land and Water Conservation Act and the National Forest Roads and Trails Act.

1965 Game warden training is initiated at the law enforcement training academy.

Congress passes the Water Quality Act.

1966 The Endangered Species Preservation Act and the Historic Preservation Act are passed by Congress.

1967 The state boat-launching ramp program begins.

1968 The Wild and Scenic Rivers Act is passed by Congress.

1969 All counties in Mississippi are opened to deer hunting.

The National Environmental Policy Act becomes law.

1970 The Malmasion Wildlife Management Area is acquired.

Indian Bayou (in Leflore County) and Greentree Waterfowl Projects are completed.

President Richard Nixon sets up the Environmental Protection Agency

The first Earth Day is held.

1971 The Hunter Safety Program is initiated by the Mississippi Game and Fish Commission.

The Jackson Audubon Society is organized.

Okatibbee Waterfowl and Upland Game Management Area is established.

1972 Wild turkey harvest reaches 5691 in sixty counties.

The Environmental Protection Agency bans the use of DDT.

The Mississippi Game and Fish Commission organizes the Committee on Rare and Endangered Species.

1973 Alligators are stocked in the Delta.

The Delta Lakes Pesticide Study begins.

The new Mississippi Museum of Natural Science building is dedicated.

Congress creates the Forestry Incentives Program.

The Endangered Species Act becomes law.

1974 A resident Canada goose flock is established on Malmasion Wildlife Management Area.

The Mississippi Wildlife Heritage Program is launched.

The Mississippi Legislature passes the Forest Resource Development Act to share the cost of forest resource development with landowners.

Longtime Mississippi forester Richard C. Allen emphasizes the role of trees in absorbing carbon dioxide.

Congress passes the Forest and Rangeland Renewable Resources Planning Act.

1975 The Hunter Safety Program is recognized as one of the best in the nation.

Hillside National Wildlife Refuge is purchased by U.S. Army Corps of Engineers and transferred to the U.S. Fish and Wildlife Service.

Congress establishes the Pascagoula Wildlife Management Area.

The Cooperative Wildlife Research Agreement is signed between the Mississippi Game and Fish Commission and Mississippi State University in Starkville.

The Shipland Wildlife Management Area in Issaquena County is acquired.

The 1000-acre Clarke Creek Natural Area is acquired through a donation from International Paper Company.

1976 Record high deer harvest in eighty-two counties reaches 43,608, and the wild turkey harvest exceeds 8300 in spring and fall seasons in seventy-one counties.

First state waterfowl stamp is issued (31,000 sold).

Congress passes the National Forest Management Act.

The Southeastern Association of Fish and Wildlife Agencies convenes in Jackson.

The Payments in Lieu of Taxes Act, which provides federal payments to local governments to offset losses in property taxes for federal lands within their boundaries, and National Forest Management Act become law.

1977 Mississippi Game and Fish Commission negotiates the purchase of McIntyre Scatters.

Congress passes the Soil and Water Resource Conservation Act.

Mississippi Legislature passes the Forest Registration Act.

The federal Soil and Water Resources Conservation Act becomes law.

1978 The Panther Swamp National Wildlife Refuge is established with the initial purchase of the Curran tract.

Congress passes the Cooperative Forestry Assistance and Renewable Resources Extension Act.

The Mississippi Natural Heritage Act becomes law.

The Mississippi Legislature consolidates the Mississippi Geological Survey, Board of Water Commissioners, Air and Water Pollution Control Commission, Department of Parks and Recreation, and Mineral Lease Commission into the Mississippi Department of Natural Resources.

1979–80 Morgan Brake and Mathews Brake National Wildlife Refuges are established.

Mississippi's wild turkey population exceeds 200,000.

1981–2010

1981 The Mississippi Department of Wildlife Conservation releases 400 ring-necked pheasants in Humphreys County.

1983 Dr. George Hurst, professor at Mississippi State University, is instrumental in initiating the Cooperative Wild Turkey Research Project with the Commission on Wildlife, Fisheries, and Parks.

1984 Congress designates National Duck Stamp Week.

1985 The Wallop-Breaux Federal Aid in Fisheries Restoration Act is passed.

Kemper and Neshoba County Lakes open to the public.

1987 The Mississippi Legislature authorizes the Commission on Wildlife, Fisheries, and Parks to set regulations for managing alligator populations in the state.

The Environmental Protection Council is created by the Mississippi Legislature.

1988 A new10,000-gallon aquarium opens at the Mississippi Museum of Natural Science.

1989 The deer population approaches 1.7 million.

The Mississippi Chapter of the Nature Conservancy establishes a field office in Jackson.

The Mississippi Legislature creates the Mississippi Department of Environmental Quality out of the Mississippi Department of Natural Resources.

1990 The Mississippi Band of Choctaw Indians begin offering forestry and consulting services to the public.

1991 The Wetland Reserve Program begins enrolling land to restore wetlands in Mississippi.

1992 The U.S. Fish and Wildlife Service extends the closing date of duck season from January 5 to January 20.

1993–94 Mississippi landowners impound more than 90,000 acres of winter water for waterfowl.

1995 Mississippi Department of Wildlife, Fisheries, and Parks buys land with $10 million in bonding authority from the Mississippi Legislature.

1996 Senator Thad Cochran introduces a bill to initiate the Wildlife Habitat Incentives Program.

The exhibit "For the Sake of Future Generations: The History of Organized Wildlife Conservation in Mississippi Since 1890" was established at the Mississippi Museum of Natural Science with a grant from the Mississippi Humanities Council.

1997 The Mississippi Fish and Wildlife Foundation (Wildlife Mississippi) is formed. Its first project is the Mississippi Wildlife Habitat Seed Program.

1998 Sky Lake Wildlife Management Area is established. It includes the largest stand of ancient cypress trees in the world.

2000 The Mississippi Land Trust is formed.

2001 Senators Thad Cochran and Trent Lott initiate a bill to add $117 million to the Wetland Reserve Program.

2002 Congress authorizes the Grassland Reserve
 Program.
 The Wildlife Habitat Incentives Program is
 reauthorized at $700 million, and the Wetland
 Reserve Program is reauthorized for 250,000
 acres per year.

2003 The Healthy Forest Restoration Act is signed
 into law. It includes the Healthy Forest Reserve
 Program, which was conceptualized by Wildlife
 Mississippi.
 Wildlife Mississippi creates the Urban For-
 estry Network.

2004 The Theodore Roosevelt National Wildlife
 Refuge and the Holt Collier National Wildlife
 Refuge are established.

2005 The nonprofit Carbon Fund and the consor-
 tium PowerTree Carbon Company partner to
 conduct the first carbon sequestration project
 in Mississippi.
 Hurricane Katrina decimates the Gulf
 region, making landfall at Bay St. Louis, Mis-
 sissippi, and affecting the entire state. The
 Mississippi Sound, coastal estuaries, and forest
 ecosystems are drastically affected.

2006–07 Restoration efforts begin on the Mississippi
 Gulf Coast.

2008 The Endangered Species Recovery Program,
 which aims to recover listed species using fed-
 eral income tax benefits, is drafted.
 The Emergency Forest Restoration Pro-
 gram, which assists private landowners in
 restoring their forests after a natural disaster, is
 drafted.

2010 The Deep Water Horizon Oil Spill (also called
 the BP Spill) causes vast economic and ecologi-
 cal impacts across the Gulf of Mexico, includ-
 ing Mississippi. As a result of fines and settle-
 ments between the federal government and
 the responsible parties, billions of dollars are
 secured for long-term ecological impact studies
 and regionwide restoration activities.

2009–10 Students from Mississippi State University and
 Michigan State University are invited to Wash-
 ington, D.C., for placement in key conserva-
 tion-related positions.

2011–12 A 1735-foot boardwalk is constructed at Sky
 Lake Wildlife Management Area, showcasing
 the oldest stand of ancient cypress in the world.

These hunting lease agreements are for educational purposes only. It is important to check with your attorney before writing and signing a binding legal agreement. You may want the lease to be more detailed or include more requirements, or you may want it to be less detailed. If you want to provide other services or rights, such as guides, cleaning game, or allowing the lessee to improve the habitat, you should include those provisions. (Adapted from Miller, J. E., 2002. *Hunting Leases: Considerations and Alternatives for Landowners*. Natural Resource Enterprises Wildlife and Recreation Series. Mississippi State University Extension Service Publication 2310.)

STATE OF:

COUNTY OF:

TRACT:

This Lease Agreement (the "Lease") entered into as of the day of _____, by and between _____hereinafter referred to as Lessor, and _____a/an (state whether an individual, a partnership, corporation, or unincorporated association) hereinafter referred to as Lessee.

The Lessor agrees to lease the Hunting Rights, as defined below, on _____acres more or less, to Lessee for_____ ($_____/are), for a term commencing on _____, (the "Commencement Date") and ending on _____ (the "Expiration Date") on the following described property (the "Land").
See Attached Description

The Hunting Rights shall consist of the exclusive right and privilege of propagating, protecting, hunting, shooting, and taking game and waterfowl on the Land together with the right of Lessee to enter upon, across, and over the Land for such purposes and none other.

This Hunting Lease Agreement shall be subject to the following terms and conditions:

PAYMENT
1. The Lessee shall pay to the Lessor _____, the amount of one (1) year's Rent in full, on or before _____ by check payable to Lessor.

COMPLIANCE WITH LAW
2. Lessee agrees for itself, its licensees and invitees to comply with all laws and regulations of the United States and of the State and Local Governments wherein the Land lies relating to the game or which are otherwise applicable to Lessee's use of the Land. Any violation of this paragraph shall give Lessor the right to immediately cancel this Lease.

POSTING
3. Lessee shall have the right to post the Land for hunting to prevent trespassing by any parties other than Lessor, its Agents, Contractors, Employees, Licensees, Invitees, or Assigns provided that Lessee has obtained the Lessor's prior written approval of every sign designed to be so used. Every such sign shall bear only the name of the Lessee. Lessor reserves the right to prosecute any trespass regarding said Land but has no obligation to do so.

LESSOR'S USE OF ITS PREMISE
4. Lessor reserves the right in itself, its Agents, Contractors, Employees, Licensees, Assigns, Invitees, or Designees to enter upon any or all of the Land at any time for any purpose of cruising, marking, cutting, or removing trees and timber or conducting any other acts relating thereto and no such use by Lessor shall constitute a violation of this Lease. This right reserved by Lessor shall be deemed to include any clearing, site preparation, controlled burning, and planting or other forestry work or silvicultural practices reasonably necessary to produce trees and timber on the Land. Lessee shall not interfere with Lessor's rights as set forth herein.

GATES/BARRIERS

5. Lessor grants to Lessee the right to install gates or other barriers (properly marked for safety) subject to the written permission of Lessor and the terms and conditions relating thereto as set forth elsewhere in the Lease, on private roads on the Land, and Lessee agrees to provide Lessor with keys to all locks prior to installation and at all times requested by Lessor during the term of this Lease.

ROAD OR FENCE DAMAGE

6. Lessee agrees to maintain and surrender at the termination of this Lease all private roads on the Lands in at least as good a condition as they were in on the date first above-referenced. Lessee agrees to repair any fences or other structures damaged by itself, its licensees or invitees.

ASSIGNMENT

7. Lessee may not assign this Lease or sublease the hunting rights the subject of this Lease without prior written permission of Lessor. Any assignment or sublease in violation of this provision will void this Lease and subject Lessee to damages.

FIRE PREVENTION

8. Lessee shall not set, cause, or allow any fire to be or remain on the Land. Lessee covenants and agrees to use every precaution to protect the timber, trees, land, and forest products on the Land from fire or other damage, and to that end, Lessee will make every effort to put out any fire that may occur on the Land. In the event that any fire shall be started or allowed to escape onto or burn upon the Land by Lessee or anyone who derives his/her/its right to be on the Land from Lessee, Lessor shall have the right immediately to cancel this Lease without notice, and any payments heretofore paid shall be retained by Lessor as a deposit against actual damages, refundable to the extent such damages as finally determined by Lessor are less than said deposit. In addition, Lessor shall be entitled to recover from Lessee any damages which Lessor sustains as the result of such fire. Lessee shall immediately notify the appropriate state agency and Lessor of any fire that Lessee becomes aware of on Lessor's lands or within the vicinity thereof.

INDEMNIFICATION AND INSURANCE

9. Lessee shall indemnify, defend and hold harmless Lessor, its directors, officers, employees, and agents from any and all loss, damage, personal injury (including death at any time arising therefrom) and other claims arising directly or indirectly from or out of any occurrence in, or upon, or at the said Lands or any part thereof relating to the use of said Land by Lessee, Lessee's invitees or any other person operating by, for, or under Lessee pursuant to this Lease. Lessee further agrees to secure and maintain a $1,000,000 public liability insurance policy in connection with the use of the Land with Lessor named as insured and with such insurance companies as shall be agreeable to Lessor. This indemnity shall survive the termination, cancellation, or expiration of this Lease.

RULES AND REGULATIONS

10. Lessor's rules and regulations attached hereto as Exhibit "A" are incorporated herein by reference and made an integral part hereof. Lessee agrees that any violation of said rules and regulations is a material breach of this Lease and shall entitle Lessor to cancel this Lease as its option effective upon notice by Lessor to Lessee of such cancellation.

Lessor reserves the right from time to time to amend, supplement, or terminate any such rules and regulations applicable to this Lease. In the event of any such amendment, supplement, or termination, Lessor shall give Lessee reasonable written notice before any such rules and regulations shall become effective.

MATERIAL TO BE SUBMITTED TO LESSOR

11. If this Lease is executed by or on behalf of a hunting club, Lessee shall provide Lessor, prior to the execution hereof, a membership list including all directors, officers, and/or shareholders, their names and addresses, and a copy of Lessee's Charter, Partnership Agreement, and By-Laws, if any. During the term of this Lease, Lessee shall notify Lessor of any material change in the information previously provided by Lessee to Lessor under this paragraph 11.

LESSEE'S LIABILITY RE: TREES, TIMBER, ETC.

12. Lessee covenants and agrees to assume responsibility and to pay for any trees, timber, or other forest products that may be cut, damaged, or removed from the Land by Lessee or in connection with Lessee's use of the Land or any damages caused thereupon.

NO WARRANTY

13. This Lease is made and accepted without any representations or warranties of any kind on the part of the Lessor as to the title to the Land or its suitability for any purposes; and expressly subject to any and all existing easements,

mortgages, reservations, liens, rights-of-way, contracts, leases (whether grazing, farming, oil, gas, or minerals) or other encumbrances or on the ground affecting Land or to any such property rights that may hereafter be granted from time to time by Lessor.

LESSEE'S RESPONSIBILITY

14. Lessee assumes responsibility for the condition of the Land and Lessor shall not be liable or responsible for any damages or injuries caused by any vices or defects therein to the Lessee or to any occupant or to anyone in or on the Land who derives his or their right to be thereon from the Lessee.

USE OF ROADS

15. Lessee shall have the right to use any connecting road(s) of Lessor solely for ingress, egress, or regress to the Land; such use, however, shall be at Lessee's own risks and Lessor shall not be liable for any latent or patent defects in any such road nor will it be liable for any damages or injuries sustained by Lessee arising out of or resulting from the use of any of said Lessor's roads. Lessee acknowledges its obligation of maintenance and repair for connecting roads in accord with its obligation of maintenance and repair under paragraph 6.

SURRENDER AT END OF TERM

16. Lessee agrees to surrender the Land at the end of the term of this Lease according to the terms hereof. There shall be no renewal of this Lease by implication or by holding over.

MERGER CLAUSE

17. This Lease contains the entire understanding and agreement between the parties, all prior agreements between the parties, whether written or oral, being merged herein and to be of no further force and effect. This Lease may not be changed, amended, or modified except by a writing properly executed by both parties hereto.

CANCELLATION

18. Anything in this Lease to the contrary notwithstanding, it is expressly understood and agreed that Lessor and Lessee each reserve the right to cancel this Lease, with or without cause, at any time during the Term hereof after first giving the other party thirty (30) days prior written notice thereof. In the event of cancellation by Lessee, all rentals theretofore paid and unearned shall be retained by the Lessor as compensation for Lessor's overhead expenses in making the Land available for lease, and shall not be refunded to Lessee.

APPLICABLE LAW

19. This Lease shall be construed under the laws of the State first noted above.

IN WITNESS WHEREOF, the parties have hereunto caused this Agreement to be properly executed as of the day and year first above written.

WITNESSES:

_____, owner of _____farm, (legal description of the land), County, (state), herein referred to as "Landowner," for good and sufficient consideration, as hereinafter set forth, leases hunting rights on those portions of the _____ farm, hereinafter described, to _____ and others so executing this agreement and hereinafter referred to as "Lessees," on the following terms and conditions:

1. The tract of land, hereinafter referred to as "lease" upon which hunting rights are granted, is the_____ _____ farm described herein consisting of approximately _____ acres.
[Add description of land with aerial photograph if available.]

Lessees understand the location and boundaries of said tract and agree that no hunting rights are granted hereunder on any tract other than the tract herein designated and that no hunting or discharging of firearms shall be done by Lessees while traveling to or from the lease.

2. This agreement and the rights and duties granted and incurred hereunder shall be for a term commencing with the opening of _____ season in 20___, and the closing of _____ season in 20_____, as set for

_____ County, (state), under regulations enforced by the (state wildlife agency) unless terminated pursuant to provisions of this agreement hereinafter set forth. Provided that either the Landowner or Lessee may cancel this agreement by giving written notice of its intent to do so thirty (30) days prior to the date that rental for the second or third year of the term here provided is due. In which event, Lessee shall be relieved of the obligation to pay further rental under the terms and shall deliver possession of the premises.

3. The consideration to be paid by Lessee to Landowner at _____ County, (state), is $_____ in cash, one-half to be paid on or before June 1, 20_____, and the balance to be paid on or before October 1, 20_____. Failure to pay the second installment shall thereupon terminate and cancel the lease and the amount already paid shall be forfeited as liquidated damage for the breach of the agreement. A $_____ deposit will be required to insure that lease premises are left in a clean and orderly condition. Farm personnel will inspect the premises within thirty (30) days after the lease expires. If cleanup is necessary, the farm will accomplish such, and the $_____ deposit will be forfeited by the Lessees. If the premises are determined by farm personnel to be clean and orderly, the $_____ deposit will be returned to the Lessees within sixty (60) days after expiration of the lease.

4. Lessees shall not assign this lease or sublet the leased premises without the written consent of_____ _____.

5. Lessees shall at all times abide by and obey all state and federal hunting laws and regulations and Lessee shall be responsible for the conduct of Lessee's guests or members in connection with said hunting laws and shall be responsible for any violation of said hunting laws or regulations by said Lessee, its guests, or members. Any violation of the hunting laws or regulations of any governmental authority shall give rise to the right of immediate cancellation of this lease by the Landowner upon written notice to Lessees, and in the event of the cancellation of said lease due to violation of game laws by Lessees, its guests or members, no pro rata of the rent previously paid shall be made, same to be forfeited as liquidated damages, and Lessees shall, upon receipt of such notice, immediately vacate and surrender unto the Landowner possession of the leased premises.

Lessees shall, during the period in which it has access to the leased premises, continually protect same against trespassers and squatters, and to the best of Lessee's ability have such persons apprehended and prosecuted.

6. This lease agreement is expressly made subject to the "General Conditions of the Lease," which are attached hereto as Exhibit "A," and made a part hereof for all purposes the same as if copied herein verbatim.

7. If Lessees default in the performance of any of the covenants or conditions hereof, including the "General Conditions of Lease," which are attached hereto as Exhibit "A," then such breach shall cause an immediate termination of this lease and a forfeiture to Landowner of all consideration prepaid. The Lessee shall have no further rights under the term of this lease agreement. In the event a lawsuit arises out of or in connection with this lease agreement and the rights of the parties thereof, the prevailing party may recover not only actual damages and costs but also reasonable attorneys' fees expended in the matter.

8. Landowner shall not be liable for any injuries, deaths, or property damage sustained by (1) any Lessees hereto, (2) any employees of Lessees, (3) any business invitees of Lessees, (4) any guest of Lessees, (5) any person who comes to the leased premises with the express or implied permission of Lessees on the _____ farm with permission of the Lessee hereunder except for such injury, death, or property damage as may be sustained directly as a result of Landowner's sole negligence. Lessee hereunder jointly and severally agrees to indemnify Landowner, his agents or employees against any claim asserted against Landowner or any of Landowner's agents or employees as a result of personal injury, death, or property damage arising through: (1) the negligence of a Lessee or any persons on the farm with the permission of a Lessee, or (2) through the concurrent negligence of a Landowner or his agents or employees, any one or more of Lessees, or any person on the _____ farm with the permission of the Lessee.

All minors permitted by Lessee to hunt, fish, or swim on the leased premises shall be under the direct supervision of one of their parents (or guardian) and when children are present on the leased premises, the parents shall be fully responsible for their acts and safety and agree to hold Landowner harmless therefore, regardless of the nature of the cause of damage, whether property or personal injury, to themselves or others.

9. The leased premises are taken by Lessee in an "as is" condition, and no representation of any kind is made by _____ regarding the suitability of such premises for the purpose for which they have been leased.

10. This lease may not be terminated or repudiated by Lessee except by written notice signed and acknowledged in duplicate before a Notary Public by Lessee, and such termination or repudiation shall not be effective until Lessee has mailed one executed copy thereof to Landowner by registered mail and filed the other executed copy thereof for record in the Office of the County Clerk, _____ County, (state). This lease shall be binding upon the distributes, heirs, next of kin, successors, executors, administrators, and personal representatives of each of the undersigned. In signing the foregoing lease, each of the undersigned hereby acknowledges and represents:

(a) That he has read the foregoing lease, understands it, and signs it voluntarily; and

(b) That he is over 21 years of age and of sound mind;

In witness whereof, the parties have set their hands this the _____ day of _____, 20_____.

LESSEES: DATE:

LANDOWNER: DATE:

WITNESS: DATE:

STATE OF ___ _____

COUNTY OF _____

The foregoing instrument was subscribed, sworn to, and acknowledged before me this_____ day of _____, 20_____, by_____ and _____.

My commission expires:_____

Notary Public

EXHIBIT "A," GENERAL CONDITIONS OF LEASE (EXAMPLES OF OPTIONAL CLAUSES)

_____ LANDOWNER, LEASE TO _____ LESSEE

These general conditions of lease are applicable to the lease agreement between_____, hereinafter referred to as LANDOWNER, and _____, LESSEE. Lessee and all persons authorized to Lessee to hunt upon the leased premises shall be hereinafter collectively referred to as "Hunters."

1. It will be the responsibility of the Lessee to furnish each hunter or guest with a copy of these general conditions of lease.

2. Lessees understand and agree that the leased premises are not leased for agricultural or grazing purposes and, consequently, taken subject to the rights thereof.

3. Lessee acknowledges that Landowner owns the property herein leased, primarily for agricultural purposes and the growing of timber. Lessee shall in no manner interfere or obstruct Landowner's farming, forestry, or livestock operations.

4. Landowner reserves the right to deny access to the leased premises to any person or persons for any of the following reasons: drunkenness, carelessness with firearms, trespassing on property of adjoining landowners, acts that could reasonably be expected to strain relationships with adjoining landowners, or any other activities that to the ordinary

person would be considered objectionable, offensive, or to cause embarrassment to Landowner or be detrimental to Landowner's interest. Failure of Lessee to expel or deny access to the premises to any person or persons after being notified to do so by Landowner may result in the termination of this lease at discretion of Landowner.

5. No hunter shall be allowed to:
(a) Shoot a firearm from a vehicle;
(b) Erect a deer stand within 150 yards of the boundary of the herein leased premises;
(c) Permanently affix a deer stand in trees;
(d) Abuse existing roads by use of vehicles during wet or damp conditions;
(e) Fire rifles or other firearms in the direction of any house, barn, other improvements, or across any haul road located on the leased premises;
(f) Build or allow fires on the leased premises, except in those areas specifically designated by Landowner in writing, and, in event, shall be kept fully liable for such fires; and
(g) Leave open a gate found closed or close a gate found open.

6. Hunters shall at all times maintain a high standard of conduct acceptable to _____.

Hunting Club Bylaws

Hunting club bylaws should contain provisions that govern the day-to-day operation of the club. The bylaws should be adapted to local conditions that affect the club, its relationship with landowners(s), and the well-being of the land and wildlife resources. You should keep the bylaws as simple, concise, and understandable as possible for the benefit of the members and yourself. Some clubs develop bylaws that are too complex and too extensive for the basic needs and are too difficult to manage or enforce adequately. Bylaws should be written to be basic to the operation of the club or group's interest and to add others as needed based on the club/group's growth, changing needs, changing wildlife regulations, or changes you need. Some examples of items that need to be considered when drafting bylaws are:

◆ Guest privileges and/or regulations;
◆ Safety for members, for the landowners, and/or property;
◆ Land management and stewardship of the property;
◆ Appropriate disciplinary procedures for all members and guests, if allowed;
◆ Rules of the hunt for all participants;
◆ Strict adherence to all state and federal wildlife regulations;
◆ Functional/operational committees, such as camp operation and maintenance, stand or blind placement and maintenance, food and cooks for organized hunts, and such;
◆ Maintenance of appropriate member and landowner(s) relations;
◆ If management for quality deer management is a club/group objective, this needs to be made clear in the bylaws;
◆ Any club/group self-imposed management requirements, such as no dogs, use of trailing dogs for retrieving cripples, or for chasing deer. Also consider if other species are allowed to be hunted during regulated seasons, such as turkey, squirrels, raccoons, waterfowl, and doves.

 Hunting club/group bylaws are essential for many organized hunting operations, and if you have concerns about the legality of the bylaws and their enforcement, you may consult a lawyer. Clearly, one of the most important considerations is that all members and invited guests must understand and agree in writing to the adopted bylaws for the bylaws to be useful and effective. The items listed above are not all you need to consider. The list can be expanded based on the desires and needs of you and the membership.

Written by Tim Traugott and Steve Dicke, Department of Forestry, Mississippi State University

FOREST MANAGEMENT PLAN

for
John Doe
222 Acorn Road
Macon, Mississippi 39341
Property located in
Noxubee County

Field data collected and prepared by
Joe Q. Consultant
Trees R Us, Inc.
P.O. Drawer 1645
Starkville, Mississippi 39759
662-333-9999

Time period covered by this plan
2008–2018

Date prepared
April 9, 2008

INTRODUCTION
This management plan was prepared for John Doe to serve as a guideline for the management practices undertaken in order to satisfy his stated landowner objectives. The plan covers activities used to improve the quality of timber and wildlife resources available on the property and includes recommendations for maintaining the soil, water, and aesthetic quality of the site.

In addition to providing direction for forestry-related activities on the property, this plan may also qualify the landowner for various state and federal cost-share programs such as the Forest Resource Development Program (FRDP), which provide financial assistance for responsible management practices. Limited funding under these programs is available on a first-come first-serve basis and this plan does not guarantee that assistance will be awarded.

LANDOWNER OBJECTIVES
The landowner's primary objective is to maximize timber income with some consideration for wildlife while making the property aesthetically pleasing. Would like to leave enough timber to sell at death in order for one son to buy out other siblings' share of estate without debt.

TRACT DESCRIPTION
Tract Location
This property is located in Sections 10, 11, 14, and 15, Township 14N, Range 15E in Noxubee County, Mississippi, approximately 11 miles west of Macon.

Tract Acreage
The Sample property consists of approximately 460 acres, which can be divided into

124 acres of pine plantation, established 2000;

220 acres of pine plantation, established 2007;

65 acres of bottomland hardwoods; and

51 acres of other/open land.

Accessibility of Tract
Accessibility to the tract is excellent in all areas.

Hydrology
Special protection must be given on this property to maintain the water quality. This protection will be done through the use of streamside management zones and other precautions identified in the best management practices guidelines. Intermittent streams and a pond are the only water sources that will need protection on this site.

Historical, Cultural, or Archeological Features
These areas can range from old cemeteries or Indian mounds to old home sites or other areas of historical significance. There were no such areas of historical, cultural, or archeological value identified on the property.

Soil Series Present
The USDA Soil Survey of Noxubee County shows the following soil series present on the site:

Cahaba Series: Cahaba soils are well-drained soils found on uplands. They are usually associated with Lexington, Luverne, Providence, and Susquehanna soils. These soils are well suited to both pines and hardwoods. The erosion hazard for these slopes is severe due to the slope.

Ruston Series: Ruston soils are well-drained sandy soils found mostly in the eastern part of the county on hilly uplands with side slopes of 12% to 50%. These soils are best suited for pine production.

Stough Series: Stough soils are somewhat poorly drained sandy loam soils located on upland flats and nearly level stream terraces. These soils have a slight erosion hazard and are best suited for loblolly pine production.

Soil Types Present
(CaA) Cahaba fine sandy loam, 0–2% slopes: This well-drained soil occurs on terraces and is low in natural fertility and organic matter. These soils have a slight to moderate equipment limitation and erosion hazard. Loblolly pine is the best-suited timber species for this soil type with a site index of 75–85.

(RuB2) Ruston fine sandy loam, 2–5% slopes: This well-drained soil type is found on upland ridgetops. RuB2 soils are best suited for loblolly pine production and have a site index of 84 for this species. Both the erosion hazard and equipment limitations are considered slight, so there are no significant restrictions for properly conducted forest management activities.

(StA) Stough fine sandy loam, 0–2% slopes: This somewhat poorly drained soil is found on nearly level stream terraces and upland flats. Although sites containing this soil type are moderately suited for cherrybark and water oak production (site indices are 85 and 80, respectively), they are best suited for loblolly pines and have a site index of 90 for this species. The erosion hazard is slight and equipment limitations are considered moderate due to potential wetness, so forest management activities involving heavy equipment use should be restricted to dry periods.

STAND DESCRIPTIONS AND RECOMMENDATIONS
For management purposes, it is common practice to break property down into different stands that are similar in age class distribution, species composition, and structure. Each stand identified in this document will contain all areas on the property that should be managed under the same management regime. The following stand(s) are present on this property:

Stand 1: Pine plantation, established 2000
This area contains approximately 124 acres of 8-year-old pine plantation. Deer and turkey habitat is considered good to fair for this stand. Soil types present on the stand are as follows: CaA and RuB2 (see "Soil Types Present").

There is currently no evidence of any existing erosion problems or any threats to water quality in this stand. Care should be taken in any management activities to ensure that no such problems occur in the future. This can be

accomplished by using best management practices in forestry operations, which are discussed in a separate section of this management plan. A streamside management zone will be needed around the stream if any logging operations are carried out on the property.

Prescription
This stand is currently in good condition. Let it grow until age 14–16 and check for a first thinning. A prescribed burn is needed prior to thinning.

Stand 2: Pine plantation, established 2007
This area contains approximately 220 acres of pine plantation. Deer or turkey habitat is considered good to fair for this stand type. Soil types present on the stand are as follows: CaA (See "Soil Types Present").

There is currently no evidence of any existing erosion problems or any threats to water quality in this stand type. Care should be taken in any management activities to ensure that no such problems occur in the future. This can be accomplished by using best management practices in forestry operations, which are discussed in a separate section of this management plan.

Prescription
This stand is in good condition and should be left to grow.

Stand 3: Bottomland hardwood
This area contains approximately 65 acres of bottomland hardwoods. The average age is 60 years. The average basal area is 80 square feet/acre. The stand is 75% sawtimber and the rest is pulpwood. The major hardwood species present are white oak, hickory, water oak, and cherrybark oak. Deer and turkey habitat is considered good for this stand type. Soil types present on the stand are as follows: StA (See "Soil Types Present").

There is currently no evidence of any existing erosion problems or any threats to water quality in this stand type. Care should be taken in any management activities to ensure that no such problems occur in the future. This can be accomplished by using best management practices in forestry operations, which are discussed in a separate section of this management plan.

Prescription
Maintain this stand as a hardwood stand. Thin periodically to promote establishment of desired hardwood regeneration. An alternative to thinning would be to make small clearcuts for regeneration.

WILDLIFE CONSIDERATIONS
Habitat Assessment and Recommendations
Overall, this tract currently offers good habitat for deer and turkey. Keep in mind that most silvicultural practices recommended for timber management also enhance wildlife habitat.

Threatened and Endangered Species
There was no evidence of any threatened or endangered species noted on this property while conducting the field visit.

TENTATIVE 10-YEAR ACTIVITY SCHEDULE

Year	Stand no.	Activity
2009		
2010		
2011	3	**Check for timber stand improvement or clearcut**
2012		
2013	1	**Check for first thinning**
2014		
2015		
2016		
2017		
2018		

This schedule is a timetable of suggested timber management practices that will assist you in meeting the stated objectives for your property. It is highly recommended that you seek professional assistance before performing any of these activities.

Sample Pine Thinning Contract

This sample pine thinning contract is intended only as a guide for the forest landowner to ensure that pertinent provisions are addressed in their pine thinning contracts. We strongly encourage landowners to obtain the legal advice of an attorney when preparing all legal contracts.

STATE OF MISSISSIPPI

COUNTY OF _____

TIMBER CUTTING AGREEMENT

WHEREAS, _____ (hereinafter referred to as "PURCHASER") and _____ (hereinafter referred to as "SELLER") have reached an agreement whereby PURCHASER shall purchase from SELLER certain timber, and whereas all parties desire to reduce their agreements to writing.

IT IS THEREFORE AGREED AS FOLLOWS, TO WIT:

1. The relationship between the PURCHASER and SELLER is contractual only. No partnership or joint venture is entered into by the parties hereto and the PURCHASER is an independent contractor.

2. PURCHASER shall cut and haul the following described timber located on the following described property which timber SELLER owns and has a right to sell without permission from anyone. Thinning of _____ acres, more or less, of pine trees in _____ County, Mississippi located in Section ___, Range ____ East, Township __ North, as designated on the attached map.

3. The timber purchase contract shall begin on the ____day of _____, in the year of _____ and end on the ___ day of _____, in the year_____, inclusive.

4. The total consideration and purchase price of timber cut hereunder shall be based upon the weight of timber cut and delivered at the rate of $_____ per ton for pulpwood trees, $_____ per ton for chip-n-saw trees, and $_____ per ton for sawtimber trees. Payment shall be made weekly to SELLER for timber cut and removed the preceding week. The weight of the timber cut and removed will be determined by scalers at the place of delivery. PURCHASER shall furnish SELLER weekly settlement records and scale tickets. The weight as shown on the settlement records and payments therefore shall be binding upon SELLER unless contested within thirty (30) days following receipt of any settlement records and payments.

5. PURCHASER shall hold SELLER harmless from any damage caused by him or his employees or agents to persons or property arising from his operations on the said lands. PURCHASER will have liability insurance in force.

6. PURCHASER may use employees to accomplish the timber harvest. No one participating in the timber harvest is an employee of the SELLER. When required by law, PURCHASER will have workman's compensation insurance on his employees while harvesting the timber. SELLER shall not be responsible for any injuries to any employees of PURCHASER.

7. The PURCHASER and SELLER agree to the following:

A. This agreement shall not be assigned in whole or in part by either party without written consent of the other party.
B. PURCHASER shall cut and haul timber in accordance with THINNING TECHNIQUE # _____ as described as follows:

THINNING TECHNIQUE # 1: THIRD ROW THIN
Thinning of trees will be accomplished by removing every third (3rd) row. Twenty-five percent (25%) of the trees on the two rows on either side of the removal row will be cut. Trees cut from remaining rows will be slower growth, smaller,

malformed, or diseased trees. An average of _____ square feet of basal area and/or _____ trees per acre will be left after thinning. See table below.

THINNING TECHNIQUE # 2: FOURTH ROW THIN
Thinning of trees will be accomplished by removing every fourth (4th) row. Thirty-three percent (33%) of the trees on the two rows on either side of the removal row will be cut. Trees cut from remaining rows will be slower growth, smaller, malformed, or diseased trees. An average of _____ square feet of basal area and/or _____ trees per acre will be left after thinning. See table below.

THINNING TECHNIQUE # 3: FIFTH ROW THIN
Thinning of trees will be accomplished by removing every fifth (5th) row. Forty percent (40%) of the trees on the two rows on either side of the removal row will be cut. Trees cut from remaining rows will be slower growth, smaller, malformed, or diseased trees. An average of _____ square feet of basal area and/or _____ trees per acre will be left after thinning. See table below.

THINNING TECHNIQUE # 4: STRIP THINNING
Thinning of trees will be accomplished by removing a strip of trees about 20 feet wide along the contours of the plantation to make room for a truck and/or skidder to drive through without damaging trees on each side. A 40-foot-wide leave or uncut strip shall be left between the cut strips. Twenty-five percent (25%) of the trees in the 40-foot leave strip will be cut. Trees cut from remaining strips will be slower growth, smaller, malformed, or diseased trees. An average of _____ square feet of basal area and/or _____ trees per acre will be left after thinning. See table below.

Description of Average Tree Size and Density to Leave
Target BA (circle one): 60 70 80 square feet per acre
Target DBH = average DBH before thinning plus
1 inch = _____ inches
Target trees per acre to achieve target BA and DBH
from table below =_____ trees per acre

Thinning target trees/acre by DBH and basal area			
Target DBH	Target BA sq. ft. per acre		
	60	70	80
5	440	513	587
6	306	357	408
7	225	262	299
8	172	201	229
9	136	158	181
10	110	128	147
11	91	106	121
12	76	89	102
13	65	76	87
14	56	65	75

THINNING TECHNIQUE # 5: MARKED LEAVE TREE
Thinning will be accomplished by cutting trees **not marked** with _____ colored paint. Trees marked with _____ colored paint shall not be harvested or damaged during the harvesting operation.

THINNING TECHNIQUE # 6: MARKED CUT TREE
Thinning will be accomplished by cutting all trees **marked** with _____ colored paint. Trees not marked with _____ colored paint shall not be harvested or damaged during the harvesting operation.

C. Dry weather logging only will be permitted. SELLER retains the right to stop the logging due to wet ground conditions.

D. Reasonable care shall be taken to protect the residual stand from damage. SELLER retains the right to stop logging if he considers excessive damage is occurring, or residual stand does not meet the basal area and trees per acre requirements stated in Item 7B.

E. Location of all logging/loading decks will be agreed upon by the SELLER and PURCHASER prior to construction of said decks.

F. The thinning operation will be conducted in accordance with Mississippi's best management practices.

G. Prior to commencement of logging, SELLER and PURCHASER or his agent will examine all roads and ditches on SELLER'S property. PURCHASER agrees to leave all roads and ditches in as good as condition as when he started the thinning operation. Thirty (30) days after the completion of logging if PURCHASER has not accomplished this requirement, the SELLER has the right to hire the necessary work to return roads and ditches to their original condition and the PURCHASER agrees to pay for this expense.

H. In case of dispute over the terms of this contract, the final decision shall rest with an arbitration board of three registered foresters, one to be selected by each party to this contract and a third to be selected by the other two members of the arbitration board.

THIS AGREEMENT entered into on this, the_____ day of _____, 2012.

_____ _____
WITNESS SELLER

_____ _____
WITNESS BUYER

FARM POND HARVEST RECORD

Instructions: Accurate and complete data are important to fisheries management. All anglers should complete a record after each trip. For convenience, you can group fish by length group as follows:

Bass categories: < 12 inches, 12 - 15 inches, > 15 inches
Bluegill categories: 3 - 6 inches, > 6 inches

Under each column, in each size group, enter the number of fish harvested (H) and released back into the lake (R).

Date	Angler	BASS			BLUEGILL		CATFISH	OTHER
		< 12 inches	12 -15 inches	> 15 inches	3-6 inches	> 6 inches		
		H R	H R	H R	H R	H R	H R	H R
		H R	H R	H R	H R	H R	H R	H R
		H R	H R	H R	H R	H R	H R	H R
		H R	H R	H R	H R	H R	H R	H R
		H R	H R	H R	H R	H R	H R	H R
		H R	H R	H R	H R	H R	H R	H R
		H R	H R	H R	H R	H R	H R	H R
		H R	H R	H R	H R	H R	H R	H R
		H R	H R	H R	H R	H R	H R	H R
		H R	H R	H R	H R	H R	H R	H R
		H R	H R	H R	H R	H R	H R	H R
		H R	H R	H R	H R	H R	H R	H R
		H R	H R	H R	H R	H R	H R	H R
		H R	H R	H R	H R	H R	H R	H R
		H R	H R	H R	H R	H R	H R	H R
		H R	H R	H R	H R	H R	H R	H R

Appendix 5

Trees, Shrubs, Vines, and Wildflowers for Mississippi Backyard Wildlife Habitats

Large evergreen trees	Region [a]	Soil [b]	Light [c]	Type of fruit	Season of fruiting [d]	Value to wildlife
Cedar, eastern red (*Juniperus virginiana*)	all	D	S–Sh	berry	A–W	Berries eaten by many birds and mammals. Important nesting and protective cover.
Magnolia, southern (*Magnolia grandiflora*)	all	M	S–Sh	seed	A	Berry-like seeds eaten by a few birds and mammals. Mississippi state tree and flower.
Oak, live (*Quercus virginiana*)	S, GC	D–M	S–Sh	acorn	A–W	Acorns are an excellent food source for birds and mammals. Good cover.
Pine, loblolly (*Pinus taeda*)	all	D	S	seed	A	Pine seeds are an important food source for many birds and mammals. Pines provide excellent year-round cover. Larger pines are favorite roosting sites. Pines are one of the most common mourning dove nesting sites. Larval host plant for eastern pine elfin butterfly. Loblolly, longleaf, and slash pines are not recommended for Delta soils.
Pine, longleaf (*P. palustris*)	S, GC	D–M	S	seed	A	
Pine, slash (*P. elliottii*)	S, GC	M	S	seed	A	
Pine, spruce (*P. glabra*)	C, S, GC	M	S–Psh	seed	A	
Redbay (*Persea borbonia*)	S, GC	M	Psh	drupe	A	Bitter fruit eaten by birds. Larval host plant for spicebush and palamedes swallowtails.
Large deciduous trees	**Region [a]**	**Soil [b]**	**Light [c]**	**Type of fruit**	**Season of fruiting [d]**	**Value to wildlife**
Ash, green (*Fraxinus pennsylvanica*)	N, C	D–M	S	samara	Su–A	Seeds eaten by some birds and mammals. Good bird nesting cover. Larval host plant for swallowtail, mourning cloak, viceroy, and red-spotted purple butterflies.
Ash, white (*F. americana*)	all	D–M	S	samara	Su–A	
Beech, American (*Fagus grandifolia*)	all	M	Psh–Sh	nut	A	Beech nuts eaten by many species of birds and mammals. Good cover and nest tree.
Cypress, bald (*Taxodium distichum*)	all	W–D	S–Psh	seed	A–W	Seeds eaten by some species. Good insect tree for birds. Good cover and nesting sites.
Gum, black (*Nyssa sylvatica* var. *biflora*)	all	W–M	S–Psh	drupe	Su–A	Fruit valuable for many birds and mammals. Fruit drops in autumn. Good honey tree.
Hickory, pecan (*Carya illinoinensis*)	all	M	S	nut	A	Nuts relished by many species. Good insect tree. Larval host plant for gray hairstreak.

Large deciduous trees	Region[a]	Soil[b]	Light[c]	Type of fruit	Season of fruiting[d]	Value to wildlife
Hophornbeam, eastern (*Ostrya virginiana*)	N, C, S	D–M	S–Sh	nutlet	A–W	Nutlets eaten by some songbirds and small mammals. Larval host plant for mourning cloak and red-spotted purple butterflies.
Maple, red (*Acer rubrum*)	all	M	S–Psh	seed	Sp–Su	Seeds, buds, and flowers provide food for many kinds of birds and mammals. Birds use the leaves and seed stalks as nest material. Maples also are natural insect attractors, providing a food source for insectivorous birds.
Maple, silver (*A. saccharinum*)	all	M	S–Sh	seed	Sp–Su	
Maple, sugar (*A. saccharum*)	N	M	S–Sh	seed	Sp–Su	
Oak, pin (*Quercus palustris*)	N	W–M	S–Sh	acorn	A–W	Oaks are of major importance to wildlife. Greatest value is in winter when other foods are scarce. Acorns are consumed by many game birds, songbirds, and mammals. White oak acorns are more palatable. Oaks also provide good cover, nesting sites, and den trees. Many wildlife species use the leaves and twigs as nesting material. Oaks are the larval host plant for red-spotted purple and hairstreak butterflies.
Oak, southern red (*Q. falcata*)	all	D	Psh	acorn	A–W	
Oak, water (*Q. nigra*)	all	W–M	Psh	acorn	A–W	
Oak, white (*Q. alba*)	all	M–D	S–Sh	acorn	A–W	
Oak, willow (*Q. phellos*)	all	W–M	Psh	acorn	A–W	
Persimmon (*Diospyros virginiana*)	all	D–M	Psh	berry	A–W	Fruit important for many birds and mammals. Fruit borne on female trees.
Poplar, tulip (*Liriodendron tulipifera*)	all	M	Psh–Sh	seed	Su–W	Flowers attract hummingbirds. Birds and squirrels eat seeds. Swallowtail host plant.
Sweetgum (*Liquidambar styraciflua*)	all	W–M	S–Psh	seed	A	Seeds eaten by a number of birds and small mammals. Good nesting site and cover.
Small evergreen trees	**Region[a]**	**Soil[b]**	**Light[c]**	**Type of fruit**	**Season of fruiting[d]**	**Value to wildlife**
Holly, American (*Ilex opaca*)	all	M	S–Psh	drupe	A–W	Berries eaten by many songbirds, especially mockingbirds, thrushes, catbirds, robins, bluebirds, and thrashers. Berries persist through winter. Good cover and nesting sites. With hollies, plant both male and female trees to ensure fruit production.

Small evergreen trees	Region[a]	Soil[b]	Light[c]	Type of fruit	Season of fruiting[d]	Value to wildlife
Holly, dahoon (*I. cassine*)	all	W–M	S–Psh	drupe	A–W	
Holly, yaupon (*I. vomitoria*)	all	W–D	S–Psh	drupe	A–W	
Magnolia, sweetbay (*Magnolia virginiana*)	all	M	Psh	seed	A	Berry-like seeds eaten by songbirds. Leaves used in nest building. Larval host plant for tiger, spicebush, and palamedes swallowtail butterflies.
Wax myrtle (*Myrica cerifera*)	C, S, GC	W–M	S–Psh	drupe	A–W	Fruit used by many species of birds. Larval host plant for red-banded hairstreak.
Small deciduous trees	**Region[a]**	**Soil[b]**	**Light[c]**	**Type of fruit**	**Season of fruiting[d]**	**Value to wildlife**
Birch, river (*Betula nigra*)	all	W–M	S–Psh	seed	Sp–Su	Seeds eaten by a few birds. Larval host plant for mourning cloak and eastern tiger swallowtail butterflies. Good insect tree.
Buckeye, red (*Aesculus pavia*)	N, C, S	D–M	S–Sh	seed	Su–A	Red tubular flowers attract bees and hummingbirds. Squirrels eat the seeds.
Cherry, black (*Prunus serotina*)	N, C, S	D–M	S	drupe	Su–A	Fruit eaten by many species. Larval host plant for spring azure, red-spotted purple, eastern tiger swallowtail, and viceroy.
Crab apple, southern (*Malus angustifolia*)	all	D–M	S–Psh	pome	A–W	Fruit eaten by many species of wildlife. Good nest tree.
Dogwood, flowering (*Cornus florida*)	all	D–M	Psh–Sh	drupe	A	Fruit eaten by many birds and mammals. Larval host plant for spring azure butterfly.
Fringetree, white (*Chionanthus virginicus*)	all	M	Psh	drupe	Su–A	Fruit eaten by many birds and mammals. Fruit produced from fertilized perfect or female flowers. Plant several trees to increase the chance of fruit production.
Hawthorn (*Crataegus* species)	all	W–M	S	pome	A–W	Fruit eaten by many birds. Favorite nesting site for birds, including hummingbirds.
Holly, possumhaw (*Ilex decidua*)	all	M–W	S–Psh	drupe	A–W	Fruit favored by many birds and mammals. Provides nectar for insects. Good nest tree.
Mulberry, red (*Morus rubra*)	all	M–D	S–Psh	berry	Sp–Su	Early summer food for many birds. Larval host plant for mourning cloak butterfly.
Pawpaw (*Asimina triloba*)	N, C	M	Psh–Sh	berry	Su	Banana-like fruit eaten by many species. Larval host plant for zebra swallowtail. Plant two trees for pollination.
Plum, American (*Prunus americana*)	all	D–M	S	berry	Su	Fruit eaten by some species. Valuable nesting cover. Host for many butterflies.
Redbud, eastern (*Cercis canadensis*)	N, C, S	D–M	Psh–Sh	legume	Su–A	Flowers attract bees. Seeds eaten by a few species. Larval host plant for Henry's elfin butterfly.

Small deciduous trees	Region[a]	Soil[b]	Light[c]	Type of fruit	Season of fruiting[d]	Value to wildlife
Sassafras (*Sassafras albidum*)	all	M	S–Sh	berry	Su–A	Fruit eaten by birds. Larval host plant for eastern tiger and spicebush swallowtails.
Willow, weeping (*Salix babylonica*)	all	D–W	S	capsule	Su	Hummingbirds use seed cotton for nesting. Host plant for red-spotted purple, mourning cloak, eastern tiger swallowtail, and viceroy.
Evergreen shrubs	**Region[a]**	**Soil[b]**	**Light[c]**	**Type of fruit**	**Season of fruiting[d]**	**Value to wildlife**
Holly, large gallberry (*Ilex coriacea*)	S	D–W	S–Psh	berry	A–W	Fruit eaten by birds and small mammals. Good hedge plant. Provides winter cover.
Farkleberry (*Vaccinium arboreum*)	all	D–M	Psh	berry	Su–A	Fruit eaten by many species. Host plant for striped hairstreak and Henry's elfin butterfly.
Juniper (*Juniperus* species)	all	D–M	S	berry	A–W	Fruit eaten by many birds and mammals. Provides good cover and nesting sites.
Laurelcherry, Carolina (*Prunus caroliniana*)	all	D	S–Psh	drupe	A	Fruit relished by many birds and mammals. Good cover and nesting sites.
Leucothoe (*Leucothoe axillaris*)	all	M–W	Psh–Sh	capsule	Su	Low-growing, spreading shrub. Flowers attract bees. Deer browse foliage.
Lyonia (*Lyonia lucida*)	all	D–M	Psh–Sh	capsule	Su	Flowers attract bees. Some food value, but more valuable for cover. Understory shrub.
Spindletree, Japanese (*Euonymus japonica*)	all	M–D	S–Psh	berry	A	Fruit eaten by several songbirds. Provides winter cover. Introduced, non-native plant.
Deciduous shrubs	**Region[a]**	**Soil[b]**	**Light[c]**	**Type of fruit**	**Season of fruiting[d]**	**Value to wildlife**
Beautyberry, American (*Callicarpa americana*)	all	M	Psh	berry	Su–W	Purple berries relished by mockingbirds, catbirds, robins, and thrashers.
Blackberry (*Rubus* species)	all	D–W	S	berry	Su	Very important summer food for wildlife. Blackberry thickets provide excellent cover.
Blueberry, Elliott's (*Vaccinium elliottii*)	all	M–W	S–Psh	berry	Su	Good late-summer food for many species. Larval host plant for spring azure butterfly.
Elderberry (*Sambucus nigra* ssp. *canadensis*)	all	W–M	S	berry	Su–A	Favorite food for many birds. Provides good cover and nesting sites for birds.

Deciduous shrubs	Region[a]	Soil[b]	Light[c]	Type of fruit	Season of fruiting[d]	Value to wildlife
Pepperbush, sweet (*Clethra alnifolia*)	all	M–W	S–Psh	capsule	A	Birds and mammals eat fruit. Flowers attract bees, butterflies, and hummingbirds.
Plum, Chickasaw (*Prunus angustifolia*)	all	D–M	S–Psh	berry	Su	Fruit eaten by many species. Flowers attract insects. Forms thickets for overhead cover.
Serviceberry (*Amelanchier* species)	all	M	S–Psh	berry	Su	Fruit relished by many songbirds. Cover and nesting sites for robins and thrushes.
Spicebush (*Lindera benzoin*)	C, S	M	Psh–Sh	berry	Su	Birds and mammals eat fruit. Host plant for spicebush and eastern tiger swallowtails. Berries produced on female trees.
Strawberry bush, American (*Euonymus americanus*)	all	M	Psh	capsule	F–W	Fruit eaten by many songbirds. Favorite deer browse. Deer can eliminate plant.
Sumac, smooth (*Rhus glabra*)	all	D	S–Sh	drupe	A–W	Important winter food for many birds and small mammals. Good overhead cover.
Viburnum, arrowwood (*Viburnum dentatum*)	all	D–W	S–Psh	drupe	Su–A	Fruit eaten by birds and mammals. Provides cover and nesting sites for some birds.
Vines	**Region[a]**	**Soil[b]**	**Light[c]**	**Type of fruit**	**Season of fruiting[d]**	**Value to wildlife**
Crossvine (*Bignonia capreolata*)	all	M–D	S–Psh	seed	Su	Early nectar source for hummingbirds and butterflies. Winter deer browse. Evergreen.
Cypressvine (*Ipomoea quamoclit*)	all	M	S–Psh	seed	Su–A	Excellent nectar source for hummingbirds and butterflies. Introduced, non-native.
Grape (*Vitis* species)	all	D–W	S–Psh	grape	Su	Fruit eaten by many birds and mammals. Foliage provides cover and nesting sites.
Greenbrier (*Smilax* species)	all	D–W	S–Psh	berry	A–W	Fruit eaten by many species. Important late-winter and early-spring food for birds.
Passionflower (*Passiflora incarnata*)	all	M–D	S–Psh	berry	Su	Fruit eaten by birds. Larval host plant for Gulf and variegated fritillary butterflies.
Pipevine (*Aristolochia macrophylla*)	all	M	Psh	capsule	Su–A	Climbing, deciduous vine. Larval host plant for pipevine swallowtail butterfly.
Trumpet creeper (*Campsis radicans*)	all	M–D	S	seed	Su–A	Bright orange, tubular flowers provide nectar for hummingbirds and bees.
Trumpet honeysuckle (*Lonicera sempervirens*)	all	M	S–Psh	berry	Su	Flowers attract hummingbirds, butterflies, and bees. Larval host plant for spring azure butterfly.

Vines	Region[a]	Soil[b]	Light[c]	Type of fruit	Season of fruiting[d]	Value to wildlife
Virginia creeper (*Parthenocissus quinquefolia*)	all	M	S–Sh	berry	A–W	Important autumn and winter food for wildlife. Berries often persist until late winter.

Wildflowers	Soil[b]	Light[c]	Height	Color of flowers[e]	Season of blooming	Value to wildlife
Beardtongue (*Penstemon* species)	W–D	S–Psh	3 ft.	W, B	Su	Flowers attract hummingbirds, butterflies, and bees. Deer will browse foliage.
Bee balm (*Monarda* species)	D–M	S–Psh	3 ft.	Pi, P	Su	Flowers provide nectar for hummingbirds, butterflies, and bees.
Black-eyed Susan (*Rudbeckia* species)	D–M	S–Sh	2 ft.	Y	Sp–Su	Flowers provide nectar for butterflies and bees. Birds eat seeds. Reseeds readily.
Blazing star (*Liatris* species)	D–M	S	3 ft.	P, Pi	Su–A	Flowers provide nectar for butterflies, bees, and hummingbirds. Blooms from top down.
Blue mistflower (*Conoclinium coelestinum*)	M	S–Psh	3 ft.	B, P	Su–A	Flowers attract butterflies and bees. Good nectar source for late-season butterflies.
Butterfly milkweed (*Asclepias tuberosa*)	M–W	S	2 ft.	O	Su	Butterflies and bees use nectar. Larval host plant for monarch and queen butterflies.
Cardinal flower (*Lobelia cardinalis*)	M–W	S–Sh	3 ft.	R	Su–A	Good nectar source for hummingbirds. Soils must be kept wet or moist.
Coreopsis (*Coreopsis* species)	M	S–Psh	2 ft.	Y	Sp–A	Flowers provide nectar for hummingbirds and butterflies. State wildflower.
Eastern red columbine (*Aquilegia canadensis*)	M–D	Psh–Sh	2 ft.	R, Pi, Y	Sp–Su	Flowers attract hummingbirds, butterflies, and bees. Finches and buntings eat seeds.
Fire pink (*Silene virginica*)	M	S	10 in.	R	Sp–Su	Flowers attract hummingbirds, bees, and butterflies. Songbirds eat the seeds.
Indian blanket (*Gaillardia pulchella*)	D	S–Psh	2 ft.	R, Y	Su–A	Flowers provide nectar for butterflies. Reseeding wildflower.
Indian paintbrush (*Castilleja coccinea*)	D–M	S	2 ft.	O, R	Sp–Su	Flowers provide nectar for hummingbirds. Larval host plant for variegated fritillary.
Iris (*Iris* species)	W–M	S–Psh	3 ft.	B, P, R, Y	Sp	Flowers attract hummingbirds and bumblebees (most important pollinator).
Phlox (*Phlox* species)	M	Psh–Sh	18 in.	W, R, Pi, P	Sp–Su	Flowers attract butterflies. Seeds eaten by finches and sparrows. Rabbits eat roots.

Wildflowers	Soil[b]	Light[c]	Height	Color of flowers[e]	Season of blooming	Value to wildlife
Prairie coneflower (*Ratibida columnifera*)	D–M	S	3 ft.	O, Y	Sp–Su	Provides nectar for butterflies and bees. Birds eat seeds. Deer will browse flower.
Purple coneflower (*Echinacea purpurea*)	D	S–Psh	3 ft.	Pi, P	Su–A	Flowers provide nectar for butterflies and hummingbirds. Cut off dead flowers to prolong blooming season. To attract birds, keep late-season flowers on the plants to mature.
Scarlet rosemallow (*Hibiscus coccineus*)	W	S	6 ft.	R	Su–A	Flowers attract butterflies and bees. Flowers over a long period of time in the summer.
Scarlet sage (*Salvia coccinea*)	M–D	S–Psh	2 ft.	R	Sp–A	Flowers provide nectar for hummingbirds, butterflies, and bees.
Sunflower (*Helianthus* species)	D–W	S	7 ft.	Y	Su–A	Seeds eaten by birds. Larval host plant for painted lady and silvery checkerspot.
Yarrow, common (*Achillea millefolium*)	M–D	S–Psh	3 ft.	W	Sp–Su	Flowers provide nectar for butterflies, bees, and other insects.

[a] Regions of the state are shown as north (N); central (C); south (S); and Gulf coast (GC).

[b] Soil requirements are classified as: wet (W); moist (M): dry (D).

[c] Light requirements are classified as: full sun (S); partial shade (Psh); and shade (Sh).

[d] Seasons are shown as: spring (Sp); summer (Su); autumn (A); and winter (W).

[e] Colors are shown as: blue (B); orange (O); pink (Pi); purple (P); red (R); white (W); and yellow (Y).

Page numbers in **bold** indicate illustrations.